Living Matter

Living Matter

The Preservation of Biological Materials in Contemporary Art

Edited by Rachel Rivenc and Kendra Roth

GETTY CONSERVATION INSTITUTE, LOS ANGELES

Getty Conservation Institute
Timothy P. Whalen, *John E. and Louise Bryson Director*
Jeanne Marie Teutonico, *Associate Director, Strategic Initiatives and Publications*

The Getty Conservation Institute (GCI) works internationally to advance conservation practice in the visual arts—broadly interpreted to include objects, collections, architecture, and sites. The Institute serves the conservation community through scientific research, education and training, field projects, and the dissemination of information. In all its endeavors, the GCI creates and delivers knowledge that contributes to the conservation of the world's cultural heritage.

This publication was created using Quire™, a multiformat publishing tool owned by the J. Paul Getty Trust.

The free online edition of this publication is available at getty.edu /publications/living-matter/ and includes videos and zoomable high-resolution photography. Also available are free PDF, EPUB, and Kindle/MOBI downloads of the book.

First edition, 2022
github.com/thegetty/living-matter/

Published by the Getty Conservation Institute, Los Angeles
Getty Publications
1200 Getty Center Drive, Suite 500
Los Angeles, California 90049-1682
getty.edu/publications

Tevvy Ball, *Project Editor*
Lindsey Westbrook, *Manuscript Editor*
Greg Albers, *Digital Manager*
Kurt Hauser, *Cover Designer*
Molly McGeehan, *Production*
Leslie Rollins and Nancy Rivera, *Image and Rights Acquisition*
Audrey Warne, *Digital Assistant*

Distributed in the United States and Canada by the University of Chicago Press

Distributed outside the United States and Canada by Yale University Press, London

Library of Congress Cataloging-in-Publication Data
Names: Getty Conservation Institute, author, issuing body. | Rivenc, Rachel, editor. | Kendra Roth, editor.
Title: Living Matter: The Preservation of Biological Materials in Contemporary Art
Description: First edition. | Los Angeles : Getty Conservation Institute, 2022. | Proceedings of the symposium "Living Matter: The Preservation of Biological Materials in Contemporary Art / La Materia Viva: Conservación de materiales orgánicos en el arte contemporáneo" which took place June 3–5, 2019, in Mexico City and was co-organized by the Getty Conservation Institute (GCI), the Museo Universitario Arte Contemporáneo (MUAC) of the Universidad Nacional Autónoma de México (UNAM), and the Escuela Nacional de Conservación, Restauración y Museografía "Manuel del Castillo Negrete" (ENCRyM) of the Instituto Nacional de Antropología e Historia (INAH). | Includes bibliographical references. | Summary: "This is the first book to provide a comprehensive overview of the conservation of biological materials used in contemporary art"— Provided by publisher.
Identifiers: LCCN 2021056356 (print) | LCCN 2021056357 (ebook) | ISBN 9781606066874 (paperback) | ISBN 9781606066881 (mobi) | ISBN 9781606066898 | ISBN 9781606067673 (epub)
Subjects: LCSH: Art, Modern—20th century—Conservation and Restoration—Congresses. | Art, Modern—21st century—Conservation and Restoration—Congresses. | Artists' Materials—Deterioration—Congresses. | Museum conservation Methods—Congresses.
Classification: LCC N8554.5 .L58 2019 (print) | LCC N8554.5 (ebook) | DDC 702.8/8—Dc23/eng/20220118
LC record available at https://lccn.loc.gov/2021056356
LC ebook record available at https://lccn.loc.gov/2021056357

Front cover: Adrián Villar Rojas (Argentinian, b. 1980), from the series *The Theater of Disappearance (XIII)*, 2015–18 (detail). Organic, inorganic, and human- and machine-made matter, 381 × 312.4 × 243.8 cm. Collection of The Bass. © Adrián Villar Rojas. Installation view, Geffen Contemporary at MOCA, Los Angeles, 2017. Studio Michel Zabé, courtesy the artist, Marian Goodman Gallery, New York / Paris / London; kurimanzutto, Mexico City; and The Geffen Contemporary at MOCA

Back cover: Gabriel de la Mora (Mexican, b. 1968), eggshell pieces for potential use in the series *CaCO3*, 2013–ongoing (fig. 22.10, detail). Courtesy the artist and Proyectos Monclova

Contents

Foreword
Timothy P. Whalen . viii

Preface
Rachel Rivenc and Kendra Roth . x

Keynote: In the Unpredictable Garden of Forking Paths
Adrián Villar Rojas and Sebastián Villar Rojas . 1

Part One: Living Matter in Contemporary Art: Snapshots 31

1. Biological Material Indeterminacy Rebukes the Social and the Artistic: Cases from the Documentary Archives of the Arkheia Documentation Center, Mexico
Eugenia Macías and Cristina Reyes . 32

2. Can We Use the Concept of Programmed Obsolescence to Identify and Resolve Conservation Issues on Eat Art Installations?
Claudia María Coronado García . 39

3. The Artist's Body in the Age of Genomic Reproduction
Barbara Ursula Oettl . 47

4. The Eternal Metabolic Network: Fluxus, Food, and Ecofeminism
Natilee Harren . 55

5. Plump and Pliant: The Preservation of Bacterial Cellulose in Textile Bioart
Courtney Books . 64

6. Some Survive, Few Are Conserved, Even Fewer Can Travel: Paradoxes and Obstacles in Maintaining and Staging Biomedia Art
Jens Hauser . 74

Part Two: Working with the Artist: Between Conservation and Production 84

7. Preserving Mortality through a Sacrifice for Your Country: A Performance by Carlos Martiel and a Conservator's Challenge
Flavia Perugini ... 85

8. Cross-Disciplinary Collaboration and Innovation in the Exhibition of Living Matter at the National Gallery of Zimbabwe: The Case of the *Planetary Community Chicken* Exhibition
Davison Chiwara ... 92

9. The Life-Death Movement of Fruits, Tubers, and Vegetables in Nydia Negromonte's *POSTA*
Magali Melleu Sehn ... 99

10. Conservation/Restoration of Biological Material in Contemporary Art: A Perspective from Academia in Collaboration with Artists
Ana Lizeth Mata Delgado ... 106

Part Three: Living Matter: Challenging Institutions 113

11. Killing with Kindness? The Challenges of Conservation and Access for Living Matter
Marcia Reed ... 114

12. Flora and Fauna as Art: A Contemporary Art Conservation Approach to Living Systems
Sherry Phillips and Sjoukje van der Laan 126

13. Conserving Active Matter in Contemporary Design
Jessica Walthew and Sarah Barack 135

14. Research, Conservation, and Exhibition of a Contemporary Art Installation Containing Living Organisms as Part of the Creative Process
Claudia Barra, Cristina Bausero, María Pía Cerdeiras, Silvana Alborés, Belén Estévez, and Soledad Martínez 145

15. When Installation Art Depends on Live Surroundings to Survive
Camilla Ayla Oliveira dos Anjos and Magali Melleu Sehn 153

16. Building Communities and Conserving Living Matter in the Collection of the Museo Universitario Arte Contemporáneo, MUAC-UNAM, Mexico City
Claudio Hernández ... 160

Part Four: Different Approaches and Responses 165

17. Stabbing Our Own House: A Biography of Joseph Beuys's *Wirtschaftswerte*
Rebecca Heremans and Katrien Blanchaert 166

18. *Pieces of the People We Love*: Challenges in Caring for Works by Adrián Villar Rojas in the Moderna Museet Collection
Thérèse Lilliegren, Tora Hederus, My Bundgaard, Sara Norrehed, and Tom Sandström .. 177

19. Nature and Its Energy: Considerations on the Processes of Conserving Organic Matter
Mercedes Isabel de las Carreras 186

20. Conservation as an Enhancing Factor in the Interpretation of Living Materials Artworks
Flavia Parisi, Maura Favero, and Rosario Llamas Pacheco 191

21. A Crumb(ling) Display: Conserving Bread in the Collection of the Museum of Contemporary Art, Zagreb
Mirta Pavić, Jasna Jablan, Ivana Bačić, and Harald Fitzek 199

Part Five: Artists' Reflections ... 208

22. Living Matter: Research as Creative Process
Gabriel de la Mora .. 209

23. *Murmelte Instrumente*: The Body, Like a Hand to an Instrument
Kelly Kleinschrodt .. 217

24. Dissolving Matter: Notes on *Símbolo descarnado*
Darío Meléndez ... 226

Bibliography ... 231

Contributors ... 241

Symposium Participants ... 246

Foreword

The appetite of contemporary artists for experimentation is seemingly infinite, and the variety of materials they use is therefore correspondingly immense. This poses numerous conservation challenges, perhaps none as acute as with the use of biological materials in works of art. These can include flowers and plants, food and bodily fluids, and microorganisms. And because all that lives eventually dies, the preservation of such living matter can seem like an impossible paradox. Yet museums and institutions are routinely tasked with ensuring that these artworks endure.

It was to address this challenge that the symposium "Living Matter: The Preservation of Biological Materials in Contemporary Art / La Materia Viva: Conservación de materiales orgánicos en el arte contemporáneo" was conceived. The international meeting was co-organized by the Getty Conservation Institute (GCI), the Museo Universitario Arte Contemporáneo (MUAC) of the Universidad Nacional Autónoma de México, and ENCRyM (Escuela Nacional de Conservación, Restauración y Museografía "Manuel del Castillo Negrete") and held in Mexico City in June 2019. It was attended by more than 150 conservators, curators, artists, art historians, and archivists, all of whom have a keen interest in preserving these unique and increasingly ubiquitous "living" materials. This volume documents the proceedings of this exciting and groundbreaking meeting.

The GCI's involvement in both the conference and these proceedings stems from its Modern and Contemporary Art Research Initiative, launched in 2007 to address some of the complex challenges raised by the conservation of contemporary art. The initiative includes a strong research component, yet it also recognizes that one of the most effective ways of meeting these challenges is through networking and the dissemination of information among professionals in the field. One of the strategies adopted to achieve this goal is the organization of focused, singled-themed meetings, like this symposium, which present an opportunity to hear a range of different points of view, compare practices, and survey the current state of thinking.

Additionally, the GCI has a long history of collaborating with partners in Latin America. We were delighted to work alongside both MUAC and ENCRyM and to be able to host the symposium in vibrant Mexico City, which is teeming with contemporary art and artists and claims a dynamic contemporary art conservation community. We are extremely thankful to our partners for hosting a very successful symposium, and for their many contributions, both logistical and intellectual. We also

gratefully acknowledge Kendra Roth and Rachel Rivenc for their careful and thoughtful editing of this volume.

"Living Matter / La Materia Viva" generated in-depth exchanges of knowledge and perspectives. As the first symposium dedicated to this topic, this conference has a singular significance, and it is important for everyone in the emerging field of preservation of biological materials to be able to access the resulting research, case studies, and discussions. We are therefore delighted that these proceedings are available in both digital and print formats, and we hope that they will play their part in helping keep these artworks alive.

Timothy P. Whalen
John E. and Louise Bryson Director
Getty Conservation Institute

Preface

Rachel Rivenc
Kendra Roth

For decades, contemporary art has challenged collecting institutions and, as a consequence, the conservators and others tasked with caring for the art. Conceptual art, readymade and found objects, time-based media, performance art—many of these were attempts to expand the boundaries of traditional art forms and defy the conservatism of institutions. In response to such challenges, conservators had to expand the conventional definition of an artwork as a discrete object directly embodied by and contained in a set of materials and consider different forms of incarnation and manifestation, different modes of being. They also had to drastically expand their skill sets, and therefore their networks of collaborators, to address these new art forms.

The introduction of biological materials into the ever-expanding palette of materials used by contemporary artists has certainly been one of the greatest challenges to institutions, and a difficult puzzle to solve for conservators. Art that lives, breathes, grows, morphs, sprouts, mutates, oozes, decays, and might decompose entirely, certainly goes against the idea of the museum as a static place where objects are housed, contemplated, and preserved as much as possible in their existing form. The challenges are both conceptual and practical. In this volume, Marcia Reed underscores that Fluxus works were specifically created to challenge institutional authority and questions the ethics of preserving works not meant to last; she reminds us that, literally, "Fluxus means change." On the more practical side, Mercedes Isabel de las Carreras remarks that the conservation of Víctor Grippo's *Analogía I* (Analogy I, 1970–71) hinges just as much on the proper

selection of potatoes as it does on the museum's environment, and notes that if the work were to be exhibited continuously for two years, the cost of more than 2,160 replacement potatoes and a minimum of 120 conservator work hours would have to be factored in.

The advent of bioart, in which artists draw upon scientific advances of genetically modified organisms (GMOs) and other types of manipulations of living beings and tissues, poses yet another level of intertwined ethical and practical challenges, as outlined in Jens Hauser's article. The responsibility of museums toward the living organisms they are caring for, and transparency toward the public, must be reckoned with. For instance the loan agreements can involve complex ethical negotiations, and shipments may need to be handled by biomedical companies rather than conventional art transporters.

A challenge to the institution is not, however, always the primary goal of using living matter in art. In many cases, it is the aesthetic, tactile, and poetic properties of biological material that the artist is forefronting. Flavia Parisi, Maura Favero, and Rosario Llamas Pacheco's article in this volume discusses *Precipitazioni Sparse* (Scattered Precipitations, 2005), a work by Bruna Esposito in which white, golden, and red onion peels are scattered across a marble slab. The artist was attracted to the beauty of the onion peels—their infinite variations in color, shape, and translucency—which in juxtaposition with a traditionally noble art material, namely Carrara marble, calls attention to the beauty and poetry discoverable in everyday things. Other times it is the process of change itself that the artist wishes to deploy for its symbolic value. The Mexican artist

Darío Meléndez here discusses *Símbolo descarnado* (2013), a collective installation realized in collaboration with Omar Soto and Diana Bravo, in which he displayed the rotting carcasses of an eagle and a serpent inside a glass case to evoke "the atmosphere of deterioration in which [his] country is submerged."

For some works, periodic replacement of their biological materials may be appropriate, even convenient, as long as the criteria are well defined and the resources are available. In fact, following this logic could represent the ultimate form of commodification, in one of those spins with which the art market is familiar. There is perhaps no better example of this than Maurizio Cattelan's *Comedian* (2019), which is in part a critique of the art world but nevertheless fetched $120,000 at a Miami art fair, where it fascinated patrons and became a social media sensation. When an edition of the work was donated anonymously to the Guggenheim, the museum's conservators were happy to discover that, thanks to extensive instructions on how to select and install the banana and the duct tape, the work was rather easy to conserve (Bowley 2020). It is not always the case, though, that replacement is possible, or that the possibility of replacement leads to commodification.

In 2007, Adrián Villar Rojas used a sponge cake in his installation *Pedazos de las personas que amamos* (Pieces of the People We Love). After the installation, the cake was brought back to Villar Rojas's hometown of Rosario, Argentina, where his parents kept it for eight years, until it was shipped to Sweden in 2015 to be part of the exhibition *Fantasma*, and subsequently acquired by the Moderna Museet in Stockholm (see the essays by Adrián and Sebastián Villar Rojas and Thérèse Lilliegren et al. in these pages). The cake, made by the artist's aunt and identical to cakes she made for his childhood birthdays, acquires more ontological value as an object with each year that passes and every event it survives. Reusing entire parts of an installation in a new one, in a process of continuity and reinvention, has become a feature of Villar Rojas's work. The replacement of the now thirteen-year-old cake is not considered an option at the moment; rather, the Moderna Museet is working in consultation with the artist to store it in an oxygen-free environment. In fact, the artist sees his work on the opposite spectrum of commodification, with "the material dimension of [his] practice," as he writes in his essay here, being more the "precarious act of bearing witness to an activity that is lost forever (all of the richness of a nomadic life in that community or of the processes of exploration) than the ultimate goal of a 'career' aimed at producing commodities."

The symposium "Living Matter: The Preservation of Biological Materials in Contemporary Art / La Materia Viva: Conservación de materiales orgánicos en el arte contemporáneo" took place June 3, 4, and 5, 2019, in Mexico City and was co-organized by the Getty Conservation Institute (GCI), the Museo Universitario Arte Contemporáneo (MUAC) of the Universidad Nacional Autónoma de México (UNAM), and the Escuela Nacional de Conservación, Restauración y Museografía "Manuel del Castillo Negrete" (ENCRyM) of the Instituto Nacional de Antropología e Historia (INAH). Over the course of the three days, a lively international group of conservators, curators, artists, art historians, philosophers, and archivists explored the many different ways that living matter can be incorporated into art, its multifaceted significance, and different conservation approaches and institutional responses. Several artists were present throughout the conference, each at a different phase of their career and with very different and deeply personal practices, thus reflecting a plurality of artistic voices. The dialogue with the custodians of their works was curious, rich, and respectful.

As expected, no monolithic solution was found. Any consensus that did emerge was around the necessity to continue these conversations so that each work of art, each situation, can be considered in all its complexities, and to accept that while we want to preserve these works, we cannot tame them or fix them in a final state of unchanging objecthood. We want them to continue to live and to challenge us—as does life itself.

We would like to thank the MUAC and ENCRyM, who were wonderful partners in the organization of the seminar, and in particular Julia Molinar and Claudio Hernández (MUAC-UNAM) and Ana Lizeth Mata Delgado and Claudia María Coronado García (ENCRyM-INAH), who worked tirelessly to make the symposium happen. Their enthusiasm, diligence, and efficiency made them a joy to work with. We also thank the director of MUAC, Graciela de la Torre, and director of ENCRyM, Gerardo Ramos Olvera, for their support of the symposium and being such generous hosts. At the GCI we are extremely grateful to Tom Learner, head of science; Kathy Dardes, head of collections at the time; Jeanne Marie Teutonico, associate director, strategic initiatives and publications; and Tim Whalen, John E. and Louise Bryson Director, for their support of the project. The symposium would certainly not have been possible without Reem Baroody's work; her limitless energy and dedication made it possible to overcome all sorts of logistical obstacles. Nicole Onishi's help was frequently crucial. Cynthia Godlewski, Chelsea Bingham, and Gary Mattison at the GCI expertly coordinated the

preparation for publication of these proceedings. At Getty Publications, our gratitude to Tevvy Ball, Greg Albers, Kelly Peyton, Karen Levine, and Kara Kirk.

BIBLIOGRAPHY

Bowley 2020
Bowley, Graham. 2020. "It's a Banana. It's Art. And Now It's the Guggenheim's Problem." *New York Times*, September 18, 2020, https://www.nytimes.com/2020/09/18/arts/design/banana-art-guggenheim.html.

In the Unpredictable Garden of Forking Paths

Adrián Villar Rojas
Sebastián Villar Rojas

From suicidal or ephemeral sculptures to diachronic, mutant, or hybrid objects, the presence of the living in my projects has been developing for more than a decade. In this essay, I attempt to provide a panoramic overview of this journey, while showing how each phase of this relationship with living matter causes my team's collaborative work to be organized differently. I will follow a chronological order in coordination with theoretical considerations, many of which emerged in interviews, books, and catalogues written together with my brother Sebastián, a writer, playwright, and theater director. Accordingly, the notion of praxis fits in well with my own practice, which is affected both by contingent discovery and by the intention to formalize it in idea systems.

◆ ◆ ◆

Century follows century, and things happen only in the present. There are countless men in the air, on land and at sea, and all that really happens, happens to me.

—*Jorge Luis Borges,* The Garden of Forking Paths, *1944*

I will approach the notion of "living matter" in two ways. One is the presence of material able to generate phenomena such as autopoiesis or auto-production in the "language games" (Wittgenstein 1953) that I weave into my projects. The other is the presence in them of human work, or simply work, since, as the central thesis in the Marxist theory of value suggests, it is the application of "muscle, nerve, and brain" to transforming material that is at the core of human action on the planet. In effect, the human dimension is the primary "living matter" that, I believe, I have devoted myself to shaping, both in

respectful exchanges with local actors and in the social experiment that my team has been and continues to be. It is these two directions (*work* along with my collaborators and the *auto-production* of organic material) that I will address in this essay, inscribing them diachronically in the evolution of a praxis.

2004: YEAR 0

If I had to choose a relative starting point for my dialogue with living matter, it would not be the direct use of an organic element, but a pictorial representation of life, namely the reproduction of two Jurassic landscapes by Charles R. Knight, who created the murals at the Museum of Natural History in New York, which I commissioned my friend and faculty of fine arts colleague Juan Manuel

1

Hernández to produce for my first solo show, *Incendio* (Fire) at Nuevo Espacio, Ruth Benzacar Art Gallery, Buenos Aires, in 2004. In them, two dinosaurs graze and look toward the horizon on the savannah seventy million years ago, in a hypothetical scene from daily life in the Late Jurassic. The only difference, missing from the original and added by Juan at my request, is a handful of tiny trails of fire, almost imperceptible, in a corner of the blue sky: a group of meteorites that in just a few moments will trigger the start of a new mass extinction on Earth.

2006 AND THE *CLOSE ENCOUNTERS* MOUNTAIN: ANTHILLS IN FRONT OF THE ELEMENTARY SCHOOL

A man wakes up in the morning and hurries to his garden. He gathers soil in a wheelbarrow and takes it inside his house. He dumps it in the living room. He repeats this activity for days. He doesn't stop until he has made a mountain with a precise shape and size: a homemade three-dimensional map of the place where the close encounter will take place. The scene changes the history of film.

It is the same obsession that pursues me: soil/earth. Wire structures covered in Kraft paper, coated in glue, and sprinkled with black dirt until they become a volcano, or actually an anthill. The theme of the alien runs through my drawings, my notebooks, the little projects that look as if they were made by a teenager, a nerd, a loner, at home in his garage. With these giant anthills, it is not the theme but the logic that produces them that seems alien, strange, alienated, emancipated from the "human." Rather than content, it is an ontology that is glimpsed beneath the obsessive creation of those anthills: an exercise in distancing in order to produce material noise in the environment, silent entities that barge or burst onto the scene implosively like an autistic presence. There has been a photograph for years on the Wikipedia entry in my name: I am installing anthills in front of the door to an elementary school in Rosario during Art Week 2006, surrounded by students who look at me as if I were an alien consumed by a useless or incomprehensible task.

The mountain-anthills reappeared in 2007 at the Centro Cultural Borges and Belleza y Felicidad, both in Buenos Aires, eliciting the same sense of an autistic impact on the space, and ended up stored for years in my parents' living room, crumbling on their carpet (fig. 0.1).[1]

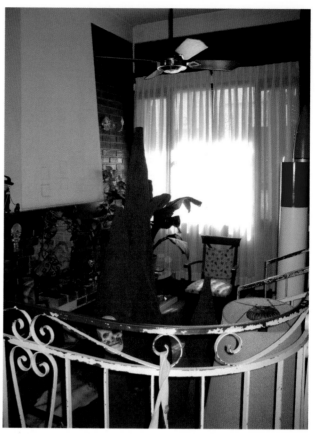

Figure 0.1 Two ant nests made in 2006, stored in the living room of the artist's parents, Rosario, Argentina. Soil, glue, Kraft paper, and small graveyard crosses. Photo: Adrián Villar Rojas

2007 AND THE MAP OF MAPS: THE PETROBRAS TABLE

Pedazos de las personas que amamos (Pieces of the People We Love, 2007, fig. 0.2) is a twenty-meter-square table where, with countless materials and homemade processes, all of the cause-and-effect relationships needed in the multiverse for a tragically ending love story are put into play: she is infected with bacteria carried by a meteorite on exhibition in the forest, and he commits suicide inside his robot on the side of a mountain (made out of cake by my aunt, just like the ones she used to make for my birthday when I was a child). Nearby, another cake covered in green sprinkles serves as the base for a dinosaur lying amid balsa-wood crosses and little pastry trees. A school of goldfish swim in their world of glass and electrically oxygenated water. A canary song echoing snippets of Nirvana and Radiohead drifts from a PC's humble speakers. And under the table, again, the soil piles up in a series of hills sprouting sepulchral crosses. The interaction of low-cost industrial objects (Chinese imports bought in

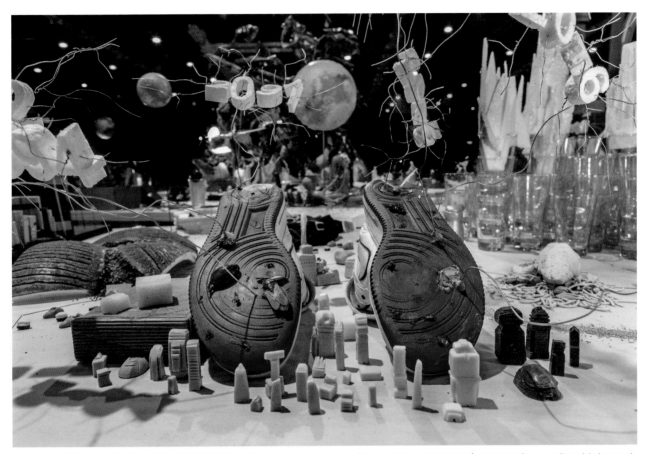

Figure 0.2 Adrián Villar Rojas (Argentinian, b. 1980), *Pedazos de las personas que amamos* (Pieces of the People We Love), 2007. Styrofoam, cardboard, balsa wood, epoxy putty, unfired clay, soil, sponge cakes, insects, paper, ketchup, corn flour, potatoes, cacti, artificial plants, tree branches, miniature pine trees, trophies, lamps, fish, fish tank, loudspeakers, graphite pencil leads, motocross helmet, trainers, televisions, and DVD players, all collected in Rosario, 640 × 440 × 130 cm. Installation view, 4th arteBA-Petrobras Visual Arts Prize, Buenos Aires, 2007. Photo: Tomás Lerner, courtesy the artist

the wholesale commercial zones of Rosario) such as articulated dolls, backpacks, decorative ceramics, costume jewelry, stickers, dishes, electronics, and Styrofoam packing materials is combined with this—somewhere between ominous and innocent—presence of the organic in a trans-temporal microcosm where every element in the chain of causation has not yet been destroyed by entropy—that is, by the arrow of time—and is therefore frozen in the instant of greatest productivity to be an explanation or consequence of their previous or future link. It is done in a way that reprises Antonio Campi's *The Mysteries of the Passion of Christ* (1569), where Jesus is alive, dead, resuscitated, and ascending, not only in the same painting, but in an apparent single chronotopic unit: an Aleph with no chronology, or with a chronology that has been undone by its own exacerbation.

That is where the first sculptures appear, in that whirlwind of three-dimensional stimulation, modeled out of two materials that are diametrically opposed in their durability: clay and epoxy. The raw clay figurines and objects will

disappear in a matter of weeks once the project is dismantled. The epoxy ones (the busts of the tragic couple, for example) are still on top of the souvenir display case at my parents' house, intact, like the youthful melancholy beauty of lovers.

Here, using the very temporal multidimensionality of the project, I will flash forward: the cake-mountain, made of four stories of cake, where the protagonist would go to commit suicide, will be returned to Rosario and stored in the warehouse of the family business along with other remnants of the Petrobras table.[2] My parents kept it on a shelf for eight years until 2015, when, now practically reduced to dust, rock, and mold, it was moved to Sweden using a sophisticated logistical plan that spanned thirteen thousand kilometers. In Stockholm it was displayed in a specially designed case with ideal humidity and temperature conditions as part of *Fantasma* (Ghost, fig. 0.3). That project was an attempt to imagine what a retrospective of my oeuvre would be like two hundred years from now, given that because of its radical entropy,

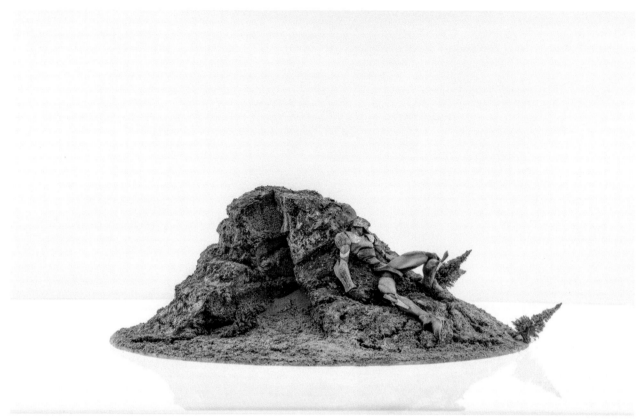

Figure 0.3 Adrián Villar Rojas (Argentinian, b. 1980), *Untitled*, from the series *Pedazos de las personas que amamos* (Pieces of the People We Love), 2007. Sponge cake, marzipan, robot, miniature pine trees, confetti sprinkles, and balsa wood, 30 × 50 × 50 cm. Moderna Museet, Stockholm. Installation view, *Fantasma*, Moderna Museet, Stockholm, 2015. Photo: Åsa Lundén, courtesy the artist and Moderna Museet

there would be nothing more than some residuals or remnants of its material form. We will get back to this point.

2008 AND THE BIRTH OF ENTROPIC AWARENESS

I used to say that the Petrobras table is a map of maps, a master plan for my life project, meaning that, in retrospect, one might see each of my subsequent steps as the hyperbolic development of a particular vein of work that was already present in that work and in the experience of producing it. This is absolutely apparent in *Lo que el fuego me trajo* (What Fire Has Brought Me, 2008, fig. 0.4), a hyper-entropic universe born from a particle of the Petrobras table: the clay figurines I mentioned above, barely noticeable among the myriad creatures that populated its surface like the multitudes of every species that teemed throughout *Star Wars'* intergalactic Tijuanas.[3] All I had left of them were five unused bags of clay, and the experience of making something that simply disintegrated.

In January of 2008, I sank my fingers into the clay and started to model without any preconceived outcome. In a couple of hours, I imitated the life I saw around me: a jar of pills, an iPod, a spoon. I was in the first and only studio I have had, a house in Buenos Aires that I rented and lived in for two years. It was a first time for many things: living alone, away from Rosario, having a place to work, and the ominous imminence of grief that I would experience in March of that year with the death of my maternal grandfather. In a couple of months (once again picture the lonely, quasi-autistic adolescent, driven by an apparently useless obsession, a kind of calling from elsewhere, as with the unraveled time Kurt Vonnegut's character experiences in *Slaughterhouse-Five* [1969], but unlike the catatonic state that character falls into when traveling to a parallel universe; my condition was still more akin to that of the compulsive man in *Close Encounters of the Third Kind* [1977]), I filled the house with a clay "memory" that was already starting to crack the minute I set it down on the shelves or the floor, wherever there was a place to put it. The clay interacted violently with the air, the temperature, the humidity, the vibrations of the noisy world into which the pieces were born to simply die, like Martin Heidegger's

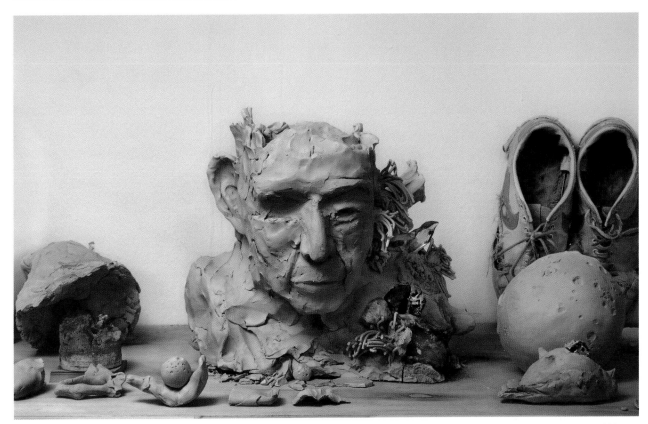

Figure 0.4 Adrián Villar Rojas (Argentinian, b. 1980), *Lo que el fuego me trajo* (What Fire Has Brought Me), 2008. Unfired clay, bricks, cement, demolition rubble, water tanks, water, lime, sand, wood, metal, mirrors, glass, soap, mollusk shells, car windscreen, car hood, badges, stickers, sprouting potatoes, corals, stones, ceramic objects, cold porcelain, trainers, glass jars, burned bread, pasta, Post-it note cube, and jewelry, all collected in Buenos Aires. Photo: Ignacio Iasparra, courtesy the artist and Ruth Benzacar Galeria de Arte

Dasein. They were—I discovered—beings conceived to perish.

Like the condensers that Nikola Tesla conceived to transform the electromagnetic waves that surround us into instant energy, these humble raw clay *Daseins* were hypersensitive to time. They absorbed it from every particle that came into contact with them, accumulating and amplifying it. They magnified it thousands of times, as if under a microscope lens: that lens was their very body, which cracked and aged in just a few hours until it was transformed into a fossil, before disintegrating and vanishing. For me, then, clay represented the possibility to fossilize beings, whether figurative, abstract, or symbolic. There was one step between this discovery and playing with the oxymoron: the future (incarnated in a cyborg, in a device for the digital era, or however our imagination represents the future) can be fossilized until it becomes a cemetery of what is to come. And at the same time, what is clay but the prehistory of life on Earth, organic matter pounded into infinity, the sediment of everything that has lived on its cool shores or beneath the surface of its waters? The remote past and the distant future draw

closer to the present, and the present distances itself with them or opens up to its othernesses (to the multiverse, to its parallel dimensions). With clay, time becomes manipulable. Time becomes sculpture. And sculptures become suicidal.

FROM TIME AS SCULPTURE TO TIME AS SCULPTOR: MOVING FROM SUICIDAL TO DIACHRONIC OBJECTS

I began to multiply these clay entities dramatically in 2009. It started with the whale at Parque Yatana in Ushuaia, Argentina, for the Biennial at the End of the World (fig. 0.5).[4] There were key moments, like the eleven monoliths at the 2011 Venice Biennale, the hundred-meter cylinder at the Tuileries Garden in Paris, also in 2011, or the sculpture forest at *dOCUMENTA (13)* in Kassel (2012).[5] These projects condensed all the ideas laid out above: noise or estrangement from the landscape; the radicalization of time as representation or narrative; a distancing from the human world through its fossilization; and hyper-entropy

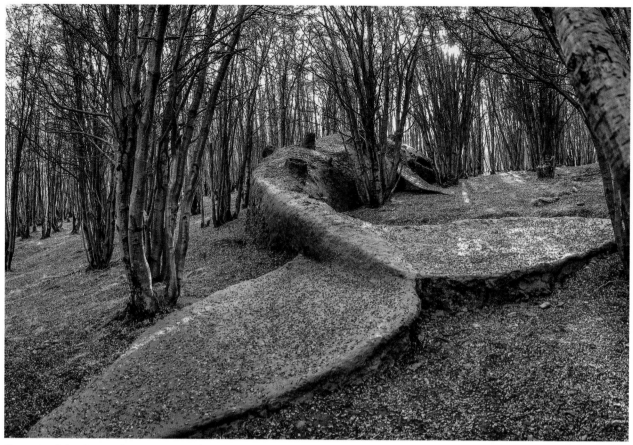

Figure 0.5 Adrián Villar Rojas (Argentinian, b. 1980), *Mi familia muerta* (My Dead Family), 2009. Unfired local clay and rocks, 300 × 2700 × 400 cm. Installation view, Parque Yatana, 2a Bienal del Fin del Mundo, Ushuaia, Argentina, 2009. Photo: Carla Barbero, courtesy the artist

that annihilated objects that were ever more labor-intensive because of their magnitude or complexity.

Adding to that, on the one hand, there was an increasing defiance against the limits of the field of "art" (the variables that ensure that its reproduction and even its transformation into a commodity—transport, durability, scale, costs—were continually mined or taken to the extreme, first in a more intuitive way, and then in a more systematic and conscious way, which I will call "the philosophy of limits"). On the other hand there was the birth of a community of collaborators that embarked on its own path of development vis-à-vis clay, expanding its possibilities as a material while improving strategies and accumulating knowledge and technology. Here, clay begins to turn into a language that is transferable to future generations. Each new collaborator internalizes and tests the techniques, the processes, the group dynamics, all of which vary from project to project. Sometimes the serial and repetitive logic of the factory comes into play; at other times, it is the creative and loose logic of the artisanal workshop; and at yet other times, it is the harrowing and uncertain dynamic of the experimental laboratory. I am

always the coordinator of these metamorphoses, generating different communication dynamics with each team member, at times more transparent and direct, and at other times more opaque and ambiguous. No one person is the same, and no one person requires the same thing.

From the language of engineering to the language of psychoanalysis, from the prompt to Socratic catharsis, from Frederick W. Taylor's assembly line to Melanie Klein's negative transference, the discourses that spark ideas in the studio are numerous, hybrid, mixed. I try to take maximum advantage of the gaps in communication (misunderstanding as a source of discovery, as a space for creative freedom), but also of the possibility of establishing very strict codes when necessary. In short, the "community" engages in a dialogue with itself and with its surroundings in the hyper-specialized language of raw clay. Over time, cement was added to it, leading to the mixture that would dominate the period between 2008 and 2013: clay + cement. This formula also signals a key metaphor in my practice: "before human beings" + "after

human beings": the traces of life before the Anthropocene (clay) and the traces of our lives in its wake (cement).

What began in 2009 with the two collaborators I found in Ushuaia based on recommendations from locals, César Martins and Mariano Marsicano, and Alan Legal, a technical assistant I brought from Buenos Aires, became *Today We Reboot the Planet* (2013) in an enormous warehouse on the outskirts of London.[6] This is an organized system with workstations (self-designed mini-studios), where more than ten collaborators function as actors on their own sets (jewelry, sculpture, construction, metalworking, et cetera), improvising their roles based on interactions with a director (me), who shapes their performance in real time, reacting to each of them based on what they provide and building their scenes along with them. The material results of this process of "rehearsals" come together in the "premiere": the opening of an exhibition, which is increasingly less satisfying or representative to me as a mechanism for the visibilization of work, given its complexity. The actual richness of this process—the intense human activity, the living matter of the theater (muscular and neural energy put into play)—has disappeared forever. The resulting pieces barely bear precarious witness to what is no longer there, namely the life of a community developing a language over weeks or months. To survive, that community has become nomadic—an itinerant company that, even as the current exhibition is opening, is already flying to its next destination.

As projects pass by, I am more and more aware that human experience is the lost core of my practice and that physical material is just evidence of it. It is no longer just about the idea of a suicidal materiality that, over time, won't leave more than a trace of itself, but about the very idea of materiality (no matter how many centuries it lasts) as residue, as remnant, as an utterly insufficient record of a life that is always a fleeting present. The stage metaphor takes on its full meaning in that the theater is a perpetual dueling ground. In every performance, the "play" is born, lives, and dies. It is human activity in a continuous present, and it is only in acting out that loss that the next performance can be accessed (which will also lead to a next death). No record (audiovisual, written, or oral) can supplant shared experience. The bodily ritual that exists between actors and spectators is structurally irreplaceable. That logic somehow runs through my own praxis, the "disappearance" of which becomes less about the material than about the human hand that works with it.

Two other changes in London are connected with a space that has been operating in Rosario since December 2012, the *Brick Farm* (fig. 0.6). It is an experimental open-air camp installed in a corner of a lot belonging to an artisanal brickworks on the outskirts of my hometown, in a transitional area between rural and urban environments. Members of my team work on a variety of activities there, mainly testing materials (looking for greater stability in combinations of clay and cement), exploring the surroundings to gather organic materials or "residuals," and exchanging knowledge and experience with the workers at the brickworks, who utilize the same traditional methods used for more than one hundred and fifty years to produce adobe bricks. This experience yields surprising results, opening new horizons in experimentation with highly unstable organic materials, from vegetables, fruit, legumes, and plants to even small animals that are found decomposing near the brickworks (fig. 0.7).

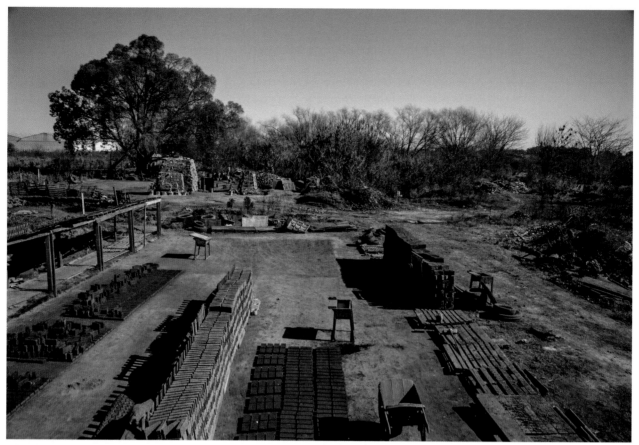

Figure 0.6 *Brick Farm*, 2012–ongoing, an experimental collaborative studio located in a traditional brickyard on the outskirts of Rosario, Argentina. Photo: Mario Caporali, courtesy the artist

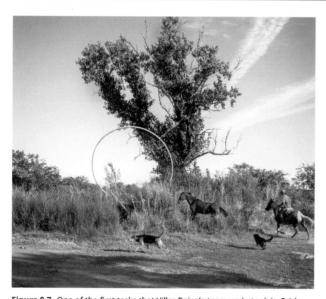

Figure 0.7 One of the first tasks that Villar Rojas's team undertook in *Brick Farm* was to reproduce some elements of the *dOCUMENTA (13)* installation. This instinctive exercise allowed them to revisit the intense period of production that had just finished with a slower and more reflexive spirit. The photograph shows horses galloping alongside one such replica. Photo: Mario Caporali, courtesy the artist

It also leads to an encounter with a species of synanthropic (highly adaptable to human environments) bird and its peculiar architecture: the hornero bird, a national symbol, and its nest, which resembles a traditional domestic mud oven used to bake bread in rural Argentina (fig. 0.8). I discovered that this bird, the brickworks, and my team all share the same material as object of transformation: soil. Each has their own methods and techniques to manipulate it, shape it, and stabilize it, but all have the same goal: to build with mud. In one case, cow intestines bought from local slaughterhouses are dumped into a giant hole filled with dirt and water, where a herd of horses trample it all until the mix is blended to make adobe (mud blended with the dung from those intestines), which is then dried in rectangular molds and fired in pyramids made of those same raw bricks (fig. 0.9). In the other, the adobe is fashioned by making a ball in the beak, blending saliva with bits of straw, branches, and grasses gathered in the area as the ovaloid walls of the nest are erected. And in the third, mud is blended with cement, wooden structures, screen, and wire.

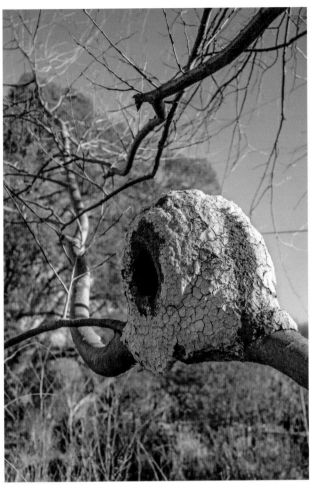

Figure 0.8 Hornero nest with interventions by Ariel Torti, who added his own mixture of clay to the exterior. Here the hornero added more layers of matter over Torti's intervention—a unique bird-human interaction. Photo: Mario Caporali, courtesy the artist

Figure 0.9 Construction of a brick kiln. Each layer of bricks is coated with charcoal, which helps amplify the heat during the firing process. A hornero nest is fired in the oven along with the bricks. Photo: Mario Caporali, courtesy the artist

THE PATHS FORK: THE HORNERO NESTS SERIES AS A KIND OF DEPARTURE FROM *BRICK FARM*

The horneros make use of the technologies and resources of the Anthropocene, building their nests not only in tree branches but on utility and telephone poles, building facades, window ledges, air conditioning and ventilation units, urban traffic lights, and pretty much any other opportune spot to serve as the foundation for their construction. The birds use the nests for just a single reproductive period, abandoning them once their offspring are ready to fly. Veritable abandoned residential complexes, sometimes with five or six units stacked atop one another, grow silently in the cities and towns of the Argentine Humid Pampas. You only have to look in the right spots to find them. My collaborators did just that. They began to track down and gather these abandoned nests from the brickworks' surroundings, instantly associating them with their own work as sculptor-builders. The team started using them in different experiments with clay and with the artisanal firing techniques of the brickmakers. It was the start of a project with no temporal or territorial boundaries: to expand the architecture of this unique South American avian species across the planet.

I started installing these nests in different places around the world: New York (2014), Kalba, UAE (2015), Stockholm (2015), Havana (2015), Anyang, South Korea (2016), Riga, Latvia (2018), Drenthe, the Netherlands (2018).[7] I used the hornero's own construction and installation logic, and stimulated a dialogue not only with other regions in the Anthropocene but also with other species, because those nests often serve as shelters for different creatures, for instance snakes, mice, and other kinds of birds. I make use of institutional opportunities like the Havana Biennial or the Riga Biennial. Cities and towns become the stages for

an invisible, silent project whose protagonists are for the most part not human, but the small animals and insects that occasionally inhabit the nests. For the people who see them, these ovoid mud forms, which remain indefinitely on building facades and light posts after the "event" they were a part of ends, become a kind of curiosity in the landscape, unlikely to be seen as art.

This liminal state—the integration of these objects into the environment and the refusal to identify them as fetishistic objects protected by a field and an artist, instead letting them become things that exist autonomously—is an exploration that has been systematized in the series titled *Brick Farm*. Nonetheless, it has other very significant moments, like the whale constructed in the San Juan desert of northeastern Argentina in 2010 and "found" by a drone in 2017, when technology could finally access this inhospitable place. Area newspapers and social media spread reports about the discovery of a fossil of an unidentified animal, possibly a prehistoric cetacean that lived there when the Andean mountain range was dominated by the ocean. The emancipation of the thing, which is not even from this geological era, dumped onto the world completely naked, seems to me the highest aspiration for a work of art: to simply stop being one.

ROSARIO INSEMINATES LONDON: *BRICK FARM* IN *TODAY WE REBOOT THE PLANET*

Ariel Torti became a key player in *Brick Farm*, the open-air experimental lab at the brickworks in Rosario. His upbringing in an agricultural area of Argentina gives him an understanding of rural matters that he puts to use at the brickworks. He knows gardening, horticulture, and botany. He is the main force behind the germination and hybridization experiments with potatoes and beans. He composts all the organic matter he comes across, and grafts plants and legumes with vegetables or tubers. He will allow life to take its course in the fierce heat of the Argentine summer, which in the central littoral region can easily reach temperatures of 40°C (104°F). Everything emulsifies, grows, fills with mold; forms burst forth within forms. It is a biological kaleidoscope unfolding before his very eyes, while he paints hornero nests with clay and fires them in artisanal brick pyramids.

When the team left for London to start work on the project at Serpentine Gallery in July 2013, Ariel remained at *Brick Farm*, where he continued working for six more weeks. He has become a fixture there—or, more precisely, he is the *Brick Farm*. So when he lands in the British capital, one

month after the others and dealing with administrative delays for permissions to enter the studio, he is far from being slowed down or paralyzed. He begins to carry out his experiments with organic materials in the house where we all are staying. He goes out on long exploratory walks in the area that generate a haul of found materials and photographic records. Excited, he sends me emails telling me and showing me what he is doing. It dawns on me that Ariel has arrived in London, but he is still in Rosario at the brickworks. He has brought his logic and dynamics to the English metropolis. So, I propose that he makes a psycho-dramatic experiment: to become *Brick Farm*, to absorb that project in his own body, and have a dialogue with the project we are engaged in there, no longer as Ariel, but as this topographic character.

From that moment on, I communicate with *Brick Farm* through a continuous exchange of emails. We reflect, ramble, and share impressions about his botanical and horticultural experiments. He is taking his search in the landscape for "things" even deeper, from trash, knickknacks, textiles, and other industrial items to vegetables, tubers, fruit, edible animals, seeds, flowers, legumes, and plants. He grafts beans onto a watermelon, fills it with clay, plants it in the backyard of the house. He buys a shoe, fills it with dirt, plants sunflower or flax seeds, and inserts a chicken liver. He is completely obsessive. He photographs everything he is doing and writes about it cryptically, almost illegibly, in his accounts sent via email, which I respond to in an utterly natural way.

When *Brick Farm* is finally in the studio, it is ready to start a revolution at the workstations: its mission is to provoke them, to be a parasite, to introduce anomalies, like a satellite off its orbit that uses the orbits of functioning satellites not to reestablish its own, but to drive the whole system mad (fig. 0.10). Basically, living matter, in a state of decomposition or growth, penetrates every worktable. It blossoms, flows, gushes forth; it settles in between the spaces of the materials it intervenes in, whether inorganic, like plastic or metal, or more stable organic ones like wood. Each variation incorporates fauna and flora. Even the lunch leftovers are transformed into a source: the waste matter is reintroduced into the process as a destabilizing mechanism. Everything is convulsing.

A pair of pliers suddenly disappears and reappears lodged in a sculpture at another station, almost like an act of vandalism, and sparks a new logic in the pieces. The studio enters directly into the final product as metonymy (a tool becomes part of the object, sticking to it like a mushroom on a humid surface). The borders between workstations, supplies, materials, waste, people, and "artwork" blur

Figure 0.10 Hybrid pieces mixing clay, cement, organic, and industrial elements being manufactured by the team at workstations at a temporary studio for *Today We Reboot the Planet*, Serpentine Sackler Gallery, London, 2013. Photo: Adrián Villar Rojas, courtesy the artist

without disappearing, but stretch in their capacity to offer certainty and order. The situation becomes barely tolerable. The system tries to immunize itself; there is contact and friction; there are attempts to expel the foreign object. Where there is life, there is the struggle for survival, but also cooperation, dialogue, politics. *Brick Farm* questions, using the discourse of a psychotic person or an analyst. For this intrusive character, the stations become plots of land displaying a twisted agriculture of symbols that, through the living matter, continue with their unpredictable contortions.

The parasitosis soon bears fruit. The jungle cracks the cement—or in our case, cracks the "clay + cement" formula, whose painstaking development inside that "community" of sculptor-builders has led to increasing stabilization, a *programmed* disappearance, a *controllable* instability that is exhausting its revolutionary power. There is a need to dynamite the ankylosis and introduce new processes that cannot be manipulated by complex wood,

wire, and steel mesh structures, the way the clay ultimately is. That same clay that fell apart in Ecuador during a storm the day before the opening at the 2009 Cuenca Biennial, leaving nothing of the piece behind but photographic records as the water and wind demolished it, is now the material base for an organized community that is highly developed technically and symbolically, and able to transmit its structure from one generation to the next.[8]

It is no coincidence that cement, the crust that the Capitalocene (the geological era that corresponds to capitalist modernity) will leave behind long after we disappear as a species, came to consolidate this order of things. It represents, in my praxis, the redesign of the planet for and by human actions. After five years (2008–13) the clay + cement equation has reached its greatest degree of operational and semiotic equilibrium. Through this clay + cement period, the phase of time as sculpture—as a narrative with its relative center in that human action—is coming to an end. It will make way for time as sculptor,

and for nonhuman agents as the protagonists. The time has come for one cycle to end and another to begin, starting with intense work of micropolitical, micro-poetic, and micromolecular sabotage. This political-poetic-material agitation has at its core Rosario's insemination of London, of *Brick Farm* in *Today We Reboot the Planet*. The result will be the transition from programmed suicide to deprogrammed auto-production—from suicidal sculptures to diachronic, mutant, or hybrid objects.

FROM PROGRAMMED DISAPPEARANCE TO A DEPROGRAMMED AUTO-PRODUCTION

What we have in *Today We Reboot the Planet*, then, is this world interfered with via sabotage, negotiation, and resignification operations by the satellite *Brick Farm*, the character-project-place that injects an "anomalous" logic, as Thomas Kuhn might say, into a "normally" functioning planet (Kuhn 1962). This saboteur's chemical weapon is, on the one hand, the organic material collected in situ, and on the other, what we can call the insemination of the different contextual levels within the microcosm of the workshop (including the workshop itself as the last of those levels, from the atomic perspective of the workstations). This takes place through Ariel Torti–*Brick Farm*'s exploration of the project's urban environment (London) and the pollinating act of circulation among the different stations, just as he/it did in and around the brickworks in Rosario. While the workstations are already engaged in a dialogue, their communications are catalyzed by this "bee" until they are transformed into an authentic hybridizing force—a genetic mutation.

When the planet reboots, it will find its whole system reconfigured. The echo of a world at once in silent agony and in continuous transformation will appear on the specially designed shelves, as if in an alien warehouse, inside the new Serpentine Sackler space (a former gunpowder store repurposed by the institution, and now also adulterated for this project by my team of architects). Potatoes, onions, apples, mushrooms, beans, leaves of plants, all of that still-timid life that is now woven into the "suicidal sculptures" germinates, grows, rots, dries up, attracts more life—insects, bacteria, microorganisms. It radicalizes a logic that will be key from this point forward, namely the openness and plasticity of the "object" that becomes a porous system in permanent interaction with the environment, yet with more morphological possibilities that are less predictable, while the incorporation of new

biological structures multiplies the diversity of behaviors and the physical-chemical reactions of its components.

It is not the greater instability, but rather the greater contingency and number of movements—the depth and complexity of the mutations to the point of dissolving the idea of "final form" on that of the "horizon"—that is released here as the core of the ontological revolution initiated within my practice in *Today We Reboot the Planet*. Thus, the final leap of variable time from the surface (as theme, as representation) into the interior of the modeling mechanism (as a sculptural force) is essential for redefining these new entities as diachronic objects. Their real wealth is not in the photograph but in film, in the comparison between two points in time. From one day to the next, from one week to another, from one season to the other, the mutant proffers observable changes. Of course, this dynamic was already present in the "suicidal" pieces, but its radicalization leads us firmly to the notion of autopoiesis, of deprogrammed auto-production. The various paths already existing in the garden have forked into hundreds of possible (and unforeseeable) paths.

THE THEATERS OF SATURN: ANOMALY AS LAW

In the way that the Phrygian cap used by freed slaves in ancient Rome became a symbol in modern European and American republics, anomaly became law in the project immediately following *Today We Reboot the Planet*, titled *Los teatros de Saturno* (The Theaters of Saturn, 2014, fig. 0.11, fig. 0.12, fig. 0.13).[9] In Mexico City, the out-of-orbit satellite is the locus of a new orbit of processes, operations, techniques, directions, and detours. Everything that was insinuated conceptually, experienced as a team, and accumulated as a technical and methodological legacy at Serpentine is transferred, expanded, and legitimized at kurimanzutto gallery. On one hand, the mutants take center stage, and the *Brick Farm* devices now become a work structure, a way forward based on exploration of the environment. This is the core mechanism for obtaining local materials and knowledge that will be hybridized on the nomadic studio's worktables. This studio in Mexico City is turning into a mutant garden, a nursery for monsters, where the workstations do not disappear but instead subordinate themselves to this logic, providing the other key ingredient in the combination (the products of collaborators, like Mariano Marsicano in his role as jeweler, or of Martín Pazienza as ceramicist) or momentarily shifting over to a second plane, as with those stations that are still subject to the rules of the previous paradigm and set to reproduce some pieces from *dOCUMENTA (13)*. On

the other hand, the system's increasingly porous condition is visible in another aspect with clear antecedents in *La inocencia de los animales* (The Innocence of Animals, 2013), and even in *Today We Reboot the Planet*.[10] However, now it is presented as a true dialogue with the environment, whereas before it was an imposing force. I am referring to the reformulation of architectural-institutional space with which the project interacts.

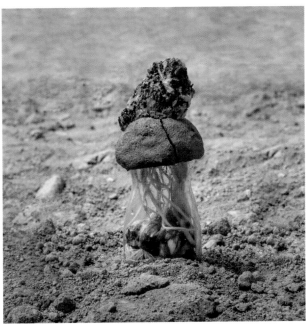

Figure 0.12 Adrián Villar Rojas (Argentinian, b. 1980), *Los teatros de Saturno* (The Theaters of Saturn), 2014. Organic, inorganic, human-made, and machine-made matter, including *tezontle* (red volcanic soil), pigmented plaster, unfired clay, water, coal, *Heliconia*, banana flower, trainers, iPod, opal, obsidian, pearls, bronze, silver, fungi, bread, snails, freshwater fish, crabs, lobsters, pumpkins, watermelons, potatoes, and onions, all collected in Mexico City. Installation view, kurimanzutto, Mexico City, 2014. Photo: Michel Zabé, courtesy the artist and kurimanzutto

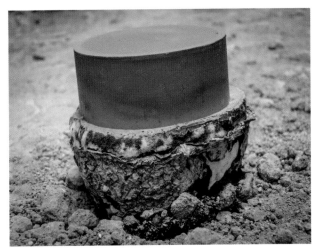

Figure 0.11 Adrián Villar Rojas (Argentinian, b. 1980), *Los teatros de Saturno* (The Theaters of Saturn), 2014. Organic, inorganic, human-made, and machine-made matter, including *tezontle* (red volcanic soil), pigmented plaster, unfired clay, water, coal, *Heliconia*, banana flower, trainers, iPod, opal, obsidian, pearls, bronze, silver, fungi, bread, snails, freshwater fish, crabs, lobsters, pumpkins, watermelons, potatoes, and onions, all collected in Mexico City. Installation view, kurimanzutto, Mexico City, 2014. Photo: Michel Zabé, courtesy the artist and kurimanzutto

Figure 0.13 Adrián Villar Rojas (Argentinian, b. 1980), *Los teatros de Saturno* (The Theaters of Saturn), 2014. Organic, inorganic, human-made, and machine-made matter, including *tezontle* (red volcanic soil), pigmented plaster, unfired clay, water, coal, *Heliconia*, banana flower, trainers, iPod, opal, obsidian, pearls, bronze, silver, fungi, bread, snails, freshwater fish, crabs, lobsters, pumpkins, watermelons, potatoes, and onions, all collected in Mexico City. Installation view, kurimanzutto, Mexico City, 2014. Photo: Michel Zabé, courtesy the artist and kurimanzutto

In *Los teatros de Saturno*, the spaces at kurimanzutto are modified to house the mutants and the rest of the show. This includes an exhibition in the second story of the gallery in the form of a "3D fanzine" that features a considerable amount of the information about production and direction generated in the London project with its curator, Sophie O'Brien, who also comes to Mexico to work as another station on the team. This second story will thus be entirely devoted to serving as a kind of archive or record of *Today We Reboot the Planet*, with hundreds of emails, notes, sketches, maps, drawings, lists, and other assorted papers. In general, such things are either kept or discarded, but they are rarely exhibited, at least not in this way, namely as an artist's subsequent project, highlighting the organic nature of the chain, the residual energy that passes from one project to another. It is one more way of forestalling death, of recovering the dense life that goes well beyond the possibilities of the visible. What can't be trapped is clamoring to emerge and incorporate itself.

The surface of the ground floor is covered in soil, and the results of this mutant botany are planted in it. Ariel Torti–*Brick Farm* works on these hybrids along with two Mexican floral project and landscape specialists (AR COSMOS), who recommend exploration of the local markets: La Lagunilla, La Merced, Jamaica, the fish and meat markets, and the Central de Abasto wholesale market, among others. Expeditions to these commercial centers, either open-air or in giant hangars, jammed with vendors and customers offering and comparing merchandise, are decisive for the project in that they allow both the synesthetic impact of encountering a world of colors, flavors, smells, shapes, and even sounds to fill the work, and a myriad of materials without precedent in my practice, due to their variety and number: fruits, vegetables, seeds, legumes, herbs, mushrooms, flowers and ornamental plants, minerals, rocks, even antiques.

With the palette laid out on tables throughout a warehouse of more than five hundred square meters, and with very few tools (blades, spoons, plastic containers, hand mixers), the three "botanists," Ariel, Alfredo, and Ramiro, begin to outline the various methods for intervening in, modifying, and arranging these mutants, added to by other stations that provide sculptures, jewelry, geometries in pigmented plaster. The ontological question I have asked in order to set up this game is: What would the world look like if it had to be re-created by this community of sculptor-builders? What would its fauna and flora, its fish, its insects, its fruit, its stones, its animals be like? Ultimately, what would the three realms look like after this team of "aliens" encountered it?

That is how a line of inquiry in my practice matured—one that was sustained from the beginning but is now very clearly defined. Human agency is replaced in favor of other agencies (bacteria, mushrooms, insects, climate, seasons, reproduction, growth, decomposition) that employ time to exert their influence to shape things. From the museological paradigm of protecting "things" against the passage of time, we move toward "things" that are "beings *in* time," with pasts, presents, and projected futures, auto-produced but also conditioned by contextual variables. Thus, the institutions that house these mutants take on a central role. The hybrid's "quality of life" depends on their control and monitoring, their care and interest, in conjunction with oversight by my office.

The Guggenheim in New York or the Fondation Louis Vuitton in Paris do not provide the same context as the one experienced by an object left at the *Brick Farm*, or at the Garden of Babur in Kabul, Afghanistan.[11] Or at Eco Flor, an edible-flower nursery in Xochimilco, on the outskirts of Mexico City, which I visited with Ariel Torti and Noelia Ferretti after the opening of *Los teatros de Saturno* to continue our research, bringing with us all of the material that was left over from the project, including pieces that were not installed. This horticultural and agricultural region was central to the imperial Aztec economy. It supplied a million and a half inhabitants five centuries ago using techniques based on the artificial expansion of arable land, by building floating islands (*chinampas*) on the lake in the Valley of Mexico. We speak there with local producers, and intensify our explorations of the territory. We test and study methods with crops, landscape, and the local terrain. We end up developing two stratified cubes made of plaster, clay, and compost (fig. 0.14), which will become the basis of the next steps: *The Evolution of God* (2014), *Where the Slaves Live* (2014), and *Planetarium* (2015).[12] This is how *Brick Farm*, as a praxis, develops its twin sister in Mexico, a kind of experimental farm in Xochimilco (where Ariel Torti additionally becomes the protagonist of a film that has yet to be produced). This farm signals the change of a period, the birth, from the womb of an anomaly, of a new law: the law of Saturn, the Roman god of agriculture, who managed to cling to his belt of seven rings, made of thousands of other rings. Those are the theaters of Saturn, which endlessly fork and give rise to new scenes and vicissitudes.

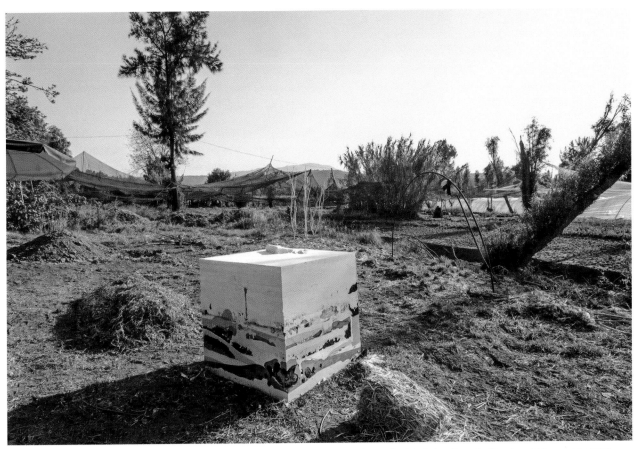

Figure 0.14 On the outskirts of Mexico City, the team found an agricultural and horticultural area, the Colonia San Gregorio Atlapulco, which was rented and treated as a sister space to *Brick Farm*. *Los teatros de Saturno* fed off and spilled over this area. The photograph shows a stratified cube; when it collapsed, its fragments went on to become part of *Fantasma*. Photo: Michel Zabé, courtesy the artist and kurimanzutto

THE PROJECT AS SYSTEM TO ABSORB THE ENVIRONMENT, THE "CUBE" AS ARCHETYPE, THE "TABLE" AS MAP, THE "WORLD" AS TERRITORY (2014–PRESENT)

Everything in *Los teatros de Saturno* stems from the ecosystem where the project develops. Even the volcanic soil (*tezontle*) covering the floor is the result of an intense exploration of the region's possibilities. We visit quarries, sand plants, and horticultural areas like Colonia San Gregorio Atlapulco, where we have access to an artisanal potato plot that will serve as the model to design the ground floor at kurimanzutto (the field of *tezontle* planted with mutants) (fig. 0.15). The local markets provide the materials that will be the biological basis for the hybrids, from tubers and flowers to crustaceans and fish. The local culture provides the poetics for the project: soil and color spontaneously emerge, with the latter returning after a six-year absence in the form of pigmented plaster.

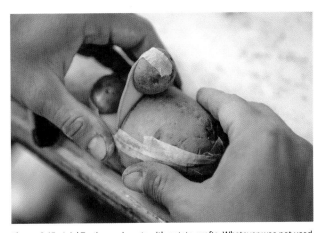

Figure 0.15 Ariel Torti experiments with potato grafts. Whatever was not used for *Los teatros de Saturno* was recycled, mixed, and exposed to the elements at Colonia San Gregorio Atlapulco—rotting, growing, and sprouting spontaneously. Photo: Michel Zabé, courtesy the artist and kurimanzutto

Through dialogues with producers, merchants, neighbors, and other key actors in the process, local lore and history provide the information and the images that bring specificity to the project.

Geography, especially in Xochimilco, provides the territory to carry out a Mexican *Brick Farm*, and through it a dynamic of immersion in the topographical features of the environment. So powerful is the force that the landscape exerts on our senses—the diversity of the crops, of techniques, of species, of layers of sediment on the edges of the canals, of life fermenting within life—that the mutants become literally chronotopic (time-space) crystallizations, surfaces to absorb everything that surrounds us, like a screenshot of a dream, given the extreme metaphorical-metonymic concentration of these living entities. That is the case with those stratified cubes made of pigmented plaster, clay, and compost, which were born as a kind of multidimensional snapshot of Xochimilco. They are a material emulsion of our commitment to the site, the result of a state of interpenetration with the context, evidence in motion (since those cubes will remain at Eco Flor and be photographed in their diachronic transformation) of a fleeting present in a specific spot on the planet.

Ultimately, we have two levels operating at the same time in *Los teatros de Saturno*. One is micro, with the mutants, and the other macro, the project acting as a system of subsystems absorbing the environment. These two articulated levels render the ontological logic and the functioning of a new phase in my practice, where deep immersion in local contexts and the transport of vernacular material from one point of the planet to another to generate ever more complex hybridizations become the key to access future experiences.

A PICTORIAL HOMAGE TO XOCHIMILCO

Inspired by the Xochimilco cubes, *The Evolution of God* and *Where the Slaves Live* are a "pictorial" homage to the change taking place in Mexico, where I set out to design, draw, and paint in 3D using the resources and techniques acquired in *Los teatros de Saturno*. In a way, this homage is a statement in which we lay out the rhetoric of a new poetics touched by that Mexican experience. This is why both projects enact a formalist play with stratification, the pigmented layers of sediment, the organic, the vegetation, blended with industrial detritus (sandals, textiles, ropes, bottles, personal items belonging to the team), which appear trapped in the mixture and which will lead various readers to see a metaphor with the Capitalocene. Both the "cube" in New York and the "tank" in Paris (fig. 0.16) are entities that replicate that autism of the early clay period (they are in some measure alien in the contexts where they are installed). But, like the project in Mexico, they return to

the range of colors, materials, and elements of the Petrobras table, that map of maps where the dynamic of absorption of the environment was already implicit, on a scale appropriate to the period in which it was produced: everything that was used for the table was acquired through a process of exploring the commercial wholesale neighborhood of Rosario.

The "tank" in *Where the Slaves Live* at Fondation Louis Vuitton in Paris is an example of the new institutional approach stimulated by this mutant dynamic. Its organic components and the growth of its vegetation require constant monitoring and exchange of information with my office, as well as daily gardening maintenance such as pruning, watering, et cetera, in order to keep its autopoietic drift under control. This is also the case with *Motherland* (2015) at the Guggenheim in New York, where I create a poetic gesture based on the institutional actions generated by taking care of the diachronic object. It is at once an eternal project and an incognito one on the building's roof, a place inaccessible to visitors and only made visible by an annual "ritual" on the same day at the same time: a designated maintenance staff member goes up to the rooftop, walks around the walkway that circles the glass cupola of the rotunda, and opens a small square in the mesh ultraviolet filter that covers it, letting natural light through that opening into the museum for one hour. This ritual is not announced publicly, but instead is seen as an ordinary task, performed without any "artistic" sense. Installed next to the heating equipment in a corner of the rooftop is a small sparrow made of clay, viscera, twigs, and weeds. Its permanent exposure to the atmosphere means that it must be replaced at intervals established by the museum and my office, based on observation. Both the ritual and the object will be replicated under the same protocols until the institution is permanently closed in some distant or nonexistent future. Both dimensions of living matter that I am trying to grasp in this article (the interaction between human and nonhuman agency, between *work* and *auto-production*, and one could now add a third element: *environment*) are poeticized here in a silent system of material and performative gestures.

TRANSPORTING MATERIAL AND ENERGY IN A NEW RELATIONSHIP WITH THE ENVIRONMENT

The Most Beautiful of All Mothers (2015) and *Rinascimento* (Renaissance, 2015) are associated projects and represent a turning point in two issues: the connection with the environment and how to navigate the transition from one

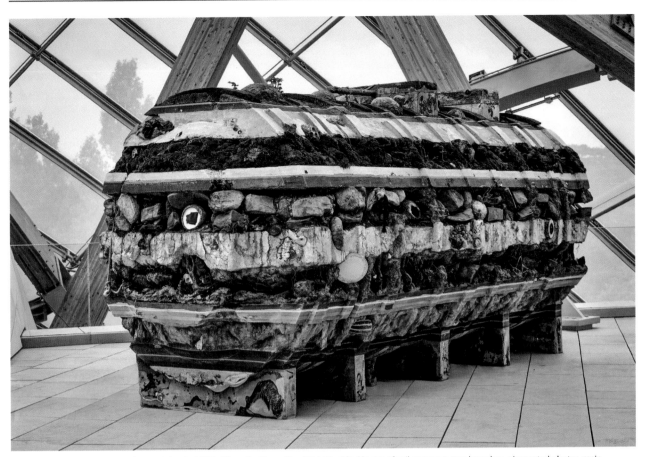

Figure 0.16 Adrián Villar Rojas (Argentinian, b. 1980), *Where the Slaves Live*, 2014. Stratified layers of soil, compost, tree branches, pigmented plaster, resin, trainers, watermelons, pumpkins, sprouting potatoes, courgettes, beetroots, germinated beans, fungi, seeds, corn, herbaceous plants, lichen, ivy leaves, and ferns, collected in Dover, London, and Yangji-ri, 560 × 300 × 240 cm. Fondation Louis Vuitton, Paris. Installation view, Fondation Louis Vuitton, Paris, 2014. Photo: Jörg Baumann/baumann fotografie frankfurt a.m., courtesy the artist and Fondation Louis Vuitton

experience to another in a very short period of time, in terms of both the transportation of vernacular materials and the transfer of collective residual energy from one project/point on the planet to another.[13] *The Most Beautiful of All Mothers* is a large-scale sculptural and aquatic installation (executed at sea) combining animals in a disorienting, absurd, or illogical way, for instance using some pieces as pedestals for others (fig. 0.17). Elements are also introduced that have been collected around the site, or from the store of transported materials or derived from the studio activities themselves that are unfolding in situ. The list includes fishing nets, livestock, scrap, clay, residue, minerals, and vegetation. It is a montage that makes use of the landscape as a kind of stage set, since these animals are installed on cement bases in the water, alongside the house where Leon Trotsky lived during the first three years of his Stalinist exile (1929–33) on the island of Büyükada in the Sea of Marmara facing Istanbul. The project demands very intense physical commitment, given, for example, the need to swim at night from one sculpture to the other to finish smoothing the cement at the bases

and add finishing touches. It is a phenomenally transformative experience for us. Small sea snails soon appear on the parts exposed to saltwater, which triggers a fundamental question for me: What if this play of platforms, of animals holding up animals, has all of these tiny mollusks as the ultimate ending? What if this is only there for them to use?

The more than two-month sojourn with my team in Turkey, which the production and assembly of these pieces for the Istanbul Biennial requires, leads to interactions with locals, from curators and producers to transportation specialists and suppliers. Some of those interactions result in lasting friendships. It also paves the way for a deep exploration of Istanbul—its marketplaces and landscapes, its geography and history and surroundings. During this process of exploration we collect vernacular materials, such as the one-meter-diameter stones to be used as the basis of the Turin project *Rinascimento*. Production on that project begins immediately following the opening of *The Most Beautiful of All Mothers*.

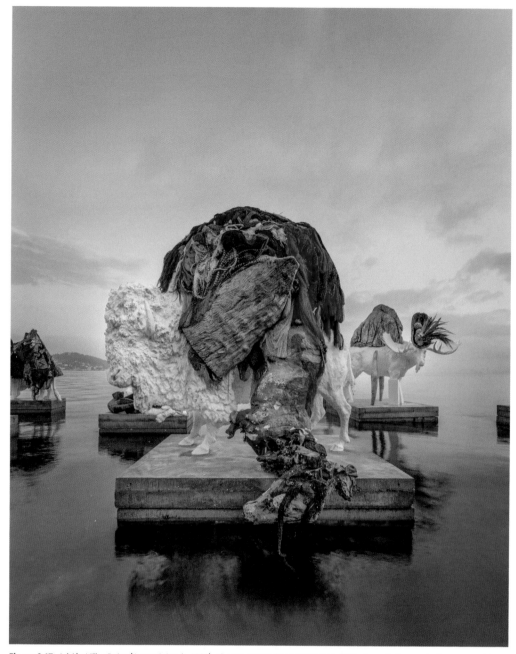

Figure 0.17 Adrián Villar Rojas (Argentinian, b. 1980), *The Most Beautiful of All Mothers*, 2015. Organic, inorganic, human-made, and machine-made matter, including cement, resin, polyurethane paint, lacquer, sand, soil, rocks, fishing nets, wood, snails, raw beef, corals, mollusk shells, feathers, and petrified wood, collected in Istanbul, Kalba, Mexico City, and Ushuaia. Installation view, shore by Leon Trotsky's former house, Büyükada Island, 14th Istanbul Biennial, 2015. Photo: Jörg Baumann/baumann fotografie frankfurt a.m., courtesy the artist, Marian Goodman Gallery, and kurimanzutto

We arrive at this engagement enormously burned out and with no time to recover. The "community" of sculptor-builders, who have traveled the world as a tightly knit group, is threatening to fall apart as a natural consequence of exhaustion. The only alternative is to tap into that charged residual end-of-the-party or hangover state—to clean and organize the house the day after a big night. And that is literally what we do. The space at the Fondazione Sandretto Re Rebaudengo is submitted to a housekeeping process. It is a dynamic that we will stick with from then on, with ever higher levels of awareness and conceptualization: the idea of domestic work as an activity generally assigned to women, with almost no acknowledgment or remuneration throughout history, yet vital for the rest of human activities.

With *Rinascimento*, we begin a diagnosis of the state of the physical and institutional space that will be impacted, with the understanding that the project should establish an ecological equilibrium with it. Based on this diagnosis, the process of deep cleaning of the operational terrain is deployed in order to clear these zones, unconscious of the accumulation of things, filth, deterioration, or chaos that institutions, through habit or negligence, tend either not to see or to normalize. Thus, in Turin, once the "semiotic noise" has been "weeded" from the building, we begin to set up the stones brought from Turkey (fig. 0.18). The almost psychoanalytical logic of diagnosing the overall state of an institution based on its spatiality and my possibilities of "cleaning" the excess of unconscious semiotic production enable me to explore an aspect of *work* that will take on a central role in my practice: negotiating with the authorities, or in other words the political dimension of the projects. In effect, the adjustment of the institutional environment to the ecological needs of the project will depend on a highly refined use of the "art of the possible."

TOWARD A NEW HUMAN ECOLOGY: THE GEOPOLITICS OF FRIENDSHIP

The convergence of ecological equilibriums that involve a strong empathetic and political commitment to otherness is manifest in *El momento más hermoso de la guerra* (The Most Beautiful Moment of War, 2014).[14] This experience can be thought of as a third phase of *Brick Farm*, since it involves long-term immersion in a rural setting, this time Yangji-ri, a village in the demilitarized zone (DMZ) between the two Koreas, whose stable population has an average age exceeding eighty years. Here, the intention is to establish contact with residents from the very beginning in order to develop a film project focused on their lives, selecting some "characters" and encouraging activities that may trigger situations or atmospheres, such as a community lunch in which my team prepares a pig using the Argentine grilling technique of *asado*. In this way, without a script and giving in to serendipity, we are able to get takes in alleys, in the countryside, in the town church, in residents' homes—ultimately a range of audiovisual records, both of the villagers in their daily lives and of my collaborators interacting with them, exploring the place, or intervening in sites with fabricated or found objects. *El momento más hermoso de la guerra* (2017, fig. 0.19, fig. 0.20) is the product of these records, a film that is one part of the film trilogy *The Theater of Disappearance* (2017), which encompasses the fleeting present of the projects.[15]

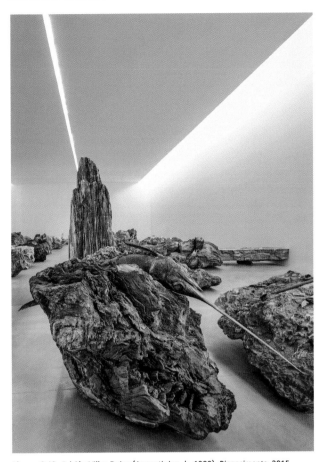

Figure 0.18 Adrián Villar Rojas (Argentinian, b. 1980), *Rinascimento*, 2015. Organic, inorganic, human-made, and machine-made matter, including metamorphic, igneous, and sedimentary rocks, petrified wood, butterfly wings, raw beef and pork, swordfish, crows, geese, corals, mollusk shells, grapes, artichokes, watermelons, rubber and plaster molds, trainers, fishing nets, burned ropes, metal pots, and utensils, collected in Turin, Istanbul, Kalba, New York, and Mexico City. Installation view, Fondazione Sandretto Re Rebaudengo, Turin, Italy, 2015. Photo: Jörg Baumann/baumann fotografie frankfurt a.m., courtesy the artist and Fondazione Sandretto Re Rebaudengo

Figure 0.19 Adrián Villar Rojas (Argentinian, b. 1980), still from *El momento más hermoso de la guerra* (The Most Beautiful Moment of War), 2017. Video, color, sound, 55:23 min. Photo: Courtesy the artist and Real DMZ Project

Figure 0.20 Adrián Villar Rojas (Argentinian, b. 1980), still from *El momento más hermoso de la guerra* (The Most Beautiful Moment of War), 2017. Video, color, sound, 55:23 min. Photo: Courtesy the artist and Real DMZ Project

This first experience in Yangji-ri in 2014 along with a small group of my collaborators, chosen on the basis of their social and communicative abilities, is the start of a close bond and prolonged engagement with the village residents. Together with the curators of the Real DMZ Project, our host, we decide to return regularly to visit them and make footage. This process will lead to a second film, *The War of the Stars* (2018).[16] In 2016, a house recently vacated by its owner (a man who moved to his son's home due to his advanced age) is acquired to deepen this sustained relationship with the village. Some of the man's personal effects remain, like a pair of sandals and his actual footprints in the dust on the floor. Preserved as a humble and silent museum in his honor, these belongings and traces of the house's former occupant become parts of a project that will function there, in his dwelling, in perpetuity. With a respectful housekeeping process, the space is prepared for future activities yet to be defined. Two cakes, baked by my team, are kept (perhaps forever) in a refrigerator in the kitchen.

TURNING TOWARD THE ENVIRONMENT: ARCHITECTURE AS A MODEL FOR THE ECOSYSTEM "PROJECT"

In *Two Suns* (2015, fig. 0.21), dozens of tiles, handmade in Rosario with leaves from trees, cigarette butts, seashells, coins, iPods, butterflies, glass, paper, and many other organic and industrial "residuals" inlaid in the cement, are transported to New York to cover the floor at Marian Goodman Gallery. Michelangelo's *David* lies on that floor "asleep": a scale replica of the iconic Florentine sculpture, with the physical posture modified to appear reclining, seemingly either defeated or dead. The *David*-tiles relationship is an attempt to contemplate the art-versus-

background relationship, in other words that contiguous tension between the "work of art" and its context. Between that which carries the weight of being the human project (embodied in the *David* archetype) and what seems to be there to sustain that intention with its silence (and with its signage, its walls, its order, and its rules): the physical environment of the gallery, the museum, the institution. This is the architectural dimension of the problem of the environment, the negotiation for a redesign of the exhibition space as a part of the project, which, while earlier established in *Lo que el fuego me trajo*, is systematically attacked in *Los teatros de Saturno* and consolidates as a specific theme in *Two Suns*, *The Work of the Ocean* (2013),[17] *Fantasma*, *Planetarium*, and the four projects of *The Theater of Disappearance* (2017).[18]

In *The Work of the Ocean* (fig. 0.22), the entire interior of a house (kitchen, bathroom, living room, and bedrooms) is designed and built in the gallery in order to imagine an alternative life of some of the "suicidal" sculptures from *dOCUMENTA (13)* as small decorative statues made of epoxy putty (a highly durable material), and scenes from *Brick Farm* modeled from photographic records. The entire "home" is a silent location that acts as a neutral zone, as if it were an exhibition system of white gallery walls and bases, so as to create a semiotic trap: a comfortable and bourgeois environment resignifying sculptural objects as tasteful decoration, the originals of which (many no longer in existence) carry a dense burden of both conceptual and symbolic history as part of enormously complex processes.

In *Fantasma* (fig. 0.23), the display devices usually used for museological exhibition are taken to their climax to show a series of surviving "mutants," in a state of virtual mummification, from *Los teatros de Saturno*. These mostly organic items have been stored for almost a year at kurimanzutto gallery and are now transported to Moderna Museet in Stockholm in order to imagine a retrospective of my work in two hundred years—what these diachronic objects and other remaining evidence of my work would look like in the distant future. Being also a reflection on the notions of document, memory, and preservation, the project includes some suggestive found images showing the protection and evacuation tasks involved in saving artistic and cultural heritage in Europe during World War II, together with photographic registers documenting the recent dismantling in Buenos Aires of a statue of Christopher Columbus, the Spanish Italian navigator, and its replacement with a statue of Juana Azurduy, the Bolivian mestizo female South American independence war leader. The rooms are completely redesigned, with added walls, display platforms, and bases to house these surviving mutants and documents as well as the second

Figure 0.21 Adrián Villar Rojas (Argentinian, b. 1980), *Two Suns*, 2015. Unfired clay and cement re-creation of Michelangelo's *David*, blackout curtains, and handmade tiles (cement, sand, turba, and pigments) embedded with organic, inorganic, human-made, and machine-made matter collected in New York, Kalba, Rosario, and Ushuaia. Installation view, Marian Goodman Gallery, New York, 2015. Photo: Jörg Baumann/baumann fotografie frankfurt a.m., courtesy the artist and Marian Goodman Gallery

Figure 0.22 Adrián Villar Rojas (Argentinian, b. 1980), *The Work of the Ocean*, 2013. Drywall, paint, carpet, wallpaper, furniture, decorative objects, and nineteen figurines made of wire, modeling clay, and epoxy putty, dimensions variable, ranging from 17 × 29 × 13 cm to 26 × 66 × 20 cm. Installation view, De 11 Lijnen, Oudenburg, Belgium, 2013. Photo: Jörg Baumann/baumann fotografie frankfurt a.m., courtesy the artist and De 11 Lijnen

Figure 0.23 Adrián Villar Rojas (Argentinian, b. 1980), diachronic object (potato with hypertrophied germination) from *Los teatros de Saturno* (The Theaters of Saturn), from the series *Fantasma* (Ghost), 2014. Installation view, *Fantasma*, Moderna Museet, Stockholm, 2015. Photo: Jörg Baumann/baumann fotografie frankfurt a.m., courtesy the artist, kurimanzutto, and Moderna Museet

life of "things" that were not originally "art," but rather supplies in the production process, such as the pallets of the wooden boxes where the stratified cubes from *The Evolution of God* were made—now multicolored abstract landscapes because of the pigment absorbed by the wood. In other cases, display platforms house the second life of "things" that had been "art" in the now-disappeared sculpture installations, such as the cake-mountain from the Petrobras table, which my parents stored in a back corner of their business for almost a decade before it was transported to the Swedish capital using a sophisticated logistical plan and "revived" as a petrified mutant made of sugar, flour, fungus, and dust.

In *Planetarium* (fig. 0.24, fig. 0.25), we clean, refurbish, and redesign an abandoned ice factory on the outskirts of the town of Kalba, on the edge of the Persian Gulf, in order to install a series of stratified columns made of pigmented plaster, clay, cement, compost, and organic and industrial products in that deconstructed space. These columns are directly derived from the Xochimilco "cubes," both formally and technically, and in their function of chronotopic (time-space) crystallization. In addition to incorporating materials transported from other parts of the planet, like Xochimilco and the *Brick Farm* in Rosario, the components are brought together after an intense

process of exploration and collecting in the Sharjah region. Indeed, it is this multidimensional immersion in the Emirate territory—involving geographic, socioeconomic, cultural, and human aspects—and the resulting interactions with a network of local contacts, that give me access to the Kalba waste treatment plant. This state-owned company, created to process the growing amount of garbage resulting from the region's economic and demographic boom, is producing black dirt through a composting process for local agricultural use. One ton of this composted soil becomes a part of the landscape created with the ice factory, arranged into six mounds that encapsulate the expansion of the Capitalocene fertile frontier over the desert, based on the treatment of its own organic residue. Everything in *Planetarium*, as a system to absorb the environment or chronotopic crystallizer, suggests this anthropogenic conquest of the desert.

This is how we come to *The Theater of Disappearance*, four projects in Bregenz, Athens, New York, and Los Angeles developed under the same umbrella title. In them, the various kinds of spatial, ontological, thematic, and procedural logics described above all come together, from transporting vernacular materials to exploring the environment, from reconfiguring the exhibition space to combining production methods from the different phases

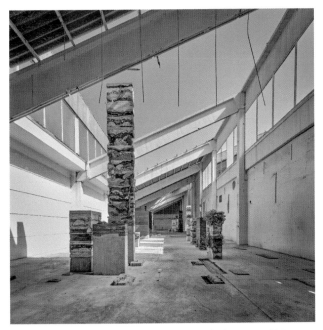

Figure 0.24 Adrián Villar Rojas (Argentinian, b. 1980), *Planetarium*, 2015. Organic, inorganic, human-made, and machine-made matter, including compost, cement, gypsum, pigments, sand, soil, ropes, obsidian, smithsonite, dogtooth calcite, jeans, sweaters, trainers, mollusk shells, tree branches, gastropod fossils, canaries, finches, parakeets, shark fins, corals, crabs, lobsters, fungi, watermelons, oranges, corn, sprouting potatoes, germinated beans, and pumpkins, collected in Kalba and Sharjah. Installation view, 12th Sharjah Biennial, Kalba, United Arab Emirates, 2015. Photo: Jörg Baumann/ baumann fotografie frankfurt a.m., courtesy the artist and Sharjah Foundation

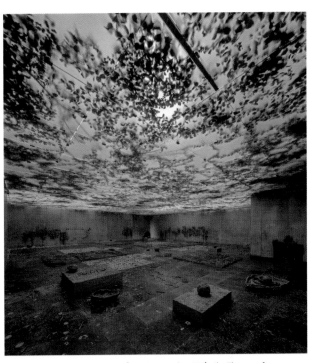

Figure 0.26 Adrián Villar Rojas (Argentinian, b. 1980), *The Theater of Disappearance*, 2017. Ivy, colored lights, re-creation of parietal pictographs, *pixação*, and Roman-period graffiti, floor tiles and blocks of Moroccan marble encrusted with ammonites and *Orthoceras* fossils, fossilized turtle shells, Neolithic stone tools, and septarian concretions. Installation view, Kunsthaus Bregenz (first floor), Austria, 2017. Photo: Jörg Baumann/baumann fotografie frankfurt a.m., courtesy the artist, Marian Goodman Gallery, and kurimanzutto

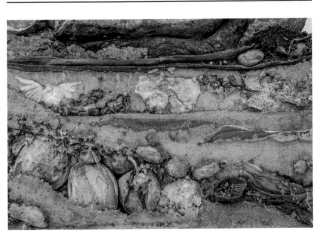

Figure 0.25 Adrián Villar Rojas (Argentinian, b. 1980), *Planetarium*, 2015. Organic, inorganic, human-made, and machine-made matter, including compost, cement, gypsum, pigments, sand, soil, ropes, obsidian, smithsonite, dogtooth calcite, jeans, sweaters, trainers, mollusk shells, tree branches, gastropod fossils, canaries, finches, parakeets, shark fins, corals, crabs, lobsters, fungi, watermelons, oranges, corn, sprouting potatoes, germinated beans, and pumpkins, collected in Kalba and Sharjah. Installation view, 12th Sharjah Biennial, Kalba, United Arab Emirates, 2015. Photo: Jörg Baumann/ baumann fotografie frankfurt a.m., courtesy the artist and Sharjah Foundation

of my practice. A new variable is added to the language game: the human factor is removed from spaces that were heretofore essentially the province of manual work, such as sculpture, and replaced by digital modeling technologies such as a computerized robotic arm.

THE THEATER OF DISAPPEARANCE AS CLIMAX OF ONE ERA AND DAWN OF ANOTHER: SUPERFLUOUS HUMANITY

Kunsthaus Bregenz in Austria, designed by the architect Peter Zumthor, serves as the setting for the culmination of the examination of art and exhibition space ties, as the project itself was the total redesign of the building's four floors into a "home" for the staff that have looked after it since it opened in 1999. It is a kind of silent homage to those who, in the shadows, live to take care of this architecture. This homage is filtered through a melancholy look back at the Western notion of reason that feeds the museum's unconscious. Text and context, work and environment, exhibit and exhibition spaces are all impossible to distinguish here, impelling the visitors to actually generate the boundaries between them, based on their movements and their sensory and hermeneutical activity (fig. 0.26).

In addition to the usual array of vernacular materials from different parts of the planet, we incorporate granite containing four-hundred-million-year-old fossilized zooplankton extracted from the quarries of Erfoud and Rissani in Morocco. This granite was used to manufacture the tiles, flooring, and furniture used to remodel the museum's interior. The almost imperceptible yet ubiquitous presence of this Paleozoic fossil contrasts (along the anachronistic and poetic path from a distant past toward the Western notion of reason that the exhibit traces) with the metonymic legs of Michelangelo's *David* on a pyramid-shaped base on the upper floor, made from the same marble taken from the quarry in Carrara, Italy, that was used for the original sculpture.

In Greece, the National Observatory of Athens is the ideal setting for imagining the conquest of other planets from a disputed territory, no longer through war but symbolically. It is one of the premier scientific institutions in a country considered the cradle of Western civilization, but also a region that exists as a liminal zone between the Muslim East and the Christian West, recovered for "Europe" in 1832 after almost four hundred years of Turkish rule. Meanwhile, there in Athens, the nation's historical identity and memory is defined by decisions made by the archaeological institutions regarding how deep to excavate to look for the "past"—which layers of earth to remove. Thus, reformulating the observatory's exterior space, which is located on Nymphs' Hill, one of the seven hills where Athens is situated, and transforming it into a field of grasses (after obtaining complicated permits from the local archaeological authorities), as well as corn (an American crop), introduces the play of chronotopic juxtapositions addressing the problem of the appropriation of the ground, what lies beneath it or on top of it, by different countries, regions, and civilizations, with relation to the development of their economies and their identities (fig. 0.27).

Figure 0.27 Adrián Villar Rojas (Argentinian, b. 1980), *The Theater of Disappearance*, 2017. Biotope assemblage, corn, pumpkins, watermelons, wild grass, artichokes, olive trunks, common reed, rocks, compost, and soil. Installation view, Hill of the Nymphs, Athens. Commissioned by NEON in collaboration with the National Observatory of Athens, 2017. Photo: Jörg Baumann/baumann fotografie frankfurt a.m., courtesy the artist and NEON

Argentina developed its foundation myth at the end of the nineteenth century, with the countryside as a binding marker for nationhood, and agricultural exports the only source of prosperity and integration with Western powers, much the way that modern Greece finds the material proof of its rightful place in that same cohort of "free nations," claiming the Parthenon or the Acropolis as the nexus of that ideological and cultural matrix (fig. 0.28). For both countries, the soil, on its surface or in its depths, in its material or historical wealth, plays a central role in their connection to the "civilized world." It is also in the soil that, with the early beginnings of agriculture and sedentism, more specifically the growth of grasses such as wheat ten thousand years ago, we find the key to the development of ever more complex human groups: city-states, kingdoms, empires, nation-states, and, finally, the modern global societies of advanced techno-capitalism that must now seek new inhabitable territories outside Earth, just as in other eras when arable land expanded, swaths of desert or sea were won, continents were conquered, or new commercial routes were created. But now the issue is no longer attempting to grow; it is attempting to survive the catastrophe of growth.

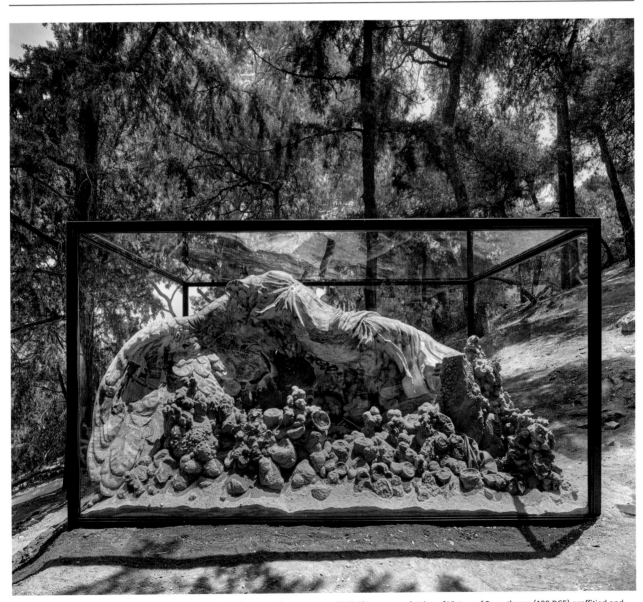

Figure 0.28 Adrián Villar Rojas (Argentinian, b. 1980), *The Theater of Disappearance*, 2017. Plaster reproduction of Victory of Samothrace (190 BCE) graffitied and fly-postered, military rucksack embroidered with Christian cross, military clothing, silver peace-sign pendant, Chinese flag, stromatolites, orange powder, metal, and glass vitrine, 210 × 314 × 175 cm. Installation view, Hill of the Nymphs, Athens. Commissioned by NEON in collaboration with the National Observatory of Athens, 2017. Photo: Jörg Baumann/baumann fotografie frankfurt a.m., courtesy the artist and NEON

One last detail brings the telluric cycle full circle in the Athens project: while beneath that city the ruins of one civilization lie under another, providing ample material for archaeology and anthropology, Argentina's tendency has been to see its ties to the land as a connection with a young fertile uterus, almost without history. And yet it is layered with the remains of the megafauna that inhabited the subcontinent until seven thousand years ago. Besides, Jurassic fossils feed a national paleontology that even has a blockbuster star: the Argentinosaurus, the largest dinosaur ever unearthed. Two debts to truth and justice, however, still lie buried beneath that soil: the genocide of the Indigenous peoples (the Argentine territory's former expropriated owners) and the disappeared of the last military dictatorship (1976–83). Over the past few decades, there has been increasing will to settle those debts. Forensic anthropology is playing a key role by collaborating to identify the skeletal remains found in NN (from *ningún nombre*, or no name) tombs and graves, or even in museum anthropological archives, as is the case with the Museo de La Plata of natural science, where the Grupo Universitario de Investigación en Antropología Social (GUIAS, or Social Anthropology Research Group) uncovered more than ten thousand human remains, as well as in other museums in Germany, France, and England that were beneficiaries of that institution. The remains belonged to more than two thousand five hundred unidentified people murdered during the extermination and expropriation of Indigenous peoples by the Argentine state, known as the Conquest or Campaign of the Desert (1878–95). In the Athens chapter of *The Theater of Disappearance*, this accumulation of questions surrounding the complex problem of the soil is laid out on the carpet.

In the New York chapter, the rooftop of the Metropolitan Museum of Art becomes the setting for an examination of the compartmentalization of "world history" based on a white Eurocentric paradigm, and for the possibility of its deconstruction, starting with a counter-hegemonic geopolitical-poetic reorganization. Following a several-months-long process of research and selection in the different departments (Arts of Africa, Oceania, and the Americas, Greek and Roman Art, Medieval Art, the American Wing, et cetera), I arrive at a kind of convulsion of official chronological, geographic, ethnic, and cultural divisions.

Three-dimensional scans are taken of hundreds of pieces from the collection—frequently of objects on the peripheries of the departmental canon, such as utensils or everyday tools. They are reactivated in new sculptural combinations modeled via a 3D milling process (a robotic arm), along with human figures derived from scans of real people. The goal is to present these new objects in a "living" way, bound to the body, the head, and the hands—returned to their ordinary function as "tools for life" that exhibition display systems (cases, supports, tempered glass) often negate or hide as they follow security and conservation protocols. It is also a response to the fetishization of materials that operates in the unconscious of these institutions. These new sculptural forms are displayed on the Met rooftop, on top of and in between large tables with tablecloths and place settings, as if served for a bacchanal that the public can move through, activating their own ritualistic, festive, hedonistic, and even anthropophagic fantasies (fig. 0.29). It is, pure and simple, an attempt to reactivate the frozen materiality of the museum.

A not-insignificant detail: the sculptures presented at the Met no longer respond to the artisanal and suicidal logic. They are fully produced by a robot and made of materials such as nylon and polyurethane: highly resistant and durable plastics. We flip the poles of the temporal paradox that was laid out in the "suicidal" phase, and which very broadly consisted of representing the present and the distant future using techniques from the past and perishable materials. Here, humanity's distant past, thematically reactivated with these pieces, is approached technically using tools from the future and ultra-resistant materials, in processes where the intervention of the human hand has virtually disappeared. Compared to earlier periods in my practice, and even more so with the objects chosen from the collection, we are dealing with an "art" that can well correspond to a phase characterized by a "superfluous humanity": replacing muscle, nerve, and brain with artificial intelligence. As such, the project as system to absorb the environment takes another step forward, risking a certain poetic hypothesis about the future that, not coincidentally, is unfolding on the museum rooftop.

The chapter of *The Theater of Disappearance* at MOCA in Los Angeles also presents an examination of this "superfluous humanity" that techno-capitalism seems to be heading toward (along with new forms of semi-enslaved work in regions with exceedingly low levels of unionization, workers' rights, and salaries, such as South Asia, Africa, and Latin America). This time it is seen from the perspective of the new digital technologies used by Hollywood to create its super-productions, connecting the blue screen or green screen in California studios with the so-called render farms in countries like China, India, or Pakistan, where thousands of outsourced workers cut out silhouettes of movie stars to insert them in computer-

designed locations. On the final frontiers of this radical replacement of the analog by the digital in the movie industry, articulated dolls are literally built with images and sensors from a package of key movements and gestures belonging to the actor or actress, doing away with the need for fully acted sequences from the script. In this sense, superfluous humanity in the Western metropole has its counterpart in the superfluous humanity of the periphery or factory countries.

The use of blue screens as a leitmotif and framework for the objects presented at MOCA signals this white noise that Hollywood film has become, where the actors, connected to mobile sensors, isolated from their environment and above all from other actorly connections, perform a series of disconnected movements in front of a neutral backdrop, which will later be hyper-processed in a render farm somewhere in South Asia, where they will be virtually transformed into video game characters who become the real stars of the movie. Like actors with no future, submissive to whatever may come, the "things" presented against the blue screens in the central spaces of the museum not only absorb the myriad elements collected in the very intense months-long explorations I made in California's "innovative milieu" and leafy stores of cinematographic junk; they also incorporate the remains of earlier projects and vernacular materials, gathered over years, stored in rental warehouses and brought from various corners of the planet, involving the largest logistical operation to date in my practice. Stones from Turkey, wood from Turin, marble from Morocco, flora and fauna from Mexico and Argentina, stratified columns, and even a bicycle wheel found along the shore in Sharjah all arrive in Los Angeles to blend alchemically with the organic and industrialized local materials (fig. 0.30). An enormous polymorphous mutant, a Leviathan project, rises up on the West Coast of the United States.

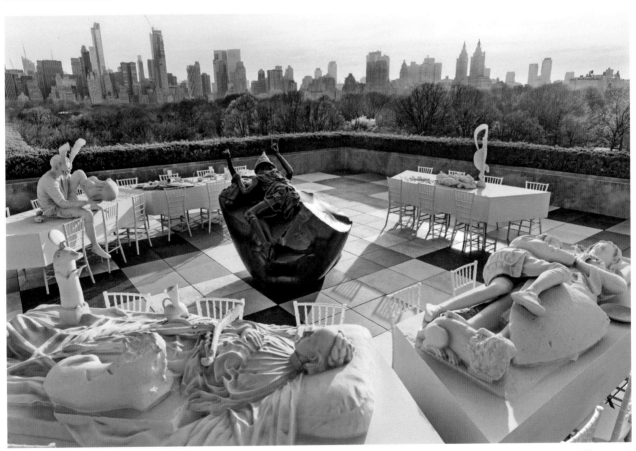

Figure 0.29 Adrián Villar Rojas (Argentinian, b. 1980), *The Theater of Disappearance*, 2017. Nylon-printed and polyurethane CNC-milled reproductions of human and nonhuman animal figures, food, and artifacts from the Metropolitan Museum of Art's permanent collection coated in bespoke automotive paint, porcelain tiles, diamond plate flooring, hollybush hedges, public bar, signage, benches, and adapted and repainted pergola. Installation view, Roof Garden Commission at the Metropolitan Museum of Art, New York, 2017. Photo: Michael Kirby Smith, courtesy the artist, Marian Goodman Gallery, and kurimanzutto

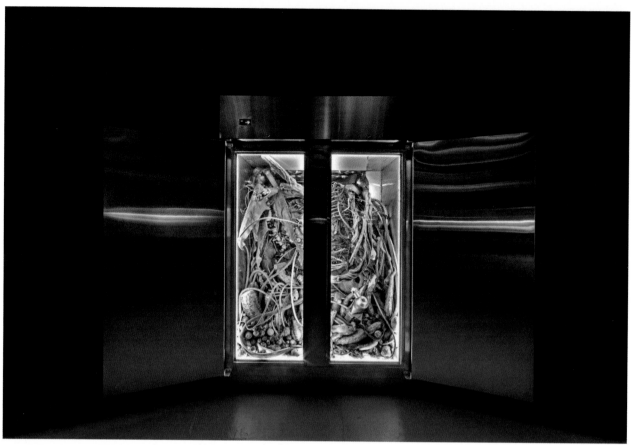

Figure 0.30 Adrián Villar Rojas (Argentinian, b. 1980), *The Theater of Disappearance*, 2017. Organic, inorganic, human-made, and machine-made matter, including freezer, saber-tooth tiger's spine, skulls of both *Homo erectus* "Peking man" and Neanderthal "La Chapelleaux-Saints," orangutan skeleton, rubber molds (from *The Most Beautiful of All Mothers* [2015]), crucifix and tree branches (from *Rinascimento* [2015]), fungi, vines, sprouting tubers, robotics, shark fins, and hornero nests, collected in Los Angeles, Istanbul, Kalba, Mexico City, Morocco, Argentina, and Turin, 330 × 111 × 203 cm. Installation view, Geffen Contemporary at MOCA, Los Angeles, 2017. Photo: Michel Zabé studio, courtesy the artist, Marian Goodman Gallery, and kurimanzutto

One last point that encapsulates the pivotal nature of the Californian iteration of *The Theater of Disappearance* in relation to the key elements and dynamics of this period is the total absorption of the exhibition space as a decisive part of the system. It is a transformation the likes of which I have never attempted before, after facing together with its curatorial authorities such profound deconstruction of MOCA's physical-institutional space that it almost caused the entire project to collapse. The architecture of the space is operated on to elicit a true ecosystem, capable of hosting a macro-project that is absorbing virtually all of my previous projects. Stairways and ramps are removed. Floors are leveled. Walls and banisters are taken out. The lighting is modified. Offices, bathrooms, and hallways are moved. There is not a single element of the building that is not part of the project, whose sovereignty over the space is reticular. In that way an Aleph, a point that is all points, a *chronotopic crystallizer* of my entire project-life, happens temporarily in Los Angeles, that Western cradle of the fiction of the masses, at a critical junction of its own transformation, where the prospect of disappearing or sharing arable land with new species of "grasses" planted in Silicon Valley is being debated. Google, social media, Netflix, apps—all of them are, perhaps, new forms of fiction.

CONCLUSION: THE LONG ROAD FROM THE WORK OF ART TO THE GARDEN OF FORKING PATHS

Ever since my years as a student at the Escuela de Bellas Artes in Rosario, I understood that contemporary art was something that could not last forever. On the contrary, I intuitively knew that a central problem was its very disappearance, its speed, and its superabundance, which in fact made it insignificant. That insignificance resulting from overproduction clashed with the will to survive and to transcend that all things have, especially humans. Adopting the fictional gaze of an alien from another world,

looking from a distance with an icy horizontality, I threw myself into working with that physical and metaphysical tension that has time as its central and agonizing question, but also as its great tool.

All things are beings in time, straddling life and death, the ephemeral and the eternal, the present and its incessant pull in opposite directions: toward the past and toward the future. The entities that I have designed attempt to access some of that existential tension of *Dasein*, and as such are positioned, singular and unrepeatable: they are not being, they are *happening*. The early appearance of the organic in my practice in the form of clay gave me the material basis to think of their corporeality as a happening, as the fleeting present doing battle with entropy. That was combined with a dynamic of work (my team) and movement (nomadism) in environments that demanded ever-greater immersion and commitment. It was not long before time became space-time. The space-time of the Other.

With this article, I have attempted to create a descriptive record of how living matter exists in my practice, understanding not only the presence of a certain organic materiality, but more precisely the complex connection between work, auto-production, and environment via a chronology that spans from the suicidal sculptures (the clay + cement period that results in a programmed disappearance), to the diachronic objects, hybrids, or mutants (incorporating new organic and industrial components that reinforce autopoiesis and deprogrammed growth), to arrive at the notion of the project as a system to absorb and be reabsorbed by the environment (deep immersion in local contexts that ends up in a chronotopic crystallization), and lastly, *as ecosystem* (the emergence of a new ecological balance through housekeeping and the negotiated redesign of the architectural-institutional space).

In relation to these transformations of the object, I have attempted to demonstrate their correspondence with a simultaneous transformation of the subject—that is, of the organization of my team's collaborative work, which spans various phases (community of builder-sculptors, itinerant company, workstations) to arrive at what is currently a range of available organizational forms in conjunction with the incorporation of new technologies like rendering, three-dimensional scans, and the robotic arm, complicating the systemic equilibrium of living matter: the latent threat of superfluous humanity.

Within this framework, I have presented a series of projects that, when linked, serve as hinges in the progressive emergence of a new paradigm, from

hibernation in raw clay (2008–13) to the blossoming of a "garden of mutants" in an unpredictable forking of paths beginning in 2012 with *Brick Farm*, and its effect on *Today We Reboot the Planet*. This anomaly became law in *Los teatros de Saturno* and Xochimilco, which marked the consolidation of a phase characterized by organic material as the organizing factor of an extended (diachronic) temporality, and by the withdrawal of human agency in favor of other modeling forces. In this phase, there was a shift from time as representation to time as sculptor, stemming not only from entropy (the principal nonhuman agent of the previous period) but also from auto-production, which provokes another shift, this one from the idea of "completion" to the idea of "horizon," a never-ending process of self-modeling from inside out. This constant self-modeling via growth and decay opens a new stage that follows the end of the human part of the projects, that of monitoring of the autonomous life of the diachronic objects by the institutions that house them and my office. This led to examinations such as the one in *Motherland*, touching on the "eternal" link that ties us to institutions in charge of mutant objects, or like that of *Fantasma*, where I attempted to imagine a retrospective of my work in two hundred years.

Furthermore, I have attempted to demonstrate how the transporting of vernacular materials, fragments of projects, and residual team energy from one point of the planet to another in order to be recycled into subsequent projects stemmed from that same nomadic dynamic, and from the accelerated speed that was a result of the hyper-entropic nature of the system. That system has sought to perpetuate itself more through action (with the communal geneticization of a language aimed at "doing") than with "done" materiality, and through creating a record of that fleeting present with poeticized archives, pictorial homages to studio activities,[19] or films based on audiovisual records with varying degrees of cinematographic self-awareness.[20] The publication of texts such as this article, catalogues, and artist's books, which are currently in production, is a fourth source of records.

Accordingly, my objective here was to examine how the material dimension of my practice is more the precarious act of bearing witness to an activity that is lost forever (all of the richness of a nomadic life in that community or of the processes of exploration) than the ultimate goal of a "career" aimed at producing commodities. That is why the environment, first in the form of an immersive process that led me to develop a geopolitics of friendship, with strategies for respectful connections with different local realities and the actors who experience them, and next in the form of housekeeping within physical and institutional

spaces with the goal of reaching a singular and unrepeatable ecological equilibrium, was posited here as the final stop on a journey that aspires to constantly escape the work of art and move toward the thing, long oblivious to its condition as fetish, and that, without labels or proper nouns, surrenders completely to bare life. It is there, at that point, where matter becomes, in the end, living.

NOTES

1. Adrián Villar Rojas, *Diario íntimo 3D* [Intimate Diary 3D], Centro Cultural Borges, Buenos Aires (2007); Adrián Villar Rojas, *15.000 años nuevos* [15,000 New Years], Belleza y Felicidad, Buenos Aires (2007).

2. This nickname is related to the institutional space where *Pedazos de las personas que amamos* was developed and exhibited: the 4th arteBA-Petrobras Visual Arts Prize.

3. Adrián Villar Rojas, *Lo que el fuego me trajo*, Ruth Benzacar, Buenos Aires (2008).

4. Adrián Villar Rojas, *Mi familia muerta* [My Dead Family], at *Intemperie*, 2a Bienal del Fin del Mundo [2nd Biennial at the End of the World], Ushuaia, Argentina (2009).

5. Adrián Villar Rojas, *Ahora estaré con mi hijo, el asesino de tu herencia* [Now I Will Be with My Son, the Murderer of Your Inheritance], Argentina National Pavilion, 54th Venice Biennale (2011); Adrián Villar Rojas, *Poems for Earthlings*, SAM Art Projects in collaboration with Musée du Louvre, Jardin des Tuileries, Paris (2011); Adrián Villar Rojas, *Return the World*, at *dOCUMENTA (13)*, Kassel, Germany (2012).

6. Adrián Villar Rojas, *Today We Reboot the Planet*, Serpentine Sackler Gallery, London (2013).

7. Adrián Villar Rojas, *From the series Brick Farm*, at Rockaway!, Fort Tilden and Rockaway Beach, New York (2014); Adrián Villar Rojas, *Planetarium*, at *The Past, the Present, the Possible*, Sharjah Biennial 12, Kalba, United Arab Emirates (2015); Adrián Villar Rojas, *Fantasma*, Moderna Museet, Stockholm (2015); Adrián Villar Rojas, *From the series Brick Farm*, 12ª Bienal de La Habana (2015); Adrián Villar Rojas, *From the series Brick Farm*, APAP 5: Anyang Public Art Project, South Korea (2016); Adrián Villar Rojas, *From the series Brick Farm*, at *Everything Was Forever Until It Was No More*, 1st Riga International Biennial of Contemporary Art, Latvia (2018); Adrián Villar Rojas, *From the series Brick Farm*, at *Into Nature: Out of Darkness*, Drenthe, the Netherlands (2018).

8. Adrián Villar Rojas, *El momento más hermoso de la guerra no sabe distinguir el amor de cualquier sentimiento* [The Most Beatiful Moment of War Cannot Distinguish Love from Any Other Feeling], at *Intersecciones: Memoria, realidad y nuevos tiempos* [Intersections: Memory, Reality and New Eras], X Bienal de Cuenca, Ecuador (2009).

9. Adrián Villar Rojas, *Los teatros de Saturno*, kurimanzutto, Mexico City (2014).

10. Adrián Villar Rojas, *La inocencia de los animales*, at *Dark Optimism*, EXPO 1: New York, MoMA PS1, New York (2013).

11. Adrián Villar Rojas, *Motherland*, at *Storylines: Contemporary Art at the Guggenheim*, Solomon R. Guggenheim Museum, New York (2015); Adrián Villar Rojas, *Where the Slaves Live*, Fondation Louis Vuitton, Paris (2014); Adrián Villar Rojas, *Return the World*, at *dOCUMENTA (13)*, Bagh-e Babur, Queen's Palace, Kabul, Afghanistan (2012).

12. Adrián Villar Rojas, *The Evolution of God*, High Line at the Rail Yards, New York (2014).

13. Adrián Villar Rojas, *The Most Beautiful of All Mothers*, 14th Istanbul Biennial (2015); Adrián Villar Rojas, *Rinascimento*, Fondazione Sandretto Re Rebaudengo, Turin, Italy (2015).

14. Adrián Villar Rojas, *El momento más hermoso de la guerra*, Real DMZ Project, Yangji-ri, South Korea (2014).

15. Adrián Villar Rojas, *The Theater of Disappearance*, three films, total run time 118:37 min. (Buenos Aires: Rei Cine SRL, 2017).

16. Adrián Villar Rojas, *The War of the Stars*, at *Imagined Borders*, 12th Gwangju Biennale, South Korea (2018).

17. Adrián Villar Rojas, *The Work of the Ocean*, De 11 Lijnen, Oudenburg, Belgium (2013).

18. These all take the same title and appeared in 2017 at Kunsthaus Bregenz, Austria; NEON Foundation at Athens National Observatory (NOA); the Roof Garden Commission at the Metropolitan Museum of Art, New York; and Geffen Contemporary at MOCA, Los Angeles.

19. As in Adrián Villar Rojas, *Films before Revolution*, Museum Haus Konstruktiv, Zurich (2013).

20. As in Adrián Villar Rojas, *Lo que el fuego me trajo*, 32 min. (Buenos Aires: Rei Cine SRL, 2013).

BIBLIOGRAPHY

Kuhn 1962
Kuhn, Thomas. 1962. *The Structure of Scientific Revolutions*. Chicago: University of Chicago Press.

Wittgenstein 1953
Wittgenstein, Ludwig. 1953. *Philosophical Investigations*. New York: Macmillan.

Living Matter in Contemporary Art: Snapshots

Biological Material Indeterminacy Rebukes the Social and the Artistic: Cases from the Documentary Archives of the Arkheia Documentation Center, Mexico

Eugenia Macías
Cristina Reyes

This paper addresses three cases of documentary materials housed at the Centro de Documentación Arkheia at the Museo Universitario Arte Contemporáneo (MUAC) of the Universidad Nacional Autónoma de México (UNAM): works by Santiago Rebolledo of Editorial Cocina Ediciones; by Rocío Boliver, also known as "La Congelada de Uva"; and by César Martínez Silva. In each case, biological material plays a central role in the critical rethinking of practices and concepts in art. The paper uses historiographic methodologies and visual analysis to discuss the biological material and its conservation implications in each case.

◆ ◆ ◆

Some of the items held at the Centro de Documentación Arkheia of the Museo Universitario Arte Contemporáneo (MUAC) of the Universidad Nacional Autónoma de México (UNAM) exemplify unusual artistic uses of diverse biological material that distort received canons of art. This paper discusses works by Santiago Rebolledo, Rocío Boliver (also known as "La Congelada de Uva"), and César Martínez Silva that alter the concept of archive and documentary resource through the presence of biological components and their precarious, indeterminate status in terms of material permanence. In these cases the role of the archivist is productive, as proposed by Hal Foster (Foster 2015, 31–35) and Anna María Guasch (Guasch 2011) and revised and paraphrased by Andrés Maximiliano Tello (Maximiliano Tello 2015), who imagine the paradigm of archiving as a sort of uncertain, fragmentary, and playful memory in which human testimonies provide a foundation for proposing critical art practices.

SANTIAGO REBOLLEDO: A LIVING PROCESS

El Archivero was a gallery and bookshop active from 1985 to 1991 in the Colonia Roma neighborhood of Mexico City. It started as a project to promote dissemination, distribution, and collaboration in publishing within the artist's book movement. It arose from the passion for experimentation and self-publishing that Felipe Ehrenberg brought from England in the early 1970s with the Beau Geste Press / Libro Acción Libre publishing community, which had survived over subsequent generations. This is also how Agru-pasión entre Tierras was born, a sort of traveling publishing company founded by Santiago Rebolledo, René Freire, Manuel Zavala, Ana Checchi, Diego Mazuera, Elsa Zambrano, Gabriel Macotela, and Paul Rolfe.

This publishing company was specifically created for mail art and thus began to collaborate with El Archivero. One of these collaborations was *Hoja de vida / El Cabello está en la cabeza* (Résumé / Hair Is on the Head, 1985, fig. 1.1) by Rebolledo, a coauthored book consisting of a wooden shoeshine box with cutouts of photos, coins, and other metal objects adhered to its exterior. Inside the box is a large piece of parchment that unfolds to reveal repetitions of the typewritten phrase "El Cabello está en la cabeza," accompanied by hanks of hair from different artists, along with their signatures.

Figure 1.1 Santiago Rebolledo (Colombian, 1951–2020), *Hoja de vida / El Cabello está en la cabeza* (Résumé / Hair Is on the Head), 1985. Typewriting and human hair on manila paper, wood box, 27 × 29.5 × 15 cm. Fondo El Archivero, Centro de Documentación Arkheia, MUAC-UNAM. Photo: Courtesy Fabián Cadena

The making of this piece occurred in stages that are worth revisiting, as they represent relevant and significant activations, or diffusion events of public circulation. The piece originated with a sheet of paper that Freire found on the street. He thought the phrase it bore was interesting and mailed it to Rebolledo, who at that time was living in Colombia. Some time later, Rebolledo returned to Mexico, bringing Freire's letter with him. At a gathering at Macotela's home, Freire and Macotela made a mimeograph stencil of the phrase and printed it repeatedly on a large piece of Kraft paper.

Rebolledo proposed an intervention into this sheet of paper by inviting several attendees to cut a lock of their hair, glue it to the paper, and sign it, after which they released the parchment out a third-floor window of the building. The paper fell to the street. It seems that part of the sheet was lost in this action, and what remains is slightly less than a meter in length (fig. 1.2).

Figure 1.2 Santiago Rebolledo (Colombian, 1951–2020), *Hoja de vida / El Cabello está en la cabeza* (Résumé / Hair Is on the Head), 1985. Typewriting and human hair on manila paper, wood box, 27 × 29.5 × 15 cm. Fondo El Archivero, Centro de Documentación Arkheia, MUAC-UNAM. Photo: Courtesy Fabián Cadena

This account, constructed in April 2019 from memories and electronic communications between Rebolledo, Freire, and another friend of their generation, the photographer Armando Cristeto, is a clear example of how the works these groups published were not simply printings on paper, but artworks that included the actions that led to them. The hair stored in the box is evidence of a living process that is undergoing change even now (fig. 1.3).

Figure 1.3 Santiago Rebolledo (Colombian, 1951–2020), *Hoja de vida / El Cabello está en la cabeza* (Résumé / Hair Is on the Head), 1985. Typewriting and human hair on manila paper, wood box, 27 × 29.5 × 15 cm. Fondo El Archivero, Centro de Documentación Arkheia, MUAC-UNAM. Photo: Courtesy Fabián Cadena

Figure 1.4 Rocío Boliver (Mexican, b. 1956), *Pocos mocos* (*Little Snots*), ca. 1999. Tissues and swabs with human secretions, 13 × 8 × 2 cm each. Fondo Rocío Boliver "La Congelada de Uva," Centro de Documentación Arkheia, MUAC-UNAM. Photo: Courtesy Rocío Boliver and Centro de Documentación Arkheia, MUAC-UNAM

ROCÍO BOLIVER, "LA CONGELADA DE UVA": I'M HAPPILY LIVING MY SLOGAN, "LET ME SHOW YOU"

Pocos mocos (*Little Snots*, ca. 1999, fig. 1.4, fig. 1.5, fig. 1.6) is a collection of packets, each containing a commercial cotton swab, disposable tissue, paper, earwax, and nasal mucus from the maker's artist friends. What slightly mitigates the instinctive reaction of disgust is the range of responses on the notes accompanying each bag: drawings, phrases, texts, other objects. The creator of this project is Rocío Boliver, also known as "La Congelada de Uva" (The Grape Popsicle), who has a long history of performances and other actions involving the handling of human fluids.

One may wonder sometimes whether the exercise of provocative intellectual argumentation by critics carries more weight than an action itself, which borders on excess. However, we find useful Fabián Giménez Gatto's problematization of the pornographic aspects in Boliver's work. In an article on her obscenity and trans-aesthetic games published in 1999 at the Uruguay-based site H Enciclopedia, Gatto suggests that the elements of her actions are expressive units (which he calls pornograms) that provide two processes, or lenses, by which we can assess *Pocos mocos*: the link between the body and inscriptions with, from, on, and in it, and the breaking of the boundary between what is inside an artistic situational framework and what is outside of it. He describes it as an obscenity seeking an enormous immersion or nesting within the observer, to the point of being unrepresentable

Figure 1.5 Rocío Boliver (Mexican, b. 1956), detail (Rossana Ponzanelli) from *Pocos mocos* (*Little Snots*), ca. 1999. Tissues and swabs with human secretions, 13 × 8 × 2 cm each. Fondo Rocío Boliver "La Congelada de Uva," Centro de Documentación Arkheia, MUAC-UNAM. Photo: Courtesy Rocío Boliver and Centro de Documentación Arkheia, MUAC-UNAM

because it is beyond all limits, because the experience is placed on a chaos of scales, making it hard to find any dimension of weight between the components of certain actions and the world of reference (broad or limited) of the person contemplating them. It is an experience that Boliver expressed with the phrase: "I'm happily living my slogan 'LET ME SHOW YOU'" (Giménez Gatto 1999).

Sol Henaro, Alejandra Moreno, and Christian Aravena deserve acknowledgment for recommending texts and providing an oral account of this project by Boliver. These three, along with Brian Smith, were the curators of an

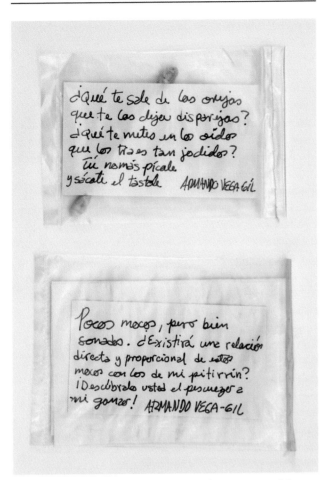

Figure 1.6 Rocío Boliver (Mexican, b. 1956), detail (Armando Vega-Gil) from *Pocos mocos* (*Little Snots*), ca. 1999. Tissues and swabs with human secretions, 13 × 8 × 2 cm each. Fondo Rocío Boliver "La Congelada de Uva," Centro de Documentación Arkheia, MUAC-UNAM. Photo: Courtesy Rocío Boliver and Centro de Documentación Arkheia, MUAC-UNAM

exhibition that opened in 2019 at the University Museum of Contemporary Art (MUAC), *Arte acción en México: Registros y residuos* (Action Art in Mexico: Registers and Residues). This exhibition brought together—under various reflexive criteria—the documentary records of projects along this creative line in Mexico and included *Pocos mocos* in the group "Salir de la carne: Prótesis y accesorios" (Out of the Flesh: Prostheses and Accessories), which sought to emphasize works that expand the usual perimeters of bodily experience (Henaro et al. 2019, 12, 13).

In an oral account Boliver provided regarding this project in November 2018, she stated that she requested mucus from fellow artists, and supplied packets in which they could deposit their secretions along with a comment. Juan José Gurrola gave her a scab and a fingernail; Felipe Ehrenberg was happy to oblige, but Astrid Haddad was not; Guillermo Fadanelli proffered only colored sprinkles.

At that time, Boliver had recently seen an installation at ExTeresa in Mexico City by an unidentified foreign artist consisting of little labeled plastic bags containing such things as river water from Spain, Japan, and Mexico—all apparently alike—and rose petals from India, Chile, and Canada—again, all seemingly identical. It occurred to her to take the idea to an abject extreme, suggesting that artists and non-artists all have similar mucus and earwax. Broach what is private and flaunt it. One does not extract these excretions in public (or if one does, there are social protocols). It also aligned with other performances in which she used her own excretions: tears, eye discharge, mucus, excrement, urine, menstrual and other blood, saliva, and phlegm.

Conservator Alexandra Samkova performed basic conservation treatments on the material record of this project when Boliver's documentary archives entered the MUAC in 2017 and were added to the Centro de Documentación Arkheia. She stated in an interview at the museum in November 2018 that she only stabilized each unit (examining and registering its conservation condition, and transferring the group to preservation covers and cases) and repacked it, since the packets were all part of the devised system that Boliver had created to gather the materials. Samkova said that it would be intriguing from a conservation perspective to conduct a physical and chemical analysis of each one to determine whether it contained latent biological activity, and thus whether other storage or preventive isolation methods might be called for.

CÉSAR MARTÍNEZ SILVA: *RETRATOS DE CHOCOLARTE*, OR THE EPHEMERAL AS FUTURE CONDITION

Retrato de chocolARTE (Portrait in ChocolART, 2013, fig. 1.7) is one of three faces 3D printed in chocolate by César Martínez Silva and first presented in the 2013 solo exhibition *Antropofagia Gourmet* at Café La Gloria, Mexico City (fig. 1.8). This work exemplifies one of the fundamental ideas behind Martínez Silva's processes: the ephemeral transformed into a future condition, or how conceptual artistic practices can generate as much or more meaning than an artwork's material permanence. Some of Martínez Silva's *chocolARTE* works are completed when they are devoured, or at least tasted, by people in situations arranged by the artist, as a critique of certain unconscious ethical-political stances on humanity; for instance some persons attending Martínez Silva's

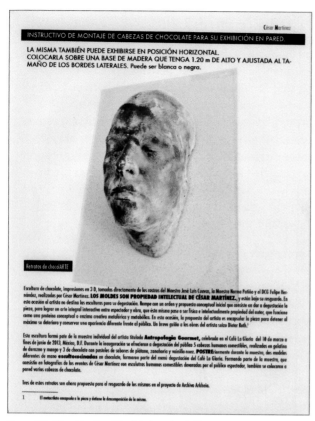

Figure 1.7 César Martínez Silva (Mexican, b. 1962), *Retrato de ChocolARTE* (Portrait in ChocolART), 2013. 3D modeling chocolate and clear acrylic box or cape, head: 25 × 18 × 15 cm. Fondo César Martínez, Centro de Documentación Arkheia, MUAC-UNAM. Photo: Courtesy César Martínez Silva

performances with chocolate in human form become actors in symbolic anthropophagic actions.

But this piece, produced along with two others and based on the faces of Norma Patiño, Felipe Hernández, and José Luis Cuevas (this information comes from the artist; we are not sure who these people are except for the famous artist Cuevas), emanates from another conceptual event recounted by Martínez Silva in an email message from May 2019: isolate chocolate faces in jars made of acrylic plastic to decelerate the process of biodegradation and oxidation, and then encourage their contemplation not by eating but by dislocating or diverting from the primary function of ingestion toward vision alone (to eat with one's eyes?).

The artist engages in a dialogue with the premise of conservation by having an exhibition of his work simultaneously display elements made to be eaten and others made from foods but mounted on a wall to be observed and protected from environmental conditions that might accelerate their deterioration. The system for securing the pieces to the wall posed a challenge. The chocolate is not fastened directly to the acrylic jars, but is

hollow, with a wooden core that anchors it to the container. Martínez Silva prepared detailed instructions for mounting them.

In her recent research into the work of Martínez Silva, the art historian María Luisa González proposed that his projects activate transubstantiations of sociopolitical critique and behaviors restored in the performance space itself. They re-signify acts, discourses, objects, and cultural products drawn from religious ritual practices having to do with the transformation and/or transubstantiation of matter, and with the artist's own unsettled relationship with his Catholic upbringing (González 2018). Furthermore, by alternately allowing either ingestion or observation of the portraits in *Retratos de chocolARTE*, Martínez Silva makes it possible to enter and exit the situation of anthropophagy, as he has done in other installations, such as an event-exhibition in Santander, Spain, in 2015, which also included pieces of chocolate (fig. 1.9) and built another alternative to the spiritualization of matter. González refers to this interpretation via a comparison to the writer Nikos Kazantzakis's conception of transubstantiation. For González, these entreaties to specific means of contemplation (eating and/or observing) also bring about changes in the status of the individual participants as they reflect on themselves and what they have experienced, similar to the way Richard Schechner links ritual performativity and aesthetics.

Martínez Silva himself recently reflected on this in a dialogue with contemporary art conservation scholars regarding his approach to the case of artist Dieter Roth (countering the restorers' logic of material preservation), concerning another sculptural trend in his work—works in latex—that can be extrapolated to the sculptures in chocolate (Martínez Silva 2013). And in a 2018 email exchange with these authors, Martínez Silva stated, "The ethereal, the fleeting, the invisible, the imperceptible, the perishable, the momentary, the fugitive, and passing are the subjects of my research and, therefore, the very basis of my sculptures. . . . They were envisioned as events, situated in a concrete space/time dimension, not to be understood as concrete, sculptural objects of art."

In this line of work, Martínez Silva plays with encounters between physical properties of materials and their conceptual auras, willingly assuming the risk of accidents that accompany the passage of time. For this artist, such risks provide new paths—his strategies for documenting visual accounts of damage to the pieces and their material degradation correlate with their sociopolitical meanings. They have also led him into scientific research into materials, as in the case of his pieces in latex. Such

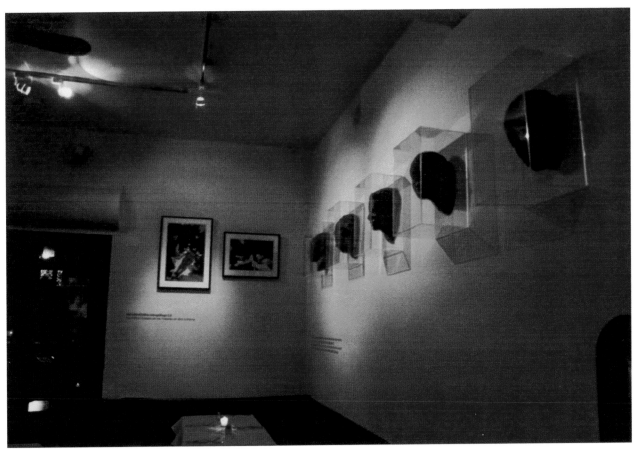

Figure 1.8 César Martínez Silva (Mexican, b. 1962), *Retratos de ChocolARTE* (Portrait in ChocolART), 2013. Installation view at *Antropofagia Gourmet*, Café La Gloria, Mexico City, 2013. Fondo César Martínez, Centro de Documentación Arkheia, MUAC-UNAM. Photo: Courtesy César Martínez Silva

research is still pending for his pieces in chocolate, exploring the improbability that gives life to the long lasting.[1]

CONCLUSION

This overview of three specific cases reveals the dilemmas concerning the role of organic or biological matter in artwork as it pertains to material preservation as a means of protecting the historical memory of artistic practices of dissent; and also ethical dilemmas that the projects themselves actuate through organic matter, for instance sublimated cannibalism and anthropophagy, or abject or scatological intimacy.

Hoja de vida / El Cabello está en la cabeza is just one of many pieces to emerge from a generation that decided it did not need fine paper or professional printing systems to create art. A shoeshine box, hair, and glued cutouts are testimony that the artist's book movement would not simply begin or end with the printing of a book, thus calling into question

the common conception of the archive and its conservation.

In *Pocos mocos*, biological waste plays a leading role in the disruption of what might be considered artistic or worthy of collection. Its current storage arrangement raises various conservation issues: Is a microclimate operative in each plastic bag such that the organic material is undergoing deterioration or other behaviors? Would it be preferable to transfer each unit to more stable storage arrangements, even if it entails replacing the original artist-created packets?

In the sculptural approach envisioned in *Antropofagia Gourmet*, on the one hand samples of processed animal milk are eaten in an elegant banquet attended by the artist and the public, which, if the faces were real, would be a cannibalistic act. At the same time, the busts of chocolate are exhibited as hunters might display mounted animal heads. The organic matter evokes community rituals in traditional cultures in which the purpose of collective participation is to make a connection through rites, food, masks, and accessories.

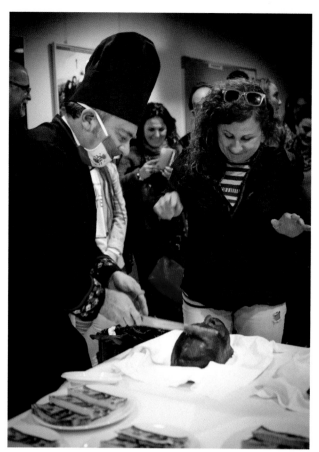

Figure 1.9 César Martínez Silva (Mexican, b. 1962), artistic action in Santander, Spain, 2015. Fondo César Martínez, Centro de Documentación Arkheia, MUAC-UNAM. Photo: Courtesy César Martínez Silva

NOTES

1. César Martínez Silva, email message to the authors, November 2018.

BIBLIOGRAPHY

Foster 2015
Foster, Hal. 2015. *Bad New Days: Art, Criticism, Emergency.* London and New York: Verso.

Giménez Gatto 1999
Giménez Gatto, Fabián. 1999. "Obscenidad a la mexicana: Los juegos transestéticos de Rocío Boliver (I y II)," *H Enciclopedia,* http://www.henciclopedia.org.uy/autores/FGimenez/Obscenidad1.htm, http://www.henciclopedia.org.uy/autores/FGimenez/Obscenidad2.htm.

González 2018
González, María Luisa. 2018. "La transubstanciación. El performance en el performance. Un abordaje a La perforMANcena, 'North America Cholesterol Free Trade Agreement' (1999) in César Martínez Silva." In *Aproximaciones interpretativas multidisciplinarias en torno al arte y la cultura,* edited by Raúl Wenceslao Capistrán Gracia, 135–45. Aguascalientes, Mexico: Universidad Autónoma de Aguascalientes.

Guasch 2011
Guasch, Anna María. 2011. *Arte y archivo. Genealogías, tipologías y discontinuidades.* Madrid: Akal.

Henaro et al. 2019
Henaro, Sol, Alejandra Moreno, Christian Aravena, and Brian Smith. 2019. *Arte-acción en México. Registros y residuos.* Mexico City: MUAC-UNAM.

Martínez Silva 2013
Martínez Silva, César. 2013. "Permanencia en el tiempo de esculturas hinchables realizadas con hule látex vulcanizado, mecanismos de aire y sensores electrónicos; La conservación del futuro." Presentation at the 14th Jornada de Conservación de Arte Contemporáneo, Museo Nacional Centro de Arte Reina Sofía, Madrid.

Maximiliano Tello 2015
Maximiliano Tello, Andrés. 2015. "El arte y la subversión del archivo." *Aisthesis,* no. 58, 125–43. http://dx.doi.org/10.4067/S0718-71812015000200007.

Can We Use the Concept of Programmed Obsolescence to Identify and Resolve Conservation Issues on Eat Art Installations?

Claudia María Coronado García

Eat Art installations trace back to 1968, when contemporary artists began to use food to express different emotions and meanings. Food is indeed something that everyone can relate to, but not all food is equivalent from a conservation standpoint. Sonja Alhäuser's Braunes Bad V *(Brown Bath V, 2009/2015), Laurent Moriceau's* Found and Lost #1 *(2003), and Janine Antoni's* Lick and Lather *(1993) are installations made with chocolate, and at first glance, they seem like they might call for similar conservation approaches because they use identical materials. But they most certainly do not. Understanding their differences, both physically and in terms of artistic intent, aids in recognizing the appropriate preservation response: allowing programmed obsolescence through replacement; accepting consumption; or allowing for continual decay.*

◆ ◆ ◆

Daniel Spoerri and a few other artists, including Dieter Roth and Peter Kubelka, decided in 1970 to organize an exhibition featuring quite a few experiments they had carried out since 1968, when Spoerri Restaurant opened, and then subsequently the Eat Art Gallery, which was unique in its presentation of something as common as food as capable of inducing emotions, memories, and sensations, even evoking personal memories among visitors. The show was titled *Eating the Universe* and took place at Burgplatz in Düsseldorf, Germany. Spoerri described it as follows:

a) the tables in the restaurant became trap-paintings, b) as in my "grocery shop" regular foods (meals) are exhibited as artworks, c) the works of art are in transformation (and transient), . . . d) everyone could have produced at will his own trap-painting under my license, and e) the sense of taste was directly involved, in addition to touch and sight, etc. (Novero 2010, 159)

These artistic principles were the foundation of Eat Art. The artists intended to demonstrate the power of food—that it can communicate meanings, transmit clear ideas, and provoke even the most passive observer. The exhibition

evidenced that using food as a material for artistic expression is just as or even more powerful than re-creating it on canvas. The name Eat Art is now commonly used for installations containing some element that is edible or closely linked to food—so much so that some previous artworks by Roth or Joseph Beuys that were not created with the intention of eating the food are now considered Eat Art installations (fig. 2.1).

Figure 2.1 Joseph Beuys (German, 1921–1986), *Zwei Fräulein mit leuchtendem brot* (Two Girls with Bright Bread), 1966. Chocolate painted with oil on imprinted card and paper in box, approx. 75 × 21 × 1.2 cm. Private collection. © 2021 Artists Rights Society Society (ARS), New York / VG Bild-Kunst, Bonn. Photo: © Lempertz

This paper discusses Eat Art installations and proposes the concept of planned obsolescence to approach their conservation. What would that obsolescence look like, and how would we recognize it?

TYPOLOGIES OF EAT ART INSTALLATIONS

Little is firmly established about the conservation of Eat Art, and even less about how to determine when changes to the organic parts are decay intended by the artist versus decomposition that should be combated. Yet other installations involve a constant replenishment or replacement of materials to function as intended.

In the history of art, food has often been portrayed, in one form or another, as a symbol of power and well-being. It is thanks to Spoerri, however, that the art world came to consider food items as raw material able to "generate associations that, together with the forms into which they are shaped, establish the subject or content of the work of art" (Buskirk 2003, 13). Food items in Eat Art installations can fulfill a variety of functions. Using food promotes a fuller sensory experience, inviting us to utilize not just our vision, but also our sense of smell, and even maybe touch and taste. Involving more than a single sense makes the created experience stronger. The artists have achieved their objective if they generate in the viewer whatever sense of playfulness, cryptic-ness, grotesquerie, eroticism, repulsion, savageness, transgression, or surreality that they intended. The material creates a visual or sensory experience in a specific environment (fig. 2.2).

Food items in Eat Art installations might suggest the fleetingness of life because, just like us, the food will undergo change that is inherent to its organic state. The work will start out with one shape, color, and smell and undergo transformations until these aspects are unrecognizable. Perhaps the piece will completely deteriorate. This deterioration is a clear reminder of our fragile nature, of the organic decomposition that every human being is destined to undergo. As Pere Salabert puts it, from the beginning our bodies contain an anomaly, an error in the production process. Art that advocates decomposition of matter is connecting us with our body's final destiny. It forces us to confront what we strive to avoid: "the expiration of living matter, its stinking vocation, its propensity to decay," because materials that must be eaten will degrade, decompose, or even perish, which is what will convey meaning or transform into the sensations and interactions between ourselves and the works of art (Salabert 2004, 86). This is sometimes confusing because these installations promote consumption, asking for direct interaction rather than being simply observed; they are presented as a temptation that breaks with traditional exhibition rules by asking us to approach the artworks, touch them, even eat them.

The wide variety of food that has been used as art material has led to a great diversity in the types of artworks created, as well as in terms of the time and place of exhibition, the idea to be conveyed, and the type of audience the work is intended to impact. This variety of presentations and contexts means that works that might

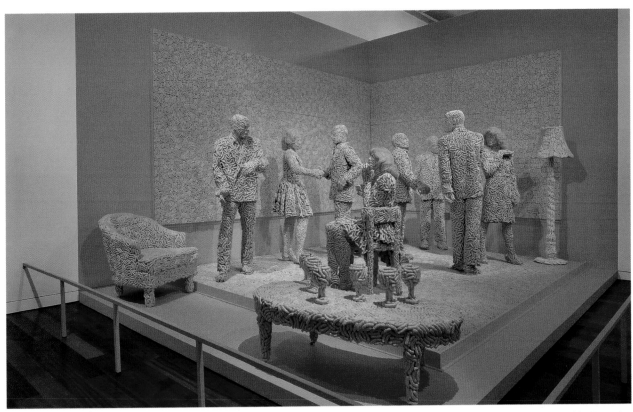

Figure 2.2 Sandy Skoglund (American, b. 1946), *The Cocktail Party*, 1992. Installation with found objects, Cheez Doodles, and paint, dimensions variable. McNay Art Museum, San Antonio, Texas. Photo: © 1992 Sandy Skoglund, Collection McNay Art Museum, San Antonio, Texas

look alike could require different actions from their audiences and have different meanings. In other words, not all artists endow the same food with the same meaning or significance; the food might fulfill very different functions. New artworks employing food items are still able to produce new and different discourses, and new sensations and experiences (fig. 2.3).

At present, there is no single way to characterize these types of installation. They could be categorized by era, by artist, by type of material, or by the artist's intention. Intentionality encompasses everything from the reason why the artist selected, from among various materials, some in particular and assigned to them specific tasks to perform within an exhibition space to the way in which they will interrelate with visitors. This categorization is based on prior knowledge of the installations; they cannot be grouped by the type of food chosen because, as we will see, three installations using chocolate as the raw material could have quite different intentions behind them (Hummelen 1999). Knowing the ideas behind the choice, and familiarity with the artist's previous work, enables an understanding of what motivated the artist to select that material and its significance within the particular context.

With food installations, at least three typologies of intentionality can be recognized.

The first group comprises edible art objects that the artist has endowed with an emotional charge, sensitive to human relationships with this type of food item. This group, which conveys sensations and reactions, utilizes the physical, formal, and material qualities of the food products to create a connection with viewers. These objects are sometimes treated chemically so they will not change over the course of the exhibition in which they will be presented, as is the case depicted in figure 2.2, where in 1992 Sandy Skoglund stabilized Cheez Doodles chemically to keep their peculiar color and form.

Another typology reflects on the daily ritual of eating, tasting food in communion, which brings families together around the table not only to eat but also to share how their day has gone, listen to one another, and strengthen emotional ties. This typology attempts to create moments in which humans, through food, share experiences and communicate with others while simultaneously satisfying their own biological and social needs.

The third situation consists of exhibitions in which the artist allows the process of deterioration to be a

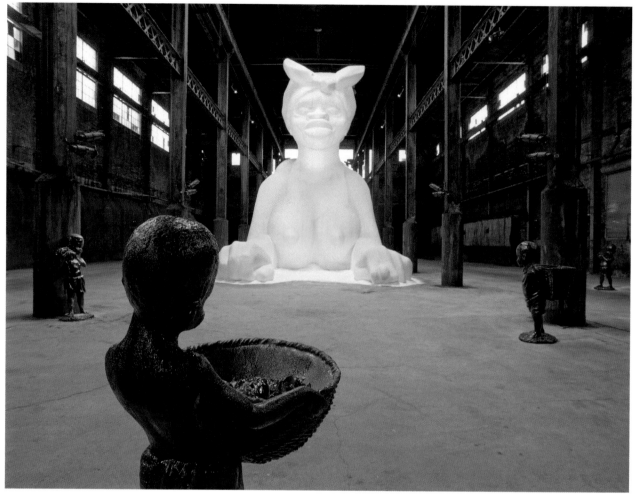

Figure 2.3 Kara Walker (American, b. 1969), *A Subtlety, or the Marvelous Sugar Baby, an Homage to the unpaid and overworked Artisans who have refined our Sweet tastes from the cane fields to the Kitchens of the New World on the Occasion of the demolition of the Domino Sugar Refining Plant*, 2014. Polystyrene sphinx coated with thirty-five tons of sugar, approx. 10.8 × 7.9 × 23 m. Installation view, Domino Sugar Refinery, Williamsburg, Brooklyn, 2014. Photo: Jason Wyche, courtesy Creative Time, © 2014 Kara Walker

fundamental part of the experience. The objects displayed will not only communicate with the visitor through their sense of vision; smell will likely play an important role as well. These foods have a limited shelf life if they are not consumed, but in art their usefulness is extended through decomposition.

Each of these typologies corresponds to the action or the function that the artist wants the food to fulfill, and each of them asks the audience for a specific (re)action that reinforces the intention behind the choice. Consequently, any one of these works presents a challenge to the viewer—and to the conservator—through smell, vision, presentation, and the actions taking place around them.

CASE STUDIES

To put forward just one example, a great number of artworks use chocolate as a raw material. Three case studies are discussed here, each representing one of the typologies described above: Sonja Alhäuser's *Braunes Bad V* (Brown Bath V, 2009/2015, fig. 2.4), Laurent Moriceau's *Found and Lost #1* (2003, fig. 2.5), and Janine Antoni's *Lick and Lather* (1993, fig. 2.6). All three are made with edible milk chocolate. All three are portraits of the artists. But they differ by period, size, and above all function.

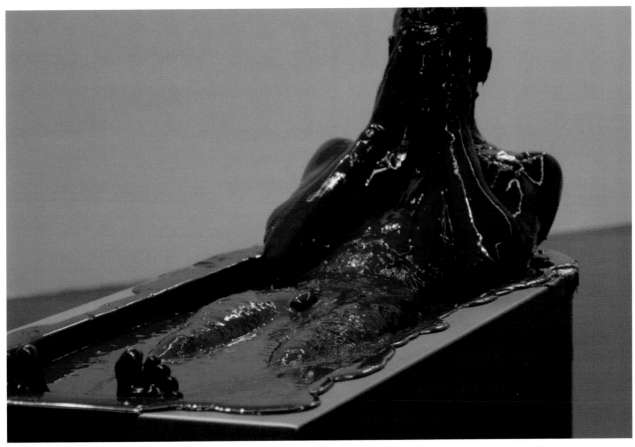

Figure 2.4 Sonja Alhäuser (German, b. 1969), *Braunes Bad V* (Brown Bath V), 2009/2015. Stainless steel tub, chocolate, temperature control function, and artist action, tub: 60 × 160 × 80 cm. Installation view, *Black Box*, Lehmbruck Museum, Duisburg, Germany, 2015. © 2021 Artists Rights Society Society (ARS), New York / VG Bild-Kunst, Bonn. Photo: Alex Heide, Braunschweig, @sonja-alhaeuser.de

Figure 2.5 Laurent Moriceau (French, b. 1964), *Found and Lost #1*, 2003. Chocolate, 169 × 51 × 23 cm. Installation/performance view, Palais de Tokyo, Paris. Photo: Laurent Moriceau

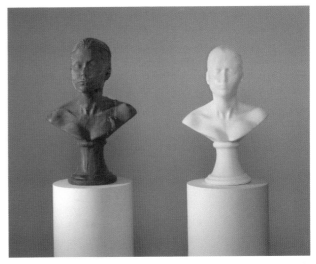

Figure 2.6 Janine Antoni (American, b. 1964), *Lick and Lather*, 1993. One licked chocolate self-portrait bust and one washed soap self-portrait bust on pedestals, edition of 7 + 2 APs + TP, busts: approx. 61 × 40.6 × 33 cm each; pedestals: 116 × 40.6 × 40.6 cm each. Collection of Carla Emil and Rich Silverstein and the San Francisco Museum of Modern Art. Photo: © Janine Antoni, courtesy the artist and Luhring Augustine, New York

Alhäuser exemplifies the first typology described above. Her work promotes the culture of communion and often involves sculptures and installations made with different edible items, including chocolate, to smell, taste, feel, and eat. Many of Alhäuser's works not only promise pleasure in the traditional sense but also provide the taste buds with a direct, immediate pleasure (Schultz n.d.). *Braunes Bad V* takes the viewer by surprise. Nothing suggests opulence more than those banquets where one sees a fountain of endless chocolate for dipping fruit. This work is a fantasy brought to life, the dream of any chocolate addict, from the smell upon entering, to the possibility of tasting it as part of the experience that Alhäuser promotes.

Found and Lost #1 portrays Moriceau himself in three different mediums: bars of soap, lollipops, and a life-size version in chocolate. At first, the project seems to be a set of self-portraits. But each one of these propositions creates multiple dialogues, a set of approaches that address not only the relationships between audience and artist and between audience and artwork, but also the artist's sensual approach to the body of the viewer (Taddei 2009). Each one presents a "communion" of the artist's body with visitors. Moriceau as executioner smiles as he distributes and redistributes his body, sacrificing himself, one might say, so others may taste. Here audience participation—not only as observers but also as "cannibals"—is necessary for the work to make sense.

Antoni's *Lick and Lather* began with a mold of the artist's own head that was used to cast seven iterations with soap and seven with chocolate. These self-portrait busts observe us in a challenging manner, like bishops on a chessboard, but we cannot eat them or touch them; we can only observe them and witness their transformation over the years. Antoni uses the soap bust to wash her body, and she licks the surface of the chocolate bust with each encounter. She has specifically prohibited these actions from being undertaken by anyone but her.

What these examples demonstrate is that, although they might appear similar in form and rendered in a common material, each artist expects the public to react and interact in a specific and different way. So, as the conservator, how does one know what to do? In which cases is it valid to conserve the works, and in which cases not? In which cases should they be allowed to deteriorate and in which cases should they be remade, changed, or replaced so they will continue to fulfill their assigned function?

Based on the foregoing typologies, the next step would be to assess what percentage of the work is composed of organic matter and what one is expected to do with it. Only

when work is meant to be *observed*—the organic matter is the work itself and cannot be replaced in the event of deterioration—must the work be conserved through preventive measures, perhaps by storage in a climate-controlled room or case. Or, if the artist so agrees, it can be intervened in with materials appropriate for its preservation.

In the other two cases (consumption or replacement) the organic materials present are expected to fulfill a specific task within the exhibition. In other words, if the work is made to be eaten, then the museum or gallery will allow it to be consumed. In the case of Moriceau, the work was produced for the opening of an exhibition, and once distributed, there would be nothing left of it, only a record of the action and the experiences of the visitors. The work will not be repeated until the artist decides to do so.

There are several ways to resolve the matter of replacement. It can be when the artist is planning a new exhibition, or it might be periodic and/or continual. When replacing organic materials, questions arise as to the appropriate person to do so, how it should be done, when should it be done, and why should it be done. It should not be done if these questions have not been answered or if one lacks a deep knowledge of the artist's intention and the various meanings of the work.

PROGRAMMED OBSOLESCENCE

Material replacement can be a systematic modification regulated by the artist, who dictates the intervals for replacement, its parameters, and the reasons for doing so. In some cases, the system or protocol to be followed confirms that replacement should be continual; otherwise, the installation will cease to function. Merriam-Webster defines obsolescence as the process of becoming obsolete or the condition of being nearly obsolete. Therefore, we are dealing not only with obsolescence, but also with programmed obsolescence, as in, "a business strategy in which obsolescence (the process of becoming obsolete, that is, no longer fashionable or no longer usable) of a product is planned and built into it from its conception" (*The Economist* 2009).

The concept of programmed obsolescence arose in 1920, when businesspeople from different light bulb manufacturers decided to regulate the characteristics of a commercial light bulb: its electrical resistance, materials, and life span. At the time, it was normal for light bulbs to last for fifteen hundred to two thousand hours. But the Phoebus cartel, as it would afterward be called, determined that it would be more profitable for the light

bulb market if they did not last that long, and the limit was newly set at one thousand hours. Even today there are regulations around how many hours a light bulb should function.

There are many reasons why an object can become obsolete, even several ways of classifying it. John Ippolito and Richard Rinehart (Ippolito and Rinehart 2014) state that technology, institutions, and legislation can be the causes of producing obsolescence, referring to new media and social artworks. Another classification system, based on economic processes, can depend on an item's quality (because it has defects or a malfunction), on desire (new styles or fashion on the market), or on the item's function if it is no longer useful and needs to be replaced. We will focus on this last classification: programmed obsolescence based on function.

Joseph Beuys's *Capri Battery* (1985, fig. 2.7), a light bulb with a plug socket and a lemon, summons the bright Mediterranean sun, and relates to the artist's interests in energy, warmth, and the environment. This artwork is peculiar for several reasons. Beuys required that when it is exhibited, the lemons may come only from the island of Capri, Italy, because he felt they are the best, and because they could fulfill the essential requirement of form and function in an exhibition of one thousand hours. With each presentation, a new lemon is procured so the work will function properly. The citric acid in the lemon contains an electrolyte that can conduct electricity, such that it is essentially an electrochemical battery. Once a thousand hours have elapsed, the lemon ceases to fulfill the function that was assigned to it and needs to be replaced, which is clearly comparable with the previously defined concept of programmed obsolescence.

A similar case is Víctor Grippo, an Argentinian artist who, in the 1970s, created a series of works that deal in traditionally opposing binaries such as art versus science, nature versus culture, and real versus artificial, such that they evidence the basic processes of cooperation, production, and consumption and reflect on the city-versus-country duality. The works are related to conceptual art and utilize organic materials such as potatoes and bread. His best-known works from that period are *Analogía I* (Analogy I, 1970–71, fig. 2.8), *Analogía IV* (1972), *Algunos oficios* (Some Jobs or Some Trades, 1976), *Valijita de panadero* (Small Bread Maker's Suitcase, 1977), and *Tabla* (Table, 1978) (MALBA 2012). In these artworks, a voltmeter makes evident that potatoes carry energy. What is interesting about these installations is that their organic components must be replaced when the energy is exhausted. That is, the potatoes as batteries must be

Figure 2.7 Joseph Beuys (German, 1921–1986), *Capri Battery*, 1985. Light bulb with plug socket and lemon, 8 × 11 × 6 cm. Broad Museum Foundation. © 2021 Artists Rights Society Society (ARS), New York / VG Bild-Kunst, Bonn

replaced by others with similar characteristics every so often for the artwork to continue to function.

Giovanni Anselmo's *Untitled (Sculpture That Eats)* (1968) is also a work of this type. In this case, it is essential to change the romaine lettuce leaf on the granite monolith about every week, before it rots or dries up, because the artistic intent is to suggest that this sculpture needs food to exist.

Felix Gonzalez-Torres's candy works are another example where understanding the reasons behind the artist's rules for how the work should exist and function is key. This may permit us to identify in them a few elements related to programmed obsolescence, since there are certain preestablished guidelines, such as the type of candy to be used in *"Untitled" (A Corner of Baci)* (1990). The work—an accumulation of Baci Perugina chocolates, which have a specific shiny wrapping—converts a pile of chocolates into a recognized work attributed to this author. Visitors to the museum or gallery are invited to take away a candy and eat it later. The weight, disposition, location, and replenishment rate of the pile of candies may vary as an exhibition progresses, but only within certain set parameters. The candy works of Gonzalez-Torres have some aspects that must always be the same, but also various malleable aspects whose performativity, if you will, makes them unique and unrepeatable. We must be careful, since previous research as well as the intention of the artist are fundamental to understanding when, how, and in what way the concept of programmed obsolescence plays into decisions on the conservation and restoration of a particular work.

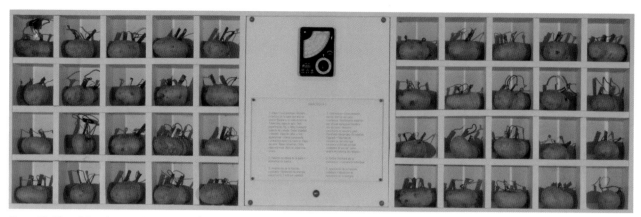

Figure 2.8 Víctor Grippo (Argentinian, 1936–2002), *Analogía I* (Analogy I), 1970–71. Potatoes, painted wood, electrical connectors, voltmeter, and text, 47.4 × 153 × 10 cm. Museo Nacional de Bellas Artes, Buenos Aires, gift of Fundación Antorchas. Photo: © and courtesy the Museo Nacional de Bellas Artes

CONCLUSIONS

The concept of programmed obsolescence is present in some Eat Art installations, and understanding it facilitates the conservation approach to take. We must recognize when the artist has the intention of replacing edible material for the artwork to function, versus when the artist desires the deterioration or other transformation of the materials.

In the case of installations in which the artist has the intention of replacing edible material for the artwork to function, it should be understood that the ephemeral elements are the guiding principle and that, without systematic replacement, the work will no longer exist as intended. But replacement or substitution must take into account the considerations specified or suggested by the artist so that the modifications do not alter the meaning or diminish the work's ability to fulfill the artist's intention.

These kinds of installations question the role of the conservator and call for study toward a full comprehension of their intentions and meanings. The concept of programmed obsolescence may be inherent in them, so understanding if their function is affected by the deterioration of the edible materials will help us prevent the installations from actually becoming obsolete.

BIBLIOGRAPHY

Buskirk 2003
Buskirk, Martha. 2003. *The Contingent Object of Contemporary Art.* Cambridge, MA: MIT Press.

Hummelen 1999
Hummelen, IJsbrand. 1999. "Decision-Making Model for the Conservation and Restoration of Modern Art." In *Modern Art: Who Cares? An Interdisciplinary Research Project and an International Symposium on the Conservation of Modern and Contemporary Art,* edited by IJsbrand Hummelen, Dionne Sillé, and Marjan Zijlmans, 4–18. Amsterdam: Foundation for the Conservation of Modern Art.

Ippolito and Rinehart 2014
Ippolito, John, and Richard Rinehart. 2014. *Re-collection: Art, New Media, and Social Memory.* Cambridge, MA: MIT Press.

MALBA 2012
MALBA. 2012. "Víctor Grippo: Homenaje." https://malba.org.ar/evento/victor-grippo-homenaje/.

Novero 2010
Novero, Cecilia. 2010. *Antidiets of the Avant-Garde: From Futurist Cooking to Eat Art.* Minneapolis: University of Minnesota Press.

Salabert 2004
Salabert, Pere. 2004. *La redención de la carne, hastío del alma y elogio de la pudrición.* Murcia, Spain: Editorial Centro de Documentación y Estudios Avanzados del Arte Contemporáneo (CENDEAC).

Schultz n.d.
Schultz, Michael. n.d. "Sonja Alhäuser." https://www.schultzberlin.com/de/sonja-alh%C3%A4user.

Taddei 2009
Taddei, Jean-François. 2009. *Les Perméables = The Permeables.* Paris: MeMo.

***The Economist* 2009**
The Economist. 2009. "Planned Obsolescence." March 23, 2009, https://www.economist.com/news/2009/03/23/planned-obsolescence.

The Artist's Body in the Age of Genomic Reproduction

Barbara Ursula Oettl

As soon as the reprogramming of human cell material became the state of the art, artists made use of this possibility, investigating its implications for humankind. And as biological substances such as blood, flesh, and DNA found their way into the art context, they caused unprecedented problems, demanding unconventional conservation approaches as well as innovative handling toward their care and preservation within the white cube. The British artist Marc Quinn and the French performance artist ORLAN's collaborations with the Tissue Culture & Art Project in some ways exemplify this material turn in art, and raise ethical, legal, as well as conservational questions through their art production.

◆ ◆ ◆

Curating the living—be it flora, fauna, or the human—has always held risks. Edward Steichen's *Delphiniums* (1936) is a good early example of the application of traditional and new chemical influences to established breeding methods for plants, such as selection and hybridization, toward the creation of a work intended as art. The *Delphiniums*, on display in vases, withered away after a week on view at New York's Museum of Modern Art. To this day, the latest scientific standard of knowledge is unable to completely prevent the living from growing, changing, aging, or dying while on view in a museum setting. With living art, one can never be entirely sure what to expect, which at best is part of the experience, but is hard to accept for many people involved in creating displays of such art: curators, visitors, artists, and last but not least the art itself, especially if we are talking about art that is alive.

One work of art that could not be hindered from not prospering at all, indeed from withering away, was a restaging of Hans Haacke's *Grass Grows* (1969). When the grass refused to grow in the freshly sown earthwork presented in a Land art retrospective at the Haus der Kunst in Munich, it was not favorably received by the public. At the turn of the millennium, the press released pictures of the artist Eduardo Kac holding his transgenic creation *GFP Bunny Alba* (2000), a bioluminescent rabbit, but the French laboratory where the genetically altered animal was bred ultimately refused to hand the never-to-become-domestic pet over to the artist. And during *dOCUMENTA (13)* in Kassel, Germany, in 2012, two artists had to deal with partly unwanted outcomes of their works in public space: the butterflies Kristina Buch had released in a little patch of garden for her installation *The Lover* escaped into freedom as intended by the artist, never to be seen again by visitors, and the beehives that Pierre Huyghe had brought to his artificially created biotope *Untilled* had to be replaced twice when the colony died out.

These things happen. But instead of trying to prevent them, or criticizing the museum, the curators, or the art when they do, it should be understood that such glitches may be an essential side effect of living artworks. Indeed, there is a need to understand how and why art that is alive should have all the same privileges and disadvantages as the living beings who come to visit it. A living exhibit may prosper or wither, and both might be absolutely appropriate for the work of art and its significance. In the foreseeable future this may no longer hold true, as the various sources of error may be eradicated by the latest discoveries in medicine and biotechnology. What if the flaws of the living are one day eliminated by achievements in scientific research?

In 2012 the Japanese cell researcher Shinya Yamanaka and the British biologist John B. Gurdon received the Nobel Prize for their successful reprogramming of human cellular material. Reducing a cell to its original status of pluripotency is desirable in a medical context, as only a not-yet-specified cell has the ability to develop into almost any other cell type in an organism. The baseline in a medical and also in an artistic context is that whatever holds a complete set of DNA is able to reproduce that set of DNA. A layperson cannot be expected to understand the quintessential forebodings held within the groundbreaking potential of this discovery. But maybe art can enlighten in this case. This essay will demonstrate how and why bioartists are addressing the riddles of human life and death, and how to offer these insights to the public in a well-curated frame. After all, one thing is clear: by passing down their complete DNA and forcing us (curators, conservators, visitors, art historians) to make existential decisions about life and death, artists raise ethical and legal questions regarding who we are—and for how long.

Bioartists operate at the interface between medicine, biology, and informatics. The knowledge and techniques that have become available to the biotechnological sciences are now available to fine artists as well. What the two disciplines—science and art—disagree on is less bioscientific methodologies than the motivation in applying them. The fine arts can offer ways to articulate questions and confront both scientists and the public with provocative statements on biotechnological accomplishments and biopolitical power. Such artists have devoted themselves to suggesting what consequences are to be expected in the face of a constantly shifting and modifiable *conditio humana* that has been downgraded to a mere information pool on growth, health, biological functions, age, and disease.

Walter Benjamin's much-discussed essay on the aura of an artwork that is reproduced (Benjamin [1935] 2006) enters its next round with these case studies on artists who hint at the potential to hybridize and clone the human body with the (un)predictable prospect of releasing their personae into the future, into the age of the genomic reproduction of the artist's body.

MARC QUINN

The British artist Marc Quinn is widely known for his series *Self*, portraits cast from his own blood. Beginning in 1991 and every five years thereafter, Quinn has produced a new version (fig. 3.1). In order to obtain the material for this sculptural piece, the artist collects four and a half liters of his own blood. It goes without saying that this artwork cannot survive in a typical museum storage or display context; it is coated with silicone and needs to be kept at a constant temperature of -18°C. The cast is housed in a transparent cabinet positioned on a custom-built cooling device made of stainless steel.

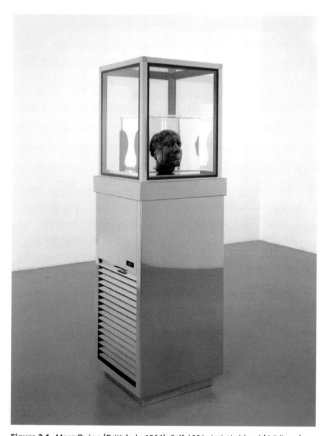

Figure 3.1 Marc Quinn (British, b. 1964), *Self*, 1991. Artist's blood (4.5 liters), stainless steel, Perspex, and refrigeration equipment, 63 × 208 × 63 cm. Photo: Courtesy the artist

It took several incarnations of *Self* before Quinn developed a technique to hold it in a state of permanent frozen equilibrium. The first cast needed to be re-modeled four times. In the first attempts, Quinn cast the head directly from the mold and put it into a showcase at -18°C. But since the vulnerable sculpture had not received a coating, the air caused the water content in the blood to rise to the surface of the cast and down toward the coolest area of the case—the bottom. This disintegration of *Self* prompted the next iteration to be sealed with a transparent silicone skin. But this solution did not last long; over time, little holes developed in the silicone, through which the blood that had started to coagulate showed. This mishap was successfully corrected by immersing the blood head in liquid silicone cooled to -18°C (Self 2009, 7).

Today, different versions of *Self* are in collections all over the globe. When in 2009 the Foundation Beyeler in Basel, Switzerland, organized a retrospective of the artist's oeuvre, four of Quinn's *Selfs* were flown to Switzerland, creating for a brief moment, with the addition of the artist, a quasi-identical-quintuplet scenario.[1] Unfortunately, the changing air pressure in the airplane's cargo hold compromised the seals within the cabinets, which caused condensation on the glass. This problem has now been solved by heating the panes to counteract the cooling system for the heads and thus provide a clear vista on both sides. Unless any of these devices is unplugged, the *Selfs* can be displayed in museum settings as intended, indefinitely. And as the casts hold the artist's complete genetic information, possibly he will outlive every single one of us.

It is worth noting that in 2001 Quinn made another interesting work from his own bodily components, *Cloned DNA Self Portrait 26.09.01* (fig. 3.2). By using standard biotechnological methods of cloning, the artist's DNA was extracted, replicated, and framed in a transparent colony of bacteria to keep it alive (Quinn 2007, 309). In the age of a possible genetic reprogramming of unipotent cells such as blood and sperm, his cloning options are infinite.

ORLAN

The French multimedia artist ORLAN is taking this concept even further. ORLAN has radicalized body art with her long-term performance *La Ré-Incarnation de Sainte ORLAN*. From 1990 to 1993, ORLAN underwent nine "surgical manipulations" (Bouchard 2010, 63) that included skin transplant, liposuction, facial surgery, and the reshaping of her flesh and bones. During these procedures, ORLAN only received local anesthesia, which allowed her to respond to

Figure 3.2 Marc Quinn (British, b. 1964), *Cloned DNA Self Portrait 26.09.01*, 2001. Stainless steel, polycarbonate agar jelly, bacteria colony, and human DNA, 26.2 × 20.5 × 2.7 cm. Photo: Courtesy the artist

audience questions sent by fax or videoconference, provided she was not prevented from speaking by surgical necessities (fig. 3.3). From these performances, she created recordings, videotapes, and even relics of biological material (10 grams of her flesh apiece) for sale on the art market. The vials and reliquaries contain her blood, fat, and tissue. All the products are certified by ORLAN's signature and the following inscription: "This is my body, this is my software" (fig. 3.4).

ORLAN's live performative oeuvre has been personally witnessed by an exceedingly small number of spectators. However, it is possible to access the testimony of her performances. According to Jens Hauser, there are three possibilities to collect, preserve, and exhibit ephemeral art practices in the gallery space: there is the initial spark of the live performance; there are documents that remind the viewer of what and how it happened such as photographs, videos, and sketches; and there are the physical remains of the processes that allow the contemporary visitor to trace back the events on a physical level (Hauser 2008, 91–92). ORLAN's oeuvre includes all of these options. From a conservation viewpoint, her once-living materials pose

Figure 3.3 ORLAN (French, b. 1947), *Omniprésence*, the seventh surgery-performance in the series *La Ré-Incarnation de Sainte ORLAN*, New York, 1993. Cibachrome print in Diasec mount, 165.1 × 109.2 cm. Photo: Courtesy the artist

Figure 3.4 ORLAN (French, b. 1947), *Small Reliquary: My Flesh, the Text, and Language* (English text), no. 11, 1993. Soldered metal, burglar-proof glass, and 10 grams of ORLAN's flesh preserved in resin, 30.5 × 30.5 × 5.1 cm. Photo: Courtesy the artist

Figure 3.5 ORLAN (French, b. 1947), *The Harlequin's Coat*, 2007–8. Bioreactor, biopsies of human flesh, and petri dishes. Installation view at *sk-interfaces*, Foundation for Art and Creative Technology (FACT), Liverpool, England, 2008. Photo: Courtesy the artist

particularly pressing questions regarding their safekeeping. For secure preservation of this material, the biopsies are sustained in resin, and the collectibility of the relics is guaranteed by their welded, burglar-proof receptacles. In the case whereby an art museum accepts ORLAN's last will—to exhibit her body after her death—it would not be acting any differently than a museum of natural history exhibiting medical and histological preparations, or than churchgoers adoring the human remains of saints and martyrs. With her relics, ORLAN

takes the measure of physical possibilities to convey her post-mortal persona.

In recent years ORLAN has begun to refine the methods and options of her reincarnation, including exploring the co-culturing and fusion of human and nonhuman cells and tissue. Her first project using biotechnology and the living matter of others is *The Harlequin's Coat* (2007–8, fig. 3.5). The idea was to hybridize skin tissue of various ethnicities (white and Black) and other species (marsupial and bovine) with her own skin cells (ORLAN 2010, 116–17). These were shown intermingling in vitro in constantly moving petri dishes that were attached to the back of a Harlequin's gown.[2] But the impure cell-bastard did not morph infinitely: "Of course, all the cells or bacteria are dead."[3]

The current state of science does not allow for complete transendence of the mortal body—in other words, eternal

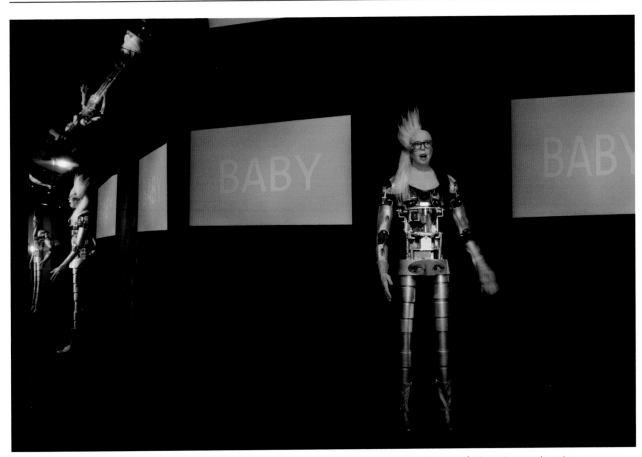

Figure 3.6 ORLAN (French, b. 1947), *ORLANoid*, 2018. C3I-robot (command-control-communication-intelligence system). Photo: Courtesy the artist

life. Future knowledge and insights will continue to illuminate the healed, modified, transformed, hybridable, exchangeable, and maybe someday-obsolete body. Just like science, ORLAN is struggling "against the innate, the inexorable, the programmed, Nature, DNA (which is our direct rival as artists of representation), and God!" (ORLAN 1998, 325). ORLAN has made many attempts to outpace science, to outlive the body, and to keep the audience in literal touch with her tissue, cells, and flesh within the museum setting. For the moment she has stored new stem cells and tissue and bacteria cultures at the Institut Pasteur in Paris, where they are kept in a freezer at -80°C.

When the time is right, her cells might fuse with *ORLANoid* (2018, fig. 3.6), her look-alike robot, thus extending ORLAN's body by means of electronically and digitally encoded information. Currently, the *ORLANoid* is capable of deep learning and has the ability to react and interact through language skills, giving it artificial, collective, and social intelligence. To remain on the safe side—legally, biotechnically, curatorially, and concerning problems of eventual contagion—ORLAN is working hand in hand with professionals such as the Tissue Culture & Art Project.[4]

THE TISSUE CULTURE & ART PROJECT

The formation of the artistic collective the Tissue Culture & Art Project (TC&A Project) in 1996 led in turn to the foundation of the collective's current workplace, the Art & Science Collaborative Research Laboratory (aka SymbioticA), situated at the School of Anatomy and Human Biology at the University of Western Australia, Perth, and at the Tissue Engineering and Organ Fabrication Laboratory at Massachusetts General Hospital / Harvard Medical School.[5] SymbioticA was the first institution in the world to offer artists and researchers the possibility to engage in wet biology by using tissue engineering and biotechnological tools within the surroundings of a research laboratory at a university science department. Its output is thus far dedicated to widening scientific and humanistic perspectives, particularly in the fields of bioengineering and transgenics, and producing art at the intersection of bio (nature) and tècne (art, science, and technology). SymbioticA functions as the home base for TC&A Project and has developed and applied tissue culture and tissue engineering methods to create so-called semi-living sculptures (fig. 3.7). These artworks shed light on

humanity's relationship and behavior toward partially living systems—a new category of yet-unclassified object-subjects. So far, no rights or status have been given to these semi-living organisms; they are a no-man's-land in terms of biological, legal, and ethical valuations and judgments. The production, mutation, and hybridization of the living with the nonliving and the human with the nonhuman remains a scientific and ethical balancing act.

Figure 3.7 The Tissue Culture & Art Project (hosted @ SymbioticA, School of Human Sciences, the University of Western Australia) (founded 1996, Australia), *A Semi-Living Worry Doll H*, 2000. McCoy cell line, biodegradable/bioabsorbable polymers, and surgical sutures, 2 × 1.5 × 1 cm. Photo: Courtesy the artists

Wherever it goes, semi-living art is in need of a sterile environment, as its crucial vulnerability is the lack of an immune system. Thus, TC&A Project provides museums and galleries with the necessary equipment and instructions to maintain the works. In order to protect the semi-living from its surroundings, a fully functional laboratory is an integral part of any exhibition (fig. 3.8). This involves an enclosed environment at bio-safety-level 1 provided by a sterile hood for the bioreactor.[6] In addition, the cells must be fed on a daily basis with specific nutrients

and biological agents, which in turn produce waste that needs to be removed (Catts and Zurr 2002, 367; Catts and Zurr 2003, 5–6). All these tasks are either performed by the artists or carried out by museum staff, in the latter case transforming the curators into their literal definition as caregivers.

The constitutional guarantee of scientific and artistic freedom covers not only the work produced but also the effect the work produces. The effect of living art in turn generates *affect* in the viewer, resulting in socially and ethically motivated questions such as: Of what exactly does the semi-living consist? Is it alive and sentient? To whom does it belong? On a purely legal level, these questions are framed by the laws that allow tissue culturing under certain requirements and are complied with by the artists involved. There is no property right over body tissue. Research, manipulation, growth, and mutation of human cell and tissue material is allowed unless it is done before the sixteenth division of a totipotent (embryonic) cell. This is valid in the United States and most European countries, but not Germany. For example, TC&A Project had to apply to the Human Ethics Committee of the University of Western Australia, which issued an executive decision stating that the animals, humans, and materials used in their projects be treated according to the ethical rules applied to scientists.[7]

Just like any other living system, semi-living organisms are doomed. When they are publicly placed in the gallery space and exposed to voluntary human touch, they are contaminated by the fungi and bacteria in the air or on people's hands and inevitably die.[8] The removal of the semi-living from their sterile environment at the end of the exhibition has come to be known as the killing ritual: "The Killing ritual also enhances the idea of the temporality of living art and the responsibility that lies on us (humans as creators) to decide and act upon their fate" (Catts and Zurr 2003, 6).[9]

CONCLUSION

All of the works of art discussed above—Marc Quinn's blood heads, ORLAN's hybridizations, and TC&A Project's semi-living works—have proven to be exhibitable, curatable, and, if needed, preservable in the museum space. The museums who host them face biological, medical, legal, and ethical challenges, to which enlightening and promising solutions have already been given by the mere existence of these works of art. The uncontrollability of the new materials used in contemporary art practices points to the need for an

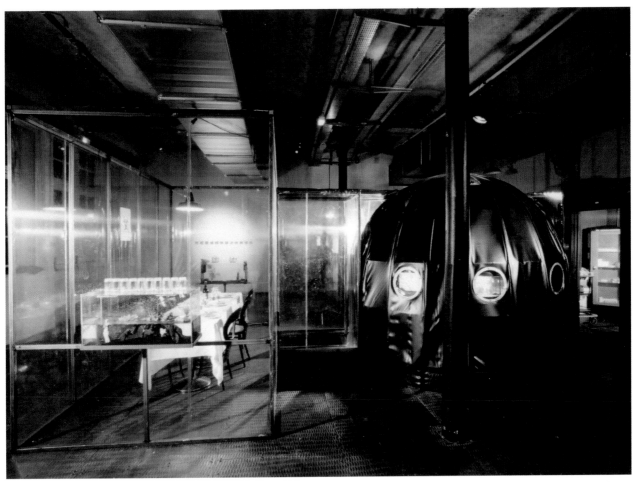

Figure 3.8 The Tissue Culture & Art Project (hosted @ SymbioticA, School of Human Sciences, the University of Western Australia) (founded 1996, Australia), bioreactor used for *Disembodied Cuisine Installation*. Installation view at *L'Art Biotech*, Nationalen Kunstzentrum Lieu Unique, Nantes, France, 2003. Photo: Axel Heise, courtesy the artists

extended catalog of vantage points to evaluate the proper handling of such artworks. The work of art in the age of genomic reproduction (as Benjamin might put it)—the duplicated, multipliable, hybridizing, and presently still thriving artworks discussed above—certainly does not lack a peculiar, and quite particular, aura. The aura is on the rise, as the potential of growth is intrinsic to these works.

NOTES

1. Pun not intended but nice.

2. The work was presented with a custom-made bioreactor, marking the head of the larger-than-life model of the Harlequin that was indicated by colorful diamond shapes on the gown.

3. Author email correspondence with ORLAN, July 27, 2016.

4. ORLAN is also working with Sub'Biotech, the Higher Institute of Biotechnologies of Paris. Author email correspondence with ORLAN, July 27, 2016.

5. The founding members were Oron Catts and Ionat Zurr; from 1999 to 2003 Guy Ben-Ary became part of the collective.

6. At bio-safety-level 1 (BSL-1), only well-characterized agents with minimal hazards to humans and the environment are in use. That's why the precautions are on a low level, consisting of washing hands, decontaminating potentially infectious agents before disposal, and a lockable door, providing limited access. BSL-1 labs do not have to be isolated from the general site. The ease and safety of maintaining such a lab makes it suitable for schools or museums.

7. TC&A Project's pledge is registered at Human Ethics Committee, Research Ethics, Research Services, University of Western Australia, Project No. 0813, September 2003. As mentioned above, neither the cells nor the tissue culture possesses an agency or identity status and neither is yet biologically or culturally classified. This is why science and the arts are given unconstrained access and modus operandi concerning these objects.

8. That is, visitors may be invited to touch the semi-living voluntarily—this is not exclusively the purview of museum workers.

9. This decision is for practical reasons, as the semi-living is not allowed to travel or cross borders and usually no one is willing to adopt it. For those feeling guilty about euthanasia, TC&A Project has developed the *De-Victimizer* (2006), a kit with instructions to build a bioreactor in which to keep the semi-living alive.

BIBLIOGRAPHY

Benjamin [1935] 2006
Benjamin, Walter. (1935) 2006. *Das Kunstwerk im Zeitalter seiner technischen Reproduzierbarkeit = The Work of Art in the Age of Mechanical Reproduction*. Frankfurt am Main: Suhrkamp.

Bouchard 2010
Bouchard, Gianna. 2010. "ORLAN Anatomized." In *ORLAN: A Hybrid Body of Artworks*, edited by Simon Donger, Simon Shepard, and ORLAN, 62–72. London and New York: Routledge.

Catts and Zurr 2002
Catts, Oron, and Ionat Zurr. 2002. "Growing Semi-Living Sculptures: The Tissue Culture & Art Project." *Leonardo* 35 (4): 365–70. http://www.tca.uwa.edu.au/atGlance/pubMainFrames.html.

Catts and Zurr 2003
Catts, Oron, and Ionat Zurr. 2003. "Are the Semi-Living Semi-Good or Semi-Evil?" *technoetic arts—an international journal of speculative research*, no. 1, 1–12. http://www.tca.uwa.edu.au/atGlance/pubMainFrames.html.

Hauser 2008
Hauser, Jens. 2008. "Observations on an Art of Growing Interest: Toward a Phenomenological Approach to Art Involving Biotechnology." In *Tactical Biopolitics: Art, Activism, and Technoscience*, edited by Beatriz Da Costa and Kavita Philip, 83–103. Cambridge, MA: MIT Press.

ORLAN 1998
ORLAN. 1998. "Intervention" (1995). In *The Ends of Performance*, edited by Peggy Phelan and Jill Lane, 315–27. New York: New York University Press.

ORLAN 2010
ORLAN. 2010. "The Poetics and Politics of the Face-To-Face." In *ORLAN: A Hybrid Body of Artworks*, edited by Simon Donger, Simon Shepard, and ORLAN, 103–18. London and New York: Routledge.

Quinn 2007
Quinn, Marc. 2007. "Genomic Portrait." In *Signs of Life: Bio Art and Beyond*, edited by Eduardo Kac, 309–11. Cambridge, MA: MIT Press.

Self 2009
Self, Will. 2009. "Bring Me the Head of Marc Quinn!" http://marcquinn.com/assets/downloads/Bring_me_the_Head_of_Marc_Quinn_Will_Self_FULL.pdf.

The Eternal Metabolic Network: Fluxus, Food, and Ecofeminism

Natilee Harren

Connecting the disciplines of contemporary art history and conservation, this essay explores how living-matter artworks produced by the 1960s neo-avant-garde Fluxus collective have generated an "eternal metabolic network" in which conservators and curators are enlisted in a program of permanent creation alongside the artists. The chemical processes that ostensibly degrade the work of art in fact sustain organic life, enriching the work's conceptual value while engaging a shifting array of collaborators in its ongoing care. Special attention is given to food-related works by Fluxus artist Alison Knowles, discussed in relation to the ethics of ecofeminism and to contemporary artworks by Jae Rhim Lee, Anicka Yi, Kelly Kleinschrodt, and Emily Peacock.

◆　　◆　　◆

In 1978 Fluxus artist Alison Knowles (b. 1933) assembled the boxed edition *Bean Bag*, one among numerous works she has created involving a favorite food material, dried beans (fig. 4.1). Not long after, the small collection of legumes and related ephemera unexpectedly became the object of nonhuman consumption by attracting mites, leading the artist to send notes to collectors instructing them to place the work's bean-filled cloth bag in a freezer for two days in order to exterminate the insects. Knowles's charming letter argues that the infestation effectively enhances the work of art, now made "lively," "self-devouring," and "mighty" (pun intended) by having incorporated "a life and death cycle" into its materials and process of creation (fig. 4.2). Seen through this episode, *Bean Bag* instructively orients us to the international Fluxus collective's other, more ephemeral engagements with food, such as curated feasts, collaborative cooking

experiments, and interactive and edible multiples. Food was embraced as an artistic material by many Fluxus affiliates, including George Maciunas, Benjamin Patterson, Takako Saito, Daniel Spoerri, Ben Vautier, and Robert Watts, with the full knowledge that it degrades, decays, and disappears as it is consumed by those who eat it or simply by time and the elements (Higgins 2011).

Linking the disciplines of contemporary art history and conservation, this essay speculatively explores how Fluxus artworks generate an "eternal metabolic network" in which conservators and curators are enlisted in a program of permanent creation alongside and in the wake of the artist.[1] Following from the pioneering work of Knowles and connecting it with discourses of ecofeminism and the Anthropocene, one can draw an art historical vector to contemporary art practices involving food and other biological materials as poignant means of addressing

Figure 4.1 Alison Knowles (American, b. 1933), *Bean Bag*, 1978. Box containing dried beans, gelatin silver print, and printed bag containing objects in various media, closed: 14 × 13.3 × 13.3 cm. Published by Printed Editions, New York. Photo: Gilbert and Lila Silverman Fluxus Collection Gift, Museum of Modern Art, New York, 3749.2008, © 2019 Alison Knowles

ALISON KNOWLES
122 SPRING ST.
NEW YORK, N. Y. 10012

March 19 '79

Dear Jean

This year past I made an edition of Bean Bags of which
you have one. Last week I got a letter from Anders Tornberg
who also has one. This lively work of art has become in fact,
self-devouring: . . small black mites are eating the beans.
(an art work lively AND mighty[mitey!]). Examining my editions
here I found mine had winged creatures as well. So, this is
what we shall do, and I hope you have a refrigerator with a
freezer. Take the cloth bean bag out of the green box and
put it into a plastic bag. Seal off the plastic bag and put
your bean bag into the freezer for two days. Your bean bag
has now been returned to its original state, the mites
frozen, and the art work itself inhanced by containing a
life and death cycle.
 ACT NOW. There's no time to waste. Otherwise I hope you
are enjoying your Bean Bag.
 Sincerely,

Figure 4.2 Alison Knowles (American, b. 1933), letter to Jean Brown about *Bean Bag*, March 19, 1979. Jean Brown papers, 1916–1995 (bulk 1958–1985), Getty Research Institute, Los Angeles (890164 and 2016.M.14). Photo: © 2019 Alison Knowles

humans' caring relationships to the environment, its objects, and one another. Such works engage an eternal metabolic network of nonhuman "living matter" in ways

that do not shy away from its inevitable transformation. The ever-unfolding chemical processes that ostensibly degrade the artwork as a static object in fact sustain organic life, thus enriching the artwork's conceptual value while enlisting a shifting array of collaborators in its ongoing care.

Adopting food as an artistic material was a direct means for Fluxus artists to approach their avant-garde goal of merging art with everyday life on the way to making art— or at least its qualities of preciousness and elitism— obsolete. In 1974 the Lithuanian American Fluxus artist George Maciunas, a leading organizer of the collective, gathered together all the empty packages from food items he had consumed over the past year and called it an artwork. The assemblage, *One Year* (1973–74), is now part of the permanent collection of the Museum of Modern Art, New York. According to Maciunas, the arranged towers of (now depleted) industrially processed consumer packaged goods—everything from rice pilaf and granola to cottage cheese, preserved strawberries, and instant dry milk— were deserving of aesthetic appreciation. Indeed, *One Year* is an impressive readymade in the post-Duchampian tradition, while its homage to everyday commercial design aligns with the aesthetic orientation of Pop. But *One Year* gestures beyond those immediately visible art historical affinities. As David Joselit has argued, food was for Fluxus artists the perfect "metabolic readymade" or "bio- readymade." As a (nearly) universally accessible and approachable material able to, in Joselit's words, "articulate the metabolism of life with the global circulation of commodities," Fluxus food objects cannily addressed the symbolic social body by passing through the actual body of the individual. "It was precisely by linking individual bodies—what might be called wetware—to the hardware of global markets that Maciunas opened an aesthetic paradigm in which organic flux was metabolized as art—as *Fluxus*" (Joselit 2013, 192, 196, 192).

Indeed, Fluxus art provides a theoretical object lesson in how to manage and bear material indeterminacy of all kinds, particularly in matters of curation and conservation (Harren 2016). This was brought home to me through my encounter in 2009 with Benjamin Patterson's *Hooked* (1980, see fig. 11.8 in this volume) in the Jean Brown papers of the Getty Research Institute. *Hooked* is a readymade consumer-grade fishing tackle box filled with dozens of small objects outfitted with hooks, all of them joke lures assembled by the artist. It also contains a can of sardines in tomato sauce—sustenance for the unlucky fisherman— which had corroded to the point of leaking when I called it up from storage during my research, unwittingly releasing its putrid stench throughout the GRI special collections

reading room. Quite literally in this case, organic flux had been metabolized as art. With advice from Patterson and GRI chief curator Marcia Reed, objects conservator Albrecht Gumlich devised a conservation solution that entailed carefully documenting the old can and adding in its stead a new reference can that had been emptied, sanitized, and refilled with a weight of plaster equivalent to its prior contents (Patlán 2010). Taken alone, neither the old (exploded, degraded) can, now represented by a printed image, nor the new (imposter) can, with its false contents, constitute a total solution. Only taken together do the cans adequately convey the material truth of the original object.

The provisionality of this solution—much enjoyed by the artist, who called it "Montazuma's [sic] revenge" on the museum—is philosophically rooted in Fluxus artists' general attitude and approach to objects, which draws on cultures of performance.[2] Foundational to historic Fluxus practice in the 1960s and 1970s was the format of the event score, typically a brief text written in colloquial language instructing the reader to make a gesture, object, or observation within their immediate environment. Centering their practice on scores composed to be interpreted by diverse performers and makers, Fluxus artists were groundbreaking in translating performance protocols into collaboratively produced, highly interactive art objects (Harren 2020). Accordingly, Fluxus output stands in an ever-curious relationship to institutions and disciplines, existing between art history, poetry, music, dance, and performance studies; between the unique object and the edition or multiple; and between the art museum's permanent collection and other special collections, libraries, and concert halls, as well as the public domain. Ephemerality and iterativity are fundamental to the ontology of the Fluxus work. At the same time, the score as a technology of performance inscription and reanimation carries with it a long history and culture of preserving artistic intent. Fluxus artworks produce an eternally evolving system that toggles between abstract instructions (scores, notations) and substantive materials (often ephemeral, unstable, biological), necessitating a rethinking of conventional approaches to conservation in order to better honor and even embrace their essential qualities of change (Hölling 2015; Hölling 2017).

Fluxus offers ethical case studies and useful models for curators and conservators thinking through a broad array of subsequent contemporary art practices wherein the preservation of an aesthetic concept requires de-privileging specific original materials and embracing processes of transformation and even decay. The putrefying elements of Patterson's Hooked present an extreme conservation problem, one seemingly opposite the conceptual, text-based, more readily enduring format of the Fluxus event score. Indeed, Fluxus scores have received scholarly attention for modeling an artwork that lives on precisely because of its acceptance of change through varying interpretations, thereby de-fetishizing the work of art as a unique, original, authentic, materially fixed entity. In comparison, the collective's provisional food objects present a complementary tactic, albeit in more material terms. As Joselit writes, "Fluxus stages an art of witnessing: It testifies to the thin line between organic stuff (i.e., food) and human consciousness and sociality, and it marks the fragile border between life and its expiration as shit" (Joselit 2013, 200). By reminding us that all works of art are to some degree transitory, Fluxus engagements with food orient our attention to the ongoing, collaborative labor of caregiving that artworks engender.

In addition to calling to mind global commodity networks, as Joselit posits, Fluxus work with food illuminates the intersections of feminist and environmentalist concerns. Among Fluxus artists, Knowles, with her elevation of everyday objects and gestures, including domestic and caregiving activities related to food, was especially successful in trans-valuing the minor into something precious and worth honoring through care (Robinson 2004; Woods 2014). Her score *Proposition #2 (Make a Salad)* (1962, fig. 4.3) instructs the performer, quite simply, to "make a salad." And *The Identical Lunch* (1969) reframed her habitual midday meal as a readymade event for others to perform (as maker and/or eater): a tuna fish sandwich on wheat toast with lettuce and butter (no mayonnaise) and a large glass of buttermilk or a cup of soup. Among a multitude of works involving the cheap and lowly bean, Knowles published the editioned Fluxus object *Bean Rolls* (1963), a tea canister containing loose dry beans and small paper scrolls printed with bean imagery and trivia (prefiguring her *Bean Bag* of 1978). Referencing the vitalist material philosophy of Jane Bennett (Bennett 2010), Aurelie Matheron has argued that in works like *Proposition #2*, Knowles "conditions the durability of her performance to the inevitable decay of biological material." The work subtly critiques our common regard of food as a form of immanent waste, turning this around so that "what has been discarded matters again" (Matheron 2019, 107, 103).

Like *Proposition #2*, *The Identical Lunch*—performable by almost anyone—turns food preparation and consumption into a special, mindful experience. This is convincingly illustrated by *Journal of the Identical Lunch* (fig. 4.4), an artist's book chronicling performances of the piece, which details interactions with a particular waitress at Riss Diner

Figure 4.3 Alison Knowles (American, b. 1933), *Proposition #2 (Make a Salad)*, performed at Festival of Misfits, ICA, London, October 24, 1962. Gelatin silver print, sheet: 25.4 × 20.3 cm. Gilbert and Lila Silverman Fluxus Collection Gift, Museum of Modern Art, New York. Photo: Digital image © The Museum of Modern Art / Licensed by SCALA / Art Resource, NY, © 2019 Alison Knowles

Figure 4.4 Alison Knowles (American, b. 1933), *Journal of the Identical Lunch* cover, 1971. Artist's book, 20 × 14 cm. Published by Nova Broadcast, San Francisco. Photo: © 2019 Alison Knowles

in midtown Manhattan where the meal was originally eaten (Knowles 1971). We quickly learn that the lunch is about more than simply a sandwich, as the seemingly straightforward recipe produces endlessly indeterminate results choreographed by the restaurant staff as unwitting performers alongside Knowles. The ephemeral foodstuff that inevitably ends up as human waste is revealed as a medium that brilliantly highlights the typically invisible, unheralded labor and care behind its preparation.

Knowles's work further reveals to us the degree to which notions of the everyday are entangled with what is conventionally understood as women's experience or women's work. As part of a collaborative publishing practice that has involved Marcel Duchamp, John Cage, Pauline Oliveros, and, more recently, Rirkrit Tiravanija (another famous food artist), in 1975 Knowles coedited with composer Annea Lockwood the anthology *Women's Work* (fig. 4.5). A collection of experimental scores written by woman-identifying artists, *Women's Work* followed the upswell of second-wave feminism and more than a decade's worth of new performance practices exploring alternative approaches to scores. The anthology identified the correlations between experimental music's phenomenology of heightened awareness, an ethics of noticing and care, and female labor. Its title thus carried a double meaning, as both an anthology of compositions by women but also pieces that paid attention to so-called

women's work as worthy of appreciation and an art form in itself. Knowles and Lockwood's project anticipated the trenchant arguments of anthropologist and labor theorist David Graeber, who has said, "We need to start by redefining labor itself, maybe, start with classic 'women's work,' nurturing children, looking after things, as *the paradigm for labor itself* and then it will be much harder to be confused about what's really valuable and what isn't" (Graeber 2014, my emphasis). In the realm of art, the kinds of socially oriented, participatory, communitarian activities that are celebrated under the terms of relational aesthetics or social practice may be viewed as simply reframing what has been traditionally considered women's work, long undervalued while being absolutely essential to the functioning of society.

Figure 4.5 Alison Knowles (American, b. 1933) (designer and coeditor) and Annea Lockwood (coeditor), *Women's Work*, 1975. Self-published artist's book, 22 × 21 cm. Photo: © 2019 Alison Knowles

By recasting women's work as performance art, Knowles collapsed the roles of performer and caregiver, making the experience of women's work available to diverse others. Like the "maintenance art" of Mierle Laderman Ukeles, her gestures elevated to the level of art the mundane work by which women's time and energy is already consumed. In using the score format in conjunction with biological materials, however, further elisions take place once such pieces enter museum collections, with the roles of performer, beholder/participant, curator, and conservator equalizing to a remarkable degree. Engaging with Knowles's work, all partake, for example, in the making and eating of a salad or a simple lunch. For curators and conservators, minding the work of art becomes a form of domestic labor transferred to the workplace, inviting us to notice the ways in which the practical and disciplined care of arts professionals is fundamentally gendered, aligned with what we traditionally think of as women's work regardless of whether or not that work is performed by those who identify as women.

If Knowles's Fluxus practice resonated with concerns of both the feminist and the environmentalist movements unfolding contemporaneously in the 1960s, by the 1970s her imbrication of female-associated forms of caregiving, management of biological processes and materials, and acceptance of metabolic decay as a fundamental condition of life resonated with the emerging discourse of ecofeminism. From its beginnings in the mid-1970s, ecofeminist theory and activism have strengthened connections between feminism, environmentalism, and broader social justice struggles by identifying the parallels among marginalized human populations, on the one hand, and on the other, entities in and of nature that have been marginalized, colonized, polluted, or otherwise exploited (Warren 1997; Adams and Gruen 2014). As a vibrant, evolving discourse, ecofeminist frameworks and methodologies have since aligned with renewed awareness of Indigenous and racialized knowledge and the decentering of anthropocentric frameworks in favor of new materialisms and object-oriented ontologies. The ecofeminist ethic of Knowles's work—its attention to and care for biological matter, its radical empathy with nature—means that "the work" in both its material and processual dimensions (the physical artwork and the labor that sustains it) do not end. Such an approach opposes the techno-futuristic aesthetic of artists such as ORLAN or Stelarc, whose work typically comes to mind when we think of contemporary bioart and its approach to living matter, which seeks to artificially extend life through complex technological, genetic, or other biological modification. Taking a different tack, Fluxus artists have paid attendant, appreciative witness to ruin, occupying us with quite simple means of caring for and maintaining the material world and its beings while simultaneously accepting the fate of their degradation and decay.

If, as an avant-garde, Fluxus was invested in integrating art into everyday life, its food objects understood life in terms of biotic networks. As such, Fluxus food art's embrace of metabolic transformation and ruin stands as a compelling precedent (one perhaps more appropriate than bioart's speculative science) for a number of contemporary art practices that employ biological materials in ways that similarly honor the aesthetics of decay and take this as the basis for multispecies collaborations. One thinks, for example, of Jae Rhim Lee's *Infinity Burial Suit* (2008–ongoing, fig. 4.6), a jumpsuit adorned with mushrooms that have been adapted to consume the wearer's hair, nails, and skin, such that upon death, their body will be actively broken down and returned to soil by the bespoke fungi. Or Anicka Yi's experiments with mold as a material, including in sculptural works such as *Grabbing at Newer Vegetables* (2015, fig. 4.7), which utilizes bacteria collected from the artist's network of female friends and colleagues to cultivate gorgeous, grotesquely fascinating messages and visual designs. Other artists, including Kelly Kleinschrodt and Emily Peacock, have embedded human-generated biological materials in soap-based artworks that explicitly link living matter with performative gestures of care and remembrance.

Kleinschrodt's soaps, made with the artist's own breast milk, translate intersubjective maintenance acts of nutrition and hygiene into the form of beautiful objects for contemplation that are also extremely vulnerable to their environment (fig. 4.8). Peacock's soaps, poured into simple marble vessels, cradle within them amounts of her son's umbilical cord and placenta, her husband's hair, and her mother's cremated remains, looking generationally both forward and back to metabolic processes of the individual body that reach beyond the self to entangle others (fig. 4.9). These works remind us of the always astonishing proximity of caregiving and death. With exquisite tenderness, they acknowledge the entropic inevitability that we (and they) will perish someday. At the same time, fittingly, their deliberate fragility activates a circuit of care for the object that mirrors the very activities that inspired their creation.

Figure 4.6 Jae Rhim Lee (South Korean, b. 1975), *Infinity Burial Suit*, 2008–ongoing. Custom garment infused with mushroom mycelium, dimensions variable. Collection of the artist. Photo: Courtesy the artist

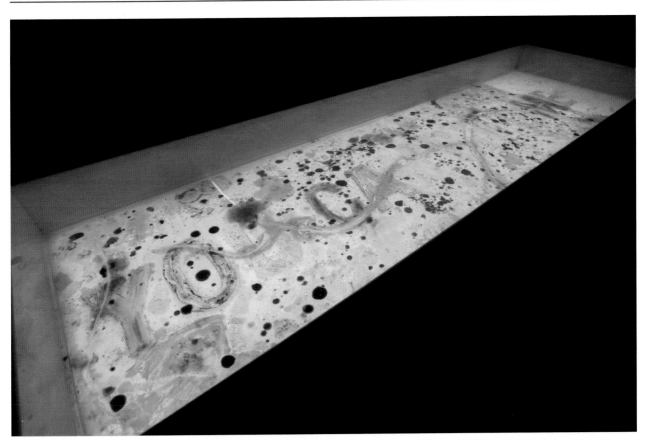

Figure 4.7 Anicka Yi (Korean American, b. 1971), *Grabbing at Newer Vegetables*, 2015. Plexiglas, agar, female bacteria, and fungus, 214.6 × 62.2 cm. Photo: © Anicka Yi, courtesy the artist, Gladstone Gallery, New York and Brussels, and 47 Canal, New York

Figure 4.8 Kelly Kleinschrodt (American, b. 1983), *breastmilksoap, variation IV (for Eliotte)*, 2013. Glycerin, breast milk, honey, castor oil, and acrylic, 5.1 × 14 × 10.2 cm. Collection of Candace Worth. Photo: Courtesy the artist

Figure 4.9 Emily Peacock (American, b. 1984), *Smother: My mother's ashes*, 2019. Soap, ashes, marble, and custom-flocked triangle table, 91.4 × 35.6 × 7.6 cm. Collection of the artist. Photo: Courtesy the artist

The anthropologist Anna Lowenhaupt Tsing has illuminated parallel dynamics in her ethnography of the communities of foragers and dealers that have sprung up around the wild harvesting and trade of the treasured matsutake mushroom, which thrives in forests (of Oregon, China, Japan, and beyond) that have been ruined by the logging industry. In late or post-capitalist/industrial landscapes of "transformative ruin," it is only "assemblages of species" that survive because they have adapted via "contaminated diversity," a paradoxical form of enrichment in the wake of pollution. She writes, "Staying alive—for every species—requires livable collaborations. Collaboration means working across difference, which leads to contamination." In addition to foregrounding symbiosis as the rule of nature and not the exception, Tsing further argues that "precarity *is* the condition of our time" (Tsing 2015, 28, 20, emphasis in original). With it comes indeterminacy, or the unplanned nature of life's unfolding through time. Although indeterminacy is often frightening, Tsing reminds us that "indeterminacy also *makes life possible*" (Tsing 2015, 20, my emphasis).

A more recent anthology coedited by Tsing, *Arts of Living on a Damaged Planet* (2017), opens with an illustration of an indeterminate musical score by John Cage, an experimental composer and progenitor of Fluxus. The work, *Fontana Mix* (1958), is in fact composed of overlaid transparencies that combine a tightly gridded rectangle with a wild web of curved lines and a fixed constellation of individual dots. In the context of Tsing's volume, the curious graphic suggests how, in nature, infinite forms of indeterminacy are achieved through the overlay of multiple life systems or ecologies: humans, individual animals, plants, environments, and atmospheres or microclimates. But we might also relate this model to the indeterminacies that arise when artworks rendered in diverse materials encounter and move through various institutional systems, populated by human actors with all their individual investments. Tsing and her coauthors argue that "to survive, we need to relearn multiple forms of curiosity" and become experts in the art of noticing, attuned to the complexity of "multispecies entanglement" (Tsing et al. 2017, G11). In the development of organisms— and, arguably, human culture too—nature selects and privileges successful *relationships* rather than singular individuals or entities. Correspondingly, the radical forms of multispecies collaboration that define living-matter artworks render obsolete our conventional notions of the autonomy of the work of art. Thus it may help us in our work (as conservators, curators, scholars, or otherwise) to understand collaboration as extending not only to our near-at-hand colleagues but also to the very materials with

which we are dealing, including their inherent microbial agents. With the aforementioned examples in mind, especially the signal work of Knowles, the ecofeminist ethic behind this work demonstrates that the artwork reconceived as an eternal metabolic network haltingly lives on—not despite but *because of* the collaborative proposition of its ongoing decay, transformation, and regeneration (fig. 4.10).

Figure 4.10 Alison Knowles (American, b. 1933), *Proposition #2 (Make a Salad)*, performed at MoMA PS1, New York, in collaboration with Julia Sherman and Salad for President, 2014. Photo: © 2019 Alison Knowles

NOTES

1. This term adapts the language of Fluxus affiliate Robert Filliou, who once imagined all conceptual artists to be participants in a global "eternal network" of "permanent creation," which links all their actions—artistic and nonartistic, well and badly executed—into a continuous creative gesture (Fredrickson 2019).

2. Email from Benjamin Patterson to the author, November 30, 2009.

BIBLIOGRAPHY

Adams and Gruen 2014
Adams, Carol J., and Lori Gruen, eds. 2014. *Ecofeminism: Feminist Intersections with Other Animals and the Earth*. New York: Bloomsbury.

Bennett 2010
Bennett, Jane. 2010. *Vibrant Matter*. Durham, NC: Duke University Press.

Fredrickson 2019
Fredrickson, Laurel Jean. 2019. "Life as Art, or Art as Life: Robert Filliou and the Eternal Network." *Theory, Culture & Society* 36 (3): 27–55.

Graeber 2014
Graeber, David. 2014. "Spotlight on the Financial Sector: Did Make Apparent Just How Bizarrely Skewed Our Economy Is in Terms of Who Gets Rewarded [interview with Thomas Frank]." *Salon*, June 1, 2014, https://www.salon.com/2014/06/01/help_us_thomas_piketty_the_1s_sick_and_twisted_new_scheme/.

Harren 2016
Harren, Natilee. 2016. "The Provisional Work of Art: George Brecht's Footnotes at LACMA, 1969." *Getty Research Journal*, no. 8, 177–97.

Harren 2020
Harren, Natilee. 2020. *Fluxus Forms: Scores, Multiples, and the Eternal Network*. Chicago: University of Chicago Press.

Higgins 2011
Higgins, Hannah. 2011. "Food: The Raw and the Fluxed." In *Fluxus and the Essential Questions of Life*, edited by Jacquelynn Baas, 13–21. Hanover, MA: Hood Museum of Art.

Hölling 2015
Hölling, Hanna. 2015. *Revisions—Zen for Film*. New York: Bard Graduate Center.

Hölling 2017
Hölling, Hanna. 2017. *Paik's Virtual Archive: Time, Change, and Materiality in Media Art*. Oakland: University of California Press.

Joselit 2013
Joselit, David. 2013. "The Readymade Metabolized: Fluxus in Life." *RES: Anthropology and Aesthetics*, nos. 63/64, 190–200.

Knowles 1971
Knowles, Alison. 1971. *Journal of the Identical Lunch*. San Francisco: Nova Broadcast.

Matheron 2019
Matheron, Aurelie. 2019. "Performing Waste, Wasting Performance: The Ecology of Fluxus." *Resilience: A Journal of the Environmental Humanities* 6 (1): 102–17.

Patlán 2010
Patlán, Lorena. 2010. "Career Profile: Albrecht Gumlich, Objects Conservator." *Iris: Behind the Scenes at the Getty*, November 24, 2010, http://blogs.getty.edu/iris/career-profile-albrecht-gumlich-objects-conservator/.

Robinson 2004
Robinson, Julia. 2004. "The Sculpture of Indeterminacy: Alison Knowles's Beans and Variations." *Art Journal* 63 (4): 96–115.

Tsing 2015
Tsing, Anna Lowenhaupt. 2015. *The Mushroom at the End of the World: On the Possibility of Life in Capitalist Ruins*. Princeton, NJ: Princeton University Press.

Tsing et al. 2017
Tsing, Anna Lowenhaupt, Heather Swanson, Elaine Gan, and Nils Bubandt, eds. 2017. *Arts of Living on a Damaged Planet: Ghosts and Monsters of the Anthropocene*. Minneapolis: University of Minnesota Press.

Warren 1997
Warren, Karen J., ed. 1997. *Ecofeminism: Women, Culture, Nature*. Bloomington: Indiana University Press.

Woods 2014
Woods, Nicole L. 2014. "Taste Economies: Alison Knowles, Gordon Matta-Clark and the Intersection of Food, Time and Performance." *Performance Research: A Journal of the Performing Arts* 19 (3): 157–61.

Plump and Pliant: The Preservation of Bacterial Cellulose in Textile Bioart

Courtney Books

An innovative newcomer to textile materials, dehydrated bacterial cellulose decays at a rate prohibitive to performance art and exhibition. This paper presents collaborative research realized between the art conservation department at Queen's University in Kingston, Ontario, and the Speculative Life Biolab at Concordia University in Montreal. Results produced an immersion treatment for bacterial cellulose that allows the material to persist externally from fluid containment while preserving vital qualities of pliancy and fluid retention, thus achieving longer functionality as a wearable, performance-ready textile. This case study explores the role that conservation and future collaborations may perform in the development and preservation of biomaterials.

◆ ◆ ◆

Bioart and preservation are unnatural co-players. Distinguished from the control and malleability of biomimetic art, bioart attempts to harness the quasi-uncontrollable growth of living organisms. Biological organisms, with few exceptions, represent an enemy camp for art conservation. Moreover, bioartists often embrace material degradation as an inherent aspect of an individual or iterative work. Conceptual strength is derived from the uniqueness of a living organism, and showcasing its pathway of creation, life, and inevitable decay becomes a type of performance art.

In contrast, some bioartists seek to defy the laws of ephemerality and deterioration by extending the natural life and postmortem span of their materials. A prime example is Doris Salcedo's *A Flor de piel* (2011–12), developed in collaboration with scientists. The biotextile artwork consists of thousands of rose petals sutured together with wax thread and treated with a solution of glycerin, collagen, and turpentine. Desiring that the textile remain flexible, Salcedo's studio has shared with conservators the recipe and method for processing the rose petals.[1] Conservation scientist Narayan Khandekar of the Straus Center for Conservation and Technical Studies, Harvard Art Museums, subjected sample petals to the stress of induced environmental aging in order to make the prediction that each petal, many of which have already been replaced, will eventually require a surrogate (Khandekar 2016). Salcedo has granted permission to remanufacture petals, yet stresses that the piece should not lose function as textile. Curator Mary Schneider Enriquez explains: "It is the impossibility of securing the presence of the absent body and the skin of petals in a lasting physical state that confounds the viewer, and defines the success of this work" (Schneider Enriquez 2016,

129). The rose petals conceptually embody the absent flesh of a disappeared murder victim; the work is a shroud for mourning, and as soon as it loses this functionality, the concept is also lost.

In a similar vein, textile artist Astrid Lloyd constructed a garment from pomegranate peels for the performance piece *Mother* (2008, fig. 5.1). Despite continuous treatment with vegetable glycerin, the biotextile quickly showed signs of deterioration (absorbing ambient moisture, developing mold, crumbling, and resulting loss of material) and is now housed in an airtight glass case. Lloyd has expressed that the encasement is an undesired barrier but a nonnegotiable solution in order to salvage the piece as wearable and therefore performance-ready. After future manifestations of the performance series, nature can be unleashed on the pomegranate peels, or in the artist's words: "Like skin, it should age."[2]

Figure 5.1 Astrid Lloyd (Canadian) *Mother*, 2008. Pomegranate peels stitched and treated with glycerin, pictured here as performed in *Mother, after Natalie Barney*, 2010. Digital print from digital photo taken by Bob Siemens, 76.2 × 63.5 cm. Photo: © Astrid Lloyd

Salcedo and Lloyd represent a clear desire on the part of some artists to extend not only the lifetimes of their ephemeral materials but also degrees of the physical plasticity of biological matter. Biotextiles and the use of cellulosic (plant- or bacteria-derived) biofilms exemplify a subset of bioart where the continued functionality and perception of the material as *textile* relies upon preservation.

BACTERIAL CELLULOSE: A TEXTILE BIOFILM WITH INHERENT VICE

In 2017 textile artist WhiteFeather Hunter and biodesigner Théo Chauvirey began experimenting with bacterial cellulose at the Speculative Life Biolab, a research cluster within the Milieux Institute for Arts, Culture and Technology at Concordia University, Montreal. They co-created *Bucci* (2017, fig. 5.2), a two-piece garment fashioned from bacterial cellulose biofilm and 3D-printed bioplastic.[3] While the skirt of the garment was seemingly stable, the shirt, made from thinner biofilm and processed differently (that is, unwashed), was actively falling apart within weeks (fig. 5.3). Why did half of *Bucci* degrade more rapidly? Would the bottom half succumb to the same fate as the top, and when? Could bacterial cellulose be manipulated to last longer, allowing for a longer exhibition duration?

Figure 5.3 WhiteFeather Hunter (Canadian, b. 1972) and Théo Chauvirey (French, b. 1991), detail of *Bucci*, 2017. Deteriorating *Acetobacter xylinum* bacterial cellulose with 3D-printed PLA embedded designs. Photo: © WhiteFeather Hunter

Figure 5.2 WhiteFeather Hunter (Canadian, b. 1972) and Théo Chauvirey (French, b. 1991), *Bucci*, 2017. *Acetobacter xylinum* bacterial cellulose with 3D-printed PLA embedded designs. Photo: © WhiteFeather Hunter

Dehydrated bacterial cellulose, also known as "kombucha leather," as it is the same substance used to ferment kombucha tea, has surged in popularity as a new textile material due to properties akin to animal and plant-based leathers. Bacterial cellulose is flexible, sustainable, biodegradable, and widely considered ethically responsible. Artists such as Susan Lee, with her TED Talk "Grow Your Own Clothes," have popularized economical and easily reproducible production methods (Lee 2011). When grown in a large vat, the biofilm colony, scientifically termed a pellicle and commonly referred to as a SCOBY (symbiotic culture of bacteria and yeast), is large enough to produce human-size clothing. Through an aerobic fermentation process that converts simple carbohydrates into acetic acid and carbon dioxide gas, the water-insoluble material grows from an active yeast culture that colonizes in layers to create a cellulosic biofilm. The pellicle conforms to the shape of the incubation vessel as it floats to the top of the air-liquid interface, suspended by the

carbon dioxide gas and blocking competitor access to the sugar-laden food source.

Bacterial cellulose differs from plant cellulose in that it contains no hemicellulose or lignin and is characterized by a higher degree of crystalline structure and polymerization due to the cellulose grouping in microfibril ribbons; this lends the biofilm impressive strength and flexibility (Keshk 2008). The hydrated pellicle is firm and fleshlike in texture and sandy-pink hued. Dehydrated pellicles darken to deep sienna-umber hues, lose up to 95 percent of fluid mass, and remain semiflexible. Microscopic photo documentation of cross sections taken from bacterial cellulose illustrates the changes in topographical morphology that occur with natural dehydration; the significant change in texture and hue is evident in images of untreated, hydrated bacterial cellulose (fig. 5.4) versus untreated, dehydrated bacterial cellulose (fig. 5.5). The rate at which the material deteriorates over time varies according to processing, thickness, and environment, but can occur within weeks, as seen in the case of *Bucci*. Critically, when the dehydrated material is exposed to ambient moisture fluctuation or skin contact, the biofilm's cellular structure, weakened during dehydration, degrades and the biofilm fractures. This vulnerability results in a short time allowance for static gallery display and an even shorter allowance when worn on a human body. The inherent vice of water vulnerability is still considered the leading obstacle for artists working with this material.

Figure 5.4 Photomicrograph of untreated cellulose, biologically active (control sample); reflected light, 200X. Photo: © Courtney Books, Queen's University, Kingston, Ontario, 2017

Figure 5.5 Photomicrograph of untreated, dehydrated cellulose (control sample); reflected and transmitted light, 200X. Photo: © Courtney Books, Queen's University, Kingston, Ontario, 2017

PROJECT COLLABORATION: COMBINING SPHERES OF ART CONSERVATION AND MATERIAL PRODUCTION

The degradation that eroded *Bucci* inspired the collaborative project *Plump and Pliant* (2017–18), involving the author (art conservation graduate student, Queen's University, Ontario) and WhiteFeather Hunter (interim principal of the Speculative Life Biolab). The project was driven by a common goal: to create an immersion treatment for bacterial cellulose that would allow the material to persist externally from containment (for instance preservation within a liquid bath, storage and/or exhibition inside a hermetic vitrine, et cetera) while preserving lifelike qualities of pliancy and fluid retention. The challenge was to retain as much fluid, flexibility, hue, and texture of untreated, hydrated bacterial cellulose as possible while reducing hygroscopic properties (that is, imparting water resistance). To note, the primary aim was to *extend* the viable exhibition time of the bacterial cellulose beyond the threshold of normal degradation processes. Instead of measuring the exhibition window of the biotextile in weeks, artists could exhibit for months and plan for multiple performance-art pieces worn on human skin for longer durations. Significant longevity of the materials (up to one year or more) calls for further research.[4]

Inspired by Doris Salcedo's process created for *A Flor de piel*, *Plump and Pliant* combined materials and methodologies used in the conservation of waterlogged archaeological organic material with cellular stabilization

and dehydration materials and methodologies used in botanical, medical, and food industries (Botfeldt, Gelting, and Hovmand 2009; Giachi et al. 2010). Immersion treatments were selected and adapted from each of these fields based on potential for reducing hygroscopicity in the bacterial cellulose and to minimize cellular-wall damage experienced by the biofilm during and after dehydration.

An overarching parameter of the project was that the resulting immersion treatment method, technology, and materials should be easily reproducible, affordable, nonhazardous, and nontoxic for practicing artists. This stipulation forbade the consideration of cellular fixatives, champion (but also toxic) defenders against decay, such as turpentine, formaldehyde, or dimethyl sulfoxide.[5] In addition, vacuum-freeze drying, a preferable method of stable dehydration, was omitted due to relative inaccessibility and biolevel safety codes observed by the Speculative Life Biolab (for instance prohibition of removal of biologically active testing material from the laboratory).

EXPERIMENTATION: CORRALLING BACTERIA INTO COOPERATION

Test samples of bacterial cellulose used for the research project derived from the same pellicle, grown in the Speculative Life Biolab and sourced from RISE *Acetobacter xylinum* bacteria/yeast. Significantly, this was the same cellulosic body used to create the top piece of *Bucci*—further verifying the success or failure of the experimental treatments. Ninety-nine samples were cut from the main pellicle (each sized 5 × 5 × 0.5 to 1 cm) and rinsed with distilled water. Half of the samples were sterilized by autoclaving the biofilm at high-pressure steam held at 121°C, while the remaining half of samples were allowed to remain biologically "active" (with bacterial yeast strains thriving or dormant). Each immersion solution was tailored with three main components—a plasticizer, a consolidant, and a preservative—all designed to protect the cellular structure during dehydration and to decrease hygroscopicity.[6] Concomitant antifungal properties imparted to the test samples by the immersion treatments were also observed and documented.

The treatment method relied upon cyclic displacement of fluids; alternating between immersion and dehydration stages, the aqueous incubation fluids (mainly acetic acid, leftover sugars, and bacterial strands) were driven out of the samples via capillary forces and replaced with preservative materials (listed below). Dehydration was performed by air drying or with artificial-aging ovens. Samples were often treated first with solvents (for instance

acetone or mineral spirits) followed by the immersion baths. To encourage higher penetration and saturation of treatment materials, immersion solutions were gently heated or kept for longer dwell times at room temperature (fig. 5.6). Immersion materials included collagens, glycerol, alcohols, cellulose ethers, and low-molecular polyethylene glycol (PEG: the long-standing darling for consolidation treatment of wood and leather conservation) as well as common preservatives used for fruits and vegetables such as sucrose, mannitol, and waxes.

Figure 5.6 Array of bacterial cellulose samples in petri dishes during immersion solution treatment. Photo: © Courtney Books, Speculative Life Biolab, Concordia University, Montreal, 2018

Technical analyses used to map the pilot results included ASTM cantilever bend tests to evaluate preserved or improved textile pliancy, mass/weight calculations to indicate fluid retention, cross sections and polarized light microscopy (PLM), and ultraviolet microscopy (UVM) to monitor adjustments in surface morphology and cross-contamination.[7]

RESULTS: A NEW, BIOLATEX-LIKE TEXTILE MATERIAL

Three qualifiers were used to evaluate success: retention of fluid, flexibility, and "lifelike" texture; reduction of hygroscopic properties; and anti-biodeteriogen properties (that is, treated samples that avoided becoming hosts for raging bacterial parties). Of the twenty-one different immersion treatments ultimately tested, three were deemed successful enough to repeat using new samples (deriving from the same pellicle and also from a different pellicle) in order to confirm results. It is noteworthy that

several discarded treatments, although deemed losers by the parameters of the project goals, produced materials that were of interest to the consulted artists. For example, despite substantial fluid loss, collagen/glycerol treatments produced a strength and flexibility similar to wearable latex, while treatments with alcohol and PEG produced a semi-firm, gelled texture that was, despite increased tackiness, most suggestive of the lifelike "plumpness" of the original wet biofilm. The dynamic nature of working in a biolab full of practicing artists allowed for a proverbial recipe exchange—some artists recorded discarded treatments (for instance the rubbery, cellulose-nitrate-like results of samples treated with pure collagen) for future art applications.

All treatments aesthetically altered the cellulose to some degree—challenging the goal of retaining lifelike verisimilitude. According to Hunter and Chauvirey (whose voices here are operative as artists), some changes, including in color and in texture, were deemed acceptable as long as the material's resistance to degradation was strengthened and it "read" as biomaterial: flexible, pliant, and, ideally, plump (indicative of hydration). After the second-phase testing of the three initially successful candidate treatments, one emerged victorious.

Ultimately, a trifecta involving collagen, glycerol, and a PEG manifested the most promising results. Despite fluid loss (approximately 60 percent), the aesthetics of hue and surface morphology in these samples were the most unaltered in comparison with untreated, hydrated bacterial cellulose, as visible in the photomicrograph shown in fig. 5.7 (compare with fig. 5.4). This new form of treated bacterial cellulose exhibited a notable increase in flexibility and tensile strength (fig. 5.8) and proved to be water resistant (but not water impermeable). Since untreated cellulose has shown to deteriorate within hours of skin contact, samples prepared with the winning treatment were worn directly on skin for twenty-four hours in order to demonstrate that the treated material could withstand longer exposure to the microenvironment of human skin (moisture, salts, et cetera). At the time of this article submission (approximately three years later), these samples have shown no visible or tactile signs of degradation.[8] The new treated bacterial cellulose has achieved a tentative permanence that, while subject to eventual decay, allows for further use in performances and exhibition.

Figure 5.7 Photomicrograph of cellulose treated with PEG, collagen, and glycerol, sterilized and oven dried; reflected and transmitted light, 200X. Photo: © Courtney Books, Queen's University, Kingston, Ontario, 2017

Figure 5.8 Physical demonstration of tensile strength, cellulose treated with PEG, collagen, and glycerol. Photo: © WhiteFeather Hunter, Speculative Life Biolab, Concordia University, Montreal, 2018

EVOLUTION: CONTINUED APPLICATION AND DEVELOPMENT

The intersections between biofilms and art conservation continue to multiply as new applications for cellulosic biofilms and bio-produced gels continue to pepper conservation literature. Cleaning techniques for treating paper, paintings, and objects that involve rigid, polysaccharide-based biofilms (for instance agar, low-acyl gellan gum) rely upon the capillary action of the still-hydrated gel to perform as a poultice.[9] Archaeological conservators have recently attempted to consolidate waterlogged wood by growing the bacterial cellulose internally within the object (Gregory et al. 2017). Conservation scientists have explored dehydrated bacterial cellulose as an alternative lining material to Japanese paper (Santos et al. 2016a; Santos et al. 2016b). The potential of treated bacterial cellulose for serving as strength-reinforcing repair material for hygroscopic leathers, parchments, and textiles holds exciting promise.

Perhaps the most compelling results branching from the *Plump and Pliant* study rest not with what has been created but with what is yet to come. Montreal-based medical scientists, working in collaboration with Hunter, have proposed researching the treated bacterial cellulose as a potential patch material applied to internal tissue repair of mammalian organs.[10] Hunter and Chauvirey have received requests to apply the treatment in commissioned garments for an annual festival in Ottawa affectionately named Boochfest.

Moreover, Hunter developed adaptations of the treatment in order to tailor specific properties better suited for a collaboration with bioartist Tagny Duff. This collaboration occurred for the occasion of the 2019 exhibition *MATTER(S) matter(s): Bridging Research in the Arts and Sciences* at the Eli and Edythe Broad Art Museum at Michigan State University, Lansing. The work, *Wastelands*, is an ongoing project created by Duff to include multiple iterations and collaborations (Duff 2018).[11] In this iteration, Hunter augmented the recipe proportions of the treated bacterial cellulose to enhance properties of elasticity. She constructed cordage and hand-stitched carriers (fig. 5.9, fig. 5.10) to house Duff's biogas generators—tiny glass vessels that house excrement, viruses, and methane. In this case, the conceptual performance of the treated bacterial cellulose is implicated in the viewer's perceived network of anxiety surrounding containment and exposure to bacteria—in the project, the success of the rendered biomaterial transforms it into an effective container of another biomatter—all the while able to be worn, as designed, on an incubator (a living body).

Figure 5.9 WhiteFeather Hunter in collaboration with Tagny Duff, *Wastelands*, 2016–ongoing. Bag 1 (alone without full apparatus), 2018–19. Treated bacterial cellulose. Bioplastic bags codesigned and solely produced by WhiteFeather Hunter for the *Wastelands* project by Tagny Duff, 2018; bioplastic formula treatment for the bags researched and developed by Courtney Books and WhiteFeather Hunter, 2017. Photo: © WhiteFeather Hunter

Figure 5.10 WhiteFeather Hunter in collaboration with Tagny Duff, *Wastelands*, 2016–ongoing. Bag 2 (alone without full apparatus), 2018–19. Treated bacterial cellulose. Bioplastic bags codesigned and solely produced by WhiteFeather Hunter for the *Wastelands* project by Tagny Duff, 2018; bioplastic formula treatment for the bags researched and developed by Courtney Books and WhiteFeather Hunter, 2017. Photo: © WhiteFeather Hunter

CONCLUSION: COLLABORATION BETWEEN ARTIST, CONSERVATOR . . . AND BACTERIA?

Initially, *Plump and Pliant* was designed as a graduate thesis research project in collaboration with an interested and generous bioartist and hosting lab. The project quickly morphed into something more, shifting beyond the core goal to preserve bacterial cellulose in its original, familiar form to the new applications and possibilities of an invented material. As the author attempted to limit variables and establish controls for the project's

parameters, Hunter emphatically pushed in the direction of the experimental in pursuit of results that were actually desirable and *applicable* for a practicing artist. Without this constant retuning, the project may have remained stagnant instead of leapfrogging between artistic communities and spreading preservation methodologies into productions of bioart.

The entanglement of bioart, preservation, and ethics will continue to develop as the genre grows and innovates. More biomaterial will fall under the purview of preservation; working alongside an artist at the creation point of a material offers invaluable opportunities in negotiating common goals. Yet there also exists an often-unacknowledged player in such projects: the bacteria. Each fermentation of the bacterial cellulose produces an irreproducible iteration of the art. A certain degree of uniqueness, and of success (or failure), is owed to the unpredictable, uncontrollable role performed by the bioagent as directed by the bioartist.

Contemporary ethical awareness of the bacterial role in material processing is ever more nuanced as concerned societies move toward sustainable, environmentally conscious products. Are we comfortable growing and killing a bacterial colony to make a kombucha "leather" handbag? Are we *more* comfortable if the dead colony is repairing a historical artifact? Our materialism is spun from an unwilling or unknowing participant, and how this material production differs from animal husbandry or plant horticulture is highly debatable. The bioartist group known as the Tissue Culture & Art Project ends the exhibition of performance pieces such as *Victimless Leather* (2004) with a "killing ritual" of cellulose and tissue that rips apart the illusion that their art objects are in a sense "play." Paola Antonelli, who curated the piece at New York's Museum of Modern Art in 2008, lamented: "[It] started growing, growing, growing until it became too big. And [the artists] were back in Australia, so I had to make the decision to kill it. And you know what? I felt I could not make that decision. I've always been pro-choice and all of a sudden I'm here not sleeping at night about killing a coat. That thing was never alive before it was grown" (Dixon 2016, 174).

When asked for her opinion, Hunter will state that she's as comfortable with the killing ritual as she is with washing her hands (given that the two acts involve the same level of destruction). Rather, a shared discomfort for Hunter and the author derives from calling the substance "vegan" or claiming that this material is inherently more sustainable than an alternative—too many variables remain. In this light, conceptualization of bacterial cellulose as a living

colony is brushed aside in the quest to promote the production of each new material as neutralized, as safe from reproach.

In her 2019 article "Culturing Creativity, and a Little Bit of Shit-Stirring," Hunter introduces the concept of the bacteria as another collaborator in order to dismantle it as anthropomorphism or aggrandization within a hip "lifestyle" or "next big thing" framework: "I might say that *Acetobacter xylinum*, rather than functioning as a 'collaborator' or solution to any global or future problem, instead acted as a metaphorical leavening (and leveling) agent, fermenting new levels of cross-disciplinary (and anti-disciplinary) work that both elevated and re-calibrated each human collaborator and our creations" (Hunter 2019, 10). Hunter instead privileges the agency of the human players, celebrating their ability to interact and co-compose—a fitting note to rest upon until culturing the next bioexperiment.

NOTES

1. Salcedo's recipe, summarized as quoted: "The solution is a multistep process that involves treating the petals first with turpentine, followed by glycerin and collagen, followed by an immersion in shellsol and pigment; then pressing them between sheets of Mylar with glycerin and pigment; then soaking and saturating them with pigmented wax; before finally flattening them in between high-density foam for a month. The petals are stitched together with waxed thread, and the juncture between the petal and thread is also waxed" (Khandekar 2016, 150).

2. Author telephone call with Astrid Lloyd, October 30, 2017.

3. For more work by the artist and researcher WhiteFeather Hunter see https://www.whitefeatherhunter.ca/bio-tech. For more on the research and collaborations engendered by the Speculative Life Biolab, such as a documentary by Théo Chauvirey on the creation of *Bucci* (*Beauty and the Booch* [2019]), see https://speculativelifebiolab.com/2019/02/13/beauty-and-the-booch-is-live/ and https://speculativelifebiolab.com/.

4. Future analysis conducted with electron microscopy (for instance ESEM) may provide advanced topographical mapping of the alterations made to the bacterial cellulose. Sorption isotherm testing may be useful to establish acceptable moisture content thresholds for the exhibition of bacterial cellulose (treated or untreated).

5. Additional eliminated materials (due to prohibitive costs) included trehalose (sugar) and genipin (cross-linking agent). The polyol D-mannitol ≥98% (Sigma-Aldrich) was tested as a consolidant but ultimately eliminated due to the requirement that all bacterial cellulose samples be clinically sterilized before treatment; according to medical research dating from the 1980s, mannitol treatments can lead to combustive activity when they involve carbon-dioxide-gas-producing live cultures (La Brooy et al. 1981).

6. Casts of pure immersion mixtures were poured into petri dishes in order to compare and analyze the interaction of cellulose with immersion fluids.

7. ASTM testing was completed using: American Society for Testing and Materials, ASTM Committee D-13 on Textiles, and American Society for Testing and Materials 1988 Annual Book of ASTM Standards: Textiles: Yarns, Fabrics, and General Test Methods. Philadelphia: ASTM. Cross sections/polarized light microscopy documentation was captured using: Olympus microscope (model BX53) with a semi-motorized fluorescence microscope Olympus DP73 camera (CellSens software). Light sources included polarized light or reflected light, and ultra-fluorescence filters.

8. A sample treated with the winning trifecta of collagen, glycerol, and a PEG was cut in half with a scalpel (resulting in approx. 2.5 × 5 × 0.75 cm) and taped to the author's and Hunter's upper left chest. The samples were worn for twenty-four hours and were examined two weeks later under polarized light microscopy for evidence of degradation such as layer separation, micro-cracking, and moisture bloom; no differences between the samples before and after skin contact were observed. Visual (to the naked eye) and tactile inspection indicate no changes as of spring 2021, approximately three years post-treatment.

9. For a comprehensive view on the use of hydrated and semi-hydrated biofilms in conservation see *Gels in the Conservation of Art* (Angelova et al. 2017).

10. In 2007 the performance artist Stelarc had a third ear, engineered from polyethylene scaffolding and stem cells harvested from the artist's body, implanted into his arm; this is widely considered a generative work that sparked heated ethical debate as well as further experimentation using cellular scaffolding and implants across bioart communities. See Stelarc.org and the book *The Cyborg Experiments: The Extensions of the Body in the Media Age* (Zylinska 2002). Similarly, the ethics and biocompatibility of grafting or implanting plant or bacteria-derived tissue within human tissue are also considered polemic. Many artists encounter legal obstacles to any work involving human tissues. For literature on the topic published by bioartists and medical researchers see Modulevsky, Cuerrier, and Pelling 2016; Hickey and Pelling 2019.

11. *Wastelands* by Tagny Duff is an ongoing bioart project that imagines how a dystopian future, five hundred years advanced, generates biogas. The project involves varied collaborative research, fabrications, and installations. For more on the project and on Duff's art see https://tagnyduffcom.wordpress.com/2017/10/12/first-blog-post/.

BIBLIOGRAPHY

Angelova et al. 2017
Angelova, Lora V., Bronwyn Ormsby, Joyce H. Townsend, and Richard Wolbers. 2017. *Gels in the Conservation of Art*. London: Archetype.

Botfeldt, Gelting, and Hovmand 2009
Botfeldt, K. B., U. Gelting, and I. Hovmand. 2009. "Conservation and Restoration Methods Used for Waterlogged Archaeological Leather: A Retrospective." In *Proceedings of the 10th ICOM Group on Wet Organic Archaeological Materials Conference, Amsterdam, 2007*, edited by K. Strætkvern and D. J. Huisman, 707–21. Amsterdam: Rijksdienst voor Archeologie, Cultuurlandschap en Monumenten.

Dixon 2016
Dixon, Deborah P. 2016. *Feminist Geopolitics: Material States*. London: Routledge.

Duff 2018
Duff, Tagny. 2018. "Wastelands: A Dirty Future." *Centre for Sustainable Practices in the Arts Quarterly* 21 (September 18, 2018): 31–35.

Giachi et al. 2010
Giachi, Gianna, Chiara Capretti, Nicola Macchioni, Benedetto Pizzo, and Ines Dorina Donato. 2010. "A Methodological Approach in the Evaluation of the Efficacy of Treatments for the Dimensional Stabilisation of Waterlogged Archaeological Wood." *CULHER Journal of Cultural Heritage* 11 (1): 91–101.

Gregory et al. 2017
Gregory, David, Yvonne Shashoua, Nanna Braunschweig Hansen, and Paul Jensen. 2017. "Anyone for a Nice Cup of Tea? The Use of Bacterial Cellulose for Conservation of Waterlogged Archaeological Wood." In *ICOM-CC 18th Triennial Conference, 2017, Copenhagen*, edited by J. Bridgland. Paris: International Council of Museums. https://pure.kb.dk/en/publications/anyone-for-a-nice-cup-of-tea-the-use-of-bacterial-cellulose-for-c.

Hickey and Pelling 2019
Hickey, R. J., and A. E. Pelling. 2019. "Cellulose Biomaterials for Tissue Engineering." *Front. Bioeng. Biotechnol.* 7 (45): https://www.frontiersin.org/articles/10.3389/fbioe.2019.00045/full.

Hunter 2019
Hunter, WhiteFeather. 2019. "Culturing Creativity, and a Little Bit of Shit-Stirring." *Musings* 2019:2–10. https://www.academia.edu/41620679/Culturing_Creativity_and_a_little_bit_of_shit_stirring.

Keshk 2008
Keshk, Sherif M. A. S. 2008. "Homogenous Reactions of Cellulose from Different Natural Sources." *Carbohydrate Polymers* 74 (4): 942–45.

Khandekar 2016
Khandekar, Narayan. 2016. "Inherent Vice and the Ship of Theseus." In *Doris Salcedo: The Materiality of Mourning*, edited by Mary Schneider Enriquez, Doris Salcedo, and Narayan Khandekar, 141–52. New Haven, CT: Yale University Press.

La Brooy et al. 1981
La Brooy, Susan J., Fendick Avgerinos, C. B. Williams, and J. J. Misiewicz. 1981. "Potentially Explosive Colonic Concentrations of Hydrogen after Bowel Preparation with Mannitol." *The Lancet* 317, no. 8221 (March): 634–36.

Lee 2011
Lee, Susan. 2011. "Grow Your Own Clothes." TED Talk, March 2011. https://www.ted.com/talks/suzanne_lee_grow_your_own_clothes.

Modulevsky, Cuerrier, and Pelling 2016
Modulevsky, D. J., C. M. Cuerrier, and A. E. Pelling. 2016. "Biocompatibility of Subcutaneously Implanted Plant-Derived Cellulose Biomaterials." *PloS one* 11 (6): e0157894. https://doi.org/10.1371/journal.pone.0157894.

Santos et al. 2016b
Santos, Sara M., José M. Carbajo, Nuria Gómez, Ester Quintana, Miguel Ladero, Arsenio Sánchez, Gary Chinga-Carrasco, and Juan C. Villar. 2016b. "Use of Bacterial Cellulose in Degraded Paper Restoration. Part II: Application on Real Samples." *Journal of Materials Science* 51 (3): 1553–61.

Schneider Enriquez 2016
Schneider Enriquez, Mary. 2016. "Organic and Ephemeral: Salcedo's Recent Material Challenges." In *Doris Salcedo: The Materiality of Mourning*, edited by Mary Schneider Enriquez, Doris Salcedo, and Narayan Khandekar, 119–39. New Haven, CT: Yale University Press.

Zylinska 2002
Zylinska, Joanna, ed. 2002. *The Cyborg Experiments: The Extensions of the Body in the Media Age.* London: Continuum.

Some Survive, Few Are Conserved, Even Fewer Can Travel: Paradoxes and Obstacles in Maintaining and Staging Biomedia Art

Jens Hauser

Biomedia art that appropriates the most recent technologies of the life sciences updates, at first sight, art historical tropes of "aliveness" and "creation" when coming close to "life" in a very literal, biological sense. However, while museums and collectors traditionally deal with the ontological paradox that aesthetic representations made out of dead matter can, indeed, appear as alive, such strategies fail with regard to artistic modes that insist on the authenticity of their staged biological agents, functions, and processes. Such contemporary practices pose unprecedented challenges in terms of staging, conservation, and transport. In addition, they may willfully challenge institutions' status as art depositories or "cemeteries."

◆ ◆ ◆

The creation of lifelike appearances is a persistent feature in art, from early anthropomorphic statues and myths of artists' works "coming to life," to notions of the artwork as an organism in itself, to robotic and software simulations of digital media art, to, more recently, artistic artifacts created in bioscientific contexts. By means of form, material, or process, art has imagined, represented, mimicked, simulated, and quite recently actually manipulated living beings and systems, since genetics, tissue engineering, DNA chips, and so-called synthetic BioBricks have entered the repertoire of experimental artistic strategies—for which cultural institutions remain dramatically ill-equipped.

Three primary typologies of "alive" artworks exist today: representational and concept-based art, often including organic matter; process-based "dry" media art using software and hardware such as informatics and robotics to simulate lifelike behaviors via media that are not biological; and process-based "moist" media art with wetware that uses biotechnological methods to manipulate organic systems, organisms, or their constitutive parts in an aestheticized technical framework.

The first category includes the use of biological materials such as bodily fluids, food, or intentional putrefaction processes in an attempt to attribute semantic value to

unstable materials. The potentially fragile works are likely to pose serious challenges for display and shipping, but above all for preservation. However, a large part of these issues can be solved through established best practices of conservation treatment that claim "universal applicability"—for example, a methodology that consists of first characterizing an object, including its history and ideal state, followed by the creation of a realistic treatment goal accompanied by complete documentation of all steps (Appelbaum 2007, xxii, xix).

The second category can be addressed according to methodologies for preservation and reenactment of performative, digital, or time-based media art. These have been recently developed as the urgency of conserving and collecting technological art has been recognized. Here, software and hardware conservation, accompanied by artist interviews, are key when faced with rapid technological obsolescence, deterioration, and future incompatibility. Process- and communication-based art, often with expanded concepts of artistic authorship, "reduce the hitherto valid collecting criteria of longevity, authenticity, and intrinsic value to absurdity" (Serexhe 2013, 24).

Devoid of institutional advocacy, the third category lacks any coordinated methodology, since these practices cut across many disciplines, from art to natural history, medical, and design museums, media art and performance festivals, biotechnology and bioethics, and are still only supported by a few collectors ready to engage with the subsequent challenges beyond conservable objects. Some of the challenges of biomedia art present similarities to those of performance art—especially as their actual presence may not only be reenacted but "survive" in the form of documents or physical remnants (Hauser 2006). However, the various nonhuman and techno-scientific agencies of micro-performativity (Hauser 2014b; Hauser and Strecker 2020) involved in such artworks destabilize human scales (both spatial and temporal) as the dominant plane of aesthetic experience and link together the machinic and the organic (Salter 2010). The shift from organic representation to biological manipulation results in technical, institutional, regulatory, legal, ethical, bureaucratic, philosophical, and aesthetic issues with regard to museum infrastructures, the status of living organisms, tissues, and genetically modified organisms (GMOs), and their fragility when maintaining, conserving, reenacting, or shipping them.

Interestingly, the first reported historical case of genetically modified organisms exhibited as artworks in a major museum already anticipated the entanglement of today's challenges. In 1936, at New York's Museum of Modern Art, photographer Edward Steichen showed hundreds of living delphinium plants that he had bred and altered with colchicine, drawing parallels between the authentic aliveness of his photography and flower breeding. The exhibition followed his motto "art for life's sake"; the museum "reduced to showing 'art for art's sake,' to Steichen . . . [was] a mausoleum" (Gedrim 2007, 353). Steichen drove the blooms to MoMA in a refrigerated truck, and the display during the eight-day show needed to be occasionally refurbished. The museum took care to "avoid confusion; it should be noted that the *actual* delphiniums will be shown in the museum, not paintings or photographs of them" (Museum of Modern Art 1936).

The artist's desire to see purposeful genetic mutation applied to plant breeding recognized as art seems to be correlated with shipping and customs issues he had previously encountered. It is reported that Steichen was involved in an exhibition at MoMA for which he shipped Constantin Brâncuși's *Bird in Space* (1923), which was refused both duty-free entry into the United States and status as a work of art because of its lack of representative qualities, since "no feathers were visible" (Gedrim 2007, 350). Steichen's battle against the $600 penalty is therefore to be seen as a part of a larger battle to redefine aesthetics. However, his delphiniums were not for sale as art "objects," and his MoMA works "survived" as unsalable photo documentation only before they later appeared beyond the confines of the art market, in the form of commercially available, affordable seed packs under the name *Delphinium Steichen strain mix*.

Half a century later, Steichen has been rediscovered and rehabilitated as the precursor of biotechnological art by George Gessert, a painter who exchanged brushes for genetic plant hybridization in the early 1980s. In his installations of "inverted Darwinism," Gessert selects plants diametrically opposed to dominant aesthetics and the "laws" of the market. But in the age of molecular genetics and after the horrors of World War II's human experimentations, his arrangements trigger, behind their facade of beauty, reflections on eugenics and genetic selection driven by politics or fashion (Gessert 2003). Downplaying human centrality, he acknowledges "insects and wind" as equal nonhuman co-creators (fig. 6.1) and insists on keeping his seeds "out of the marketplace" and away from art collectors.[1] Instead, for him the "art to scatter" consists of inserting his hybrids into the ecological cycle: sowing seeds, sending pollen or plants to people, or transplanting them at unexpected urban or wilderness places (Gessert 1993).

PACIFIC COAST NATIVE IRIS

Hybrids by Insects, G. Gessert, and Wind

Figure 6.1 George Gessert (American, b. 1944), *Pacific Coast Native Iris*, 1991. Seed pack, 9.5 × 13.7 cm. Private collection. Photo: Jens Hauser

Despite the formal similarities, significant changes have occurred with the general shift from objecthood to process-based art linked to the cybernetic paradigm in the second half of the twentieth century. Lucy Lippard described a phenomenon she called the "dematerialization of the art object" whereby a greater focus is placed on conceptual artistic thought and processes than on collectible objects (Lippard 1973). Similarly, Jack Burnham's *Beyond Modern Sculpture* (1968) aptly anticipates what biomedia art will become in an era of technical media competence, interest in scientific insights, awareness of ecosystems, and the desire to biotechnically create "aliveness." Burnham examines the evolution of sculpture over the last twenty-five hundred years and states that art's survival depends on its transition "from a psychically-impregnated totemic object toward a more literal adaptation of scientific reality via the model or technologically inspired artefact," then to "life-simulating systems through the use of technology" and "away from biotic *appearances* toward biotic *functioning* via the machine" (Burnham 1968, 76). Influenced by cybernetics,

environmental concerns, and Ludwig von Bertalanffy's systems biology (Bertalanffy 1949), Burnham hoped that such art would encourage spectators to adopt a holistic view and develop environmental consciousness—not contra but qua technology. It is unlikely, however, that he anticipated the incredible variety of biotechnology-based art today, and all its consequences for staging, conservation, and transport (fig. 6.2).

An ideal-case scenario in which a work of biomedia art may be seamlessly shipped and staged alive, and be functionally conserved in its potential to be reenacted whenever needed, is the rare exception. From a curatorial standpoint, this means that a large part of exhibition budgets is dedicated to regrowing potentially rotting and fragile ephemerals and facilitating a greater number of artist visits, since works constantly face the threat of contamination, deterioration, or death. Diligent curatorial work requires time and effort be spent negotiating specific local laboratory infrastructures, sometimes more than a year in advance, endless legal and bioethical paperwork, perpetual shipping and customs problems, and manifold technical, ethical, and legal challenges to maintain literally alive art.

Staging biomedia art is, technically, most challenging when artists insist that their work has to be shown alive. This often overexerts, and sometimes voluntarily challenges, the museum's ability to provide the needed infrastructure for works that fall outside standard display methods. Regular care and maintenance by specially trained assistants is necessary. In addition, the health and safety and ethics regulations for the public display of materials such as tissues or GMOs are not the same in every country. Living organisms are sometimes euthanized by museums after an exhibition against the artist's will in order to comply with animal health inspection and quarantine rules—even after organizing gallery talks that glorify interspecies empathy. Legally, some works may even be shown only "in transit" on their way to authorized labs. Common practices such as loan agreements or condition reports encounter obstacles when the work consists largely of ephemeral, living, or perishable entities and customized or borrowed laboratory equipment. At the same time, these institutional limitations push artists to consider showing simulacra, documentation, or remnants instead of the actual "alive" artwork.

Conservation of art that deals with the manifold characteristics of the living, such as metabolism, growth, reproduction, or mutation, unfolds per se as paradoxical. Functional preservation of works may be possible in cases where the artist establishes precise protocols for

Conservation

functional preservation

cryoconservation

plastination

ethanol/formaldehyde

multi-modal conservation

artistic intention decay/deterioration/death/loss

scores/sketches/scripts loan agreement insurance

narratives, paratexts, relics/physical remains
media reaction

documents authorized lab handling
(photo/film/video/audio) GMO rules health & biosafety

reenactment simulacrum veterinarian rules
 legal issues

biofabrication issues pest regulations

institutional infrastructures

physi(ologi)cal audience interaction

self-experimentation

a/live biological process

Staging

Transport

shipping living organisms

shipping biomaterials

customs issues

Figure 6.2 Overview of issues occurring with staging, conservation, and transport of biomedia art. Jens Hauser, 2019

reenactment. However, an ongoing debate among protagonists in the field is whether a biological entity should be preserved, plastinated, or taxidermied after its performative display. Instead of the actual artwork, documentation, scores, sketches, and other mediated paratexts are increasingly deployed and produced by artists aware of institutional constraints (Hauser 2008). In some cases, technical solutions are conceived for collectors to preserve the work's apparent "aliveness" even in the event of its biological death.

The *transport* of such works—including actual organisms, organic matter, or biological samples such as genetic sequences, plants, or tissue—can often not be handled by regular art shippers. Instead biomedical companies must transport them from lab to lab. Additionally, customs declarations may require different details to be reported when such art travels across international borders, conforming to national policies in regard to biodiversity, ethics, veterinary, phyto-sanitary, or pest regulations. The following short case studies illustrate some of these issues and solutions.

A striking example of how GMO regulations affect biomedia art differently, even across countries within the otherwise homologized space of the European Union and associated countries, is Jun Takita's bioluminescent sculpture *Light, only light* (2003). The work is meant to be experienced by visitors in total darkness, and consists of a 3D print of the artist's brain covered with moss containing a genetic sequence from the firefly. Confronting the viewer with a light-emitting plant, materializing the historical association of light with life, Takita presents the transgenic as an ambiguous cognitive achievement of the human brain. The brain shape is strongly reminiscent of skull motifs seen in vanitas and memento mori paintings. Initially developed as a fully functioning version, perceivable with the naked eye, for the exhibition *sk-interfaces* at FACT art center, Liverpool (Takita 2008), thousands of pounds and many months were spent developing the piece with a team of Japanese scientists and a supporting lab in Leeds. After discussions with the UK Department for Environment, Food and Rural Affairs, and just a week before the opening, the art center reconsidered the artwork. Despite being double-contained

in a specially built Plexiglas case and displayed in a closed gallery, potential release of spores into the environment could not be 100 percent excluded "in the event of a systems failure." And although given that "the chance is slight and that if such an event were to occur it would constitute a category 1 (low) release," this was a risk they were unwilling to take.[2] As a result, *sk-interfaces* only included a non-glowing, non-GMO simulacrum—a fact disclosed to audiences.

A few months later, however, a fully functional version of *Light, only light* made its debut as part of the Article Biennale in Stavanger, Norway (fig. 6.3).[3] Here, the glowing brain sculpture was shown in the lantern room as the only form of illumination at a coastal lighthouse, where visitors were invited in to contemplate the stunning effect. This time, the organizers had decided to operate in a legal gray zone by displaying *Light, only light* "in transit." A permit for contained use of genetically modified plants was obtained with the condition that the transgenic moss, after having been sent from Leeds to a laboratory in Uppsala, Sweden, and driven over the border by the artist himself, would be autoclaved at a laboratory at the University of Stavanger.

Figure 6.3 Jun Takita (Japanese, b. 1966) prepares his installation *Light, only light* (2003) for display in the Tungenes lighthouse near Stavanger, Norway, 2008. Photo: Jens Hauser

And finally, no regulatory issues at all occurred during the next venue of the *sk-interfaces* exhibition, Casino Luxembourg. In close coordination with that country's Ministry of the Environment and taking the issue seriously several months before the opening, the venue deemed Takita's piece as not presenting any danger of unintended release, and organized popular weekly demonstrations of the moss glowing in a specially constructed gallery room.

Luxembourg's decision might have been influenced by a precedent: the official authorization obtained for another transgenic art piece to be shown at the same exhibition: Eduardo Kac's *Natural History of the Enigma* (2009). This work involves the creation of a transgenic "plantimal" by combining human and plant DNA to produce a genetically engineered flower: a molecular hybrid of the artist himself and a petunia, called *Edunia*. In this new strain, the artist's DNA extracted from his blood produces a human protein in the red veins of the flower. Ironically, the actual plant could not be displayed at Casino Luxembourg either, only as photographic representation. While all applications to Luxembourg's state authorities regarding the import of genetically modified organisms and phyto-sanitary risk management were successful, the flower was ultimately not shipped. The Weisman Art Museum at the University of Minnesota, Minneapolis, which commissioned the work, claimed a last-minute loan fee of $3,500 to $4,000 to prepare paperwork and packing for the loan, in addition to the pretense "that the usual lead time needed for us to approve a loan is at least twelve months prior to the opening."[4]

It is understandable that artists who struggle for their work to be shown alive mock museums' inefficiencies to provide the required infrastructure and increasingly conceive of their participation in large exhibitions as deliberate institutional critique. A recent example shows how the Tissue Culture & Art Project, a protagonist of biomedia art for the last two decades, challenged the Centre Pompidou in Paris by staging work that brands museums as the ultimate necropolis. Referencing Samuel Butler's *Erewhon* (Butler 1872), their piece *(for art is like a living organism). . . Better Dead Than Dying* (2014, fig. 6.4) consists of a closed bioreactor where cancerous HeLa cells grow a miniature figurine shaped after Henrietta Lacks, the person from whom this cell line originated (Skloot 2010). However, the bioreactor is specifically designed with limited nutrients and without a waste removal system, so that it becomes, purposefully, a death chamber. Tissue Culture & Art Project cofounder Oron Catts explained the ironic design of the piece included in the 2019 *La Fabrique du vivant* show as a reaction to previous correspondence, revealed in public, with Centre Pompidou's curators: "I am afraid it would be difficult to realize a living installation work as part of the show *Designing the Living* at the Centre Pompidou."[5]

Figure 6.4 The Tissue Culture & Art Project (hosted @ SymbioticA, School of Human Sciences, the University of Western Australia) (Australian, founded 1996), *(for art is like a living organism). . . Better Dead Than Dying*, 2014. HeLa cells grown over a polymer structure in a custom-designed bioreactor vessel. Installation view at *La Fabrique du vivant*, Centre Georges Pompidou, Paris, 2019. Photo: Aniara Rodado, courtesy the artists

Another piece by the Tissue Culture & Art Project, *Victimless Leather* (2004), sparked headlines like "Murder at MoMA?" when the bioreactor growing miniature leather-like jackets out of immortalized animal and human cell lines had to be stopped due to unforeseen cell proliferation taking over the apparatus in MoMA's *Design and the Elastic Mind* show (Yap 2009). While the art died a month into the exhibition, the institution turned the failure to stage the piece as intended into a popular selling narrative. *Victimless Leather* was indeed performed successfully just before and after the MoMA exhibition at *sk-interfaces* in Liverpool and Luxembourg. Here, the question of the "afterlife" of the grown biotechnological garments was debated between the artists and the curator, resulting in the decision to have the surviving cell cultures plastinated (fig. 6.5), but to keep them strictly for documentation purposes—neither exhibit them in place of the actual piece, nor sell them.

Figure 6.5 The Tissue Culture & Art Project (hosted @ SymbioticA, School of Human Sciences, the University of Western Australia) (Australian, founded 1996), *Victimless Leather*, 2004. Tissue-engineered cell sculpture plastinated by Gilles Desraisses in 2010, 5 × 4.3 cm. Private collection. Photo: Axel Heise

In contrast, artist Brandon Ballengée has found a way to both carry out bio-artistic research and preserve material outcomes that can be collected. In *Species Reclamation via a Non-linear Genetic Timeline* (1998–2006, fig. 6.6, fig. 6.7) he aims at phenotypically re-creating an extinct aquatic frog species using closely related extant species by resurfacing historically described physical traits, resulting in "living sculptures" (Hauser 2010). They live their natural life span before being cleared and stained (a chemical process to reveal the animal's skeletal anatomy consisting of bones and cartilage), photographed, and sold as prints or as conserved specimens, ready to be released into glycerin, where their translucent members seem to gracefully swim.

Figure 6.6 Brandon Ballengée (American, b. 1974), *Species Reclamation via a Non-linear Genetic Timeline – An Attempted Hymenochirus curtipes Model Induced by Controlled Breeding*, 1998–2006. Preservation and storage kit for collectors, 9 × 20.4 × 20.4 cm. Private collection. Photo: Axel Heise

Figure 6.7 Brandon Ballengée (American, b. 1974), *Species Reclamation Via a Non-linear Genetic Timeline – An Attempted Hymenochirus curtipes Model Induced by Controlled Breeding*, 1998–2006. Preserved specimen in glycerin, 1.7 × 1.7 cm. Private collection. Photo: Axel Heise

An exemplary case of conservation of a complex synthetic biology-based work is *Living Mirror* (2013, fig. 6.8) by the artist duo C-Lab, which solves the challenge of optimizing a living biomedia piece so its function is preserved in potential perpetuity. *Living Mirror* uses magnetotactic bacteria's ability to swim along the Earth's magnetic field in order to create a living mirror image of the silhouette of its observer. Once an input image is translated into a magnetic field, the bacteria reorient their bodies in real time, causing light to scatter and create an image in a liquid bacteria culture. The piece draws on the myth of Narcissus, who fell in love with his own image in the water's reflection, and at the same time emphasizes contemporary science's discovery that human bodies are made up of a majority of nonhuman bacterial cells. The development of a collectible version in which this shimmer effect persists over time took several years—with bottles available for replacement in case of anomalies. Even if the bacteria die, whatever nanomagnetic chain they created would remain intact beyond their death.

Figure 6.8 C-Lab (British, founded 2003), *Living Mirror*, 2013. Mirror consisting of glass vessels with magnetotactic bacteria in liquid medium, camera, approx. 80 × 90 cm. Collection of Wiyu Wahono. Installation view, Ars Electronica, Linz, Austria, 2019. Photo: Adam Brown

An early art piece involving tissue culture, Art Orienté Objet's *Artists' Skin Cultures* (1996, fig. 6.9), is curious with regard to conservation and transportation issues. Initially grown out of the artists' epidermal cells grafted onto pig dermis and tattooed with motifs of lab model organisms and endangered species, these trans-species totems were supposed to be offered for grafting to collectors, but were finally conserved in formaldehyde and sold. Ironically, although the pieces were made in the United States in 1996, they could not be shipped back from France for the *MATTER(S) matter(s): Bridging Research in the Arts and Sciences* show at the Eli and Edythe Broad Art Museum at Michigan State University, Lansing, in 2018. Since formaldehyde is flammable, no art shipper agreed to take this on, and companies specializing in shipping biological samples refused to transport the work due to its hybrid human-animal nature. This necessitated applying for a special permit from the US Department of Agriculture and involved a monthslong process. Previously, when shipping the work to Australia, a workaround was created whereby the customs declarations contained different descriptions on the way in and out: while "pig cells" were disguised under more generic "human and animal cells" on the way to Australia, only cells labeled "domestic pigs" were sent back to France, since shipping human cells would have caused legal complications.

The worst-case scenario consists of loss or theft during transport resulting from the use of companies not specialized in art shipping nor offering adequate insurance coverage. Take Tagny Duff's *Cryobook Archives* (2010) as such an example. The *Cryobook Archives* are frozen sculptures made of human skin. It takes weeks to prepare the packages to meet international shipping standards for biological samples, and they can only be shipped from lab to lab as research items. Since no art shipper was willing to transport living biological samples on dry ice, as required for this work, the pieces were shipped via FedEx from Canada to France and simply disappeared in transit. While the box with the dry ice arrived, all the fleshy sculptures were missing without any explanation (they had last been tracked at the FedEx hub in Memphis). The artist speculated that maybe "an underpaid chain worker believed this to be a precious organ, worth thousands of dollars on the black market," or that "customs or state authorities considered the art piece to be suspicious and infectious."[6]

The difficulties with regard to staging, conservation, and transport should not, however, be treated as a straightforward grid of practical problems to solve in order to enable museums to stage new "living images." The conceptual challenges are philosophically most inspiring

Figure 6.9 Art Orienté Objet (French, founded 1991), *Artists' Skin Cultures*, 1996. Tattooed tissue sculptures conserved in formaldehyde, approx. 10 × 15 cm. Private collection. Photo: Courtesy the artists

and point as much to profound changes in contemporary art practices as to institutions' incapacity to adapt and evolve accordingly. Phenomena that once took the form of artistic images are being fragmented into a variety of instances of "biomediality" (Hauser 2014a; Hauser 2016), which need to be considered an integral part of the aesthetic idiom—including the challenges, intended or not, prone to exasperate and disrupt museum routine.

Acknowledgments

This paper has been supported by a Continuing Professional Development grant from the Gabo Trust for Sculpture Conservation.

NOTES

1. George Gessert, personal letter to the author containing a selection of seeds resulting from artistic hybridization, 2008.

2. Email communication between FACT, the curator, and the author, January 24, 2008.

3. The author co-curated this biennale.

4. Internal email communication between the Weisman Art Museum and the author, November 5, 2009. This museum was the original commissioner of the work and did not anticipate all the problems that would accompany its great success. It was flooded with loan requests from all over the world, and email communications seem to demonstrate that it hoped to discourage requests for loans by putting up new hurdles each time one issue was solved. It the end, the museum let the artist handle all further shows alone.

5. Oron Catts at the Behavioral Matters conference, March 29, 2019, Centre Pompidou, Paris.

6. Tagny Duff, "Cryobook Archive," explanatory text displayed at Espace multimédia Gantner, Bourogne, France, 2015.

BIBLIOGRAPHY

Appelbaum 2007
Appelbaum, Barbara. 2007. *Conservation Treatment Methodology.* Oxford: Butterworth-Heinemann.

Bertalanffy 1949
Bertalanffy, Ludwig von. 1949. *Das biologische Weltbild. Band 1. Die Stellung des Lebens in Natur und Wissenschaft.* Bern, Switzerland: Francke. English version published as *Problems of Life: An Evaluation of Modern Biological Thought.* New York: John Wiley & Sons, 1952.

Burnham 1968
Burnham, Jack. 1968. *Beyond Modern Sculpture: The Effects of Science and Technology on the Sculpture of This Century.* New York: George Braziller.

Butler 1872
Butler, Samuel. 1872. *Erewhon: or, Over the Range.* London: Trübner and Ballentyne.

Gedrim 2007
Gedrim, Ronald J. 2007. "Edward Steichen's 1936 Exhibition of Delphinium Blooms: An Art of Flower Breeding." In *Signs of Life: BioArt and Beyond*, edited by Eduardo Kac, 347–69. Cambridge, MA: MIT Press. First published in *History of Photography* 17, no. 4 (1993): 352–63.

Gessert 1993
Gessert, George. 1993. *Scatter.* Eugene, OR: Green Light.

Gessert 2003
Gessert, George. 2003. "Notes sur l'art de la sélection végétale." In *L'art biotech*, edited by Jens Hauser, 47–55. Nantes, France, and Trézélan, France: Filigranes.

Hauser and Strecker 2020
Hauser, Jens, and Lucie Strecker, eds. 2020. "On Microperformativity." *Performance Research: A Journal of the Performing Arts* 25 (3): https://www.tandfonline.com/doi/full/10.1080/13528165.2020.1807739.

Hauser 2006
Hauser, Jens. 2006. "Biotechnology as Mediality: Strategies of Organic Media Art." *Performance Research: A Journal of the Performing Arts* 11 (4): 129–36.

Hauser 2008
Hauser, Jens. 2008. "Observations on an Art of Growing Interest: Toward a Phenomenological Approach to Art Involving Biotechnology." In *Tactical Biopolitics: Art, Activism, and Technoscience*, edited by Beatriz Da Costa and Kavita Philip, 83–103. Cambridge, MA: MIT Press.

Hauser 2010
Hauser, Jens. 2010. "Sculpted by the Milieu: Frogs as Media." In *Praeter Naturam. Brandon Ballengée*, edited by Claudio Cravero, 38–41. Turin, Italy, and Biella, Italy: Eventi & Progetti Editor.

Hauser 2014a
Hauser, Jens. 2014a. "Biotechnologie als Medialität – Strategien organischer Medienkunst." PhD diss., Ruhr Universität Bochum.

Hauser 2014b
Hauser, Jens. 2014b. "Molekulartheater, Mikroperformativität und Plantamorphisierungen." In *Wahrnehmung, Erfahrung, Experiment. Wissen, Objektivität und Subjektivität in den Künsten und den Wissenschaften*, edited by Susanne Stemmler, 173–89. Zurich: Diaphanes.

Hauser 2016
Hauser, Jens. 2016. "Biomediality and Art." In *Artists-in-Labs: Recomposing Art and Science*, edited by Jill Scott and Irene Hediger, 201–19. Berlin: Springer.

Lippard 1973
Lippard, Lucy R. 1973. *Six Years: The Dematerialization of the Art Object from 1966 to 1972.* New York: Praeger.

Museum of Modern Art 1936
Museum of Modern Art. 1936. "Press Release: Steichen Delphiniums." June 22, 1936. New York: Museum of Modern Art. https://assets.moma.org/documents/moma_press-release_325057.pdf.

Salter 2010
Salter, Chris. 2010. *Entangled: Technology and the Transformation of Performance.* Cambridge, MA: MIT Press.

Serexhe 2013
Serexhe, Bernhard, ed. 2013. *Preservation of Digital Art: Theory and Practice: The Digital Art Conservation Project.* Vienna: Ambra V.

Skloot 2010
Skloot, Rebecca. 2010. *The Immortal Life of Henrietta Lacks.* New York: Crown.

Takita 2008

Takita, Jun. 2008. "Light, only light." In *sk-interfaces. Exploding Borders: Creating Membranes in Art, Technology and Society*, edited by Jens Hauser, 141–43. Liverpool, UK: Liverpool University Press.

Yap 2009

Yap, Chin-Chin. 2009. "Murder at MoMA?" *ArtAsiaPacific* 62:49–50.

Working with the Artist: Between Conservation and Production

Preserving Mortality through a Sacrifice for Your Country: A Performance by Carlos Martiel and a Conservator's Challenge

Flavia Perugini

Award Martiel, Carlos (2014) by Carlos Martiel, a living Cuban performance artist, consists of a piece of skin removed from the artist's body and sealed in a gold medal after desiccation. The medal, coupled with a video of the surgery, was made for the 2014 Cisneros Fontanals Art Foundation (CIFO) Grants and Commissions Program exhibition Fleeting Imaginaries. *The project was a collaboration of experts with different backgrounds. Pathologists and hospital laboratories were contacted for information on skin preservation. Natural history and medical collections were investigated to learn about the treatment of animal and human remains. Tattoo museums, leather manufacturers, and taxidermy practices were contacted. Professionals from various fields offered their knowledge and input to help make the project a success.*

◆　　◆　　◆

The Museum of Fine Arts, Boston, is one of the largest encyclopedic collections in the United States, holding about 450,000 artifacts ranging from ancient to contemporary art. It sees a very active program of exhibitions, loans, and tours, and occasionally collaborates with other institutions or collections on special exhibitions and events. In 2013 it partnered with the Cisneros Fontanals Art Foundation (CIFO), a nonprofit organization based in Miami, to organize the 2014 exhibition at the MFA titled *Permission to Be Global / Prácticas Globales: Latin American Art from the Ella Fontanals-Cisneros Collection*. In early 2014, while preparing for the show, CIFO's (now

former) collection manager, Diego Machado, approached this author about preserving human skin for a piece that would be a part of an (unrelated) CIFO grant and commission program. He explained that the Cuban artist Carlos Martiel, one of ten artists participating in an upcoming exhibition titled *Fleeting Imaginaries*, intended to have a piece of skin removed from his body, preserved, and encased in a medal he had designed. Martiel, who had been planning this event as a performance for several years, only had six months to realize the plan and understood that the process required further study and specific steps to be followed. He had been advised to

contact a taxidermist to help with the treatment, but he felt that taxidermy was not the appropriate approach. The request for collaboration was accepted, and research on the unfamiliar topic of practical live human skin preservation began.

THE CISNEROS FONTANALS ART FOUNDATION

CIFO was founded by Ella Fontanals Cisneros in 2002 to promote and support Latin American contemporary art. The foundation serves as a platform for living Latin American artists through its many national and international programs, such as the Grants and Commissions Program, the Traveling Exhibitions Program, the CIFO Collection, and more. Fontanals Cisneros is CIFO's founder and honorary president, and Liz Munsell, curator of contemporary art at the MFA, serves as a CIFO advisory committee member. To date, the foundation has exhibited the work of more than 130 Latin American artists and awarded grants amounting to more than $1.5 million.

CIFO's 2013–14 Grants and Commissions Program explored the theme of displacement—literal, conceptual, and fragmentary, through fluctuation and transformation. Ten artists selected from a pool of applicants each received a grant to create an artwork that would be shown in *Fleeting Imaginaries*, running September 5 through November 2, 2014. The recipients were Pablo Accinelli (Argentina), Teresa Burga (Peru), Nayarí Castillo (Venezuela), Claudia Joskowicz (Bolivia), Marcellvs L. (Brazil), Carlos Martiel (Cuba), Mateo Pizarro (Colombia), Adrián Regnier (Mexico), Rosângela Rennó (Brazil), and Antonieta Sosa (Venezuela).

CARLOS MARTIEL

Carlos Martiel (fig. 7.1) was born in 1989 in Havana. In 2009 he graduated from the Escuela Nacional de Bellas Artes San Alejandro, and between 2008 and 2010 he studied under the guidance of Cuban performance artist Tania Bruguera. Since 2007, Martiel, who currently lives between New York and Cuba, has performed extensively in the Americas, Cuba, Europe, and North Africa. He has participated in many biennials, such as the Venice Biennale, and performed in many important museums and galleries. Martiel's work highlights social, economic, and racial matters, such as discrimination, migration, and power relations. In his performances the artist subjects himself to extreme physical and psychological conditions. Blood and skin piercing are common in many of his

Figure 7.1 The artist Carlos Martiel, Miami, 2014. Photo: Daniel Godoy/Farisa Co, with permission by the artist Carlos Martiel

performances, and so having a piece of skin removed from his body was an extension of this practice and did not seem unusual for the artist.

Martiel had originally planned this project back in 2010, but due to logistical complications, on that occasion he ended up performing a work titled *Prodigal Son*, in which he pinned medals his father had earned through military achievement onto his bare chest. Both the 2010 and the rescheduled 2014 performances were intended to illuminate Cuba's racial problems, specifically its systemic and institutional racism toward Afro-Cubans.[1] Despite Fidel Castro's attempts to end racial discrimination at the end of the 1950s, it continues to affect people of color in Cuba; they are ostracized and/or segregated and lack social supports. In this 2014 work, Martiel would "award" himself a gold medal similar to those given by the government to state officials and the military, such as his father.

RESEARCH

While researching for this project, it soon became evident that medical professionals don't commonly assist artists who want to use their bodies in such a manner. Many universities and medical facilities in the Boston area were contacted for advice on the preservation of human specimens, but little to no information was gathered; indeed, some commented that, in their opinion, the artist was irrational and attempting something that no medical professional should get involved with. The Hippocratic oath involves swearing "to treat the ill to the best of one's ability," and thus, the prospect of a healthy patient wanting a piece of healthy skin surgically removed and desiccated for an art project would be inappropriate, even unethical.

Meanwhile, internet research yielded different and more useful results. Medical articles revealed that since the nineteenth century, doctors around the world have been involved with skin removal to preserve tattoos, albeit from deceased people. Today many museums associated with hospitals and universities host collections of tattooed skin, not all of which are for medical research purposes. A query was posted on the Global Conservation Forum—at that time called the Conservation DistList—in hopes of acquiring more relevant advice. Surprisingly, an inundation of replies from professionals such as conservators and biologists who had worked on skin or were familiar with processing human specimens provided the necessary directives.

SKIN PREPARATION TECHNIQUES

Skin preparation is executed in different manners, depending on factors such as whether the skin is of human or animal origin, and whether the whole body is available or only parts of it (Kite and Thomson 2006). Mummification is one method that has been practiced in several countries since early civilization. The procedure consists of exposing a body to drying elements such as salts that absorb water from the body and desiccate it (Spindler et al. 1996). The desiccated bodies remain susceptible to moisture in the environment. Mummification was not considered appropriate for this project due to the lack of control over the specimen's results and the length of time the process requires.

In the case of treatment of animal skin, any of the following three methods may be employed: taxidermy, tanning, or rawhide (Grantz 1969). *Taxidermy* is a process that preserves an animal's exterior body. The animal skin, with fur or feathers, is separated from the flesh and bones and then stuffed to give shape back to the body. *Tanning* is used for leather production, whereby a skin undergoes exposure to many liquids and extensive manipulation; it involves salting, soaking, liming, un-hairing, de-liming, and/or pickling. Liming involves extensive alkaline baths to remove hair, fat, and flesh and soften the skin, followed by acidic baths for the purpose of neutralization. Production of *rawhide* consists of removing the skin from the animal body and stretching it over a frame for air drying. This process is also used to make parchment. These three treatments leave the dehydrated skin reactive to moisture and susceptible to biological degradation.

The treatment of human tissues differs from that of animal tissue and may involve plastination, freeze-drying, or solvent drying (Brenner 2014). *Plastination* involves fixing a human specimen in formalin (a preservative for human and animal tissue specimens that prevents degradation and mold formation), followed by flooding it with acetone, and subsequently impregnating it with polyethylene glycol (PEG), silicon rubber, polyester, or other polymers. This system is typically used by embalmers and achieves long-lasting results (Quigley 2015). Plastination is the only method that renders the skin a little more resistant to humidity, although it doesn't completely protect from mold growth. *Freeze-drying* is carried out with a process called lyophilization: the specimen is gently frozen and water is extracted in the form of vapor using a high-pressure vacuum. A gradual temperature rise extracts all remaining "bound" moisture from the specimen. This treatment is also used in conjunction with taxidermy. The main drawback to this method is that a dried specimen remains very susceptible to fluctuations in relative humidity. In *solvent drying*, the skin is separated from flesh and fat to reduce the possibility of putrefaction. After fixation in formalin, the tissues are bathed in a drying solvent solution that is adjusted daily until all water has been removed.

Solvent drying was ultimately selected for the treatment of Martiel's skin, due to its ease of execution and affordability.

EXPERIMENTATION

With only one chance to remove a piece of skin and succeed in its dehydration, experimentation was necessary to understand the physical behavior of skin removed from a live body. For practical reasons, the experiments were carried out on animal skin. Pig skin has similar characteristics to human skin, and was therefore selected. Arrangements were made for the conservator to visit a

local farm on a day when pig slaughtering was scheduled. Suitable skin was identified on the necks of three pigs, which varied in color. Following slaughter, the skin specimens were extracted and placed in a glass container with distilled water for transportation in a cooler. Upon arrival at the conservator's studio, the skin was rinsed in fresh distilled water and small sections were cut for the experiments. For safety reasons, formalin was not used in this instance due to its toxicity, although it would be used to preserve the final human specimen. The outlines of these skin samples were marked on paper to track any dimensional changes that might occur during the tests.

Over the course of ten days, the skin was bathed in a distilled water and ethanol solution that was changed daily to facilitate the drying process. Afterward the pieces of skin were cut into smaller sections and allowed to slowly air dry in a controlled environment. The edges were stapled onto a plain cardboard support covered with a sheet of Volara, a closed-cell polyethylene foam, to prevent curling or warping.[2]

These experiments were repeated three times to ensure consistency in the results. After drying, consistent shrinking in all directions was observed and calculated at around 1 or 2 percent. This information was shared with the artist in preparation for the surgery.

With this new information, the artist revised his initial idea of having a tattoo removed and dehydrated; given the small size of the medal that would contain the specimen, Martiel realized that the shrinking of the skin would make the tattoo illegible. He decided to have an un-tattooed piece of skin removed and to get a new tattoo consisting of the title of the work—*Award Martiel, Carlos*—applied after the surgery, near the scar.

THE SURGERY AND SKIN TREATMENT

With a clear list of appropriate steps required to execute this project and a timeline in place, the surgery was scheduled for July 9, 2014 (fig. 7.2). The event was filmed and photographed by Daniel Godoy, a professional filmmaker and producer. Godoy also filmed an interview with the artist for a possible documentary on art and social issues.

Figure 7.2 The artist before the surgery with Doctor Flor Mayoral, Miami, 2014. Photo: Daniel Godoy/Farisa Co, with permission by the artist Carlos Martiel

Doctor Flor Mayoral, professor in the Department of Dermatology and Cutaneous Surgery at the University of Miami Miller School of Medicine, was selected to perform the surgery. An artist herself and a friend of Fontanals Cisneros, Mayoral was interested in the project and actively participated in the conversations with the conservator throughout the process. Knowing that the medal was 45 mm in diameter, she marked Martiel's skin on the left side of his waist accordingly. The area of the incision was selected based on Langer's lines, which determine where a surgeon should cut the skin to obtain the least invasive scarring and optimal healing.[3] The measurement was determined by considering the shrinking of the skin upon removal from the body, as well as the age of the patient; being in his early twenties, he had healthy and very elastic skin. It was calculated that after surgery the skin would shrink at least 1 percent, and about the same amount or a little more after drying.

Upon removal (fig. 7.3), the piece of skin was cleaned with a scalpel to remove deposits of fat, which would have encouraged putrefaction and thus compromised the desiccation and preservation of the specimen. The piece of skin, which measured about 3 mm in thickness (fig. 7.4), was placed in a sterile cup containing formalin. After twenty-four hours, the specimen was removed from the cup, rinsed in distilled water, and placed in a new sterile container with distilled water and ethanol. This solution was replaced daily over the course of ten days.

Figure 7.3 Skin specimen after being cut. Photo: Daniel Godoy/Farisa Co, with permission by the artist Carlos Martiel

Figure 7.4 Skin specimen being measured after removal. Photo: Daniel Godoy/Farisa Co, with permission by the artist Carlos Martiel

Figure 7.5 Preparation for the skin dehydration process. Photo: Daniel Godoy/Farisa Co, with permission by the artist Carlos Martiel

The specimen appeared oval in shape. This was likely due to the fact that the marking on the skin had been carried out with the artist standing up, and the marked circle had become distorted when he lay down on the operating table. Overall, the width of the specimen was about 40 mm at the largest point and about 35 mm at the narrowest.

After bathing, the piece of skin was prepared for the slow air-drying process (fig. 7.5). The specimen was placed face-down onto a biological mat and pinned in place with entomology steel pins, slightly pulling out the edges to gently restore a circular shape, which proved successful.[4] After drying, the specimen appeared darker in color and smaller in size (fig. 7.6) as predicted, and measurements confirmed the desired size of 20 mm in diameter (fig. 7.7).

Figure 7.6 Air drying the skin specimen. Photo: Daniel Godoy/Farisa Co, with permission by the artist Carlos Martiel

Figure 7.7 Measuring the dehydrated specimen. Photo: Daniel Godoy/Farisa Co, with permission by the artist Carlos Martiel

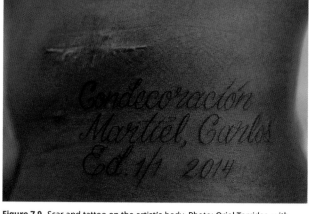

Figure 7.9 Scar and tattoo on the artist's body. Photo: Oriol Tarridas, with permission from the artist and CIFO, Miami

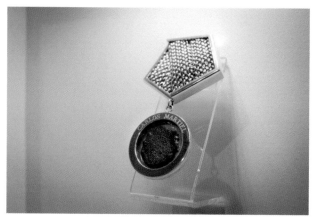

Figure 7.8 The skin specimen in the medal. Photo: Oriol Tarridas, reproduced by permission of CIFO, Miami

The specimen was inserted in the medal just in time for the opening reception of *Fleeting Imaginaries* at CIFO, Miami, on September 5, 2014. The final work, titled *Award Martiel, Carlos*, comprised the medal containing the skin (fig. 7.8), a video of the surgery, and an image of the artist's scar and tattoo (fig. 7.9). At the end of the show, the medal containing the skin was packed in archival materials and retired to the CIFO's environmentally controlled storage facilities.

CONCLUSION

Martiel's performance was originally planned in 2010 but not executed until four years later due to a lack of resources and information. Communication between the artist, CIFO's staff, the conservator, the surgeon, and many other parties was extensive and highlighted the need for everyone to be in conversation at all times. The artist's wound healed well and the skin was successfully preserved. Through this performance, Martiel used his CIFO grant to shed light on the social effects of segregation in Cuban society. By placing a piece of his skin into a gold medal, he highlighted the importance of Afro-Cuban influence in Cuba's social structure and provided a platform for Afro-Cuban artists.

The preparation of biological specimens is complex and requires a clear understanding of the available processes, the behavior of the specimen, and the characteristics of the results. Without extensive research, conversations with several professionals, and numerous trials, the project would likely not have been possible. The conservator's involvement, which began with thorough research and practical experiments, allowed for the most appropriate skin preservation method to be selected, and for more control over the dehydration of the skin. Close collaboration between the conservator and the surgeon was crucial in the calculation of the size of the skin specimen to be removed, as well as in the treatment of the specimen, in order to obtain the best results.

Acknowledgments

The author wishes to thank Martyn Cooke, head of conservation, Royal College of Surgeons of England, UK; Jesse Meyer, Pergamena, Montgomery, New York; Emily O'Reilly, principal conservator paper, National Museum of Wales; Éloïse Quétel, conservator-restorer of ethnographic objects, France; and John Simmons, adjunct curator of collections, Penn State University.

NOTES

1. Martiel is Afro-Cuban. His father was able to join the army and get decorated for his merits, a particularly honorable matter for a Black Cuban. With this work Carlos sacrificed his skin for his father and for the country in an attempt to assert his place in Cuban society.

2. For more information on Volara see http://www.paccin.org/content.php?275-Volara-Crosslinked-Polyethylene-Foam.

3. A good summary is at Wikipedia: https://en.wikipedia.org/wiki/Langer%27s_lines.

4. A typical mat is pictured here: https://www.carolina.com/dissecting-pans-pads/vinyl-dissecting-pads/FAM_629006.pr.

BIBLIOGRAPHY

Brenner 2014
Brenner, Erich. 2014. "Human Body Preservation: Old and New Techniques." *Journal of Anatomy* 224 (3): 316–44. https://dx.doi.org/10.1111%2Fjoa.12160.

Grantz 1969
Grantz, Gerald J. 1969. *Home Book of Taxidermy and Tanning.* Harrisburg, PA: Stackpole.

Kite and Thomson 2006
Kite, Marion, and Roy Thomson. 2006. *Conservation of Leather and Related Materials.* Boston: Elsevier Butterworth-Heinemann.

Knoeff and Zwijnenberg 2016
Knoeff, Rina, and Robert Zwijnenberg, eds. 2015. "The Fate of Anatomical Collections." Special issue, *Social History of Medicine* 29 (4).

Quigley 2015
Quigley, Christine. 2015. *Modern Mummies: The Preservation of the Human Body in the Twentieth Century.* Jefferson, NC: McFarland.

Spindler et al. 1996
Spindler, Konrad, Herald Wilfing, Elisabeth Rastbichler-Zissernig, Dieter ZurNedden, and Hans Nothdurfter, eds. 1996. *Human Mummies: A Global Survey of Their Status and the Techniques of Conservation.* New York: Springer Science and Business Media.

Cross-Disciplinary Collaboration and Innovation in the Exhibition of Living Matter at the National Gallery of Zimbabwe: The Case of the *Planetary Community Chicken* Exhibition

Davison Chiwara

This paper describes the considerations involved in staging the 2016 exhibition Planetary Community Chicken *at the National Gallery of Zimbabwe, Harare. The undertaking was a collaboration between the Belgian artist Koen Vanmechelen; Chido Govera, a Zimbabwean entrepreneur; and museum staff. It included live chickens, chicken eggs, and fresh mushrooms. The exhibition of living matter in a museum environment poses numerous conservation challenges. In light of this, a spirit of innovation was demonstrated, and the Courtauld Gallery wing was transformed into a fowl run, an all-encompassing installation with appropriate conditions and facilities to support the rearing of chickens and the growing of mushrooms.*

◆　　◆　　◆

The National Gallery of Zimbabwe was officially established in 1952 through an act of parliament, and opened to the public in 1957 as a center for exhibiting sculptures, paintings, drawings, print works, and installations by Zimbabwean and international artists. It acquires traditional and contemporary art from local and international artists through loans, bequests, purchases, and donations, and likewise exhibits both traditional and contemporary art. An appropriate environment must be provided for the conservation of all artworks on view, and thus the exhibition of living matter as contemporary art can be a challenge due to its fragile and complex nature.

The exhibition team for the 2016 show *Planetary Community Chicken* was made up of Koen Vanmechelen and his exhibition crew from Belgium; Chido Govera, a Zimbabwean entrepreneur specializing in mushroom and poultry farming; Raphael Chikukwa, the exhibition's curator; and gallery staff from the Conservation and Collections, Exhibitions, Workshop, Education, and Public Programming departments. Vanmechelen and Govera

came up with the concept and provided the key resources, including the chickens and mushrooms. The role of Conservation and Collections was to preserve the exhibited elements as well as other artworks in the gallery. Workshop provided equipment and crew for the installation. Vanmechelen's crew and Exhibitions were responsible for designing the presentation and led the installation work. Education prepared learning materials, and Public Programming publicized the exhibition to the media, corporate and other sponsors, and the public.

Planetary Community Chicken was the first show of its kind in terms of exhibiting living matter at the National Gallery of Zimbabwe. Its goal was to leverage the museum as a respected public platform to empower people with the knowledge necessary to diversify their agricultural activities, specifically through the production of chickens, eggs, and mushrooms for self-sustenance (mushrooms are an excellent source of fiber and protein).

The idea was born of an urgency to educate citizens about the need to restock a local species of roadrunner, which had depleted due to diseases resulting from inbreeding. The chickens in the show were a new species resulting from the crossbreeding of Vanmechelen's cosmopolitan rooster with the Zimbabwean common chicken, also known as the roadrunner. The resultant offspring are less susceptible to disease, stress, and physiological problems than the roadrunner.

The intended audiences for the demonstrated food production system involving chickens and mushrooms were rural communities in Zimbabwe surrounding the capital city, Harare; the exhibition was connected to a social project of empowering residents. The new breed of chicken was donated to them to be used for crossbreeding with local chickens beyond the exhibition. One such community was Seke, where local residents successfully crossbred the chickens, produced eggs, and grew mushrooms. The production fulfilled their consumption needs, and the surplus was sold.

The exhibition was an intricate one, demanding a conscious conservation mindset to keep the chickens alive as well as ensuring that the chicken eggs and mushrooms remained fresh for the month-long duration of the show. Caution was also taken to prevent potential pest infestation of other artworks, especially those composed of organic materials, for instance sculptures, paintings, drawings, or prints made using wood or paper.

CONSERVATION CHALLENGES

Contemporary artworks containing biological materials such as food, bodily fluids and/or tissues, plants, animals, and animal parts pose specific challenges for museums, conservators, and collectors. They are prone to illness, decay, putrefaction, and eventual disappearance, which makes them difficult to exhibit and preserve for future museum visitors. In the case of this exhibition, numerous challenges presented themselves. Confinement of live chickens in an environment that is too hot or cold, without sufficient ventilation, without regular cleaning or hygiene, or without adequate feed or water can cause illness, stress, even death. A hot environment also causes the decomposition of chicken eggs. Mushrooms will likewise not survive if they are exhibited in an unregulated environment; overly hot temperatures, lack of humidity, or inadequate watering can all result in wilting and decomposition. In light of all this, the exhibition of live chickens, chicken eggs, and mushrooms required an understanding of issues that are vital for their preservation.

INNOVATION FOR THE CONSERVATION OF LIVING MATTER AND ARTWORKS

Pest Control

The exhibition team proactively addressed potential pest hazards. The nests prepared for the egg-laying chickens were to be made from logs gathered in the forest—these nests would be more cost effective for the gallery compared to buying specially prepared nests from the market—but they posed a greater possibility of pest infestation on both the chickens and other artworks made from organic materials. Thus, the nesting materials were treated with pesticides, then covered with black polyethylene sheets and placed for a prolonged time in the sun to kill any pests present (fig. 8.1, fig. 8.2a, fig. 8.2b). This was a low-cost method of preventing pest infestation in the gallery, since the museum had no fumigation chambers.

Figure 8.1 Spraying nests with pesticides. Photo: National Gallery of Zimbabwe

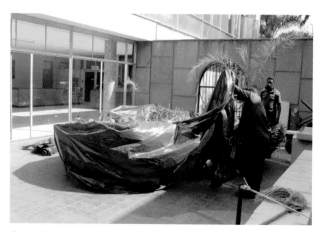

Figure 8.2a **Figure 8.2b**

Covering nests with polyethylene fumigation sheets. Photos: National Gallery of Zimbabwe

Additionally, the museum environment was disinfected to prevent the outbreak of diseases that affect chickens.

Mushrooms are a fungus whose spores could potentially harm some of the gallery's organic artworks. To prevent this, polyethylene bags were used for mushroom production, which helped to contain the mushroom spores and prevent them from entering the galleries (fig. 8.3a, fig. 8.3b).

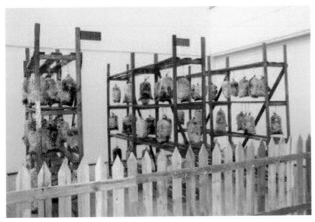

Figure 8.3a

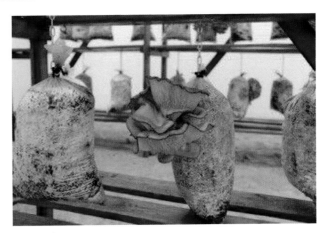

Figure 8.3b

Mushroom production in polyethylene bags. Photos: National Gallery of Zimbabwe

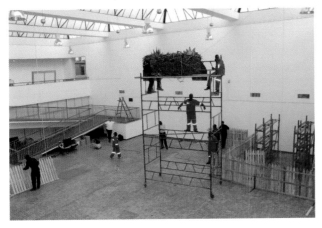

Figure 8.4a

Figure 8.4b

Installing *Planetary Community Chicken* at the Courtauld Gallery, National Gallery of Zimbabwe, Harare, 2016. Photos: National Gallery of Zimbabwe

Creating an Environmentally Friendly Atmosphere for Living Matter

The exhibition team created an all-encompassing installation, transforming the Courtauld Gallery wing into a representation of a farmyard (fig. 8.4a, fig. 8.4b) with enough space to allow free air circulation, which in turn created a cool environment, preventing stress and suffocation of chickens or rotting of the chicken eggs and mushrooms. The exhibition team added soil to the main ground-floor space along with a wooden palisade fence—an enclosure mirroring a typical fowl run. The fowl run allowed for free movement of the chickens and ample space for them to forage living organisms in the soil.

Govera was responsible for cultivation of the mushrooms. She noted: "We manipulate places around us into the right kind of incubators of the ideas or the activities we want to carry out. . . . Chickens were scratching on the floor, they

were mating, they were laying eggs, eggs were incubated." The transformation of the gallery's wing was in line with Amalia Kallergi's assertion that for an institution to host a living exhibition, it must undergo spatial modifications and introduce new routines and procedures into its normal practices (Kallergi 2008).

The gallery's transformation complied with the provisions of ICOM, which stress that, with regard to living collections, special consideration should be given to the natural and social environment from which they derive. Institutions should display live animals only if they can be looked after appropriately, and when they can form part of a positive message about nature for visitors (ICOM 2006, 10, 15; ICOM 2013, 3). The exhibition team did this by simulating a natural environment in which chickens and mushrooms can be cultivated successfully.

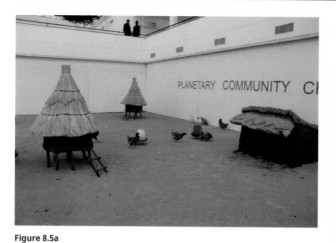

Figure 8.5a

Figure 8.5b

Zimbabwean and Senegalese chicken hutches. Photos: National Gallery of Zimbabwe

Installation of Chicken Hutches

The chicken shelters were two Zimbabwean-style hutches and two Senegalese-style hutches. According to Chikukwa, the curator, the juxtaposition was intended to show cross-cultural similarities in the rearing of chickens in these two countries. The similarities involve the use of dagga (an earthen structure made by molding clay mixed with water) and thatch. These materials help regulate temperatures, keeping chickens warm when temperatures are low, and cool when temperatures are high. The only difference is that the Senegalese hutches are elevated, whereas the Zimbabwean hutches are not (fig. 8.5a, fig. 8.5b).

Feeding of Chickens

The chickens foraged for food and other organisms found in the soil, but the exhibition team also provided supplementary feed and fresh drinking water to keep them healthy and thriving. Those responsible for this task acquired basic knowledge of domestic poultry rearing from an ordinary level agriculture subject (a practical subject offered at secondary schools under the Zimbabwe School Examinations Council).

The Preservation of Mushrooms

According to Govera, mushroom production is an indoor activity requiring an environment with sufficient humidity and air flow. She stated that the creation of this environment in the gallery was an interpretation of science in the form of art. The exhibition team provided shelves for the mushrooms and sand on the ground to maintain the required humidity. The mushrooms were kept fresh by watering them in the morning and evening throughout the duration of the exhibition. Mature mushrooms were harvested, and pieces of mushroom that fell to the ground were removed to keep the environment clean.

Govera further explained that they housed the mushrooms in polyethylene bags to keep them fresh (see fig. 8.3a, fig. 8.3b) and highlighted a long process that started with the humidification, pasteurization, and incubation of the bags before the gallery installation. Nutrients for mushroom growth were added to the bags as part of the incubation process.

IMPORTANCE OF COLLABORATION IN THE EXHIBITION OF LIVING MATTER

Cross-disciplinary collaboration was crucial in preserving living matter in the *Planetary Community Chicken* exhibition. In addition to the creative collaboration between artist Koen Vanmechelen and entrepreneurial mushroom and poultry farmer Chido Govera that led to the concept for the exhibition, staff members from the gallery's various departments were essential in executing and maintaining it. The involvement of people from different disciplines created a hub of ideas and skills as well as human and material resources for the successful exhibition of living matter. Everyone shared an understanding of the need to provide an environment suitable for preserving a living ecosystem. Govera, who has collaborated with Vanmechelen since 2012—their projects have been featured at the 2014 Havana Biennial and the 2015 Venice Biennale—states: "The key to a successful exhibition of chicken and mushrooms in the gallery was understanding and appreciation of each other's work. I have an

appreciation of [Vanmechelen's] work, and he has an appreciation of my work. It's just merging these two roles, which are complemented by Koen's artistic eye in the context of art. He is an exceptional artist who can transform anything into art."

Their long history of working together on international exhibitions made it possible for them to bridge their disciplines and collaborate in exhibiting living matter in *Planetary Community Chicken*. Their artistic collaboration was supported by the commitment of the gallery staff, who provided the needed person-hours, resources, and guidance on technical aspects. The exhibition of biological art poses complex issues, often requiring collaborative and interdisciplinary approaches to conservation. Beyond the artist's creative vision, other experts must provide technical knowledge and skills (DiNoia 2019; Kallergi 2008).

The involvement of experts from different disciplines enabled the museum to provide an environment and facilities that supported the preservation of living matter. This cross-disciplinary collaboration created an "innovation hub" for the preservation of live chickens, fresh eggs, and fresh mushrooms in the gallery. Innovative ideas emerged from this hub, transforming the Courtauld Gallery into an environment mirroring a real fowl run supporting live chickens and eggs and the growing of mushrooms.

Preventing any cruelty to the chickens was an important consideration in the overall design of the exhibition environment. The team's collaborative efforts provided key facilities and an environment that guaranteed the safety of the chickens. Cruelty to animals manifests in various forms such as physical harm, psychological pain, exploitation, health risk, and commodification of animals (Kaplan 2017). All these were prevented by the exhibition team; the chickens felt at home and looked healthy, with no signs of psychological or physical harm. With regard to the ethics of exhibiting living animals, institutions, artists, and art historians are entangled in tricky discussions about the rights and treatment of animals (DiNoia 2019). Such challenges were not encountered in *Planetary Chicken Community*, as the exhibition team observed the rights of the chickens through an environment that supported their survival.

CONCLUSION

The *Planetary Chicken Community* exhibition attracted many visitors from all walks of life. The exhibition showcased a project run by Chido Govera in rural areas to empower communities to be more self-sufficient in food production. The project on the crossbreeding of the chickens and the growing of mushrooms empowered communities with knowledge for rearing chickens and growing mushrooms for healthy nutrition and a source of livelihoods.

The exhibition fused science and art. It was a novel and challenging undertaking for the gallery, as it encompassed living matter that required the transformation of the gallery environment in order to preserve it, as well as the adoption of precautionary measures to protect the organic artworks in the collection from potential pest infestation.

Planetary Community Chicken showed that the integration of different disciplines, a shared goal, proactive teamwork, and mutual understanding among the exhibition team members are vital in the conservation of living matter in a museum. The conservation discipline immensely benefits from tapping into the knowledge of other fields to safeguard living matter and other artworks in a museum. A common goal ensures shared responsibilities and overlapping of tasks among members of the exhibition team, which simplifies work on exhibiting living matter. Proactive teamwork helps in identifying critical conservation needs in the exhibition of living matter and ensures that the needs are addressed in a timely manner. Mutual understanding between the artist and exhibition team members helps in the fusion of ideas in transforming living matter into art in a museum. The preservation of living matter in museums is a complex issue requiring versatility and integration of people from different disciplines, including artists, conservators, curators, exhibition designers, and other stakeholders. These were key in *Planetary Community Chicken*, where collaborative efforts ensured a smooth flow of operations.

BIBLIOGRAPHY

DiNoia 2019
DiNoia, Megan. 2019. "Decomposing Art: How Museum Professionals Treat Living Matter." *Heritagebites*, April 15, 2019, https://heritagebites.org/2019/04/15/decomposing-art-how-museum-professionals-treat-living-matter/.

ICOM 2006
International Council of Museums (ICOM). 2006. *ICOM Code of Ethics for Museums*. Paris: ICOM.

ICOM 2013
International Council of Museums (ICOM). 2013. *ICOM Code of Ethics for Natural History Museums*. Paris: ICOM.

Kallergi 2008
Kallergi, Amalia. 2008. "Bioart on Display: Challenges and Opportunities of Exhibiting Bioart." Leiden, the Netherlands: Leiden University. https://www.researchgate.net/publication/266333742_Bioart_on_Display-_challenges_and_opportunities_of_exhibiting_bioart.

Kaplan 2017

Kaplan, Isaac. 2017. "When Is It Okay to Use Animals in Art?" *Artsy*, May 11, 2017, https://www.artsy.net/article/artsy-editorial-animals-art.

The Life-Death Movement of Fruits, Tubers, and Vegetables in Nydia Negromonte's *POSTA*

Magali Melleu Sehn

Nydia Negromonte's ongoing artwork POSTA *is made from fruits, tubers, and vegetables enveloped in raw clay and placed on a wooden table. Over the course of the exhibition, the plant materials undergo various stages of transformation. Some dry up until they are completely desiccated; others decompose; some sprout. This article outlines the process of constructing the work and the actions of each plant type to free itself from the layer of raw clay, leading to aesthetic alterations and new interactions between the materials and their surrounding space. The implications of such a work being acquired by an institution and an analysis of the limitations involved in replacement of individual elements are also considered.*

◆ ◆ ◆

Nydia Negromonte (b. 1965) is a visual artist born in Lima and presently living in Brazil. She graduated from the School of Fine Arts of the Universidade Federal de Minas Gerais with a specialization in graphic arts and has participated in numerous exhibitions in Brazil and abroad. Some of the artist's installations illustrate the idea of exploring, participating in, and collaborating on changes affecting matter, as in the ongoing work *POSTA*, an art installation made from clay-enveloped fruits and vegetables arranged on a wooden table. Over time, the objects change: the fruits and vegetables either grow or wither, and the clay dries and cracks, revealing the temporality of the objects and the transformations that occur to them due to (favorable or unfavorable) characteristics in the environment. According to the artist,

this work investigates the movements of "vigor and decay": some of the objects sprout, others decompose, and yet others dry up.[1] The curator and critic Jorge Villacorta Chávez has written about *POSTA*:

> *Temporality is a crucial factor in these works by Nydia Negromonte. The artist suggests that time must be allowed to do its part. Thus, the growth and life force that breaks through the clay enveloping the fruits and vegetables brings us face to face with a dimension in which processes take place that we don't keep any record of at all (or which we only identify in order to discard the matter undergoing transformation). This reveals the power—and fragility—of the process of memory if we pay attention and cultivate it.* (Chávez 2018, 3)

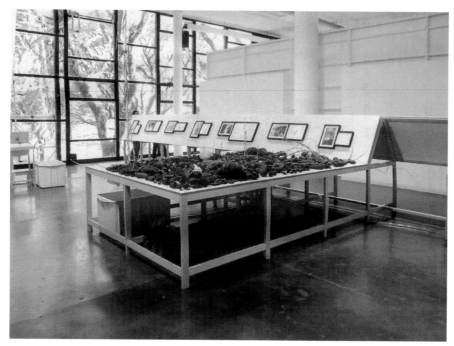

Figure 9.1 Nydia Negromonte (Brazilian, b. Peru, 1965), *POSTA*, 2012–ongoing. Vegetables and raw clay on wooden table, dimensions variable. Collection of the artist. Installation view, *A iminência das poéticas*, 30th Bienal de São Paulo, 2012. Photo: Daniel Mansur, courtesy Nydia Negromonte archive

POSTA EXHIBITION HISTORY

POSTA has been shown in five exhibitions to date: *Lección de cosas* (Lesson of Things), curated by Renata Marquez at the Museu de Arte da Pampulha, Minas Gerais, Brazil (2012); *A iminência das poéticas* (The Imminence of Poetics), curated by Luis Péres-Oramas, 30th Bienal de São Paulo (2012, fig. 9.1); Palácio das Artes, Belo Horizonte, Brazil (2013); Centro Cultural Chacao, Caracas, Venezuela (2013); and *Lección de cosas*, curated by Andrea Elera and Jorge Villacorta Chávez at Sala Luis Miró Quesada Garland, Lima (2018, fig. 9.2). At all of these locations, the work was mounted following a script, which consisted of the artist selecting fruits and vegetables from local markets, having assistants encase them in clay, and arranging the wrapped vegetables on a table designed by the artist. Although the same procedure was followed each time, the vegetables naturally had different reactions and behaviors of expansion, retraction, and stabilization. These movements, some anticipated and others not, added symbolic meanings.

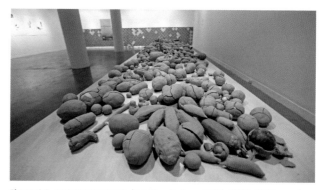

Figure 9.2 Nydia Negromonte (Brazilian, b. Peru, 1965), *POSTA*, 2012–ongoing. Vegetables and raw clay on wooden table, dimensions variable. Collection of the artist. Installation view, *Lección de cosas*, Sala Luis Miró Quesada Garland, Lima, 2018. Photo: Mirella Moscheta, courtesy Nydia Negromonte archive

The selection process for the fruits and vegetables is based on somewhat loose criteria, such as shape and color; vegetables that will sprout; vegetables that won't sprout; and affordability (what might be cheap in one state or country can be expensive in others). The next step is to instruct the assistants in the process of encasing the fruits and vegetables in a black clay, or when that is unavailable, a locally sourced clay with similar composition and color. At this stage, the artist conveys technical information, such as how to handle the raw clay, emphasizing the importance of "form rather than texture" (fig. 9.3). During the process, the artist offers discussions on art and the

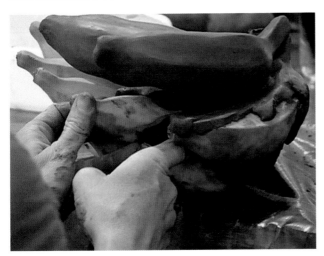

Figure 9.3 Detail of the wrapping process. Photo: Courtesy Nydia Negromonte archive

Figure 9.4 Assembly of the work by the artist. Photo: Marcelo Drummond, courtesy Nydia Negromonte archive

works of the participants, who are almost always art students, friends, or teams hired by the institution where the exhibition is taking place. Lastly, the artist arranges the pieces on the simple, unvarnished wooden table, laying out the large pieces first and then the medium and smaller ones, thereby creating a composition. The artist carries out this part alone (fig. 9.4).

The artist notes: "The most interesting thing about this work is that it invites observation. People spend a long time looking, trying to identify what something is, what it is not, if it is sprouting, if it is smelling. The banana, for example, smells not like rot, but like it is roasted, and it dehydrates, like a banana-raisin." The installation requires replacement of selected materials so that the transformations happen according to the artist's intention, although across the spectrum of transformations, some

are expected and others are not expected, but accepted by the artist. The artist's experience with the transformation of materials at each exhibition expands her understanding of the reaction of materials in different contexts. The vegetables that dehydrate and stabilize might even be used in another exhibition. And excess clay fragments that break during the germination process are removed to avoid unwanted noise.

THE MOVEMENT OF LIFE AND DEATH: VIGOR AND DECAY

According to the artist, new conceptual and practical issues arise each time the work is installed. As an example, she cites her experience with potatoes, which generally decompose and start to smell bad and thus were at first mostly avoided. But when she was mounting the work in Peru, it felt impossible to omit potatoes, considering that the region has such an enormous variety of them. As a result, she indicated that in future installations no fruit or vegetable should be systematically avoided. What is important is the movement of "vigor" that is represented in life through flowering and expansion (fig. 9.5) and the "decay" that is represented in decomposition, desiccation, withering, and death (fig. 9.6, fig. 9.7). Some types of produce, such as ginger and potatoes, sprout more than others. Others, such as cucumbers and watermelons, contain a considerable amount of water and have to be removed after a time to prevent disrupting the entire assemblage. Others, such as star fruit, dry up and stabilize: "It is a work comprising two opposing forces, decay and vigor. These two forces are essential. Thus, in future mountings of the work, I won't use just star fruit because life isn't like that, it's not made solely of things that bear up well under adversity."

POSTA employs ephemeral, organic materials that undergo transformations over time, and each fruit or vegetable responds differently to being enveloped and imprisoned, testing its capacity to free itself to sprout and expand. Through the various processes of selecting vegetables, encasing them, and observing transformations such as changes in appearance and shape, one can understand the symbolic meanings that change with each movement of vigor or decay. The concept is preserved through continual replacement of materials during each exhibition, and by making the selections in keeping with the specific context, which allows for observing new reactions.

The work poses a number of questions when considering its viability for a long-term exhibition: What would be the parameters and limitations of maintenance, partial

Figure 9.5 Flowering and expansion detail. Photo: Daniel Mansur, courtesy Nydia Negromonte archive

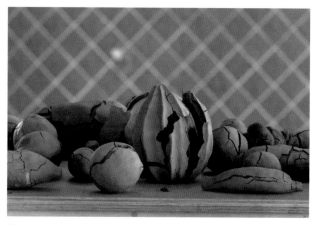

Figure 9.6 Desiccation and withering detail. Photo: Fabio Del Re, courtesy Nydia Negromonte archive

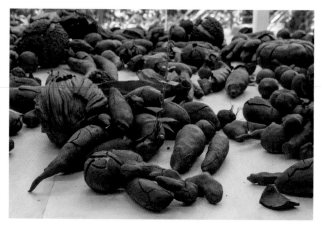

Figure 9.7 Desiccation and withering detail. Photo: Daniel Mansur, courtesy Nydia Negromonte archive

replacement, or reconstruction? Generally, potential permanent acquisition is feasible in the same way that many other works made from ephemeral materials have been acquired—namely, the purchase of the project must include instructions regarding the materials, the assembly process, acceptable methods of exhibition and interaction with the public, and an artist's statement about its conceptual and material aspects. There is already a general consensus on these protocols among professionals and institutions that acquire complex collections of contemporary art. But based on the artist's observations during the new iterations of the work in different spaces and climates, some desired and some undesired outcomes have already been encountered that affect the work as a whole.

What limitations are presented by the sprouting and expansion of the plants and the interactions among them? What limitations are entailed in desiccation and shrinking and emanation of odors? What limitations are involved in the elimination of the fragments of clay that break off during the sprouting process? The answers to such questions depend mainly on the context and how each institution can continually update preestablished protocols for the work's maintenance and criteria for ongoing replacement. Regarding maintenance, the artist suggests

a daily review to find fruits or vegetables that may have decomposed (leaking liquid or foul odors) and eliminating them along with their fragments. If they exhibit very disagreeable odors, spray the moldy parts with an antibacterial spray, but avoid spraying nearby vegetables that are in the process of sprouting. In the event of replacement, wrap the replacement item in raw clay one centimeter thick, seeking fidelity to the shape rather than the texture.

The maintenance instructions are based on her experience viewing the work in temporary exhibitions that generally do not exceed three months. If the work is acquired by an institution to be on permanent or periodic display, factors that will need to be considered include: having a team of professionals capable of reconstructing the work for each exhibition; financial conditions for continued maintenance and replacement; and appropriate location and space so that the work doesn't interfere with the welfare of other works in the collection.

Although the artist says that the process begins with her own selection of fruits and vegetables in local markets, she does note that if an institution purchases the work and reconstructs it in the future without her being present, all the other instructions should still be followed in this manner:

- Select varied fruits and vegetables, considering shape and color—some that sprout and others that don't

- Have a team wrap the fruits and vegetables, emphasizing shape over texture

- Display them on a table designed by the artist specifically for exhibiting these pieces

- The wrapped fruits and vegetables must be laid out by only one person, using the following order of distribution: the large fruits and vegetables first, then the medium-size ones, and lastly the smallest ones

- Limitations on expansion of fruits and vegetables that sprout will depend on the context in which the work is exhibited

- Limitations on the permanence of the fruits and vegetables in the desiccation process will depend on how much they disrupt the work as a whole

- In the event of permanent acquisition by an institution, the exhibition duration will be determined by curatorial proposals, since interactions can occur ad infinitum through continual replacement of the fruits and vegetables

- At the end of each exhibition, the institution may choose to completely discard even the pieces that have stabilized

- The work may be displayed in simultaneous exhibitions

For observation purposes, the artist still keeps some fruits or vegetables today that have stabilized. During the exhibitions, documentation is carried out on some transformations, which resulted in another work titled *Post POSTA Series* (2014, fig. 9.8), a photographic essay of *POSTA* fruits and vegetables carried out during the dismantling of the installation after the 30th Bienal de São Paulo (2012).

THE POTENTIAL FOR LONG-TERM OR PERMANENT ACQUISITION

Regardless of whether the work will be acquired by an institution or not, it is extremely important that conservators, working with the advice of an institution, take part in the main phases of evaluating a long-term loan or permanent acquisition, including maintenance capabilities. Other professionals to consult should be trained in preparing documentation and intervention protocols; drawing up contractual agreements that consider the transformation of materials; remaining in contact with the artist for potential changes in her stance over time, and other considerations.

My 2013 article "El problema de la conservación de arte contemporáneo en el contexto de los préstamos a largo plazo" (The Problem of Conserving Contemporary Art in the Context of Long-Term Loans), which treats loans of up to twenty years, partially assesses the problem of long-term acquisitions of contemporary art and the role of the conservator in drawing up contractual agreements, which is an acquisition practice in Brazil. In an interview I conducted for that article, curator Felipe Chaimovich emphasized the importance of long-term loans to evaluate whether the work in question definitely fits an institution's mission statement and collecting policies, and to evaluate whether a museum has adequate technical facilities for maintaining the work. The matter is complex, but it is a practical intermediate step toward a permanent acquisition (Sehn 2013, 89). In the case of *POSTA*, the concept encompasses the process, the symbolic meaning of the materials, and the transformations in shape and appearance that, in the case of a long-term or permanent acquisition, entail the preparation of detailed protocols.

In spite of the many existing bibliographic references regarding issues surrounding the preservation of contemporary art as a reflection on criteria, methodologies, documentation, and so on, conservators are continually struggling with opposing forces during the decision-making processes that will also affect the life and death of the work. *POSTA*, with its literal and symbolic balance between movements of vigor and decay, in this way offers possibilities for maintaining vigor in particular.

Acknowledgments

Many thanks to Nydia Negromonte for a highly productive conversation in her studio, and for making photographs available from her personal archive; to the Graduate Program of the Universidade Federal de Minas Gerais; to PPGARTES and PROEX for their financial support for the presentation in Mexico; and to the organizing and editorial team for the "Living Matter" symposium.

NOTE

1. All artist quotes come from a 2018 interview with the artist in her studio, later supplemented by email and telephone conversations. For more information on the artist visit https://nydianegromonte.com/.

BIBLIOGRAPHY

Chávez 2018

Chávez, Jorge Villacorta. 2018. "A Presentation." In *Lección de cosas*. Lima: Sala Luis Miró Quesada Garland. https://www.academia.edu/36890339/Nydia_Negromonte.

Cologne Institute of Conservation Sciences and Technology Arts Sciences 2019

Cologne Institute of Conservation Sciences and Technology Arts Sciences. 2019. *The Decision-Making Model for Contemporary Art Conservation and Presentation*. Rev. ed. Cologne: Cologne Institute of Conservation Sciences and Technology Arts Sciences. https://www.th-koeln.de/en/decision-making-model-for-contemporary-art-conservation-and-presentation--revisited_63959.php.

Macedo and Henriques da Silva 2010

Macedo, Rita, and Raquel Henriques da Silva, eds. 2010. *A arte efímera e a conservação: O paradigma dos bens etnográficos e da arte contemporânea = Ephemeral Art and Conservation: The Paradigm of Contemporary Art and Ethnographic Objects*. Lisbon: Instituto de História da Arte, IHA FCT-UNL. https://run.unl.pt/bitstream/10362/16429/1/Livro_Actas_Completo.pdf.

Negromonte 2016

Negromonte, Nydia, ed. 2016. *D.U.C.T.O: Nydia Negromonte*. Belo Horizonte, Brazil: Autêntica.

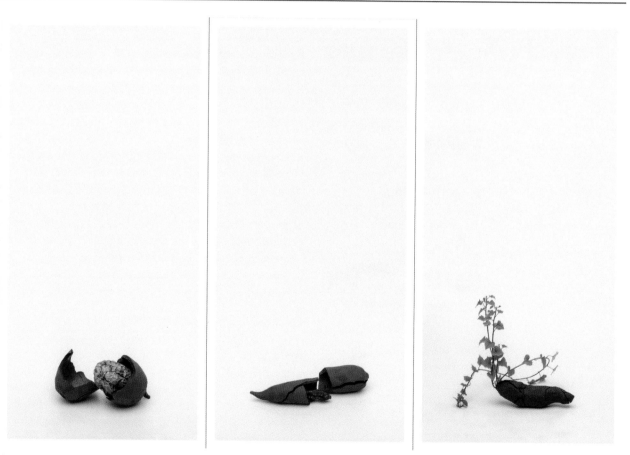

Figure 9.8 Nydia Negromonte (Brazilian, b. Peru, 1965), *Post POSTA Series*, 2014. Four hundred mineral pigment prints on 305 g cotton paper, each 73 × 36.5 cm. Collection of the artist. Photos: Courtesy Nydia Negromonte archive

Sehn 2013

Sehn, Magali Melleu. 2013. "El problema de la conservación de arte contemporáneo en el contexto de los préstamos a largo plazo," 87–94. Conservación de arte contemporáneo 14. Madrid: Museo Nacional Centro de Arte Reina Sofía.

Sehn 2014

Sehn, Magali Melleu. 2014. *Entre resíduos e dominós: Preservação de instalações de arte no Brasil.* Belo Horizonte, Brazil: C/ARTE.

Wharton et al. 2016

Wharton, Glenn, et al. 2016. "The Artist Archives Project: David Wojnarowicz." In *Saving the Now: Crossing Boundaries to Conserve Art Works*, edited by Austin Nevin et al., 241–47. Los Angeles and London: Studies in Conservation (IIC).

Conservation/Restoration of Biological Material in Contemporary Art: A Perspective from Academia in Collaboration with Artists

Ana Lizeth Mata Delgado

Mexico's Escuela Nacional de Conservación, Restauración y Museografía has developed the Seminario Taller de Restauración de Arte Moderno y Contemporáneo (Workshop-Seminar on Restoration of Modern and Contemporary Art). The methodologies it employs take into consideration factors such as the artist, production technique, context, compatibility and interactions of materials, as well as present and possible future deterioration dynamics. A related but separate research project titled Documentación, Registro y Experimentación Material en Arte Contemporáneo (Documenting, Registering, and Experimenting with Material in Contemporary Art) was aimed at documenting and experimenting with different organic materials. This allowed for collaboration with artists based on experimentation with biological materials to generate, conserve, and/or restore works of art.

◆　　◆　　◆

Since 2004 the Seminario Taller de Restauración de Arte Moderno y Contemporáneo (Workshop-Seminar on Restoration of Modern and Contemporary Art) offered at Mexico's Escuela Nacional de Conservación, Restauración y Museografía (ENCRyM), which is part of the Instituto Nacional de Antropología y Historia (INAH), has positioned itself nationally and internationally as an academic space that researches, conserves, restores, and documents new artistic proposals created in the twentieth and twenty-first centuries. The workshop-seminar was created in 2001 in response to in-depth reflections on new professional challenges facing ENCRyM's graduates with bachelor's degrees in restoration. New artistic production techniques and new vocational opportunities outside INAH in both the public and private spheres also influenced its creation. The workshop-seminar is presently being offered in the ninth semester of the bachelor's degree program as a full-time, on-site elective. At this time it is the only course of its kind in Mexico; none of the other schools or universities currently providing a bachelor's degree in restoration offer courses that address cultural issues in an integrated manner. Its uniqueness attracts students outside of ENCRyM to take the course to supplement their training.

Over the course of its fifteen years so far, distinct methodologies have been developed in the workshop-seminar for addressing issues in the conservation and restoration of artworks made from organic and inorganic material. This paper addresses only the cases of art made from organic material. These methodologies consider different fundamental aspects—for instance production techniques, context of creation, context of exhibition, artist/creator, compatibility and interaction of materials, and existing as well as possible future dynamics of deterioration—to establish the best course of intervention. A primary consideration is collaboration with the artist in order to understand the meaning of the work, the artist's intention behind using a specific material, and their long-term vision for and opinion on the work's conservation.

Within the structure of the workshop-seminar's academic program are three research projects: documenting, registering, and experimenting with materials in organic or inorganic contemporary art; conserving, registering, and documenting urban art and graffiti; and conserving and researching plastics. The first of these involves close collaboration with the creators of contemporary artworks in order to record their testimonies, which serve as vital documents for the conservator's task, and experimenting with different substantive raw materials.

A distinctive aspect of this project is collaboration with artists to experiment mainly with biological material in the creation, conservation, and restoration of works of art. Examples of such collaboration have included works made with leather and pigs' feet, others made with eggshells, and yet others crafted with coconut and maize fibers—a diversity of materials that reveals the creators' ongoing search to innovate and produce works with different perspectives, which in turn also generates new problems and research urgencies vis-à-vis their conservation.

It is important to mention that artists are increasingly open to and interested in collaborating with conservators, and this dynamic paves the way for new research into both the constituent materials and new materials and strategies for conservation and restoration, thereby generating new, creative alternatives for proper conservation.

CONSERVATION, RESTORATION, AND RESEARCH ON WORKS OF ART MADE FROM ORGANIC MATTER

As a result of the daily work within the workshop-seminar, and as part of the collaboration with artists such as Darío Meléndez, Grupo SEMEFO, Antonio Serna, Marta Palau

Bosch, and Noemí Ramírez, to mention but a few, research projects have been conducted that have resulted in the conservation and/or restoration of works made with materials such as maize leaves, coconut fibers, animal skin, embalmed horse fetuses, and a taxidermied crocodile. For instance:

◆ Grupo SEMEFO, *Lavatio Corporis*, 1994. Three embalmed horse fetuses on metal pedestals.

◆ Antonio Serna, *Untitled*, 1984. Mixed media (oil, acrylic, mortar, pumice stone, and birdseed) on fabric.

◆ Marta Palau Bosch, *Mis caminos son terrestres XVII* (My Paths Are Earthly XVII), 1985. Textile sculpture involving dyed henequen (agave) and totomoxtle.

◆ Noemí Ramírez, *Mirada del tiempo* (Time View), 1985. Henequen, coconut, and palm fibers filled with wadding.

◆ Santiago Rebolledo, *Christo* (Christ) (fig. 10.1), 1981. Wood, leather, ink, and paper.

◆ Taxidermied crocodile from a scientific collection, 1980s.

The research projects and interventions follow a process through which the researchers investigate the material and its meaning, and issues in conserving the work. They usually follow the following procedure:

1. Diagnosis of the Work of Art

Before the work is selected, it is assessed at its current site to determine whether it is an appropriate subject for the workshop-seminar. Collections normally considered for this are mainly in public museums.[1] Once a diagnosis has been conducted on the state of conservation of the work, a project is created that identifies in detail the deterioration, options for conservation, scope of intervention, and any agreements required. Once both parties accept the initial agreement, the work is transferred to ENCRyM and its conservation and/or restoration begins.

2. Artist Interview

While assessing the specific work at hand, the research project investigates the artist's broader body of work, processes, motivations, and materials. Guidelines are established and defined for an interview, which may focus on the work to be restored and/or the artist's broader production. Usually, once an artwork is in the workshop, the artist is invited to visit and begin the interview process

Figure 10.2 Interview with artist Noemí Ramírez. Photo: STROMC-ENCRyM, INAH

Figure 10.1 Santiago Rebolledo (Colombian, 1951–2020), *Christo* (Christ), 1981. Mixed media (wood, leather, ink, and paper), 104 × 84 cm. Centro Nacional de Conservación y Registro del Patrimonio Artístico Mueble (CENCROPAM) del Instituto Nacional de Bellas Artes y Literatura (INBAL). Photo: STROMC-ENCRyM, INAH

Figure 10.3 Taxidermied crocodile under ultraviolet light. Photo: STROMC-ENCRyM, INAH

(fig. 10.2). To date, the workshop-seminar has a database of more than forty artist interviews, all focused on the conservation of their works and on conservation and/or restoration of modern and contemporary art in general. The information collected during the interview plays an important role in determining possible solutions for conservation; sometimes the artist has a specific opinion on the matter, which is considered and conveyed to the owner of the work (usually, as noted above, this is a museum or cultural institution).

Two particularly interesting interviews were with Darío Meléndez and Colectivo Sonámbulo. Meléndez's *Tilma Porca* is an installation that uses pigskin in different presentations to reflect the image of the Virgin of Guadalupe (Meléndez and Mata Delgado 2012). Colectivo Sonámbulo's *Incontenible* (Uncontainable) involved a research project for the purpose of evaluating and determining alternatives to slow the rotting of pigs' feet (Rebolledo et al. 2019).

3. Scientific Analysis and Research

For the research and the interdisciplinary work, the team works at ENCRyM and/or in external laboratories, depending on the type of analysis required. Team members conduct biological, physical, forensic, and chemical analyses, depending on the issues present (fig. 10.3, fig. 10.4). Professors may contribute their expertise to answer questions posed by a particular artwork. When ENCRyM does not have the specialist required, external specialists are consulted who can provide supplemental information.

4. Evaluation of Conservation Alternatives

After an artwork's state of preservation is assessed and diagnosed and the meaning and conceptual aspects of the work considered, different conservation options are proposed. The artist's opinion, technical resolutions, technical and financial resources, viability of the processes, and aesthetic and artistic factors are all considered. This usually occurs after several weeks of working closely with

Figure 10.4 Detail of colorimetric analysis for the taxidermied crocodile. Photo: STROMC-ENCRyM, INAH

the artwork and after obtaining all analytical results. Next steps include determining the scope, a time schedule, equipment and materials needed, and human and financial resource requirements.

5. Presentation of the Best Alternative

After assessing advantages and disadvantages of each proposed conservation process, a meeting is held with the custodians of the work in which findings and recommendations are presented. This includes general information, research done on production techniques, material and scientific analyses, state of conservation and diagnosis, graphic and photographic registry, the interview with the artist, and the artist's opinion. Based on this presentation, a consensus is reached between the museum and the restoration team, and formalized as an agreement.

6. Intervention

Having established the scope, processes, materials, and agreement(s) among the parties, conservation and/or restoration begins. It usually lasts from four to eight months, depending on the type of work and the issues involved. This intervention is usually conducted in the workshop-seminar facilities at ENCRyM (fig. 10.5, fig. 10.6).

Figure 10.5 Eliminating earlier repainting on the snout of the taxidermied crocodile. Photo: STROMC-ENCRyM, INAH

Figure 10.6 Antonio Serna (Spanish, 1927–2011), *Untitled*, 1984, undergoing restoration and stabilization of the birdseed. Mixed media (oil, acrylic, mortar, pumice stone, and birdseed) on fabric, 90 × 80 cm. STROMC-ENCRyM collection. Photo: STROMC-ENCRyM, INAH

7. Delivery of Results and Work Report

When all restoration work is complete, an exhaustive report is delivered to the museum, to the ENCRyM library, and sometimes to the artist, containing all the information concerning the work, from the start of the registration to the research, analysis, and actions carried out, plus a complete photographic record of the intervention. This document aggregating all the relevant information is now a unique file on the work that will serve for future research and/or intervention (if necessary).

8. Dissemination in Specialized Forums and Publications

Last, the research and work conducted are disseminated and circulated in various academic forums: conferences, lectures, symposia, and written articles.

CASE STUDY

Grupo SEMEFO's *Lavatio Corporis* is a useful case study to illustrate the methodology explained above. This installation involves three embalmed horse fetuses placed on metal pedestals. These are part of a series of five installations exhibited in four galleries of the Museo de Arte Carrillo Gil, Mexico City, in 1994 (Ganado and Herrera 1994). Although, in this case, the work that was restored was not the original piece (the first version decomposed as a result of excessive humidity), the piece we worked on is authentic in conceptual and material terms; Grupo SEMEFO created a new version within the same year and with the same characteristics, which it donated to the Museo de Arte Carrillo Gil.

This work came to the workshop-seminar in 2010 as a result of its conservation issues, which consisted mainly of material and aesthetic changes. Interestingly, it was not initially clear whether these contributed to or detracted from the piece's meaning. The material state of the work indicated that, without intervention, in would likely continue to deteriorate and perhaps be lost, yet this was potentially congruent with the concept proposed by the artists. It is a processual work whose deterioration is intrinsic to it.

Two main condition issues were observed. *Lavatio Corporis* was in fact at that time mostly materially stable, but the fetuses were noted as having reduced density due to loss of bodily fluids, as well as desiccation and contraction of the tissues. There was also a loss of flexibility to the skin and resulting parchment-like texture caused by progressive desiccation and polymerization of the proteins structurally modified by the embalming process. The pedestals were neither original nor stable in supporting the fetuses. Additionally, the storage box was moldy and without any ventilation, such that mold continued to attack the fetuses.

Several scientific analyses were performed, including examination of the fetuses under UV light, analysis of the skin and the threads suturing the wounds inflicted during taxidermy, and incubation of a mold culture in the box and on the fetuses to determine the best way to eradicate it. Generally speaking, three possible options for conservation presented themselves:

◆ The ephemeral work: the work will eventually be lost thanks to the decomposition in which it is engaged. In this case, a record would remain of the work's existence and transformation.

◆ The permanent work: conservation and/or restoration treatments and resources will be used to achieve permanence of the work.

◆ The renewable work: when the fetuses have deteriorated to an agreed-upon degree, the organic components will be replaced with fetuses deemed equivalent, but newer.

After interviewing Grupo SEMEFO, it was determined that the fetuses' current state of deterioration was central to the work's meaning. It was therefore deemed essential to make conservation efforts to stabilize its present appearance, and so the second option was chosen. The pedestals were replaced, and the storage box and fetuses were fumigated to kill the mold (fig. 10.7, fig. 10.8, fig. 10.9).

The piece has great historical, aesthetic, and political relevance to the contemporary art of Mexico, representing a historical period and art movement that explored specific discourses and means of expression. There was a collective consensus at the time the installation was donated that the museum would provide for its long-term conservation and maintain its permanence. Any ephemeral consideration was superseded. Over time, that characteristic has nourished the work's discourse, making it an example of the fact that institutions, museums, and galleries house not only works but, in some cases, processes as well (López Guzmán 2010, 54).

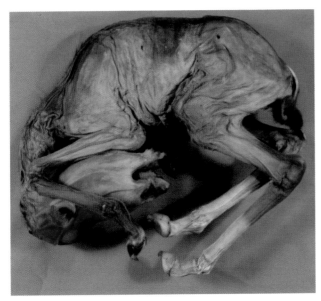

Figure 10.7 Grupo SEMEFO (Mexican, active 1990–99), *Lavatio Corporis*, 1994, showing an embalmed fetus after processing. Three embalmed horse fetuses on metal pedestals, dimensions variable. Museo de Arte Carrillo Gil, Mexico City. Photo: STROMC-ENCRyM, INAH

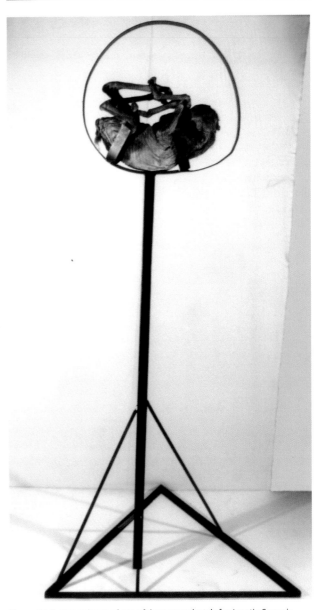

Figure 10.9 General view of one of the new pedestals for *Lavatio Corporis*. Photo: STROMC-ENCRyM, INAH

Figure 10.8 General view of the packing box that was part of *Lavatio Corporis*. Photo: STROMC-ENCRyM, INAH

CONCLUSIONS

Material experimentation in art opens new perspectives and poses challenges for conservation and restoration, so it is essential to develop strategies aimed at better solutions to issues presented in conserving art made from organic matter. Direct interactions between artist and restorer are becoming increasingly relevant in the conservation and restoration of contemporary art, in the interest of both creating new works of art and conserving existing ones. Exchanges of knowledge and experience lead to a better understanding of certain works and their meaning and function, as well as future conservation efforts. Documentation through interviews, notebooks,

archive materials, and reports serves not only as testimonies concerning conservation work, but also as background for future research.

NOTE

1. We have worked with the Museo Universitario Arte Contemporáneo, Mexico City; the Museo de Arte Carrillo Gil, Mexico City; and the Museo Regional de Nayarit, Tepic.

BIBLIOGRAPHY

Ganado and Herrera 1994
Ganado, Edgardo, and Carolina Herrera. 1994. "SEMEFO, Museo de Arte Carrillo Gil. Catálogo de Exposición." Consejo Nacional para la Cultura y las Artes. Instituto Nacional de Bellas Artes. Mexico City: Museo de Arte Contemporáneo Alvar and Carmen T. de Carrillo Gil.

López Guzmán 2010
López Guzmán, Javier. 2010. "Informe de los trabajos de conservación sobre la obra: Lavatio Corporis / Grupo SEMEFO." Seminario Taller de Restauración Arte Moderno y Contemporáneo. Temporada de trabajo agosto-diciembre 2010. Unpublished.

Meléndez and Mata Delgado 2012
Meléndez, Darío, and Ana Lizeth Mata Delgado. 2012. "Tilma Porca." In *Memorias del 5º Foro Académico*, edited by ENCRyM, 33–40. Mexico City: ENCRyM-INAH. https://www.repositoriodepublicaciones.encrym.edu.mx/pdf/4-TilmaPorca.pdf.

Rebolledo et al. 2019
Rebolledo, Karla, et al. 2019. "Incontenible: Entre la creación artística y la conservación." *Estudios sobre conservación, restauración y museología* 5:157–70. https://www.repositoriodepublicaciones.encrym.edu.mx/pdf/13%20incontenible_corregido2019.pdf.

WORKING WITH THE ARTIST

Living Matter: Challenging Institutions

Killing with Kindness? The Challenges of Conservation and Access for Living Matter

Marcia Reed

The most difficult moment in the life of an artwork is sometimes when it enters an institution. Challenging establishment authority, many avant-garde and Fluxus works were created to act out. They warp, wrinkle, and ooze as they age, occasionally deteriorate, or even completely disappear. Such works are documents as much as art, made to be experienced and handled rather than entombed as untouchable treasures. This paper discusses a Surrealist cellulose acetate book casing adorned with butterflies and a seahorse; stabilization of Benjamin Patterson's tackle box Hooked (1980) *following a sardine can explosion; and ongoing monitoring of Dieter Roth's editions.*

◆　　◆　　◆

One of the most difficult moments in the life of an artwork can be when it enters an institution. In this author's experience, private collectors tend not to over-conserve, most often erring on the side of passive storage. Some of the most discerning collectors simply wish to appreciate and enjoy their works of art on a daily basis, which means that the works are, for instance, displayed for lengthy periods in too much light. Such collectors enjoy living with art, and they don't worry about extending its life or preserving works in perpetuity. Indeed, it could seem a bit pretentious to assume responsibility for creating an eternal life for a work of art.

Collecting plays out very differently with libraries, archives, and museums, sometimes taking on the worst senses of "institutionalization." While early works on paper can behave well for centuries, more recent ones, particularly twentieth-century avant-garde and Fluxus works, present problems. Indeed, many were created specifically to challenge institutional authority, to act out, and were thus intentionally *not* made to last. They warp, wrinkle, leak, ooze, or explode as they age. These artworks were created to be in an extended state of process. It is a given that they will deteriorate, and maybe completely disappear, as is the case with early photocopies and faxes. They exist as documents as much as art. Most significantly, they're made to be experienced and handled rather than entombed like untouchable treasures in cases. I have thought more than once that if something unpleasant happened to certain works, it might even please the artist, who may no longer be with us but whose work is still actively talking back. The incorporation of living materials

is especially sympathetic to creating art that is not static, but rather notable for its tendencies to change and decay, effectively as if it were a living organism.

The Getty Research Institute (GRI) special collections include rare and unique works that document the history of art. Up to the twentieth century, they are mostly works on paper. But modern and contemporary artists have occasionally included food, plants, or even dead animals in their works. When considering objects in the GRI's special collections that are made from living matter, it is clear that references to both their initial status as well as to their present, now-changed condition are crucial to their meaning and to an appropriate—that is, direct and unmediated—experience and appreciation of the work. For both historical documentation and surrogate viewing, photography and digitization are remarkably helpful, often revealing more information than the naked eye can discern. And documentation of how these objects are stored, conserved, and accessed is also critical to their comprehension.

The important questions include: Is it possible to preserve the work responsibly without interfering with the artist's intent that it age and/or disintegrate? Can it still have a life? And should it? Once works become institutional assets, must we preserve them as typical institutional assets if that counters what the artists intended? If a work is made to be handled and we only show it behind glass or in a case, are we denying the right of the work to exist and function as the artist wished? In certain cases, at least one of these issues can be simple. For instance, if an artist's book is made to be read, then we must provide a way to do that at some point, thus allowing the crucial experience of the book's materiality to take place. Dieter Roth's books,

for example, have not been read so much as simply viewed as book sculptures, but they are filled with his words, his poetry. To deny access to the texts fails to acknowledge a critical facet of the work, which is the interactions of words and images in the context of Roth's selections of specific materials.

Signature characteristics of twentieth- and twenty-first-century art include such intricately interwoven presentations of texts and images, for which, it should be stressed, reading is often crucial. A touchstone of the genre is Marcel Duchamp's *Green Box* (1934, fig. 11.1), filled with quasi-archival documents that present an explication of his *Large Glass* (1915–23). Like Duchamp's *Boîte-en-valise* (Box in a Suitcase), produced in multiple editions as a box or valise that presents miniatures of his works, the *Green Box* requires firsthand access to touch and to read. This becomes difficult when these are designated masterpieces—significant works by a major artist. In Mexico City on the last day of the "Living Matter" conference, attendees viewed works by Duchamp, including the *Green Box*, in glass cases at Museo Jumex as part of the exhibition *Appearance Stripped Bare* (Gioni 2019). The boxes were shown in galleries together with works by Jeff Koons, and the juxtaposition was telling. The exhibition presented Duchamp's boxes in a state of embalmed inaccessibility, like closed books. The implicit denial that they are made to be unpacked, handled, and read took away their aura and retracted their power. Meanwhile, Koons's brightly colored paintings and shiny sculptures grabbed visitors' immediate attention. Duchamp smiled wisely and somehow knowingly out from the vintage photographs and film in the show.

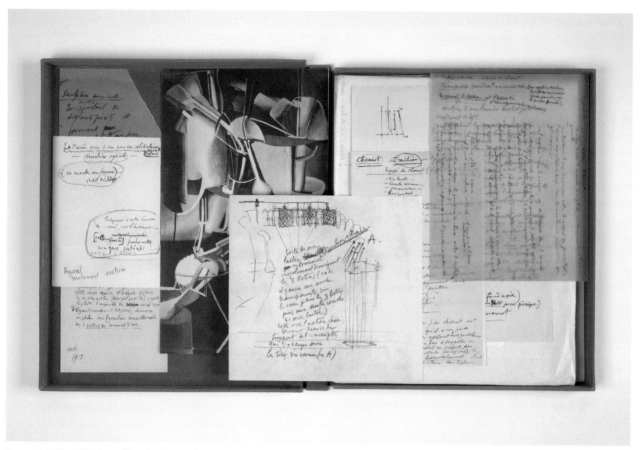

Figure 11.1 Marcel Duchamp (French, 1887–1968), *Green Box*, 1934. Box containing collotypes and hand-colored lithographs reproducing Duchamp's works, closed: 33.4 × 27.8 × 2.5 cm. Paris: Edition Rrose Sélavy. GRI 95-B1934. Photo: © 2019 Artists Rights Society (ARS), New York / ADAGP, Paris / Estate of Marcel Duchamp

At the GRI, one of our first experiences with making major conservation decisions regarding living matter came with the acquisition of the Jean Brown Collection. Although Brown is well known today as a collector of Fluxus works, in collaboration with her husband, Leonard, she also collected an extraordinary group of Dada and Surrealist editions in the late 1950s and 1960s. The Browns had especially complete holdings of Duchamp's signature boxes and publications. Their Dada, Surrealist, and Fluxus collections were acquired by the GRI in 1985, and the first encounter with living matter concerned a small case of books (fig. 11.2, fig. 11.3). This Surrealist cellulose acetate case filled with butterflies, feathers, a seahorse, and eyelashes arrived with the Jean Brown Collection in a state of serious deterioration. Attributed to Duchamp and André Masson, it dates from around 1939. A Surrealist object in itself, the book case holds 1939 editions of four literary classics published by in Paris by Guy Lévis Mano under his GLM imprint in the series Biens Nouveaux. The small, elegant books are Lewis Carroll's *La Canne du destin* (The Walking Stick), Franz Kafka's *La chasseur Gracchus* (Gracchus, the Hunter), Gisèle Prassinos's *Sondue*, and Duchamp's *Rrose Sélavy*. In the 1930s and 1940s, GLM published hundreds of illustrated Surrealist editions in these sorts of tastefully designed paperbound quartos. While the Surrealists often *portrayed* bizarre variations on living bodies—contorted, dismembered, part animal, part insect—they did not often actually employ living matter in their art. (The major exception is of course Meret Oppenheim's *Object* [1936], the fur-covered cup and saucer.) To date, no documentation has been found concerning the fabrication of this unique book case, except for an unknown dealer's description. Possibly it was designed by Duchamp's companion at this time, the book designer and binder Mary Reynolds, in collaboration with Masson, who drew the figures in ink on the cardboard chemise. The box serves as an overlay for the drawings on the chemise. They are created as an ensemble, to be enjoyed visually while reading the deliberately strange selection of texts stored within.

Figure 11.2 Marcel Duchamp (French, 1887–1968), design possibly by Mary Reynolds (American, 1891–1950), ca. 1939. Cellulose acetate case containing Lewis Carroll, *La canne du destin*, trans. André Bay; Marcel Duchamp, *Rrose Sélavy*; Franz Kafka, *Le chasseur Gracchus*, trans. Henri Parisot; and Gisèle Prassinos, *Sondue*, with added butterflies, feathers, a seahorse, and drawings on the chemise attributed to André Masson (French, 1896–1987), closed: 17 × 12 × 2.5 cm; object: 18.7 × 12.3 × 4.7 cm. GRI 95-B2292.

GETTY RESEARCH INSTITUTE
Periodic Action Item
[individual components of this item or material as a whole needs a periodic check of condition]

Next check anticipated in: 2009 > ☐ 2010 > ☐ 2011 > ☐ 2012 > ☑ 2013 > ☐

Object Identification

Image:

TMS/Accession No.: 95-B2292
Source: Jean Brown Collection

Titles/respective Authors:
La canne du destin / Lewis Carroll.
Le chasseur Gracchus / Franz Kafka.
Sondue / Gisèle Prassinos.
Rrose Sélavy / Marcel Duchamp.

Series: "Biens Nouveaux"

Media: mixed
Materials:
Outer cover: organic materials in clear, hard plastic (CN or CA?)
Inner cover: hand decorated paper, covering card board with leather spine, containing 4 volumes

Date: 1939

Dimensions: of slipcase
(approx.)
Height x L x W [inches or cm]

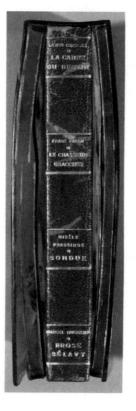

95-B2292
MARCEL DUCHAMP
VERSO

✋ **Special note for handling:**

➢ Avoid any vibration when transporting the storage box, or when handling the item.

➢ The plastic slipcase should be handled with unpowdered nitile gloves (due to the deteriorating plastic) and with extreme care (mind the fragile butterflies).

➢ Check plastic cover periodically for possible crazing, cracking, or further deformation.

➢ Item should be kept in cold storage, reducing the rate of deterioration.

Figure 11.3 Conservation guidelines housed with the case. GRI 95-B2292.

By the mid-1980s, when the GRI acquired the Jean Brown Collection, the case was yellowed and warped, partly split at the seams. The gilded seahorse, butterflies, and feathers were desiccating. This hauntingly beautiful and truly surreal book-object, evoking a dreamlike otherworld and the perfect enclosure for its fantastical literary works, has been exhibited once as of this writing, in the 1994 GRI exhibition *Sites of Surrealist Collaboration*. It was displayed in a wall vitrine with a black velvet curtain to protect it from sustained direct light.

In the years before the new Getty Center was built, the GRI's collections storage building also housed the Getty Conservation Institute. One of the GCI scientists, Jim Druzik, had considerable experience with the effects of lighting and museum display. Happening by one day, he took an interest in the case and its books, offering to assess it and make recommendations. In collaboration with a GRI conservator, the case was stabilized and squared up slightly so that the books could fit into it again, although they are now stored separately with instructions for unpacking, storage, and use so as to limit abrasion and handling of both the books and particularly the case, which requires very limited handling and no sudden movement. The surface was lightly cleaned, since it had accumulated dirt. Unbeknownst to us, Druzik was a butterfly collector. He identified the butterfly species and asked whether we wanted to replace them. He brought in a drawer of very similar specimens for us to select from if we wished. But the decision was immediately obvious: to replace the butterflies seemed like unacceptable cosmetic surgery. It was a suggestion to which perhaps Duchamp would have responded with his familiar mysterious smile, but at the time, it did not seem an appropriate option. With objects such as these, there is an ongoing life. It should be tended to with care, but the process should not be interfered with.

A coda to this past decision is that the butterfly wings are now desiccating further, fading and turning to powder. As such objects age and change, conservators and curators may want to reconsider whether to enhance (meaning, restore) the artistic qualities or to continue to preserve and stabilize the objects as well as they can. Almost inevitably they will continue to change.

In addition to this unique work, Duchamp also created numerous multiples—a new category in the twentieth century, a kind of small-scale artistic mass production. Duchamp himself was an early adopter of this format because it worked well in the context of his readymades. Although multiples begin their lives produced in groups (hence the term) of identical or very similar objects, as they are acquired by collectors or institutions, they proceed to experience different histories. Their residence in various locations with different conditions of housing and display results in changes in their appearance. Plastic, itself a potentially unstable material, is often used in multiples, sometimes as a container, and sometimes combined with living matter, as in some Fluxus boxes. Post-avant-garde artists' books, multiples, and objects with text and images often use plastic for transparent enclosures, for instance as sleeves that become the leaves of a book.

Jean Brown was fascinated by the works of Dieter Roth and acquired more than fifty volumes directly from him. She particularly appreciated Roth's experiments with book design and publishing formats, such as his combination of traditional printing techniques with contemporary materials that are far more unstable than the papers that bookmakers used for centuries. Brown had at least two copies of the special edition of Roth's *Bok 3c: Wiederkonstruktion des Buches aus dem Verlag Forlag Ed* (Reconstruction of the Book from the Verlag Forlag Ed., 1961/1971, fig. 11.4), which has a separate slipcover embellished by either painted bagels or croissants. The GRI has bagels; the Museum of Modern Art, New York, has croissants (Suzuki 2013, 29). Here, the question is whether to restore the sections of the bagels that have crumbled. So far the bagels are slightly deteriorated, and the crumbs have been carefully preserved, somewhat sympathetically collected in a small bag; because of their fragility, the covers receive only supervised use.

Figure 11.4 Dieter Roth (Swiss, 1930–1998), *Bok 3c: Wiederkonstruktion des Buches aus dem Verlag Forlag Ed* (Reconstruction of the Book from the Verlag Forlag Ed.), 1961/1971. Cardboard, caraway seed roll, and paint, open (cover): 23.2 × 40.3 × 4.1 cm; closed (book): 22.9 × 17.1 × 3.8 cm. Reykjavik: H. Mayer. GRI 93-B18994. Photo: © Dieter Roth Estate, courtesy Hauser & Wirth

The GRI holds five different copies of Roth's special editions of *Poetrie*. Two are printed on plastic pages. The pages of one are filled with urine, which we know with certainty because of its smell. Another edition of *Poetrie* is filled with either cheese or pudding. The latter has not been tested because we are hesitant to disturb its apparent equilibrium. The evocative plastic pages of Roth's poems wrinkle like skin. Because they have a tendency to stick together, they have been interleaved, as is commonly done with freshly produced prints.[1] A plastic spine supports the book; the plastic pages pucker. When standing up, the volumes lean uncertainly, like elderly people.

Almost forty of Roth's variations on book structure were displayed in the 2018 GRI exhibition *Artists and Their Books / Books and Their Artists* (Reed and Phillips 2018; fig. 11.5). The volumes filled with living matter absolutely stole the show. It seems that living matter resonates especially in artists' books such as Roth's, which themselves are visual references to physicality. The editions of Roth's *Poetrie* (with variant spellings: *Poemetrie, Poeterei*) were shown, all embellished differently by him with watercolors or ink, or versions in which the poems are printed on plastic leaves filled with urine or cheese (Roth 1967–68). It seems that Roth cannot make the same book twice. Each is an inspired variant performance to be viewed and read differently. But my concerns at the time involved touch specifically. Handling the books is important to their concept, but the plastic is fragile, and the printed words of the poems could stick together or fall off the pages. And what about smell? Is the intentionally strong, unpleasant smell of the urine book part of the experience of reading it? At the time of the exhibition, these issues remained unaddressed. Viewers were not permitted to touch the books on display,

CHALLENGING INSTITUTIONS

Figure 11.5 Case displaying artist's books by Dieter Roth. Installation view, *Artists and Their Books / Books and Their Artists*, Getty Research Institute, Los Angeles, 2018. Photo: © Dieter Roth Estate, courtesy Hauser & Wirth

and the smell of the urine book did not penetrate the glass case.

Another edition of Roth's poems, also from the Jean Brown Collection, had an inserted slice of mutton. When the collection was received, conservators took the mutton out of the book (noting the page it had been on) and placed it in a separate housing because it was staining the pages. No doubt this removal was done with good intentions; mutton has no place in a proper book. However, to see the mutton stain as a problem to be rectified, rather than a deliberate intervention by Roth, is a misunderstanding of the work. The conservation treatment interferes with the deliberate insertion of a smelly piece of meat *intended* to spread a stain on the pages. Roth's essential idea was precisely that the mutton's presence is part of the life of this book. Can institutions justifiably counter an artist's intentions?

Compared to such tour-de-force gestures, Roth's editioned multiple *Taschenzimmer* (Pocket-Room, 1969/1972, fig.

11.6) always struck me as an engaging piece that conceives a simple life for an artwork. It is an exhibition in a modest container—a cardboard box that opens to show a print of a table with a small piece of banana peel tacked on. Of the two in the GRI collection, one is quite moldy, and the other is dried out. One box has no lid and is possibly a variant edition. Roth's deployment of the banana slice has to be intentional. Who is not familiar with the life cycle of a banana, and the fruit's frequent use in jokes? Fortunately, several other versions in institutional collections are well documented. All have aged differently according to storage conditions, illustrating how resonant it is to use living matter in an edition in which initially identical works go out into the world and change according to their situations. Should the decayed fruit and mold in *Taschenzimmer* be cleaned up? Again, this would seem to contradict Roth's intent. Better to just let its aging process proceed and make sure that the mold doesn't migrate.

Like Roth's books, many Fluxus works are collections of seemingly miscellaneous things drawn from life,

Figure 11.6 Dieter Roth (Swiss, 1930–1998), two copies of *Taschenzimmer* (Pocket-Room), 1969/1972. Cardboard, banana slices (one moldy, one not moldy), and rubber stamps, inner sheet: 10 × 7 cm. Remscheid: Vice-Versand. GRI 94-F202. Photo: © Dieter Roth Estate, courtesy Hauser & Wirth

significantly not composed so as to be immovable. Domestically staged and deliberately not monumentalizing, they present an accessible atmosphere of informality. But they are also cheaply made and fragile. For instance the hinges on the brittle 1960s-era plastic Fluxus boxes break. The plastic becomes cloudy. To engage with the work, you must take objects out of the boxes, some of which include found objects from nature, such as branches, nuts, pine cones, scat, and bones. Elements in many privately owned boxes have gone missing. How should they be viewed or handled, and how much is too much manipulation? Does lack of access isolate and silence them? Viewing in vitrines effectively suffocates these works. It shuts them up and cuts off the essential personal connection. Yet how can these boxes be viewed in an appropriately informal way if this very activity consumes them? Can the original artists or owners restore, or reconstitute, new works, as Barbara Moore did in her ReFlux Editions?[2] Or do original works become artistic monuments and historical markers when they are acquired by institutions or collectors, arrested in time,

needing to be stabilized and preserved but withdrawn from their intended lives? Does adding reproductions of missing elements constitute restitution of a new generation of objects for another lifetime, or inauthenticity? Perhaps with open editions (print or multiple editions without a specific number or date), that's really okay.

One Fluxus work by George Maciunas most certainly will not be considered for reproduction. In a glass jar, not plastic, the GRI's *Fluxmouse no. 1* (1973, fig. 11.7) is preserved like a specimen in a natural history museum. Murdered by Maciunas, imprisoned in a jar, and packed in an archival box, this small dead animal is presently shelved in a dark vault. Full disclosure: conservators monitor this work, and have added liquid, so there has been some intervention even here. One could observe that although Fluxus artists did make works that include living matter, the mouse is significant in large part because it is no longer living. It has become art.

CHALLENGING INSTITUTIONS

Figure 11.7 George Maciunas (American, born Lithuania, 1931–1978), *Fluxmouse no. 1*, 1973. Glass jar, paper label and tag, and dead mouse, 12.4 × 6 × 6 cm. GRI 1391-669. Photo: Marcia Reed, © The Estate of George Maciunas

About fifteen years ago, there was a true emergency, actually a confined but messy explosion in Fluxus artist and composer Benjamin Patterson's tackle box *Hooked* (1980, fig. 11.8). The lid of the box swings up and opens out to reveal several shelves; each compartment holds an everyday object with a hook in it. It is a complex work with many parts, some of them moving. The box had been stored in an archival banker's box, examined and stabilized by a GRI objects conservator. But when the box was brought out of storage it was smelly, and a sticky substance was oozing: a very old can of sardines in tomato sauce had exploded. Canned goods do have shelf lives, and this one had expired years ago. The conservator cleaned up the mess and assessed whether any of the other pieces were damaged; they weren't. Pictures were taken; documentation was noted. But what to do now about the integrity of the work? Keep the old can, but not in the tackle box? The conservator did locate a very similar

sardine can online, and purchased it. As with the Surrealist butterflies previously mentioned, should the can be replaced? Even if that would only start the clock for another explosion in the future?

Patterson had formerly worked as a librarian at the New York Public Library's Performing Arts branch, and so he was familiar with archives and library practices. He was living in Wiesbaden, Germany, and we were in occasional contact. We got in touch to ask about his intention for the work, but when asked what he would do, Patterson responded, "I don't care. It's yours now." Apparently he possibly considered the old sardine can garbage to be thrown away. Speaking for other Fluxus artists, most of whom had died by then, Patterson said he thought they would accept that their works deteriorate, and so it would be inappropriate to re-create a work that was intended to have a limited life span. This reinforced a principle of stewardship for the GRI's Fluxus and related collections—

Figure 11.8 Benjamin Patterson (American, 1934–2016), *Hooked*, 1980. Tackle box containing found objects with metal hooks attached to them, (closed): 22.2 × 43.5 × 22 cm. GRI 1408-672. Photo: Courtesy the Estate of Benjamin Patterson

namely, that Fluxus means change. The materials were selected by the artists with change as a given. Stabilizing the object and impeding this process denies the spirit of the works, which in most cases are still living long after their makers have died.

In case you are wondering, the old sardine can was retained (fig. 11.9); the newly purchased can, its near twin, was emptied but weighted similarly and placed in the tackle box.

How living matter is dealt with is finally also a curator's and conservator's ethical decision; it is a matter of respect, not only for the artist, but for all living matter. One of the most disturbing moments in my curatorial career involved finding in the archive of Los Angeles photographer Charles Brittin a small body part belonging to a woman who immolated herself during an LA civil rights protest in the 1960s. Observing city workers cleaning up, the artist saved what he could, boxed it, and forgot about it. It had been dutifully catalogued when I discovered it in the GRI special

STATE OF ORIGINAL SARDINE CAN IN 2010

SINCE REPLACED BY A (NON-ORIGINAL) REPLICA
AG · GRI · CONSERVATION

Figure 11.9 Degraded sardine can from conservation document housed with Benjamin Patterson's *Hooked*. GRI 1408-672.

collections. Realizing this archival resting place was not respectful to the woman's memory, I worked with our legal counsel to place the fragment in the Los Angeles city morgue, from whence it would be returned to the family.

This is an extreme example but points to the truth that conservation of media should always return to and respect not just the artist's concept, but also the object itself. When we can, we do ask living artists for advice. But not all creators are still with us, and so the looming question concerns appropriate care and treatment as the life cycle of the work spirals onward. The answer: we talk, we test, and we talk some more. Collaborative communication among artists, conservators, curators, and scientists informs our stewardship of our collections.

NOTES

1. They are interleaved with nonwoven polyester and thin microchamber boards containing zeolites. These act as molecular traps to neutralize acids, pollutants, and other harmful by-products of deterioration. Thanks to Rachel Rivenc, GRI head of conservation, for this information.

2. ReFlux Editions was founded by Barbara Moore, a close associate of Fluxus leader George Maciunas, as a way to continue publication of Fluxus multiples, keeping them indefinitely in print. The works are collated from original vintage printed matter from Maciunas or his estate. The plastic boxes are either vintage or from original sources. See "ReFlux Editions at Printed Matter, Inc.," *e-flux*, March 26, 2002, https://www.e-flux.com/announcements/43512/reflux-editions-at-printed-matter-inc/.

BIBLIOGRAPHY

Gioni 2019
Gioni, Massimiliano, ed. 2019. *Appearance Stripped Bare: Desire and the Object in the Work of Marcel Duchamp and Jeff Koons, Even.* London: Phaidon.

Reed and Phillips 2018
Reed, Marcia, and Glenn Phillips, eds. 2018. *Artists and Their Books / Books and Their Artists.* Los Angeles: Getty Research Institute.

Roth 1967–68
Roth, Dieter. 1967–68. *Poeterei 3/4: Doppelnummer der Halfjahresschrift für Poesie und Poetrie.* Stuttgart, Germany: Edition H. Mayer.

Suzuki 2013
Suzuki, Sarah. 2013. *Wait, Later This Will Be Nothing: Editions by Dieter Roth.* New York: Museum of Modern Art.

Flora and Fauna as Art: A Contemporary Art Conservation Approach to Living Systems

Sherry Phillips
Sjoukje van der Laan

Conservation staff members working with contemporary art at the Art Gallery of Ontario have recently developed a simple and straightforward decision-making framework in response to the unique challenges presented by artworks that contain biological materials or living matter. In the spirit of interdisciplinary approaches toward innovative ways of working, the authors invoke the role of a dramaturge in the performing arts to refine and articulate the decision-making framework of contemporary art preservation and the evolving role of the conservator.

◆　　　◆　　　◆

Intentional inclusion of living materials in art exhibitions is not a recent development. Records indicate that the Art Gallery of Ontario (AGO) was working with artists fifty years ago to display artworks with living components in its exhibition spaces. For conservators, trained as they are to slow down or even stop deterioration processes, an artwork's intent regarding change or decay, both physical and conceptual, can pose a challenge. Responses to the conservation of contemporary art are often outside traditional conservation approaches. For clarity in communication with colleagues, the authors of this paper have developed an approachable decision-making framework to guide exhibition team members operating in an increasingly collaborative work environment and dealing with the unique challenges presented by artworks that contain living matter.

Our approach to these artworks has been dynamic; we are actively involved in the logistics of artwork and exhibition development, including health and safety, ongoing maintenance, and long-term preservation of the artwork. Can we better define our role to foster improved conversations with colleagues and create an evolved description of responsibilities? In the spirit of interdisciplinary approaches that lead to innovative ways of working, we have been exploring the role of a dramaturge in the performing arts to refine our evolving role in the conservation and preservation of contemporary art.

BRIEF HISTORY OF LIVING ART AT THE AGO

Any natural process, I think, eventually destroys itself. Even if you do a painting, destruction is an element in it. Everything grows, blossoms and eventually dies.

—*John Van Saun, 1969*

Living matter in art installations at the AGO began at least as early as 1969 with the organization and installation of the exhibition *New Alchemy: Elements, Systems, Forces* (fig. 12.1). The artists Hans Haacke, Charles Ross, Takis, and John Van Saun were selected by curator Dennis Young for their work with the physical, chemical, biological, and ecological aspects of earth, air, fire, and water (Young 1969). Following *New Alchemy* and its inclusion of growing grass, hatching chickens, and bread mold, the AGO installed *Realism(e)s Survey 70* the following year. *Did You Ever Milk a Cow?* (consisting of a cow, its enclosure, painting, straw, feed, water, plus the cow's other requirements) by artists Glenn Lewis and Michael Morris was installed indoors and featured Elsie, a local Jersey cow (fig. 12.2). And just over a decade later, in 1982, the AGO again hosted an installation containing living matter, in this case works by Noel Harding, an artist known for video, installations, kinetic sculpture, and public art. Chickens, a tree, and goldfish were all living components of Harding's solo exhibition (Cameron et al. 1988).

Figure 12.2 Glenn Lewis (Canadian, b. 1935) and Michael Morris (British, b. 1942), *Did You Ever Milk a Cow?*, 1970. Installation view, *Realism(e)s Survey 70*, Art Gallery of Ontario, 1970. Photo: Art Gallery of Ontario, © Glenn Lewis and Michael Morris

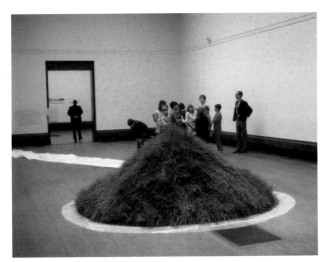

Figure 12.1 Hans Haacke (German, b. 1936), *Grass Mound*, 1967–69. Installation view, *New Alchemy: Elements, Systems, Forces*, Art Gallery of Ontario, 1969. Photo: Art Gallery of Ontario, © Hans Haacke / SOCAN (2019)

The AGO archives contain limited documentation, of varying thoroughness, from the artists or their associates regarding the care and maintenance of these flora and fauna. What conversations took place with them about the planning, installation, health, welfare, and safety of the living art, staff, and visitors? It is likely that these communications happened, but were not documented. Without contemporaneous records to guide us or artist's studio records to consult, we can only surmise the installation requirements. As noted by Stefan Michalski in *Modern Art: Who Cares?*, contemporary art objects are especially vulnerable to memory loss (Michalski 2006, 294). Until 1984 there were only two staff members in the AGO conservation department, both focused on traditional paintings, sculpture, and works on paper; they surely had very little, if anything, to do with the planning, installation, or maintenance of the living artworks.[1]

The cultural and institutional context of an installation should include the perceptions, observations, and experiences of not only the curator, the artist, and the many individuals who pack, handle, install, maintain, and even visit the work but also the documentation produced by conservators.

CASE STUDIES

Within the last five years, the AGO's contemporary art conservators have been working on four major contemporary artworks in the collection involving biological materials or living systems. Lessons learned from past living art installations underscore the need for careful documentation. All of these artworks are unique and demand an individualized approach to development and preservation.

Ron Benner's *Anthro-Apologies (and the trees grew inwards – for Manuel Scorza)* (1979–80, fig. 12.3) was acquired by the AGO in 1994 and first installed shortly thereafter. Fortunately for us, generous documentation was assembled at that time. The work includes four gelatin silver prints (two on the floor and two on the wall) that have been enhanced with photo-oil colors. Textiles, vintage newspapers, a variety of small objects of various materials, dried and fresh fruits, vegetables, seeds, and plants are arranged on top of the two floor photo panels. Desiccation and decay of the fresh produce is intentional and part of the artwork's concept. Fruit flies, sprouting seeds, mold, and decay are desired and part of the active nature of the work.

Although notes from the 1994 installation indicate an acceptance that the photo panels may be damaged by the natural processes of organic decay, and reprinting of the photos is authorized when necessary, the artist adjusted this statement during the most recent installation in 2016. Benner now prefers to preserve the original photo panels with as much of the original image layer as possible intact, complete with existing localized areas of damage. Preservation of "how it is now" has become the new benchmark. Replacement of one or both of the photo panels may still be considered an option when 50 percent of the image has been destroyed by the natural decay processes. Time and reflection, supported by past conservation documentation, probing questions, and open conversation, helped to refine the artist's expectations and our actions.

Pierre Huyghe's *Untilled (Liegender Frauenakt)* (2012, fig. 12.4) utilized the fabrication labor of honeybees to build a wax comb around the head and shoulders of a concrete reclining female nude sculpture. Coauthor Sherry Phillips was involved in the early conversations about the acquisition of the work and was able to engage in research to help guide the acquisition process.

The import of bee and bee products is strictly regulated by the Ontario Ministry for Agriculture, Food and Rural Affairs Bee Act.[2] The Huyghe studio was prepared to send a completed sculpture to Toronto, but inquires to the relevant Canadian government agencies governing animal product importation revealed that it would not be allowed into the country. The AGO received the concrete sculpture and separate base and began to develop the wax comb head and shoulders in Toronto with the assistance of a local urban beekeeper and a hive of Ontario honeybees. The health and welfare of the living beehive was foremost in the plans to create the sculpture; the Huyghe studio and AGO staff wanted to be able to demonstrate that their approach took the health and welfare of the bees seriously. (With increased emphasis in the media on the challenges faced by bee populations worldwide, visitors do ask about the humane treatment of the bees.) Once the sculpture was considered complete, the bees were transferred to a new hive and the artwork was brought into the museum building to become a static object, inactive, with no live bees.

Simon Starling's *Infestation Piece (Musselled Moore)* (2006–8, fig. 12.5) is a low-carbon-steel cast sculpture covered with mussels. To create this artwork, the steel sculpture was immersed for eighteen months in Lake Ontario specifically to become colonized by thousands of zebra mussels, a non-native invasive species in the Great Lakes region. Biologists at the University of Guelph and conservation scientists at the Canadian Conservation Institute and the Canadian Museum of Nature, who are experienced with shells and corroded marine metals, respectively, helped to formulate a plan to achieve the desired appearance and understand the potential aging expectations of the materials. As with the Huyghe piece, the components of this sculpture transitioned from active to inactive when it was brought into a gallery environment.

The AGO's most recent contemporary acquisition of an artwork with living matter is *Today We Reboot the Planet* (2013, fig. 12.6) by Adrián Villar Rojas. This room-size installation consists of a wide variety of materials, among which are plants such as sprouting garlic, potatoes, and grasses. Villar Rojas studio representatives were present during the first installation of the artwork at the AGO to guide us through the importance of the physical appearance and conceptual aspects. Most notably, the

Figure 12.3 Ron Benner (Canadian, b. 1949), *Anthro-Apologies (and the trees grew inwards – for Manuel Scorza)*, 1979–80. Gelatin silver prints, photo-oil colors, newspapers, *mantas* (Peruvian shawls), fresh and dried fruits, vegetables, flowers, seeds, nuts, metal, and wood, 300 × 300 × 214 cm. Art Gallery of Ontario, AGO 94/299. Photo: Art Gallery of Ontario, © Ron Benner

Figure 12.4 Pierre Huyghe (French, b. 1962), *Untilled (Liegender Frauenakt)*, 2012. Concrete with beehive structure and wax, 75 × 145 × 45 cm. Art Gallery of Ontario, AGO 2012/956. Photo: © Pierre Huyghe

Figure 12.5 Simon Starling (British, b. 1967), *Infestation Piece (Mussell ed Moore)*, 2006–8. Steel replica of Henry Moore's *Warrior with Shield* (1953–54) and Eastern European zebra mussels, 155 × 73 × 71 cm. Art Gallery of Ontario, AGO 2011/273. Photo: © Simon Starling, courtesy Casey Kaplan, New York

ACTIVE OR INACTIVE

Each of our living matter case studies was discussed or defined through our decision-making model. We have found that artworks with biological materials or living systems can be classified as either active or inactive. As with every organic element in nature, biological materials grow, flourish, die, and decay. The process is expected but often follows its own timeline. We need to adapt to the pace set by the materials.

Active artworks have a continuous, changing living system; the life cycle may be crucial to the authenticity of the concept. Pip Laurenson posits that authenticity in contemporary art and artistic intention are better articulated as work-defining properties (Laurenson 2006, 9). The pieces by Benner and Villar Rojas, as well as Harding, Haacke, and Van Saun thirty and fifty years prior, exemplify active artworks in a gallery environment, whether they are micro- or macro-biological. Active living systems require a dynamic and unique approach to their maintenance; living and changing components define the artwork.

For example, the Benner has actively decaying fruits and vegetables, and the Villar Rojas has actively growing but preferably struggling plants. When the display period has ended, the living organisms are rehomed, or dried and preserved, or discarded, while the concept is retained to allow for re-creation at a later date according to documentation and installation guidelines. The Starling and Huyghe works are currently inactive; the sculptures have become more like traditional museum objects. Their living systems were once active but by design became intentionally inactive when the artwork came into the gallery environment. Each will eventually be treated like a traditional artwork with a conservation plan based on the needs of the materials.

With experience gained through managing the many facets of biological organisms and artists' concepts, we began to see patterns that guided us in the formulation of a flowchart (fig. 12.7). The flowchart assists with planning, installation, and maintenance of an installation in the context of a busy institutional schedule, but also supports communication of a structure and strategy for these nontraditional contemporary artworks to others who are involved in an increasingly collaborative process.

Replacement, replication, or reconstruction of component parts may be part of the conservation strategy for active or inactive artworks containing living systems.[3] This contemporary strategy may be as simple as replacement of a handful of dislodged mussel shells to fill in an area

sprouting plants should appear to be struggling to survive in their postapocalyptic museum-like display.

The installation opened at the AGO in December 2019 and is expected to be on view for at least two years. Close collaboration with the artist's representatives occurs on a weekly basis for the duration of the installation. The sprouting garlic, potatoes, sweet potatoes, and grasses are constantly assessed and replaced when necessary to maintain the desired conceptual context for the installation. A replacements garden is located in the AGO's Conservation Department, partly for the practical reason that we have windows, and partly because we were the only department equipped to take on the responsibility for this part of the ongoing maintenance.

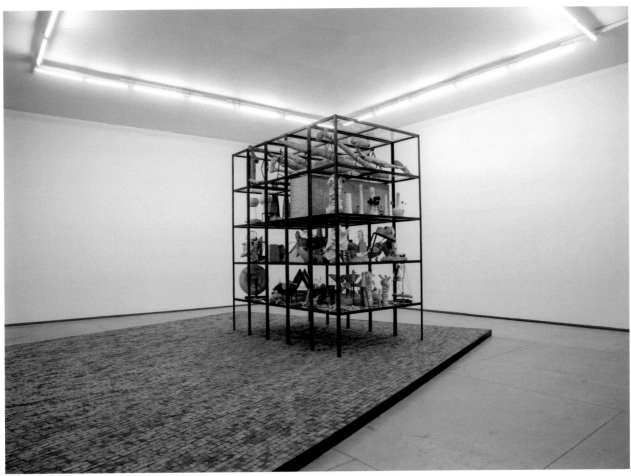

Figure 12.6 Adrián Villar Rojas (Argentinian, b. 1980), *Today We Reboot the Planet*, 2013. Organic, inorganic, human-made, and machine-made matter, including unfired clay, cement, handmade bricks, metal, and glass, all collected in London and Rosario, Argentina, 360 × 195 × 330 cm. Art Gallery of Ontario, AGO 2016/38. Photo: Art Gallery of Ontario, © Adrián Villar Rojas, courtesy the artist and Marian Goodman Gallery

that requires visual or physical support during consolidation treatment, or as extensive as reconstructing an entire wax comb with a new hive of bees when the artist determines that the comb (if or when irreparably damaged) no longer represents his vision. Replication may also be a strategy when components age or are lost, for example when a sprouting potato in the Villar Rojas installation deteriorates to the point that replacement is necessary to replicate the artist's original intent (Curtis 2007, 2).

Working through the flowchart, replacement, replication, or reconstruction strategies can be aligned with or equivalent to traditional conservation treatments, but also equivalent to sanctioned decay. Conservation of contemporary art is a productive activity, based in traditional practice but including interpretation and even coproduction of the artwork (van Saaze 2011, 252).

Secondary living systems may appear within the intentional living systems. In Benner's case, he appreciated the need to manage fruit fly populations but preferred to not altogether eliminate their part in the natural decay process. His thoughts on mold growth were similar, but he left it for us to decide and act as necessary if mold growth posed a hazard to the health of staff and visitors. Our strategy was ultimately to manage the decay of fruits and vegetables with camouflaged absorbent pads to reduce the impact on the original photo panels.

While on open display at the AGO, Starling's *Infestation Piece (Musselled Moore)* developed an infestation of webbing clothes moths (*Tineola bisselliella*) that were attracted to desiccated mussel flesh. The infestation put other works in the collection at risk and necessitated intensive treatment, first to eliminate the moths and second to restore the mussel array. The continued vulnerability has also led to artist-supported restricted loan status and the creation of a permanent display case for the sculpture.

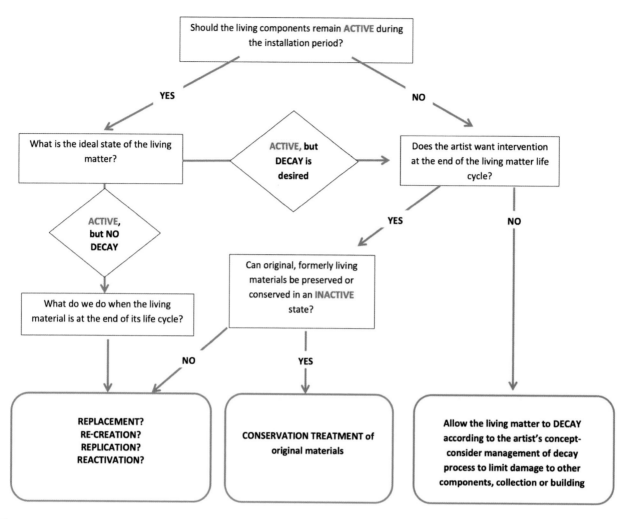

Figure 12.7

The Huyghe wax comb still contains organic matter that cannot be cleaned away; it will be vulnerable to unintended occupation by other living systems when displayed without a case at the AGO. Its installation plan includes establishing an emergency infestation response.

The Villar Rojas work has to date been pest free. Atypical pests in gallery spaces such as fungus gnats in the garden in the Conservation Department and grain mites on bread components can be resolved with simple proactive monitoring and cleaning, but they are not desired auxiliary active living systems, nor are they harmful to other artworks in the vicinity. We work closely with the artist's studio to manage the living components' decay, knowing that the form and rate of decay is only revealed once the installation is living within our specific gallery environment.

COLLABORATION AND THE ROLE OF A DRAMATURGE

Knowing the intent and establishing tolerances regarding how far components may deviate from the artist's original intent assists in the determination of if and how we replace, replicate, reconstruct, or preserve an artwork while keeping its appearance and conceptual intention animated. Careful and extensive documentation is vital, as is close collaboration with many different colleagues and stakeholders for a successful resolution to a project incorporating living systems. This includes the artist and their studio as well as AGO staff such as installers, curators, and technicians, along with external professionals such as biologists or engineers. Being open-minded, thinking laterally, and persevering through challenging installations are increasingly parts of our job. Experts external to the gallery and continuous collaboration and conversation are all tangible elements in

the appropriate presentation of contemporary art with living systems.

We gather together divergent expectations and information and mediate between what might be best for the artwork and potentially conflicting institutional expectations. As members of exhibition content and installation teams, we also try to think ahead to potential conflicts with visitor and staff safety and security concerns. In order to determine that how and what we do to install an artwork meshes well with existing procedures, it is convenient to have a model to describe how our work could fit within the larger context. Vivian van Saaze in *Installation Art and the Museum: Presentation and Conservation of Changing Artworks* (van Saaze 2013) provides an excellent discussion and overview of several individuals who have thought deeply about authenticity and artistic intent, and the evolution of how conservators work with and maintain the notion of authenticity in contemporary art. Performance theory, and dramaturgy in the theater arts in particular, has become a useful way for us to describe how and what we do with some works in the contemporary collection.

A dramaturge can have many different roles, but essentially they ask questions and start conversations in the development of a theater performance. It may be described as an exploration of the context in which a performance resides (McCabe 2001, 64; Cardullo 2005). Customary roles often come into clearer focus through the perspective of someone outside the familiar museum world. Dramaturgy was first mentioned to Phillips as she was working with a Toronto artist, Seika Boye, who was in residence at the AGO in August 2018. Boye's project, *This Living Dancer*, is a self-archiving exercise that examines her evolving life in dance performance.[4] During one session, as they prepared objects from Boye's personal archives, exchanging questions and conversations as a working partnership, Boye turned to Phillips and exclaimed, "You're a dramaturge!" The idea of a conservator proposing creative and pragmatic solutions within a museum and/or archival context to help the artist refine concepts for an installation seemed to Boye very much like the definition of a dramaturge.

The contemporary art conservator's role at the AGO has evolved since the position was first created in 1984. Alongside repairs or restoration, we tend to be primarily responsible for establishing, fostering, and actively maintaining appropriate physical care within the context of authenticity and the larger environmental needs of the work. Like a dramaturge, we are accustomed to guiding an artist by asking questions, listening to their answers, and then negotiating with a larger team to find practical, achievable means of authentically realizing their work.

CONCLUSION

When an artwork contains living matter, a conservator can utilize a decision-making framework to establish whether the work is meant to be inactive or active, and from there develop a suitable animation or preservation strategy. The physical artwork is not always a sufficient guide on its own to create the preservation or maintenance plan. Decaying biological materials each have their own rate of change, which depends on local environmental factors such as light, relative humidity, and temperature. Conservation of contemporary art may diverge from traditional and established conservation concepts; for example, acceptance of material loss or replication may be part of the strategy.

Conservators must be involved, from the earliest inception to the final deliberations, in care and maintenance. Our practical knowledge of materials and processes does not have to be prescriptive. Documentation and close collaboration with the artist and their studio is essential to determine the necessary baseline of desired visual and conceptual appearance and atmosphere, now and in perpetuity. A conservator not only takes care of the physical aspects of the artwork, but may also act as a mediator between the various stakeholders involved in the work's creation, installation, and preservation. How we define and improve our role in the process can come through other fields that have already established a similar role, for instance the role of a dramaturge in the theater arts.

Acknowledgments

The authors wish to express their sincere gratitude to the Michael and Sonja Koerner Fund for Conservation Initiatives for its support of Sjoukje van der Laan's participation in "Living Matter: The Preservation of Biological Materials in Contemporary Art / La Materia Viva: Conservación de materiales orgánicos en el arte contemporáneo" and ultimately our inclusion in this publication. We also thank Marilyn Nazar, AGO archivist, for her keen research assistance.

NOTES

1. Ralph Ingleton, personal communication to Sherry Phillips, July 2019.

2. See the organization's website, http://www.omafra.gov.on.ca/english/food/inspection/bees/apicultu.html.

3. Curtis 2007 discusses the concepts of replacement, replication, and reconstruction as part of contemporary art conservation. These papers were produced for "Inherent Vice: The Replica and Its Implications in Modern Sculpture Workshop," held at Tate Modern, London, October 18–19, 2007.

4. "Seika Boye Will Move You," *AGO Insider*, February 4, 2019, https://ago.ca/agoinsider/seika-boye-will-move-you.

BIBLIOGRAPHY

Cameron et al. 1988
Cameron, Eric, Claude Gosselin, Rick Rhodes, and Ritsaert ten Cate. 1988. *Noel Harding*. Toronto: Art Gallery of Ontario.

Cardullo 2005
Cardullo, Bert. 2005. *What Is Dramaturgy?* New York: Peter Lang.

Curtis 2007
Curtis, Penelope. 2007. "Replication: Then and Now." *Tate Papers*, no. 8 (Autumn): https://www.tate.org.uk/research/publications/tate-papers/08/replication-then-and-now.

Laurenson 2006
Laurenson, Pip. 2006. "Authenticity, Change and Loss in the Conservation of Time-Based Media Installations." *Tate Papers*, no. 6 (Autumn): https://www.tate.org.uk/research/publications/tate-papers/06/authenticity-change-and-loss-conservation-of-time-based-media-installations.

McCabe 2001
McCabe, Terry. 2001. *Mis-directing the Play: An Argument against Contemporary Theatre*. Chicago: Ivan R.Dee.

Michalski 2006
Michalski, Stefan. 2006. "Conservation Lessons from Other Types of Museums and a Universal Database for Collection Preservation." In *Modern Art: Who Cares? An Interdisciplinary Research Project and an International Symposium on the Conservation of Modern and Contemporary Art*, edited by IJsbrand Hummelen, Dionne Sillé, and Marjan Zijlmans, 290–95. Amsterdam: Foundation for the Conservation of Modern Art.

van Saaze 2011
van Saaze, Vivian. 2011. "Acknowledging Differences: A Manifold of Museum Practices." In *Inside Installations: Theory and Practice in the Care of Complex Artworks*, edited by Tatja Scholte and Glenn Wharton, 249–55. Amsterdam: Amsterdam University Press.

van Saaze 2013
van Saaze, Vivian. 2013. *Installation Art and the Museum: Presentation and Conservation of Changing Artworks*. Amsterdam: Amsterdam University Press.

Wharton and Molotch 2009
Wharton, Glenn, and Harvey Molotch. 2009. "The Challenge of Installation Art." In *Conservation: Principles, Dilemmas and Uncomfortable Truths*, edited by Alison Bracker and Alison Richmond, 210–22. London: Elsevier.

Young 1969
Young, Dennis. 1969. *New Alchemy: Elements, Systems, Forces = Nouvelle alchimie: Eléments, systèmes, forces: Hans Haacke, John Van Saun, Charles Ross, Takis*. Toronto: Art Gallery of Ontario.

Conserving Active Matter in Contemporary Design

Jessica Walthew
Sarah Barack

Cooper Hewitt's 2019 Design Triennial, Nature, *celebrated designers working at the cutting edge of synthetic biology, biomedical research, data visualization, urban agriculture, renewable energy, and additive manufacturing, among other design fields. The exhibition highlighted sixty-two projects, including live bacterial cultures, light-emitting textiles, and live plants growing in engineered microclimates. Cross-departmental and inter-institutional collaborations proved integral to the success of the exhibition, and in-depth discussions with the designers themselves minimized ongoing areas of concern. Still, the complex nature of many installations challenged the museum's conservators and pushed against entrenched paradigms, forcing the adoption of novel approaches to staging and maintaining the pieces.*

◆　　◆　　◆

Cooper Hewitt, Smithsonian Design Museum houses the United States' national collection of design, which ranges across all media, encompassing graphic and textile design, decorative arts, product prototypes, process materials, and archives. The museum's triennial exhibitions celebrate designers working at the cutting edge of their disciplines. The 2019 nature-themed Triennial inaugurated the first co-organized execution, with Cooper Hewitt partnering with Cube design museum in Kerkrade, the Netherlands, for a simultaneous display. The exhibition aligned well with the museum's recently enacted strategic plan, which envisions the museum as both a repository of historic collections and an active platform for contemporary design.

The use of "active" materials in contemporary design creates challenges for exhibiting and maintaining complex works in museums. "Active matter" has been the theme of several research projects across the globe examining responsive materials, and forms of material and conceptual "activity" inherent in art and design.[1] While interpretations of this phrase vary, this triennial exhibition presented projects ranging from truly live organisms and plants to synthetic media designed to react to its local environment. This paper considers this range of "active" media and its impact on conservation staff and practices. The featured case studies notably illuminated biases inherent to conservation practice and challenged the museum's conservators to accommodate and even facilitate uncertainty and change to display designers' innovative works. Reconceptualizing these works as process-oriented iterations that are constructed and

maintained through networks of feedback loops has shifted conservation approaches away from those typical for static objects, where maintaining stasis (limiting change) is usually the explicit goal.

The most challenging projects were examples of speculative design—proposals that examine contemporary problems and provoke visitors with visions for futuristic outcomes.[2] The projects featured bioengineered and bioresponsive media (which change rapidly in response to changes in light and temperature), living plants, and microorganisms that were to be exhibited for eight months and required both complex installations and intense maintenance. Other works, though not technically alive, displayed lifelike behaviors and demanded environmental management in a continual feedback loop. Together these works necessitated an interdisciplinary, cohesive approach to their care, and required conservators to interface creatively with colleagues across specialties.

Consistent with the goal of the Triennial, many of the featured designers hoped to exhibit examples of their most recent work, and thus the details of many projects were still being developed during the exhibition planning process. As a result, the specifics of many projects remained unconfirmed until dates very close to the installation. In several cases, the iteration displayed represented an ongoing technological development, with active refinement of the design strategy continuing beyond that iteration—a sort of snapshot of the project as communicated through a bespoke model. Cooper Hewitt's conservators worked closely with internal staff and the designers to realize their desired visions. This alone required flexibility, adaptability, and frequent communication among stakeholders—greatly eased by digital technologies, given that there were sixty-two international design teams. The following case studies highlight the projects that best capture these evolving challenges.

CASE STUDY: LIVING PLANTS

Supporting living plants in three projects involved substantial coordination of parties inside and outside the museum. While one project, Sam Van Aken's *Tree of 40 Fruits* (2008–ongoing, fig. 13.1), was sited in the garden and maintained by the museum's gardener, two other projects were located inside the galleries and required major

resource investments from the designers themselves. The Open Agriculture Initiative (OpenAg) team at MIT Media Lab designed *Personal Food Computer v.3.0* (2018–ongoing, fig. 13.2), a 3D-printed growing chamber. Sensors track climate variables, and a coded "climate recipe" determines the lighting regimen and controls ventilation. Two of these self-sustaining chambers were displayed with growing hydroponic basil plants, which required maintenance: nutrients were replenished by staff twice weekly, and plants were pruned to prevent them from getting too tall. The designers, who had traveled to the museum for the initial installation to train staff, provided replacement plants when needed.

Figure 13.1 Sam Van Aken (American, b. 1972), *Tree of 40 Fruits*, 2008–ongoing. Grafted fruit tree. Installation view in the garden of Cooper Hewitt, Smithsonian Design Museum, New York. Photo: Matt Flynn for Cooper Hewitt, Smithsonian Design Museum

CHALLENGING INSTITUTIONS

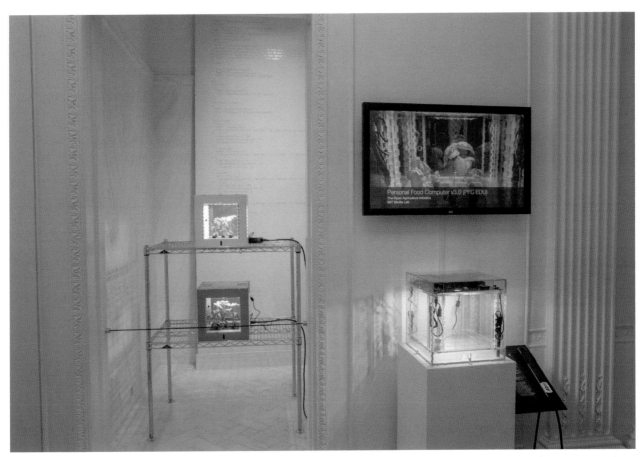

Figure 13.2 Caleb Harper (American, b. 1982), Hildreth England (American, b. 1978), Open Agriculture Initiative (American, active 2015–20), and MIT Media Lab (American, founded 1985), *Personal Food Computer v.3.0*, 2018–ongoing. PVC, polycarbonate, LEDs, electronics, and sensors, each unit 30.5 × 30.5 × 30.5 cm. Photo: Matt Flynn for Cooper Hewitt, Smithsonian Design Museum

Plant Properties (2016–ongoing, fig. 13.3) by Kennedy Violich Architects and the Strano Research Group at MIT likewise required plant replacements, but on a much more intense schedule. This work imagines how bioluminescent plants could be integrated into future architectural settings so as to reduce our society's dependency on electricity. The functional architectural model included living watercress plants along with complex lighting and irrigation systems. Due to the highly specialized plant treatment conducted at MIT to create the luminescing watercress, representatives from the lab traveled weekly to provide and install new plants. The success of this display, as with *Personal Food Computer v.3.0*, relied on active collaboration between internal museum staff and the external design studios, and a significant time investment. While replacement was a viable strategy in both cases, communication took on greater significance to coordinate ongoing intervention in the projects.

CASE STUDY: LIVING CULTURES

Living cell cultures were critical components of two Triennial projects: Teresa van Dongen's *Electric Life* (2018, fig. 13.4) and Oron Catts and Ionat Zurr's *BioMess* (2018–ongoing, fig. 13.5). Close coordination with the designers and their domestic scientific collaborators ensured that live cultures could be used, either transported across international borders or sourced domestically. In each case the bacteria or cultures were nonpathogenic, but still occasioned special handling concerns. Unlike a typical lamp that relies on traditional alternating current, the living lamp in *Electric Life* is powered by an aqueous anaerobic bacterial culture housed at its center. Prior to assembly, the bacterial culture required cultivation for more than one week until it was robust enough to generate the required current. With the designer unable to personally attend the installation, the conservators quickly adapted to the roles of ad hoc bacteriologists and electricians in close consultation with her. Continued feeding and care of the culture proceeded

Figure 13.3 Kennedy Violich Architects (American, founded 1990) and Strano Research Group, Massachusetts Institute of Technology Department of Chemical Engineering (American, founded 2003), *Plant Properties*, 2016–ongoing. Architectural model and nanobionic watercress plants, 152.4 × 106.7 × 61 cm. Photo: Matt Flynn for Cooper Hewitt, Smithsonian Design Museum

Figure 13.4 Teresa van Dongen (Dutch, b. 1988), *Electric Life*, 2018. Steel, aluminum, glass, and liquid with electroactive bacteria, 137 × 90.8 × 78.5 cm. Photo: Matt Flynn for Cooper Hewitt, Smithsonian Design Museum

in a similar fashion, with conservators as proxies for the designer, as had been the case at a previous installation of the work at the Centre Pompidou, Paris, in spring 2019.

BioMess also contains living cells, in this case a hybridoma culture (fig. 13.6) displayed inside a bioreactor, alongside specimens borrowed from the Smithsonian National Museum of Natural History and shown in backlit luxury display cases. The project probes the human fixation with creating new life forms by questioning what is recognized as life. The natural history specimens may be considered "life," but the only actual living matter—the hybridoma cells—is abstracted, completely devoid of environmental context. Made by humans, the hybridoma cells are

contained in and dependent on a technological body, namely a bioreactor. Two bottles containing bright pink live cell cultures were installed by the designer but were not expected to live for the duration of the exhibition without activating the bioreactor, which the museum could not manage. Museum conservators and curators, along with the designers, agreed that if and when the color of the medium indicated that the cells had died, the conservators would remove and replace them with identical bottles, simulating the culture with an inert liquid. This decision was initiated following conversations with Catts during the installation, when he suggested this

Figure 13.5 Oron Catts (Australian, b. Finland, 1967), Ionat Zurr (Australian, b. United Kingdom, 1970), and the Tissue Culture & Art Project (Australian, founded 1996), *BioMess*, 2018–ongoing. Incubator, hybridoma cells, and natural history specimens in exhibition cases, dimensions variable. Photo: Matt Flynn for Cooper Hewitt, Smithsonian Design Museum

Figure 13.6 Oron Catts (Australian, b. Finland, 1967), Ionat Zurr (Australian, b. United Kingdom, 1970), and the Tissue Culture & Art Project (Australian, founded 1996), detail of living hybridoma cell culture, 2019–20. Photo: Matt Flynn for Cooper Hewitt, Smithsonian Design Museum

step. Though this request appeared an aggressive intervention, the staff felt it acceptable after considerable discussion, so that the display would not shift in appearance without ample public didactics. Further, as the cultures would by then be dead, exhibiting a replacement liquid would have the same net result as maintaining the original media—both would contain nonliving matter.

Following successful installations, the conservators grappled with both logistical concerns—safely discarding the *BioMess* culture; the proper feeding schedule for *Electric Life*—and others more philosophical in nature. For instance, is it ethical to obtain living cells but not provide them with the nourishment they need to thrive? Catts and Zurr have written that their work with dependent "semi-

living" cultures broaches but does not intend to resolve these concerns. The works are meant to provoke viewers to examine their own unsettled and ambiguous feelings with regard to what is living and nonliving by presenting them with something in between. In previous works, the designers had involved museum staff and visitors in the rituals of feeding and killing, to contribute to the performance and bring fuller meaning to the works (Zurr and Catts 2002; Catts and Zurr 2006). For Cooper Hewitt's iteration, the conservators assumed that they would eventually (uncomfortably) play the role of executioners. By the close of the exhibition, however, the cell cultures had not shifted significantly in color, and no replacement media had been required. This surprise left the staff with a sort of ironic understanding of the piece, as it became akin to Schrödinger's cat. Were the cells still alive or not? With no visible signs of die-off, but yet no means to test, the vials existed with a vague liminal status of possibly living and possibly deceased.

As opposed to a planned one-time intervention, conservators for *Electric Life* routinely made decisions that directly impacted the health of the bacteria in order to keep the lamp brightly lit. Van Dongen aims to engage owners of her lamps in intimacy through caretaking, while seeing the natural facets of her lamps as "something that exists on its own, in a way" (Design Indaba 2015).[3] Although museum visitors were not consulted, their presumed experiences weighed in on decision making, as did the appearance of the displays. As it turned out, the lamp's intensity waxed and waned as the bacterial culture changed over time, but these changes were imperceptible to the public.

CASE STUDY: ENVIRONMENTAL PASSIVITY/ACTIVITY?

The final case studies present simulations of nature in two contrasting artificial environments, one frozen in time and the other ever-changing. Terreform ONE's *Monarch Sanctuary* (2018–ongoing, fig. 13.7) proposes cladding a skyscraper in an architectural envelope that supports all phases of the butterfly life cycle with adequate heat, moisture, habitat, and food sources. Modern building construction could one day support biodiversity by providing alternate habitats for endangered species. Design studio mischer'traxler's *Curiosity Cloud* (2015–19, fig. 13.8) is an immersive environment featuring more than

one hundred handblown glass bulbs, each outfitted with LED lights, a motor, and a model insect (fig. 13.9). Thermal sensors respond to gallery visitors moving among the pendants: sections of insects turn on and fly around inside the lit bulbs. The piece captures the magic and beauty of the natural world through synthetic media and fosters larger discussions on nature and our contemporary relationship to it. Both installations actually refer to acts of conservation, in this case of the natural world. The architects plan to eventually realize *Monarch Sanctuary* in New York, and are collaborating with butterfly keepers at the American Museum of Natural History to understand the optimal synthetic habitat. In *Curiosity Cloud*, the model insect species were carefully researched and crafted to create a simulation uniting extinct, critically endangered, commonly occurring, and recently discovered species that could never coexist in the real world, highlighting the fragility and mutability of "nature" in the Anthropocene (Lipps et al. 2019, 34–35).[4]

Figure 13.7 Mitchell Joachim (American, b. 1972), Vivian Kuan (American, b. 1966), and Terreform ONE (American, founded 2006), *Monarch Sanctuary*, 2018–ongoing. Architectural model, 411.5 × 350.5 × 121.9 cm. Photo: Matt Flynn for Cooper Hewitt, Smithsonian Design Museum

Figure 13.8 Katharina Mischer (Austrian, b. 1982) and Thomas Traxler (Austrian, b. 1981) as mischer'traxler Studio (Austrian, founded 2009), *Curiosity Cloud*, 2015–19. Blown glass bulbs, handmade artificial insects, aluminum hoods, custom-made circuit boards, motors, LED lights, cables, ceiling plate, and sensors, dimensions variable. Commissioned by Maison Perrier-Jouet. Photo: Matt Flynn for Cooper Hewitt, Smithsonian Design Museum

Figure 13.9 Katharina Mischer (Austrian, b. 1982) and Thomas Traxler (Austrian, b. 1981) as mischer'traxler Studio (Austrian, founded 2009), detail of *Curiosity Cloud*, 2015–19. Blown glass bulbs, handmade artificial insects, aluminum hoods, custom-made circuit boards, motors, LED lights, cables, ceiling plate, and sensors, dimensions variable. Commissioned by Maison Perrier-Jouet. Photo: Matt Flynn for Cooper Hewitt, Smithsonian Design Museum

Exhibition design concerns dictated the staging of each project in specific gallery locations, though in each case unavoidable localized environmental conditions influenced the function and performance of the work. While one may ordinarily perceive the museum environment as a passive player, in these two cases it was the source of major conservation concerns. *Monarch Sanctuary* was originally planned as a fully functional model containing live milkweed and butterflies in the museum's Conservatory, which in itself posed several challenges. The Conservatory lacks effective climate control, and so additional mechanical systems inside the model would be required. The museum staff is not trained to care for live butterflies, and the release of mature butterflies and introduction of new ones raised ethical concerns. Staff expressed ethical qualms about treating butterflies as disposable. Butterflies are attractive and popular (as insects go), potentially opening the museum up to public criticism, and also the sacrifice would undercut the conservation message of the work in a particularly ironic way. Sharing these concerns, the curators and the designers agreed that the museum would display the sanctuary design with simulated (3D-printed) butterflies, reconceptualizing the project's iteration/instantiation as a model without any functional systems or live inhabitants.

Curiosity Cloud's complex system requires particular environmental conditions to allow it to respond to visitors' thermal presence. In this iteration, it was customized for Cooper Hewitt's gallery space and prominently sited at the exhibition entrance. Gallery temperature required tight control to avoid tripping the thermal sensors meant to respond only to actual visitors' bodies. When no sensors are activated (that is, when the temperature is below the 23.5°C "action threshold"), the program activates "allure mode," illuminating just a few bulbs at a time to tempt visitors into the gallery. The precariously balanced system could be viewed as a complex interaction between the human actors (visitors, designers, museum staff) and the electronic elements in the constructed environment.

The environment itself, usually invisible except to collections preservation specialists (as numbers or graphs on data loggers), further assumed status as an active player in the network. When the room became too warm, all the insects were activated, preventing the piece from being experienced as designed. In response, museum staff (conservators and building engineers) participated in a delicate dance with the display, resetting room temperature controls to levels that would be practical from a visitor and gallery perspective but would not inappropriately activate the piece. Exhibition design elements (stanchions to direct visitor flow) also contributed to the work's performance. The designers, working remotely from Austria, modified the code that controlled the sensors and motors, and sent an additional room sensor midway through the exhibition to improve calibration. In this way, multiple actors massaged the installation throughout the exhibition's run, caring for the simulated insects with almost as much attention as they would give living organisms.

DISCUSSION AND CONCLUSIONS

The nature-themed Design Triennial featured cutting-edge designs that engaged with, manipulated, simulated, and re-created the natural world. Installations included micro- to macro-ecology and digitally interactive elements, encouraging the museum's conservators to reconceptualize conservation goals and approaches to working with designers. Considering the complexities of the works early in the planning process, the conservators began to (reflexively) categorize projects—living/nonliving, inactive/active, reactive/interactive—in other words, high maintenance versus low maintenance for conservation. The department further dissected internal conservation assumptions and strategized around proactive versus reactive approaches to planning, installation, and ongoing

maintenance. With the designers continually refining their own projects, advance preparation proved challenging. Flexibility and collaborative approaches were key to success, along with clear communications among all parties. Reflecting on the works now, these lines of communication might be considered inextricable links between all stakeholders and components, who together created an interwoven network operating within the boundaries of the museum environment. Much as actor network theory (ANT, see Latour 1996; Sayes 2014) activates nonliving components of a system, the exhibits both reacted to and acted on all engaged parties, regardless of their initial classification as synthetic or authentic biology.

ANT and other frameworks from material culture studies that seek to understand complex interactions between objects, people, and meanings have been employed infrequently with regard to conservation decision making (van Saaze 2013). However, for many years, conservators have embraced their roles as intermediaries and interpreters, transmitting and translating information between objects and various parties (curators, scholars, artists, students, the public) and serving as advocates for the typically nonverbal objects. In the Design Triennial, concerns for safe display went beyond the customary packing and shipping, mount making, and environmental guidelines, extending conservation's reach into truly intimate interaction with the materiality of the works on view. Instead of focusing on concrete objects, envisioning the works in the Triennial as systems or networks allowed further progression of the idea of managing change over the duration of the exhibition: as feedback builds in a network, the footprint shifts, the players react, and new paths are formed.

WHAT DOES IT MATTER IF THE MATTER IS ACTIVE?

The instinct to classify the works as living versus nonliving, digital versus analog, or according to other binaries did not serve us well in understanding their full complexity. While natural/artificial and analog/digital are often understood as in opposition, many works in the Triennial specifically challenged such dichotomies by blurring boundaries. Designers of active matter often work in explicitly transdisciplinary or anti-disciplinary modes. As Danny Hillis has argued regarding today's era, pulling from anthropological theory, "Entanglement artifacts are simultaneously artificial and natural; they are both made and born. In the Age of Entanglement, the distinction has little significance" (Hillis 2016; Ito 2016).

As conservators working with these highly complex installations, more boundaries began to blur, these in terms of responsibility: between those in charge of creating the works, those delimiting their boundaries, and those maintaining them (in fact, participating intimately in their making and their meaning). It is indeed an interesting coincidence that the work of conservators is often described in the same terms as the fields of bioart or active matter: at the intersection of art and science. Does the distinction between these arenas retain significance? Perhaps only in reevaluating conservation's attempts to engage in scientific, "objective" decision making. In these case studies, there was no "objective" path forward that could have been determined in advance. With so many variables in flux, and actors involved, it was at most times impossible to predict the course of an installation. Works transgressing boundaries between hardware, software, and "wetware" certainly bristle against traditional divisions of museum labor.[5] While conservation and A/V tech sometimes work together, we had never before collaborated as closely as we did for this exhibition. As Jens Hauser argues, in contemporary biodesign, "synthetic biology is being approached as a discipline in which both top-down and bottom-up approaches, and the virtual and the actual, oscillate" (Hauser 2018, 265). Indeed, although conservators attempted predictions and projections to manage change, uncertainty held a much greater role in this exhibition than in typical installations.

Those conserving active matter in contemporary design in a museum context will continue to confront troubling issues of classification. When the works privilege process over representation, how does this change the way we need to conserve them? Neil Leach and other philosophers have already engaged with the provocations of these new media, finding that self-assembling systems push against traditional epistemologies in which forms derive significance from the either hylomorphic (representational, top-down) or morphogenetic (bottom-up, process-oriented) processes that constitute them (Leach 2017, 20–22). Conservators too must wrestle with the philosophical in our decision making. Do we need to actively participate in processes to ensure that the meaning of the work is carried through? What does substitution or simulation of parts do to the meanings of these works? How is disclosure or transparency (conversely, deception) part of the conservation process? It might not matter to visitors that conservators periodically feed the bacteria or replace ailing plants with healthy new ones, but they might be distressed to find out that the hybridoma culture had been replaced with tinted water, essentially Kool-Aid.[6]

Given that many of the Triennial projects discussed here are part of active research programs, feedback from the exhibition may influence future decisions made by the artists and designers—carrying the feedback loop further outside the museum's walls and into the future as new networks build. Among conservators of contemporary art, it is still debated to what extent we should consult on or interfere with artists' practices—acknowledging that conservation interventions can substantially affect both material and meaning of present as well as future works. The projects in the Design Triennial were presented as snapshots, iterations, or test cases, providing valuable data for the designers as processes were negotiated in a new (museum) environment, lacking the controlled conditions of the laboratory or the tidiness of a digital rendering. Yet as conservators, curators, and other museum staff, along with visitors, take part in the enacting of these works, the museum also provides a context where great attention is paid to the controlled framing and staging of the projects. As many of the designers are searching for practical applications for their yet-unrealized concepts, this consideration contextualizes the value of change and iteration. Here change is desirable, encouraged, and an indispensable part of the design process.

Acknowledgments

Thanks to the Cooper Hewitt Triennial team, the designers mentioned in this paper, and especially Larry Silver, Rick Jones, Emily Frank, Andy Wolf, and Emma Mooney, who helped maintain the living exhibits through the duration of the Triennial.

NOTES

1. See Tibbits 2017. The Matters of Activity group at Humboldt-Universität, Berlin, explores "materials' own inner activity, . . . a new source of innovative strategies and mechanisms for rethinking the relationship between the analog and the digital and for designing more sustainable and energy-efficient technologies." See https://www.matters-of-activity.hu-berlin.de/en. Bard Graduate Center's Conserving Active Matter initiative focuses on conservation, exploring the lenses of materials science, history, philosophy, and Indigenous ontologies "that never made the assumption that matter was inactive." See https://www.bgc.bard.edu/research-forum/projects/3/cultures-of-conservation. In this paper, the usage incorporates aspects of both of these conceptions as well as conservation's traditional focus on matter's change over time.

2. See "Next Nature," an interview between Michael John Gorman and Koert van Mensvoort (Lipps et al. 2019, 49–55).

3. According to the artist's website: "A future owner of this living light installation will have to feed and nurture it; a bit of tap water with some additional nutrients and a teaspoon of vinegar a week will do. Van Dongen imagines that having to feed and thus take care of Electric Life, could result in a closer relationship between the light installation and its owner" (van Dongen 2019).

4. The term "Anthropocene" refers to the most recent geological epoch, in which human activity has caused irreversible climatic and environmental shifts. For a concise discussion see https://www.smithsonianmag.com/science-nature/what-is-the-anthropocene-and-are-we-in-it-164801414/.

5. Wetware utilizes cells, protocols, or molecular devices used in synthetic biology, but as applied to art can encompass bioart or the various biotechnological developments highlighted in the Design Triennial (Hauser 2018).

6. For comparison, consider the installation of Josh Kline's *Skittles* (2014) at the Museum of Modern Art, New York, in 2019, in which authentic (wildly eccentric) recipes were reproduced by conservators and the artist's studio working together (Moody, Kavaliunas, and Kuo 2019).

BIBLIOGRAPHY

Catts and Zurr 2006
Catts, Oron, and Ionat Zurr. 2006. "The Tissue Culture and Art Project: The Semi-Living as Agents of Irony." In *Performance and Technology: Practices of Virtual Embodiment and Interactivity*, edited by S. Broadhurst and J. Machon, 153–68. London: Palgrave Macmillan.

Design Indaba 2015
Design Indaba. 2015. Interview with Teresa van Dongen, April 15, 2015. https://youtu.be/-wukvLHp6Cc.

Hauser 2018
Hauser, Jens. 2018. "Art and Agency in Times of Wetware." *Stream* 4: https://www.pca-stream.com/en/articles/jens-hauser-art-agency-in-times-of-wetware-107.

Hillis 2016
Hillis, Danny. 2016. "The Enlightenment Is Dead, Long Live the Entanglement." *Journal of Design and Science*: https://doi.org/10.21428/1a042043.

Ito 2016
Ito, Joichi. 2016. "Design and Science." *Journal of Design and Science*: https://doi.org/10.21428/f4c68887.

Latour 1996
Latour, Bruno. 1996. "On Actor-Network Theory: A Few Clarifications Plus More Than a Few Complications." *Socziale Welt* 47:369–81. http://www.bruno-latour.fr/sites/default/files/P-67%20ACTOR-NETWORK.pdf.

Leach 2017
Leach, Neil. 2017. "Matter Matters, a Philosophical Preface." In *Active Matter*, edited by Skylar Tibbits, 18–23. Cambridge, MA: MIT Press.

Lipps et al. 2019
Lipps, Andrea, Matilda McQuaid, Caitlin Condell, and Gene Bertrand. 2019. *Nature: Collaborations in Design*. New York: Cooper Hewitt, Smithsonian Design Museum.

Moody, Kavaliunas, and Kuo 2019
Moody, Ellen, Lina Kavaliunas, and Michelle Kuo. 2019. "Strange Brew." *MoMA Magazine*, May 9, 2019, https://www.moma.org/magazine/articles/51.

Sayes 2014
Sayes, Edwin. 2014. "Actor-Network Theory and Methodology: Just What Does It Mean to Say That Nonhumans Have Agency?" *Social Studies of Science* 44 (1): 134–49.

Tibbits 2017
Tibbits, Skylar, ed. 2017. *Active Matter*. Cambridge, MA: MIT Press.

van Dongen 2019
van Dongen, Teresa. 2019. "Electric Life." http://www.teresavandongen.com/Electric-Life.

van Saaze 2013
van Saaze, Vivian. 2013. *Installation Art and the Museum: Presentation and Conservation of Changing Artworks*. Amsterdam: Amsterdam University Press.

Zurr and Catts 2002
Zurr, Ionat, and Oron Catts. 2002. "An Emergence of the Semi-Living." In *The Aesthetics of Care?*, edited by Oron Catts, 63–68. Nedlands, Australia: Symbiotica.

Research, Conservation, and Exhibition of a Contemporary Art Installation Containing Living Organisms as Part of the Creative Process

Claudia Barra
Cristina Bausero
María Pía Cerdeiras
Silvana Alborés
Belén Estévez
Soledad Martínez

The installation Lo que mata es la humedad *(It's the Humidity That Kills, 2017) by the Uruguayan artist Federico Arnaud in the collection of the Museo Juan Manuel Blanes in Montevideo, Uruguay, includes elements of living matter. A collaborative effort was formed with the Department of Biosciences at the Universidad de la República, also in Montevideo, to identify microorganisms in the work and in the surrounding environment. Preliminary results indicated the presence of fungi of the genus* Penicillium *and signs of* Alternaria. *Taking into account the artist's intention and the microbiological findings, an interdisciplinary team prepared protocols for preserving the components containing living matter while in storage as well as during exhibition.*

◆　　◆　　◆

The collections of the Museo Juan Manuel Blanes (fig. 14.1) in Montevideo, Uruguay, initially consisted of donations and acquisitions by the city of Montevideo. Starting in 1940, these were supplemented by acquisitions of prizewinning works from the Salones Municipales (Municipal Exhibitions), which brought in pieces by the more renowned Uruguayan artists of the twentieth century, such as José Cuneo, Carmelo de Arzadun, Alfredo De Simone, Amalia Nieto, Joaquín Torres García, Eduardo Yepes, María Freire, Miguel Ángel Pareja, and Hilda López, to name a few. Their works generally employed traditional techniques such as oil on textile support or on wood, drawings in graphite or ink, watercolor on paper, or sculpture in marble, bronze, wood, or plaster. As the twentieth century unfolded, many works began to be created using cardboard as a support, notably by Joaquín

Torres García and his fellows in the Escuela del Sur (Southern School), Pedro Figari, and others. The pictorial language evolved as well from figurative to abstract, covering a wide range of expressions. Screenprinting appeared in the 1950s and 1960s, and left a strong mark on Uruguayan art. In the mid-twentieth century, works of art using new materials and formats such as video art, installations—and, importantly for our discussion here, biological material and digital art—entered the museum's collection.

Figure 14.1 Museo Juan Manuel Blanes, Montevideo. Photo: Javier Ventura, courtesy the author and Museo Juan Manuel Blanes

Contemporary art requires that we consider traditional concepts of conservation, deterioration, and sustainability in a new light, in which the artist's intent and the functionality of the objects often take on crucial roles. With this in mind, new challenges in their preservation must be faced, ranging from aspects of the infrastructure required for storing large-format works to the preservation of new materials, novel combinations of elements, including objects originally intended for industrial or domestic use, and new requirements for the preservation of immaterial functionality and content. Knowledge of the artist's intentions and an interdisciplinary approach are required to establish criteria for registering and documenting works and for storage and exhibition.

The installation *Lo que mata es la humedad* (It's the Humidity That Kills, 2017, fig. 14.2, fig. 14.3) by Uruguayan artist Federico Arnaud (b. 1970) won Second Acquisition Prize in the Montevideo city government's 2017 Premio Montevideo competition (the new name for the Salones Municipales). The installation consists of a metal desk with a swivel office chair and a portable lamp, which directly illuminates a photograph album and nine binders.[1] The desk has a surface layer of dirt that was applied by the artist in the form of mud. Dirt also covers the outsides of the binders and the other elements, with the exception of the album. A video is projected on the wall behind the desk, showing photographs from the album in slide format. An audio track accompanies the imagery in the video; the sound of a working slide projector bursts with each new image that appears.

Figure 14.2 Federico Arnaud (Uruguayan, b. 1970), *Lo que mata es la humedad* (It's the Humidity That Kills), 2017. Paper, cardboard, glass, metal, mud, various synthetic polymeric materials, microorganisms, and insects, approx. 200 × 120 × 130 cm. Museo Juan Manuel Blanes, Montevideo. Installation view, *48 Premio Montevideo*, Museo Juan Manuel Blanes, Montevideo, 2017. Photo: Rodrigo Arrillaga, courtesy the author and Museo Juan Manuel Blanes

Figure 14.3 Detail of *Lo que mata es la humedad*. Photo: Rodrigo Arrillaga, courtesy the author and Museo Juan Manuel Blanes

The installation testifies to the military dictatorship in Uruguay, which is conveyed in the album's photographs showing military and political leaders from the period. In the artist's own words: "There is a silent violence in the images that is being lost to the mold of humidity" (Álvarez 2017, 28–31). Arnaud is alluding to a parallelism between the idea of the deterioration of those who played a part in that period and the deterioration of the photographic evidence. As digitized in the video that is part of the installation, these images are preserved, thus safeguarding a testament to those times.

CONSERVING THE INSTALLATION

Once the primary technical and photographic records of the installation were made, an evident need emerged to utilize new criteria in recording, documenting, and conserving it. The artist was invited for an interview for the purpose of hearing his thoughts regarding the future conservation of the work and to prepare protocols for mounting it for exhibition. These interviews revealed the express need to keep alive the microorganisms that were contributing to the deterioration of the photographs in the album, of the cellulose material contained therein, and of the binders. Research on these aspects was thus begun after assembling an interdisciplinary team. Docents specializing in photographic conservation were called in from the Centro de Fotografía de Montevideo,[2] and studies of microbiological contamination were carried out in collaboration with specialists from the Universidad de la República.[3] The documentation and records team worked with the conservation team to prepare an identification file (also called a unique object record) and enter it into the museum's digital database. A report was prepared on the installation's state of preservation and the requirements for preserving it while in storage and when exhibited.[4]

The interview required that the artist acknowledge the difficulties of conserving the work and the risks entailed in its conservation. He was also informed of the need to research new conservation strategies by which materials in the installation containing microorganisms would be conserved (namely, at low temperatures).[5] The interview led to a protocol of documenting the artist's intentions and a proposal for mounting, in which the artist stated: "I

admit that I am aware that the photograph album is affected by mold that will eventually obscure the images. I feel it is useless to attempt its conservation because the meaning of the work is that the memories it contains are disappearing due to the circumstances of their abandonment, and that that has material and political consequences."[6]

MICROBIOLOGICAL STUDY OF THE WORK AND ITS SURROUNDING ENVIRONMENT

The objectives of the museum's plan for preventive conservation and a program of scientific research include a plan to determine the level of microbiological contamination present in both the photograph album and the binders, and in the environment of Store F, where the work resides when not on view.[7] Specific objectives include isolating and identifying the mold species present in and on the photograph album and binders, and the mold species present in the environment surrounding the installation. The investigation included determining whether there is any correlation between the microorganisms present in the room and those present in the installation's elements under study, as well as understanding the pathogeny of the species found.

For the study, samples were taken from three photographs from the album and the exterior surface of one binder. The samples were taken in the museum, in triplicate, using sterile commercial cotton swabs minimally dampened with physiological saline solution, sampling areas where the presence of mycelium and stains, apparently from mold contamination, were observed (fig. 14.4). The swabs were immediately put into test tubes with NaCl 9 g/L (physiological serum) for transportation. In the laboratory, the samples were inoculated in petri dishes with potato dextrose agar (oxoid) (PDA) with chloramphenicol and incubated at 25°C, in the dark, for five days. After the growth period, to obtain pure cultures, three petri dishes with PDA were inoculated consecutively and incubated at 25°C for five days. In the cases in which isolated colonies were not obtained, monosporic cultures were performed, making adequate dilutions with spores of the mold under study, introducing them into the PDA and incubating them at 25°C for five days (fig. 14.5, fig. 14.6, fig. 14.7).

Figure 14.4 Taking a microbiological sample from the photographic album with a swab. Photo: Natalia Boero

Figure 14.5 Detail of sample from the photo album after five days on potato dextrose agar. Photo: Claudia Barra

Figure 14.6 Culture from the cardboard surface after five days on potato dextrose agar. Photo: Claudia Barra

Figure 14.7 Inoculated colonies from growing plates corresponding to the file cabinet after five days on potato dextrose agar. Photo: Claudia Barra

Figure 14.8 Growth from environmental samples from Space F after five days on potato dextrose agar. Photo: Claudia Barra

At the same time that samples were taken from the components of the installation, samples were also taken from the surrounding environment of Space F. The environmental conditions during the sampling were 16°C and 58 percent relative humidity, during the winter season. This was done by placing open petri dishes with the PDA culture medium containing chloramphenicol in the room for thirty minutes. The number of dishes set out was based on the area to cover, and they were placed in duplicate (fig. 14.8).

First the genus was identified through observation of the macro- and micro-morphological characteristics of the colonies, following the keys according to J. I. Pitt and R. A. Samson (Pitt and Samson 2000; Samson et al. 1995; Frisvad and Samson 2004). Fresh samples from the isolated colonies were examined under a Nikon ECLIPSE E200

microscope with a digital Y-TV55 camera. From the set of six samples taken from the objects, species corresponding to the *Penicillium* genus were isolated based on their morphological characteristics (fig. 14.9). Since they could be seen with the naked eye, a high number of fungus colonies were isolated from the objects. Confirmation of the presence of species of the *Alternaria* genus on the samples from the binder is still pending.

Figure 14.9 Samples viewed under a 40X optical microscope. Photo: Belén Estévez, courtesy the author and Laboratorio de Microbiología, FQ/Udelar

Although the researchers have not yet obtained final results, they were able to observe that the fungi isolated from the room environment did not match those isolated from the installation's components. The result of the samplings from the room environment was promising: the number of colonies that deposited on the dishes within the thirty minutes of exposure was not high.

The genera of fungi found so far are the usual agents of deterioration in organic materials. They proliferate in enclosed, damp places with low air ventilation. They are in the air and on the floor, and they disperse through spores. The risk for contamination of different materials can be evaluated in relation with water activity.[8] Different ranges of this parameter have been reported that are linked to the growth of fungi (Valentin 2010, 2). The method chosen for identifying the species was amplification and sequencing of the rDNA of ITS1 and ITS2. (These studies were done outside the country, along with another group of environmental samples that were taken from the museum's collection.) The sequences obtained will be entered into the appropriate software that will identify them by comparing them to fungus nucleotide sequencing reports from the database of the National Center for Biotechnology Information (NCBI) using the BLAST tool.[9]

Once we know for certain the species of fungi present in the room's environment and in the stored components, we can draw conclusions regarding the risks of contamination in that part of the museum, in the rest of the collection, and to the health of staff and visitors (Di Carlo et al. 2016). Among the great variety of fungi genera that are usually found in closed rooms, *Penicillium* and *Alternaria* stand out as significant allergens. Their pathogenicity may affect people who are immunocompromised, such as children, the elderly, and the immunosuppressed (Al-Doory and Domson 1984). Among these fungus genera, certain species have a greater pathogenic potential than others, so it is important to continue the study until they are identified (Valentin 2010, 5).

Safekeeping and conservation of artworks made with living matter, as is the case with the installation at hand, is a new situation for the Museo Blanes to address and research. The challenge does not end with the need to ensure the safekeeping, preservation, and accessibility of the work; additionally, it is necessary to ensure that conservation of the rest of the museum's collection is not affected and that healthy conditions are maintained for staff and the public. It was confirmed that the components contaminated with living matter must be isolated, taking into account the intentions of the artist.

CONSERVATION STRATEGIES

Keeping microorganisms alive is a complex matter, both for conservation of the museum's collection and for this particular work, as has been mentioned, due to the high risk of contamination to the rest of the collection and due to these particular microorganisms' adverse effects on people. Considering the artist's intentions, the museum ruled out applying biocide treatments and consequently made the choice to freeze the material containing living biological matter during periods of storage, and to isolate the installation during exhibition. The components of the installation containing living matter will be kept at a low temperature when in storage (likely somewhere between -10°C and -20°C) to prevent microbial development without the effects that a biocide would have on the microorganisms. When they are returned to favorable temperature and relative humidity, they will regain the ability to proliferate. As opposed to a standard procedure, and based on the conservation objectives established, there will be no packing protocol to minimize deterioration due to variations in humidity during these processes (Voellinger and Wagner 2009). Only selected pages of the album will be interleaved with polyester film in order to avoid adhesion between pages, as the album is exhibited

in an open position. Based on the same conservation objectives established, this interleaving will not be necessary to the conditioning inside of the binders, as they are exhibited closed. Each of the ten components will be individually packed in a hermetically sealed, double polyethylene bag and placed in containers with polypropylene inside a freezer at a temperature around -10°C.

The flash drive containing the audio and video was backed up in triplicate on the institution's server and on two other external memory drives. It has been packed and put into storage under controlled environmental conditions (18°C to 20°C and 48 to 55 percent relative humidity). All digital material will be migrated to appropriate media every five years or sooner to avoid obsolescence.

The dirt that is on the desk will be the subject of future studies. Plans call for it to be stored at a low temperature, and its potential replacement will be considered. The remaining components of the installation will remain in Space F.

PROPOSAL FOR FUTURE EXHIBITION

The proposal is to exhibit the installation inside an enclosure with side walls and a glass wall in front, a double back wall of white plaster with access for staff, and a lightweight roof. The size and type of lighting will depend on the curatorial proposal and the funds available for carrying it out. Inside will be a dehumidifier and an air-conditioning unit to maintain the appropriate environmental conditions to prevent possible condensation on the front glass wall. Ideally, the exhibition hall should have controlled conditioning of temperature and relative humidity. The video projector will be placed inside the enclosure, centered with respect to the desk, and the audio will play outside the enclosure, near the projector, following the instructions in the assembly protocol. A drawing of the proposal can be seen in figure 14.10. The need to refresh and filter the air should be assessed (Valentín, Muro, and Montero 2010).

FINAL CONSIDERATIONS

This study of the conservation, storage, and exhibition of this installation revealed the importance of having the artist's input and of conducting interdisciplinary research. The conducting of microbiological studies and exchange of criteria and experiences with different specialists exemplify collaboration among specialists, and were highly significant for the purpose of proposing and assessing new

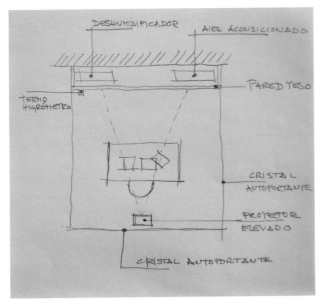

Figure 14.10 Cristina Bausero, sketch proposal for the exhibition installation. Photo: Cristina Bausero

conservation strategies. Aspects such as the sustainability of these strategies continue to be subjects for debate concerning how to resolve the various situations we encounter in dealing with contemporary art.

Acknowledgments

The authors wish to express their gratitude to the organizers of the Getty Conservation Institute symposium, MUAC and ENCRyM; visual artist Federico Arnaud; Nilda Mila of the Archive and Documentation Area of the Blanes Museum; Leire Escudero, Natalia Boero, and Marcos Delgado of the Blanes Museum Conservation Area; Daniel Sosa, director of the Photography Center of Montevideo; docents Fernando Osorio and Gisa Villanueva; and Rachel Rivenc for encouraging us to take part in this symposium.

NOTES

1. Área de Documentación y Archivo, Museo Juan Manuel Blanes, admission of works, ST records, C5-CR-209/2018.

2. Fernando Osorio Alarcón and Gisa Villanueva, Centro de Fotografía de Montevideo, Intendencia de Montevideo, Uruguay.

3. Department of Biosciences, School of Chemistry, Universidad de la República, Uruguay.

4. Claudia Barra, 2018 technical documentation, Área de Documentación y Archivo, Museo Juan Manuel Blanes, Informe de Conservación_Inv. 4085-18.

5. Cristina Bausero, interview with Federico Arnaud, October 18, 2018, Área de Documentación y Archivo, Museo Juan Manuel Blanes.

6. Federico Arnaud, "Protocolo de montaje e intenciones de conservación para la instalación: Lo que mata es la humedad," 2019, Archivo del Museo Juan Manuel Blanes, Ingreso de obras; ST:C5-CR-209.

7. Store F is an open area in the basement that is currently undergoing transformation into an isolated and equipped storage area.

8. Water activity (a~w~) is the quantity of water available for growth of microorganisms. The term comes from food engineering and is determined as a ratio of pressures of water vapor.

9. On BLAST see the US National Library of Medicine website: http://www.ncbi.nlm.nih.gov/BLAST.

BIBLIOGRAPHY

Al-Doory and Domson 1984
Al-Doory, Y., and J. F. Domson. 1984. *Mould Allergy*. Philadelphia: Ed. Lea & Febiger.

Álvarez 2017
Álvarez, Raúl (Rulfo), ed. 2017. *48 Premio Montevideo de Artes Visuales 2017*. Montevideo: Centro de Exposiciones SUBTE, Intendencia de Montevideo.

Di Carlo et al. 2016
Di Carlo, Enza, Rosa Chisesi, Giovanna Barresi, Salvatore Barbaro, Giovanna Lombardo, Valentina Rotolo, Mauro Sebastianelli, Giovanni Travagliato, and Franco Palla. 2016. "Fungi and Bacteria in Indoor Cultural Heritage Environments: Microbial-Related Risks for Artworks and Human Health." *Environment and Ecology Research* 4 (5): 257–64.

Frisvad and Samson 2004
Frisvad, Jens C., and Robert A. Samson. 2004. "Polyphasic Taxonomy of Penicillium Subgenus Penicillium: A Guide to Identification of Food and Air-borne Terverticillate Penicillia and Their Mycotoxins." *Studies in Mycology* 49:1–174.

Pitt and Samson 2000
Pitt, J. I., and R. A. Samson. 2000. *Integration of Modern Taxonomic Methods for Penicillium and Aspergillus*. Amsterdam: CRC Press.

Samson et al. 1995
Samson, R., F. Ribera, V. Sanchis, and R. Canela. 1995. *Introduction to Food-Borne Fungi*. Baarn, the Netherlands: Central Bureau for Schimmel Cultures.

Valentín, Muro, and Montero 2010

Valentín, N., C. Muro, and J. Montero. 2010. "Métodos y técnicas para evaluar la calidad del aire en museos: Museo Nacional Centro de Arte Reina Sofía," edited by CARS – IIC Grupo Español, 63–81. Madrid: Museo Nacional Centro de Arte Reina Sofía. https://www.museoreinasofia.es/sites/default/files/actividades/programas/metodos_y_tecnicas_restauracion.pdf.

Valentin 2010

Valentin, Nieves. 2010. "Microorganisms in Museum Collections." *Coalition*, no. 19 (January): 2–5. http://www.rtphc.csic.es/issues/19_01.pdf.

Voellinger and Wagner 2009

Voellinger, T., and S. Wagner. 2009. "Cold Storage for Photograph Collections: Vapor-Proof Packaging." *Conserve O Gram*, no. 14/12: 2–5.

When Installation Art Depends on Live Surroundings to Survive

Camilla Ayla Oliveira dos Anjos
Magali Melleu Sehn

This paper investigates the genesis of Aqui Estão *(Here They Are, 1999), a site-specific installation by Anna Maria Maiolino in the Museu do Açude, Rio de Janeiro, an institution in the middle of one of the largest urban forests in Latin America. It discusses Maiolino's artistic intentions; the issues arising from the lack of any documentation about the outdoor site-specific installation since its construction; the decisions and actions made in order to conserve it; and the installation's specific needs for preservation, which take into account its living surroundings. The use of a risk management tool intended to minimize discrepancies and misunderstandings created by the near-complete lack of documentation is proposed, and parameters to guide the installation's preservation and establish priorities are discussed.*

◆　　◆　　◆

Although living matter in art is often associated with rapid decay, the artwork discussed here, *Aqui Estão* (Here They Are, 1999, fig. 15.1) by Anna Maria Maiolino (b. 1942), is made from a material that is organic yet relatively stable: wood. The living matter that supports the existence of this artwork is the tree to which it is attached. For this installation, the natural surrounding is as important as the wood sculpted by the artist's hand.

The Museu do Açude in Rio de Janeiro is a historic museum founded by Raymundo Ottoni Castro Maya (1894–1968) using property and money that he acquired through his family's lucrative coffee business, with a collection primarily composed of objects collected in Brazil and during his travels across the world.[1] Castro Maya was an important patron of the arts in Rio de Janeiro in the mid-twentieth century. The museum was inaugurated during his lifetime, in 1964, and until the 1990s was focused on its historical collection. In 1983 the Castro Maya Foundation ceased to exist and the museum became federal property when the estate transferred the responsibility for its administration to the Instituto do Patrimônio Histórico e Artístico Nacional.

What sets the Museu do Açude apart from other historical institutions is its location in one of the largest national parks inside a huge urban area in Brazil: the Tijuca Forest.[2] In the 1990s, increased awareness of the importance of the surrounding natural space prompted the director of the museum at the time, Carlos Martins, along with the artist Tunga, to invite artists to submit proposals for site-specific

Figure 15.1 Anna Maria Maiolino (Brazilian, b. 1942), *Aqui Estão* (Here They Are), 1999, pictured here in 1999. 750 rolls made using five different wood types: cedar, *freijó* (jenny wood), yellow heart, mahogany, and *jatobá* (courbaril or purpleheart). Museu do Açude, Rio de Janiero. Photo: Vicente de Mello, courtesy Castro Maya Museums

installations within the forest. In 1993 the first such, entitled *Aquadorado*, was realized by Shelagh Wakely: Wakely sprinkled a thin layer of powdered gold in the waters of one of the museum's outdoor fountains. After this first experience with contemporary art outdoors, Martins decided to host an exhibition called *Potências do Orgânico* (Organic Potencies) in 1994 consisting entirely of temporary site-specific installations, curated by Marcio Doctors. Some of the installations were meant to decay and eventually disappear; for example, Tunga created an art installation using tables covered in syrup and a UV light to attract insects, which became incorporated into the installation. Artur Barrio wrapped a gate in raw meat.

Following this first outdoor exhibition, the new museum director, Vera de Alencar, implemented a project for the occupation of the museum's forest space with permanent, site-specific installations. Called *Espaço de instalações permanentes* (Space of Permanent Installations), it was inaugurated with two works: Anna Maria Maiolino's *Aqui Estão* (Here They Are) and Iole de Freitas's *Dora Maar na Piscina* (Dora Maar in the Pool). This collection eventually grew to include ten works by different artists and was

renamed *Circuito de Arte Contemporânea* (Contemporary Art Track). The most recent additions came in 2016. Since 2013 the museum has also hosted annual temporary exhibitions of site-specific works in its outdoor spaces.

AQUI ESTÃO

Aqui Estão is one in a series of works exploring composition, material, and gesture initiated by Anna Maria Maiolino in the beginning of the 1990s. The manufacturing by Maiolino's hand (fig. 15.2) is as important as the aesthetic result. The repetition of the same gesture created "primitive forms," which look alike but are never exactly the same (Doctors 1999, 32). The gesture imprints a singularity in each one (fig. 15.3). The art critic Suely Rolnik regards *Aqui Estão* as the climax of this series:

> Solid cylinders with rounded ends made from a variety of wood shaped on a lathe, providing a rich range of colors, shades and nuances. The forms are linked by a metal wire that goes through a hole made at one end and binds them to the trunk of an ancestral tree in its natural forest habitat. The work establishes a living composition comprised in the natural trunk and its exuberant cloak of artificial fruit. In this intimate contact, the woods of the artwork evolve with the natural changes in the wood of the trunk; exposed to the same milieu, they are again covered with moss and take on the textures and colors of the trees they originally came from. (Rolnik 2002, 110–11)

Maiolino notes that she chose wood because it would last longer than the unfired clay she had been using thus far in the series. She selected five kinds of wood, made 750 basic forms, and tied them to a huge tree beside the main structure of the Museu do Açude (fig. 15.4). The installation was specifically created for that spot, and only exists as long as the tree and all the cylinders are there. The following passage is from the only known extant interview about the work. Conducted by the curator at the Museus Castro Maya (the parent organization), it has since 2003 played continuously in the Museu do Açude's reception area:

> I don't mean to compete with nature but clearly nature is powerful—it contains the elements, the wind, the storms. In other words, the artwork should be something to stay there. At the same time, I want to cherish a concept that I have been developing for a long time and is still important to me: it is about repetition, about the gesture in the action of basic forms in repetition. Then I thought about using wood. Then I produced almost eight hundred wood cylinders, shaped them on a lathe, with different kinds of wood, I mean, the idea was to return the matter to the

CHALLENGING INSTITUTIONS

Figure 15.2 Anna Maria Maiolino working on a lathe, 1999. Photo: Vicente de Mello, courtesy Castro Maya Museums

Figure 15.3 Anna Maria Maiolino hanging the wood rolls to dry, 1999. Photo: Vicente de Mello, courtesy Castro Maya Museums

original matter, right? I felt that the artwork's power takes place from an accumulation, right?! In addition, this installation produces these basic handmade forms, rescuing the idea of a collective labor, those forgotten ideas, and those gestures—not those forgotten ideas—those forgotten gestures. Then the people regain themselves in their labor. The point about the accumulation is that the more time stretches, with more accumulation, the more powerful the artwork is.[3]

In the exhibition catalogue, Doctors, the curator, also underlines the importance of the installation's color nuances:

> *Those who saw the locale before the work was placed in it probably remember it as a neutral space, a space to pass through. Now, what becomes evident is the chromatic explosion of this space, which has been unleashed by the richness of the tones of the wood into many nuances of greens and yellows.* Aqui Estão *draws us close to the landscape (illusory representation) to usher in an experience of the immanence of this space (installation).* (Doctors 1999, 52)

ARTIST INTENT MODIFICATION: COLOR APPEARANCE VERSUS MATERIAL DECAY

Aqui Estão was initially meant to decay. With the passing of time, it would increasingly blend in with nature to the point that it might no longer, at first glance, be recognizable as an artwork made by human hands. Microbiological attacks and patination would cause the wood to lose its rich nuances of color and blend with the tree that supports it. But the museum staff reported that Maiolino changed her mind when she realized that the alterations brought about by gradual deterioration were not going the way she had imagined (the only documentation for this is the oral testimony of former museum staff). Apparently the artist once visited and disliked the visual aspect of her installation so much that she requested a restoration. The artwork was restored around 2014, but again the documentation is very scarce, and consists only of staff recollections and a few digital images.

Two pictures show the process of detachment of the wood pieces from the tree and their reinstallation, but there is no

Figure 15.4 Anna Maria Maiolino attaching the wood rolls to the tree, 1999. Photo: Vicente de Mello, courtesy Castro Maya Museums

image of the whole work and no documentation of the installation's condition or the reasons why the restoration was done. Two additional pictures are known, depicting what appears to be the application of a coating, but no one on staff was able to provide information on what precisely they show. One after-treatment picture was found as well, showing just one side of the installation.

The photos and information on the installation's inauguration in the exhibition catalogue constitute most of the accessible documentation (Doctors 1999). The Açude has not maintained any records of the installation's history besides the images described above.

RISK MANAGEMENT: A TOOL TO IDENTIFY PRIORITIES

The decision-making model for the conservation and restoration of modern and contemporary art proposed by the Foundation for the Conservation of Contemporary Art (SBMK) in 1999 and recently revised was initially suggested for *Aqui Estão*, but could not be practically applied because

of the lack of documentation on the work, which is a prerequisite for the model.[4] Instead, the risk management process (ABC method) was used, as it had successfully been applied to another indoor installation (Ankersmit et al. 2011; Michalski and Pedersoli 2016). Because there was no data about how the installation had interacted with its surroundings, the model was deemed generative of more potential approaches to its conservation. The following steps were followed for evaluating the artwork and its associated risks and future status.

Thirty-three primary risks were enumerated in the evaluation and used to generate table 15.1. The red bars represent the A score (risk probability or damage accumulation), the yellow bars represent the B score (risk impact in the installation), and the green bars represent the C score (chances for reversing the damage). The blue lines represent the uncertainty.

Some of the main considerations in an application of risk management were the importance of the color nuances for the artist and critics, as discussed above; the manufacturing by the artist's hand as an important aspect of the concept; that the installation is site specific and tied to actual living matter; its location, in the sense of both being outdoors and in this specific geographic site; the interaction of the materials and the environment over time; the work's current conservation status; and any possible link between present damage and possible causes. Information to identify possible problems was drawn in part from the media (news and digital archives from magazines, and other images and information from secondary sources on the internet with specific dates associated) and past museum publications.

The major risks are linked to the geographic location of the Açude and its administration. The seasonal rains—and their physical force—had destroyed two site-specific installations in the past, and damaged the museum buildings themselves. Besides that, the museum suffers from a lack of funding and staff, which is in great part responsible for the absence of documentation and monitoring. The scarcity of planning and funds leads to delayed responses toward conservation, which in this case had led to the loss of important material and immaterial characteristics.

The location outdoors is the major cause of damage to *Aqui Estão*, yet nothing can be done about that: the work is site specific and impossible to relocate, and its environment cannot be modified. The forest, as a national park, cannot be altered in any way, and the installations will therefore suffer daily the consequences of being outdoors. As a result, the most immediate, urgent, and

Risk Type	C Score	B Score	A Score	Uncertain Positive	Uncertain Negative
Landslide	-2	4	3	1	2
Car Crash	-2	3.5	1	1	2
Branch or fruit fall	-2	2.5	2	1	2
Fall of surrounding trees	-1	4.5	2.5	1	2
Fall of the tree the installation is attached to	0	5	1	1	0
Human action that results in physical forces	-3	3	1	1	2
Rain	-2	3	5	3	2
Floods	-1	3.5	1	1	2
Pipe burst	-3	4.5	2	1	2
Forest fire	0	5	1	1	2
Acidental fire	0	4.5	1.5	2	2
Fire from electric malfunction	0	4	1	2	2
Fire from flammable materials	0	4.5	1	2	2
Termites	-3	4.5	3	1	2
Plants	-4	2	5	1	2
Birds, mammals, and insects living in the installation	-3	1.5	5	1	2
Pollutants	-2	2	5	1	2
Dirt and particulate	-2	1.5	5	1	2
Mircobiotic degradation	-1	4	5	2	2
Animal excrement	-4	3	5	1	2
Natural light	-2	3.5	5	1	2
Natural temperature	-2	2.5	5	1	2
Natural humidity	-1	4	5	1	2
Lack of documentation	-4	5	5	2	3
Dissociation or dispersal of the installation's components (wood rolls)	-1	4	1	3	2
Vandalism	-3	3	1	3	2
Artwork component theft	0	2	4	1	3
Arson	0	5	1	2	2
Lack of or inadequate maintenance	-1	4.5	5	1	2
Lack of or nonexistent documentation	0	5	5	2	3
Lack of previous condition reports	0	4.5	3.5	1	2
Lack of funds for preservation programs/proposals	-1	5	5	1	2
Change of wood natural nuances from outdoor display	-2	3.5	2.5	1	2

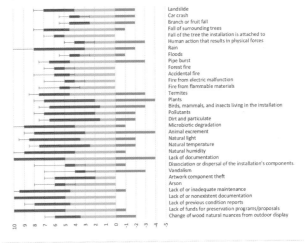

Table 15.1 *Aqui Estão* risk management. Camilla Ayla Oliveira dos Anjos, 2019

cheap preservation measure that can be taken is to adequately document the work.

CONSERVATION PROPOSAL: MODEL FOR DOCUMENTATION AND PRESERVATION

Since the institution's documentation is not sufficient to evaluate the alterations that *Aqui Estão* has already undergone, and given that these same changes cannot be ignored as part of the installation's history, a model of documentation is proposed that should remedy some lack of information. Models presented in publications from Getty (Beekens and Learner 2014; Pullen and Heuman 2007; Levin 2012; Learner and Rivenc 2014; McNally and Hsu 2012; Verbeeck 2016), Tate (Heuman 1999), the University of Amsterdam (Hummelen, Sillé, and Zijlmans 1999, 179–90, 191–95), and the publications *Modern Art: Who Cares?* (Hummelen, Sillé, and Zijlmans 1999) and *Inside*

Installations (Scholte and Wharton 2011) exemplify this suggestion of documentation. The model presented here is the first step for preserving the installation. A model file for documentation of the museum's site-specific installations that integrates the contemporary outdoor collection was proposed. To make this model, already-revised reports systems in relevant contemporary collections were used.

Since the museum already possesses valuable (albeit unorganized) documentation, mostly photographs and information in exhibition catalogues, the main goal for the initial phase is to organize this information and combine it with additional sources such as artist interviews and newspaper clippings. At the same time, we propose to give the museum staff tools and methods to complete the information bank. Hopefully, compiling the existing information will also encourage the museum to study the various installations' surroundings and how nature is impacting their preservation.

Once the first steps of the documentation are completed, an interview in situ should be conducted to ask the artist detailed questions about her intentions for the creation of the work and its appearance, and her wishes for its preservation. This should serve as the base to design a conservation plan. It would also be important to create an institutional memory by recording oral histories with staff who were working at the museum when the artwork was created.

The documentation is the most urgent measure because it is the tool and guide when any preservation measure is necessary. The conservation and restoration measures need financial resources to be completed, and one way to obtain these is by presenting the government with a proposal. It is impossible to demonstrate any urgency about these measures if there are no records of the material damage, its rate of occurrence, and by what standards it should be preserved. Having consistent documentation is necessary to show what should be done and how to do it, and obtain the necessary financing. The model file could then be applied to all of the Açude's outdoor site-specific installations.

With the record of the artist's current opinion about how the installation should look, a path for preservation in consonance with its material and immaterial aspects can be drawn. Even if the artist decides to accept the material's decay, the documentation will still be paramount as a way to record its existence—how it has passed through the years and eventually dissolved back into nature.

If instead a decision is taken to mitigate the damage of time, different actions are suggested. First, a study of the microorganisms present on the wood's surface would be useful to eliminate them in a targeted way. The wooden cylinders would need to be detached from the tree, with adequate documentation of the process and mapping of the cylinders' positions. The treatment of the wood should include cleaning and removing microbiological attack, consolidating the wood, and filling losses and retouching surfaces as necessary. Most importantly, a protective surface coating should be applied. Finally, the cylinders would be reattached to the tree with a material that does not degrade the artwork, damage the tree, or impede the tree's continued growth. It would be important, after the restoration, to create a maintenance routine, including periodic application of a biocide and regular monitoring of the artwork's appearance.

CONCLUSION

The main threat to *Aqui Estão* is its location outdoors, yet the work is site specific. In establishing a conservation plan, it is paramount to start by clarifying the artist's position in regard to the acceptability of decay. Two main pathways are envisaged: one where the work is allowed to decay and slowly disappear, and one in which the wood is treated and its color nuances restored. In both cases, systematic documentation is needed. But the economic reality of the Museus Castro Maya and its overall priorities also must be taken into consideration. There are more than ten thousand items in the collection, and the Açude has only four staff responsible for all its works, both indoors and outdoors.

Unfortunately, considering the resources needed to preserve the site-specific outdoor installations on the one hand, and the pressing needs of the entire collection on the other, one realizes that there is little chance of being able to address the conservation of the outdoor installations. Funding is needed to implement any preservation measures, and the reality of federal museums in Brazil has been, for a long time, one of a lack of funds. This tendency has been worsening in recent years, but we can only hope that the trend will be reversed in the future.

NOTES

1. "Castro Maya was the son of Raymundo de Castro Maya, a renowned engineer with connections to Emperor D. Pedro II, and Theodozia Ottoni de Castro Maya, heiress of a traditional liberal intellectual family. From his father, Castro Maya inherited the taste for collections of art objects, and from his mother, the fondness for literature. The family lived in France when his father occupied the position of Brazilian vice consul in Paris, a city to which Castro Maya returned several times, and which influenced his cultural formation." From the museum's website: http://museuscastromaya.com.br/castro-maya/?lang=en.

2. The Tijuca Forest is a mountainous place covered with human-made reforestation. What was once a natural forest had been devastated during colonial times to grow sugar and coffee. Replanting was initiated in the second half of the nineteenth century in part to protect Rio's water supply, and in part by order of the Portuguese Royal Family, who moved to Rio de Janeiro in the nineteenth century and ordered a wholesale redesign of the city along European lines. They hired landscapers and other professionals to enact the transformation from a coffee plantation to a tropical European-inspired forest. In 1961 Tijuca Forest was declared a national park. It contains most of the city's natural and human-made attractions, such as the sculpture of Christ the Redeemer atop Corcovado mountain; Mayrink Chapel, decorated with murals painted by Cândido Portinari; and imperial-era constructions such as the pagoda-style gazebo at Vista Chinesa outlook. Other attractions include natural heritage such as the Cascatinha Waterfall and a colossal granite picnic table called Mesa do Imperador (Imperator's Table).

3. My transcript and translation. The recording in the original Portuguese is available here: https://vimeo.com/125530548.

4. The decision-making model is available at https://sbmk.nl/source/documents/decision-making-model.pdf.

BIBLIOGRAPHY

Ankersmit et al. 2011
Ankersmit, Bart, Agnes W. Brokerhof, Tatja Scholte, Simone Vermaat, and Gaby Wijers. 2011. "Installation Art Subjected to Risk Assessment: Jeffrey Shaw's Revolution as Case Study." In *Inside Installations: Theory and Practice in the Care of Complex Artworks*, edited by Tatja Scholte and Glenn Wharton, 91–101. Amsterdam: Amsterdam University Press.

Beekens and Learner 2014
Beekens, Lydia, and Tom Learner, eds. 2014. *Conserving Outdoor Painted Sculpture*. Los Angeles: Getty Conservation Institute.

Doctors 1999
Doctors, Marcio, ed. 1999. *A forma na floresta: Espaço de instalações permanentes: Iole de Freitas, outubro, 1999: Anna Maria Maiolino, novembro, 1999*. Rio de Janeiro: Museu do Açude.

Heuman 1999
Heuman, Jackie, ed. 1999. *Material Matters: The Conservation of Modern Sculpture*. London: Tate Gallery Publishing.

Hummelen, Sillé, and Zijlmans 1999
Hummelen, IJsbrand, Dionne Sillé, and Marjan Zijlmans, eds. 1999. *Modern Art: Who Cares? An Interdisciplinary Research Project and an International Symposium on the Conservation of Modern and Contemporary Art*. Amsterdam: Foundation for the Conservation of Modern Art.

Learner and Rivenc 2014
Learner, Tom, and Rachel Rivenc. 2014. *Conserving Outdoor Painted Sculpture: Proceedings from the Interim Meeting of the Modern Materials and Contemporary Art Working Group of ICOM-CC*. Los Angeles: Getty Conservation Institute.

Levin 2012
Levin, Jeffrey, ed. 2012. "Conservation of Public Art." Special issue, *Conservation Perspectives: The GCI Newsletter* 27 (2): https://www.getty.edu/conservation/publications_resources/newsletters/pdf/v27n2.pdf.

McNally and Hsu 2012
McNally, Rika Smith, and Lillian Hsu. 2012. "Conservation of Contemporary Public Art." *Conservation Perspectives: The GCI Newsletter* 27 (2): 4–9.

Michalski and Pedersoli 2016
Michalski, Stefan, and José Luiz Pedersoli Jr. 2016. *The ABC Method: A Risk Management Approach to the Preservation of Cultural Heritage*. Ottawa: Government of Canada, Canadian Conservation Institute, and ICCROM.

Pullen and Heuman 2007
Pullen, Derek, and Jackie Heuman. 2007. "Modern and Contemporary Outdoor Sculpture Conservation: Challenges and Advances." *Conservation Perspectives: The GCI Newsletter* 22 (2): https://www.getty.edu/conservation/publications_resources/newsletters/22_2/feature.html.

Rolnik 2002
Rolnik, Suely. 2002. "Flowerings of Reality." In *Anna Maria Maiolino: Vida afora = A Lifeline*, edited by Catherine de Zegher and Paço Imperial, 110–11. São Paulo: Museu de Arte Moderna de São Paulo; New York: Drawing Center.

Scholte and Wharton 2011
Scholte, Tatja, and Glenn Wharton, eds. 2011. *Inside Installations: Theory and Practice in the Care of Complex Artworks*. Amsterdam: Amsterdam University Press.

Verbeeck 2016
Verbeeck, Muriel. 2016. "There Is Nothing More Practical Than a Good Theory: Conceptual Tools for Conservation Practice." *Studies in Conservation* 61, supplement 2: 233–40.

Building Communities and Conserving Living Matter in the Collection of the Museo Universitario Arte Contemporáneo, MUAC-UNAM, Mexico City

Claudio Hernández

This paper describes work carried out by Mexico's professional community in the field of contemporary art conservation, and especially the ongoing collaboration between the Restoration Laboratory of the Museo Universitario Arte Contemporáneo (MUAC) and the Seminario Taller de Restauración de Arte Moderno y Contemporáneo (Workshop-Seminar on Restoration of Modern and Contemporary Art) of the Escuela Nacional de Conservación, Restauración y Museografía (ENCRyM), both in Mexico City. It describes two case studies in the preservation of art in which organic and biological materials were used by artists Marta Palau Bosch (b. 1934) and Teresa Margolles (b. 1963). These works belong to the MUAC collection.

◆　◆　◆

The "Living Matter" symposium offered a great opportunity to celebrate the tenth anniversary of the Restoration Laboratory of the Museo Universitario Arte Contemporáneo (MUAC), Mexico City, while also reflecting on and contributing some solutions to the problem of preserving biological materials used in contemporary art. As one of the organizers of this gathering, the museum reaffirms its commitment to the study and conservation of contemporary collections, as well as to promoting the professional training of conservators specializing in contemporary works in Mexico, in collaboration with the Escuela Nacional de Conservación, Restauración y Museografía (ENCRyM), also in Mexico City and part of the Instituto Nacional de Antropología e Historia (INAH).

The first collaboration between MUAC's Restoration Laboratory and ENCRyM's Seminario Taller de Restauración de Arte Moderno y Contemporáneo (Workshop-Seminar on Restoration of Modern and Contemporary Art) was established in 2010. Since that time, a dynamic has evolved that allows for discussions

with professors on conservation issues anchored in several case studies from the MUAC collections, which the students are able to address with the advice of various specialists. One of the questions the collaboration strives to answer regards how theory and practice should be combined in the conservation of contemporary art. The answer proposed: via strategic collaborations between academia and the spaces where conservation is practiced, namely museums (fig. 16.1).

Figure 16.1 Students of the Escuela de Restauración carrying out diagnoses at MUAC, September 2017. Photo: Claudio Hernández

In this institutional collaboration, MUAC's contributions have been to supplement student training through the case study method, thereby contributing to research on and conservation of a significant diversity of materials. The students have also followed guidelines for conducting interviews with artists and other cultural agents for the purpose of understanding the artist's intention for each work and the material and conceptual significance of the materials used. Lastly, they come to understand how the passage of time may or may not alter a work. Through this dialogue between students and specialists, the students come to understand the needs of a public institution like MUAC, where research and intervention proposals go hand in hand with guidelines for conserving collections.

Additionally, long-term accessibility is fundamental, since the entire collection belongs to the Universidad Nacional Autónoma de México.

In the last decade, Mexican contemporary art conservators have been a very active professional group working through public and private institutions to discuss and solve issues together, and to contribute to the international scene with Mexican case studies and context. One of the main takeaways has indeed been the need to work as a professional community and broaden networks and teams, due to the characteristics and adversities in the context of Mexico's contemporary cultural heritage and institutional complexities.

Following are two case studies from the MUAC collection in which the research, diagnosis, stabilization proposals, and conservation treatments were carried out by students and professors from ENCRyM in dialogue with other specialists and staff from the MUAC Restoration Laboratory. Note that the conservation treatments were concluded in the first case, but in the second case the treatment is still in progress.

CASE STUDY: MARTA PALAU BOSCH

The work of artist Marta Palau Bosch (b. 1934) is characterized by the use of organic materials such as textile fibers, handmade paper, branches, and mud, although she has also used synthetic fibers to a lesser extent. Her sculptural textiles are noted for the diversity of their subjects (migration, myths, femininity) as well as their excellent manufacture and concern for material significance. Historian Jorge Alberto Manrique has referred to her *Mis caminos son terrestres XVII* (My Paths Are Earthly XVII, 1985, fig. 16.2) as a "textile work," or perhaps a "woven shape," as opposed to a tapestry. The work shares two elements inherent in sculpture: it occupies real three-dimensional space (even though it is a rectangle, its volume requires a head-on view) and has tactile qualities (Manrique 1978, 12). MUAC chief curator Cuauhtémoc Medina notes that critics have used the terms "soft sculpture," "multi-dimensional textile," and "sculpture in textile material" to refer to Bosch's work (Medina 2006, 65). These definitions help us differentiate Palau's artistic practice from that of other artists of the period.

Figure 16.2 Marta Palau Bosch (Spanish, b. 1934), *Mis caminos son terrestres XVII* (My Paths Are Earthly XVII), 1985. Low-warp henequen and totomoxtle (corn), dyed, two parts, 165 × 385 cm overall. Museo Universitario Arte Contemporáneo, UNAM, Mexico City. Photo: Registration photo courtesy Seminario Taller de Restauración de Arte Moderno y Contemporáneo

Mis caminos son terrestres XVII is made of henequen (a type of agave) and totomoxtle (a type of corn). Since the time of its making, deformations had occurred in the work's textile support due to poor distribution of weight. Further, there was an accumulation of dust, decoloring of the dyed maize leaves, salts on some parts of the leaf surfaces, and overall rigidity and poor flexibility of the organic materials.

Preservation of this work required an understanding of its material authenticity based on the function to which the artist put the materials. The dyed maize leaves and their deployment in the textile is the most relevant component and holds the greatest significance. Therefore, intervention focused mainly on eliminating the deformations in the textile support and modifying its hanging system, since the original system was inconsistent and largely the cause of the deformation.

Following that, it was locally dry-cleaned to remove dirt and salt deposits. Controlled humidity (steaming) was also applied (within a chamber) to relax the deformations and make the leaves and the textile more flexible. Taking into account the meaning of the work, the fading coloration on the maize leaves was addressed. One ethical dilemma involved understanding and trying to reproduce Palau's dyeing technique using new maize leaves. Because of her advanced age, Palau was unable to participate in an interview, so the students interviewed her assistant, Roberto Guillén Rodríguez. After conducting a test to identify the colorants used as dyes, the results revealed that the artist had used indigo and that the preparation

techniques were very irregular, since the tones ranged from a darker black and some blue parts to others that were more reddish (Ortega Espinoza 2014, appendix 26). For that reason, it was decided not to attempt to replace, intensify, or retouch the original color. The researchers concluded that trying to match the colors seen in the piece would be highly complicated, and after assessing the alterations in the work, it was agreed that the present fading did not mar an appreciation of the work, and retaining the existing appearance better preserved its authenticity.

A sheet of Tyvek was used to wrap and store the work to prevent the accumulation of dust and to reduce exposure to light.

This research was important not only because of the significance of this specific artwork, but also because MUAC's collection includes other Palau artworks. This case study established criteria for conservation of those as well as other textile works.

CASE STUDY: TERESA MARGOLLES

The work of Teresa Margolles (b. 1963) is noted for its rawness and its appropriation of materials associated with violent acts, mainly in northern Mexico. In the case of *Encobijados* (The Covered Ones, 2006, fig. 16.3), she arranged blankets that had been used to cover corpses on metal pipes. Medina writes of contemporary Mexican art,

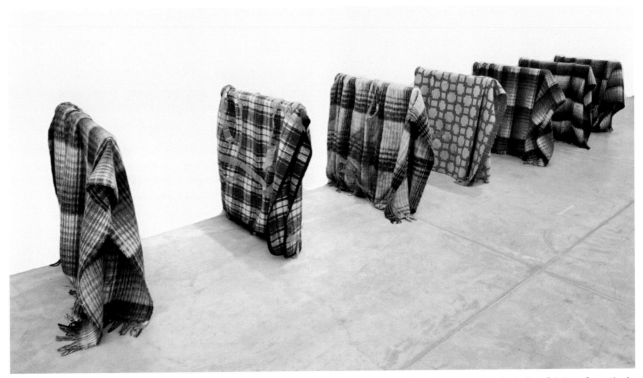

Figure 16.3 Teresa Margolles (Mexican, b. 1963), *Encobijados* (The Covered Ones), 2006. Mass-produced blankets used to wrap the bodies of victims of organized crime, metal T-shaped pipes, seven parts, 94 × 116 cm each. Museo Universitario Arte Contemporáneo, UNAM, Mexico City. Photo: Irene Barajas, courtesy MUAC

"Installation has been the privileged medium for expressing conceptual, activist, and experimental exploration since the 1970s. . . . Installation suddenly became common in galleries and museums, and demanded the type of contemplation that was appropriate for paintings and sculpture. . . . The work is altered to adapt to the museum enclosure" (Medina 2017, 13). In this sense it is significant that Margolles has been working in installation since the 1990s.

The blankets bear organic bodily fluids, remains of plant matter (grass, dirt, dead insects), and adhesive tape because of their former use to wrap corpses (fig. 16.4). As they were never given any treatment to preserve the biological remains, the fluids have noticeably degraded. Some stiffened areas have also been noted, corresponding to the stains on the blankets, and some sections of tape have lost their adhesive and come loose. The last elements of the installation are metallic T pipes, which present no conservation issues.

Figure 16.4 Detail of *Encobijados*. Photo: Claudio Hernández

It should be mentioned that only the diagnosis and proposal for stabilization have been conducted for this work; no interventions have yet been carried out. The main ethical dilemma regarding conservation of this piece is that its material authenticity is based on the function to which the artist puts the materials. Consequently, any intervention could irreversibly alter the meaning. Since the work's acquisition in 2006, it has been in storage in an isolated drawer, under stable temperature and relative humidity (20°C, 55 RH) in order to reduce organic degradation and oxidation processes. It is wrapped in

Tyvek and thus not in contact with other artworks. The installation has been exhibited only once—in 2008, at MUAC's inaugural show.

The diagnosis undertaken proposes treatments to disinfect the biological residue and document the stains under different specialized lights (UV, oblique, clear) as well as the locations of the pieces of adhesive tape in case it proves necessary to apply some type of bonding agent to keep them from coming loose (Mata and Coronado 2018, 8). Lastly, the remains of grass, dirt, and insects should be analyzed to obtain more information on the place where the blankets were found. A biologist also provided important health and safety recommendations for handling of the work: as it contains bodily fluids, it is necessary to avoid direct contact with the skin (wear disposable globes, a face mask, eye protection, and a lab coat), and the artwork needs to stay in a stable environment (Mata and Coronado 2018, 8).

It is relevant to continue researching and studying Margolles's artworks, since MUAC holds in its collection other objects and installations by her and the group SEMEFO (active in the late 1980s and 1990s), of which she was a part.

CONCLUSION

Recent years have witnessed many productive collaborations in the Mexican conservation community involving partnerships between academia and museums, combining theory and practice in the care of contemporary art. Museums have served as spaces for practice and professional training for students, and for promotion of active dialogue among a range of specialists.

In the case studies above, the first conclusion is that it is essential to research the significance of organic and biological materials in artworks and to understand the intent of the artists, since these works must be understood as outcomes of a process, thus making them records of actions. The second conclusion is that the organic and biological materials used in contemporary art are extremely sensitive and delicate, so preventive conservation is key to preserving this type of work.

In the field of global contemporary art conservation, the Mexican community needs to study and publicize the context of Mexican art through case studies, new methodologies, and proposals for study and intervention. We should continue to disseminate internationally an understanding of the profession's role and concepts in order to conserve our contemporary cultural heritage.

BIBLIOGRAPHY

Eder and Palau 1985
Eder, Rita, and Marta Palau. 1985. *La intuición y la técnica.* Mexico City: Comité editorial del gobierno de Michoacán.

Hernández, Yasky, and Learner 2017
Hernández, Claudio, Caroll Yasky, and Tom Learner. 2017. "The Conservation of Modern and Contemporary Art in Latin America: Recent Approaches in Chile and Mexico." *Conservation Perspectives: The GCI Newsletter* 32, no. 2 (Fall): https://www.getty.edu/conservation/publications_resources/ newsletters/32_2/feature.html.

Manrique 1978
Manrique, Jorge Alberto. 1978. *30 escultoras en materiales textiles.* Mexico City: Museo de Arte Moderno, INBA.

Mata and Coronado 2018
Mata, Lizeth, and Claudia Coronado. 2018. *Diagnóstico de conservación y propuesta de estabilización de la obra Encobijados, de Teresa Margolles.* Mexico City: Seminario Taller de Restauración de Arte Moderno y Contemporáneo, ENCRyM-INAH.

Medina 2006
Medina, Cuauhtémoc. 2006. "Escultura suave, disidencia suave." In *Marta Palau. Nahualli,* edited by Virginia Ruano. Mexico City: CONACULTA, Gobierno del estado de Michoacán, UNAM, Centro Cultural Tijuana, and BBVA Bancomer.

Medina 2017
Medina, Cuauhtémoc. 2017. *Abuso mutuo: Ensayos e intervenciones sobre arte postmexicano (1992–2013).* Mexico City: Editorial RM.

Ortega Espinoza 2014
Ortega Espinoza, Daniela. 2014. *Informe de los trabajos de restauración de la obra "Mis Caminos son Terrestres XVII" de Marta Palau.* Mexico City: Seminario Taller de Restauración de Arte Moderno y Contemporáneo, ENCRyM-INAH.

Rinehart and Ippolito 2014
Rinehart, Richard, and Jon Ippolito. 2014. *Re-Collection: Art, New Media, and Social Memory.* Cambridge, MA: MIT Press.

van Saaze 2013
van Saaze, Vivian. 2013. *Installation Art and the Museum: Presentation and Conservation of Changing Artworks.* Amsterdam: Amsterdam University Press.

Different Approaches and Responses

Stabbing Our Own House: A Biography of Joseph Beuys's *Wirtschaftswerte*

Rebecca Heremans

Katrien Blanchaert

Historic treatments of Joseph Beuys's Wirtschaftswerte *(1980) were carried out without taking into account the context of the work as a whole, and the varied approaches to treatments over an extended period of time have proven problematic for decision making around the long-term care of the work. The need to make decisions about future restoration treatments in a systematic, reasoned manner became obvious to the professionals caring for the work starting around 2014. Historical, ethical, and technical aspects of the installation were investigated by the Collection Department at S.M.A.K. in Ghent, Belgium. Utilizing the results from this research, a tailor-made decision tree was created that will govern future restoration treatments.*

◆　　◆　　◆

Wirtschaftswerte (1980, fig. 17.1), an installation artwork by Joseph Beuys (1921–1986), is one of the most iconic artworks in the collection of the S.M.A.K. museum in Ghent, Belgium. Its history and conservation appeal to the imagination, mainly due to the ephemeral nature of some of its elements.

To understand the origin and history of *Wirtschaftswerte*, it is necessary to first sketch the museum's history. S.M.A.K. is a museum with a collection of contemporary artworks dating from the 1940s to the present. In 1957 an organization called Vereniging voor het Museum voor Hedendaagse Kunst (VMHK, or Association for the Museum for Contemporary Art) was founded by a group of private collectors and art lovers interested in contemporary art. From 1975 to 1999, Jan Hoet, founder

and former director of S.M.A.K., was given the opportunity to put the VMHK collection (and more) on display in parts of the Museum voor Schone Kunsten (Ghent Museum of Fine Arts). In 1999 VMHK moved to its own building on the other side of the street and changed its name to the Stedelijk Museum voor Aktuele Kunst (S.M.A.K.).

Before that, in 1980, Hoet curated the legendary exhibition *Kunst in Europa na '68* (Art in Europe after '68), in which Art and Language, Mario Merz, Gilbert & George, Panamarenko, and many other artists took part. It was at that time, in one of the smaller halls near the center of the museum building, that Beuys created *Wirtschaftswerte* with his assistants. Several of the works made specifically for this exhibition were later added to the museum's collection, and Beuys's installation was one such. *Wirtschaftswerte* was acquired in December 1980. Hoet

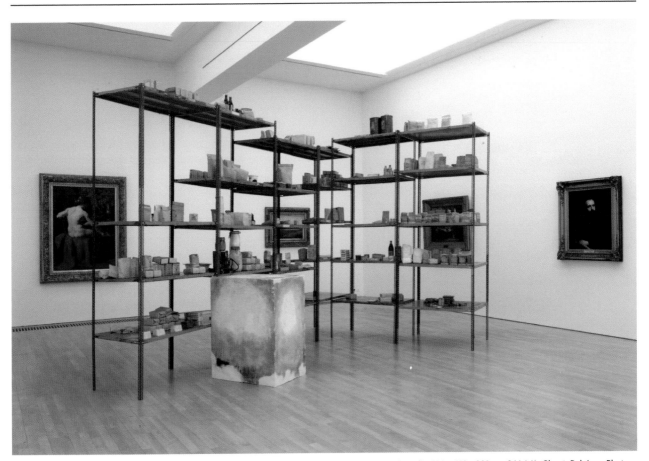

Figure 17.1 Joseph Beuys (German, 1921–1986), *Wirtschaftswerte*, 1980, as it appeared in 2014. Mixed media, 330 × 400 × 266 cm. S.M.A.K., Ghent, Belgium. Photo: Dirk Pauwels, © S.M.A.K.

bought it from Beuys himself, at a friend's price. Since VMHK was a municipal museum, the acquisition of this piece needed to be approved by the city council. There are records of heated discussions among the Ghent councilors about the purchase. Some had doubts about its "artistic qualities"; others expressed concerns about the transient nature of certain constituent materials and their conservation (Blanchaert 2014, 180–81).

The title, *Wirtschaftswerte*, can be translated as "economic values." The content and concept was part of Beuys's so-called *Wirtschaftswertprinzip* (economic value principles), an idea that had occupied the artist since 1977. He used art as a changing medium to raise social and/or political issues. This installation suggests reflection on the contrasts between East and West, and all their different aspects (Verhoeven 2019).[1]

The components break down into four general categories. First, there are six metal racks. These were bought by the German publisher Gerhard Steidl at a pawnshop or metal dealer in Berlin (Blanchaert 2014, 178).[2] Since they were secondhand, the racks already showed wear in 1980.

Positioned on the racks are a variety of packaged food items and other provisions: sugar, cookies, beer, rice, sulfur, honey, tea, barley, millet, salt, rabbit pâté, chocolate, bandages, batteries, and more. Beuys began collecting these packages from the former German Democratic Republic several years before the creation of *Wirtschaftswerte*. His friend, the graphic designer Klaus Staeck, had family in the GDR and regularly brought packages to West Germany for Beuys. While it is assumed that in 1980 there were about 510 packages in the installation, today there are only 462 packages. Every item shows the artist's signature and the inscription "1 Wirtschaftswert" (fig. 17.2). The third element of the installation is a rectangular plaster block. This block had been in the artist's studio since the 1960s and became part of a fixed work in 1980, specifically in front of the metal racks of *Wirtschaftswerte* (Hoet and De Baere 1990, 21). The corners of the block were intentionally damaged by the artist, and he used butter—a common product in his oeuvre—to restore the rectangular shape (fig. 17.3). On the top of the block, Beuys has written "Der Eurasier läßt schön Grüßen. Joseph" (The Eurasier sends kind

Figure 17.2 Inscription detail of *Wirtschaftswerte*. Photo: © Gerhard Steidl + Klaus Staeck, from *Joseph Beuys – Das Wirtschaftswertprinzip* (Göttingen, Germany: Steidl Verlag/Edition Staeck, 1997)

greetings). While the butter is removed at the end of each exhibition, it has penetrated the plaster over the years, giving the work quite a specific aroma. And last but not least, wherever *Wirtschaftswerte* is displayed, several paintings are shown alongside it. There are no specific paintings that belong to the installation; the subject matter may vary, but, per a S.M.A.K. condition report from 1999, the paintings must date from between 1818 and 1883, the life span of Karl Marx.

RESEARCH

In order to create a decision tree to assist in the future conservation and/or restoration of the installation, particularly the packaged food items, it was necessary to conduct research that highlighted its different aspects. The rich history of the work, the variety of materials present, and the ethical issues that arose when thinking about the conservation and restoration of specific elements were all investigated. In this way, it was possible to make substantiated compromises between different

considerations (Foundation for the Conservation of Modern Art and the Institute for Cultural Heritage 1999).

To better understand the work's current condition, its history was investigated from its purchase to the present day. In 1990 *Das Wirtschaftswertprinzip* was published: a book full of photographs by Klaus Staeck and Gerhard Steidl showing the original installation process of *Wirtschaftswerte* at *Kunst in Europa na '68*. This book was crucial for the historical and technical research on the installation's various elements and materials.

Also, apart from its origin story, a few key events are worth noting. A thorough search through the S.M.A.K. archives in 2014 revealed that *Wirtschaftswerte* had definitely been displayed at least thirty-eight times, and perhaps more than that. Regarding the conservation of the work, several treatments had been undertaken since the establishment of the museum's restoration department in 1998. Notes referencing a treatment in 1999 were found, but no specific details were mentioned. Presumably it was for controlling insects.[3] In 2002 a design for crates and packaging of the different parts was formulated. The intent was to store the packaged items in an environment with reduced oxygen levels, but this was too difficult to realize in loan situations (Gilman 2015, 180). In 2011 seventy-two packaged food items were treated by two freelance restorers. Information about the treatments is available, but no other research on *Wirtschaftswerte* was carried out at that time. And since this intervention, no further conservation treatments have been completed to date.

The further one goes back in time, the less is known about the conservation and management of the installation. There are no written records about *Wirtschaftswerte*'s conservation between 1980 and 1999; most of the information from that period comes from oral sources and loan documentation. The latter proves that Beuys was closely involved when *Wirtschaftswerte* was requested for loan from the VMHK in 1984 for the exhibition *Von hier aus. Zwei Monate neue deutsche Kunst in Düsseldorf* presented by the city of Düsseldorf (Blanchaert 2014, 187). In Düsseldorf, Beuys made a few changes to the installation, the most obvious of which was the addition of chicken wire around the metal racks to prevent the packaged items from being stolen. Afterward it was decided that this mode of presentation was a one-off. The installation was the first time *Wirtschaftswerte* was put together with Beuys present since the original in Ghent. He noted at that time that more than half of the packages present on the racks no longer contained their original contents. These replacements were made in 1983 or 1984 by a then

Figure 17.3 Joseph Beuys applies butter to the plaster block for the exhibition *Kunst in Europa na '68*, Vereniging voor het Museum voor Hedendaagse Kunst, Ghent, 1980. Photo: © Gerhard Steidl + Klaus Staeck, from *Joseph Beuys – Das Wirtschaftwertprinzip* (Göttingen, Germany: Steidl Verlag/Edition Staeck, 1997)

museum employee due to biological attack by insects.[4] Beuys objected to the difference in weight of the substituted material compared to the original and suggested replacing the affected contents with champagne chalk or sand (Hoet and De Baere 1990, 24). Alas, this all happened during a stage in which, as previously mentioned, no records were kept, making it impossible to understand the thoughts behind those decisions. The exact number of packaged items present in 1984 is uncertain, but of the 462 that remain today, 292 contain non-original content.

Packages that had their contents replaced were filled with a variety of materials. Many of these were not suitable for long-term conservation, and some even caused damage to the packaging. Among the replacement materials were wooden lath, sawdust, and chalk, but the majority of the foodstuff packages were filled with polystyrene (fig. 17.4a, fig. 17.4b). In order to document the packages' different contents, an inventory was made in 2014 with a focus on the materials present and their condition (table 17.1). This document also includes suggestions for suitable restoration treatments for the exterior of each package. More than a handful of damage types were observed: fading and/or discolorations, brittle paper, faded artist signatures, mechanical damage of the paper support, sticky and/or dirty plastic or glass jars, splintered plastic foils, bulging tins, and so on (fig. 17.5a, fig. 17.5b). It was also noted that identical-looking packages sometimes had different contents.

Figure 17.4a

Figure 17.4b

Examples of packages with nonoriginal fillings. Photos: Rebecca Heremans © S.M.A.K.

Figure 17.5a

Figure 17.5b

Examples of damage. Photos: Rebecca Heremans © S.M.A.K.

DIFFERENT APPROACHES AND RESPONSES

Rack	Object	Material(s)	Condition of whole (good/ moderate/ bad)	Condition support (outside) (good/moderate/ bad)	Original content present? (Yes + what /No)	Non-original content (What?)	Secondary support present? (Yes + what/No)	Other, previous restorations (What?)	Current damage (What?)	Conservation/ restoration treatments: suggestions
5A	Ricolit Rotbraun Holzschützender Anstrichstoff (green label)	Metal can + paper label	Good	Moderate	Yes, sort of varnish	/	No	No	Corrosion Loss of paint layer - can Drips of content - outside can Deformation (dent) - can Stains	Dry cleaning Treatment of corrosion (?)
5A	Ricolit Rotbraun Holzschützender Anstrichstoff (red label)	Metal can + paper label	Good	Moderate	Yes, sort of varnish	/	No	No	Corrosion Loss of paint layer - can Drips of content - outside can Small deformation (dent) - can Stains	Dry cleaning Treatment of corrosion (?)
5A	Roggen Vollkorn Waffeln	Paper + sort of tracing paper + piece of transparent tape	Moderate	Moderate	No	Styrofoam	No	No	Discoloring Thinned/weakened support Tears/holes Exit holes by bugs Yellowed + brittle tape Loose sealing Stain of adhesive - removed sticker	Dry cleaning Reinforcement of weakened zones Mending of tears/holes Mending of sealing Removal of tape/adhesive rests Adding a secondary support (?)
5A	Berliner Knusperbrot	Paper + sort of tracing paper	Moderate	Moderate	No	Ethafoam + silicone	Yes, tyvek	Yes (2011): Mending of tears New content Secondary support	Discoloring Thinned/weakened support Tears Loose sealing	Dry cleaning Reinforcement of weakened zones Mending of tears Mending of sealing
5A	Kinderberuhigungstee	Cardboard	Good	Moderate	Yes (?), tea	/	Yes, plastic (audible)	No	Discoloring Thinned/weakened support Stains	Dry cleaning Reinforcement of weakened zones Adding a secondary support (?)
5A	Stoffwechseltee	Cardboard	Good	Moderate	Yes (?), tea	/	Yes, undefined plastic (audible)	No	Discoloring Thinned/weakened support Stains	Dry cleaning Reinforcement of weakened zones Adding a secondary support (?)
5A	Schlankheitstee (blue sticker "5")	Cardboard	Good	Moderate	Yes (?), tea	/	Yes, undefined plastic (audible)	No	Discoloring Thinned/weakened support Stains	Dry cleaning Reinforcement of weakened zones Adding a secondary support (?)
5A	Schlankheitstee (blue sticker "6")	Cardboard	Good	Moderate	Yes (?), tea	/	Yes, undefined plastic (audible)	No	Discoloring Thinned/weakened support Stains	Dry cleaning Reinforcement of weakened zones Adding a secondary support (?)
5A	Hunger's Familien Frühstückstee (blue sticker "7")	Cardboard	Good	Moderate	No (?)	Styrofoam + piece of cardboard (?)	No	No	Discoloring Thinned/weakened zones Loose pieces	Dry cleaning Reinforcement of weakened zones Adding a secondary support (?) Mending of loose piece
5A	Hunger's Familien Frühstückstee (blue sticker "8")	Cardboard	Good	Good	No	Styrofoam	No	No	Discoloring Thinned/weakened zones	Dry cleaning Reinforcement of weakened zones Adding a secondary support (?)
5A	Hunger's Familien Frühstückstee (blue sticker "9")	Cardboard	Good	Good	No	Styrofoam + piece of cardboard (?)	No	No	Discoloring Thinned/weakened zones Glue stain at bottom	Dry cleaning Reinforcement of weakened zones Removal of glue stain Adding a secondary support (?)
5A	Hunger's Familien Frühstückstee (blue sticker "10")	Cardboard	Moderate	Moderate	No	Styrofoam	No	No	Discoloring Thinned/weakened zones Loose piece Leaking content package	Dry cleaning Reinforcement of weakened zones Mending of loose piece Closure of packing Adding a secondary support (?)

RACK 5, SHELF A
12 (?) objects in 1980
12 objects on sketch between 1980-1988
12 objects on German list in 1988
12 objects before 2004
12 objects in 2014

Table 17.1 Detail of inventory: materials and damage of objects on shelf 5A. Rebecca Heremans, © S.M.A.K.

Both the appearance and the physical condition of the packaging were taken into account, and terms such as "good," "moderate," or "bad" soon came to seem too limited to identify the treatment requirements of the entire object. Also quickly realized was that the failure of the physical structure of the packaging instantly affects the contents, including potential loss. Loss of the package contents complicates the manipulation of the package, and may even disrupt its perception. All these factors confirmed the need for a more elaborate and tailor-made decision-making model for *Wirtschaftswerte*.

OTHER WORKS BY BEUYS AND ETHICAL ISSUES

To clarify and define the future needs of *Wirtschaftswerte*, the research also looked beyond the immediate walls of the museum. Reading about the conservation of other three-dimensional pieces by Beuys and talking to other conservators who care for his work clarified some similarities and differences between this case and others.[5] Besides the presence of specific organic materials that he typically used, such as felt, fat, and honey, and the fact that these are often in need of cleaning or other conservation treatments, the most striking similarity appeared to be that caretakers of other sculptures and installations by the artist also asked themselves: "When should conservation stop?" This is because Beuys's opinion on aging and alteration differed with every artwork, and often these opinions were not recorded at the time they were expressed. It is known that Beuys was aware of the ephemeral aspect of his art (Bader 2017, 215). He once said: "My sculpture is not fixed and finished. Processes continue in most of them: chemical reactions, fermentations, color changes, decay, drying up. Everything is in a *state of change*" (Barker and Bracker 2005, 8). But it would be reductive to conclude from this quote that Beuys wouldn't mind letting his work simply decay. After all, it is also known that he gave advice to the employees of VMHK on "treating" the packages damaged by insects, which shows that he acknowledged the need for conservation treatments (Hoet and De Baere 1990, 24).

On the other hand, *Wirtschaftswerte* differs most clearly from other Beuys installations in that it doesn't have a fixed exhibition space. It was shown in numerous venues, and repeated handling caused specific damages. The presence of non-original content in many food packages and the damages that occurred during replacement also seem to be exclusively linked to *Wirtschaftswerte*. The presence of these non-original contents raised many ethical questions regarding future conservation and/or restoration treatments of the packaged items: What did Beuys think about the aging of this installation in particular? What is more important to the installation: concept or material? Do the non-original contents blemish the meaning of the work? Should non-original content be replaced if it hasn't harmed the packaging? Are materials that are suitable for long-term conservation in conflict with the artistic intent? What types of damage could or should be tolerated? If the original content is still present, can it be replaced as a preventive intervention if needed? When should a package be considered a total loss? To what extent should the museum let the installation "fade away"? When should the installation as a whole be considered a total loss? Should exhibition copies of the packaged items be considered?

These are just some of the questions that the museum asked itself when thinking about the conservation of *Wirtschaftswerte*. Since the artist's current opinion on the conservation of his work can no longer be procured, a compromise must be found between Beuys's concept and the vision of the museum regarding the conservation of the installation. Considering the varied nature of the packaged items and the different opinions of museum staff, it was not easy to reach conclusive answers. Taking all different aspects of the research into account, it can be concluded that there is no straightforward solution for treating an installation like this one. The most important thing is that decisions made for conserving the packages have a rationale, can be justified, and are implemented uniformly.

DECISION-MAKING MODEL

The most important ethical questions concerned how far a conservation treatment should go, and what should happen with the current content of the packaged items. To find answers, the most compelling questions about the condition of the packages were included in the decision tree. All packaged items will go through the different steps of the diagram, since all show damage or changes (fig. 17.6).

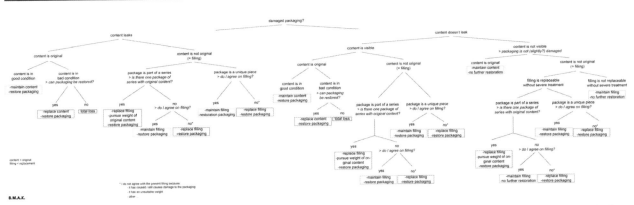

Figure 17.6 Decision tree for restoration treatments of packages. See detail views in figures 17.7 and 17.8. Katrien Blanchaert + Rebecca Heremans, © S.M.A.K.

The model starts from the following question: "Is the package leaking?" The answer to this question can be yes or no. If a loss of content is noted, further steps proceed on the left side of the decision tree (fig. 17.7). Every effort is made to retain original contents unless they are in poor condition or pose a threat to the condition of the packaging. When the original packaging is in such bad condition that no restoration treatment can improve its structure or appearance, the package might be considered a total loss. If the contents are not authentic, the presence of similar or non-similar packages and their content is considered. If there are several identical packages present—called "a series" in the model—and one or more of them still contain original content, this is taken into account when considering a replacement material.

The next step is a consideration of a material that gives the packaging the "look and feel" it had with its original enclosed matter. Günter Schott, a former conservator at the Hessisches Landesmuseum Darmstadt who often worked with Beuys, and even restored some works together with the artist, said that to him, it is clear that when restoring works by Beuys, "one cannot use any material that looks like the original but being something else. One should always use the original material" (Berlinghof 2014, 72). In the case of *Wirtschaftswerte*, the condition of the original packaging makes it ineligible for replacing non-original content with new, "original" content. If the package is unique, the suitability of the current contents is evaluated. If it has caused or still causes damage to the original packaging, or when the weight of the whole doesn't match the information on the packaging (for instance if a one-kilo bag of salt is filled with polystyrene balls), this can be defined as an unsuitable filling.

If the content of a package doesn't leak, decision making proceeds on the right side of the model (fig. 17.8). The next

question asks whether the content is visible. If yes, this is due either to the shape of the package or to serious damage. The next steps are then identical to the left side of the decision tree as in the case of lost content. If the content is not visible, the packaging is usually barely or only superficially damaged. If the content is not authentic, then opening the package is considered along with the accompanying risks: if further treatment poses more risk to the package than the non-original content, the package is left untouched. When a treatment is simple and without further risk to the packaging, the branch continues and the uniqueness of the package is assessed. The further outcome is similar to those mentioned elsewhere in the decision model.

The division will finally result in five different treatment proposals, which concern both the restoration of the packaging and the preservation of its contents. In addition, it is also defined when a package should be considered a total loss. The more severe the damage, the more urgent it is to carry out a restoration treatment. The five treatment proposals each have a different color code, which corresponds to the urgency of treatment (fig. 17.9). Red and yellow indicate the most urgent treatments, and green and blue indicate the least urgent; pink is in the middle. The urgency is unconnected to whether the content of the package is original. As mentioned earlier, the most crucial question is if the content leaks or not.

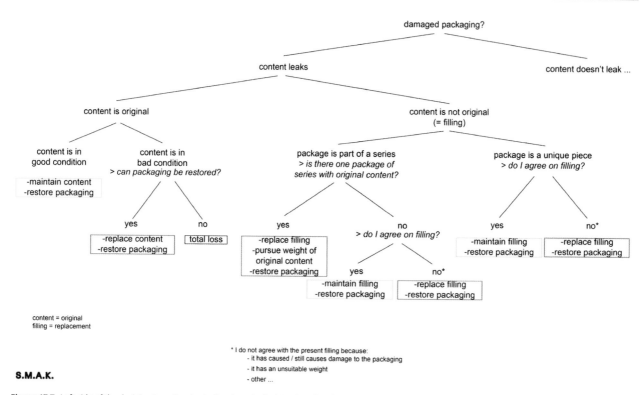

Figure 17.7 Left side of the decision tree: "content of package leaks." Katrien Blanchaert + Rebecca Heremans, © S.M.A.K.

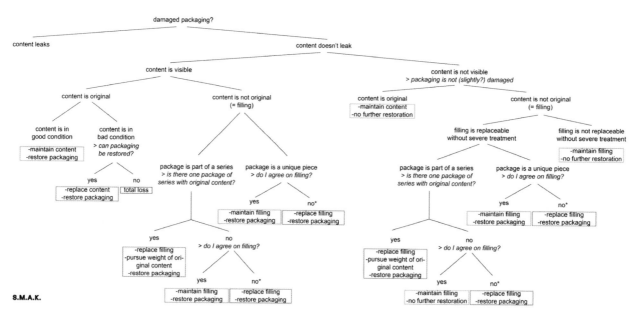

Figure 17.8 Right side of the decision tree: "content of package doesn't leak." Katrien Blanchaert + Rebecca Heremans, © S.M.A.K.

DIFFERENT APPROACHES AND RESPONSES

Content		Leaking of content	Maintain / replace content	Restoration treatments of packaging	Urgency of treatment
Content of package is NOT original (= filling)	Content of package is original	Yes	Replace	Yes	↑ Most
		Yes	Maintain	Yes	
		No	Replace	Yes	
		No	Maintain	Yes	
		No	Maintain	No	Least

Content is original	Content is in bad condition	Packaging is in bad condition	Packaging can't be restored	Total loss

Figure 17.9 Quick overview on urgency of treatments. Rebecca Heremans, © S.M.A.K.

CONCLUSION

The development of this decision-making model was challenging due to the many different aspects of the research and different opinions on treatment, but it was essential to take the past and present condition of this installation into account in order to think in an organized manner about its future. Because *Wirtschaftswerte* will continue to degrade, it is certain that this "patient" will need ongoing care. There is a lot of work still to be done, and S.M.A.K. is aware that the time and budget necessary for realizing treatments will be spread over several years. Now that the decision tree exists, it is possible to carry out future treatments following the same decision-making pattern—a pattern that is consistent with the vision of the museum. In this way it is hoped that *Wirtschaftswerte* can be exhibited for as long as possible, while avoiding future damage and having a consistent plan in place should damage occur.

Acknowledgments

Many thanks to Eva Bader, Rachel Barker, Frances Berry, Gesine Betz, Katrien Blanchaert, Dr. Carolin Bohlmann, Charlotte Bouteligier, Leonie Colditz, Nav Haq, Frederika Huys, Sebastian Köhler, Claudia Kramer, Iris Paschalidis, Dirk Pauwels, Eva Rieß, Philippe Van Cauteren, and Thibaut Verhoeven for your help and inspiring ideas during the research.

NOTES

1. It is clear that this particular work mostly concerns contrasts between East and West Germany, but Beuys's ideas about *Wirtschaftswertprinzip* concern the contrasts between East and West on a global scale.

2. Gerhard Steidl is the founder of the Steidl publishing house, which together with Klaus Staeck put out the book *Joseph Beuys – Das Wirtschaftswertprinzip* (1990/1997).

3. Personal communication to author, May 8, 2019, from Frederika Huys of the Protocol Room, formerly S.M.A.K.

4. Personal communication to author, February 6, 2019, from Véronique Van Bever, a colleague at S.M.A.K. who worked at the museum at the time this treatment happened.

5. Oral and written communications were conducted with Rachel Barker (Rachel Barker Associates), Sebastian Köhler (Kaiser Wilhelm Museum, Krefeld), Leonie Colditz (freelance conservator), Eva Rieß (Hamburger Bahnhof Museum für Gegenwart, Berlin), Dr. Carolin Bohlmann (Hamburger Bahnhof Museum für Gegenwart, Berlin), Gesine Betz (Hessisches Landesmuseum, Darmstadt, Germany), Eva Bader (Das Städel Museum, Frankfurt am Main, Germany), Nav Haq (M HKA, Antwerp, Belgium), Frederika Huys (Protocol Room, formerly S.M.A.K.), Dirk Pauwels (formerly S.M.A.K.), and others.

BIBLIOGRAPHY

Bader 2017
Bader, Eva. 2017. "Die 'Barraque D'Dull Odde' 1961–67 von Joseph Beuys. Dokumentation, Oberflächenreinigung und Sicherung einer ortsspezifischen Installation im Vorfeld der Sanierung des Kaiser Wilhelm Museums in Krefeld." *ZKK Zeitschrift für Kunsttechnologie und Konservierung* 31 (2): 203–24.

Barker and Bracker 2005
Barker, Rachel, and Alison Bracker. 2005. "Beuys Is Dead: Long Live Beuys! Characterising Volition, Longevity, and Decision-Making in the Work of Joseph Beuys." *Tate Papers*, no. 4 (Autumn): https://www.tate.org.uk/research/publications/tate-papers/04/beuys-is-dead-long-live-beuys-characterising-volition-longevity-and-decision-making-in-the-work-of-joseph-beuys.

Berlinghof 2014
Berlinghof, Harald. 2014. "BLOCK BEUYS Erinnerungen von Günter Schott 1969 bis 2010 Restaurator am Hessischen Landesmuseum Darmstad." Interview by Inge Lorenz, Jan Peter Thorbecke, and Klaus-D. Pohl. Darmstadt, Germany: Hessisches Landesmuseum Darmstadt.

Blanchaert 2014

Blanchaert, Katrien. 2014. "Joseph Beuys – *Wirtschaftswerte* (1980)." In *Kunst in Europa na '68 = Art in Europe after '68 Ghent / 21st June–31st August 1980*, edited by S.M.A.K., 177–94. Ghent: S.M.A.K.

Foundation for the Conservation of Modern Art and the Institute for Cultural Heritage 1999

Foundation for the Conservation of Modern Art and the Institute for Cultural Heritage. 1999. "The Decision-Making Model." In *Modern Art: Who Cares? An Interdisciplinary Research Project and an International Symposium on the Conservation of Modern and Contemporary Art*, edited by Ijsbrand Hummelen, Dionne Sillé, and Marjan Zijlmans, 164–72. Amsterdam: Foundation for the Conservation of Modern Art.

Gilman 2015

Gilman, Julie. 2015. "The Role of Science in Contemporary Art Conservation: A Study into the Conservation and Presentation of Food-Based Art." PhD diss., Ghent University Faculty of Arts and Philosophy.

Hoet and De Baere 1990

Hoet, Jan, and Bart De Baere. 1990. "Ekonomische Waarden." In *Joseph Beuys – Das Wirtschaftswertprinzip*, edited by Klaus Staeck and Gerhard Steidl, 21–25. Heidelberg, Germany: Edition Staeck.

Verhoeven 2019

Verhoeven, Thibaut. 2019. "Joseph Beuys – *Wirtschaftswerte* (1980)." In *S.M.A.K. De Collectie A–Z*, edited by S.M.A.K., 149. Ghent: S.M.A.K.

DIFFERENT APPROACHES AND RESPONSES

Pieces of the People We Love: Challenges in Caring for Works by Adrián Villar Rojas in the Moderna Museet Collection

Thérèse Lilliegren
Tora Hederus
My Bundgaard
Sara Norrehed
Tom Sandström

In 2015 the Moderna Museet in Stockholm presented Adrián Villar Rojas's exhibition Fantasma *and subsequently acquired two of the featured works, a then eight-year-old sponge cake and a large installation involving diverse objects made of organic and inorganic materials in various stages of decay. How can the field of conservation engage with such works, which are fundamentally characterized by decay and entropy? In preparation for storage and future display, a strategy to balance conservation issues and artistic intent was sought. Defining the ephemeral parameters of the pieces was a prerequisite. A project to investigate the possibilities for anoxic long-term storage was formulated, and the creation of a combined storage-showcase solution was initiated.*

◆　　◆　　◆

No doubt there is a paradox within my practice: In order to keep on existing it has to be somehow preserved, and at the same time it involves disappearance and the political rejection of commodification as represented by the capitalocene-submissive form of art practiced in the twenty-first century.

—*Adrián Villar Rojas, 2018*

The conservation of artworks made from unconventional or unstable organic materials—materials that decay and change in galleries and storage spaces—poses challenges to traditional museum principles. This became evident in the encounter with works by Adrián Villar Rojas (b. 1980) at the Moderna Museet in Stockholm (fig. 18.1) in 2015. How should conservation meet and embrace the decay and entropy that are important to this work? A balance between artistic intent, curatorial needs, and conservation care was sought.

A central notion in Villar Rojas's work relates to time and life spans; ephemeral qualities are significant. Few of his former pieces still exist, and his previous productions are

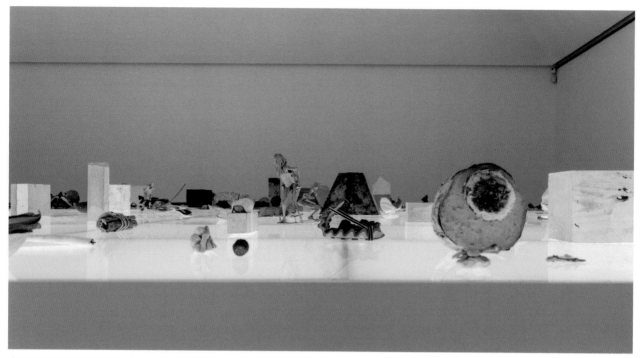

Figure 18.1 Adrián Villar Rojas (Argentinian, b. 1980), *Los teatros de Saturno III* (The Theaters of Saturn III), from the series *Fantasma* (Ghost), 2014. Mixed media on plinth, dimensions variable. Moderna Museet, Stockholm; kurimanzutto, Mexico City; and Marian Goodman Gallery. Installation view, *Fantasma*, Moderna Museet, Stockholm, 2015. Photo: Åsa Lundén / Moderna Museet

now mainly experienced through documentation. In this context, the decisions regarding any conservation action need to be carefully considered and executed. This paper describes the ethical and practical conservation concerns that were encountered in caring for the work of Villar Rojas. The initial challenges appeared when preparing the 2015 exhibition, but the later acquisition of two works in the show highlighted issues of long-term conservation. The project is a work in progress, and we are presenting our thoughts and actions so far.

FANTASMA

In 2015 the Moderna Museet in Stockholm produced one of the first major museum solo exhibitions by Adrián Villar Rojas. The featured works included materials such as bread, fruit, vegetables, a lobster tail, and a then eight-year-old sponge cake.

The starting point for the projects created by Villar Rojas and his team is often site-specific—indeed, interaction with the site is taken to its utmost limits. The exhibition at Moderna Museet, entitled *Fantasma*, was such a case.[1] A central theme was interrelated with the museum context, highlighting issues of memory and the shaping of objects, inclusion and exclusion of objects and audiences, and the question of who determines and who has access to

museum contents. The self-consuming practice of the artist confronted the museum's traditional perspective of eternity.

The space was designed to partly disorient visitors in order to heighten their awareness of the museum's features. Villar Rojas wanted to create what he described as "a crazy passage, where people would wonder what is going on or what went wrong in terms of display of objects, use of walls, use of textures, use of the space" (Villar Rojas 2015). Typical museum features and details were distorted by narrowed passages, raised podiums, and faux wall panels. Slick, pristine, shiny surfaces and illuminated showcases were used. These features surrounded objects consisting of various kinds of organic and inorganic materials, partly in decay, creating a contrasting setting that highlighted and commented on the works as museum pieces. In the film introducing the exhibition, Villar Rojas stated how he wanted to reflect on the concept of documents and on the objects as documents, and what that means to him specifically, since most of his earlier works no longer exist (Villar Rojas 2015).

For this project, adhering to a core feature of museum practice, Villar Rojas for the first time chose to reinstall works from earlier exhibitions. "This show is a big mirror, in a way, of these wrinkled objects," he noted (Villar Rojas 2015). The objects were effectively "elevated" to museum

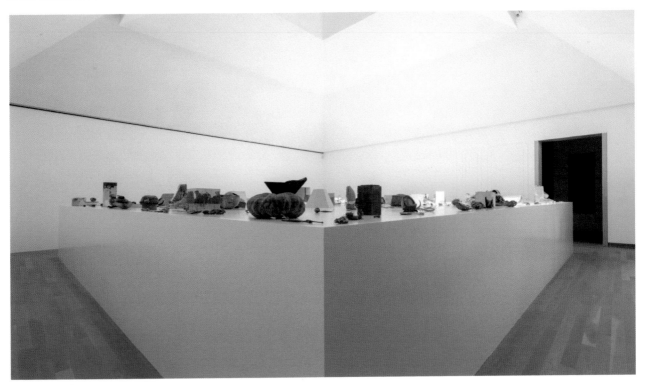

https://vimeo.com/592950662/292edbfb3d

Figure 18.2 *Fantasma*, Moderna Museet, Stockholm, 2015. Video: Stefan Wrenfelt / Moderna Museet

documents, and the vulnerable, originally temporal pieces, in this setting, challenged classical museum terms like permanence, inherent value, treatability, and transportability (fig. 18.2).

INITIAL CHALLENGES

On arrival in Stockholm, some of the objects were found to be infested by insects—mainly biscuit beetles (*Stegobium paniceum*)—and mold. Since the exhibition was to take place amid the permanent collection, rather than in the more separate galleries that usually host the temporary exhibitions, the infestation risk called for an immediate action plan. An entomologist and a mold expert were consulted. Due to the short time available prior to installation, the infested parts were treated with Vikane gas (sulfuryl fluoride). Mold spores were analyzed before further exposure to museum staff or visitors was allowed. Fortunately, the examination showed low concentrations and no toxic spores.

During preparation and through the exhibition period there was an open dialogue between the conservators and the artist regarding the display of objects. Dilemmas, big or small, were attended to with perfect attention to minute detail by the Villar Rojas studio. For example, there were

discussions about vulnerable pieces that could not be secured or protected, and about the handling of debris and losses, namely whether these should be removed or retained. Images were exchanged and mutual decisions made. Conservators had to work outside their comfort level, accepting change and losses, and the artist had to be understanding toward necessary treatments and limitations of display.

The long exhibition period, April to October, required daily monitoring by conservators. It went well, the only exception being that of recurring minor infestations, which were heat treated in the conservation department.[2]

ACQUISITION: *PEDAZOS DE LAS PERSONAS QUE AMAMOS*

Two of the more challenging works in *Fantasma* were acquired by Moderna Museet after the exhibition. Despite the inherent museological challenges, the works were selected because they were central to *Fantasma* and also represent key characteristics of how the artist addresses the time-based, the ephemeral, and the cinematic in sculpture. During the exhibition, the main aim was to control and stop infestations. The options available for this

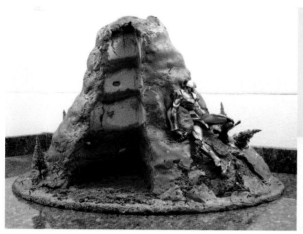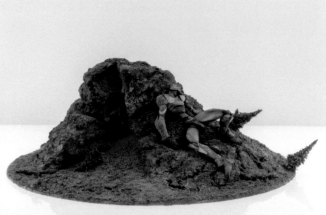

Figure 18.3 Adrián Villar Rojas (Argentinian, b. 1980), *Untitled*, pictured in 2006 when it was first baked but not yet part of the 2007 artwork, and in 2015. Sponge cake, marzipan, milk chocolate, and plastic, 18 × 50 × 51 cm. Moderna Museet. Photos: Courtesy the artist and kurimanzutto, Mexico City / New York (2007) and Åsa Lundén / Moderna Museet (2015)

were limited given that the works were on view. With the later acquisition came long-term conservation concerns related to the works' essential nature. Should they be allowed to decay, or could they be approached in a more traditional way?

Untitled (fig. 18.3) is a cake originally baked in 2006, which at the time of acquisition was nine years old. The materials are described as sponge cake, marzipan, milk chocolate, and plastic, and it measures 18 × 50 × 51 cm. It was baked by the artist's aunt and was originally part of *Pedazos de las personas que amamos* (Pieces of the People We Love), a large installation shown in 2007 at arteBA, a contemporary art fair in Buenos Aires. The original installation was arranged on a large wooden table and depicted the universe from God's point of view, with objects following a life cycle ending with an intentional death (fig. 18.4). The cake was the final and pivotal scene of the tragedy, a miniature landscape in the shape of a cemetery where the heartbroken main character dies inside a giant robot shell, surrounded by small crosses (Essling and Villar Rojas 2015, 9).

Villar Rojas never intended for the cake to be saved after this initial installation, but it was collected by the artists' parents and brought to their hometown of Rosario, Argentina, where it was stored in a warehouse for eight years before traveling to Stockholm. In *Fantasma* it was displayed in a wall vitrine with a rounded inner back wall, behind glass and on a white underlit (LED) surface of acrylic (fig. 18.5).

Since entering the Moderna Museet collection, its visual appearance has not changed significantly, but the cake shows heavy signs of passing time. Colors are faded, and

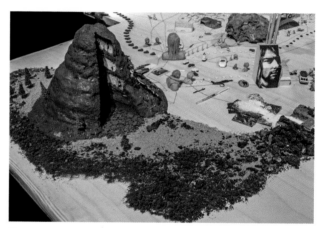

Figure 18.4 *Pedazos de las personas que amamos*, arteBA, Buenos Aires, 2007. Photo: Courtesy the artist and kurimanzutto, Mexico City / New York

dimensions and textures show dramatic changes, with cracks and many losses. Past infestations are visible as bore holes, and dead beetles are fused to the surface—easy to mistake, at first, for sprinkles.

ACQUISITION: *LOS TEATROS DE SATURNO III*

Los teatros de Saturno III (The Theaters of Saturn III, fig. 18.6) consists of eighty-five different parts, each with different measurements and made of diverse materials, including plants, bread, fish, sneakers, electronics, and a lobster tail. The objects were originally shown at kurimanzutto in Mexico City in 2014, where they were part of the larger installation *Los teatros de Saturno* (fig. 18.7). Components of this installation were produced by the Villar Rojas team in a temporary workshop in Mexico.

Figure 18.6 *Los teatros de Saturno III*, Moderna Museet Malmö, 2016. Photo: Åsa Lundén / Moderna Museet

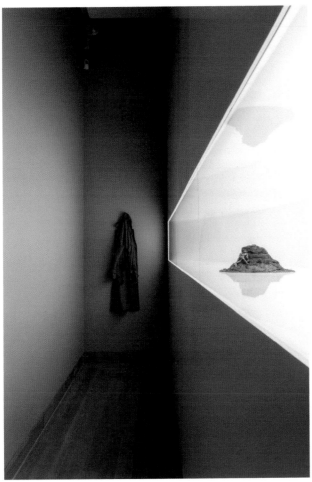

Figure 18.5 *Untitled*, from the series *Pedazos de las personas que amamos*, as installed at *Fantasma*, Moderna Museet, 2015. Photo: Åsa Lundén / Moderna Museet

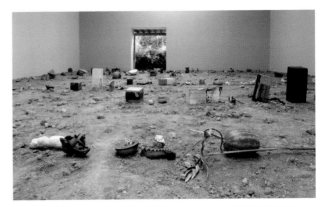

Figure 18.7 *Los teatros de Saturno*, kurimanzutto, Mexico City, 2014. Photo: Courtesy the artist and kurimanzutto, Mexico City / New York

Found objects were combined with organic material and foodstuffs; for instance fresh vegetables and fruits were molded into shapes using gesso. The resulting objects were spread out over the gallery floors, which during the exhibition were covered with soil, and they changed by growing, rotting, and decaying throughout the exhibition period (fig. 18.8).

In *Fantasma*, a selection of 284 objects were shown, including epoxy figures from the series *The Work of the Ocean*.[3] They were put on a large white podium 1.55 meters high. Half of the surface holding the objects was painted, and the other half was opaque white acrylic lit from below with LED lights. These two very different presentations show that the artist does not have a static approach, and that objects can transform according to context.

After the exhibition, the installation was split into four parts, of which Moderna Museet acquired one, consisting

of eighty-five objects. Shortly after the acquisition, the work was shown at Moderna Museet Malmö, a subsidiary of the Stockholm museum. In dialogue with Villar Rojas, it was decided that the objects should be exhibited on a podium of the same construction and height as in *Fantasma*, but one-fourth the original size. The surface was still half underlit opaque white acrylic, and half a painted surface. Even if the same type of presentation was chosen for the exhibition in Malmö, the artist is open to other display constellations, with these possibilities still to be determined.

Objects from *Los teatros de Saturno* are in different stages of decay. The most significant and dramatic changes, mainly to the organic parts, occurred already during the exhibition at kurimanzutto, but degradation is an ongoing process, albeit now a lot less dramatic. Vegetables, fruits, and other matter were hard to recognize upon arrival at Moderna Museet, and so documentation from the production in Mexico was used to trace and identify the materials of the objects.

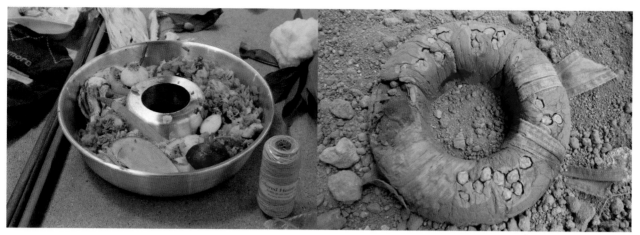

Figure 18.8 The life cycle of one of the objects displayed in *Los teatros de Saturno*: first in the production mold, 2014, and later as displayed at kurimanzutto, 2014. Photos: Courtesy the artist and kurimanzutto, Mexico City / New York (2014)

Today, both of the artworks that were acquired are stored in the conservation department, continuously being monitored for infestation while awaiting a complete conservation plan.

ETHICS: ACCEPTING CHANGE?

When an ephemeral work enters a museum collection, its status needs to be determined, and the artist's intention identified. Ephemeral works can vary in nature, and different approaches can be adopted. There is a wide spectrum of possible conservation strategies, from a total non-intervention policy to the possibility of replacing components.

Villar Rojas has described his works as diachronic objects that transform and mutate over time (Villar Rojas 2017). Time and life spans are important in his practice. Parallel to this is his interest in what will be the last artwork on the planet, and an engagement in the aging of the objects and their conservation care: "They are so fragile; they need so much care. That's another of my extreme fantasies: maybe the children of the children of the people I work with will still have to be restoring and preserving and taking care of these objects, whichever are left. It will be an endless battle against time" (Villar Rojas 2015).

At the creation point, both works were clearly ephemeral, and degradation was originally a natural part of their life cycle (Villar Rojas 2014). Different circumstances made the continuation of their existence possible, and with the reinstallation in the Stockholm exhibition, their lives took a new turn. Between the two venues, the identity of the *Los teatros de Saturno* objects went through a change from actively performing as "mutant sculptures" living in the

soil at kurimanzutto in 2014 to passive highlighted museum pieces at Moderna Museet in 2015. This transformation has implications for future care and points to the importance of defining the identity of the objects.

As the artist put it: "The Moderna Museet is the very first moment where I am introducing objects that were previously shown in another exhibition. And I think that was the key motor, the engine, of this show" (Villar Rojas 2015). The habit of reusing materials from former works was not new to the artist, but the Stockholm exhibition was the first time that objects as complete entities were stored and reinstalled in their same configuration. The museum context and the way the theme of the exhibition related to this will be an important factor in any future reinstallations, and should be taken into account in the decision making and conservation approach.

Defining the nature of and temporal aspects governing the ephemerality of these objects is not straightforward. Could the conservation care and activities be incorporated in their life cycle, given the particular context in which they were exhibited? One could claim that fundamental, defining factors of the objects' existence changed when they became museum artifacts in the *Fantasma* context, and that this continues into their future life at Moderna Museet, thus making conservation care a part of their natural change. The dialogue between artist, museum curators, and conservators regarding any larger decisions is ongoing. A thorough artist interview was completed on December 4, 2019. It will be an important tool for any decisions regarding the definition of objects and how to proceed with conservation care.

DIFFERENT APPROACHES AND RESPONSES

PREPARATIONS FOR STORAGE AND FUTURE DISPLAY

Regardless of the guidelines that will be set, preparations for storage needed to be made, and insects are in no way acceptable in storage spaces. A project was initiated to investigate options for long-term storage, with the primary aim being to avoid infestation. The project is a collaboration with the Heritage Science laboratory at the Swedish National Heritage Board through the Guest Colleague program. This program offers scientific support, including relevant instrumentation and analyses, to assist conservators working with public collections. The project is ongoing and is planned to be presented in the near future.

The project investigates the prerequisites for anoxic storage, which early in the process was suggested as a sustainable option to avoid infestations. This would also slow all deterioration caused by oxygen-related processes. Normally this is a desired effect for conservation, but in this case one might not want this disturbance to degradation processes, due to the work's intentionally ephemeral qualities.

Another concern was how to detect and predict emissions from the materials—the objects themselves but also the materials chosen for storage and packing (Canosa and Norrehed 2019). For the *Los teatros de Saturno* objects, an effort has been made to identify the different plastic materials to determine how best to store the items and minimize their negative effects on one another. This has primarily been done using Fourier-transform infrared spectroscopy (FTIR). A study of volatiles and emissions is planned in order to see if there is a need for additional absorbents in anoxic storage. Dye-coated pH-sensitive A-D strips have been used to detect acidic gases. Still, many of the individual objects involve multiple materials, and so a complete identification of all constituents does not take away from the fact that a strategy for co-storing materials is needed. Therefore, the possibility of adding adsorbents to the storage system in order to mitigate emissions has been considered, with activated charcoal likely being the best suited. To minimize storage space, the objects need to be stored together. Storage boxes will be transparent to facilitate monitoring.

The final storage solution should leave the objects visible, facilitate monitoring without opening, offer minimal contact points to the vulnerable objects, and avoid unnecessary handling. The packing materials need to be long-term, sustainable, and not emit any gases that could be harmful to the collection. All the potential packing materials are therefore being Oddy tested as a starting

point in determining what is suitable (Thickett and Lee 2004, 9).[4]

Possibilities for documenting changes in dimension, shape, and color are also being sought. A first step was to perform photogrammetry to generate a 3D model of the sponge cake (fig. 18.9). Care was taken to document the performance of the photogrammetry in order to accurately replicate the investigation at a later time, so as to visualize dimensional and color changes; specifically, small hidden markers were placed under the base plate of the cake to facilitate comparative photogrammetry in the future. This method, if successful, could be applied to all the Villar Rojas objects.

A planned X-ray examination will, in the best scenario, give us structural information and make it possible to see the impact of insects on the inner structure.

DEVELOPMENT OF A SHOWCASE PROTOTYPE

Together with the Swedish National Heritage Board, the conservators started planning for an oxygen-free storage solution for the cake. A transparent hemisphere shape was chosen to minimize the amount of air and to facilitate monitoring. When a digital sketch was rendered, it was reminiscent of a hibernation pod, a recurring reference in Villar Rojas's work (fig. 18.10). There were sci-fi connotations and suggestions of a survival sphere connecting it to the last-art-object-on-Earth thoughts, and to the aesthetics of later Villar Rojas projects.[5] This, in turn, led to the idea of a combined storage and showcase solution, a way to permanently keep the piece in an oxygen-free environment.

A plan for this was drawn and a digital mockup produced. In this, the work is placed on a white acrylic support. The bottom part holds the devices monitoring and adjusting the air quality: relative humidity, temperature, pH, and oxygen levels. A port will make it possible to extract small amounts of air for control measurements. When exhibited, the white acrylic support can be integrated to hide the bottom part housing the controls. Since it is transparent, it can still be lit from underneath, as in the *Fantasma* installation. The initial presentation to the artist and to collection curators elicited positive responses. The first brief was well received, and the digital sketch will be a useful tool.

The hemisphere raises many questions. Can we keep the piece oxygen-free without compromising the intent of the artist? In the event that the permanent hemisphere is

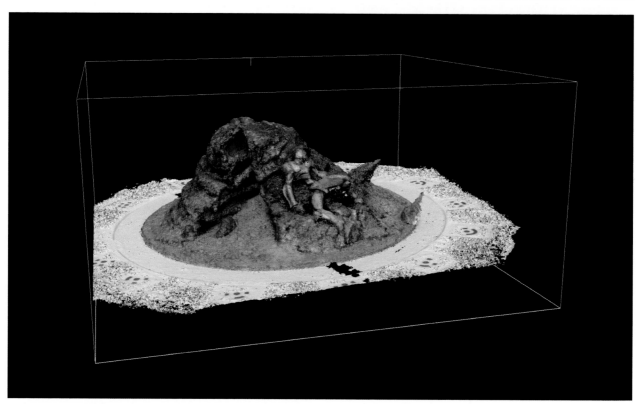

Figure 18.9 Photogrammetry rendering of *Untitled* carried out in 2019. Image: Albin Dahlström / Moderna Museet

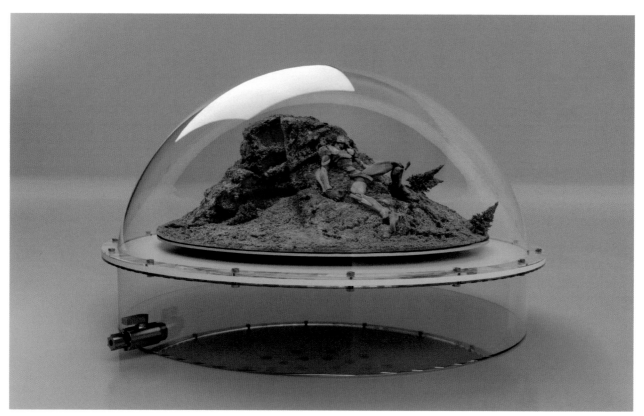

Figure 18.10 Digital sketch of storage/showcase for *Untitled* carried out in 2019. Image: Albin Dahlström / Moderna Museet

found to be acceptable, how will it affect the integrity of the work? Will it in fact make it a new piece, or will it remain the same work dated 2007? Had we, in the moment we presented the sphere, stepped out of our roles as conservators and affected the future display and perception of this work? Again, continued conversations with Villar Rojas in order to more closely define the work are crucial to any further decisions.

CONCLUSION

Caring for the works by Villar Rojas in the Moderna Museet collection is a work in progress. Research into the development of these works has indicated that their ephemeral nature might have changed when entering the museum, from being active, performing, deteriorating objects to more passive artifacts. This eventual redefinition will open possibilities for conservation measurements that at first were considered impossible.

Conservation and collection management must be open to the fact that the identity and appearance of artworks can change over time and prepared to redefine approaches. The acquired works are examples of objects being both materially transformed and affected by different presentations. Professional roles are also shifting. Conservation crossed traditional professional borders by taking an active part in the life span and aesthetic future of the *Pieces of the People We Love* cake by presenting the idea of the permanent showcase. Villar Rojas and collection curators have had and will hopefully continue to have active roles in the development of the conservation strategy.

NOTES

1. Curated by Lena Essling and Matilda Olof-Ors, April 25–October 25, 2015.

2. Inner temperature 60℃ for two hours.

3. Exhibition by Adrián Villar Rojas at De 11 Lijnen, Oudenburg, Belgium, 2013.

4. The Oddy test is an accelerated corrosion test that involves putting a small amount of material in a sealed enclosure at 60℃ and 100 percent relative humidity for twenty-eight days, together with metal coupons (silver, lead, and copper), and observing the effect of the material emissions on the metals.

5. Examples include *The Theater of Disappearance*, Geffen Contemporary at MOCA, Los Angeles (2017), and *The Theater of Disappearance*, National Observatory of Athens (2017).

BIBLIOGRAPHY

Canosa and Norrehed 2019
Canosa, Elyse, and Sara Norrehed. 2019. *Strategies for Pollutant Monitoring in Museum Environments*. Visby, Sweden: Swedish National Heritage Board. https://www.diva-portal.org/smash/get/diva2:1324224/FULLTEXT01.pdf.

Essling and Villar Rojas 2015
Essling, Lena, and Sebastián Villar Rojas. 2015. "Fantasma Adrián Villar Rojas." Exhibition booklet. Edited by Maria Morberg. Stockholm: Moderna Museet.

Thickett and Lee 2004
Thickett, D., and L. R. Lee. 2004. "Selection of Materials for the Storage or Display of Museum Objects." British Museum Occasional Paper 111. London: British Museum.

Villar Rojas 2014
Villar Rojas, Adrián. 2014. Filmed interview by Jordan Bahat at kurimanzutto, Mexico City. https://www.youtube.com/watch?app=desktop&v=qJEE-yNCHQM.

Villar Rojas 2015
Villar Rojas, Adrián. 2015. Filmed interview by Lena Essling, Moderna Museet, Stockholm. https://youtu.be/g6yv6qKJjG4.

Villar Rojas 2017
Villar Rojas, Adrián. 2017. Filmed interview by Elina Kountouri, Neon, Athens, June 3, 2017. https://player.vimeo.com/video/224171178.

Villar Rojas 2018
Villar Rojas, Adrián. 2018. "In the Studio: Adrián Villar Rojas." Interview by Gabriel Roland. *Collectors Agenda*, August 20, 2018, https://www.collectorsagenda.com/en/in-the-studio/adrian-villar-rojas.

Nature and Its Energy: Considerations on the Processes of Conserving Organic Matter

Mercedes Isabel de las Carreras

The collection of the Museo Nacional de Bellas Artes in Buenos Aires includes Víctor Grippo's Analogía I *(Analogy I, 1970–71), which features potatoes connected via cables to a voltmeter. These materials— unconventional in the museum environment—require unusual conservation procedures and methodologies. The conservation condition of the potatoes is essential to the functioning of the work, as it impacts the energy measurements—a potato's energy fades as it deteriorates. Therefore, protocols had to be established to ensure that there would always be measurable energy. The conservation of organic matter requires time and specific resources, which must be factored into the protocol if this work is to be exhibited for long periods.*

◆ ◆ ◆

The Museo Nacional de Bellas Artes in Buenos Aires was inaugurated on December 25, 1896. The founding works came through donations from private collections. The museum's first director, Eduardo Schiaffino, encouraged friends and collectors to give generously, and he visited Europe on buying trips with the mission to build out the collection. Over time, there have been significant additional legacies, acquisitions, and donations, and the collection nowadays, numbering around twelve thousand works, continues to grow while supporting the mission to disseminate the history of art from all periods. Víctor Grippo's work *Analogía I* (Analogy I, 1970–71, fig. 19.1) was donated by Fundación Antorchas in 1990.[1] The organic materials comprising the piece give it ephemeral characteristics and present specific conservation requirements that museum conservators had not previously needed to consider.

Grippo was born in Buenos Aires in 1936.[2] His education in chemistry, industrial design, visual communication, and fine arts brought about a convergence of art and science in his works. Finding his voice as an artist involved the creation of an innovative school of thought in which he gave new meanings to ordinary objects. His first paintings aligned with geometric abstraction and were done in oil paint. They were shown in his first solo exhibition in 1966. His greatest development as an artist occurred later, in the 1970s, when Buenos Aires's political climate was conducive to intellectual stimulation and growth.

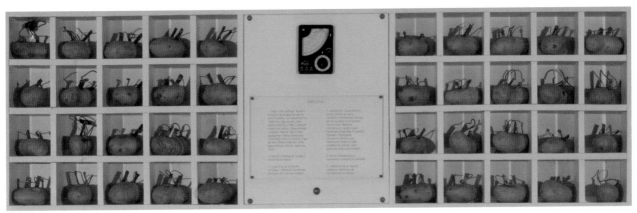

Figure 19.1 Víctor Grippo (Argentinian, 1936–2002), *Analogía I* (Analogy I), 1970–71. Potatoes, painted wood, electrical connectors, voltmeter, and text, 47.4 × 153 × 10 cm. Museo Nacional de Bellas Artes, Buenos Aires, gift of Fundación Antorchas. Photo: © and courtesy the Museo Nacional de Bellas Artes

Analogía I was the first in his series of *Analogías* (Analogies), or "potatoes with wires," as they are colloquially called. It consists of a circuit of forty potatoes, each placed in an individual cubicle in a wooden case, interconnected via small electrochemical means consisting of two electrodes, one copper and the other zinc, inserted into each potato. In this way, electrical current is obtained from each potato, and, linked together, they produce a total amount of direct current that is measured precisely and displayed via a central voltmeter. The mechanism measures the total energy output of the potatoes and provides an empirical demonstration of their energy capacity. The center of the structure also bears a text panel explaining the artist's intended analogy between the potato as an object and consciousness as an intangible, thereby incorporating the viewer into the work as a conceptual participant. The work sets up dualities such as visible and invisible, tangible and intangible. It establishes an analogy between the potato and human awareness—between the meaning of each object, its daily function, and other possible meanings of that function.

Grippo's motifs always centered on ideas of transformation, daily life, the world of farm labor, food, and the energy that food produces. The artist sought to produce power-generating processes through very simple material and technical resources such as the potato, which originated in the Americas and was subsequently cultivated around the world. The unconventional materials and media in his objects and installations reflect on the social and spiritual conditions of workers and artists. Considering that the potato is the most popular food in Argentina, consumed by all social classes, the poorest in particular, his choice was highly significant. Based on the potato's cultural symbolism and the relationship between plant life, the soil, and farm laborers, using potato energy

as an electrical battery expresses how humanity is transformed by engaging in a rural occupation related to the soil.

Grippo's artwork also demonstrates the underlying power that is present in plant life and the energy that can be liberated by human creativity. It is an alchemical transfiguration of the material world from invisible to visible. The concept expressed is the result of the artist's research in science and art, in which humanity is an essential medium in the symbolism of conceptual art. This type of work was characteristic of Grippo, and he developed it across different installations around the world.

This work in many ways falls under the umbrella of conceptual art, which swept the art world just as Grippo was finding his artistic voice. It invites the audience to find satisfaction in following the creator step by step through his thought processes, without asking that those processes take a concrete form. The underpinning ideas have precedence over its material or tangible aspects, favoring intellectual reflection over visual stimulation. The viewer participates in the process of formulating the concept, and follows the creative steps that comprise the idea. In this way, the artist's constructive inquiries influence the viewer's momentary conceptualization, and the idea prevails over the physical artwork itself.

In *Analogía I*, the ephemeral materials also speak of the transience of life—of the limited length of time in which matter undergoes a transformation and then disappears, leaving only the idea. Conservators become part of the maintenance of that idea by periodically changing the organic materials, which to some extent is a detriment to the concept of originality and uniqueness, demonstrating

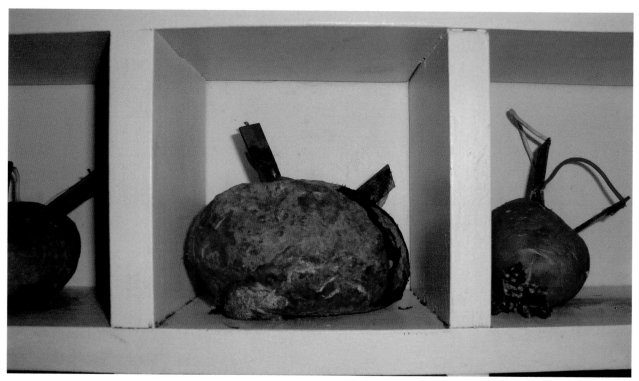

Figure 19.2 Detail of the potatoes' deterioration; they leave stains on the wood and smell bad. Photo: Courtesy the Museo Nacional de Bellas Artes

that, for the artist, the work exists within his intellectual process.

Since 1990, *Analogía I* has been exhibited at the museum several times.[3] In terms of conservation, it has presented problems since its first installation. Potatoes are organic and deteriorate very quickly depending on their quality, environmental conditions, the amount of time that has passed since they were harvested, and the conditions under which they were transported. The potato peel is coarse and resistant, but thin, and if it breaks, decomposition accelerates. The internal liquids produced during decomposition ooze out through the weakest part of the peel, which takes on a dark color and a bad smell over time (fig. 19.2, fig. 19.3).

The conservation challenges are various, and so specific protocols to facilitate control of the work's state of conservation for the duration of an exhibition were prepared. These cover procedures for installing the work, quality requirements for the organic matter, environmental conditions in the room, exhibition duration, and more. The protocols establish organized methodologies for conserving the organic matter and using staff resources prudently. The seemingly simple task of changing the potatoes on a regular basis requires funds and an interdisciplinary team of technicians and conservators to be regularly available at just the right time.

Figure 19.3 Detail of the rotten potatoes; they begin to sprout depending on their quality and environmental conditions. Photo: Courtesy the Museo Nacional de Bellas Artes

The protocols first detail all the procedures for installing the artwork. The painted wood structure is cleaned, and insulating material is placed in each cubicle to prevent the fluids exuded by decomposing potatoes from staining it.

Choosing the potatoes at the market is no minor task. Although there are no specifications from Grippo regarding which variety should be used, we do try to buy potatoes similar to those he himself employed, and we sometimes encounter certain difficulties in this due to variation in supply at the local market. Furthermore,

DIFFERENT APPROACHES AND RESPONSES

empirical research conducted on the different qualities of potatoes based on their origins and physical history has enabled us to reach certain interesting conclusions. Among the supplies at the market we find potatoes of different colors, some scrubbed, some not, in a variety of sizes and qualities.

Conservation depends to a large extent on the potatoes' quality and state of conservation at the time they are installed. They must all be of similar size so they will fit into the cubicles. The peel must be healthy, without cuts or sprouts growing. Any soil on them is removed with a soft cloth or brush, while avoiding injuring or dampening the surface, both of which accelerate decomposition (fig. 19.4). Purchase of the potatoes is ideally scheduled for the same day as the change-out in order to maximize the good condition of the organic material.

Figure 19.5 Swapping out new potatoes for deteriorated ones; in the process of inserting the new potatoes, one must take care not to break the connector soldering. Photo: Courtesy the Museo Nacional de Bellas Artes

Figure 19.4 Cleaning the potatoes with a dry cloth is important for their material conservation. Photo: Courtesy the Museo Nacional de Bellas Artes

After the potatoes are installed, we confirm that each electrical connection is still functioning. The connection requires good contact between the cables and connectors in order for the total energy output to be measurable by the voltmeter (fig. 19.5). We periodically monitor the state of conservation of the living matter to confirm that it is functioning correctly. The experience of the conservator in observing the deterioration of the organic matter helps guide appropriate choices regarding when to change the potatoes, taking into account the time it takes to obtain new ones. Experience has shown that the potatoes must be changed every fifteen days or so in order for them to have sufficient energy to be measurable. Despite having protocols in place, conserving the work is still difficult due to the fragility of the system of electrical connections and the influence of the quality of the potato.

Environmental conditions in the gallery space matter a great deal as well, since the damp, warm climate of Buenos Aires accelerates decomposition. In the most recent installation, the work was on view for a long period of time, during which more than ninety potatoes per month were purchased. If a particular collection rotation were to last two years, 2,160 potatoes and more than 120 conservator work hours would be needed to make the two changes per month (fig. 19.6, fig. 19.7). This has prompted conservators to occasionally consider possible alternatives that might save both financial and human resources, such as replacing the organic matter with something less perishable that would still produce electrical power, but sacrificing the aesthetic aspects was dismissed as a potential solution, despite the acknowledgment that the artist's primary intent was the expression of his idea. It would change the piece too much. In the end, our valuation and appreciation of this piece of art warrants every effort of conservation. The compromise that was finally reached consisted of shortening exhibition durations and carefully planning the allocation of human resources.

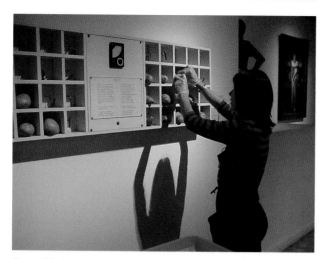

Figure 19.6 The potatoes are generally changed two or three times per month. Photo: Courtesy the Museo Nacional de Bellas Artes

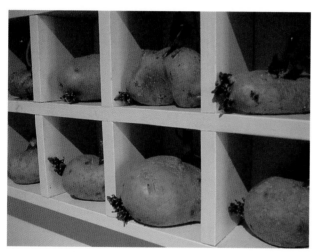

Figure 19.7 Potatoes may be retained even if they have visible sprouting, as long as they have not leaked liquid to stain the wood or cause a bad smell. Experience over time has shown the limits of tolerance. Photo: Courtesy the Museo Nacional de Bellas Artes

NOTES

1. The museum's web page devoted to the work is at https://www.bellasartes.gob.ar/coleccion/obra/9336/.

2. Read more about the artist at the websites of the Centro Virtual de Arte Argentino (http://cvaa.com.ar/03biografias/grippo.php), Ludion (http://ludion.org/archivos/articulo/260411_rocha-margarita_v%C3%ADctor-grippo.pdf), Clarin (https://www.clarin.com/tema/victor-grippo.html), and Fundación Malba (https://malba.org.ar/sobre-vida-muerte-y-resurreccion-de-victor-grippo/?v=diario).

3. As in *Homenaje*, a solo presentation staged on the ten-year anniversary of the artist's death: https://malba.org.ar/evento/victor-grippo-homenaje/.

Conservation as an Enhancing Factor in the Interpretation of Living Materials Artworks

Flavia Parisi
Maura Favero
Rosario Llamas Pacheco

Conservation, as an inclusive discipline that encompasses material and conceptual challenges, can expand interpretive perspectives for works of art. Research on Precipitazioni Sparse *(Scattered Precipitations, 2005), an installation by Bruna Esposito made of onion skins scattered on a marble slab, exemplifies the need to share conservation questions with all the professionals involved in staging a work in order to close the gap between the artist's intention and its transmission among diverse stakeholders. The authors' investigation included interviews with the artist, private collectors, dealers, and a museum director, and analysis of archival documentation. Like peeling an onion, the artwork's concept was explored layer by layer, removing existing interpretive assumptions toward a more comprehensive understanding of the values embedded in the artwork's materials.*

◆　　◆　　◆

Conservation issues are usually key to a comprehensive understanding of an artwork, and foster dialogue between art historians and those physically working with artworks such as curators and collectors. If the art history approach tends to focus on the past context and life of the artwork, providing an essential background for its interpretation, conservation expands this perspective to its present and future life, offering a deep framework for specific interpretive readings. By questioning what is valued and what needs to be preserved, conservation investigates some of the most relevant and distinctive aspects of an artwork.

The display of contemporary artworks made with living materials highlights the strong interdependence of practical and interpretive issues, which must be addressed through an integration of conservation and art historical approaches. The importance of such materials, food in particular, can be overlooked if interpreted only for what they immediately represent and not for their function in the specific context of the artwork. As artistic materials, their color, shape, and texture are relevant.

Public institutions and private art galleries often constitute the channels through which an artwork and its significance

are made accessible to a broader audience. Their understanding of the multiple layers of interpretation of the artwork's material and symbolic values as intended by the artist, and of the layers of meanings related to the work's historical and artistic context, is essential to accompany the work through its journey into society.

In the case study presented here, the fact that no conservators were directly involved in the display of the work in question, especially given the very specific nature of the materials and composition, meant that it was not fully understood by those taking care of exhibiting it, and skewed the way it was presented to the public. *Precipitazioni Sparse* (Scattered Precipitations, 2005) is a work of art by the Italian artist Bruna Esposito (b. 1960) composed of white, golden, and red onion peels placed randomly on a marble slab. There is no additional material applied to secure the peels to the marble. The artist calls this work an "impermanent sculpture," since the onion peels can shift with the slightest air movements, creating continuous changes in the work's composition.[1] Onions are a familiar cooking ingredient in most regions of the world. Marble is a strong and noble material that evokes classical aesthetics. So if onions are an ordinary material of daily life, in this composition, they are elevated into an artistic material thanks to the marble.

Precipitazioni Sparse has been exhibited only twice, and the way it was presented on both occasions offers an opportunity to consider the interrelations between various assumptions and interpretations of the work and its documentation. In order to explore these issues, our research included analysis of archival documents and interviews with the artist, the two collectors owning the artwork, an art dealer who has worked with the artist for many years, and a museum director who is particularly familiar with Esposito's research and has curated several shows of her work.

BACKGROUND

Esposito is well known for her multimedia and sensory works that engage sound, sight, smell, and more. Her artistic practice includes sculptures, videos, installations, performances, site-specific projects, drawings, photographs, and collages. Her works are often made with simple, ordinary materials and techniques, which are ennobled by poetic associations. Her collaborations with artists, poets, and musicians have produced work that blends these various disciplines, defying classification.

Precipitazioni Sparse was specifically commissioned for the Venice Biennale in 2005 (Martinez and de Corral 2005). The artist realized the project on site. She ordered the marble slab from Carrara and organized its delivery to Venice, where it was mounted to a wooden grid in order to keep it perfectly aligned and stable on the Arsenale's irregular ground. Esposito then meticulously selected the onion peels and personally dispersed them on the marble in an apparently accidental composition that harmoniously covered the entire surface area (fig. 20.1).

The project was subsequently purchased by two Italian collectors who have been patrons of Esposito for many years and were immediately seduced by its beauty. The same collectors, who are also the directors of a private foundation dedicated to the promotion of contemporary artists, decided to reproduce and exhibit the work in 2011 on the occasion of a local art fair in Rome, titled Road to Contemporary Art.

At the moment the work is only accessible through photographic images, which are easily found online and represent the work in the two exhibitions, and even a casual observation of these photographs reveals differences. In the image published by the Archivio Storico delle Arti Contemporanee (ASAC, or Historical Archives of the Venice Biennale), the onion peels are all concentrated at the center of the marble slab in a way that does not correspond to the picture taken when the artwork was realized (fig. 20.2).[2] And in photographs taken during the art fair in Rome, the color tone of the marble slab looks very different from its appearance in Venice, and the work looks cramped in the stand, with not much room for the air movements the artist intended (fig. 20.3).

Looking at these photographs elicits some obvious questions: Why are there differences across the pictures? Did the onion peels and marble slab remain the same from one exhibition to another? How else has the artwork been documented?

UNPACKING PRECONCEIVED IDEAS

The first findings resulting from our research were the many preconceived ideas everyone involved had, including the authors of this paper. Before interviewing the owners of the work, the authors had assumed that, after dismantling the work, a most likely difficult decision had been faced regarding what to do with the onion peels, and that the collectors had kept the marble. On the contrary: during the interview, the authors found that the issue of retaining the original materials chosen by the artist was easy to resolve for the collectors, who in the end didn't keep *anything* from the original installation. For them, the beauty and value of the work lay in the harmonic contrast

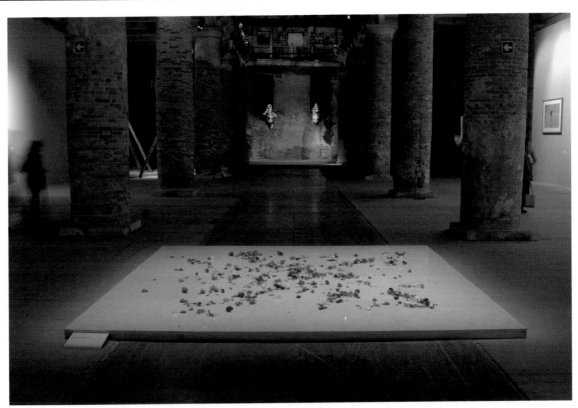

Figure 20.1 Bruna Esposito (Italian, b. 1960), *Precipitazioni Sparse* (Scattered Precipitations), 2005. Marble slab and onion skins, 3 × 400 × 400 cm (marble). Private collection. Installation view, *Always a Little Further*, 51st Venice Biennale, 2005. Photo: Enzo de Leonibus, courtesy the artist

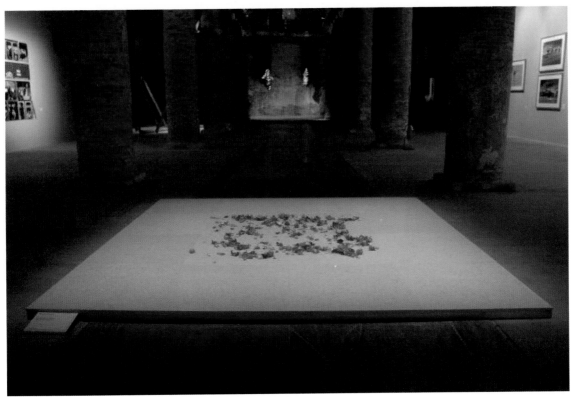

Figure 20.2 *Precipitazioni Sparse* after dusting by Venice Biennale staff. Photo: Giorgio Zucchiatti, © ASAC

20. Conservation as an Enhancing Factor

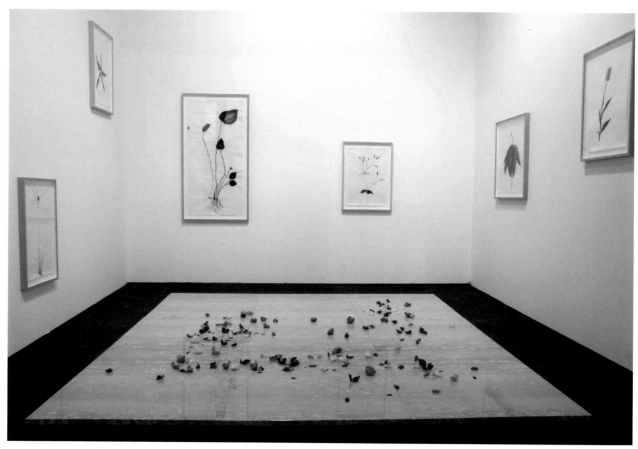

Figure 20.3 *Precipitazioni Sparse* at Road to Contemporary Art, Rome, amid artworks by Maria Thereza Alves. Photo: Yamina Tavani

between onion peels and marble—not in these specific peels or stone (for instance marble tone, color, and veins, or the colors and shapes of the selected onion peels). The collectors were eager to discuss art and poetry in general, separating that discourse from any specific artistic designation of the materials themselves.

At first sight, especially for those who are not directly involved in conservation issues, the work seems quite simple, being composed only of two elements. For the owners of *Precipitazioni Sparse*, the incredible poetry of the work resides in its immediateness and simplicity. Over the course of the interview, many of our conservation-related questions were interpreted as obvious, for instance: "We do not have the fetishism. . . . It is obvious that after a while you have to throw the onions away and buy new ones. We do not have such type of obsession with the artwork, because we are used to working with art, and we know very well the oeuvre of the artists we work with."[3] In their view, having worked closely with an artist in the past somehow guarantees an understanding of their artistic intent in all cases. If they reported an urgency to enter into, in their words, "the spirit of the artist" in order to

relay it to an audience, the so-called spirit lies, in their eyes, largely in the overall concept and not much in the specificity of the materials, nor, importantly, in the particular characteristics of the space and lighting conditions in which the work is assembled and exhibited.

The collectors' decision to not preserve the onion peels was approved by the artist, who confirmed this in a recent interview with the authors. But a subsequent reinstallation took liberties she would not have approved of. Six years after Venice, on the occasion of the 2011 Rome art fair, the artist unfortunately could not participate in the installation and the owners made some decisions independently. During our interview, Esposito mentioned that she did not approve of the marble used in the second exhibition, which was "too pink" and "too veined"—too different from the marble chosen for Venice (fig. 20.4). Apparently, she only became aware of the importance of this aspect after realizing that the two collectors exhibited the work using that type of pink marble. Had she been consulted, she would have provided more opinions regarding other aspects of the work as well. For instance, in the Rome exhibition the neon lights above affected the perception of

DIFFERENT APPROACHES AND RESPONSES

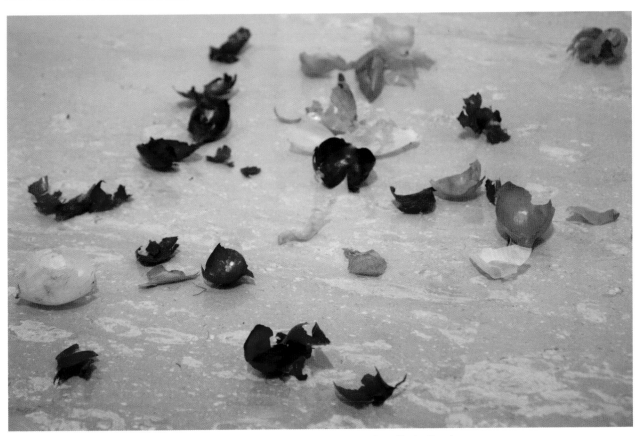

Figure 20.4 Detail of onion peels and marble coloration at Road to Contemporary Art, Rome. Photo: Yamina Tavani

the work, whereas now a pointed but gentle light that produces no reflections on the marble is recommended by the artist.

Other problems in presenting the work arose from misunderstandings on the part of the staff in Venice involved with maintaining it. In one instance, Esposito recalled friends who had seen the show telling her how much they appreciated the "flower petals." She could not understand how that confusion came about until she saw the picture published on the ASAC website (see fig. 20.2). During the Biennale, dust accumulation was greatly affecting the aesthetic of the work, so she suggested that maintenance staff periodically remove the onion peels, clear the dust, and then reposition the peels on the marble; unfortunately, the staff repositioned the peels carefully at the center of the platform, not scattered as before. The marble platform was quite big—four by four meters—which put the centered peels relatively far from the eyes of visitors, who, in the dark atmosphere of the Arsenale, could not see them properly and mistook them for flower petals.

Assumptions—by all parties involved—have a strong impact on the way artworks are exhibited and understood, and rely on the conviction that the available information and its subsequent interpretation is enough. It is almost impossible to completely avoid assumptions, especially when dealing with installation, performance, and other nontraditional forms of art. But awareness of the tendency can help stimulate both the artist and those working with them to keep questioning the specificities of the work and its context.

DOCUMENTATION

Documentation played a crucial role in our research for this paper, as it had the potential to connect practical and interpretive issues. Preliminary research related to the work's exhibition history revealed the different ways it had been presented and interpreted, but did not immediately explain the reasoning behind these differences. So we sought out further information.

Among the first documents analyzed was one provided by ASAC, after they were contacted as to why their website published a photograph representing the work in a condition so different from the original installation. They provided a document, written and signed by the artist at

the moment of creating the work, that included the work's description and recommendations related to its maintenance during the exhibition. Although the artist's phrasing was ambiguous, it does not appear that the Biennale contacted her for clarifications regarding what she meant by "ricollocare le bucce al centro e ben sparse" (position the peels at the center and well dispersed).[4] The instructions were interpreted literally, without questioning the difference in appearance before and after the dusting treatment.

The fragility of the onion peels, further complicated by the potential interactivity with the surrounding context, was not considered by any of the actors involved in the staging of the work. Their condition was not documented, and the numerous directives by the artist in the data sheet made after creating the work were not further clarified (these included the minor movements of the onion peels on the marble; the eventual need to replace some of the peels during the exhibition; and the visitors' potential interaction with the peels). Developing thorough documentation of an installation determines not only the accuracy of future installations, but also their accessibility. The information provided by diverse types of documents such as data sheets and photographs is certainly beneficial to specialists and researchers, but in some cases it can be as well to the general public. This is the case with archival material made accessible through websites such as ASAC's.

The case of *Precipitazioni Sparse* now challenges both the artist and ASAC from its two iterations. The artist does not recognize the ten images at ASAC's website as authentic representations of her work, and so she has proposed taking them down; in her view they are inaccurate documents. ASAC, for its part, seems disinclined to eliminate or modify a document that has undergone an archival process, which renders it in their mind official and definitive. If imagery provided by the artist is not made available, collective memory of the work will remain inaccurate—as confused as the idea that the onion peels were flower petals. This demonstrates quite powerfully how documentation related to contemporary artworks is crucial but cannot necessarily be relied upon. It is a tool needed to preserve the artist's intention and the artwork's memory, but also to provoke questions about its future.

INTERPRETATION

An insightful curator has compared Esposito's works to "poetic compositions, where power and lightness continually encounter each other in an apparently fragile balance, capable, however, of opening up profound spaces of reflection."[5] If the artist regards her materials as like words in a poem (Beccaria 2002, 6), how each material is interpreted by different stakeholders becomes particularly significant. The parallel with poetry might be especially useful if one equates installation with translation, and how both constitute an interpretation. Let us consider, for example, the translations of Wisława Szymborska's poem "The Onion," from the 1976 book *A Large Number*, from Polish into English and Spanish. The poem can be understood at its most basic level in other languages, but whether the reader can appreciate the nuance of each word, its sound and the image it conjures, depends completely on the careful work of the translators. Translators are the vehicles through which the poem can reach a broader audience. Their work involves a deep thinking behind each word, and the balance of literal and free interpretive choices. Their role has such a strong impact on the text's interpretation that their name is always reported.

In the two versions of *Precipitazioni Sparse* not approved by the artist, the literal execution of the work was followed, but the effect created by the composition was quite different from what she had planned. As words and their sound matter in poetry, so do material specificity and the exhibition context in art. The particular value attributed to the materials is far more a priority for Federico Luger, a dealer who holds *Sereno Variabile* (2000), a series of Esposito's works made with onion peels (Esposito 2001). During our interview with him, he mentioned the enthusiastic feedback on the work from visitors at numerous art fairs, and the symbolic meanings he attributed to this material: "The onion, one of the poorest and cheaper aliments, it is the only food that makes you cry when you open it. You can easily imagine that there was something before the onion peels: someone who cried. . . . A situation that can be changed by the moving possibility of the composition."[6]

In our recent interview with the artist, we asked about her criteria for selecting the materials for *Precipitazioni Sparse*, in particular the types of onions she chose. She replied that the choice was easy and based on three types of colors. We then showed her a basket containing many different onion types. Confronted with the variety of choices, and the possibility to manipulate the material over the course of the interview, the artist realized that her criteria were more articulated in her mind than what she had initially stated. She finally verbalized her thoughts, and explained in detail all the aesthetic qualities she seeks in the onion peels (fig. 20.5, fig. 20.6). For instance the driest, most external, thin and rounded skins are used, including

Figure 20.5 Esposito explains her selection process for the onion peels during an interview in her Rome studio, May 22, 2019. Photo: Courtesy the authors, with permission of the artist

This one for example....I don't like it. It's too "aggressive".

https://vimeo.com/592954957/6b7516fbed

Figure 20.7 Esposito demonstrates the correct method of selecting and distributing onion peels in her Rome studio, May 22, 2019. Video, color, sound, 1:44 min. Video: Courtesy the authors, with permission of the artist

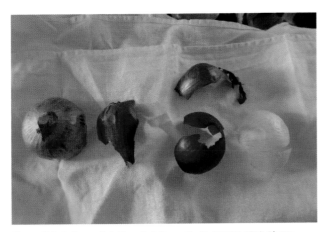

Figure 20.6 Onion peels in Esposito's Rome studio, May 22, 2019. Photo: Courtesy the authors, with permission of the artist

small pieces, and any peels with mold on them are discarded. She does not want any signs of degradation to be visible (including dust on either the marble or the onions), since this would add a dramatic component that would distract from the beauty of the composition. The artist shared her enthusiasm for the infinite play of colors, shapes, and combinations that one can find in onions: "One day I saw the onion. I saw them like I have never seen them before. I decided to work with them. They are so beautiful. Can't you see how much they are beautiful? With my work I wish to make visible something that is usually difficult to see. It is all about looking. We do not know how to look at things."

While sorting through the onions, the artist also made an impromptu demonstration of how to disperse them on the marble, which we recorded on video (fig. 20.7). This offers the intriguing opportunity to reflect on the gestures of dispersal she likely used for the initial installation in Venice (fig. 20.8). Bartolomeo Pietromarchi, director and curator of the MAXXI Museum, who has collaborated with Esposito

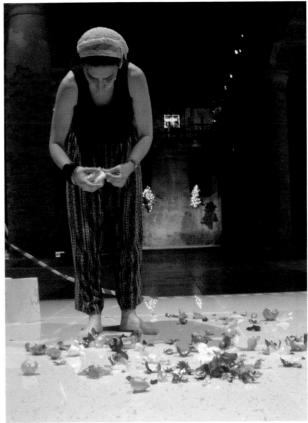

Figure 20.8 Esposito installing *Precipitazioni Sparse* at *Always a Little Further*, 51st Venice Biennale, 2005. Photo: Enzo de Leonibus, courtesy the artist

on various occasions, noted how these gestures are very much related to some of her other works involving performance, even though *Precipitazioni Sparse* itself does not have a performative element.[7]

CONCLUSION

Those exhibiting contemporary artworks, whether in the public or the private sector, have a responsibility to transmit the values embedded into the works' materials and history to audiences. This should be guided by a deep understanding of the work, its production, its context, and how it will likely be perceived by those experiencing it. The artist's intention is crucial to an understanding of the work, but it needs to be investigated and questioned, along with its surrounding context. The meanings to which the artist in this case assigned the most importance depended on material appearance. This can create interpretive challenges for those who intend to reinstall the work. How important is it for the artist that the actual material be preserved from one exhibition to another? What is her specific opinion about each onion peel and its position on the marble? Or about the marble color tone? These characteristics are not always easy to interpret, or replicate; in this case, most of the artist's choices crystallized in the moment of creating, or when thinking later about the work, but not when she was preparing instructions for its maintenance while on view.

Selection of materials and display choices are therefore the most challenging aspects concerning the installation of *Precipitazioni Sparse*. Studying the different ways in which the work was previously presented and the reactions of the artist toward these situations has shed new light on her criteria. Furthermore, sharing conservation concerns with different stakeholders can help them formulate more precise questions related to the work, and facilitate the emergence of new ways of interpreting it. The specificity of the materials with which the artist works is the starting point to fascinate audiences with an artwork's potential to transform something prosaic, like an onion, into a poem.

Acknowledgments

The authors wish to thank Bruna Esposito, Federico Luger, Sara Petracca, Mario and Dora Pieroni, Bartolomeo Pietromarchi, and Yamina Tavani.

NOTES

1. Unless otherwise noted, comments of this nature about the intent behind the work mostly derive from our author interview with Bruna Esposito, May 22, 2019.

2. The ASAC web page in question is http://asac.labiennale.org/it/documenti/fototeca/ava-ricerca.php?scheda=97513&p=1.

3. Author interview with Mario and Dora Pieroni, April 26, 2019.

4. From the data sheet signed by the artist and conserved by ASAC: Fondo_storico_arti_visive_b_840_4_ Bruna Esposito_*Precipitazioni Sparse*.

5. Marcella Beccaria, curator's comments written on the occasion of the artist's show at Castello di Rivoli, Turin, Italy, 2002, https://www.castellodirivoli.org/en/mostra/bruna-esposito/.

6. Author interview with Federico Luger, May 22, 2019.

7. Author interview with Bartolomeo Pietromarchi, July 16, 2019.

BIBLIOGRAPHY

Beccaria 2002
Beccaria, Marcella, ed. 2002. *Bruna Esposito*. Milan: Charta.

Corzo 1999
Corzo, Miguel Angel, ed. 1999. *Mortality Immortality? The Legacy of 20th-Century Art*. Los Angeles: Getty Conservation Institute.

Esposito 2001
Esposito, Bruna. 2001. "Sereno-variabile." *Cahiers intempestifs*, no. 13 (October–December): 32–35.

Llamas-Pacheco 2018
Llamas-Pacheco, Rosario. 2018. "The Ephemeral, the Essential and the Material in the Conservation of Contemporary Art: Decision-Making for the Conservation of a Work of Art Made with Butterfly Wings." *Studies in Conservation* 63, no. 8 (July): 441–49.

Martinez and de Corral 2005
Martinez, Rosa, and Maria de Corral, eds. 2005. *La Biennale di Venezia. 51a International Art Exhibition. Always a Little Further*. Venice: Marsilio – Fondazione La Biennale di Venezia.

Pietromarchi 2017
Pietromarchi, Bartolomeo, ed. 2017. *Bruna Esposito. E così sia . . . /Amen*. Imola, Italy: Manfredi Editore.

Subrizi 2012
Subrizi, Carla. 2012. *Azioni che cambiano il mondo. Donne, arte e politiche dello sguardo*. Piacenza, Italy: Postemedia Books.

Zevi 2005
Zevi, Adachiara. 2005. *Peripezie del dopoguerra nell'arte italiana*. Turin, Italy: Einaudi.

A Crumb(ling) Display: Conserving Bread in the Collection of the Museum of Contemporary Art, Zagreb

Mirta Pavić
Jasna Jablan
Ivana Bačić
Harald Fitzek

Nailed Bread *(1973) is a conceptual work by the artist Dragoljub Raša Todosijević in the collection of the Museum of Contemporary Art, Zagreb. It consists of a piece of bread into which three nails have been hammered. Over the several decades of its existence, it has begun to show signs of decay. In 2010 it was consolidated with a solution of Paraloid B-72 in ethanol, and was subjected to gamma irradiation. Eight years later, again changes were noted and further consolidation was deemed necessary. Four consolidants were tested with the aim of comparing their characteristics and determining the most appropriate for use: Paraloid B-72 (same as previously used), Mowilith 50, Aquazol 200, and Aquazol 500.*

◆　　◆　　◆

One's first association with bread is likely food. But this simple ingredient found a place for itself in an entirely different context in the work of Dragoljub Raša Todosijević (b. 1945), a pioneer in the field of conceptual art in the former Yugoslavia. *Nailed Bread* (1973, fig. 21.1) belongs to Zagreb's Museum of Contemporary Art (MSU), and is among the most exciting artworks on permanent view, judging by public feedback. It is no less interesting from a conservation point of view. In order for this perishable material, through which the artist rejects the idea that an artwork is merely an object, to retain its original form and consistency, it must be preserved with particular care.

Nailed Bread is an unmistakable example of an artwork made of a material that is at the same time its primary bearer of meaning. Bread is the material from which it is made, but it simultaneously brings to mind staple foods, and the Crucifixion, in this way breaking down the barrier between art and life.

In 2009 the MSU moved to a new purpose-built building, where *Nailed Bread* was exhibited as part of the permanent collection from the very beginning. The permanent collection is not static, but periodically rotated within the gallery space. In 2010 *Nailed Bread* was exhibited in close

proximity to other organic materials, such as Philip Corner's installation *Piano Bed* (1999, fig. 21.2), which is made of an upright piano, hay, and a cap. This probably contributed to the changes that were noted on the bread in the same year, almost four decades after its creation.

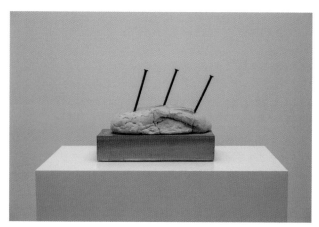

Figure 21.1 Dragoljub Raša Todosijević (b. 1945, Belgrade), *Nailed Bread*, 1973. Bread, wood, and nails, 26 × 35 × 14.5 cm. Museum of Contemporary Art, Zagreb, inv. no 1810. Photo: Jovan Kliska

EARLIER TREATMENTS

Raša Todosijević's work is, for the most part, focused on communicating with viewers through the production of a deceptively realistic piece (Tijardović 1978) and performances and texts in which he discusses his own works, rather than through static objects.[1] The MSU work speaks through its symbolism and belongs to the museum's collection of sculpture. In 2010, when the first changes—drying, cracking, and crumbling—were noted, it was therefore logical to telephone the artist (who is still living, and resides in Belgrade) to determine his attitude toward the preservation of this piece from 1973. Given that the artist used bread in many of his works, he immediately suggested that he donate a new piece of bread to the museum to replace the existing one; he had been unaware that there was even a possibility of conserving the original bread. But for us, the fact that ours is not the only bread piece by Raša Todosijević was an additional motive to attempt conservation of the original bread. The artist was informed that our intention was to consolidate the bread and expose it to gamma irradiation to eliminate insect

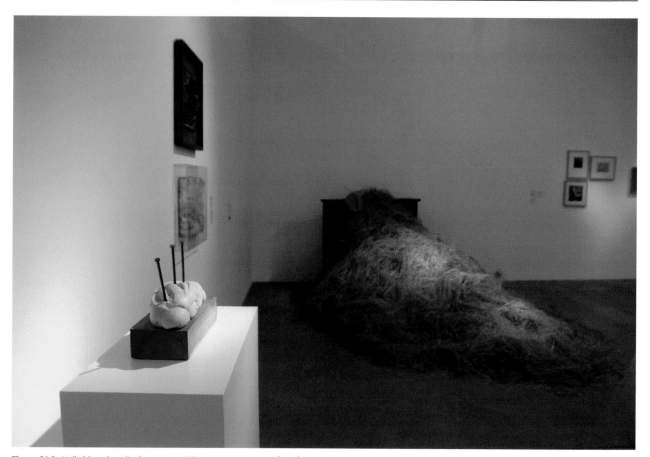

Figure 21.2 *Nailed Bread* on display next to Philip Corner's *Piano Bed* (1999) at the Museum of Contemporary Art, Zagreb, 2010. Photo: Goran Vranić

DIFFERENT APPROACHES AND RESPONSES

https://vimeo.com/592945326/13d80ae4e1

Figure 21.3 Testing the consolidated sample in comparison to a sample with no consolidant. Video: Museum of Contemporary Art, Zagreb

https://vimeo.com/592948810/c62783c8d6

Figure 21.5 Consolidation with Paraloid B-72, 2010. Video: Museum of Contemporary Art, Zagreb

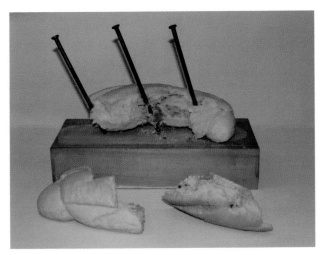

Figure 21.4 *Nailed Bread* during the first conservation treatment in 2010. Photo: Mirta Pavić

infestation. He was very surprised, happy, and eager to hear about the results.

A solution of ethyl-methacrylate copolymer Paraloid B-72 in ethanol (6 percent) was tested on a dried piece of bread baked from the same type of flour as the original. The consolidated sample was stable, and showed the desired characteristics during a test where it was dropped to the floor, in comparison to a sample that was not consolidated, which broke apart into little pieces (fig. 21.3). The original bread was then taken apart into the elements that it had already broken into through the natural process of drying out (fig. 21.4). Small decayed parts were removed from the interior, and the nails were cleaned and coated with an anti-corrosive liquid. Paraloid B-72 was then injected into the material (fig. 21.5). The separated parts of *Nailed Bread* were then successfully joined using the same consolidant. Thereafter, the object was exposed to gamma irradiation at the Ruđer Bošković Institute in Zagreb.[2]

Changes in the bread once again appeared in late 2018, namely minor local disintegration and tiny flying insects around it, which led to the suspicion that the consolidant had not been homogenously spread out across the material. It was therefore decided that the piece would be reexamined, and various consolidants tested in order to compare their characteristics to Paraloid B-72. The primary characteristics sought in the consolidant were: zero or minimal impact on visual appearance and aesthetics; the possibility of dissolving in a solvent that evaporates quickly (as the authors were concerned that prolonged contact with the bread could harm it) and that it not break down the starch; stability; and resistance to parasites.

Four consolidants were tested on the bread samples, all synthetic resins that could dissolve in a fast-evaporating solvent: polyvinyl acetatehomopolymer (Mowilith 50),[3] poly (2-ethyl-2-oxazoline) (Aquazol 200 and 500),[4] and Paraloid B-72.[5] Every sample of bread tested with a consolidant was compared to a sample of the original consolidated bread.

MATERIALS AND METHODS

Samples of bread having the same qualities as the original bread (a white bread commonly used in this region and available in all grocery stores) were prepared and consolidated with the four different polymer resins (fig. 21.6). Solutions were made using different concentrations of the consolidants (6, 10, and 15 percent solutions in ethanol). The consolidants were injected into each sample using a syringe with a needle.

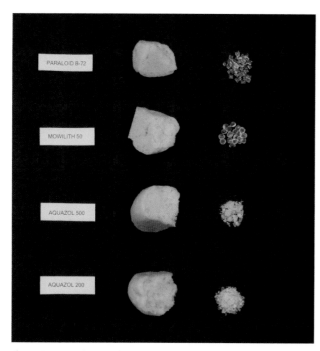

Figure 21.6 Samples consolidated with four different consolidants. Photo: Mirta Pavić

Optical microscopy, Raman microscopy, Fourier transform infrared spectroscopy–attenuated total reflection (FTIR-ATR), and correlative scanning electron microscopy (SEM)–Raman microscopy (Hollricher, Schmidt, and Breuninger 2014) provided the details necessary for the conservators to make decisions.[6] The aim was to gather information on the behavior of the consolidant applied in the first treatment (Paraloid B-72) over the period of nine years in comparison with the four new consolidants applied to the test samples. Surface characterization, changes due to conservation treatment, and evaluation of spatial distribution of the constituents were determined with FTIR-ATR. There are many advantages to this technique: it is nondestructive, does not require any sample preparation, and gives molecular information on inorganic and organic components. FTIR-ATR spectroscopy provides information about functional groups present in molecules based on the energy of vibrational transitions.

A complete picture of the chemical distribution of the components within a test sample may be obtained using Raman microscopy, which can provide chemical analysis on a micrometer scale. In addition, correlative SEM-Raman microscopy was performed as a novel technique that combines the high spatial resolution and depth of focus of SEM with the chemical analysis of confocal Raman microscopy.

Consolidated bread samples with various resins and concentrations were prepared and cured. These included samples of the original bread consolidated nine years ago as well as the newly prepared and consolidated samples. Samples used for SEM-Raman microscopy were prepared by simple cut. Parts of these samples were embedded in epoxy resin using flat embedding molds, dried at room temperature, and cut with ultramicrotomy (Leica UC6; Histo diamond knife) in order to produce a flat block surface for microscopic measurements and for Raman mapping (fig. 21.7).

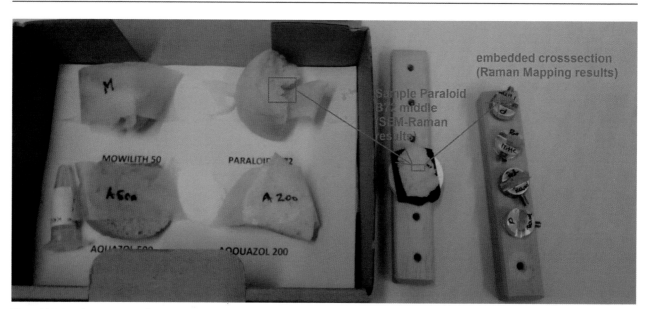

Figure 21.7 Sample preparation—the microtome cross sections. Photo: Harald Fitzek

RESULTS

FTIR-ATR was used to determine how homogeneously the consolidant had penetrated the bread samples. The obtained spectra for untreated bread (without any consolidant), samples taken from the original object consolidated with Paraloid B-72, and pure solution of Paraloid B-72 in ethanol are shown in fig. 21.8. The line drawn at 1723 cm^{-1} signals the absorption band related to carbonyl stretching (ν C=O) characteristic for Paraloid B-72. This band was used as a marker for determining the presence of Paraloid B-72 in the sample, since it is not present in untreated bread. In addition, the variations in intensity as a function of location provided semi-quantitative information on the concentration of Paraloid B-72. The significant variations in intensity indicate an uneven distribution of Paraloid B-72 (Vahur et al. 2016).

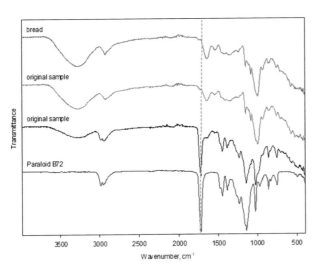

Figure 21.8 FTIR-ATR spectra of the untreated bread (red), original sample (green and black), and Paraloid B-72 (blue). Ivana Bačić

Unlike the Paraloid B-72 and Mowilith 50, as a marker for the Aquazol 200 and Aquazol 500, an absorption band with a maximum at 1195 cm^{-1} was used, since this band is not present in untreated bread. According to literature, this band is most likely attributable to the stretching of C–C bonds (Colombo et al. 2015).

Similar results were obtained for all the other samples analyzed. FTIR measurements were taken randomly at five different locations inside of each bread sample. At some points of measurement, very low concentrations of the consolidant were observed, while at some other points the concentration of the consolidant was very high. The characteristic absorption bands for each are listed in table 21.1, with the respective areas per location and per sample. The results indicate that the consolidant is

unevenly distributed in all samples irrespectively of the concentration. The results also show that the consolidation of the new test bread samples as well as the original bread sample taken from the object that was consolidated with Paraloid B-72 in 2010 did not cause any change to the vibrational modes of the starch and selected polymer materials, suggesting that the consolidant is chemically stable, and compatible with the bread.

	Paraloid B72	Mowilith 50	Aquazol 200	Aquazol 500
characteristic absorption band	1723 cm^{-1}	1723 cm^{-1}	1195 cm^{-1}	1195 cm^{-1}
Area of characteristic absorption band (average of 2 measurements)				
Pure consolidant	18.96	18.73	2.15	12.95
Area of characteristic absorption band analyzed at 5 different positions				
Bread with consolidant in 6% ethanol	2.07	0.67	0.36	0.08
	4.06	0.04	0.32	0.07
	0.56	0.17	0.27	0.09
	0.50	0.15	0.09	0.07
	1.38	0.05	0.05	0.15
Bread with consolidant in 10% ethanol	4.47	7.70	0.13	0.26
	1.23	1.07	0.13	0.16
	3.79	4.05	0.10	0.19
	0.92	7.63	1.03	0.26
	0.72	1.67	0.12	0.10
Bread with consolidant in 15% ethanol	2.21	9.20	0.69	0.45
	1.08	1.52	0.05	0.18
	2.50	17.74	0.90	1.28
	1.88	12.70	0.27	0.04
	1.59	4.07	0.10	0.04

Table 21.1 Area of the characteristic absorption band. Ivana Bačić, Jasna Jablan

Optical microscopy and confocal Raman microscopy were used as further experimental analytical techniques.[7] To confirm the results obtained by FTIR spectroscopy and for material characterization, optical microscopy on ultra-microtome cut samples was used. In the optical microscope image (fig. 21.9) it is fairly obvious that large droplets of Paraloid B-72 have formed. Raman measurements performed on ten different positions confirmed that the chemical composition of the bubbles observed using light microscopy corresponds to the

composition of Paraloid B-72 (the spectra shown are 3 and 7, fig. 21.10). On the other hand, on all other positions analyzed, the presence of the consolidant used was not confirmed (the spectra shown are 6 and 9, fig. 21.10). Direct measurements on an unprepared piece of bread excluded any influence from our sample preparation. In all samples, the obtained results have confirmed the presence of starch and an additive (zein), and the presence of Paraloid B-72 was confirmed in the treated samples of bread.

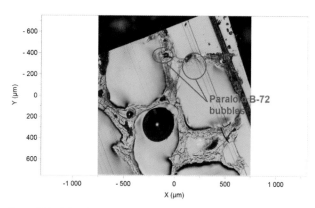

Figure 21.9 Light microscope image of the cross section of a sample with Paraloid B-72. Harald Fitzek

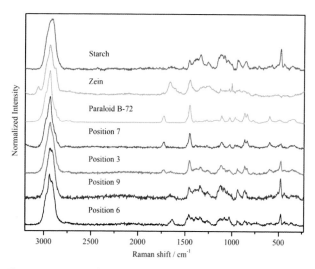

Figure 21.10 Spectra of a bread sample obtained using Raman point measurements (positions 3 and 7 with Paraloid; positions 6 and 9 with no Paraloid). Harald Fitzek

The results of light microscopy were also confirmed using a sophisticated Raman-SEM technique (Tarnowski and Morris 2001). Two correlative Raman-SEM measurements of an unembedded part of the sample were performed. The SEM's good depth of field was used to obtain reasonable images, and Raman point measurements were used to confirm the chemistry (fig. 21.11a, fig. 21.11b). The

results obtained also showed the presence of droplets of Paraloid B-72 on the top of the bread.

Based on observations obtained using light microscopy, Raman mapping was performed on one thread of the bread with no bubbles close by (fig. 21.12a, fig. 21.12b). In the mapping, only components belonging to the bread (starch and zein) and one unidentified contamination particle in the middle of the thread (but not Paraloid B-72) were found. The physical resolution of the mapping is approximately 1 μm and the pixel resolution is 0.75 μm, confirming that there is no thin coating of Paraloid B-72.

The results of Raman point and mapping analysis confirmed the inhomogeneous distribution of Paraloid B-72 in the analyzed sample, present mostly in clusters of large droplets.

All other samples were analyzed in precisely the same way, and the same results were obtained for all the consolidants used (Mowilith 50, Aquazol 200, and Aquazol 500) (results not shown) through optical microscopy. Large droplets of consolidants had formed. Some droplets of the consolidant were found on the treated bread, but the threads of the bread were not completely covered by any consolidant, which was in each case confirmed using Raman point measurements. These measurements confirmed the results of the mapping of all analyzed samples, with some positions showing consolidants and others showing no consolidants (Schmidt, Ayasse, and Hollricher 2016). The inhomogeneous distribution was observed in all analyzed samples.

MYCOLOGICAL ANALYSIS

Because the presence of microorganisms was noted in *Nailed Bread*, a mycological analysis (examining test samples for the presence of fungi) was also performed. Dry swabs were taken from six spots on the object and inoculated on the surface of malt extract agar (MEA). Control swabs were taken from an indoor environment and inoculated on MEA. Samples were incubated at 25°C in the dark for ten days.

Afterward, the incubation plates were examined under an optical microscope. Object samples recovered white mycelia on two plates, *Penicillium* spp. and *Chaetomium* spp. on one plate and one unidentified colony, while two plates remained sterile. Control samples recovered *Aspergillus* from the section *Nigri, Flavi*, and *Versicolores, Phomopsis* spp., and *Alternaria* spp.

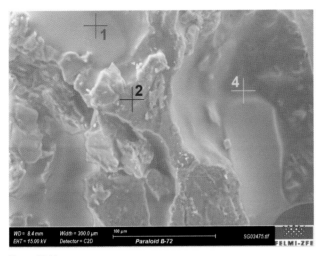

Figure 21.11a

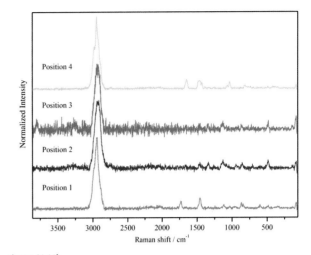

Figure 21.11b

SEM (a) and Raman point measurements, (b): Position 1 (Paraloid), positions 2 and 3 (starch), position 4 (zein). Harald Fitzek

Figure 21.12a

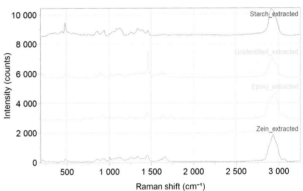

Figure 21.12b

Raman mapping of (a) sample Paraloid B-72 with reference spectra (b). Harald Fitzek

The only unusual finding on the object is *Chaetomium* spp., known as a tertiary colonizer of damp indoor materials. Since the object is kept in optimal environmental conditions, dry and with no visible mold growth, it is possible that some insects, perhaps flies, transferred the mold from another source to the surface of the object.

CONCLUDING THOUGHTS

The research carried out thus far has led to a few significant findings. When it comes to biological material, it is important to act immediately, as soon as changes appear; if not, the material might be lost. To avoid the development of mold, it is important to isolate the piece inside a vitrine while it is on display and maintain optimal environmental conditions.

The aim of the research was to analyze the characteristics and behavior of the chosen consolidants. A lot of effort was put into this initial phase of research in order to better understand the biological material and improve its long-term preservation. The selection of consolidant is limited by the type of solvent used. Water, for example, should be avoided, as it breaks down bread. All the consolidants tested showed similar characteristics, but Paraloid and Mowilith might be a little shinier in appearance than Aquazol.

Results indicated that the consolidants tested did not cause a chemical change in the starch or its incorporation into the structure of the polymer backbone, which means that they are all potential consolidants for the conservation of this type of material. Confocal Raman microscopy indicated that all consolidants distribute unevenly and tend to accumulate as large droplets. Research into application methods that might improve the dispersion of

the consolidant will continue, but overall, even with this imperfect application method, it was observed that the consolidants do prolong the life span of the bread.

Another observation on the method of application of the consolidants is that it is rather invasive: to spread the consolidant within the material, the needle needs to reach the depth of the material, in this case the bread. That said, this procedure did not affect the structure of bread due to its porosity and flexibility.

The different techniques have straightforward applications for the investigation of formation processes, mechanisms of degradation (chemical and physical), and interaction with the consolidant. Accelerated aging tests still need to be carried out on all of the samples with each of the consolidants in order to see how the consolidants react over a longer time period, as well as to test a greater variety of application methods.

Food as an artistic material transmits a message by being precisely what it is. The musealization of such materials opens up many ethical and technical questions (Temkin 1999), as contemporary art often does, as well as collaborations with experts in different scientific fields. Artworks that contain organic materials especially require the establishment of methodologies for their maintenance. *Nailed Bread* belongs to the 1970s, a very productive time for conceptual art in the former Yugoslavia, on which Raša Todosijević left a mark. The object itself, made of the original material by the artist in this particular period, has an authenticity and a special meaning for the artist and for the museum. Replacing it with a new loaf of bread would require re-hammering the nails—an action that would not only change the work's meaning, but alter its time and dating because it would take place in a new moment and under different circumstances.

The answers to some of the questions we encountered— Why this material in particular? Why is it important to preserve this particular piece of bread? What is so unique about it?—speak to the very fundamentals of our work, to thinking about and understanding what we do and why we do it.

Acknowledgments

The authors are thankful to Professor Maja Šegvić Klarić from the Department of Microbiology of the University of Zagreb, Faculty of Pharmacy and Biochemistry, for helping with the mycological analysis, and to the Austrian Center for Electron Microscopy and Nanoanalysis, Graz, and Sanja Šimić for their help in conducting the SEM-Raman experiments.

NOTES

1. Raša Todosijević began his work in the informal Oktobar (October) group, together with Marina Abramović, Era Milivojević, Neša Paripović, Zoran Popović, and Gergelj Urkom, and they continued working in specific spheres of artistic activity, for instance the body-artistic activities of Abramović, and Raša Todosijević's analysis of the social, as well as the political, function of art (Susovski 1978, 3–4).

2. This method is the easiest for eliminating insects that may be present, and when dealing with bread, irradiation of no more than 2 kGy is recommended; anything higher may lead to changes in the material, such as yellowing.

3. This has a medium molecular weight and very good penetration and drying properties, and is effective on a wide range of substrates. Its excellent light stability means that it can be used in applications subjected to intense UV radiation.

4. These have broad solubility in water and polar organic solvents, have good thermal stability, maintain a neutral pH, and have good solubility. They can be used as an adhesive, in painting medium, as consolidant, and as binder. Aquazol 500 molecular weight: 500,000; Aquazol 200 molecular weight: 200,000

5. This is a durable and non-yellowing acrylic resin more flexible than many other adhesives typically used. It tolerates more stress and strain on a join.

6. Infrared spectra were recorded on a Bruker Alpha FTIR spectrometer with the single-reflection diamond ATR technique. Spectra were collected in frequency range of 4000 to 400 cm^{-1} with a spectral resolution of 4 cm^{-1}. In this study, samples were characterized using a novel correlative method combining SEM and Raman microscopy. The instrument used is a combination of a scanning electron microscope (Zeiss Sigma 300 VP) and a fast confocal Raman microscope (RISE, WiTec) operating independently in the same vacuum chamber and allowing correlated imaging between SEM and Raman for structural and chemical information in the same region of interest without complicated manipulation of the sample.

7. Confocal Raman microscopy is a powerful characterization tool that allows collection of chemical information via Raman spectra with the same spatial resolution of a confocal laser microscope. The measurements were performed on a LabRAM HR 800 (with Olympus BX41) using a 532 nm laser (excitation power approximately 10mW) and an Olympus x50 LMPLFLN (NA=0.5) objective.

DIFFERENT APPROACHES AND RESPONSES

BIBLIOGRAPHY

Colombo et al. 2015

Colombo, Annalisa, Francesca Gherardi, Sara Goidanich, John Delaney, René de la Rie, Maria Ubaldi, Lucia Toniolo, and Roberto Simonutti. 2015. "Highly Transparent Poly (2-Ethyl-2-Oxazoline)-TiO2 Nanocomposite Coatings for the Conservation of Matte Painted Artworks." *RSC Adv.* 5 (October): 84879–88.

Hollricher, Schmidt, and Breuninger 2014

Hollricher, Olaf, Ute Schmidt, and Sonja Breuninger. 2014. "RISE Microscopy: Correlative Raman and SEM Imaging." *Microscopy Today* 22 (November): 36–39. https://doi.org/10.1017/S1551929514001175.

Schmidt, Ayasse, and Hollricher 2016

Schmidt, Ute, Philippe Ayasse, and Olaf Hollricher. 2016. "RISE Microscopy: Correlative Raman and SEM Imaging." In *European Microscopy Congress 2016: Proceedings*, 1023–24. Wiley Online Library.

Susovski 1978

Susovski, Marijan, ed. 1978. *Nova umjetničkapraksa 1966–1978*. Zagreb: Galerija suvremene umjetnosti [Gallery of Contemporary Art].

Tarnowski and Morris 2001

Tarnowski, C. P., and M. D. Morris. 2001. "Raman Spectroscopy and Microscopy." In *Encyclopedia of Materials: Science and Technology*, edited by K. H. Jürgen Buschow, Robert W. Cahn, Merton C. Flemings, Bernhard Ilschner, Edward J. Kramer, Subhash Mahajan, and Patrick Veyssière, 7976–83. Oxford: Elsevier.

Temkin 1999

Temkin, Ann. 1999. "Strange Fruit." In *Mortality Immortality? The Legacy of 20th-Century Art*, edited by Miguel Angel Corzo, 45–50. Los Angeles: Getty Conservation Institute.

Tijardović 1978

Tijardović, Jasna. 1978. "Marina Abramović, Slobodan Milivojević, Neša Paripović, Zoran Popović, Raša Todosijević, Gergelj Urkom." In *Nova umjetničkapraksa 1966–1978*, edited by Marijan Susovski, 55–59. Zagreb: Galerija suvremene umjetnosti [Gallery of Contemporary Art].

Vahur et al. 2016

Vahur, Signe, Anu Teearu, Pilleriin Peets, Lauri Joosu, and Ivo Leito. 2016. "ATR-FT-IR Spectral Collection of Conservation Materials in the Extended Region of 4000-80 Cm^{-1}." *Analytical and Bioanalytical Chemistry* 408 (13): 3373–79.

Part Five

Artists' Reflections

Living Matter: Research as Creative Process

Gabriel de la Mora

A core element of Gabriel de la Mora's artistic output involves the conservation and restoration of artworks. He considers himself a creator of questions and explorations because each concept in a given work of art requires a specific technique that might give him control over potential variables. Resolved questions have become essential elements of his production—gateways to more complex concrete experiences. The materials are not only repositories for stories or patterns, but explorations of the durability and resilience of such. The shift from the two-dimensional nature of drawing into textures and three-dimensionality has proven an ideal space for experimentation, as he has evolved into planning, consolidating, and assembling works of art in increasingly complex materials.

◆　　◆　　◆

On June 5, 2019, I gave this presentation at the "Living Matter" symposium, where the discussions centered on the challenges involved in the conservation of contemporary works of art created with biological materials. I will begin by saying this: I believe that just as matter occupies a place in space, has mass, and endures or transforms over time, research into the conservation of the materials used in an artist's production is indispensable to the artist's career or artwork. Thanks to this invitation, I was able to reflect on the exact moment when I became aware of the inevitability of decay of the organic elements in a work of art.

Consideration of living or organic matter has been present in my work as an artist from the start of my career, and perhaps since my youth. I recall an anecdote from my childhood: I was at my family home in the city of Colima, Mexico. One morning I took two clear drinking glasses

from the kitchen. I filled one with water from the water faucet, and I filled the other with clear alcohol. I went to the pond in the garden and took out two fish that looked as much alike as possible. I held one in each hand about ten centimeters from the liquid in each glass, and I dropped them both into the glasses at the same time. The fish that fell into the water swam easily, while the other twisted and contorted until, a few seconds later, it was motionless, lifeless. Within my capabilities at that age, I was able to conclude that, in both glasses, although the fish and the liquids looked the same, they were actually different; in one, life continued, and the other held only death.

I was drawing before I spoke or wrote, and drawing has always been my best form of expression toward the outside world. I was a child who discovered his environment through questions, experiments,

Figure 22.1 Gabriel de la Mora (Mexican, b. 1968), *m-294*, 1972. Pencil and ink on printed paper, 27.9 × 21.6 cm. Photo: Courtesy the artist and Proyectos Monclova

observations (fig. 22.1). I consider this the background to the importance of living matter and research in my creative process. From the perspective of the practice of art, now that I am an adult, that youthful experimentation has led to this type of question: When does an artist begin to be an artist? Are they born an artist, or do they become one when they pursue studies in the visual arts? Or at the moment when they decide to devote themselves to art? Should art be eternal, or will it have continual changes? Will all works of art disappear in the end?

I studied architecture and practiced it for five years, until August 1996, when I exchanged architecture for art. Since the beginning of my career as an artist, I began to experiment with different found materials, mostly discarded items such as latex, feathers, hair, eggshells, and many others. Since then I have enjoyed experimenting with different material elements, and that is why I always conduct a large number of tests to see which materials are ideal for the piece I am creating. All the materials present in my work, besides functioning as containers of stories, memories, or customs, are repeated tests of the durability and resistance of matter. The leap from the two-dimensionality of drawing to the texture and three-dimensionality of all those materials has been the perfect

field for experimentation, as I have moved from the simplicity of direct drawing on a support to the complexity of schematization, consolidation, construction, and assembly of pieces with increasingly complex materials.

This process of *trial-error-trial-result* entailed in my creations has led me to not only posit many questions, but seek solutions that allow me to continue using all the materials I want in building my body of artwork. When answered, these inquiries have become an essential element of my work and have opened doors to material adventures of ever greater complexity.

At some point in my creative processes, I try to seek the advice of conservators, because experience has taught me how fundamental it is to have the counsel of experts. To a large extent, my early works were either destroyed or disappeared over time, leaving only the photographic record and some negatives to speak of their existence, which showed me the importance of risk control, conservation, and restoration of the materials used in the art world (fig. 22.2).

Figure 22.2 Gabriel de la Mora (Mexican, b. 1968), *Emiliano 20:30 hrs*, 1998. Latex, artist's pubic hair, postcard, and newspaper mounted on a wooden structure, 17.8 × 12.7 cm. Photo: Courtesy the artist and Proyectos Monclova

work, I can accept that eventually, after many, many transformations and material changes, everything will disappear. I have learned that there are even pieces whose manifest existence includes, per se, the fact that they will gradually vanish over time, such as the late nineteenth-century and early twentieth-century photographic images that I have worked with. One example is *Fotografía intervenida* (Intervened Photography, 2008–ongoing), a series involving faded daguerreotypes, water-damaged photographs, first-generation vintage photographs, and destroyed, semi-destroyed, or exposed negatives. This small collection was classified by subject, source, period of origin, and state of conservation. The photograph—as a technological development that made a faithful record of reality possible—gradually becomes an archive of absences, of the invisible and the phantasmagorical, that creates no certainty and even asks how reliable an image can be, even if it is generated by a machine rather than a human being. The pieces have been severely affected by time. The images are about to disappear given their exposure to sunlight, and that disappearance represents the birth of a monochrome, resulting from a process in which the artist has no influence at all beyond merely drawing attention to something. In *Fotografía intervenida* the alteration to the pieces begins with the detachment of partial and random fragments of an image. Sometimes I only cut a millimeter off the edge at a time, and continue until I reach the center of the print. Or I simply print negatives that have been accidentally ruined by floods or humidity.

When I saw that many of my early works disappeared with the passing of time, I devoted myself to finding someone to constructively accompany me in my explorations and inquiries into the durability of certain materials, for instance the types of adhesives and compounds I should use so that the works would remain as intact as possible for as long as possible. That search led to me working hand in hand with a great conservator in Mexico City, to whom I will always be grateful for providing me with that expert support. This collaboration created countless possibilities for exploration, experimentation, and improvement in my processes. Based on this experience, I began to document as best I could, from the conception of an idea through the entire process of creation, the behavior of the finished pieces over time, and the different environmental conditions that each one underwent as it moved from the studio to the museum, the private collection, or the art gallery.

When I was young, I had the naive belief that art was obliged to survive intact over time. Now, due to all the experience I have gained over more than twenty years of

However, I think that all works change, and even if a work is destroyed, it will continue to be the same work, since art does not vanish; it only changes. If a piece breaks, it exists as the same piece, only broken. It simply changes its existence through conditions, its character, time itself. The piece will be in continual evolution. That is the immanent of the permanent. There is a series in which I decided to use my blood (fig. 22.3), which in addition to containing energy, contains my genetic information. I diluted it in acrylic varnish and applied it to a cloth in various layers, perhaps thereby creating my first monochromes. Some time later, a collector who had bought one of these contacted me to report that although the work was not in direct sunlight, it had lost almost all its color after several years. This made me think that the work remains the same work even when it has lost color, because the genetic information is still there. Even though light or UV rays made the color disappear, the work continues to exist as such. I explained this to the collector and told him I was willing to take the piece back in exchange for something else. He asked me about the final destination of the piece he would be returning, and I told him I would keep it as

part of the collection. On hearing this, the collector decided to keep it because he still liked it a lot—he was just worried about the color. In fact, from my perspective, the piece could not be remade, or discarded, or even less conserved and restored, its color brought back by reapplying diluted blood. The piece continues to be the same piece, only different, changing in some way as everything changes over time. This experience also supports the premise that Willy Kautz used for the book and exhibition *Lo que no vemos, lo que nos mira* (What We Don't See, What's Watching Us), presented at the Amparo Museum in Mexico City in 2014 (Kautz 2015).

Figure 22.3 Gabriel de la Mora (Mexican, b. 1968), detail of *G.M.C. O+ / 14,565.6 cm2*, 2009. (G.M. O+) blood on Masonite. Twenty-eight parts, 102 × 142.8 cm overall. Private collection. Photo: Courtesy the artist and Proyectos Monclova

My works only allow for maintenance, never replacements. What breaks off or disintegrates cannot be brought back through conservation. If I use waste, what interests me is consolidating and arresting as far as possible certain processes of degradation or deterioration. But I cannot go against the passing of time or the lasting nature of some materials. On the other hand, I am also interested in the paradox of the temporal within the constant—for example, how something so ephemeral as burning a sheet of paper makes the paper eternal through the chemical reaction.

The series of burned papers was, in some way, the start of a phase in my career. I began in October 2007 in Mexico City, simply burning a sheet of white paper (fig. 22.4). The process of transformation was fascinating: seeing a flat, white sheet of paper turn into an irregular, black surface, then the black turns to gray and the paper is destroyed (fig. 22.5). I burned hundreds of sheets of paper until, for some reason, the change from black to gray stopped happening and the last sheet remained burned but intact. With this experiment, I started the series that took me ten years to finally finish in December 2017. It consists of sixteen works in total: forty-three burned papers in various individual groupings—diptychs, triptychs, and polyptychs of four, five, and six pieces. Four pieces of this series currently belong to MOCA in Los Angeles, and the rest, which are constituted of the thirty-eight pages of my 2003 MFA thesis, belong to the Pratt Institute in New York. Those thirty-eight pages ended up as eleven pieces in the Pratt Institute because I wanted to respect the number of elements in polyptychs according to the number of pages of each chapter of my thesis. For conservation purposes, all I do to stabilize the ashes of the papers is to apply three layers of aerosol fixative for charcoal drawings to their backs. What is interesting about the series is how I start a process, and all the rest is far beyond my control. This led to several series afterward and, in addition to being some wonderful pieces, they formally and conceptually fulfill my idea of seeking a balance between the formal and the conceptual. The burned papers represent some of the more important pieces in my portfolio as an artist. The adhesives and paper I use are generally acid free, so under normal conditions they should keep well over time. It is important to mention that to date, fifteen years after starting the series, I have not had to conserve any piece.

Figure 22.4 Gabriel de la Mora (Mexican, b. 1968), *Catalogue of the Exhibition*, 2003–9. Burned paper, three parts, 8.1 × 28.7 × 22.5 cm each. Private collection. Photo: Michael Zabé, courtesy the artist and Proyectos Monclova

Figure 22.5 Gabriel de la Mora (Mexican, b. 1968), still from *21 intentos*, 2017. HD video, color, silent, 35:25 min. Edition of 5, 1 AP. Photo: Ramiro Chaves, courtesy the artist and Proyectos Monclova

After much consideration, I have reached a definition of art as a reflection of the definition of energy in the physics of Lavoisier-Lomonosov, in which the atoms of an object cannot be created or destroyed, but can be moved around and change into different particles. I take it to the field of aesthetic practice and say that art is not created or destroyed; it is only transformed. As an artist I don't consider myself a painter, a draftsman, or a sculptor, since I feel that reducing art to a single technique is entirely unjust. I believe that art goes beyond that, and that is why I consider myself a crafter of inquiry, experimentation, and exploration: every idea or concept that ends up as a concrete work of art requires specific techniques in which I must try to control the greatest number of variables possible.

My creative space is not just an atelier. When I am in my studio, I regard it as a laboratory more than an artist's workshop, and I think my body of work is closer to that of a scientist—although there are series in which the hand and the work occupy a greater amount of time.

I use a great diversity of organic and inorganic materials, such as human hair, fingernails, human blood, bird feathers, fish scales, butterfly wings, leaves from various trees (fig. 22.6), tortillas, eggshells, edible materials such as soup noodles, or used elements such as discarded plastic, leather soles of shoes, ceiling tiles from late nineteenth-century homes, sheets of rubber, old

Figure 22.6 Gabriel de la Mora (Mexican, b. 1968), *131*, 2016. 131 dry leaves on wood, 15 × 22.5 cm. Photo: Courtesy the artist and Proyectos Monclova

Figure 22.7 Gabriel de la Mora (Mexican, b. 1968), *3,757 I*, 2018. 3,757 human hairs (K.L.) on paper, 60 × 60 × 4 cm framed. Private collection. Photo: Courtesy the artist and Proyectos Monclova

aluminum printing plates, and laboratory microscope slides, or countless new (thus canceling the function for which they were created) materials that I gradually collect and classify. Things not being used for any series live in a storeroom as part of my archive.

In my series of drawings on paper with human hair (2004–ongoing, fig. 22.7), although the hair is organic matter, it lasts a very long time as the container of a person's energy. In the pieces with pigmented turkey feathers (fig. 22.8) and natural-colored feathers from various birds (fig. 22.9), I use acid-free materials, as suggested by conservators. To preserve the color, whether natural or artificial, I enclose them in museum glass, which protects the pieces from 99 percent of ultraviolet rays. If the works lose some color, they are still the same works, just aged over time, which I believe adds something special. The series made with eggshells, titled *CaCO3*, which I began in 2013 and continues to date, portrays my compulsion to reach degree zero in painting, which has led me to explore the medium itself outside of itself—that is,

the idea of painting without painting. The entire surface, prepared with the same care as a canvas that will slowly disappear as it is impregnated with oil paint, will be covered with tiny pieces of this material. The eggshells, previously selected and catalogued by color, are broken up, counted, and placed on the surface so that no empty space is left and, at all costs, they never overlap (fig. 22.10). Control during the process is absolute; I keep a record of the time it takes to cover the entire surface and also how many pieces fit on it. This information provides the title.

Before using any material, I conduct countless tests with advice from conservators, always keeping records and photographs of each exploratory process. All this information is generally requested by the more sophisticated collectors and by institutions or museums before acquiring any work in which the materials may entail some risk for conservation. I believe there are some series within my oeuvre in which the conservator is more like the figure of an alchemist, since they study the materials to be used and provide me with guidelines for the manipulation, work, conservation, and preservation of the elements, so they can be conserved as well as possible for the longest amount of time. What is important is not whether the piece loses commercial value or not, but rather how much it differs from its original state, with changes that differ from those that occur with the passing of time. I think it is important, and to a certain point a great responsibility, that artists receive advice on, or

Figure 22.8 Gabriel de la Mora (Mexican, b. 1968), detail of *1,156 VI*, 2019. Feathers and pigment on museum cardboard, 60 × 60 × 4 cm. Private collection. Photo: Guillame Ziccarelli, courtesy the artist and PERROTIN Galerie

Figure 22.9 Gabriel de la Mora (Mexican, b. 1968), detail of *8,100 I*, 2019. Guinea chicken feathers on museum cardboard, 75 × 75 × 4 cm. Private collection. Photo: Courtesy the artist and Proyectos Monclova

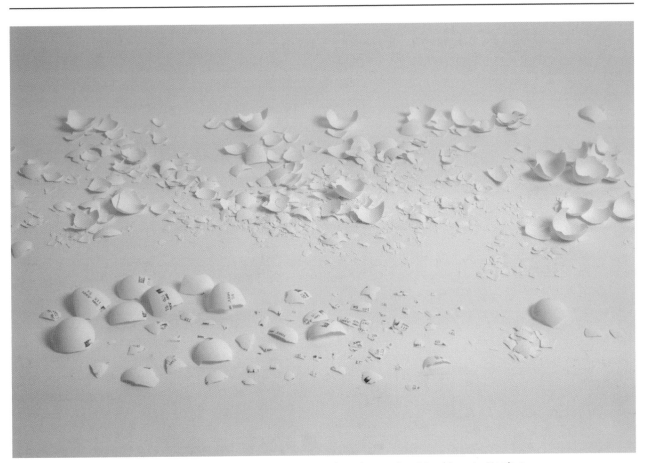

Figure 22.10 Eggshell pieces for potential use in the series *CaCO3*, 2013–ongoing. Photo: Courtesy the artist and Proyectos Monclova

22. Research as Creative Process

explore the nature of, the materials they use, as well as trying to utilize optimal methods and processes, and materials that can best extend the life of the pieces.

CONCLUSIONS

As a young, self-taught artist, I followed a path of experimentation in terms of materials, which led me to learn over the years the importance of the elements constituting each of my pieces. The most important lesson, in addition to an awareness of the material and its futile existence, was the ability I acquired to be always alert to the creation of the pieces, from their conception as an idea to their production, and to keep records of all my processes because, ultimately, it is the life history of each one of them.

Although art is always undergoing change, it is very important that the presence of conservators be a constant in the production of art, particularly in series that involve organic or biological materials. The artist must be always aware of the importance of the formation of his or her pieces, the quality of the materials, the level of risk entailed in the constituent elements, and, above all, the ultimate durability of almost all materials available for the practice of art. Nothing lasts forever, it's true, but the counsel of experts in matters of conservation can make the difference between an ephemeral piece and one that endures.

This responsibility must also be extended to everyone who works with or owns art, such as collectors and gallery owners, considering that museums, foundations, and centers for specialized studies have much greater expertise in this type of task than any other person involved in the art world. It is well known that some collectors who keep collections of clocks and even wines in the best conditions of humidity, temperature, and movement don't do the same with their works of art, which may be exposed to direct sunlight, or suffer from incorrect cleaning processes, or any number of risks. A person who acquires a work of art has the responsibility to conserve it in their collection in the best condition possible. The same is true for a gallery owner who handles and safeguards works of art for differing periods of time.

Art is not created or destroyed; it is only transformed.

All will ultimately disappear.

Mexico City, September 2019

BIBLIOGRAPHY

Kautz 2015
Kautz, Willy, ed. 2015. *Lo que no vemos, lo que nos mira*. Mexico City: Museo Amparo.

Murmelte Instrumente: The Body, Like a Hand to an Instrument

Kelly Kleinschrodt

This essay highlights the conceptual and material circumstances of Kelly Kleinschrodt's breastmilksoap *works (2013–14), which are part of the ongoing project* mother /cut, *focusing on feminine embodied experiences (creating, nurturing, consuming), attendant banal activities (pumping breast milk, sterilizing, preparing food), and the materials she uses to reflect these experiences. Glycerin, castor oil, honey, and breast milk are cast into soap bars and contrasted with "stable" materials such as acrylic. A series of anecdotes, or "movements," liken the repurposing of breast milk into another "useful" state to music making. As the* breastmilksoap *works are exhibited, circulated, and stored, each bar continues to slowly shift and absorb its changing contexts. Each is an object that encapsulates a performance and that also performs.*

◆　　◆　　◆

We make music which is not Music, poems that are not Poetry, paintings that are not Painting, but music that may fit poetry, poetry that may fit paintings, paintings that may fit . . . something, something which gives us the chance to enjoy a happy, non-specialized fantasy.

—*Festival of Misfits flyer, 1962*[1]

PRELUDE I: ELSEWHERE

Murmelte Instrumente is the title of a chapter within a larger ongoing project of mine: *mother /cut*. As a visual artist, mother, and arts educator, I find myself perpetually multitasking. I ask the same of my work.

My artistic practice is ultimately an experience and evocation of "moving between"—between bodies and objects, photography and sculpture, sculpture and performance, performance and video, video and photography. In *mother /cut*, this fluidity in approach seeps into the evolution of its central material: mother's milk. I began the project symbolically alluding to the elusive nature of this vital liquid, but then I began producing the material myself, and incorporated actual breast milk as an integral living material and sculptural cornerstone of *Murmelte Instrumente*.

Similar to the epigrammatic title of Marcel Duchamp's alter ego, Rrose Sélavy (pronouned *Eros, c'est la vie*), there are many transformations happening in *Murmelte Instrumente*. The German phrase translates to "muttering instruments." *Murmelte* is literally an "utterance" or "mutter," while

Mutter is the German cognate for "mother," and so we have *either* muttering instruments *or* *Mutter*ing instruments *and* mothering instruments. And, with my artworks toggling between multiple identities in this either/or/and paradigm (*either* photographs *or* sculptures *and* photo-sculptures), and with the referent toggling between "mutter" or *Mutter*, there is also momentary lapse. A reckoning with a lost moment of bodily exchange.

This text, too, is an evocation of moving between. The exchanges I describe herein—between bodies and objects—chart the shift in my practice toward music making, wherein materials are incited to *enact* a composition, to perform over time. This spurs a mode of artistic output reflective of the slipperiness of embodiment in life and art, the blurring and playful prodding of boundaries of artistic production / maternal production / music / consumption, wherein living matter occupies and inhabits space "like a hand to an instrument."[2]

PRELUDE II: ANOTHER ELSEWHERE

Ah, the joy of suckling! She lovingly watched the fishlike motions of the toothless mouth and she imagined that with her milk there flowed into her little son her deepest thoughts, ideals, and dreams.

—Milan Kundera, *Life Is Elsewhere, 1973*[3]

Outside the frame, my cousin, a nurse, pauses to pump milk before leaving for her shift. I am visiting her and happen to have my video camera. Natural light pours in from the window and her dark-green velvet couch miraculously registers as a black fabric studio backdrop.

In this moment, my work shifts from ambiguous depictions of the body (or of objects that look like bodies) toward an investigation of the ambiguity of the maternal body, wherein a breast can operate like a fallacious phallus and can perform with an outward fecundity by this *vacuumous* recipient, the breast pump. In the resulting video work, *sonata* (2010, fig. 23.1), the breast pump is an unapologetically transparent and melodious accompaniment to its instrumental soloist, the *body-of-mother*.[4]

FIRST MOVEMENT: DRIP

Shortly after I moved to Los Angeles in 2005, a confluence occurred in the form of a drip. Art historian Natilee Harren invited me to participate in an exhibition she was curating in response to George Brecht's event score *Drip Music (Drip*

Figure 23.1 Kelly Kleinschrodt (American, b. 1983), still from *sonata*, 2010. Mini-DV video, color, sound, 5:19 min. (looping). Photo: Courtesy the artist

Event) (1959–62). Harren's *Drip Event* of 2007 was a one-night happening at a small art space in LA, and it featured a community of artists asked to interpret Brecht's mimeographed text:

DRIP MUSIC (DRIP EVENT)

For single or multiple performance.

A source of dripping water and an empty vessel are arranged so that the water falls into the vessel.

Second version: Dripping.

G. Brecht

(1959–62)

I somewhat nervously accepted the provocation and platform. It was my first performance before a live audience, and so, naturally, I chose a gesture that would hide my face. For *pillow / breath*, I breathed face-down into a pillow until my saliva wet the outer contours of my face (fig. 23.2).[5]

The proposition to perform a rendition of Brecht's score had me post-posthumously erecting a performance from a work previously considered "done." From this event, iterations and multiples expanded outward, from resolved works into a state of always-in-process. My subsequent absorption of Fluxus ideology vis-à-vis Harren has had me experimenting with an "allographic . . . model of iterative production," in which an artistic gesture is never fully done being realized.[6] And another focus has emerged—toward *feminine* embodied experiences such as nurturing, creating, sterilizing, preparing food, and consuming while listening (aka "multitasking"). Banal activities like pumping breast milk, washing hands, preparing food, and listening

Figure 23.2 Kelly Kleinschrodt (American, b. 1983), *pillow / breath*, 2007. Chromogenic print, 27.9 × 35.6 cm. Photo: Courtesy the artist

Figure 23.3 Kelly Kleinschrodt (American, b. 1983), *soymilkstyrofoam*, 2007. Chromogenic print, 27.9 × 35.6 cm. Photo: Courtesy the artist

are now centrally studied and elongated gestures in my practice. And, like Brecht's score, my practice has evolved into a site in itself, a vessel perpetually *in medias drip*.

SECOND MOVEMENT: PROXY

Several years before I had my daughter and began to work with the material of my own body's milk, I came across Wolfgang Laib's *Milk Stone* (1978), an imperceptible collapsing of two iconic natural materials: marble and milk. I was completely enamored. Laib had delicately sanded a depression into the face of a thin, rectangular slab of Carrara marble, and then ritualistically poured milk in to fill the absence; at the surface level, the boundary between the reflective liquid and the opaque marble appears virtually seamless.[7]

I began making miniature variations of Laib's *Milk Stone*, meddling nonchalantly with milk and, instead of hard marble, soap. I watched again and again as the lip I carved into soap bars dissolved upon contact with the milk, never to retain the illusion of synthesis. My efforts resulted in milk-soap puddles, which I documented in photographs made with a four-by-five camera. I then found modern substitutes for marble and milk, and made *soymilkstyrofoam* (2007, fig. 23.3). The soy milk was creamy in color and looked nothing like the stark-white Styrofoam base into which I poured it. I found these material and color differences amusing and visually appealing. It felt sentient, forthright, and somehow more alive.

Later, during my graduate studies at UCLA between 2009 and 2011, this tension between liquid and solid materials

extended to the frame of the image. At this time, coinciding with the development of *sonata*, I began to make photographs of breast milk dripping down silky pink fabric.[8] I decided to design and fabricate peculiar ivory-colored acrylic frames that would allude to colostrum, the rich breast milk produced in the days immediately after a baby's birth (fig. 23.4). The frames were at once rigid and full of glossy depth, like a liquid surface. I also wanted a striking contrast between the surface of the frame and the surface of the print, so I decided not to glaze or protect the surfaces of the photographs. I would allow the naked final print to function as a skin, subject to time, UV light, dust, fingerprints. Just allowing. Each work would have a life span, slowly shifting over time—a proxy for the bodies I record with my camera.

In 2011, for my solo show *distant already* at Carter & Citizen in Los Angeles, I used the gallery space as an incubator for a thirty-day live performance, *theme and variations (for solo violinist and breast pump)*, developed in collaboration with violinist Morgan Paros.[9] During the run of the exhibition, Paros played daily at lunchtime to the amplified sounds of a breast pump that I had prerecorded (fig. 23.5). One important aspect of the work is that the written score provided to the violinist is suggestive, and so she becomes a coauthor/co-creator when playing the work. The violinist uses the theme melody as a foundation, but improvises variations in response to the breast pump's distinctly changing rhythms. This collapse of artistic production—via surrogate author (the violinist) of maternal production (the artist's) whetted via surrogate recipient (breast pump in place of infant)—had me wanting to push the idea of embodiment via proxy still further.

and framework of the *muttermilch* hors d'oeuvres, while Marchand brought an extensive knowledge of cheese making and Beadle concocted conceptual plant and pollen elements for the garnishes (fig. 23.6). The scanned receipts for the purchased ingredients that we combined with the breast milk to make the hors d'oeuvres remain as our pseudo-scores/recipes for future iterations.[10] The hors d'oeuvres were casually passed and consumed adjacent to the video projection of an incessantly pumping breast.

Producer of milk.

Producer of meaning.

Producer of sound.

Producer of space.

Figure 23.4 Kelly Kleinschrodt (American, b. 1983), *falling (for Jim)*, 2010. Chromogenic print in artist's acrylic frame, 104.1 × 85.1 × 2.5 cm. The Deighton Collection. Photo: Courtesy the artist

Figure 23.6 *muttermilch* hors d'oeuvres in artist's kitchen, 2011. Photo: Courtesy the artist

THIRD MOVEMENT: MUTTER

Two years after, in 2013, I became a pumping mother myself, with an ever-present, hissing metabolic metronome. The breast pump, which had formerly appeared in my artworks as an instrument for "music making," became an intensely familiar companion—an instrument laden with associations of self-preservation and obsessive sterilization, a reflection and measure of my own performance as a mother. Luckily for myself and my infant, I was overperforming, and much milk was accumulating in my freezer.[11] As some was set to expire, or was already too iffy to feed to my baby, I decided to repurpose my breast milk into soap sculptures.

I purchased a basic oval soap mold as well as an organic glycerin soap base and began making bars of *breastmilksoap*. The ingredients were minimal and motivated by personal associations: a clear glycerin soap

Figure 23.5 Installation view, *Kelly Kleinschrodt: distant already*, Carter & Citizen, Los Angeles, 2011. Left: *sonata (for breast pump) variation II*, 2011; right: *theme and variations (for solo violinist and breast pump)*, 2011. Photo: Courtesy the artist and Carter & Citizen, Los Angeles

For the closing of *distant already*, I decided to serve breast milk hors d'oeuvres from a close friend's pumped and pasteurized breast milk, and I recruited artists Sarah Beadle and Emily Marchand to collaborate on the performance with me. Both women have an established practice of incorporating thematics of service, care, and embodiment into edible artworks. I provided the concept

Figure 23.7 *breastmilksoap* works in artist's home, 2013. Photo: Courtesy the artist

base (which, having endured a terrible post-Cesarean infection, I associated with sterilization); frozen, then pasteurized breast milk (some of which was actually the first milk I produced at the hospital); castor oil (I self-induced using it); and honey (my only caloric intake during labor). One morning I sat at the kitchen table and held my young infant while my assistant, Taryn Haydostian, became an extension of my hands. We kept loose notes and labeled each bar numerically. We stirred the pot of ingredients at low heat, increasing the complexity of the base. The proportions of the ingredients in each bar of breast-milk soap were improvised. They involved an impressive variety of surfaces and textures (fig. 23.7). My kitchen thermometer happened to be broken. We were eyeballing, and there is no way to exactly replicate what happened that day. We got incredibly lucky.

My gallerist, Whitney Carter, caught wind of these works and provided a platform for them in a group show of small sculptures, titled *heroes*, at Carter & Citizen in 2013. It was during this exhibition that I realized the complexity of caring for these objects. The bars of soap with honey and castor oil were slightly sticky and attracted dust. In warm conditions, beads of sweat might form on their surfaces, uniformly distributed; if a sweating bar was handled, a fingerprint might later appear once the air temperature cooled. Several bars without honey and castor oil, made only of breast milk and glycerin, developed a delicate white crust and did not mark as noticeably. I would regularly stop by the gallery to attend to the soap works with canned air or a dry fingertip. But attending to them daily was not always feasible, and so Whitney became their surrogate caretaker. And so began the inevitable relinquishment of control.

With more exhibitions on the horizon, I started to incorporate the bars of *breastmilksoap* as components of, or companions for, other works. One such sculpture, *mothersink* (2014, fig. 23.8), features a satirical merging of a surgeon's scrub sink and a domestic sink; on an acrylic

Figure 23.8 Kelly Kleinschrodt (American, b. 1983), *mothersink*, 2014. Acrylic, glycerin, and breast milk, 88.9 × 58.4 × 40.6 cm. Galia's Collection, Belgium. Photo: Courtesy the artist

Figure 23.9a

Figure 23.9b

Kelly Kleinschrodt (American, b. 1983), *bodyofmother / breastmilksoap (for E.)* and detail, 2014. Inkjet print, acrylic, glycerin, breast milk, castor oil, and honey, 52.1 × 41.9 × 2.5 cm (print); 5.1 × 14 × 10.2 cm (soap and stand). Collection of the artist. Photos: Courtesy the artist

soap dish platform that extends from the sink's backsplash rests a *breastmilksoap* bar. In another work, the diptych *bodyofmother / breastmilksoap (for E.)* (2014, fig. 23.9a, fig. 23.9b), the soap is juxtaposed with a photo-sculpture; it sits on an independent platform directly screwed into the drywall, just below and to the right of the framed photograph, which pictures a body of water tinted to resemble a body of milk. This is an imagined view for my daughter, a view from the *body of mother*—contained, but separate.

POSTLUDE I: ELSEWHERE (CONTROL LAPSE)

Murmelte Instrumente started traveling. The *breastmilksoap* works were included in exhibitions and art fairs in the United States and abroad. To an exhibition in Chicago in 2014, I was able to hand carry the soap works, wrapping

the bars in glassine before placing them in individual plastic soap containers (purchased from the Dollar Tree). Soon after, Josh Lilley gallery in London requested a selection of *breastmilksoap* for the group show *Control Lapse* (2014). Lilley also hand carried the bars in makeshift packaging, and they miraculously arrived unscathed. But, interestingly, in the exhibition documentation I noticed that *breastmilksoap (variation V)* (2013, fig. 23.10) had acquired visible fingerprints from being handled. The marks (most likely my own, but quite plausibly from airport security or someone at the gallery) had become acutely visible because of temperature and humidity. At first I was uncomfortable with the sharpness of the surface marks, which rupture the pristine, gemlike quality of the semitranslucent objects. But these marks provided an alternate latency, one that worked within me, and circled me back toward the philosophical origins of my work as a photographer. It became somehow necessary that I embrace the fingerprints as *punctum*—as poignant but unintended occurrences within the works, "a kind of subtle *beyond*..."[12] And although the soap works were not photographs, I came to understand them as encapsulations of moments, and the fingerprints as indexical evocations of *being held*.

Figure 23.10 Kelly Kleinschrodt (American, b. 1983), *breastmilksoap (variation V)*, 2013. Glycerin, breast milk, castor oil, acrylic, 5.1 × 14 × 10.2 cm. Private collection, New York. Photo: Courtesy the artist and Josh Lilley, London

When Lilley sold three bars of soap to a New York–based collector, I was asked by the gallery to provide conservation advice. I had not yet researched what "best practices" would mean for such delicate objects. I reached out to the Getty Research Institute (GRI) and Getty Conservation Institute (GCI) for a consultation, having heard of Fluxus works containing canned biological matter in the GRI Special Collections.[13] Conservators Mary Sackett and Rachel Rivenc graciously provided conservation recommendations as best they could without having seen

the physical objects. I passed this information on to the gallery in a highly detailed document meant for both the gallery and the collector regarding long-term storage measures and guidelines for interacting with the objects. This document not only covers best conservation practices, but also includes my own guidelines for permissible handling of the works: "latex gloves or simply clean, dry hands." I further indicate that if the soap collects dust to an "unsavory and distracting" extent, its surface can then be "re-smoothed and dusted with a wet finger." This advice is, of course, in keeping with my conclusion that the handling of the work and any resulting marks are a conceptual component of the work; once relinquished by me, the soap bar is to be handled at the discretion of the caretaker.

I often wonder what happens on the receiving end of my objects. For *breastmilksoap*, how have they held up in the colder climates of London, New York, and Brussels? What was each collector's compulsion to own a sculpture with an uncertain expiration date or life span? What has been the recent history of the objects—how have they been displayed or stored?

I recently attempted to contact the various collectors of *breastmilksoap*. To date, I have received one ebullient but brief response from the collector of *mothersink* (2014): "The work is in storage but that is only a physical aspect. It is in my heart and mind. Therefore close to me." Although this response is short, and reveals that the stored work's precise condition may be unknown to the collector, it is the memory of the initial encounter—or, rather, the re-remembering of the initial encounter—that appears to be the most revered "site" of the work. So perhaps for this collector, the work has less to do with the object's state in this particular moment, and more with how it occupies and transgresses time.

I relinquished the soap works in January 2014, only a few months after they were made. Having released them to circulate in contexts beyond my control, I find myself embracing this uncertainty as a central quality of the work. It tempers and healthfully reframes my own attachment to these highly charged objects, made during an incredibly personal and vulnerable moment. In making these works, in choosing studio time over time spent with my child, I had to pump milk. Most of the milk went to my child, but the remaining ounces went *elsewhere*.

The markings on the surfaces of *breastmilksoap* are literally indexical of exchanges, and specifically of being held. Implicitly, each mark is an index of a lost moment of bodily exchange—between mother and child, mother and breast pump, hand and soap, artist and preparator, artist and

collector. I find that it is precisely this condition of "moving between" that makes works with biological matter conceptually rigorous, and utterly human. Each bar of soap will ever so slowly shift, absorb, acclimate, and inhabit space. This is an object that encapsulates a performance and can also perform. It is neither a thing nor a body; it's *like a hand to an instrument*.

NOTES

1. From a flyer for the Festival of Misfits, Gallery One and ICA, London (1962). Natilee Harren writes: "In this statement we see, crucially, that within Fluxus intermedia the language of individual mediums was roundly disrupted but not abandoned. Rather, new practices are seen to emerge from artists' engagement with multiple mediums at once, mediums set into new relations with one another or that are coarticulated while remaining individually legible" (Harren 2015).

2. "Our body is not in space like things; it inhabits or haunts space. It applies itself to space like a hand to an instrument, and this is why, when we want to move about, we do not move the body as we move an object. We transport it without instruments as if by a kind of magic, since it is ours and because through it we have access directly to space. For us the body is much more than an instrument or a means; it is our expression in the world, the visible form of our intentions" (Merleau-Ponty 2007).

3. Kundera 1974, 9. Before this Kundera quotation was co-opted here, it was a viral Instagram post by Alyssa Milano after ten ounces of her breast milk were confiscated at Heathrow Airport in 2014. Coincidentally, *Ignorance* (2002), a novel by Milan Kundera, is currently on my bedside table. Michi Jigarjian and Qiana Mestrich, *How We Do Both: Art and Motherhood* (New York: Secretary Press, 2015), is also currently on my bedside table.

4. *Body-of-mother* is a term I use in my work to refer to the poetic terrain of the mother's body. It is a horizonless gulf, an endless supply of _____, the ultimate site of projection. *sonata* has primarily been exhibited as a video installation. *sonata (for breast pump), variation I* (2011) has an audio component; *sonata (for breast pump), variation II* (2011) does not.

5. I still have this pillowcase and pillow. The pillowcase has been washed between iterations; the pillow has not.

6. "Fluxus developed an allographic as opposed to autographic model of iterative production, in which artworks—both performances and objects—were created or realized over and over again to differing results. In Fluxus performance practice, works such as Brecht's *Drip Music (Drip Event)* (1959–62) gradually morphed in appearance from concert to concert, producing also sculptural versions; and by design, Fluxus's editioned multiples, whose production was overseen by [George] Maciunas, never promised to contain the same items from one 'copy' to the next. In work after Fluxus work, we see the marriage of a general set of processes or qualities materialize in unique, specific situations. Furthermore, the manifold outcomes of an individual Fluxus score, instruction, diagram, or idea would be seen as inherently relatable to one another" (Harren 2015).

7. For a re-creation of the work see https://vimeo.com/68268886.

8. The images of this series, *falling* (2011), were made in response to an anecdote my cousin shared as she was pumping milk while I shot video for *sonata*. She recounted her first day back at work, as a nurse, after maternity leave. To her dismay, an attending physician pulled her aside to let her know that breast milk was leaking through her scrubs. The images of *falling* are also direct quotations of James Welling's *Drapes* (1981), photographs of phyllo dough flakes falling down luscious folds of fabric. Welling was my graduate school mentor at UCLA, and his conceptual abstractions have provided a foil for my theatrics of maternity.

9. Morgan Paros was one of three violinists who answered my Craigslist ad looking for a violinist. She is currently my child's legal guardian (my posthumous proxy).

10. We developed three hors d'oeuvres, each with a human and animal milk base (as human milk isn't fatty enough to make cheese). One paired, for example, fennel pollen with poached pear and breast-milk chèvre. The hors d'oeuvres were passed around by artist Tiffany Smith, who reported that 85 percent of attendees sampled them.

11. As of September 2019, I still have an entire drawer of frozen breast milk from 2013–14.

12. "The *punctum*, then, is a kind of subtle *beyond . . .*" (Barthes 1981, 59). Barthes's philosophical approach reads images by articulating the *punctum* as the small, often overlooked "detail" within the photograph that ultimately has "a power of expansion" (45). Importantly: "Nothing surprising then, if sometimes, despite its clarity, the *punctum* should be revealed only after the fact, when the photograph is no longer in front of me and I think back on it" (53).

13. For example, Harren has mentioned Piero Manzoni's *Artist's Shit* (1961), an edition of canned excrement. Harren and I have also discussed Benjamin Patterson's *Hooked* (1980), a tackle box with a plethora of rotting matter—most odiferously, a disintegrating can of sardines in tomato sauce. See Harren's contribution to this volume.

BIBLIOGRAPHY

Barthes 1981
Barthes, Roland. 1981. *Camera Lucida*. Translated by Richard Howard. New York: Hill and Wang.

Harren 2015
Harren, Natilee. 2015. "The Crux of Fluxus: Intermedia, Rearguard." Walker Art Center, http://walkerart.org/collections/publications/art-expanded/crux-of-fluxus.

Kundera 1974
Kundera, Milan. 1974. *Life Is Elsewhere*. Translated by Peter Kussi. New York: Alfred A. Knopf.

Merleau-Ponty 2007
Merleau-Ponty, Maurice. 2007. "An Unpublished Text by Maurice Merleau-Ponty: A Prospectus of His Work," translated by Arleen B. Dalery. In *The Merleau-Ponty Reader*, edited by Ted Toadvine and Leonard Lawler, 285. Evanston, IL: Northwestern University Press.

Dissolving Matter: Notes on *Símbolo descarnado*

Darío Meléndez

This paper addresses the origins, process, and potential cultural resonances of the installation Símbolo descarnado *(2013), presented at ATEA, Mexico City, in 2013, which invoked the earthly presences of the eagle and the serpent, symbols on the Mexican flag, using organic matter that was undergoing decomposition. In this approach to the image as a Warburgian force field, the work proposes viewing the material and symbolic decomposition of Mexico's foundational legend as rendering it a formless territory whose detritus appears to whisper that another nation is possible.*

◆　　◆　　◆

Thus formless *is not only an adjective having a given meaning, but a term that serves to bring things down in the world, generally requiring that each thing have its form. What it designates has no rights in any sense and gets itself squashed everywhere, like a spider or an earthworm. In fact, for academic men to be happy, the universe would have to take shape. All of philosophy has no other goal: it is a matter of giving a frock coat to what is, a mathematical frock coat. On the other hand, affirming that the universe resembles nothing and is only formless amounts to saying that the universe is something like a spider or spit.*

—*Georges Bataille,* The Sacred Conspiracy, *1936*

Why am I interested in working with organic matter? Not intending to provide a definitive answer, I could point out that my initial training as a traditional painter in the studio of artist Luis Nishizawa awoke in me a taste for process and for the emanative nature of materials undergoing transformation, which soon led me to become disenchanted with the fixed image that takes shape within a pictorial object. Even in those days, I had an irrepressible impulse for the uncertain and the vague, for all those intermediate phases in the construction of a painting in which the image would appear to be forming and/or disappearing. Drawings superimposed, glazes that melt the underlying layers, and varnish drippings were some of the visual experiences that led me to fall in love with unstable materials. What was behind that impulse? I could start by saying that maybe those evolving materials reverberate with what I am seeing, experiencing, and breathing in Mexico, and in Mexico City in particular. The stench of death is nothing more than the scent of change.

THE WORK

Símbolo descarnado was a collective installation exhibited from February 9 to 24, 2013, at ATEA in Mexico City (fig. 24.1).[1] It consisted of an ephemeral mural of the national coat of arms, drawn with cochineal by Omar Soto; a sound spatialization by Diana Bravo based on amplified noises made by larvae; and the rotting carcasses of an eagle and a serpent inside a glass case, created by me, Darío Meléndez. The main intent was to present, in the white cube, the atmosphere of deterioration in which my country is submerged and to question the viewer through an experience of formlessness in contrast to the asepsis of the site. The strategy for delivering criticism of the eroding structure and validity of the Mexican state—symbolized by the eagle and serpent on the nation's coat of arms—was to utilize the aesthetic, performative, and sonic possibilities of material and symbolic corruption through different approaches.

In Soto's ephemeral work, the corruption consisted of those attending the opening using their hands to erase (redraw?) a mural based on a nineteenth-century lithograph of Mexico's national coat of arms (fig. 24.2, fig. 24.3, fig. 24.4). In this way, the death of the state, present in its own foundational image, was deformed by the viewers themselves. In addition, because the mural had been made with cochineal, a reddish organic colorant with a heavy historical weight, the hands that blurred the image came away stained, evoking a criminal complicity. Instead of existing only as an intellectual dialogue with the viewer,

this drawing sought to involve the bodies of the attending public. Having a collective participate in this piece demonstrated that the ideals of our nation were devoured when they took the form of institutions and political figures.

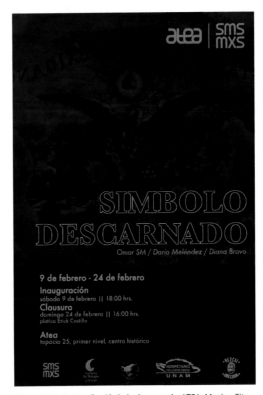

Figure 24.1 Poster for *Símbolo descarnado*, ATEA, Mexico City, 2013.

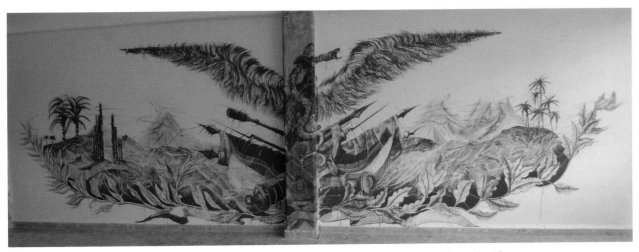

Figure 24.2 Omar Soto (Mexican, b. 1984), *Símbolo descarnado*, 2013. Cochineal on wall, 300 × 1100 cm. Photo: Pablo Martínez Zárate

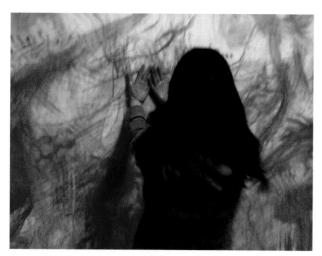

Figure 24.3 Gallery visitor manipulating Soto's *Símbolo descarnado*. Photo: Pablo Martínez Zárate

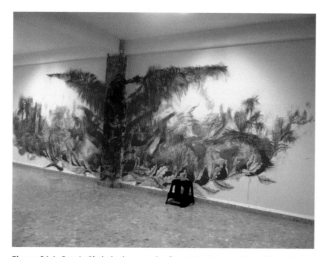

Figure 24.4 Soto's *Símbolo descarnado* after visitor interventions. Photo: Pablo Martínez Zárate

Bravo's sound spatialization consisted of an audio system that amplified the tiny sounds of insect larvae devouring rotting meat. Despite the morbid concept, the sound, instead of being terrifying, was almost a white noise, somewhat aquatic, evoking oceanic movement. Bravo revealed death as a subtle process of disappearance, disassociated from the horrible, abject images provided by our daily imaginary. Also, the sound was not continuous, but would gradually crescendo, filling the space little by little. Initially almost imperceptible, the insects' hushed chewing would rise in volume to become the opaque roar of the night sea of which we are perhaps a part.

This treatment of sound, unnoticeable at first, took me back to a literary reference from the early years of my education: the poem "A Carcass" by Charles Baudelaire:

My love, do you recall the object which we saw,
That fair, sweet, summer morn!
At a turn in the path a foul carcass
On a gravel strewn bed,

The blowflies were buzzing round that putrid belly,
From which came forth black battalions
Of maggots, which oozed out like a heavy liquid
All along those living tatters.

And this world gave forth singular music,
Like running water or the wind,
Or the grain that winnowers with a rhythmic motion
Shake in their winnowing baskets.[2]

As can be seen in the foregoing sonorous lines, the resonances between readings, media, and authors seem to address the reappearance of the forms of ancient art in times subsequent to those described by Aby Warburg (Warburg 2005, 20). I would like to point out that in this case it is not so much the reappearance of the form itself; that is, it is not a simple replica, but more like making the energy emerge from the present. Thus the importance of the act, of the presence of the matter itself in its contingency.

The last part of the installation was a partially sealed glass case containing the carcasses of an eagle and a serpent in suspension, like a monstrous apparition (fig. 24.5, fig. 24.6, fig. 24.7, fig. 24.8, fig. 24.9). Both were rotting, and they were clearly alluding to the nation's coat of arms. As in the other cases, corruption of the symbol was the essential agent of the piece, but in this case the deterioration was real. In counterpoint to the idea of representation in the recording and amplification of the sound of the larvae in Bravo's contribution, and in the participatory drawing and erasing of Soto's mural, this part included the presence of the actual symbol in and of itself deteriorating. This situation gave the installation greater corporeality—and another unforeseen factor that enriched the initial idea, namely the smell of death. Thus, the intention of evoking the atmosphere of corruption of the site from which the piece was submitted, Mexico City, appeared to be complete.

In the words of the art critic Sandra Sánchez, what the piece reveals to us is that there can be life even in the midst of destruction (Sánchez 2013). In the aquatic sounds and the red stains throbbing on the wall, in the fly larvae, and in the beetles issuing from the carcasses, we find the prelude to a new beginning. Decomposition is merely a journey toward another place. From this angle, the whole could be read as a rite of farewell, a return to the earth

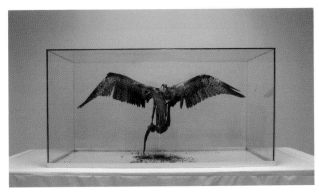

Figure 24.5 Darío Meléndez (Mexican, b. 1985), *Símbolo descarnado*, 2013. Decomposing organic matter behind tempered glass, 80 × 155 × 50 cm. Photo: Daya Navarrete

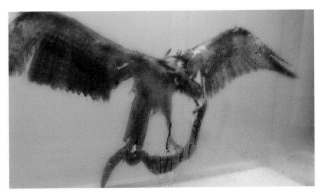

Figure 24.6 Detail showing moisture on glass. Photo: Daya Navarrete

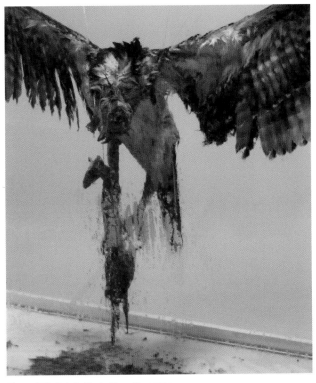

Figure 24.7 Detail. Photo: Daya Navarrete

Figure 24.8 Detail showing detritus. Photo: Daya Navarrete

Figure 24.9 Detail showing larvae. Photo: Daya Navarrete

24. Notes on *Símbolo descarnado*

with a view toward transformation, or an elevation of the spirit (of the ideal in this case).

The latter idea, which speaks of a connection between decomposition and the spiritual world, has already been addressed by the twentieth-century alchemist Fulcanelli when he mentions the works of José Mateo Orfila and Marie-Guillaume-Alphonse Devergie, nineteenth-century French physicians who conducted experiments on the slow, gradual decomposition of human cadavers:

> The odor gradually diminishes, eventually reaching a stage where all the soft parts scattered on the ground are nothing but a blackish, muddy debris, with a somewhat aromatic smell. As for the change from stench to scent, one must observe its striking similarity with what Old Masters said about the Great Work of Physics, two of them in particular, Morienus and Ramon Llull, who state that the foul smell [odor teter] of the dark decay is followed by the sweetest scent, because it is the scent of life itself and heat [quia et vitae proprius est et caloris]. (Fulcanelli 1974, 11)

FINAL NOTES

First, I believe that although the emotive, formal, and acoustic presence of the installation was powerful, it was circumscribed within the innocuous circle of emerging contemporary art. Originally presented at ATEA, a space that is part gallery, part workshop, and part cultural company, the work was contained, not only in terms of its visibility, but also in terms of its capacity to influence our daily imaginary. This last thought is due to the political implications of the work. If the piece were really to be ferocious, it should have been shown in a public space, without the aid of the sanctifier (here I am referring to the sacred in its most domesticated sense) of the white cube. Leaving the piece with no other defense than its own corporeality and seeing how it would be exploited, erased, or ignored in real life is the most desirable treatment for this type of proposal. Truly caustic criticism is done in the open air.

In addition, the presence of the decayed matter, even placed in this sociopolitical expression, implores us as well, as bodies undergoing decay. On viewing its slow, fascinating fall, we seem to return to a sense of mortality and fragility, as in the words of Radiohead's song "Fake Plastic Trees": "But gravity always wins."[3]

NOTES

1. Arte Taller Estudio Arquitectura (ATEA, or Art Architecture Study Workshop) is a cultural center founded in 2010 devoted to promoting dialogue between different disciplines. This building, located on Calle Topacio, Mexico City, holds the multidisciplinary collective Somosmexas, founded in 2006 and consisting of ten young artists. These artists promote art exhibitions, workshops, and projects with institutions both on site and externally. They also link art to the surrounding context: the heart of the La Merced neighborhood (Valdivia 2017).

2. Baudelaire 2005, 163–65.

3. Radiohead, "Fake Plastic Trees," from the 1995 album *The Bends*. Watch the video on YouTube: https://youtu.be/n5h0qHwNrHk.

BIBLIOGRAPHY

Baudelaire 2005
Baudelaire, Charles. 2005. *Las flores del mal*. Madrid: Cátedra.

Fulcanelli 1974
Fulcanelli. 1974. *El misterio de las catedrales*. Buenos Aires: Editorial rotativa.

Sánchez 2013
Sánchez, Sandra. 2013. "La historia no existe (cuatro artistas bordeando los hechos)." GASTV, n.d., https://gastv.mx/la-historia-no-existe/.

Valdivia 2017
Valdivia, Mónica. 2017. "ATEA: Renovación cultural en la Merced." *NEXOS*, April 10, 2017, https://cultura.nexos.com.mx/?p=12524.

Warburg 2005
Warburg, Aby. 2005. *El renacimiento del paganismo: Aportaciones a la historia cultural del Renacimiento europeo*. Madrid: Alianza.

Bibliography

Adams and Gruen 2014
Adams, Carol J., and Lori Gruen, eds. 2014. *Ecofeminism: Feminist Intersections with Other Animals and the Earth*. New York: Bloomsbury.

Al-Doory and Domson 1984
Al-Doory, Y., and J. F. Domson. 1984. *Mould Allergy*. Philadelphia: Ed. Lea & Febiger.

Álvarez 2017
Álvarez, Raúl (Rulfo), ed. 2017. *48 Premio Montevideo de Artes Visuales 2017*. Montevideo: Centro de Exposiciones SUBTE, Intendencia de Montevideo.

Angelova et al. 2017
Angelova, Lora V., Bronwyn Ormsby, Joyce H. Townsend, and Richard Wolbers. 2017. *Gels in the Conservation of Art*. London: Archetype.

Ankersmit et al. 2011
Ankersmit, Bart, Agnes W. Brokerhof, Tatja Scholte, Simone Vermaat, and Gaby Wijers. 2011. "Installation Art Subjected to Risk Assessment: Jeffrey Shaw's Revolution as Case Study." In *Inside Installations: Theory and Practice in the Care of Complex Artworks*, edited by Tatja Scholte and Glenn Wharton, 91–101. Amsterdam: Amsterdam University Press.

Appelbaum 2007
Appelbaum, Barbara. 2007. *Conservation Treatment Methodology*. Oxford: Butterworth-Heinemann.

Bader 2017
Bader, Eva. 2017. "Die 'Barraque D'Dull Odde' 1961–67 von Joseph Beuys. Dokumentation, Oberflächenreinigung und Sicherung einer ortsspezifischen Installation im Vorfeld der Sanierung des Kaiser Wilhelm Museums in Krefeld." *ZKK Zeitschrift für Kunsttechnologie und Konservierung* 31 (2): 203–24.

Barker and Bracker 2005
Barker, Rachel, and Alison Bracker. 2005. "Beuys Is Dead: Long Live Beuys! Characterising Volition, Longevity, and Decision-Making in the Work of Joseph Beuys." *Tate Papers*, no. 4 (Autumn): https://www.tate.org.uk/research/publications/tate-papers/04/beuys-is-dead-long-live-beuys-characterising-volition-longevity-and-decision-making-in-the-work-of-joseph-beuys.

Barthes 1981
Barthes, Roland. 1981. *Camera Lucida*. Translated by Richard Howard. New York: Hill and Wang.

Baudelaire 2005
Baudelaire, Charles. 2005. *Las flores del mal*. Madrid: Cátedra.

Beccaria 2002
Beccaria, Marcella, ed. 2002. *Bruna Esposito*. Milan: Charta.

Beekens and Learner 2014
Beekens, Lydia, and Tom Learner, eds. 2014. *Conserving Outdoor Painted Sculpture*. Los Angeles: Getty Conservation Institute.

Benjamin [1935] 2006
Benjamin, Walter. (1935) 2006. *Das Kunstwerk im Zeitalter seiner technischen Reproduzierbarkeit = The Work of Art in the Age of Mechanical Reproduction*. Frankfurt am Main: Suhrkamp.

Bennett 2010
Bennett, Jane. 2010. *Vibrant Matter*. Durham, NC: Duke University Press.

Berlinghof 2014
Berlinghof, Harald. 2014. "BLOCK BEUYS Erinnerungen von Günter Schott 1969 bis 2010 Restaurator am Hessischen Landesmuseum Darmstad." Interview by Inge Lorenz, Jan Peter Thorbecke, and Klaus-D. Pohl. Darmstadt, Germany: Hessisches Landesmuseum Darmstadt.

Bertalanffy 1949
Bertalanffy, Ludwig von. 1949. *Das biologische Weltbild. Band 1. Die Stellung des Lebens in Natur und Wissenschaft*. Bern, Switzerland: Francke. English version published as *Problems of Life: An Evaluation of Modern Biological Thought*. New York: John Wiley & Sons, 1952.

Blanchaert 2014
Blanchaert, Katrien. 2014. "Joseph Beuys – *Wirtschaftswerte* (1980)." In *Kunst in Europa na '68 = Art in Europe after '68 Ghent / 21st June–31st August 1980*, edited by S.M.A.K., 177–94. Ghent: S.M.A.K.

Botfeldt, Gelting, and Hovmand 2009
Botfeldt, K. B., U. Gelting, and I. Hovmand. 2009. "Conservation and Restoration Methods Used for Waterlogged Archaeological Leather: A Retrospective." In *Proceedings of the 10th ICOM Group on Wet Organic Archaeological Materials Conference, Amsterdam, 2007*, edited by K. Strætkvern and D. J. Huisman, 707–21. Amsterdam: Rijksdienst voor Archeologie, Cultuurlandschap en Monumenten.

Bouchard 2010
Bouchard, Gianna. 2010. "ORLAN Anatomized." In *ORLAN: A Hybrid Body of Artworks*, edited by Simon Donger, Simon Shepard, and ORLAN, 62–72. London and New York: Routledge.

Bowley 2020
Bowley, Graham. 2020. "It's a Banana. It's Art. And Now It's the Guggenheim's Problem." *New York Times*, September 18, 2020, https://www.nytimes.com/2020/09/18/arts/design/banana-art-guggenheim.html.

Brenner 2014
Brenner, Erich. 2014. "Human Body Preservation: Old and New Techniques." *Journal of Anatomy* 224 (3): 316–44. https://dx.doi.org/10.1111%2Fjoa.12160.

Burnham 1968
Burnham, Jack. 1968. *Beyond Modern Sculpture: The Effects of Science and Technology on the Sculpture of This Century*. New York: George Braziller.

Buskirk 2003
Buskirk, Martha. 2003. *The Contingent Object of Contemporary Art*. Cambridge, MA: MIT Press.

Butler 1872
Butler, Samuel. 1872. *Erewhon: or, Over the Range*. London: Trübner and Ballentyne.

Cameron et al. 1988
Cameron, Eric, Claude Gosselin, Rick Rhodes, and Ritsaert ten Cate. 1988. *Noel Harding*. Toronto: Art Gallery of Ontario.

Canosa and Norrehed 2019
Canosa, Elyse, and Sara Norrehed. 2019. *Strategies for Pollutant Monitoring in Museum Environments*. Visby, Sweden: Swedish National Heritage Board. https://www.diva-portal.org/smash/get/diva2:1324224/FULLTEXT01.pdf.

Cardullo 2005
Cardullo, Bert. 2005. *What Is Dramaturgy?* New York: Peter Lang.

Catts and Zurr 2002
Catts, Oron, and Ionat Zurr. 2002. "Growing Semi-Living Sculptures: The Tissue Culture & Art Project." *Leonardo* 35 (4): 365–70. http://www.tca.uwa.edu.au/atGlance/pubMainFrames.html.

Catts and Zurr 2003
Catts, Oron, and Ionat Zurr. 2003. "Are the Semi-Living Semi-Good or Semi-Evil?" *technoetic arts—an international journal of speculative research*, no. 1, 1–12. http://www.tca.uwa.edu.au/atGlance/pubMainFrames.html.

Catts and Zurr 2006
Catts, Oron, and Ionat Zurr. 2006. "The Tissue Culture and Art Project: The Semi-Living as Agents of Irony." In *Performance and Technology: Practices of Virtual Embodiment and Interactivity*, edited by S. Broadhurst and J. Machon, 153–68. London: Palgrave Macmillan.

Chávez 2018
Chávez, Jorge Villacorta. 2018. "A Presentation." In *Lección de cosas*. Lima: Sala Luis Miró Quesada Garland. https://www.academia.edu/36890339/Nydia_Negromonte.

Cologne Institute of Conservation Sciences and Technology Arts Sciences 2019
Cologne Institute of Conservation Sciences and Technology Arts Sciences. 2019. *The Decision-Making Model for Contemporary Art Conservation and Presentation*. Rev. ed. Cologne: Cologne Institute of Conservation Sciences and Technology Arts Sciences. https://www.th-koeln.de/en/decision-making-model-for-contemporary-art-conservation-and-presentation--revisited_63959.php.

Colombo et al. 2015
Colombo, Annalisa, Francesca Gherardi, Sara Goidanich, John Delaney, René de la Rie, Maria Ubaldi, Lucia Toniolo, and Roberto Simonutti. 2015. "Highly Transparent Poly (2-Ethyl-2-Oxazoline)-TiO2 Nanocomposite Coatings for the Conservation of Matte Painted Artworks." *RSC Adv.* 5 (October): 84879–88.

Corzo 1999
Corzo, Miguel Angel, ed. 1999. *Mortality Immortality? The Legacy of 20th-Century Art*. Los Angeles: Getty Conservation Institute.

Curtis 2007
Curtis, Penelope. 2007. "Replication: Then and Now." *Tate Papers*, no. 8 (Autumn): https://www.tate.org.uk/research/publications/tate-papers/08/replication-then-and-now.

Design Indaba 2015
Design Indaba. 2015. Interview with Teresa van Dongen, April 15, 2015. https://youtu.be/-wukvLHp6Cc.

Di Carlo et al. 2016
Di Carlo, Enza, Rosa Chisesi, Giovanna Barresi, Salvatore Barbaro, Giovanna Lombardo, Valentina Rotolo, Mauro Sebastianelli, Giovanni Travagliato, and Franco Palla. 2016. "Fungi and Bacteria in Indoor Cultural Heritage Environments: Microbial-Related Risks for Artworks and Human Health." *Environment and Ecology Research* 4 (5): 257–64.

DiNoia 2019
DiNoia, Megan. 2019. "Decomposing Art: How Museum Professionals Treat Living Matter." *Heritagebites*, April 15, 2019, https://heritagebites.org/2019/04/15/decomposing-art-how-museum-professionals-treat-living-matter/.

Dixon 2016
Dixon, Deborah P. 2016. *Feminist Geopolitics: Material States.* London: Routledge.

Doctors 1999
Doctors, Marcio, ed. 1999. *A forma na floresta: Espaço de instalações permanentes: Iole de Freitas, outubro, 1999: Anna Maria Maiolino, novembro, 1999.* Rio de Janeiro: Museu do Açude.

Duff 2018
Duff, Tagny. 2018. "Wastelands: A Dirty Future." *Centre for Sustainable Practices in the Arts Quarterly* 21 (September 18, 2018): 31–35.

Eder and Palau 1985
Eder, Rita, and Marta Palau. 1985. *La intuición y la técnica.* Mexico City: Comité editorial del gobierno de Michoacán.

Esposito 2001
Esposito, Bruna. 2001. "Sereno-variabile." *Cahiers intempestifs*, no. 13 (October–December): 32–35.

Essling and Villar Rojas 2015
Essling, Lena, and Sebastián Villar Rojas. 2015. "Fantasma Adrián Villar Rojas." Exhibition booklet. Edited by Maria Morberg. Stockholm: Moderna Museet.

Foster 2015
Foster, Hal. 2015. *Bad New Days: Art, Criticism, Emergency.* London and New York: Verso.

Foundation for the Conservation of Modern Art and the Institute for Cultural Heritage 1999
Foundation for the Conservation of Modern Art and the Institute for Cultural Heritage. 1999. "The Decision-Making Model." In *Modern Art: Who Cares? An Interdisciplinary Research Project and an International Symposium on the Conservation of Modern and Contemporary Art*, edited by Ijsbrand Hummelen, Dionne Sillé, and Marjan Zijlmans, 164–72. Amsterdam: Foundation for the Conservation of Modern Art.

Fredrickson 2019
Fredrickson, Laurel Jean. 2019. "Life as Art, or Art as Life: Robert Filliou and the Eternal Network." *Theory, Culture & Society* 36 (3): 27–55.

Frisvad and Samson 2004
Frisvad, Jens C., and Robert A. Samson. 2004. "Polyphasic Taxonomy of Penicillium Subgenus Penicillium: A Guide to Identification of Food and Air-borne Terverticillate Penicillia and Their Mycotoxins." *Studies in Mycology* 49:1–174.

Fulcanelli 1974
Fulcanelli. 1974. *El misterio de las catedrales.* Buenos Aires: Editorial rotativa.

Ganado and Herrera 1994
Ganado, Edgardo, and Carolina Herrera. 1994. "SEMEFO, Museo de Arte Carrillo Gil. Catálogo de Exposición." Consejo Nacional para la Cultura y las Artes. Instituto Nacional de Bellas Artes. Mexico City: Museo de Arte Contemporáneo Alvar and Carmen T. de Carrillo Gil.

Gedrim 2007
Gedrim, Ronald J. 2007. "Edward Steichen's 1936 Exhibition of Delphinium Blooms: An Art of Flower Breeding." In *Signs of Life: BioArt and Beyond*, edited by Eduardo Kac, 347–69. Cambridge, MA: MIT Press. First published in *History of Photography* 17, no. 4 (1993): 352–63.

Gessert 1993
Gessert, George. 1993. *Scatter.* Eugene, OR: Green Light.

Gessert 2003
Gessert, George. 2003. "Notes sur l'art de la sélection végétale." In *L'art biotech*, edited by Jens Hauser, 47–55. Nantes, France, and Trézélan, France: Filigranes.

Giachi et al. 2010
Giachi, Gianna, Chiara Capretti, Nicola Macchioni, Benedetto Pizzo, and Ines Dorina Donato. 2010. "A Methodological Approach in the Evaluation of the Efficacy of Treatments for the Dimensional Stabilisation of Waterlogged Archaeological Wood." *CULHER Journal of Cultural Heritage* 11 (1): 91–101.

Gilman 2015
Gilman, Julie. 2015. "The Role of Science in Contemporary Art Conservation: A Study into the Conservation and Presentation of Food-Based Art." PhD diss., Ghent University Faculty of Arts and Philosophy.

Giménez Gatto 1999
Giménez Gatto, Fabián. 1999. "Obscenidad a la mexicana: Los juegos transestéticos de Rocío Boliver (I y II)," *H Enciclopedia*, http://www.henciclopedia.org.uy/autores/FGimenez/Obscenidad1.htm, http://www.henciclopedia.org.uy/autores/FGimenez/Obscenidad2.htm.

Gioni 2019
Gioni, Massimiliano, ed. 2019. *Appearance Stripped Bare: Desire and the Object in the Work of Marcel Duchamp and Jeff Koons, Even.* London: Phaidon.

González 2018
González, María Luisa. 2018. "La transubstanciación. El performance en el performance. Un abordaje a La perforMANcena, 'North America Cholesterol Free Trade Agreement' (1999) en César Martínez Silva." In *Aproximaciones interpretativas multidisciplinarias en torno al arte y la cultura*, edited by Raúl Wenceslao Capistrán Gracia, 135–45. Aguascalientes, Mexico: Universidad Autónoma de Aguascalientes.

Graeber 2014
Graeber, David. 2014. "Spotlight on the Financial Sector: Did Make Apparent Just How Bizarrely Skewed Our Economy Is in Terms of Who Gets Rewarded [interview with Thomas Frank]." *Salon*, June 1, 2014, https://www.salon.com/2014/06/01/help_us_thomas_piketty_the_1s_sick_and_twisted_new_scheme/.

Grantz 1969
Grantz, Gerald J. 1969. *Home Book of Taxidermy and Tanning*. Harrisburg, PA: Stackpole.

Gregory et al. 2017
Gregory, David, Yvonne Shashoua, Nanna Braunschweig Hansen, and Paul Jensen. 2017. "Anyone for a Nice Cup of Tea? The Use of Bacterial Cellulose for Conservation of Waterlogged Archaeological Wood." In *ICOM-CC 18th Triennial Conference, 2017, Copenhagen*, edited by J. Bridgland. Paris: International Council of Museums. https://pure.kb.dk/en/publications/anyone-for-a-nice-cup-of-tea-the-use-of-bacterial-cellulose-for-c.

Guasch 2011
Guasch, Anna María. 2011. *Arte y archivo. Genealogías, tipologías y discontinuidades*. Madrid: Akal.

Harren 2015
Harren, Natilee. 2015. "The Crux of Fluxus: Intermedia, Rear-guard." Walker Art Center, http://walkerart.org/collections/publications/art-expanded/crux-of-fluxus.

Harren 2016
Harren, Natilee. 2016. "The Provisional Work of Art: George Brecht's Footnotes at LACMA, 1969." *Getty Research Journal*, no. 8, 177–97.

Harren 2020
Harren, Natilee. 2020. *Fluxus Forms: Scores, Multiples, and the Eternal Network*. Chicago: University of Chicago Press.

Hauser and Strecker 2020
Hauser, Jens, and Lucie Strecker, eds. 2020. "On Microperformativity." *Performance Research: A Journal of the Performing Arts* 25 (3): https://www.tandfonline.com/doi/full/10.1080/13528165.2020.1807739.

Hauser 2006
Hauser, Jens. 2006. "Biotechnology as Mediality: Strategies of Organic Media Art." *Performance Research: A Journal of the Performing Arts* 11 (4): 129–36.

Hauser 2008
Hauser, Jens. 2008. "Observations on an Art of Growing Interest: Toward a Phenomenological Approach to Art Involving Biotechnology." In *Tactical Biopolitics: Art, Activism, and Technoscience*, edited by Beatriz Da Costa and Kavita Philip, 83–103. Cambridge, MA: MIT Press.

Hauser 2010
Hauser, Jens. 2010. "Sculpted by the Milieu: Frogs as Media." In *Praeter Naturam. Brandon Ballengée*, edited by Claudio Cravero, 38–41. Turin, Italy, and Biella, Italy: Eventi & Progetti Editor.

Hauser 2014a
Hauser, Jens. 2014a. "Biotechnologie als Medialität – Strategien organischer Medienkunst." PhD diss., Ruhr Universität Bochum.

Hauser 2014b
Hauser, Jens. 2014b. "Molekulartheater, Mikroperformativität und Plantamorphisierungen." In *Wahrnehmung, Erfahrung, Experiment. Wissen, Objektivität und Subjektivität in den Künsten und den Wissenschaften*, edited by Susanne Stemmler, 173–89. Zurich: Diaphanes.

Hauser 2016
Hauser, Jens. 2016. "Biomediality and Art." In *Artists-in-Labs: Recomposing Art and Science*, edited by Jill Scott and Irene Hediger, 201–19. Berlin: Springer.

Hauser 2018
Hauser, Jens. 2018. "Art and Agency in Times of Wetware." *Stream* 4: https://www.pca-stream.com/en/articles/jens-hauser-art-agency-in-times-of-wetware-107.

Henaro et al. 2019
Henaro, Sol, Alejandra Moreno, Christian Aravena, and Brian Smith. 2019. *Arte-acción en México. Registros y residuos*. Mexico City: MUAC-UNAM.

Hernández, Yasky, and Learner 2017
Hernández, Claudio, Caroll Yasky, and Tom Learner. 2017. "The Conservation of Modern and Contemporary Art in Latin America: Recent Approaches in Chile and Mexico." *Conservation Perspectives: The GCI Newsletter* 32, no. 2 (Fall): https://www.getty.edu/conservation/publications_resources/newsletters/32_2/feature.html.

Heuman 1999
Heuman, Jackie, ed. 1999. *Material Matters: The Conservation of Modern Sculpture*. London: Tate Gallery Publishing.

Hickey and Pelling 2019
Hickey, R. J., and A. E. Pelling. 2019. "Cellulose Biomaterials for Tissue Engineering." *Front. Bioeng. Biotechnol.* 7 (45): https://www.frontiersin.org/articles/10.3389/fbioe.2019.00045/full.

Higgins 2011
Higgins, Hannah. 2011. "Food: The Raw and the Fluxed." In *Fluxus and the Essential Questions of Life*, edited by Jacquelynn Baas, 13–21. Hanover, MA: Hood Museum of Art.

Hillis 2016
Hillis, Danny. 2016. "The Enlightenment Is Dead, Long Live the Entanglement." *Journal of Design and Science*: https://doi.org/10.21428/1a042043.

Hoet and De Baere 1990
Hoet, Jan, and Bart De Baere. 1990. "Ekonomische Waarden." In *Joseph Beuys – Das Wirtschaftswertprinzip*, edited by Klaus Staeck and Gerhard Steidl, 21–25. Heidelberg, Germany: Edition Staeck.

Hölling 2015
Hölling, Hanna. 2015. *Revisions—Zen for Film*. New York: Bard Graduate Center.

Hölling 2017
Hölling, Hanna. 2017. *Paik's Virtual Archive: Time, Change, and Materiality in Media Art*. Oakland: University of California Press.

Hollricher, Schmidt, and Breuninger 2014
Hollricher, Olaf, Ute Schmidt, and Sonja Breuninger. 2014. "RISE Microscopy: Correlative Raman and SEM Imaging." *Microscopy Today* 22 (November): 36–39. https://doi.org/10.1017/S1551929514001175.

Hummelen 1999
Hummelen, IJsbrand. 1999. "Decision-Making Model for the Conservation and Restoration of Modern Art." In *Modern Art: Who Cares? An Interdisciplinary Research Project and an International Symposium on the Conservation of Modern and Contemporary Art*, edited by IJsbrand Hummelen, Dionne Sillé, and Marjan Zijlmans, 4–18. Amsterdam: Foundation for the Conservation of Modern Art.

Hummelen, Sillé, and Zijlmans 1999
Hummelen, IJsbrand, Dionne Sillé, and Marjan Zijlmans, eds. 1999. *Modern Art: Who Cares? An Interdisciplinary Research Project and an International Symposium on the Conservation of Modern and Contemporary Art*. Amsterdam: Foundation for the Conservation of Modern Art.

Hunter 2019
Hunter, WhiteFeather. 2019. "Culturing Creativity, and a Little Bit of Shit-Stirring." *Musings* 2019:2–10. https://www.academia.edu/41620679/Culturing_Creativity_and_a_little_bit_of_shit_stirring.

ICOM 2006
International Council of Museums (ICOM). 2006. *ICOM Code of Ethics for Museums*. Paris: ICOM.

ICOM 2013
International Council of Museums (ICOM). 2013. *ICOM Code of Ethics for Natural History Museums*. Paris: ICOM.

Ippolito and Rinehart 2014
Ippolito, John, and Richard Rinehart. 2014. *Re-collection: Art, New Media, and Social Memory*. Cambridge, MA: MIT Press.

Ito 2016
Ito, Joichi. 2016. "Design and Science." *Journal of Design and Science*: https://doi.org/10.21428/f4c68887.

Joselit 2013
Joselit, David. 2013. "The Readymade Metabolized: Fluxus in Life." *RES: Anthropology and Aesthetics*, nos. 63/64, 190–200.

Kallergi 2008
Kallergi, Amalia. 2008. "Bioart on Display: Challenges and Opportunities of Exhibiting Bioart." Leiden, the Netherlands: Leiden University. https://www.researchgate.net/publication/266333742_Bioart_on_Display-_challenges_and_opportunities_of_exhibiting_bioart.

Kaplan 2017
Kaplan, Isaac. 2017. "When Is It Okay to Use Animals in Art?" *Artsy*, May 11, 2017, https://www.artsy.net/article/artsy-editorial-animals-art.

Kautz 2015
Kautz, Willy, ed. 2015. *Lo que no vemos, lo que nos mira*. Mexico City: Museo Amparo.

Keshk 2008
Keshk, Sherif M. A. S. 2008. "Homogenous Reactions of Cellulose from Different Natural Sources." *Carbohydrate Polymers* 74 (4): 942–45.

Khandekar 2016
Khandekar, Narayan. 2016. "Inherent Vice and the Ship of Theseus." In *Doris Salcedo: The Materiality of Mourning*, edited by Mary Schneider Enriquez, Doris Salcedo, and Narayan Khandekar, 141–52. New Haven, CT: Yale University Press.

Kite and Thomson 2006
Kite, Marion, and Roy Thomson. 2006. *Conservation of Leather and Related Materials*. Boston: Elsevier Butterworth-Heinemann.

Knoeff and Zwijnenberg 2016
Knoeff, Rina, and Robert Zwijnenberg, eds. 2015. "The Fate of Anatomical Collections." Special issue, *Social History of Medicine* 29 (4).

Knowles 1971
Knowles, Alison. 1971. *Journal of the Identical Lunch*. San Francisco: Nova Broadcast.

Kuhn 1962
Kuhn, Thomas. 1962. *The Structure of Scientific Revolutions*. Chicago: University of Chicago Press.

Kundera 1974
Kundera, Milan. 1974. *Life Is Elsewhere*. Translated by Peter Kussi. New York: Alfred A. Knopf.

La Brooy et al. 1981
La Brooy, Susan J., Fendick Avgerinos, C. B. Williams, and J. J. Misiewicz. 1981. "Potentially Explosive Colonic Concentrations of Hydrogen after Bowel Preparation with Mannitol." *The Lancet* 317, no. 8221 (March): 634–36.

Latour 1996
Latour, Bruno. 1996. "On Actor-Network Theory: A Few Clarifications Plus More Than a Few Complications." *Socziale Welt* 47:369–81. http://www.bruno-latour.fr/sites/default/files/P-67%20ACTOR-NETWORK.pdf.

Laurenson 2006
Laurenson, Pip. 2006. "Authenticity, Change and Loss in the Conservation of Time-Based Media Installations." *Tate Papers*, no. 6 (Autumn): https://www.tate.org.uk/research/publications/tate-papers/06/authenticity-change-and-loss-conservation-of-time-based-media-installations.

Leach 2017
Leach, Neil. 2017. "Matter Matters, a Philosophical Preface." In *Active Matter*, edited by Skylar Tibbits, 18–23. Cambridge, MA: MIT Press.

Learner and Rivenc 2014
Learner, Tom, and Rachel Rivenc. 2014. *Conserving Outdoor Painted Sculpture: Proceedings from the Interim Meeting of the Modern Materials and Contemporary Art Working Group of ICOM-CC*. Los Angeles: Getty Conservation Institute.

Lee 2011
Lee, Susan. 2011. "Grow Your Own Clothes." TED Talk, March 2011. https://www.ted.com/talks/suzanne_lee_grow_your_own_clothes.

Levin 2012
Levin, Jeffrey, ed. 2012. "Conservation of Public Art." Special issue, *Conservation Perspectives: The GCI Newsletter* 27 (2): https://www.getty.edu/conservation/publications_resources/newsletters/pdf/v27n2.pdf.

Lippard 1973
Lippard, Lucy R. 1973. *Six Years: The Dematerialization of the Art Object from 1966 to 1972*. New York: Praeger.

Lipps et al. 2019
Lipps, Andrea, Matilda McQuaid, Caitlin Condell, and Gene Bertrand. 2019. *Nature: Collaborations in Design*. New York: Cooper Hewitt, Smithsonian Design Museum.

Llamas-Pacheco 2018
Llamas-Pacheco, Rosario. 2018. "The Ephemeral, the Essential and the Material in the Conservation of Contemporary Art: Decision-Making for the Conservation of a Work of Art Made with Butterfly Wings." *Studies in Conservation* 63, no. 8 (July): 441–49.

López Guzmán 2010
López Guzmán, Javier. 2010. "Informe de los trabajos de conservación sobre la obra: Lavatio Corporis / Grupo SEMEFO." Seminario Taller de Restauración Arte Moderno y Contemporáneo. Temporada de trabajo agosto-diciembre 2010. Unpublished.

Macedo and Henriques da Silva 2010
Macedo, Rita, and Raquel Henriques da Silva, eds. 2010. *A arte efímera e a conservação: O paradigma dos bens etnográficos e da arte contemporânea = Ephemeral Art and Conservation: The Paradigm of Contemporary Art and Ethnographic Objects*. Lisbon: Instituto de História da Arte, IHA FCT-UNL. https://run.unl.pt/bitstream/10362/16429/1/Livro_Actas_Completo.pdf.

MALBA 2012
MALBA. 2012. "Víctor Grippo: Homenaje." https://malba.org.ar/evento/victor-grippo-homenaje/.

Manrique 1978
Manrique, Jorge Alberto. 1978. *30 escultoras en materiales textiles*. Mexico City: Museo de Arte Moderno, INBA.

Martinez and de Corral 2005
Martinez, Rosa, and Maria de Corral, eds. 2005. *La Biennale di Venezia. 51a International Art Exhibition. Always a Little Further*. Venice: Marsilio – Fondazione La Biennale di Venezia.

Martínez Silva 2013
Martínez Silva, César. 2013. "Permanencia en el tiempo de esculturas hinchables realizadas con hule látex vulcanizado, mecanismos de aire y sensores electrónicos; La conservación del futuro." Presentation at the 14th Jornada de Conservación de Arte Contemporáneo, Museo Nacional Centro de Arte Reina Sofía, Madrid.

Mata and Coronado 2018
Mata, Lizeth, and Claudia Coronado. 2018. *Diagnóstico de conservación y propuesta de estabilización de la obra Encobijados, de Teresa Margolles*. Mexico City: Seminario Taller de Restauración de Arte Moderno y Contemporáneo, ENCRyM-INAH.

Matheron 2019
Matheron, Aurelie. 2019. "Performing Waste, Wasting Performance: The Ecology of Fluxus." *Resilience: A Journal of the Environmental Humanities* 6 (1): 102–17.

Maximiliano Tello 2015
Maximiliano Tello, Andrés. 2015. "El arte y la subversión del archivo." *Aisthesis*, no. 58, 125–43. http://dx.doi.org/10.4067/S0718-71812015000200007.

McCabe 2001
McCabe, Terry. 2001. *Mis-directing the Play: An Argument against Contemporary Theatre*. Chicago: Ivan R.Dee.

McNally and Hsu 2012
McNally, Rika Smith, and Lillian Hsu. 2012. "Conservation of Contemporary Public Art." *Conservation Perspectives: The GCI Newsletter* 27 (2): 4–9.

Medina 2006
Medina, Cuauhtémoc. 2006. "Escultura suave, disidencia suave." In *Marta Palau. Nahualli*, edited by Virginia Ruano. Mexico City: CONACULTA, Gobierno del estado de Michoacán, UNAM, Centro Cultural Tijuana, and BBVA Bancomer.

Medina 2017
Medina, Cuauhtémoc. 2017. *Abuso mutuo: Ensayos e intervenciones sobre arte postmexicano (1992–2013)*. Mexico City: Editorial RM.

Meléndez and Mata Delgado 2012
Meléndez, Darío, and Ana Lizeth Mata Delgado. 2012. "Tilma Porca." In *Memorias del 5º Foro Académico*, edited by ENCRyM, 33–40. Mexico City: ENCRyM-INAH. https://www.repositoriodepublicaciones.encrym.edu.mx/pdf/4-TilmaPorca.pdf.

Merleau-Ponty 2007
Merleau-Ponty, Maurice. 2007. "An Unpublished Text by Maurice Merleau-Ponty: A Prospectus of His Work," translated by Arleen B. Dalery. In *The Merleau-Ponty Reader*, edited by Ted Toadvine and Leonard Lawler, 285. Evanston, IL: Northwestern University Press.

Michalski and Pedersoli 2016
Michalski, Stefan, and José Luiz Pedersoli Jr. 2016. *The ABC Method: A Risk Management Approach to the Preservation of Cultural Heritage*. Ottawa: Government of Canada, Canadian Conservation Institute, and ICCROM.

Michalski 2006
Michalski, Stefan. 2006. "Conservation Lessons from Other Types of Museums and a Universal Database for Collection Preservation." In *Modern Art: Who Cares? An Interdisciplinary Research Project and an International Symposium on the Conservation of Modern and Contemporary Art*, edited by IJsbrand Hummelen, Dionne Sillé, and Marjan Zijlmans, 290–95. Amsterdam: Foundation for the Conservation of Modern Art.

Modulevsky, Cuerrier, and Pelling 2016
Modulevsky, D. J., C. M. Cuerrier, and A. E. Pelling. 2016. "Biocompatibility of Subcutaneously Implanted Plant-Derived Cellulose Biomaterials." *PloS one* 11 (6): e0157894. https://doi.org/10.1371/journal.pone.0157894.

Moody, Kavaliunas, and Kuo 2019
Moody, Ellen, Lina Kavaliunas, and Michelle Kuo. 2019. "Strange Brew." *MoMA Magazine*, May 9, 2019, https://www.moma.org/magazine/articles/51.

Museum of Modern Art 1936
Museum of Modern Art. 1936. "Press Release: Steichen Delphiniums." June 22, 1936. New York: Museum of Modern Art. https://assets.moma.org/documents/moma_press-release_325057.pdf.

Negromonte 2016
Negromonte, Nydia, ed. 2016. *D.U.C.T.O: Nydia Negromonte*. Belo Horizonte, Brazil: Autêntica.

Novero 2010
Novero, Cecilia. 2010. *Antidiets of the Avant-Garde: From Futurist Cooking to Eat Art*. Minneapolis: University of Minnesota Press.

ORLAN 1998
ORLAN. 1998. "Intervention" (1995). In *The Ends of Performance*, edited by Peggy Phelan and Jill Lane, 315–27. New York: New York University Press.

ORLAN 2010
ORLAN. 2010. "The Poetics and Politics of the Face-To-Face." In *ORLAN: A Hybrid Body of Artworks*, edited by Simon Donger, Simon Shepard, and ORLAN, 103–18. London and New York: Routledge.

Ortega Espinoza 2014
Ortega Espinoza, Daniela. 2014. *Informe de los trabajos de restauración de la obra "Mis Caminos son Terrestres XVII" de Marta Palau*. Mexico City: Seminario Taller de Restauración de Arte Moderno y Contemporáneo, ENCRyM-INAH.

Patlán 2010
Patlán, Lorena. 2010. "Career Profile: Albrecht Gumlich, Objects Conservator." *Iris: Behind the Scenes at the Getty*, November 24, 2010, http://blogs.getty.edu/iris/career-profile-albrecht-gumlich-objects-conservator/.

Pietromarchi 2017
Pietromarchi, Bartolomeo, ed. 2017. *Bruna Esposito. E così sia . . . /Amen*. Imola, Italy: Manfredi Editore.

Pitt and Samson 2000
Pitt, J. I., and R. A. Samson. 2000. *Integration of Modern Taxonomic Methods for Penicillium and Aspergillus*. Amsterdam: CRC Press.

Pullen and Heuman 2007
Pullen, Derek, and Jackie Heuman. 2007. "Modern and Contemporary Outdoor Sculpture Conservation: Challenges and Advances." *Conservation Perspectives: The GCI Newsletter* 22 (2): https://www.getty.edu/conservation/publications_resources/newsletters/22_2/feature.html.

Quigley 2015
Quigley, Christine. 2015. *Modern Mummies: The Preservation of the Human Body in the Twentieth Century*. Jefferson, NC: McFarland.

Quinn 2007
Quinn, Marc. 2007. "Genomic Portrait." In *Signs of Life: Bio Art and Beyond*, edited by Eduardo Kac, 309–11. Cambridge, MA: MIT Press.

Rebolledo et al. 2019
Rebolledo, Karla, et al. 2019. "Incontenible: Entre la creación artística y la conservación." *Estudios sobre conservación, restauración y museología* 5:157–70. https://www.repositoriodepublicaciones.encrym.edu.mx/pdf/13%20incontenible_corregido2019.pdf.

Reed and Phillips 2018
Reed, Marcia, and Glenn Phillips, eds. 2018. *Artists and Their Books / Books and Their Artists*. Los Angeles: Getty Research Institute.

Rinehart and Ippolito 2014
Rinehart, Richard, and Jon Ippolito. 2014. *Re-Collection: Art, New Media, and Social Memory.* Cambridge, MA: MIT Press.

Robinson 2004
Robinson, Julia. 2004. "The Sculpture of Indeterminacy: Alison Knowles's Beans and Variations." *Art Journal* 63 (4): 96–115.

Rolnik 2002
Rolnik, Suely. 2002. "Flowerings of Reality." In *Anna Maria Maiolino: Vida afora = A Lifeline*, edited by Catherine de Zegher and Paço Imperial, 110–11. São Paulo: Museu de Arte Moderna de São Paulo; New York: Drawing Center.

Roth 1967–68
Roth, Dieter. 1967–68. *Poeterei 3/4: Doppelnummer der Halfjahresschrift für Poesie und Poetrie.* Stuttgart, Germany: Edition H. Mayer.

Salabert 2004
Salabert, Pere. 2004. *La redención de la carne, hastío del alma y elogio de la pudrición.* Murcia, Spain: Editorial Centro de Documentación y Estudios Avanzados del Arte Contemporáneo (CENDEAC).

Salter 2010
Salter, Chris. 2010. *Entangled: Technology and the Transformation of Performance.* Cambridge, MA: MIT Press.

Samson et al. 1995
Samson, R., F. Ribera, V. Sanchis, and R. Canela. 1995. *Introduction to Food-Borne Fungi.* Baarn, the Netherlands: Central Bureau for Schimmel Cultures.

Sánchez 2013
Sánchez, Sandra. 2013. "La historia no existe (cuatro artistas bordeando los hechos)." GASTV, n.d., https://gastv.mx/la-historia-no-existe/.

Santos et al. 2016a
Santos, Sara M., José M. Carbajo, Nuria Gómez, Ester Quintana, Miguel Ladero, Arsenio Sánchez, Gary Chinga-Carrasco, and Juan C. Villar. 2016a. "Use of Bacterial Cellulose in Degraded Paper Restoration. Part I: Application on Model Papers." *Journal of Materials Science* 51 (3): 1541–52. https://doi.org/10.1007/s10853-015-9476-0.

Santos et al. 2016b
Santos, Sara M., José M. Carbajo, Nuria Gómez, Ester Quintana, Miguel Ladero, Arsenio Sánchez, Gary Chinga-Carrasco, and Juan C. Villar. 2016b. "Use of Bacterial Cellulose in Degraded Paper Restoration. Part II: Application on Real Samples." *Journal of Materials Science* 51 (3): 1553–61.

Sayes 2014
Sayes, Edwin. 2014. "Actor-Network Theory and Methodology: Just What Does It Mean to Say That Nonhumans Have Agency?" *Social Studies of Science* 44 (1): 134–49.

Schmidt, Ayasse, and Hollricher 2016
Schmidt, Ute, Philippe Ayasse, and Olaf Hollricher. 2016. "RISE Microscopy: Correlative Raman and SEM Imaging." In *European Microscopy Congress 2016: Proceedings*, 1023–24. Wiley Online Library.

Schneider Enriquez 2016
Schneider Enriquez, Mary. 2016. "Organic and Ephemeral: Salcedo's Recent Material Challenges." In *Doris Salcedo: The Materiality of Mourning*, edited by Mary Schneider Enriquez, Doris Salcedo, and Narayan Khandekar, 119–39. New Haven, CT: Yale University Press.

Scholte and Wharton 2011
Scholte, Tatja, and Glenn Wharton, eds. 2011. *Inside Installations: Theory and Practice in the Care of Complex Artworks.* Amsterdam: Amsterdam University Press.

Schultz n.d.
Schultz, Michael. n.d. "Sonja Alhäuser." https://www.schultzberlin.com/de/sonja-alh%C3%A4user.

Sehn 2013
Sehn, Magali Melleu. 2013. "El problema de la conservación de arte contemporáneo en el contexto de los préstamos a largo plazo," 87–94. Conservación de arte contemporáneo 14. Madrid: Museo Nacional Centro de Arte Reina Sofía.

Sehn 2014
Sehn, Magali Melleu. 2014. *Entre resíduos e dominós: Preservação de instalações de arte no Brasil.* Belo Horizonte, Brazil: C/ARTE.

Self 2009
Self, Will. 2009. "Bring Me the Head of Marc Quinn!" http://marcquinn.com/assets/downloads/Bring_me_the_Head_of_Marc_Quinn_Will_Self_FULL.pdf.

Serexhe 2013
Serexhe, Bernhard, ed. 2013. *Preservation of Digital Art: Theory and Practice: The Digital Art Conservation Project.* Vienna: Ambra V.

Skloot 2010
Skloot, Rebecca. 2010. *The Immortal Life of Henrietta Lacks.* New York: Crown.

Spindler et al. 1996
Spindler, Konrad, Herald Wilfing, Elisabeth Rastbichler-Zissernig, Dieter ZurNedden, and Hans Nothdurfter, eds. 1996. *Human Mummies: A Global Survey of Their Status and the Techniques of Conservation.* New York: Springer Science and Business Media.

Subrizi 2012
Subrizi, Carla. 2012. *Azioni che cambiano il mondo. Donne, arte e politiche dello sguardo.* Piacenza, Italy: Postemedia Books.

Susovski 1978
Susovski, Marijan, ed. 1978. *Nova umjetničkapraksa 1966–1978.* Zagreb: Galerija suvremene umjetnosti [Gallery of Contemporary Art].

Suzuki 2013
Suzuki, Sarah. 2013. *Wait, Later This Will Be Nothing: Editions by Dieter Roth*. New York: Museum of Modern Art.

Taddei 2009
Taddei, Jean-François. 2009. *Les Perméables = The Permeables*. Paris: MeMo.

Takita 2008
Takita, Jun. 2008. "Light, only light." In *sk-interfaces. Exploding Borders: Creating Membranes in Art, Technology and Society*, edited by Jens Hauser, 141–43. Liverpool, UK: Liverpool University Press.

Tarnowski and Morris 2001
Tarnowski, C. P., and M. D. Morris. 2001. "Raman Spectroscopy and Microscopy." In *Encyclopedia of Materials: Science and Technology*, edited by K. H. Jürgen Buschow, Robert W. Cahn, Merton C. Flemings, Bernhard Ilschner, Edward J. Kramer, Subhash Mahajan, and Patrick Veyssière, 7976–83. Oxford: Elsevier.

Temkin 1999
Temkin, Ann. 1999. "Strange Fruit." In *Mortality Immortality? The Legacy of 20th-Century Art*, edited by Miguel Angel Corzo, 45–50. Los Angeles: Getty Conservation Institute.

The Economist 2009
The Economist. 2009. "Planned Obsolescence." March 23, 2009, https://www.economist.com/news/2009/03/23/planned-obsolescence.

Thickett and Lee 2004
Thickett, D., and L. R. Lee. 2004. "Selection of Materials for the Storage or Display of Museum Objects." British Museum Occasional Paper 111. London: British Museum.

Tibbits 2017
Tibbits, Skylar, ed. 2017. *Active Matter*. Cambridge, MA: MIT Press.

Tijardović 1978
Tijardović, Jasna. 1978. "Marina Abramović, Slobodan Milivojević, Neša Paripović, Zoran Popović, Raša Todosijević, Gergelj Urkom." In *Nova umjetničkapraksa 1966–1978*, edited by Marijan Susovski, 55–59. Zagreb: Galerija suvremene umjetnosti [Gallery of Contemporary Art].

Tsing 2015
Tsing, Anna Lowenhaupt. 2015. *The Mushroom at the End of the World: On the Possibility of Life in Capitalist Ruins*. Princeton, NJ: Princeton University Press.

Tsing et al. 2017
Tsing, Anna Lowenhaupt, Heather Swanson, Elaine Gan, and Nils Bubandt, eds. 2017. *Arts of Living on a Damaged Planet: Ghosts and Monsters of the Anthropocene*. Minneapolis: University of Minnesota Press.

Vahur et al. 2016
Vahur, Signe, Anu Teearu, Pilleriin Peets, Lauri Joosu, and Ivo Leito. 2016. "ATR-FT-IR Spectral Collection of Conservation Materials in the Extended Region of 4000-80 Cm^{-1}." *Analytical and Bioanalytical Chemistry* 408 (13): 3373–79.

Valdivia 2017
Valdivia, Mónica. 2017. "ATEA: Renovación cultural en la Merced." *NEXOS*, April 10, 2017, https://cultura.nexos.com.mx/?p=12524.

Valentín, Muro, and Montero 2010
Valentín, N., C. Muro, and J. Montero. 2010. "Métodos y técnicas para evaluar la calidad del aire en museos: Museo Nacional Centro de Arte Reina Sofía," edited by CARS – IIC Grupo Español, 63–81. Madrid: Museo Nacional Centro de Arte Reina Sofía. https://www.museoreinasofia.es/sites/default/files/actividades/programas/metodos_y_tecnicas_restauracion.pdf.

Valentin 2010
Valentin, Nieves. 2010. "Microorganisms in Museum Collections." *Coalition*, no. 19 (January): 2–5. http://www.rtphc.csic.es/issues/19_01.pdf.

van Dongen 2019
van Dongen, Teresa. 2019. "Electric Life." http://www.teresavandongen.com/Electric-Life.

van Saaze 2011
van Saaze, Vivian. 2011. "Acknowledging Differences: A Manifold of Museum Practices." In *Inside Installations: Theory and Practice in the Care of Complex Artworks*, edited by Tatja Scholte and Glenn Wharton, 249–55. Amsterdam: Amsterdam University Press.

van Saaze 2013
van Saaze, Vivian. 2013. *Installation Art and the Museum: Presentation and Conservation of Changing Artworks*. Amsterdam: Amsterdam University Press.

Verbeeck 2016
Verbeeck, Muriel. 2016. "There Is Nothing More Practical Than a Good Theory: Conceptual Tools for Conservation Practice." *Studies in Conservation* 61, supplement 2: 233–40.

Verhoeven 2019
Verhoeven, Thibaut. 2019. "Joseph Beuys – *Wirtschaftswerte* (1980)." In *S.M.A.K. De Collectie A–Z*, edited by S.M.A.K., 149. Ghent: S.M.A.K.

Villar Rojas 2014
Villar Rojas, Adrián. 2014. Filmed interview by Jordan Bahat at kurimanzutto, Mexico City. https://www.youtube.com/watch?app=desktop&v=qJEE-yNCHQM.

Villar Rojas 2015
Villar Rojas, Adrián. 2015. Filmed interview by Lena Essling, Moderna Museet, Stockholm. https://youtu.be/g6yv6qKJjG4.

Villar Rojas 2017

Villar Rojas, Adrián. 2017. Filmed interview by Elina Kountouri, Neon, Athens, June 3, 2017. https://player.vimeo.com/video/224171178.

Villar Rojas 2018

Villar Rojas, Adrián. 2018. "In the Studio: Adrián Villar Rojas." Interview by Gabriel Roland. *Collectors Agenda*, August 20, 2018, https://www.collectorsagenda.com/en/in-the-studio/adrian-villar-rojas.

Voellinger and Wagner 2009

Voellinger, T., and S. Wagner. 2009. "Cold Storage for Photograph Collections: Vapor-Proof Packaging." *Conserve O Gram*, no. 14/12: 2–5.

Warburg 2005

Warburg, Aby. 2005. *El renacimiento del paganismo: Aportaciones a la historia cultural del Renacimiento europeo*. Madrid: Alianza.

Warren 1997

Warren, Karen J., ed. 1997. *Ecofeminism: Women, Culture, Nature*. Bloomington: Indiana University Press.

Wharton and Molotch 2009

Wharton, Glenn, and Harvey Molotch. 2009. "The Challenge of Installation Art." In *Conservation: Principles, Dilemmas and Uncomfortable Truths*, edited by Alison Bracker and Alison Richmond, 210–22. London: Elsevier.

Wharton et al. 2016

Wharton, Glenn, et al. 2016. "The Artist Archives Project: David Wojnarowicz." In *Saving the Now: Crossing Boundaries to Conserve Art Works*, edited by Austin Nevin et al., 241–47. Los Angeles and London: Studies in Conservation (IIC).

Wittgenstein 1953

Wittgenstein, Ludwig. 1953. *Philosophical Investigations*. New York: Macmillan.

Woods 2014

Woods, Nicole L. 2014. "Taste Economies: Alison Knowles, Gordon Matta-Clark and the Intersection of Food, Time and Performance." *Performance Research: A Journal of the Performing Arts* 19 (3): 157–61.

Yap 2009

Yap, Chin-Chin. 2009. "Murder at MoMA?" *ArtAsiaPacific* 62:49–50.

Young 1969

Young, Dennis. 1969. *New Alchemy: Elements, Systems, Forces = Nouvelle alchimie: Eléments, systèmes, forces: Hans Haacke, John Van Saun, Charles Ross, Takis*. Toronto: Art Gallery of Ontario.

Zevi 2005

Zevi, Adachiara. 2005. *Peripezie del dopoguerra nell'arte italiana*. Turin, Italy: Einaudi.

Zurr and Catts 2002

Zurr, Ionat, and Oron Catts. 2002. "An Emergence of the Semi-Living." In *The Aesthetics of Care?*, edited by Oron Catts, 63–68. Nedlands, Australia: Symbiotica.

Zylinska 2002

Zylinska, Joanna, ed. 2002. *The Cyborg Experiments: The Extensions of the Body in the Media Age*. London: Continuum.

Contributors

Silvana Alborés
Silvana Alborés holds a bachelor's degree in biochemistry, a master's degree in biotechnology, and a doctorate in chemistry. She has worked in the field of microbiology since 1999. She is currently a full-time adjunct professor in microbiology at the Universidad de la República, Uruguay, carrying out teaching, outreach, management, and research activities, and responsible for tracks related to researching new antimicrobials and nanotechnology. She is a researcher for PEDECIBA (Basic Science Development Program) and the National Network of Researchers (ANII / National Agency for Research and Innovation).

Camilla Ayla Oliveira dos Anjos
Camilla Ayla Oliveira dos Anjos holds a bachelor's degree in conservation and restoration of cultural heritage from the Universidade Federal de Minas Gerais, Brazil. She first worked with conservation and restoration of Baroque and classical art, but became more interested in the conservation of modern materials and art concepts after her first contact with contemporary art. In 2019 she concluded her master's in preservation of cultural heritage at the Graduate Art Program from the Fine Arts School in the Universidade Federal de Minas Gerais with the dissertation "Outdoors Installations and Their Connections with Their Surroundings: Reflections on Preservation." The same year, she specialized in contemporary art at the Universidade Estadual de Minas Gerais. The case study discussed in her article in this volume is the result of her master's research.

Ivana Bačić
Ivana Bačić is a forensics expert for fire and explosions at the Forensic Science Centre "Ivan Vučetić" of the Ministry of the Interior of the Republic of Croatia. She received a doctoral degree in chemistry in 2016 in the field of nanomaterials and corrosion protection of stainless steel. Her work involves numerous spectroscopic, chromatographic, and elemental analysis methods.

Sarah Barack
Sarah Barack studied art history and art conservation at the Conservation Center, Institute of Fine Arts, at New York University; she also holds an MBA from Columbia Business School. Barack recently joined the Cooper Hewitt, Smithsonian Design Museum in Washington, DC, as head of conservation and senior objects conservator. She is also the current treasurer of the boards of the American Institute for Conservation and the Foundation for Advancement in Conservation.

Claudia Barra
Claudia Barra holds a degree in pharmaceutical chemistry from the Universidad de la República, Uruguay, and is a researcher in natural science for cultural heritage. She began her career in conservation and restoration of paintings in 1983, and is currently a conservator and restorer of paintings at the Museo Juan Manuel Blanes, Montevideo. She is also an instructor in both preventative conservation of cultural heritage and pictorial techniques at various departments at the Universidad de la República.

Cristina Bausero
Cristina Bausero is a graduate of the School of Architecture, Universidad de la República, Uruguay, and a doctoral student in architecture in the Facultad de Arquitectura, Diseño y Urbanismo, Universidad Nacional del Litoral; she also holds a graduate degree in project research. She is an associate professor at the School of Architecture, Design, and Urbanism, Universidad de la República; director of the Museo Juan Manuel Blanes, Montevideo; director of the Centro Cultural Dodecá and the Escuela de Cine Dodecá, Montevideo; and a member of Uruguay's National Commission for Visual Arts.

Katrien Blanchaert

Katrien Blanchaert graduated with a master of architecture degree in 2008 at Sint-Lucas, Ghent, following a one-year postgraduate course on the presentation and conservation of contemporary art at KASK, Ghent. From 2009 to 2017 she worked as a collections researcher for S.M.A.K., Ghent, focusing mainly on the conservation of installation artworks. Alongside this, she started working as an assistant at KULeuven, Department of Architecture, Sint-Lucas, Ghent, in 2015. She currently works as a collection, archive, and exhibition coordinator at Herbert Foundation, Ghent.

Courtney Books

Courtney Books is a conservator specializing in easel paintings and murals. Internationally trained, she is currently assistant paintings conservator at the Saint Louis Art Museum. Books received her MAC in paintings conservation from Queen's University in 2018 and an MA in art history from McGill University in 2013. An interest in biodeterioration and bioremediation of art fuels her collaborative research with practicing bioartists.

My Bundgaard

My Bundgaard is an object and sculpture conservator at Moderna Museet in Stockholm. She holds a BSc and an MSc from KADK – Royal Danish Academy of Fine Arts, Schools of Architecture, Design, and Conservation. Her current research focus is kinetic sculpture and installations involving varied and ephemeral elements.

María Pía Cerdeiras

María Pía Cerdeiras holds a master of science in biotechnology from the University of London. She has worked in the field of microbiology in the bioscience division of the School of Chemistry, Universidad de la República, Uruguay, since 1986. She is a specialist in the study of filamentous fungi, with special concentrations in the production of enzymes for industrial use, improvement of lignocellulosic substrates in agriculture, contaminant degraders such as colorants and agrochemicals, and compound producers with antimicrobial activity. She teaches graduate and postgraduate courses.

Davison Chiwara

Davison Chiwara's research focuses on the conservation of heritage and museum and gallery practice. He has presented several research papers at American Institute of Conservation annual meetings, International Institute of Conservation congresses, the Culture in Crisis Conference, and other regional conferences in Africa. He has published in *Museum International* and IIC's *Studies in Conservation.*

Claudia María Coronado García

Claudia María Coronado García holds a bachelor's degree in restoration of movable property with a specialization in museum studies from the Escuela Nacional de Conservación, Restauración y Museografía of the Instituto Nacional de Antropología e Historia, Mexico City, and a master's degree in contemporary and modern art from Casa Lamm. Since 2014 she has been an adjunct professor at ENCRyM's Seminario Taller de Restauración de Arte Moderno y Contemporáneo, which has allowed her to coordinate and participate in various restorations and train future restorers.

Gabriel de la Mora

Gabriel de la Mora was born in 1968 in Mexico City, where he still lives and works. He completed an MFA at the Pratt Institute and a licentiate's degree in architecture at Anáhuac University North Campus in Mexico City. His work has been exhibited in solo and group shows in museums and galleries in Mexico, the United States, Canada, Colombia, Brazil, Spain, the UK, and elsewhere. He is represented by Timothy Taylor, London; Sicardi Gallery, Houston; and Proyectos Monclova, Mexico City. Through a meticulous and obsessive process of searching, gathering, selecting, classifying, cataloging, and manipulating otherwise heterogeneous materials, de la Mora explores the finite and the permanent, the passage and suspension of time, and the transformation of both material and energy.

Mercedes Isabel de las Carreras

Mercedes Isabel de las Carreras holds a graduate degree in museum studies, specializing in the restoration of easel paintings, polychrome sculptures, and contemporary art. Since 2008 she has been head manager of collections for the Museo Nacional de Bellas Artes in Buenos Aires. She has participated in events and symposia with grants received from the Getty Conservation Institute, the Gabo Trust, APOYO, and Fundación Antorchas. She formerly worked as a restorer at Fundación TAREA, Buenos Aires, and has organized restoration projects and contemporary art conferences and published articles on restoration.

Belén Estévez

Belén Estévez holds a degree in clinical biochemistry from the Universidad de la República, Uruguay. She is currently a doctoral student in chemistry and an intern at the School of Chemical Science, Universidad Nacional de Córdoba, Argentina, and the Instituto de Nanociencia de Aragón, Spain. She has received grants from CAP (Center for Professional Development), ANII (National Agency for Research and Innovation), and CSIC (Spanish National Research Council). She is a microbiology assistant (grade 1), has presented at national and international conferences, and publishes in peer-reviewed international journals.

Maura Favero
Maura Favero holds a PhD in contemporary art history from Sapienza – Università di Roma, where she was also awarded her diploma in the postgraduate school in the science of historic and artistic heritage. She collaborates with MAXXI – Museo nazionale delle arti del XXI secolo, Rome, and also works on projects related to the structuring and management of artists' private archives.

Harald Fitzek
Harald Fitzek has been working since 2018 as a senior scientist with a specialization in vibrational spectroscopy, scanning electron microscopy, and correlative microscopy at the Austrian Centre for Electron Microscopy and Nanoanalysis. In 2018 he obtained his PhD with a focus on surface-enhanced Raman spectroscopy at the Institute for Electron Microscopy and Nanoanalysis at Graz University of Technology.

Natilee Harren
Natilee Harren is an assistant professor of art history at the University of Houston and the author of *Fluxus Forms: Scores, Multiples, and the Eternal Network* (University of Chicago Press, 2020) and "The Provisional Work of Art: George Brecht's Footnotes at LACMA, 1969" (*Getty Research Journal*). Her research and teaching engage the conservation of modern and contemporary art from philosophical, art historical, and curatorial perspectives.

Jens Hauser
Jens Hauser is a Paris- and Copenhagen-based media theoretician and art curator focusing on interactions between art and technology. He is currently a guest researcher at the University of Copenhagen's Medical Museion, a distinguished affiliated faculty member at Michigan State University, and a guest professor in the Department of Arts and Sciences of Art at Université Paris I Panthéon-Sorbonne.

Tora Hederus
Tora Hederus is a paper conservator holding a BSc and an MSc from KADK – Royal Danish Academy of Fine Arts, Schools of Architecture, Design, and Conservation. Since graduation, Hederus has been working for three years as a conservator at the Moderna Museet, Stockholm, and has had opportunities to work with objects composed of a mix of paper and plastic.

Rebecca Heremans
Rebecca Heremans graduated in 2011 with a master's degree in conservation and restoration studies of photographic objects from Universiteit Antwerpen. Since 2012 she has worked as a restorer at S.M.A.K., Ghent, Belgium. She focuses on the preventive conservation of a highly diverse range of artworks from the collection, in particular the conservation and restoration of paper objects.

Claudio Hernández
Claudio Hernández holds a bachelor's degree in restoration of movable property from the Escuela Nacional de Conservación, Restauración y Museografía of the Instituto Nacional de Antropología e Historia, Mexico, and a master's degree in conservation of new media and digital information from the Freie Kunstschule Stuttgart. Since 2009 he has led the restoration laboratory at the Museo Universitario Arte Contemporáneo, Mexico City. His work focuses on documentation, research, and conservation of contemporary art. He has completed internships and organized national and international conferences on preservation. Since 2011 he has been teaching collections management and conservation as part of the master's program in art history, with a specialization in curatorial studies, at the Universidad Nacional Autónoma de México.

Jasna Jablan
Jasna Jablan is an assistant professor in the Department of Analytical Chemistry, Faculty of Pharmacy and Biochemistry, University of Zagreb, Croatia. After obtaining graduate degrees in both medical biochemistry and pharmacy, she received a doctoral degree in biomedicine and health in 2014. Her scientific interests include the application of existing analytical methods and the development of new ones for different kinds of samples.

Kelly Kleinschrodt
Kelly Kleinschrodt is a studio artist and independent arts educator who lives and works in Los Angeles. She has presented solo projects in Chicago with Andrew Rafacz, in Los Angeles and Miami with Carter & Citizen, and in London and Los Angeles with Crisp London Los Angeles. Kleinschrodt's work has also been exhibited and screened in the United States and internationally at such venues as Steve Turner, Los Angeles; Five Car Garage, Los Angeles; (OFF)ICIELLE, Paris; Josh Lilley, London; UNTITLED, Miami; Samson Projects, Boston; L.A.C.E., Los Angeles; The Wand, Berlin; Moving Image, New York; Kavi Gupta, Berlin; Museo Ex Teresa Arte Actual, Mexico City; and OPEN Contemporary Art Center, Beijing. Her work is held in private collections throughout the United States and Europe as well as in the Franks-Suss Collection, London. Kleinschrodt received her MFA at UCLA, where she was the recipient of the Elaine Krown Klein Award.

Thérèse Lilliegren
Thérèse Lilliegren is a senior paintings conservator at the Moderna Museet in Stockholm. She holds a BA in art history and conservation from Stockholms Universitet. Her research interests focus on modern and contemporary art, with a special emphasis on political and ephemeral art, conservation ethics, and the development of a digital report tool.

Rosario Llamas Pacheco
Rosario Llamas Pacheco is a professor in the Conservation and Restoration of Cultural Heritage Department, and assistant director of the Instituto de Restauración del Patrimonio, at the Universitat Politècnica de València. She specializes in conservation and restoration of contemporary art and has written numerous articles on this topic for industry journals, as well as books and chapters of books. She has led various competitive research projects and has directed numerous doctoral dissertations and master's theses.

Eugenia Macías
Eugenia Macías is a restorer for the Escuela Nacional de Conservación, Mexico City, and winner of the Paul Coremans Prize (2000) awarded by Mexico's Instituto Nacional de Antropología e Historia. She holds a master's degree in social anthropology from the Centro de Investigaciones y Estudios de Antropología Social and a doctorate in art history from the Universidad Nacional Autónoma de México. She was formerly a curator at the Museo de Arte Moderno, Mexico City, and a researcher at the Centro de Documentación Arkheia at the Museo Universitario Arte Contemporáneo. She is currently a research professor at the Escuela Nacional de Conservación, Restauración y Museografía, Mexico City.

Soledad Martínez
Soledad Martínez holds a bachelor's degree in chemistry and clinical biochemistry from the School of Chemistry, Universidad de la República, Uruguay, and is currently pursuing graduate work in chemistry there. She was an intern at the Department of Civil and Structural Engineering at the University of Sheffield, and a G1 assistant, microbiology, Department of Bioscience (since 2015), as well as a recipient of study grants from CAP (Center for Professional Development), ANII (National Agency for Research and Innovation), and PEDECIBA (Basic Science Development Program). She presents research results at national and international science events.

Ana Lizeth Mata Delgado
Ana Lizeth Mata Delgado holds a *licenciada* degree in restoration from the Escuela Nacional de Conservación, Restauración y Museografía of the Instituto Nacional de Antropología e Historia and a master's degree in history and art history from the Universidad Nacional Autónoma de México. She is a professor-researcher and head of the Seminario Taller de Restauración de Arte Moderno y Contemporáneo at ENCRyM, and currently the academic coordinator of ENCRyM's degree program in restoration.

Darío Meléndez
Darío Meléndez is a professor at the School of Arts and Design at the Universidad Nacional Autónoma de México. He pursued his bachelor's and master's degrees in visual arts with a specialization in painting, as well as his doctorate in arts and design, at that university. His artistic research focuses on material explorations based in painting, while also touching on the fields of drawing, action art, installation art, and beyond.

Sara Norrehed
Sara Norrehed is an advisor and conservation scientist at the Swedish National Heritage Board. Her main interests are in organic materials and analytical methods for organic molecules. Previous work focused on developing tools for analyzing flexible organic molecules by nuclear magnetic resonance, but recently she entered the field of conservation and heritage science. She holds a PhD in organic chemistry, including a master's degree in natural sciences, from Uppsala Universitet, Sweden.

Barbara Ursula Oettl
Barbara Ursula Oettl has studied art history, American and Italian linguistics, and art at Universität Regensburg, Germany, and at the University of Urbana-Champaign, Illinois. Her books include *White, Transgressions of Art,* and *Richard Serra*; she has also authored essays on photography, gender and body art, bioart, Land art, and the material turn. Oettl is alternately teaching at the Cologne Institute of Conservation Sciences, Kunstakademie Düsseldorf, and Universität Regensburg.

Flavia Parisi
Flavia Parisi holds a PhD from the Universitat Politècnica de València with a specialization in the interdependence of conservation and education in contemporary art museums. She collaborates with different institutions, such as the International Centre for the Study of the Preservation and Restoration of Cultural Property (2013–19) and MAXXI – Museo nazionale delle arti del XXI secolo, Rome (2017, 2019). She previously worked for the Dallas Museum of Art, the Italo-Latin American Institute of Rome, and private galleries.

Mirta Pavić
Mirta Pavić is head of the Conservation Department at the Museum of Contemporary Art, Zagreb, Croatia. She received her MA in conservation from the University of Ljubljana, Slovenia. Pavić teaches a compulsory course on modern and contemporary art conservation at the University of Split. Her research interests include modern materials, new media, modern museum practice, and the educational role of the conservation field.

Flavia Perugini
Flavia Perugini holds a master's degree in architecture from the University of Florence, and a BSc with honors in conservation and restoration from Guildhall University, London. Since 2006 she has been an associate conservator for contemporary art and time-based media art at the Museum of Fine Arts, Boston. She is a fellow of the International Institute for Conservation and the American Institute for Conservation.

Sherry Phillips

Sherry Phillips has worked at the Art Gallery of Ontario, Toronto, since 1989, and specifically as a conservator of contemporary art since 1996. Following an honors BSc in microbiology and zoology from the University of Toronto, she studied art history and studio techniques before continuing her education at Queen's University's Master of Art Conservation program.

Marcia Reed

Marcia Reed is chief curator and associate director for special collections and exhibitions at the Getty Research Institute, Los Angeles. The exhibitions she has curated include *China on Paper* (2007), *The Edible Monument: The Art of Food for Festivals* (2015–16), *Cave Temples of Dunhuang* (2016), and *Artists and Their Books / Books and Their Artists* (2018). Research in progress includes a publication and exhibition on the Jean Brown Collection of avant-garde and Fluxus works.

Cristina Reyes

Cristina Reyes studied visual arts at the School of Arts and Design at the Universidad Nacional Autónoma de México, where she is now a professor. She is a member of the Imago Post Aural research group, coordinated by Víctor Monroy. She works at the Centro de Documentación Arkheia at the Museo Universitario Arte Contemporáneo, Mexico City.

Rachel Rivenc

Rachel Rivenc is the head of conservation and preservation at the Getty Research Institute, Los Angeles. Prior to that she worked at the Getty Conservation Institute, Los Angeles, as part of the Modern and Contemporary Art Research Initiative. She was the coordinator for the Modern Materials and Contemporary Art working group of ICOM-CC for six years and sits on the steering committee of the International Network for the Conservation of Contemporary Art. Rivenc holds a master's degree in paintings conservation from Université Paris 1-Sorbonne and a PhD from the Université de Versailles Saint-Quentin-en-Yvelines.

Kendra Roth

Kendra Roth is the conservator of modern and contemporary art at the Metropolitan Museum of Art, New York. She holds a bachelor's degree in fine arts from Tufts University and a master's degree in art conservation from the State University of New York at Buffalo, and did postgraduate work at the Straus Center for Conservation and Technical Studies at Harvard University. She serves in the Conservation Advisory Group for the Public Design Commission of the City of New York and as assistant coordinator of the Modern Materials and Contemporary Art Working Group of ICOM-CC.

Tom Sandström

Tom Sandström is a conservation scientist at the Swedish National Heritage Board. He holds a MAC from Queen's University. His work focuses on the conservation of organic material, including archaeological wood, and the technical analysis of paintings and other works of art.

Magali Melleu Sehn

Magali Melleu Sehn is an associate professor of conservation of modern and contemporary art of the Conservation-Restoration Course of the Universidade Federal de Minas Gerais, Brazil. She is also a tenured professor in that university's graduate program in arts at its the School of Fine Arts and chief editor of the graduate program's academic journal. She was a conservator of paintings and sculptures for twelve years at the Museu de Arte Contemporânea da Universidade de São Paulo. She holds a bachelor of visual arts, a master's degree, and a PhD in visual poetics in art history from the University of São Paulo – ECA/USP. She authored the book *Entre resíduos e dominós: Preservação de instalações de arte no Brasil* (C/ARTE, 2014) with the support of FAPEMIG (Qualis L3).

Sjoukje van der Laan

Sjoukje van der Laan holds a master's degree and a professional doctorate (PD Res) in modern and contemporary art conservation from Universiteit van Amsterdam. She has been employed at the Art Gallery of Ontario, Toronto, since 2015 as an assistant conservator of contemporary art. Her specialization gives her a strong familiarity with the conservation of a wide variety of modern (synthetic) materials, kinetic art, electronic art, and complex contemporary art installations.

Adrián Villar Rojas

Adrián Villar Rojas creates immersive, situated, and perishing worlds using materials both organic and inorganic, human-made and machine-made, that undergo change over time. Tied to their production and exhibiting contexts, these worlds generate irreproducible experiences relying on collaborative exchange between the artist, his team, and local agents. His projects that extend over open-ended periods of time allow him to question the aftermath of the normalized production of art in the Capitalocene era. He lives and works nomadically.

Sebastián Villar Rojas

Sebastián Villar Rojas is a writer, playwright, and theater director who is currently generating "androgynous" projects that inhabit the borderline between artistic fields, taking advantage of the ontological ambiguity of this liminal zone. He studied political science at the Universidad Nacional de Rosario, Argentina, and holds a diploma in playwriting from the School of Philosophy and Letters, Universidad de Buenos Aires.

Jessica Walthew

Jessica Walthew holds an MA in art history and archaeology with an advanced certificate in conservation from the Conservation Center at New York University's Institute of Fine Arts. At Cooper Hewitt, Smithsonian Design Museum, Washington, DC, she works primarily with the product design and decorative arts collection and digital acquisitions. She is a professional associate of the American Institute for Conservation.

Symposium Participants

This reflects titles and affiliations at the time of the symposium "Living Matter: The Preservation of Biological Materials in Contemporary Art / La Materia Viva: Conservación de materiales orgánicos en el arte contemporáneo," held in Mexico City on June 3, 4, and 5, 2019.

Coline Ardouin, Conservator, Museo Universitario Arte Contemporáneo, Mexico

Mariana Arenas, Assistant Registrar, Museo Universitario Arte Contemporáneo, Mexico

Ana Laura Avelar, Biologist, Escuela Nacional de Conservación, Restauración y Museografía "Manuel del Castillo Negrete," Mexico

Ivana Bačić, Chemist, Ministry of the Interior, Croatia

Gabriel Baldomá, Conservator, Instituto Iicramc, Argentina

Claudia Barra, Pharmaceutical Chemist, Museo Juan Manuel Blanes, Uruguay

Cristina Bausero, Architect, Museo Juan Manuel Blanes, Uruguay

Courtney Books, Andrew W. Mellon Fellow, Paintings, Balboa Art Conservation Center, USA

Alejandra Braun, Conservator of Cultural Heritage, Museo de Arte Moderno, Mexico

María Eugenia Desirée Buentello García, Student, Deakin University / Brandenburg University, Australia

Martha Burgoa, Cultural Manager, CCD, Mexico

Rosa Maria Castellanos Perez, Art History Professor, Universidad Nacional Autónoma de México, Mexico

Adalberto Charvel, Exhibition Designer, Museo Universitario Arte Contemporáneo, Mexico

Davison Chiwara, Lecturer, Midlands State University, Zimbabwe

David Colorado Solis, Chemist, Museo Universitario Arte Contemporáneo, Mexico

Yamile Fernanda Contreras García, Student, Escuela Nacional de Conservación, Restauración y Museografía "Manuel del Castillo Negrete," Mexico

Claudia María Coronado García, Professor, Escuela Nacional de Conservación, Restauración y Museografía "Manuel del Castillo Negrete," Mexico

Andrea de Caso, Curatorial Assistant, Museo Universitario Arte Contemporáneo, Mexico

Magnolia de la Garza, Director, Colección Isabel y Agustin Coppel, Mexico

Gabriel de la Mora, Visual Artist, Mexico

Mercedes Isabel de las Carreras, Chief of Collection Management, Museo Nacional de Bellas Artes, Argentina

María Jimena Díaz Guzmán, Instituto Nacional de Antropología e Historia, Mexico

Megan DiNoia, Graduate Intern, Getty Conservation Institute, USA

Camilla dos Anjos, Graduate Student, Universidade Federal de Minas Gerais, Brazil

Alexandra Sasha Drosdick, Andrew W. Mellon Fellow, Brooklyn Museum, USA

Henry Estipona, Chief Executive Officer, King Financial Consultancy, Mexico

Maura Favero, Collection Department, MAXXI – Museo nazionale delle arti del XXI secolo, Italy

Leticia Fundora Rangel, Professor, Instituto Superior de Arte, Cuba

Pilar Garcia, Curator of the Collection, Museo Universitario Arte Contemporáneo, Mexico

Norma Alicia García Huerta, Chief Executive Officer, L'atelier Patrimonio y Conservación, Mexico

Aura Ximena García Reynoso, Student, Escuela Nacional de Conservación, Restauración y Museografía "Manuel del Castillo Negrete," Mexico

Silvia Ixchel García Valencia, Conservator, Instituto Nacional de Bellas Artes – Centro Nacional de Conservación y Registro del Patrimonio Artistico Mueble, Mexico

Diego González, Student, Escuela Nacional de Pintura, Escultura y Grabado "La Esmeralda," Mexico

Zuelma Ayerin Gonzalez Gamboa, Conservator, Coordinación Nacional de Conservación de Patrimonio Cultural, Mexico

María Antonia Gónzalez Valerio, Professor, Universidad Nacional Autónoma de México, Mexico

Mariana Grediaga, Conservator, Taller de Restauracion EME – Grediaga, Mexico

Guillermo Guevara, Musician, Mexico

Natilee Harren, Assistant Professor of Art History, School of Art, University of Houston, USA

Jens Hauser, Researcher, University of Copenhagen, Denmark

Sol Henaro, Curator of Documentary Collections, Museo Universitario Arte Contemporáneo, Mexico

Rebecca Heremans, Paper Conservator, S.M.A.K., Belgium

Claudio Hernández, Head of Conservation, Museo Universitario Arte Contemporáneo, Mexico

Silvia Hernández Villegas, Conservator, Programs, Instituto Nacional de Bellas Artes y Literatura, Mexico

Elizabeth Herrera, Temporary Loans Manager, Museo Universitario Arte Contemporáneo, Mexico

Carla Patricia Herrera del Valle, Art Director, Sedart, Mexico

Raquel Huerta, Conservator, Mexico

Jasna Jablan, Assistant Professor, Faculty of Pharmacy and Biochemistry, University of Zagreb, Croatia

Luis Jimenez, Student, Universidad del Claustro de Sor Juana, Mexico

Kelly Kleinschrodt, Artist, USA

Verónica Kuhliger, Conservator, Museo Nacional de Historia, Mexico

Angel Lartigue, Artist and Researcher, USA

Tom Learner, Head, Science, Getty Conservation Institute, USA

Karla Leyva, Artist, Mexico

Ana Belen Lezana Iberry, Registrar and Logistics, Colección Isabel y Agustin Coppel, Mexico

Thérèse Lilliegren, Conservator, Moderna Museet, Sweden

Rosario Llamas Pacheco, Professor-Researcher, Universitat Politècnica de València, Spain

Mariana López, Assistant Registrar, Museo Jumex, Mexico

Eugenia Macías, Investigator, MUAC Centro de Documentación Arkheia, Mexico

Jorge Martinez Perez Salazar, Director, CDMX ARTE, Mexico

Ana Lizeth Mata Delgado, Professor Researcher, Escuela Nacional de Conservación, Restauración y Museografía "Manuel del Castillo Negrete," Mexico

Darío Meléndez, Artist, Mexico

Magali Melleu Sehn, Associate Professor of Contemporary Art, Universidade Federal de Minas Gerais, Brazil

Luz Elena Mendoza, Head Registrar, Fundación Jumex AC / Museo Jumex, Mexico

Daniela Merediz Lara, Conservator, Museo Universitario Arte Contemporáneo, Mexico

Natalia Meza Mercado, Student, Escuela Nacional de Conservación, Restauración y Museografía "Manuel del Castillo Negrete," Mexico

Natalia Millàn, Museo Universitario Arte Contemporáneo, Mexico

Julia Molinar, Deputy Director of Collection Management, Museo Universitario Arte Contemporáneo, Mexico

Jo Ana Morfin, Advisor, Universidad Nacional Autónoma de México, Mexico

Rocío Mota, Conservator, Escuela Nacional de Conservación, Restauración y Museografía "Manuel del Castillo Negrete," Mexico

Mónica Nuñez Hernández, Museo Universitario Arte Contemporáneo, Mexico

Barbara Ursula Oettl, Art Historian, University of Regensburg, Germany

Lena Ortega, Artist and Researcher, Universidad Nacional Autónoma de México, Mexico

Jose Ortiz, Conservator, Instituto Nacional de Bellas Artes – Centro Nacional de Conservación y Registro del Patrimonio Artistico Mueble, Mexico

Flavia Parisi, PhD Candidate, Universitat Politècnica de València, Spain

Mirta Pavić, Head, Conservation Department, Museum of Contemporary Art, Croatia

Chantal Peñalosa, Visual Artist, Mexico

Catalina Perez, Librarian, Universidad Nacional Autónoma de México, Mexico

Luis Daniel Pérez González, Independent Artist, La Comedia Humana, Mexico

Flavia Perugini, Associate Conservator, Museum of Fine Arts, Boston, USA

Sherry Phillips, Conservator of Contemporary and Inuit Collections, Art Gallery of Ontario, Canada

Paloma Ramirez, Conservation Student, Escuela Nacional de Conservación, Restauración y Museografía "Manuel del Castillo Negrete," Mexico

Patrick Ravines, Director and Associate Professor, Garman Art Conservation Department, Buffalo State College, USA

Maria Rebora, Student, Escuela Nacional de Conservación, Restauración y Museografía "Manuel del Castillo Negrete," Mexico

Marcia Reed, Chief Curator, Associate Director, Getty Research Institute, USA

Martha Reta, Registrar, kurimanzutto, Mexico

Cristina Reyes, Researcher, MUAC Centro de Documentación Arkheia, Mexico

Renee Riedler, Conservator, American Museum of Natural History, USA

Rachel Rivenc, Head, Conservation and Preservation, Getty Research Institute, USA

Kendra Roth, Conservator, Metropolitan Museum of Art, USA

Paola Ruisanchez, Conservator, Museo Nacional de Antropología, Mexico

Ana Sacristan Civera, Professor, Escuela Nacional de Conservación, Restauración y Museografía "Manuel del Castillo Negrete," Mexico

Sintija Saldāboa, Preventive Conservator, National Library of Latvia, Latvia

Juan Gerardo Salinas, Conservation Student, Escuela Nacional de Conservación, Restauración y Museografía "Manuel del Castillo Negrete," Mexico

Andrea Sanchez Ibarolla, Freelance Conservator and Graduate Student, University of British Columbia, Mexico

Tom Sandström, Advisor, Swedish National Heritage Board, Sweden

Diego San Vicente Charles, Production Manager, kurimanzutto, Mexico

Barry Smith, Director of the Institute of Philosophy, University of London, United Kingdom

Pontus Solden, Bookdealer, Rönnells Antikvariat, Sweden

Francisca Sousa, Registrar, Museu Berardo, Portugal

Sofia Terán, Student, Escuela Nacional de Conservación, Restauración y Museografía "Manuel del Castillo Negrete," Mexico

Sarah Thompson, Administrative Assistant, Conservation, Menil Collection, USA

María del Carmen Tostado Unzueta, Restorer-Conservator, Escuela Nacional de Conservación, Restauración y Museografía "Manuel del Castillo Negrete," Mexico

Giovanna Paola Tress, Conservator, Instituto Nacional de Bellas Artes – Centro Nacional de Conservación y Registro del Patrimonio Artistico Mueble, Mexico

Sjoukje van der Laan, Assistant Conservator, Contemporary Art, Art Gallery of Ontario, Canada

Ana Vargas, Conservator, Escuela Nacional de Conservación, Restauración y Museografía "Manuel del Castillo Negrete," Mexico

Montserrat Vazquez, Conservator, Perpetua Restauración, Mexico

Irais Velasco Figueroa, Professor, Instituto Nacional de Conservación Restauración y Museografía, Mexico

Diana Velázquez, Paper Conservator, Museo Universitario Arte Contemporáneo, Mexico

Elizabeth Villanueva, Intern, Secretaría de Pueblos y Barrios Originarios y Comunidades Indígenas Residentes, Mexico

Sofia Villanueva Bello, Student, Universidad Autónoma Metropolitana Unidad Xochimilco, Mexico

Adrián Villar Rojas, Artist, Argentina

Ana Elena Vivas, Conservator, Escuela Nacional de Conservación, Restauración y Museografía "Manuel del Castillo Negrete," Mexico

Jessica Walthew, Conservator, Cooper Hewitt, Smithsonian Design Museum, USA

Herendira Yáñez García, Conservator, Museo Nacional de Antropología, Mexico

VOGUE
COMPLETE BEAUTY

VOGUE
COMPLETE BEAUTY
Deborah Hutton

First published in paperback in 1983
by Octopus Books Limited
59 Grosvenor Street, London W1

Second impression, 1984

© Illustrations: 1982 Octopus Books Limited
© Text: 1982 The Condé Nast Publications Limited

ISBN 0 86273 087 2

Printed in Hong Kong

Vogue Complete Beauty was previously published
by Octopus Books Limited in 1982 in hardback

C O N T E N T S

What is Beauty?	6
Personal Profile	12
Shape	28
Nutrition	58
Skin, Hair, Teeth and Nails	78
The Senses	118
Cosmetics	136
Lifestyle	170
Biological Body Clock	190
A-Z of Common Disorders	214
Index	222
Acknowledgments	224

Author's acknowledgments

It is, sadly, impossible to acknowledge all the help and advice that I have received while compiling this book. There are, however, a few people who have played a significant part in its production and to whom I am especially indebted.

First, my thanks to Beatrix Miller, Editor-in-Chief of British *Vogue*, who gave me the idea for the book, the opportunity of writing it and her absolute support whenever obstacles presented themselves; to Alex Kroll, Editor of *Vogue* Books, for his help and advice at every stage of the writing; and to Felicity Clark, Beauty Editor of *Vogue*, for lending an experienced eye to the photography and her expertise to the make-up pages. Thanks, too, to Georgina Boosey, Jennifer Harman and Richard Askwith for enabling my life as Health Editor of *Vogue* to proceed as smoothly as it has done, and to Penny Summers and Marie-Louise Avery of Octopus Books for the considerable time and trouble they have taken over the manuscript and its illustration.

More specific thanks go to Barbara Dale for devising the exercises for the Shape chapter and the pregnancy section at the back of the book, to Maxine Tobias for her guidance in compiling the yoga section and to Arabella Boxer for her recipes, which do more than justice to the premise that it is possible to eat healthily and deliciously. Help, comments and criticisms were also gratefully received at the various stages of research, writing and proof checking from Dr Wilfred Barlow, who introduced me to the Alexander Technique, Neville Bass, Dr Malcolm Carruthers, Professor J W Dickerson, Daniel Galvin, Dr Jeremy Gilkes, Dr Ruth Gould, Maggie Hunt, Dr Jonathan Kersley, Dr Veronica Kirton, Dr Patricia Last of BUPA, Mr Phillip Lebon, FRCS, Alastair Murray of London's City Gym, Mr Frederick Nicolle, FRCS, Dr Barbara Pickard, John Reuter, Hugh Rushton of the Philip Kingsley Trichology Clinic and Dr Nichol Thin. If, after all their comments, any inaccuracies remain in the text, they are entirely my own.

Two final and special thank yous to Patrick Collister whose affectionate bullying led me to *Vogue* in the first place and to my family who rescued me from my typewriter on innumerable occasions and sustained me in every way until the book was written.

THE ARTIST'S EYE VIEW

This page
Legendary beauty (right). The exquisite features, perfect bones and long elegant neck of Queen Nefertiti of the eighteenth Egyptian dynasty cast in limestone by an anonymous sculptor, circa 1,500 BC.

Beauty undressed (far right). Cranach's Venus depicts a medieval ideal: pale and slender, nubile and pear-shaped with long thighs low waistline and ears and hands that are disproportionately large. The model who posed for this Venus would almost certainly have been male – hence, perhaps, her slightly androgynous quality. Later painters were to endow her with more opulent charms.

Archetypal beauty (below left). Botticelli's Venus is free and unrestrained – expressive of the values of a new enlightened age and evocative of the memory of an old and golden one. She is very close to our own contemporary idea of beauty, too.

Sultry beauty (below right). Botticelli revived in the shape of Jane Morris, wife of the painter and designer William Morris, posing for Rossetti's study of Proserpine. Her heavy hair, chiselled features, swanlike neck and full expressive mouth convey the strangely sorrowful sensuality of the Pre-Raphaelite ideal.

Opposite page
Society beauty (above). Consuelo Vanderbilt, the turn of the century American heiress who became Duchess of Marlborough and, later, Madame Balsan, here painted by Boldini. Her dark eyes, small heart-shaped face and slim figure were much admired.

Ugly beauty (below). The strong, forthright profile of Lady Ottoline Morrell, in striking caricature by Bussy. A remarkable woman of decided opinions, versatile talents and considerable vanity, Lady Ottoline took 'the utmost pains to set off her beauty,' noted friend and contemporary Virginia Woolf, 'as though it were some rare object picked up in a dusty Florentine back street.'

what is beauty?

Beauty yesterday – historical perspectives

To the ancient Greeks, the secret of beauty lay in the proportions of the face. They divided it into three equal parts — hairline to eyebrow, eyebrow to upper lip, upper lip to chin — and called it the golden section. For them, beauty was a straightforward matter of mathematics.

Renaissance painters kept to mathematics but divided the face into seven. Beauty became the face of a Botticelli angel (later revived by the Pre-Raphaelite artists of the late nineteenth century). Cranach's Venus, with her long white limbs and slender, slightly pear-shaped figure meanwhile celebrated the medieval ideal of bodily perfection. Other artists, dissatisfied with both the classical and the Renaissance lineaments of physical perfection, joined the proportional pursuit of beauty. One of the most notable was Reynolds who plundered features from a number of different sitters and reassembled them to create what he considered to be the perfectly harmonious and absolutely beautiful face. That he could not find it in real life suggests that beauty is not a mathematical equation. It also suggests that perfection, which belongs to art not life, has little to do with it.

The twentieth century has separated the ideal and the actual. Leaving the arena of physical, figurative beauty, art has turned to the abstract — the faceless figures of Brancusi, the huge forms of Moore — that embody subjective ideals rather than present specific examples. Early in the century, the 'real life' image of beauty transferred from canvas and stone to celluloid, the relatively new mediums of still photography and moving film. The idea of beauty, perfect and permanent, was exchanged for that of momentary beauty captured in a single frame — inseparable from the instant that had created it.

Although the instant may have been curiously timeless, the attitude and the style were firmly rooted in their time. Beauty and ideals of beauty are reflections of the age that creates them, however studied or mannered the style, however removed from real life the setting. Whole decades can be summed up by a single image. A 1937 *Vogue* retrospective is enlightening: 'The Great War left a race of nerve-shattered, disillusioned creatures and that type, engendered by hardship and suffering, persisted into beauty's currency. It was *de rigueur* not to look innocent or unravaged.' In such a context, beauty became a decadent, raffish, weary, longer-than-life creature with bobbed hair, dark eyes and heavy drop earrings, hanging, as Cecil Beaton recalled,

TWENTIETH CENTURY BEAUTIES

From left

Paula Gellibrand (above), 1920s flapper and model, combined a fashionable langour with suitably decadent behaviour, wearing hats trailing with wistaria for luncheon appointments and dressing as a nun for her wedding. Cecil Beaton, however, remembered her as: 'a completely unaffected somewhat hearty schoolgirl type…'

Greta Garbo (below). Her Scandinavian looks had an eloquence of expression that had no need for words. Her influence reached its height in the 1930s and persisted for 20 years. Her simple style of dress and sparing use of cosmetics – for many years just a black line across the lid – were endlessly imitated.

Marilyn Monroe (centre), the first of the great sex symbols. Sensuous in red satin or wholesome in checked gingham, Marilyn was America… 'a natural phenomenon like Niagara Falls or the Grand Canyon,' said Nunally Johnson, 'You can't talk to it. It can't talk to you. All you can do is stand back and be awed by it…'

Henrietta Tiarks (below), society beauty, debutante and later successful fashion model, photographed in the year of her coming out (1957).

Penelope Tree (above) and Jean Shrimpton (inset above), two of the great British models of the 1960s… long and leggy with weeping willow hair, elfin faces and black-rimmed eyes. Jean Shrimpton's out-of-doors naturalness presaged the health revival of the next decade.

Margaux Hemingway (below), one of the first of a new generation of American models, took New York by storm in 1975. Her naturally good looks – blue eyes beneath untamed eyebrows, corn blonde hair and sleek, six foot body – made her the highest paid model of the day.

Katharine Hepburn (right), photographed in 1975 at the age of 59, still in enviable possession of the beauty she once dismissed as 'the good fortune to have been born with a set of the characteristics in the public vogue…'

'like fuchsias'. His own portrait of Paula Gellibrand describes the look exactly.

The twentieth century provides new insights. Through photography and written records we can see how images and attitudes towards beauty have changed. From 1916 onwards, *Vogue* gives an unbroken monthly commentary on how women wanted to look and who they wanted to look like. During the 30s and 40s there was an absolute passion for imitation. Garbo, Dietrich, Hepburn … these were the originals. Many of those who followed were confections rather than beauties, created by film producers and publicity managers for a public that craved new idols. Entire looks were 'lifted', gestures imitated, intonations of speech adopted. The cues came from Hollywood and its influence was enormous. In November 1941, *Life* magazine pin-pointed the forty-ninth minute of the film *I Wanted Wings* as one of the historic moments of the cinema. What happened? 'It was the moment at which an unknown young actress named Veronica Lake walked into camera range and waggled a head of long blonde hair at a suddenly enchanted public…' The article continues by describing the cut exactly ('eight inches at the front, 10 inches at the back, it falls straight from the scalp and then begins to wave slowly') and finishes with the wry observation that her hair 'catches fire fairly often when she is smoking'. The fire risk deterred no-one, and Veronica Lake's hairstyle was copied on both sides of the Atlantic for several years.

Whether women created their own idols and ideals of beauty or simply concurred with those created for them is debatable. The general inference, however, is the same — the greatest misfortune was to be born out of one's era, with

features appropriate for some undiscovered style but hopelessly inappropriate for the one of the day. As one of the imitated, Joan Crawford could afford to be scornful and coolly independent: 'Everyone imitated my fuller mouth, darker eyebrows, but I wouldn't copy anybody...If I can't be me, I don't want to be anybody...' *Vogue* was infinitely more sympathetic — 'If we can't be beauties in our period,' it commiserated, 'let's forget it and have fun.' —and concluded with the consoling thought that changing tastes might yet provide the chance of being discovered as an unappreciated star among savages in the centuries to come.

While an appreciation of the idiosyncratic or unusual in beauty was still some way away, ideas and attitudes were changing by the end of World War II. By the mid-1940s, women had secured a new independence for themselves, perhaps as a result of their involvement in the war effort, or perhaps as a culmination of a natural evolution in attitudes that had started a century earlier. They were beginning to disassociate themselves from standards of beauty set up 'on their behalf'. Although women had always been able to choose new modes of dress, make-up or hairstyles, theories of beauty had mainly been left to men — male philosophers, male painters, male poets, male film producers, husbands, boyfriends and admirers. Few had asked women what they thought beauty was, much less what it actually felt like to be beautiful. And few women volunteered such information. These questions would be asked and answered, at least in part, in future years when an energetic spirit of inquiry, born out of the women's movement, would address itself to the whole business of beauty, to woman as object and woman as subject and to the psychology behind it.

But even by the 1950s, women were thinking and talking about beauty in a different way. Nancy Astor, the first woman to break the male-dominated bastion of British politics, is quoted in a *Vogue* feature on the 'Beauty Behaviour of Five Moving Women'. 'Basic beauty,' she said, 'lies in the way a woman walks; it is health and an attitude to life.' This has a modern ring to it. The beauty pages of *Vogue* reflected the new attitudes — beauty as a means to an end, not an end in itself. For women everywhere, beauty was becoming more practical. The attitude of indefinite leisure parodied by *Vogue* in 1916 ('Art is long, and time is fleeting — and that's the reason so many women are late to the opera. It takes time to mix the correct purple for one's cheekbones, to go into details of mauve chin and lips of tender blue....') had disappeared entirely. Women's lives were too busy to allow them to spend hours on their beauty routines. A feature in 1958, simply entitled 'The Busy Beauties' cuts skincare and make-up routines to a matter of minutes and seconds: one minute 35 seconds for the quickest morning make-up and a maximum of 19 minutes and 20 seconds for the most elaborate evening one, which uses 10 different cosmetics and glows with rouge.

The 1960s was a paradoxical decade, being both a throwback to the 20s, with the exhausted stylized look of models such as Penelope Tree — bony bodies, stork-like legs, pale faces and huge, black-rimmed eyes — and an anticipation of the seventies, with models such as Jean Shrimpton and Veruschka moving, jumping, striding out

energetically, and looking well. Beauty and wellbeing were becoming inextricably linked. By the 1970s, any woman concerned about her beauty was also concerned about her health, seeing beauty, not as something to be created from the outside, but something to be nurtured from within. From the beginning of the decade, a revival of interest in natural health, natural beauty and natural remedies reflected a disillusionment with the old order and, more positively, a growing spirit of scrutiny and criticism. The advertisements in the classified pages of *Vogue* reflected the new mood — 'Does concern for your body go deeply enough?' 'Moisturizer alone can't keep skin looking its very best.'

The early 80s have seen a move away from mere 'naturalness'. Beauty retains its interest in natural resources, but now looks to the laboratory as much as to the garden or hedgerow. It is no longer a game of 'let's pretend'. Women, more scientific in their approach, want to be sure that new routines will work and to know how and why they work. In addition, there is a wider appreciation of what beauty entails. The way we live is now recognized to have as much to do with the way we look as any of the more traditional details. Today, a positive outlook counts for more than inherited good looks and a healthy lifestyle for more than the most exotic make-up or elaborate beauty treatment.

Beauty today – towards a new definition

To ask 'what is beauty?' produces many answers, but few conclusions. The small slice of history and the 15 beautiful women illustrated on these pages demonstrate two things. First, ideas of beauty, like ideals of beauty, are highly idiosyncratic. Second, they usually say more about the individual or the society expressing them than about the quality itself.

On canvas or on camera, 1883 or 1983, beauty lies in the eye of the beholder. Beauty is to be looked at, admired, copied, painted, photographed, even disputed. Appreciation of it lies with the onlooker not the owner, and the onlooker is usually a man. Not only is a woman beheld, she also tends to see herself as beheld, looking at herself through other people's eyes and applying other people's standards to what she sees. Art critic John Berger, in an essay taken from a television series which looked at the representation of women in art, maintains that tradition, culture and sexual stereotyping have been responsible for creating an atmosphere of uneasy self-surveillance: 'A woman... is almost continually accompanied by her own image of herself. Whilst she is walking across a room or whilst she is weeping at the death of her father, she can scarcely avoid envisaging herself walking or weeping... One might simplify this by saying : *men act* and *women appear*. Men look at women. Women watch themselves being looked at. This determines not only most relations between men and women but also the relation of women to themselves.'

Perhaps. But, while a woman may be 'almost continually accompanied' by an image of herself, it is not really her own image. It is an image pieced together from other people's judgements or, to be more accurate, the judgements she expects other people to make of her. Women become their own critics, measuring themselves against standards that do

not apply and ideals that do not exist, just as surely as the arithmetically perfect ideal of beauty created by the ancient Greeks did not exist. Women see a graceful slender girl and then they turn to the mirror and look at themselves. The gap between the image and the reflection does not make for beauty, it detracts from it because it generates so much misery and anxiety. If, in the future, a context and a manner of thinking could be created in which every woman, liberated from the apprehension of her own 'imperfections', were free to recognize and so to realize her own beauty potential, a much greater contribution would have been made to the field of beauty than any amount of diets or make-up tips.

For the great majority of women, beauty, as a purely abstract quality, is something that happens to other people. But beauty as an inward feeling is something that can and does happen to them. Most women not only feel beautiful at times but will also be able to ascribe that feeling to a particular mood, situation or set of circumstances. The details differ from woman to woman but the emphasis is the same. Feeling beautiful has to do with the feeling that everything is right. It is a total experience — emotional and psychological, as well as physical and aesthetic. It is summed up as 'being in control', 'feeling really well', 'being challenged', 'feeling rested and relaxed', 'liking oneself', 'liking the person one is with'. Beauty lies no longer in the eye of the beholder but in the heart of the possessor. Although appearance is undoubtedly important to these moments of beauty, it is not beauty itself. It is instead a precursor, a part and a natural consequence of the feeling that you are beautiful. This point is brought expressively to life in a short story by Virginia Woolf, when her timid, anxious, heroine tries on her new dress: 'When she put the glass in her hand, and she looked at herself with the dress on, finished, an extraordinary bliss shot through her heart. Suffused with light, she sprang into existence. Rid of cares and wrinkles, what she dreamed of herself was here — a beautiful woman. Just for a second (she had dared not look longer), there looked at her, framed in the scrolloping mahogany, a grey-white, mysteriously smiling, charming girl, the core of herself, the soul of herself...'

Beauty tomorrow – a question of commitment

Feel beautiful and you will look beautiful. But how do you go about feeling beautiful? The answer is a circular one. You must start by looking good. Beauty and appearances matter, not because we are naturally vain or frivolous, but because, as Scott Fitzgerald once said, only when you have attended to the smaller details of your appearance can you then 'go to town on the charm'. Looking good means making space for beauty in your life, taking the time to exercise and to follow simple skincare and haircare routines, eating healthily and losing weight if necessary, and revising certain aspects of your lifestyle. All these are liberating not constricting because, once you have got these aspects 'right', you will then be freed from all the smaller anxieties that interfere with your ability to concentrate on the things that you really want to do and consider to be worthwhile.

The commitment is less to a new way of life than to a new

way of thinking. Broaden your outlook. Beauty encompasses every part of you. So be aware of yourself, of how you feel in and about yourself. Be aware of the way you treat your body, the way you hold yourself, the way you react under stress, the 'props' you reach out for and the way your body responds to influences inside as well as out.

While each of these aspects is examined in the following pages, this book does not pretend to give the total answer. Books and beauty articles may give you the know-how, but commitment and motivation are the two most important factors and these you must find for yourself. Only the very optimistic or the very beautiful expect to look good without working at it. Everyone can have good health and good looks, provided they look after them. And looking after them depends not so much on what you did not do yesterday or what you intend to do tomorrow as on what you do today.

Today's beauty is radiant, healthy and entirely natural with a clear complexion, shining hair, sparkling eyes, slim figure and positive outlook – qualities epitomized by the Princess of Wales...

personal profile

' "Would you tell me, please, which way I ought to go from here?"
"That depends a good deal on where you want to get to," said the
Cat . . .'

Lewis Carroll

This book is about you. It is about your physical shape and condition, your general level of fitness, your eating and drinking habits, your beauty routines and make-up techniques, your lifestyle and methods of managing stress, your daily and monthly body rhythms. This profile is your starting point. It contains a series of exercises, questionnaires and charts, compiled to enable you to run through each of the aspects listed above and to put them into the only context that really counts: your own. Use the profile first of all to assess what shape you are in — physically, psychologically and emotionally — to see which your weak points are and which your strengths and which areas of your life are most in need of revision. Then determine your aims and objectives. The rest of the book is there to help you acquire them (the profile runs chronologically, in chapter order, through the book). Once resolutions have been made and exercise, diet and beauty routines embarked upon, use the profile as a framework for reference. Some of the charts make provision for this, asking you to fill in one set of details now and one in three months' time when you have had a chance to improve on the aspect being tested. Questionnaires to be answered and charts to be filled out can be copied into a notebook so that you can keep answers and personal details discreetly to yourself.

How do you shape up?

Before embarking on any of the more specific tests for shape and weight detailed below and in the next chapter, check your attitudes to your body.

YOUR BODY IMAGE: how accurate is it?

Your body image has to do with the way you <u>think</u> you look. It may actually have very little to do with your real size and shape. Having a healthy body image means accepting your fundamental frame and body type and feeling happy about the way you look – or, if you do not, analyzing your appearance objectively, the good points along with the bad, and setting yourself <u>realistic</u> goals of change. A less-than-healthy body image means being obsessive about the way you look and what you feel is 'wrong' with your appearance – the image usually distorting in direct proportion to the degree of criticism levelled at it. The way to a better body image lies in altering your outlook, not in trying to alter yourself.

1. Draw a quick sketch of yourself.

2. Answer the following:
a) When people compliment you on your appearance how do you react? Do you tend to disbelieve them?
b) Do you avoid looking at yourself in mirrors?
c) Do you wish you looked like someone else?
d) When you meet people, do you assess them first in terms of fatness and thinness and only then by other aspects of their appearance or personality?
e) Do you feel more at ease with other women if they are 'fatter' than you are?
f) Do you have a 'fat' wardrobe and a 'thin' wardrobe?
g) Do you tend to turn first to the diet pages in a magazine?
h) Do you diet more than once every six months?

3. Write down a list of all your features (hair, eyes, nose, mouth, skin, arms, hands, breasts, stomach, hips, thighs, bottom, etc) and award yourself marks from 3 to 0 for each. 3 is 'marvellous'; 2 is 'not perfect, but I'm happy with it'; 1 is 'I wish I could do something to change it', and 0 is 'terrible'.

1. The Freehand Sketch. Examine it. Is it a fairly accurate reproduction of your general body shape or is it noticeably thinner or fatter? (Ask a friend for her assessment too.) If you made yourself noticeably thinner than you are and, in addition, tend to avoid full-length mirrors and scales, you could be evading the inescapable fact that you are overweight. If you made yourself noticeably fatter, where have you exaggerated? Analyze it. This should help you to understand where you think 'fat'. Now try to discover why.
2. The Questionnaire. All 'Yes' answers indicate that your body image may be bruised. 'Yes' answers to the last five questions indicate that your body image is almost entirely determined by what you weigh. Try to work out why being 'thin' is so important to you. It is essential that you try to answer this if you are to see your relative size and shape in their proper perspective. You may also find the compulsive eating/dieting questionnaire in the nutrition section of the profile helpful. Check your weight against the table given here. If you are overweight, try to lose the extra – but gradually not fanatically. Record your progress on the graph, opposite.
3. The Feature List. Add up all the marks you awarded yourself and divide the total by the number of features listed to get an average. An average of 2 indicates that you are basically happy with the way you look, aware of your imperfections but not obsessed by them and have a realistic and healthy body image. A lower score of between 0 and 2 suggests that you are unhappy with the way you look, have a less-than-healthy body image and are over-exaggerating your bad points. Everyone has good features as well as bad. Cultivate a healthier body image by recognizing which these are.

YOUR BODY WEIGHT: do you need to lose or gain?

height in centimetres

normal weight range

weight in pounds

weight in kilograms

height in inches

Set yourself a goal, take a balanced diet, add incentive and perseverance and plot a steady line.
But before you start, consult the graph to make sure that the 'target weight' you set is realistic and comes within the weight range for your height.

14

YOUR PROPORTIONS: how do you measure up?

When getting into shape, measuring yourself can be just as useful a gauge to how you are doing as weighing yourself. The key is to look at your body as an integrated whole: consider your measurements in relation to each other, not just independently.

Measure yourself at bust when breathing in, at waist at its narrowest part and at hips, thighs and calves all at their widest parts. Enter them in the table below. Now subtract each from the hip measurement (your 'base') and enter these too. See page 31 for 'ideal' proportions so you can see how well you measure up and, if there is a significant discrepancy, what you should be working towards. Fill in the second set of details in three months' time when you have had time to work at improving your shape.

	Measurement	Differences more/less than hips	
Bust			now
			three months time
Waist			now
			three months time
Hips			now
			three months time
Thighs			now
			three months time
Calves			now
			three months time

The graph, right, is designed to enable you to plot your weight loss or gain, week by week, as you follow a specially-tailored eating programme (find a diet on page 74), and to see how you are progressing at a glance. What to do: fill in your present weight, together with the kilograms or pounds above and below it, where indicated along the vertical side of the graph. If aiming to lose, enter your present weight slightly below the top so that minor fluctuations and moments of weakness do not cause you to abandon the exercise, and probably the diet, altogether. Enter today's date at the axis. Plot your weight loss by weighing yourself on the same day at the same time each week and entering it up. Aim for an average weight loss of 1 kg (2 lb) a week. If you are aiming to put on weight, enter your weight towards the bottom of the graph, as indicated, and plot your line upwards.

present
weight if
slimming

present
weight if
gaining

2 4 6 8 10 12

What shapes do the spaces between your legs make when you stand with feet together and knees facing forwards? Ideally, you should be able to see a diamond at the top followed by three longish ovals between thighs and knees, knees and calves and calves and ankles respectively. Four distinct patches of daylight. Any less and your thigh muscles need toning, you are standing incorrectly or you are under or overweight. Which?

YOUR POSTURE: how much do bad habits affect your wellbeing?

Weaknesses in posture generate strain — residual tensions in the muscle, stiff 'locked' joints, pinched blood vessels that restrict circulation, compressed respiratory and digestive systems where the front of the body has slumped in on itself. Such a wide range of strains can produce an equally wide range of ill effects, both vague and specific. Answer the following questions and the next time that any of the problems listed present themselves, or indeed any others that have been puzzling you, consider your posture. There may well be a connection.

1. Do you frequently stand on one leg while 'resting' the other?
2. Do you slump?
3. Do you usually sit with your knees crossed?
4. When you bend down to pick something up, do you bend your back rather than your knees?
5. Do you have a job that entails bending over a desk for extended periods of time?
6. Are you overweight?
7. Do you suffer from backache?
8. Do you suffer from sore, strained neck muscles?
9. Do you frequently get cramp?
10. Do you frequently get headaches – in particular headaches that get worse as the day wears on?
11. Do you have poor circulation? Do your toes and fingers sometimes tingle and feel numb?
12. Do you suffer from indigestion or is your digestion generally poor?

'Yes' answers to any of the above indicate that you are holding and using your body incorrectly. Questions 1 to 4 are concerned with common bad habits that undermine the natural line of the body. They are often aggravated by a sedentary lifestyle (question 5) and, if allowed to persist, may lead to aches, pains and other more specific problems (questions 7 to 12). If you answered yes to question 6, your extra weight is adding extra strain to muscles and joints. Use the next two tests to help you to identify where you are going wrong.

YOUR POSTURE: how symmetrical are you?

We get so used to standing incorrectly, that it is difficult to assess faults in posture simply by looking in a mirror. Ask a friend to take three, full-length photographs of you – back, front and profile. Wear a leotard (no tights) or pants and a bra so that you will be able to see the line of your body quite clearly. Stand straight, but not stiff, so that you feel comfortable and relaxed. Make sure that the edge of the viewfinder is lined up with a vertical plane such as the edge of a door.

Once the photographs are developed, you will need a pen and a ruler. Taking the profile view first, line up the ruler against the side of the photograph and draw a single, vertical line, starting from just behind your ears. Then take the back and front views and, again aligning the ruler against the parallel edge of the photograph – not against the line of your body – draw two horizontal lines, the first at shoulder level and the second at mid-thigh (front) or just beneath the buttocks (back). Add two vertical lines passing along the outer edge of each shoulder straight down to the ground and you now have a set of geometrical reference points that will show you how symmetrically you are standing.

Profile. The line should pass behind your shoulder, down through your knee and out just in front of your ankle. If it does not, try to identify what is causing your body to be out of line, by using the two back and front views as your reference points.

Back and front. Look at the following:
- Your head: is it centrally balanced or is it closer to one vertical line than the other?
- Your shoulders: does the first of the horizontal lines connect to the shoulders at both sides? Is one shoulder some way above or below the other one?
- Your hips and buttocks: are they positioned in the centre of the grid or is one higher than the other or rotated to one side so that one vertical line passes through a hip or a buttock, while the other goes quite wide of it?
- Your fingertips: are they level or does one hand appear to be lower than the other?
- Your knees: are they level?
- Your feet: do you appear to be standing with your weight evenly distributed?
- Can you see any lines of tension along the sides of your neck, back and buttocks? Are your fists clenched?

YOUR POSTURE: how well are you standing?

Now that you are aware of imbalances in the way you stand and hold yourself that may not be immediately apparent when looking into a mirror, try this second test of body alignment, adapted from a technique developed by Matthias Alexander, founder of the Alexander principle, and used by teachers of the principle in order to detect faults in posture – and to correct them too (page 34). This should enable you to pinpoint specific causes for any imbalances you might have noticed earlier and is worth repeating regularly as a useful check on yourself.

Stand with your heels about 5 cm (2 inches) away from a wall and your feet hip-width apart. Now, keeping your heels where they are, sway gently backwards. Which parts of your body touch the wall first?

- If your buttocks and shoulder blades touched the wall simultaneously: you are standing symmetrically and holding your body correctly.
- If one side touched the wall first: you are not holding your body centrally. One side is rotated further round than the other. Return to the starting position and try to adjust the way you are standing so that you are facing absolutely towards the front. Now repeat the exercise.
- If your buttocks touched the wall first: you are carrying your chest too far forwards and your pelvis tilted downwards towards the floor, creating an exaggerated arch in the small of your back. Repeat the test, bringing your shoulders to the wall and placing your hand under this arch. If there is a gap between your spine and the wall such that your hand can slide easily in and out, your spine is too arched. Bend your knees, drop your buttocks and tilt your pelvis slightly upwards. Feel your spine straighten and extend, note how it feels and move up the wall again with your back in this position. Repeat this exercise daily and practise rotating your shoulders too, to bring them back and down.
- If your shoulders touched the wall first: your pelvis is either thrust too far forwards or your back is too rigid (the spine should always be flexible while extended) and your shoulders too far back. Come forward again, and look at yourself side-view in a mirror. Can you see your shoulder blades sticking out? If so, you are almost certainly holding your shoulders too far back. (When standing correctly they should lie flat across your back.) Rotate your shoulders, relax them and let them drop and try the spine extension exercise detailed above.
- If your head was touching the wall: you are holding it too far back, helping to create an exaggerated arch between the back of your head and the base of your neck. This can lead to tense, painful neck muscles and, over the years, a 'dowager's' hump at the base of the neck where these vertebrae join those of the upper back. Free your neck by lengthening it upwards. ·

HOW FIT ARE YOU?

Fitness is a combination of things and they are all important. If you can touch your toes, but cannot climb two flights of stairs without getting breathless, you are not fit. Nor are you fit if you can run a mile in under five minutes, but cannot do a press-up. You must be able to combine the three essential components of fitness – strength, suppleness and stamina. This important trio is tested in the following chapter. Turn to pages 36-9, carry out the exercises there and then enter your rating in the chart, right. Once you have run through the daily exercise programme for three months (also outlined in the next chapter), repeat the tests. You should find that you are able to do significantly better in every area. In addition to these specific aspects, your general degree of activity makes a very important contribution to your state of fitness. This is tested here.

YOUR GENERAL FITNESS: how active are you?

1. Put a pedometer in your pocket or clip it on to your belt in the morning. In the evening, note down how far you walked over the course of the day. Was it
a) more than 6 km (4 miles) **b)** 3 to 6 km (2 to 4 miles) **c)** less than 3 km (2 miles)?

2. Do you take some form of active exercise
a) nearly every day **b)** two or three times a week **c)** once a week or less?

3. When going to offices or apartment buildings, do you use the stairs instead of the lift?
a) always **b)** usually **c)** rarely, if ever

4. When going to work, do you
a) walk or cycle **b)** walk some way to and from the bus stop or the station **c)** drive or take the bus door-to-door?

5. When not in any particular hurry, what is the point in terms of distance at which you decide to take an alternative means of transport in preference to walking?
a) 3 km (2 miles) or more **b)** between ½-3 km (1-2 miles) **c)** less than 1½ km (1 mile)

a answers indicate a very good general level of fitness, **b** answers a fair level and **c** answers a poor one. If your answers were predominantly **c**, think laterally when organizing the details of your day, so that you increase the amount of time you spend on the move. You will find that it is surprisingly easy to double a walking distance of 3 km (2 miles) over the day. So easy, in fact, that you probably will not be aware of any extra effort.

SUPPLENESS, STRENGTH AND STAMINA: how well did you do?

		POOR	FAIR	GOOD	
SUPPLENESS	Deep knee bend				now
					3 months time
	Shoulder grasp				now
					3 months time
	Spinal stretch				now
					3 months time
	Ankle exercise				now
					3 months time
STRENGTH	Wall sit*				now
					3 months time
	Table press-up*				now
					3 months time
STAMINA	Skip test*				now
					3 months time
	Jog test*				now
					3 months time

*** Keep a more precise record by noting down details, such as how long you managed to control the exercise or how many you managed to do, in the appropriate column.**

HOW FIT ARE YOU GETTING?

If you follow the exercise programme outlined in the following chapter together with some form of regular aerobic or stamina-promoting activity two or three times a week, you will become fitter. You will find that exercises you previously found demanding can now be achieved with relative ease and that you can now run or cycle or swim faster and further without becoming tired or breathless. As you get fitter, your resting pulse rate will drop by several beats. It will take much more vigorous exercise to raise it to the levels reached when you were less fit and it will recover more rapidly once exercise has ceased. Make use of these observations to fill out this progress sheet.

To fill out the progress sheet: pick one exercise day each week and note down the date together with details of the exercise taken. Before starting, sit down and take your pulse for 60 seconds to get your resting pulse rate – making sure that you feel comfortable and relaxed first. Take your pulse again immediately you stop exercising (i.e. at the point at which you feel tired and/or breathless), note it down, wait for five minutes and then take it once more. This should give an indication of how quickly your heart and lungs recover after exertion.

Week	Date	Exercise taken (type and duration)	Resting pulse rate	'After exercise' rate	'Recovery' rate
1					
2					
3					
4					
5					
6					
7					
8					
9					
10					
11					
12					

If you have been advised to exercise carefully, or if any of the points listed on page 36 apply to you, you can assess your 'safety' limit when exercising by taking your pulse. Here is a simplified version of a scientific method developed by the Cardiac Research Unit at London's City Gym. Take the constant figure 200, subtract your age and an additional 40, which acts as your 'handicap'. As soon as you begin to tire or to feel breathless when exercising, count your pulse for a minute. If it is racing above your safety figure, STOP. As soon as you feel comfortable exercising within these margins (one to two weeks if exercising regularly), subtract 10 from your figure. Continue until you have taken off the 40-point handicap. If you are over 45, subtract in groups of five and leave an additional 20 with your age.

N.B. If you have hypertension (high blood pressure) and are taking drugs, known as beta-blockers, for it, you should not use the pulse rate method as a gauge of how much exercise you can take or of how fit you are getting. These drugs work to lower blood pressure and may disguise a true pulse reading.

How well are you eating?

This profile is designed to give you an insight into how healthy your eating habits and your attitudes towards food are. First, to get as objective an assessment as possible, compile a food diary. Note down everything you eat and drink over a two-week period.

Use a small notebook and fill it in immediately after eating. Include everything, from the smallest snack upwards. Note down the time, when and where you eat or drink, and how you feel after doing so, using the rating system given here, together with any symptoms that you feel may be food related, such as constipation, indigestion, pronounced mood or energy swings, or migraine.

RATINGS
When and where was food eaten?
5 With others, sitting down, undistracted.
4 On your own, sitting down, undistracted.
3 With others, sitting down, distracted (e.g. watching TV).
2 On your own, sitting down, distracted.
1 On your own or with others, standing up, in a rush.

How satisfying was it?
5 You enjoyed it: it was just what you wanted.
4 It was good initially, but you ate too much.
3 It did not really satisfy your hunger but you ate it anyway.
2 You were not really hungry; felt bloated/guilty after.
1 You did not enjoy it and soon lost interest.

YOUR APPETITE AND OUTLOOK: how healthy are they?

Add up the total number of meals eaten (nourishing snacks are meals; crackers and potato chips are not) and divide by 14. Add up the ratings separately and divide each by the total number of entries, to give an average. Now add the three figures together. Between 12 and 16: you have a good appetite and a healthy outlook towards what you eat. Less than 10 points: you are unlikely to be eating in a balanced way. Less than 8 points: you are certainly not. Three areas might be responsible.

• <u>You are not balancing your food intake.</u> Do you tend to eat nothing at all for most of the day and then eat one large meal? Or do you tend not to eat meals at all and to subsist on unhealthy snacks? Or is your appetite generally poor? Eating in a regular, balanced way does not necessarily mean eating three conventional meals a day, but it does mean balancing your eating timetable carefully so that your energy is sustained throughout it.
• <u>You do not give yourself enough time to eat, or you eat amid so many distractions that you do not have the space in which to enjoy your food.</u> Make meals a more central feature of your life. Do not rush them.
• <u>You are not a good judge of what your body needs.</u> Listen to your appetite – and stop before you reach the point of satiation.

YOUR DIET: how nutritious is it?

Go through the notebook again and check your diet against the list of foods below.

Over the two-week period, did your diet include the following?
1. Eggs – at least three a week.
2. Milk – at least 275 ml (10 fl oz) whole or skimmed a day.
3. Cheese – at least 175 g (6 oz) a week.
4. Offal, such as liver or kidney – at least one serving a week.
5. Meat or poultry – at least four servings a week.
6. Fish – at least one serving a week.
7. Seafood – at least one serving in the two-week period.
8. Vegetables – at least two different types a day.
9. Starchy carbohydrates – wholemeal bread, cereal, potatoes, rice, pasta, pulses (at least two slices/helpings a day).
10. Fresh fruit – at least one or its juice a day.

There is a maximum score of 14 for each of the 10 food groups. For foods specified on a daily basis, score 1 point for each day on which these foods were eaten; for foods specified on a weekly basis, score 7 for <u>each</u> of the respective weeks; for seafood score 14. If you have an allergy to any of the foods, and therefore cannot eat them, skip the offending category and award yourself 14. (If you are vegetarian, few of these groups will apply, so miss this section altogether and turn to page 60.) Now add up your score.
<u>Maximum total score 133.</u> You should be able to gain top marks on this test very easily, but scores of over 115 still indicate that you are eating in a healthy, balanced and varied way. Scores below this and, particularly, scores of less than 95, indicate that you should make some immediate alterations in your eating habits. If you are omitting some, or even most, of these foods from your diet, the chances are that you are eating too much highly refined and processed food. Rebalance your diet around these 10 essentials and omit, or at least cut down on, the rest. Read the Nutrition chapter for further guidelines on healthy eating.

YOUR FOOD PSYCHOLOGY: are you a compulsive eater/dieter?

Compulsive eating, often accompanied by obsessive weight watching and stringent 'crash' dieting, is particularly miserable. This test is based on a recognized method of checking your attitudes towards what you eat and what you weigh, and is known as the Herman & Polivy Scale of Restrained vs Unrestrained Eating.

1. How often do you diet?
a) never b) rarely c) sometimes d) usually e) always

2. What is the maximum amount of weight that you have ever lost in one month?
a) 0-1.8 kg (0-4 lb) b) 1.9-4 kg (4.1-9 lb) c) 4.1-6.3 kg (9.1-14 lb) d) 6.4-8.9 kg (14.1-19.9 lb) e) 9 kg or more (20 lb or more)

3. What is the maximum amount of weight that you have ever gained in a week?
a) 0-0.5 kg (0-1 lb) b) 0.6-1 kg (1.1-2 lb) c) 1.1-1.3 kg (2.1-3 lb) d) 1.4-2.2 kg (3.1-5 lb) e) 2.3 kg or more (5.1 lb or more)

4. In a typical week, how much does your weight fluctuate?
a) 0-0.5 kg (0-1 lb) b) 0.6-1 kg (1.1-2 lb) c) 1.1-1.3 kg (2.1-3 lb) d) 1.4-2.2 kg (3.1-5 lb) e) 2.3 kg or more (5.1 lb or more)

5. Would a weight fluctuation of 2.2 kg (5 lb) affect the way you live your life?
a) not at all b) slightly c) moderately d) very much

6. Do you eat sensibly in front of others and binge alone?
a) never b) rarely c) often d) always

7. Do you give too much time and thought to food?
a) never b) rarely c) often d) always

8. Do you have feelings of guilt after over-eating?
a) never b) rarely c) often d) always

9. How conscious are you of what you are eating?
a) not at all b) slightly c) moderately d) extremely

10. How many pounds over your desired weight were you at your maximum weight?
a) 0-0.5 kg (0-1 lb) b) 0.6-2.2 kg (1.1-5 lb) c) 2.3-4.5 kg (5.1-10 lb) d) 4.6-9 kg (10.1-20 lb) e) 9.1 kg or more (20.1 lb or more)

Score 1 for each **a** answer, 2 for each **b**, 3 for each **c**, 4 for each **d** and 5 for each **e**. Add them up. Out of a maximum of 45, scores of 30 or more indicate very definite compulsive eating/dieting patterns (find guidelines on breaking the compulsive habit on page 76); scores of between 20 and 30 that, although you are conscious of what you eat, you have a healthy outlook to eating and dieting; scores of less than 20 that you are almost entirely unconcerned with what you eat and how much you weigh.

What are your beauty routines?

Do you think of your beauty care in terms of routine? You should do. The small details – what you do every day in terms of looking after your skin, hair, teeth and nails – have much more bearing on their health and appearance than occasional extravagances. The perfect routine is four things: regular, thorough, simple and, most important of all, suited to your own needs. It should be flexible enough to take account of changes – an increased oiliness in face and hair just before menstruation, a change in climate, a change in scalp condition… Do not let routine simply slip into habit. Habit, like a smooth groove in the brain, is a process so automatic that you no longer have to think to do it. You <u>should</u> think about your beauty routines. You should be awake to the possibility that they are no longer appropriate for you. You should, if necessary, change them. These four questionnaires ask some of the questions you should be asking yourself.

YOUR SKIN TYPE: how much note do you take of it?

Allow skin type to determine skincare routine and you will be giving your skin the best possible attention. But how much attention do you pay to your skin? Inspect your face closely in a magnifying mirror in the daylight. Then answer the following.

1. Is your skin tone
a) even in colour and texture **b)** blotchy in colour and bumpy to the touch **c)** shiny, fairly soft and supple to the touch?

2. Are the pores on your chin and around the base of your nose visible?
a) when you hold the mirror at about 15 cm (6 inches) distance.**b)** only when you peer into it **c)** when you hold the mirror at arm's length

3. Do you have a tendency to break out in spots?
a) sometimes **b)** never **c)** frequently

4. Which age group do you come into?
a) between 25 and 35 **b)** over 35 **c)** under 25

5. Do you have a 'break through' problem with make-up?
a) occasionally during the summer; never in the winter **b)** never **c)** frequently

6. Do you have any of the following and, if so, how many? Fair or red hair; blue, green or grey eyes; a very fair complexion; asthma or eczema; a tendency to burn easily in moderate sunlight; a tendency to blush easily when nervous or embarrassed and/or a tendency to flush after drinking moderate amounts of alcohol; a dry, tight feeling after washing your face with soap and water; a tendency to blotchiness after using certain types of skincare or make-up products; rashes on your face that seem to appear and disappear for no reason at all?
a) yes, three or more **b)** yes, less than three **c)** no

7. When you sunbathe do you
a) keep your face well out of the sun <u>or</u> use a special sunscreen with a high SPF factor <u>or</u> a total sunblock **b)** use the same tanning lotion that you use for the rest of your body **c)** put nothing on your face at all – sunlight seems to help your skin?

8. How would you describe your beauty routine?
a) simple and regular – you cleanse, tone and moisturize twice a day **b)** elaborate – you are always trying new products and new routines but you have never yet found one you have been able to keep to **c)** erratic, obsessive or non-existent

9. When were you last aware of any change in the behaviour of your skin?
a) within the last month **b)** within the last year **c)** you have never noticed any change

10. How often do you use an exfoliant (peel-off mask, washing grains, abrasive glove) on your face?
a) regularly – once or twice a week **b)** occasionally – whenever your skin is looking grey and dull **c)** never

<u>Questions 1 to 6 are designed to give you an idea of your basic skin type</u>: **a** answers for questions 1 to 5 indicate that you have a fairly normal skin type; **b** that you have a tendency towards dryness and **c** that you have a tendency towards oiliness. A combination of answers? A combination skin type. If you answered 'yes' to **6a** you have a more than normally sensitive skin; **6b** may also indicate this. Find guidelines on caring for each skin type in the skin section and, if you have a sensitive skin, read pages 138-9 too.

<u>Questions 7 to 10 are designed to give you an idea of how well you look after your skin</u>: **b** and **c** answers indicate that you may not be giving your skin the chance to look its best. This may not be having immediate effects on the appearance of your skin now but it might well do in 10 or 20 years' time.

YOUR HAIR AND SCALP CONDITION: are they inflicted or inherited?

Your hair condition owes much more to what you do to it than to what nature, in terms of genetic inheritance, does to you.

1. Which best describes the texture of your hair?
a) fine and straight **b)** neither fine nor coarse and slightly wavy
c) coarse and wavy or curly **d)** none of the above

2. Which best describes the colour of your hair?
a) fair or mouse **b)** dark **c)** red, auburn or grey

3. Which best describes the condition of your hair?
a) shiny but lank **b)** glossy **c)** dull and frizzy

4. Three days after washing, how does (would) your hair look?
a) oily and limp **b)** just about ready for a wash **c)** shinier and more manageable than it was immediately after washing **d)** it would look OK, but the scalp would feel oily and itchy

5. Do you use heated rollers, curling tongs or a hair drier hot enough to make your head feel very warm when drying your hair?
a) yes, frequently **b)** yes, occasionally **c)** never

6. Have you had any of the following done to your hair within the last year?
a) highlights, temporary or semi-permanent tints **b)** bleaching at the salon or in the sunlight, perming or straightening, permanent tint (does not include 'natural' dyes such as henna) **c)** none of these

7. Does your hair lose its texture when wet?
a) no **b)** yes, it becomes very matted and limp like wet cotton wool.

8. Scrape the scalp gently with a comb. Is there any scaling?
a) yes, small white flakes **b)** yes, larger scales **c)** no

9. If you answered yes to 8a or b, do any of the following apply? You have a generally dry skin; you have been away to a hot climate recently; you tend to rinse your hair once only after shampooing; you use hair sprays and/or setting lotions; you eat a lot of hot spicy or salted foods and/or drink a lot of alcohol; you suffer from psoriasis or eczema?
a) yes **b)** no

Questions 1-4 are designed to give you an idea of your current hair type. Predominantly **a** answers indicate that your hair is oily; predominantly **b** answers that it is normal or mixed condition (dry at the ends, oily on the scalp – particularly likely if you answered yes to **4d**); predominantly **c** answers that your hair has a tendency to dryness which you may have either acquired through lack of proper care (**5a**) or through chemical processing (**6b**). This is particularly likely if your hair is porous (**7b**).

Questions 8 and 9 are designed to help assess the condition of your scalp. If you answered **8a** or **b**, you could have a flaking scalp condition – not necessarily dandruff. Positive answers to anything listed under **9** indicate other culprits. Consider these first and take the appropriate action, before switching to an anti-dandruff shampoo which may be unnecessarily harsh on your hair.

YOUR TEETH AND GUMS: how well do you look after them?

If your teeth cleaning routine is thorough, your mouth will be healthy. If dental hygiene is lax, your gums will be infected and your teeth may be in jeopardy.

1. When did you last see your dentist?
a) within the last six months **b)** within the last year **c)** you cannot remember

2. Have you ever been shown how to brush your teeth properly and how to look after your mouth?
a) yes **b)** no

3. When did you last have your teeth professionally cleaned and polished?
a) in the last six months **b)** in the last year **c)** more than a year ago

4. Do you use plaque disclosing tablets?
a) regularly **b)** rarely **c)** never

5. What happens when you use dental floss?
a) it slides easily up and down between the teeth once past the point where they meet **b)** it gets caught and snagged **c)** you never use it

6. With regular (twice daily) brushing, how long does a toothbrush last before the bristles splay out?
a) about three months **b)** one to three months **c)** less than a month

7. Look carefully at your gums in a mirror. Note how they look. Then clean them thoroughly and inspect them carefully again. Are they
a) the same colour as they were before and lying fairly flat against the teeth **b)** reddish in colour, slightly inflamed and/or bleeding a little especially at the gum/tooth margin **c)** very sore, inflamed and/or bleeding profusely?

8. How often do you clean your teeth?
a) twice a day **b)** once a day **c)** erratically, whenever you remember

All these questions are designed to help you test the relative health of your teeth and gums – in themselves a reflection of how well you are looking after them. If you scored all **a** answers, congratulations – you are one of two per cent of the population with no signs of gum disease, a healthy mouth and an efficient teeth cleaning method. If you scored any **b** and **c** answers, turn to pages 111-12 to see how your current teeth cleaning routine might be improved. If you answered **1b**, **c**, **2b** and **3c**, make an appointment to see your dentist or dental hygienist.

YOUR NAILS: how sound is your health, how good is your manicure routine?

Nails, rewardingly, will repay every minute spent looking after them – provided that you manicure them properly and protect your hands from damaging influences. Look at them carefully, then answer the following.

1. Are your nails the same colour as the skin beneath them (or the palm of your hand if you are dark skinned)?
a) yes **b)** no, they are significantly lighter or darker

2. Is the nail surface
a) smooth and even **b)** ridged?

3. Are your nails brittle and inclined to crack or to break easily?
a) no **b)** yes

4. Do you wear rubber gloves for wet domestic chores?
a) yes **b)** no

5. Do you do a lot of housework, gardening and/or decorating?
a) no **b)** yes

6. Are your cuticles damaged – cut, puffy or sore?
a) no **b)** yes

7. Do you ever use anything made from steel, including scissors, when manicuring your nails?
a) no **b)** yes

8. When you manicure your nails, do you cut or trim the cuticle?
a) no **b)** yes

Questions 1-3 are designed to give you an insight into your general health, as it is reflected in the condition of your nails. **b** answers indicate that it is not – or recently has not been – as good as it might.

Questions 4-8 are designed to check on how carefully you look after your nails. If you answered **b** to any of these, your less-than-perfect nails are probably owing to careless manicuring (turn to pages 115-17 to see where you are going wrong) or to exposure to damaging chemicals, such as detergents, paint stripper and nail varnish remover.

Do you make the most of your face?

Make-up is highly individual. Faces are different, preferences vary, fashions change. Personality makes a difference too. But even with so many variables, there are still basic principles that can make all the difference between a make-up which works and one which does not.

YOUR FACE AND FEATURES: how close to 'perfect' are they?

Measure your face to see how it compares with the perfect proportions given below. This will help you towards a better appreciation both of its general shape and of the relation of your features to each other – how close together your eyes are set, for example. Find further details on page 142.

Feature	Measurement/comments	'Perfect'
Length of face		1½ x width
Width of face		⅔ of length
Width of jaw		slightly less than face
Eye spacing		1 eye length
Width of mouth		between inner edges of iris

YOUR COLOUR QUIZ: how compatible are your make-up and your natural colouring?

There are no absolute rules about make-up colours. Unusual combinations of colour, even obvious contradictions, <u>can</u> be very effective – but you must know what you are doing. This quiz aims to guide, not to dictate. If you already have a colour scheme that works well for you, fine. If not, complete the questionnaire to see where you might be going wrong and to get some fresh ideas.

1. Is your natural colouring
a) very pale, with no pink or orange in the skin **b)** fair with a pinkish colour **c)** reddish **d)** sallow **e)** olive **f)** brown or black?

2. Is your foundation
a) the same colour as your skin **b)** lighter than your skin **c)** darker than your skin?

3. Where do you test for colour when buying foundation?
a) on the back of your hand **b)** on your face

4. Is the predominant colour tone in your foundation
a) ivory **b)** light with a hint of pink **c)** light to mid beige **d)** cream with a tinge of bronze **e)** mid beige **f)** tan brown or dark brown?

5. Which best describes your blusher colour?
a) light shimmery pink or mid pink **b)** bright pink, peach or coral **c)** tawny brown or chestnut **d)** bronze **e)** tawny red **f)** strong deep pink, such as fuchsia or raspberry

6. Are your lip colour and blusher
a) about the same general colour family **b)** completely different in colour?

7. Are your eyes
a) blue or grey **b)** green or hazel **c)** brown?

8. Which of these eye colours/colour combinations do you like?
a) silver/lilac shading with grey to emphasize **b)** pink/gold shading with brown to emphasize **c)** soft beige/pink/apricot shading with charcoal to emphasize **d)** soft neutral colours – pinks, beiges, browns **e)** pastel colours – powder blue or pink and green **f)** strong, solid colours – bright blue, deep pinks and purples?

9. How much note do you take of what you are wearing when choosing eye colours?
a) a great deal. Depending on the look you want to achieve, you choose subtle tones of the same colour or complementary neutral shades or a deliberate contrast for a dramatic effect. **b)** little, if any

Mistakes are almost inevitable when making up if skin tone is misjudged or overlooked. Here, as in real life, blusher and foundation tones should match up with natural colouring. Hence, if you answered **a** for question 1, you should have also answered **a** for questions 4 and 5. Foundation should always match skin (2) – the skin of your face <u>not</u> your hand (3). If the skin is naturally dark (**1d**, perhaps, **1e** and **1f**), the foundation can be a tone or two darker. But going lighter makes any face masklike. Lip colours and blushers should also coordinate (6); very fair skin tends to look stagey with strong lip colour and blusher, darker coloured skins look good with deeper, more vibrant shades. Almost any colour can look good on almost any colour eye. Particularly effective combinations: **8a** for **7a**; **8b** for **7b**; **8c** for **7c**. **8d** is good for anyone and makes a marvellous, natural daytime look. Clothes should always be taken into account when choosing eye colours as should skin tones: **8e**, for example, will look good on **1b** (not so good for darker coloured skins) while **8f** will look marvellous on **1e** or **1f**.

Do you pass your stress test?

YOUR HAZARD POTENTIAL: how much change is there in your life?

Variety and change are the spice of life. Too much of it and you increase your susceptibility to stress and stress-related illness and your chances of having an accident. In 1972, US Navy Doctors Thomas Holmes and Richard Rahe devised an 'early warning' system to enable you to estimate your 'hazard' potential. The system involves adding up a number of units relative to the degree of change in your life over a period of six months. A high score does not necessarily mean that you are bound to become ill or have an accident, but it does place you significantly more 'at risk'.

1. Death of husband or lover	100
2. Divorce	73
***3.** Giving up 'hard' drugs, including alcohol if dependent	71
4. Marital separation or end of a long-standing relationship	65
5. Prison sentence	63
6. Death of close family member	63
7. Personal accident or illness	53
8. Marriage	50
9. Being dismissed or made redundant from work	47
10. Reconciliation with husband or lover	45
11. Retirement	45
12. Change in the state of health of one of the family – for better or for worse	44
13. Pregnancy	40
***14.** Giving up cigarettes (40 or more a day)	39
15. Sexual difficulties	39
16. Birth of a baby in the immediate family	39
17. Changes at work (moving offices, having a new boss, etc)	39
18. Change in your financial state – for better or for worse	38
19. Death of a close friend	37
20. Change to a different type of work (promotion, new job)	36
21. Change in number of arguments with lover or husband	35
***22.** Premenstrual tension	33
23. Taking out a mortgage or loan over £20,000 ($40,000)	30
24. Change in the amount of responsibility at work	29
***25.** Jet lag	29
26. Children leaving home or going to school	29
27. Difficulties with in-laws	29
28. Outstanding personal achievement	28
29. Changing personal habits	24
30. Difficulties with superiors at work	23
***31.** Giving up cigarettes (less than 40 a day)	21
32. Moving house	20
33. Taking up a new interest or giving up an old one	19
34. Change in social activity	18
35. Taking out a large mortgage or loan	17
36. Change in sleeping habits	16
37. Change in eating habits	15
38. Seeing your family more or less often than previously	15
39. Holidays	13
40. Christmas	12
41. Minor violations of law, such as driving offences, etc	11

150 or under. You are living in a safe and stable way and are less likely than average to have an accident or to become ill.

150-200. Your likelihood of having an accident or of becoming ill is 37 per cent greater than usual.

200-300. Your chances of having an accident or of becoming ill are now 51 per cent greater than usual. You should attempt to limit the degree of change to those areas of your life that are within your control.

300 or over. Your chances of having an accident or of becoming ill are now very high – 79 per cent greater than usual. (US Airforce pilots with this score are forbidden to fly because their chances of having an accident or making a miscalculation are so high.) You should be careful, too, and lead as quiet and unstressful a life as you possibly can, until your score drops.

*Do not appear in Holmes' and Rahe's original list of Life Change Units.

YOUR PHYSICAL RESILIENCE: how fit are you for managing stress?

The body and the mind were once thought to be two quite separate entities. But now scientific research into psycho-somatic (literally 'mind-body') disease is showing that the body and the mind interact on a number of complex and very subtle levels. Negative emotions, such as fear and anxiety, can increase susceptibility to physical stress of all kinds, from indigestion to infection, and can certainly aggravate, if not produce, tangible symptoms. Positive emotions, on the other hand, seem to be able to protect. To find out how fit you are for managing stress, answer the following.

1. Do you walk less than 3 km (2 miles) a day (see fitness test)?

2. Do you smoke?

3. Do you drink more than five cups of tea or coffee a day?

4. Do you rely on sweet, sugary things, such as soft drinks and chocolate, to keep you going?

5. Are you 3 kg (7 lb) over or under the weight range given for your height (see page 31)?

6. Do you sleep badly?

7. On balance, do you work for more than nine hours a day?

8. Were you unable to take at least one complete day off last week?

9. Did you fail to take some type of exercise last week?

10. Did you find you had no time in which to pursue an interest last week, such as painting or photography, quite apart from your work at home or in the office?

11. Do you find that you are more sensitive to the comments and criticisms of others than you used to be?

12. Do you find that you are more irritable than you used to be and that it takes smaller and smaller things to upset you?

13. Do you have consistently low physical, though not necessarily nervous, energy?

14. Do you have difficulty in 'letting go' and laughing?

15. Do you suffer from any of the following: persistent mouth ulcers; digestive problems, such as frequent indigestion or loss of appetite or a diagnosed peptic ulcer; outbreaks of dry, scaly skin on your face; frequent headaches that get worse as the day wears on; nagging pains in the neck and lower back and general stiffness in the muscles and joints?

Count up the number of 'yes' and 'no' answers. A score composed entirely or very largely of 'no' answers (13 or more) indicates that you are living in a way that will not add additional and unnecessary stresses to your life and, just as important, that will tend to minimize the potentially negative effects of other, unrelated stresses that you do encounter. Three or more 'yes' answers indicate that a sedentary inactive lifestyle and/or too little time to relax and enjoy life outside the pressures exerted at home or at work (questions 7 to 10), may be undermining your ability to manage stress. More than seven 'yes' answers indicate that you are over-working, over-worrying and definitely increasing your chances of succumbing to stress-related ill health. Perhaps you already have (question 15). Analyze your answers carefully, try to lower your score and read the Lifestyle chapter for guidelines on managing stress.

YOUR PSYCHOLOGICAL RESILIENCE: do you have an 'at risk' personality type?

Some personality traits have been shown to be more likely to lead to stress-related ill health than others. Of two 'at risk' personality types, the first predisposes to excessive stress by inviting it, and the second by allowing it to become too important. Do you recognize yourself in either profile?

1. Are achievement and personal success extremely important to you?

2. Do you thrive on competitions, sports and games where you are pitting your wits or your physical strength against others?

3. Do you find other people's failings (inefficiency, incompetence, unpunctuality) infuriating?

4. Are you time conscious and do you expect others to be so too?

5. Do you tend to do everything in a rush, including walking, talking and eating?

6. Are you easily bored?

7. If your life is relatively quiet, do you tend to crave excitement?

8. Do you feel most stimulated when under pressure, such as trying for a deadline, starting a new job or undertaking something that you feel may be beyond your capabilities?

9. Do you consider sleep a waste of time?

10. Do you always wake to an alarm and/or do you feel guilty if you 'oversleep'?

11. Do you find it difficult to relax and 'switch off'?

12. When you have finished an important task or project, do you plunge into the next without savouring a sense of achievement?

13. If you have a problem at work or at home, do you tend to rehearse the scene endlessly in your head?

14. If 'yes' to the above, do you find yourself unable to act it out without becoming angry, tearful or self-effacing?

15. Do you find it difficult to express your feelings for others?

16. Would you find it difficult to ask for a raise in salary at work?

17. If something you do is criticized, do you accept the criticism, even if you feel it was unjustified?

18. Do you find it difficult to turn down invitations that you are being pressed to accept when there is something that is more urgent or that you would prefer to do?

19. Do you find it difficult to express an opinion with which others might not agree and/or to speak up when someone else is expressing an opinion with which you strongly disagree?

20. Do you find it difficult to ask for money that is owed you?

21. Would you find it difficult to take a new and faulty item back to the shop and to ask for a repair or your money back?

22. Do you feel that you have achieved nothing in life and have very little to be proud of?

Questions 1 to 12. Six or more 'yes' answers indicate very definite type 'A' personality traits. While type A women tend to be 'achievers', they also tend to be more prone to the negative effects of stress than the more easy-going type 'B' (see page 172). So, learn how to relax and find creative rather than competitive activities outside your immediate sphere of work. You will then be extending your potential and substantially reducing your chances of succumbing to stress-related ill health.

Questions 13-22. Four or more 'yes' answers indicate that your self-confidence is low and that you find it difficult to assert yourself. In addition, the difficulty you find in expressing what you feel may result in prolonged psychological stresses. Try to assert yourself, to build up more self-esteem, by finding things in yourself and in what you do that you like and feel are worthwhile. You may well find that your relationships – at home, at work and socially – improve as a result.

What do you lean on?

Props, physical and psychological, are integral parts of many twentieth-century lifestyles – particularly lifestyles that are either very high or very low in the level of stimulation they provide. In this respect, pressure and boredom seem to be equally stressful.

Smoking and drinking, two of the most common and socially acceptable props, are examined separately in the questionnaires on the following pages. But almost anything can act as a prop – people, food, music, television, sleeping pills, addictive and non-addictive drugs… anything used to buffer you from the harsher realities of life or to step up the degree of excitement it provides.

Do you know what your outlets are? What you turn to in moments of crisis? What you take refuge in when angry, anxious, frustrated or depressed? Here is a short list of questions to ask yourself. Read each through carefully; trying where possible to visualize specific events that have happened to you. You might find it illuminating.

1. Think back to the last major upheaval or set-back in your life. Replay it in your mind, detail by detail. What was the first thing you did, and the second…? How did you respond? What, if anything, did you reach out for?

2. How do you respond to smaller dramas, disappointments and frustrations, such as spending hours on a project at work to be told it is not right and will have to be done again? Do you burst into tears or lose your temper? Do you keep your cool? Do you talk it 'out of your system'? Do you attempt to put as much space as possible geographically between you and the situation? Do you seek consolation in something or from someone?

3. If you keep your cool, how long do you keep it? Indefinitely?

4. If you seek consolation, do you seek it in people or in things? If you seek it in things, what sort of things are they?

5. Do they make you feel better?

6. How were you consoled as a child? Can you see any connection between the way you were treated then and the way you respond now?

7. When you achieve something (a tight deadline, a difficult weekend with your relatives), do you reward yourself in some way? If so, is it the same way you consoled yourself when upset or is it different?

8. How were you rewarded for the things you did as a child? Can you see any connection between the way you were rewarded then and the way you are rewarding yourself now?

9. Think back to the last time you were bored. How long ago was it? What did you do to amuse yourself?

SMOKING: when and why do you smoke?

This questionnaire has been designed to help you to discover the cues, conscious and unconscious, that prompt you to reach out for a cigarette and to help you to reflect on your own habit more deeply. Once you can recognize which your particular cues or weak moments are, you can then take steps to deal with them.

If you smoke at all, answer the following.

1. Do certain things feel 'wrong' if you do not have a cigarette in your hand?
Examples: having a drink; after a meal; telephoning a friend; chopping the vegetables for dinner; watching TV; talking to someone else who is smoking. Analyze each cigarette you smoke as you smoke it, try not having one in similar circumstances next time round, and write down those circumstances in which you would feel uncomfortable without one.

2. Do you find that you sometimes absent-mindedly light a cigarette without being aware of it or that you ever have more than one cigarette alight at once?
a) yes **b)** no

3. Here are five occasions in which you might feel the desire to smoke. Rate them in order of priority.
a) You have been in a meeting or at the theatre and have not had a cigarette for two hours.
b) You have just had a furious row at work.
c) You are sitting in front of the television watching a programme that only vaguely interests you.
d) You are sitting in a bar having a drink with a friend; there is a bowl of peanuts on the table.
e) Someone else is smoking and offers you a cigarette.

Here are four occasions in which your desire to smoke may vary with the particular circumstances. Which most sums up yours?

4. When driving
a) You smoke at fairly regular intervals regardless of what is going on inside or outside the car.
b) You smoke more if you are infuriated by the traffic (there is a traffic jam, for example) or if arguing with your passenger.
c) You smoke more if there are few distractions – you are on your own, or cruising down the motorway.
d) You smoke more if someone next to you is eating chocolates.
e) You only smoke if someone else is, if then.

5. When telephoning
a) You smoke as soon as the telephone rings or you start to dial the number.
b) You smoke only if it is a call that you feel particularly nervous or excited about.
c) You smoke only if you 'settle down' to a long conversation.
d) You smoke very rarely or not at all.

6. When eating
a) You smoke in much the same way, regardless of the occasion and of who else may or may not be smoking.
b) You smoke when stimulated by the conversation – a cigarette helps to focus your mind.
c) You smoke when the coffee arrives.
d) You smoke instead of dessert; sometimes you smoke instead of eating altogether.
e) You would smoke if others were.

7. When at a party
a) You smoke as much as you normally would, perhaps a little more.
b) You smoke considerably more, particularly if you feel nervous or do not know many people.
c) You smoke less and then, usually, only if conversation is lagging.
d) You smoke to prevent yourself from tucking into the canapés and dips.
e) You smoke only if you are offered a cigarette.

8. If you were asked to give your reasons for continuing to smoke, what would they be?
a) You have never even thought about why you do it, you just do.
b) It keeps you calm and helps you to relax.
c) It gives you something to do; you enjoy it.
d) It helps you to control your appetite and hence your weight.
e) You smoke so rarely and erratically, you do not really think of yourself as a smoker.

9. Have you ever tried giving up? What was the main withdrawal effect that you noticed?
a) Craving.
b) Irritability (either noticed by yourself or commented on by others).
c) Listlessness and fidgeting.
d) Increased appetite.
e) You were not aware of any ill effects at all.

10. If 'yes' to 9, why did you start smoking again?
a) You were 'overcome' by the desire for a cigarette.
b) You were undergoing a major crisis.
c) You were curious to try it again.
d) You put on a lot of weight.
e) You were offered one and, in a moment of weakness, accepted it.

To find out which your general smoking 'type' is, count up your **a, b, c, d,** and **e** answers to questions 3 to 10. While a clear majority of one over the others indicates a definite smoking type, it is quite possible to combine the characteristics of two, or even three, of the five groups.

● The Habitual Smoker (predominantly **a** answers). You are addicted physically and psychologically to your smoking habit. You may smoke so much that you are unaware that you associate certain activities with lighting up a cigarette (1) or, even, that you have lit one at all (2).
Best time to give up: when there is going to be a change in routine – moving house, changing jobs, going away on holiday – that will temporarily remove some of the cues that fuel your desire to smoke
Main pitfall when giving up: straightforward craving. Nicotine gum or lozenges may help by weaning you first off the habit, then off the drug.

● The Nervous Smoker (predominantly **b** answers). You smoke to counteract anxiety, to focus your mind and to sedate yourself from pressure and frustration. You smoke more if going through a particularly anxious period; less if happy and relaxed. (You are also probably a type 'A' personality, see opposite.) Try alternative ways of negotiating potentially frustrating or aggravating situations, such as practising the relaxation methods outlined in the Lifestyle chapter.
Best time to give up: when things are relatively quiet and peaceful – if you are the sort of person to make room for quiet spaces in your life.
Main pitfall to giving up: any crisis.

● The Listless Smoker (predominantly **c** answers). You smoke to relieve boredom and monotony and to give yourself something to do. Make yourself busier, seek out new interests and you should find that your desire for a cigarette fades as your involvement grows.
Best time to give up: when there is some excitement in your life – a challenge, such as a job promotion, a party or big occasion to organize.
Main pitfall when giving up: boredom; having a cigarette out of curiosity to see whether you still like it. You will, so don't.

● The Weight-watching Smoker (two or more **d**s). You smoke out of a desire to curb your appetite and so control your weight. In fact, the prospect of gaining weight is probably your biggest 'reason' for not giving up. But weight need not be a necessary corollary to giving up smoking, and even if you do put on a few pounds in the first three months, research studies show that you are unlikely to be permanently the heavier for it (see page 184).
Best time to give up: when you are happy with yourself (including with what you weigh) and are unlikely to seek emotional refuge in food.
Main pitfall when giving up: being discouraged by initial weight gain in first three months.

● The Social Smoker (predominantly **e** answers). You are an occasional smoker who persists in smoking cigarettes (usually other people's) because the health risks do not seem to apply. They do.
Best time to give up: when you are going through a relatively quiet time socially; when spending your time with someone who does not smoke.
Major pitfall when giving up: not taking your resolution to stop seriously enough.

DRINKING: how large a part does alcohol play in your life?

Because alcohol is so easily available and drinking so socially acceptable, it is important to be awake to the perils as well as the pleasures. Answer the following.

1. Do you ever drink on your own?

2. Can you remember the last day when you did not have a drink?

3. Do you sometimes find that you 'need' a drink before going out in the evening in order to relax?

4. When you feel disappointed, angry, frustrated or tense, do you tend to drink more heavily than usual?

5. If you went out for the evening and alcohol was not available, would you feel uncomfortable?

6. Do you tend to drink more or faster than your friends?

7. Do you minimize the amount you drink – to others or yourself?

8. Do you sometimes find that you cannot remember part of the previous evening after you have been drinking?

9. Are you drinking more or a stronger type of drink than you were six months ago?

10. Do you sometimes feel guilty or anxious about the amount you drink?

11. Do you say or do things after drinking that you would not have said or done while sober?

12. Have you tried to limit or to control your drinking or to cut it out entirely and found it impossible to do so?

13. Have other people commented on the amount you drink?

14. Do you ever find that you resolve to do something and fail to do it because of your drinking?

15. Do you 'plan' your drinking so that your family and close friends are unaware of how much you are drinking?

16. Are you having an increasing number of problems at home, at work and financially?

17. Do your hands ever shake in the morning?

18. Do you ever drink in the morning?

19. After periods of drinking, do you sometimes hear or see things that are not there?

Count up the number of 'yes' answers. These all indicate that you may be drinking abnormally. If your 'yes' answers are to the first 10 questions, try to analyze your reasons for drinking in the manner that you do and try, too, to find alternative methods of dealing with disappointments, setbacks or challenges without resorting to alcohol. And read pages 186-7. If your 'yes' answers are to questions 11-19, you are not just drinking abnormally but dangerously so. Resolve to give up alcohol entirely for at least three months. If you find it difficult or impossible, you should see your doctor.

How health-conscious are you?

Health consciousness encompasses three things – none of them faddish or obsessional or unnecessarily time-consuming. First, it involves accepting the responsibility for your own good health – not handing it over wholesale to your doctor. Second, it involves being conscious about the details that really matter – eating healthily, exercising, not smoking. Third, it involves having regular check-ups to ensure that there are no early signs of conditions that may require medical attention. If such conditions are detected, they will be treated a stage <u>before</u> you feel unwell, so securing the best possible outlook.

YOUR CHECK LIST: how up-to-date is your preventative health prescription?

1. Have you ever had a complete physical check-up?
2. When did you last feel your breasts?
3. When were your breasts last checked by a nurse or doctor?
4. If you are over 35, have you had a mammogram – and, if so, how recently?
5. When did you last have a cervical smear ('Pap' test)?
6. Have you ever had herpes (sexually transmitted cold sores)?
7. Do you know what your blood pressure is?
8. When did you last have your blood pressure checked?
9. If you are over 35, have you ever had your blood/cholesterol levels checked?
10. If you are over 45, have you had your eyes checked for glaucoma?

Now turn to page 208 and consult the health calendar to see which aspect of your preventative health prescription needs updating.

How well do you know yourself?

YOUR DAILY AND MONTHLY RHYTHMS: is there a pattern?

This section is for you to note down specific details and observations that will help you to understand how your body works, both over the course of the 24-hour day when your state of vitality and alertness changes with the clock, and over the course of your menstrual cycle, when fluctuating hormone levels may also affect your mood, energy levels and general susceptibility to physical and psychological stresses.

These biological rhythms should not be confused with the 'biorhythms' of a 23-day physical cycle, 28-day emotional cycle and 33-day intellectual cycle, which have given rise to special 'calculators' claiming to be able to pinpoint propitious or unpropitious days according to your date of birth. Events such as Sebastian Coe's triumphant win in the 1500 metre final at the Moscow Olympic Games in 1980, on a day when his biorhythm readings were all registering critical, have combined to discredit this theory.

This method is purely observational. It should also be illuminating. Do you know how long your menstrual cycle is or whether your weight rises or remains stable prior to menstruation, or exactly when you are ovulating? It may prove helpful by enabling you to reserve your energies for those days when you are likely to be feeling at your most capable and resilient and to safeguard yourself against those times when you feel 'lower' than usual. While the set of symptoms known collectively as the premenstrual syndrome are fairly well recognized (see below), not so well recognized is the fact that these 'lows' are balanced by 'highs' elsewhere, usually over ovulation, when your strength and general capacity for coping are many times greater than average. Capitalize on this by filling in the chart and making use of your observations where appropriate. The principle is not to be ruled by your body rhythms, but to have a rough guide that enables you to work with, rather than against, them. Copy the chart and record relevant details over three, or preferably six, cycles.

Your monthly rhythm chart

Day of month																													
Weight																													
Menstruation																													
Ovulation																													
Temperature																													
Energy highs and lows	morning																												
	noon																												
	evening																												
Symptoms																													

Key to Filling in the Chart

- The day of the month on which this chart begins is deliberately left blank so that you can start it immediately, whatever the date. Simply fill in today's date against day 1, continue until you reach the last day of the month and then start again at 1 for the new month.
- Menstruation and ovulation. This is to enable you to see at a glance when your period is/was and to enter in the day when you think you have ovulated (see below). If you skip the temperature section, you can still get a rough indication of when you ovulated (though only in retrospect) by subtracting 14 days from the beginning of your period. Once you have filled in a complete cycle, look back over the chart to see how you felt.
- Temperature. There is no need to go through the rigmarole of taking your temperature every day unless you are interested in knowing when you have ovulated, are using 'natural' methods of contraception (in which case you will also need skilled instruction, see page 199), or you are trying to conceive and have been having some difficulty (see page 206). Taking your temperature is one of two observational ways of knowing when ovulation has occurred. To do so, take your temperature first thing in the morning, while still in bed and before you have had anything to eat or to drink. Leave the thermometer in your mouth for five minutes and use a clearly marked clinical thermometer. Look for a slight dip in temperature (this does not always occur), followed by a rise of about 0.5°C (0.9°F). The dip indicates ovulation has just occurred; the rise that you are anywhere from a few hours to a few days past it – the rise continues for the rest of the cycle.
- Energy highs and lows. Simply place an H, M or L (high, medium or low)

in the appropriate place, according to the time of day and how energetic you feel. We all have circadian rhythms – energy levels that rise and fall over the stages of a 24-hour day. While some of these peaks and troughs are so common as to apply generally (an example is the 1 pm lunch energy slump which occurs even when a midday meal is not eaten), others are more idiosyncratic. When the month is over and you have finished charting your various ups and downs, look to see whether any clearly decipherable pattern appears. If it does – your energy is high in the early morning, say, slumps at lunchtime and picks up in the early evening – you can help yourself by arranging your day around this, capitalizing on high-energy times to get things done and protecting those times when your energy reserves are lowest.

- Symptoms. The symptoms involved here are mainly connected with the premenstrual syndrome (see also pages 194-5). But the chart can be just as flexible as you want it to be. If you feel you have other symptoms that may or may not be cycle-related, such as acne or compulsive eating, simply award them a code letter and enter them up. There is now a certain amount of evidence that blood sugar levels rise before menstruation and drop immediately afterwards. This may affect your appetite and your general 'susceptibility' to food. So if eating habits turn out to follow a definite and discernible pattern, one way round the problem might be to take appropriate evasive action in advance.
- Suggested codes for symptoms:
PHYSICAL: AB swollen, bloated abdomen (or ankles, wrists, fingers – specify with appropriate initial); B breast tenderness; H headache; M migraine; S stomach pains.
PSYCHOLOGICAL: C clumsy; D depressed; I irritable; L lethargic.

27

shape

'Vogue knows that chic begins with a good figure . . .' ***Vogue*, 1938**

Your shape is a mixture of things, a reflection of your genes and your lifestyle — the way you eat, the way you exercise, the way you hold and use your body. This chapter begins on the premise that most of us would like to be in better shape than we are.

Being in good shape is where health and beauty start. The dividends of being lithe and fit are enormous and they are reflected in every area of your life: you look good; you feel confident, alert and involved; you give an impression of unbounded vitality and perfect physical fitness; you feel vibrantly well. If such a positive sense of wellbeing has always seemed beyond your reach, take heart. It is not as elusive as it seems, but it does require motivation and discipline. Learn discipline by practising it and you will change both your shape and your outlook for the better.

Although shape can be improved, often dramatically, by holding and using your body correctly (the most immediate body shaper), by toning your muscles to give a sleeker, tauter line and by shedding excess weight with a well-balanced diet, there are certain elements of your shape that you cannot change. So be realistic. Recognize that you have a basic body type (frame). Work with what you have. If you are out of condition, unfit, over or under weight, then what you have is probably considerably more promising than you think it is. All bodies obey their own laws of proportion and such laws are usually naturally harmonious. The less-than-perfect aspects of your shape are much more likely to be owing to a less-than-perfect lifestyle than to anything intrinsically 'wrong' with your body. Inactivity, unhealthy eating patterns, a lack of attention to small but important details, such as posture. . . Improve on these and you may well find that imperfections you have become resigned to are ones that you can do something about after all.

What would you like to change? Appraise your shape honestly, considering your good points as well as your bad ones. Stand in front of a full-length mirror in a good light and take a good long look. Fill in the appropriate charts and questionnaires in the Personal Profile and complete the fitness tests on the following pages. Record your starting point, work out your aims and objectives and go for them. Give yourself three months in which to get into really good physical shape and then work steadily towards your deadline, plotting your progress as you go and gradually increasing the effort you put into your exercising week by week.

THE UNCHANGEABLE ASPECT
Body type

The critical changing elements in any shape strategy are posture, exercise and diet. The constant is your body type, known as your somatotype. Because this is determined by your genes, no amount of dieting and exercising can change it. The basis of body wisdom lies in learning how to identify and how to accept your body type — learning how to like yourself the way you fundamentally are. This is healthy realism, not complacency. Excess weight, out-of-condition muscles and an unfit, unexercised body do not belong to any body type. They detract from it. So start by distinguishing between the imperfections that you can do something about and the inherited characteristics that you cannot.

Then take yourself to task and see how specific body contours — determined both by the tone of your muscles and by the distribution of fat on your frame — can be improved through diet, exercise and small, but important, adjustments in the way you hold and use your body.

There are three criteria for assessing body type, each based on the relative predominance of one type of body tissue over another. The first is nerves and skin (ectomorphy), the second is muscle and bone (mesomorphy) and the third is fat (endomorphy). While no-one is 'pure' ectomorph, mesomorph or endomorph, one type is usually predominant. Recognizing which general category you come into can be useful because it gives you an idea of your basic frame and of the sports and activities likely to suit you best.

THE CHANGEABLE ASPECTS
Weight

As your correct weight depends first on your height and second on your frame, or body type, the weight graph, opposite, allows for a wide variation for each height. So use it as a rough guide only, bearing in mind that, if you are lightly built, you may come within this range and still be overweight, while, if you are big-boned and large-framed and weigh in at the lower end of the scale, you may be up to 12 kg (26 lb) under your ideal weight. For this reason, signs of overweight and underweight are also given, together with guidelines on measurement and a technique to help you to assess your degree of fat. Put these together, and you can determine fairly accurately how much you should weigh.

The chart gives no 'allowance' for age. It is now generally recognized that there is no need to grow any wider as you grow older. The weight you reach at 25, _provided that it is within the limits given here and appropriate to your build_, is the weight that you should maintain throughout your adult life except, of course, when pregnant. At any other time, fluctuations in weight may disrupt your menstrual cycle, lead to stretch marks and varicose veins and cause your skin to age prematurely. Maintaining a reasonable and consistent weight should be a priority whatever your age.

In the years between puberty and the menopause, your weight will fluctuate quite naturally within a range of about 1-2 kg (2-5 lb) and sometimes more as your hormonal levels change over the stages of the menstrual cycle. If you are conscious of a large fluctuation or have been puzzled by the fact that your weight seems to go up and down almost daily despite the fact that your diet is quite constant, you may find it helpful to assess your 'real' weight as opposed to your 'random' weight. Weigh yourself every day over a complete cycle and fill in the amount for each day on the chart provided in the Personal Profile. At the end of the cycle (the onset of menstruation), add these amounts together and then divide by the total number of days. See which stage of the cycle correlates most closely with the final figure — your 'real' weight — then weigh yourself once a month at this point of the cycle to see whether you are losing or gaining.

If you are trying to lose or to gain, weigh yourself weekly (making allowance, if necessary, for hormonal disruption) and plot the amount lost or gained on the graph given in the Personal Profile.

Ectomorphy. Lean and angular, with long limbs, narrow joints, low body fat and muscle and few curves, ectomorphic types are often likened to greyhounds and racehorses. Unlike endomorphs or mesomorphs, ectomorphs tend to be able to eat quite substantially without putting on weight. At least one study has suggested that this is because they have a shorter intestine and thus less space in which to digest their food. Because ectomorphs have low weight-to-height and bone-to-muscle ratios, they are not suited for sports that require bursts of speed or strength. They often excel at distance sports, however, such as marathon or steeplechase, because their low body fat (male ectomorphic athletes have as little as five per cent) speeds up heat loss and prevents the build-up of internal body heat that leads to exhaustion. Ectomorphs will also tend to do well at sports where height and length of limb is important, such as high or long jump.

Mesomorphy. Mesomorphic types are constitutionally strong with no special concentrations of weight anywhere on the body. They are reasonably compact, with broad shoulders and pelvic girdle and well-developed muscles, particularly at the calf and forearm. Mesomorphy has been linked with a direct and naturally aggressive, even pugnacious, temperament and a greater physiological need for exercise. Men, who have a greater ratio of muscle to body fat, have higher mesomorphy ratings than women, who tend to combine this characteristic with one of the other two. Hence the terms 'ectomorphic' or 'endomorphic' mesomorphs. Such women have the capacity for great stamina and power and, with training, will do well at some of the more demanding sports that require explosive bursts of speed and/or strength. Examples are sprinting, cycling, hurdling and gymnastics.

Endomorphy. Endomorphic types are shorter limbed than either of the other two groups, have a lower centre of gravity, wider hips, larger joints, a higher proportion of body fat to muscle and a tendency to put on weight easily. They must concentrate on keeping their weight down to reasonable limits, if they are to pursue more vigorous types of exercise. With training, endomorphs can be good at sports and activities that require a good sense of judgement, agility and the ability to twist and turn easily. Some champion women tennis players have tended towards endomorphy, as have some long distance swimmers – where the higher degree of body fat can act strongly in their favour, adding buoyancy and generating heat.

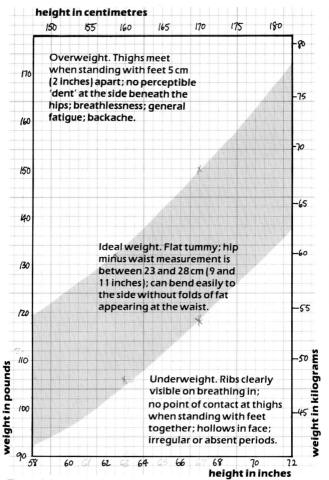

height in centimetres

150 155 160 165 170 175 180

Overweight. Thighs meet when standing with feet 5 cm (2 inches) apart; no perceptible 'dent' at the side beneath the hips; breathlessness; general fatigue; backache.

Ideal weight. Flat tummy; hip minus waist measurement is between 23 and 28 cm (9 and 11 inches); can bend easily to the side without folds of fat appearing at the waist.

Underweight. Ribs clearly visible on breathing in; no point of contact at thighs when standing with feet together; hollows in face; irregular or absent periods.

weight in pounds / **weight in kilograms**

height in inches

The weight graph, above, is based on national insurance figures and shows very broadly the weight range appropriate for your height. Check you come within it. Then look at the notes on under, over and ideal weight. These should help you to be more precise.

Measurements

The contours, or general shape, of your body are determined, first, by your body type, second, by how well-toned your muscles are and, third, by specific concentrations of flesh and distributions of fat. To find out how well-proportioned you are, measure yourself around the bust (when breathing in), around the waist (at its narrowest part, about an inch above the navel) and around the hips, thighs and calves (all at their widest parts).

Fill in your measurements in the table provided in the Personal Profile, leaving a space for assessment in three months' time when you will have followed the exercise programme outlined on the following pages and, if necessary, the diet too.

An ideal example of how you 'should' measure up is given here. Taking your bust and hip measurements as the baseline (the same), your waist, thighs and calves should be about 25, 41 and 56 cm (10, 16 and 22 inches) respectively, less than this. These are the dimensions you should work towards. But remember that they are approximations only — not an absolute set of statistics.

However, while small variations (2.5-5 cm/1-2 inches either way) are in order, notably smaller differences are not, and indicate that you are almost certainly overweight or under-exercised. It is up to you to determine which.

BUST	WAIST	HIPS	THIGH	CALF	
89	64	89	48	33	Measurement in cm
35	25	35	19	13	Measurement in inches
—	25	—	41	56	Differences comparable
—	10	—	16	22	to hip measurement

Aim to keep your weight within reasonable limits – a range of 3.2 kg (7 lb) at the outside – by keeping a regular check on yourself.
Best type of scales: the traditional type, as above. Place modern scales on a hard floor, not a carpet, for a reliable reading and check them for accuracy against another pair every six months.
Best time to weigh yourself: in the morning, before dressing and breakfast, and after going to the lavatory.

Body fat

Women have a higher ratio of fat to muscle than men — about 22-28 and 15-22 per cent respectively. If you are in good physical shape, about 1 kg (2 lb) in every 4 kg (9 lb) that you weigh will be fat. Of this kilogram of fat, half is situated just beneath the skin where it provides essential insulation and support, helping to keep the skin smooth and supple and giving firm contours. Nothing is more prematurely ageing to the skin than a rapid or excessive loss of weight. With too little fat, the body loses its shape and the skin sags as its underlying support shrinks away. With too much fat, the skin dimples and stretches as the surplus layers of fat accumulate beneath it. Either way the body loses its shape.

Not only do women have more fat than men, but it also tends to be distributed differently — accumulating around abdomen, buttocks and thighs — and seems to be more sensitive to hormonal influences. This would explain why bloating caused by sodium and water retention within the cells can be a problem in the few days preceding a period.

With the exception of a fairly drastic medical procedure (see page 169), fat cells cannot be broken down or 'dispersed'. Their number appears to be determined by heredity and early conditioning factors and to remain unalterable from the first year of life. Although diet cannot reduce fat cells numerically it can reduce them in size. Estimate your degree of body fat with the pinch test below.

Pinch test graph

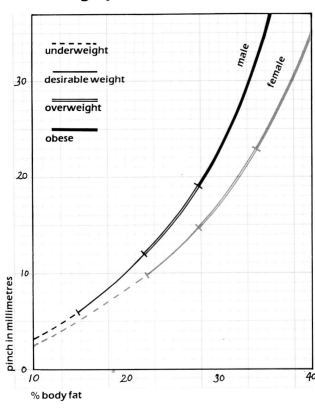

Because fat situated directly beneath the skin constitutes a predictable proportion of your total body fat (about 50 per cent), you can estimate how 'fat' you are by pinching the flesh on the underside of your upper arm. Pinch firmly but not painfully, making sure that you are pinching fat, not muscle which feels much firmer to the touch, and ask a friend to measure it for you. The width of the pinch constitutes the distance between the inner edges of your thumb and forefinger.
The pink line on the graph, right, should enable you to identify your approximate percentage of body fat. (Use the black line if carrying out the test on a man.)
A pinch of between 10 and 15 mm falls into the desirable weight range. Any more indicates that you are overweight. A pinch of 23 mm or more? Your body fat is over 34 per cent of your total weight. Definitely too much.

posture

'It has taken me years of struggle, hard work and research to learn how to make one simple gesture…' Isadora Duncan

How are you sitting as you read this? Are your shoulders in line with each other, your back straight, your weight evenly distributed on both buttocks, your knees relaxed and parallel and any forward movement coming from your hips and not your upper back? Or are you slumping forwards, with your neck curved and your spine rounded, one shoulder marginally higher than the other, your legs crossed and your weight supported through your elbows? If so, you may be in perfect physical shape but you certainly will not look it.

Of all the shape determinants, the most immediate is posture. Diet and exercise may give you the figure you want, but if you do not hold it correctly, it will never be seen to advantage. Most people, once into their teens and often much before it, stand, sit, even rest incorrectly. Teachers of the Alexander Principle, an impressive method which concentrates first on asking you to unlearn bad habits and then on setting them to rights, maintain that virtually everyone misuses their bodies to some degree, often severely so. Such misuse undermines your natural shape, robs you of the ability to move easily and freely, predisposes you to aches, pains and muscular tension and many of the more specific symptoms of 'dis-ease' — lower back pain, headaches, poor circulation, digestive troubles… If you concentrate on improving your posture, you may well find that the general quality of your life also improves enormously.

BALANCE

Your posture can only be as good as your sense of balance — no better — and you should therefore work at improving both simultaneously. Most people do not even begin to become aware of their sense of balance until it starts deserting them. But balance is much more than the difference between remaining upright and falling over. It is, or should be, a finely tuned mechanism working via a number of reflex centres in the brain.

Perfect balance is not perfect stillness. Balance is never static. It is achieved by allowing your body to move and to make the numerous fractional adjustments that enable it to remain poised and upright. Try the 'tree' exercise (right) and feel how much you oscillate as soon as you close your eyes. This is the result of the body finding, not losing, its balance as it re-establishes its links with gravity.

Three factors influence your sense of balance. The first are the eyes. You learn from an early age that walls are vertical and the floor is flat and you use your eyes to maintain these reference points when standing, sitting or running. The second factor derives from three semi-circular canals in the inner ear and is known as vestibular balance. Whenever your body moves, the fluid in one or more of these canals is also set in motion and sends messages to the brain of 'up', 'down', 'left', 'right', 'stop' and 'start'. If these messages become confused, as can happen when spinning round very fast or when rocking up and down in a boat, your sense of balance will be affected and you will feel nauseous and

dizzy. Giddiness and seasickness may be felt in the stomach but they do not originate there. The third factor that affects your sense of balance is more general. It is called proprioception and it refers to sensations of pressure gleaned from different parts of the body — the soles of the feet, the knees, the buttocks, the neck — and fed back to the brain via the central nervous system. In theory, once your brain has learned to distinguish a symmetrical norm — how it feels when the weight is evenly balanced on both feet — it can then make the fractional adjustments in your posture that enable you to keep your sense of balance and to remain upright. Although proprioception should enable you to achieve a constant state of perfect balance, it rarely does. The brain soon becomes attuned to uneven distributions of weight and adapts its messages accordingly. This is why it is quite possible to stand in a lopsided way and still to be under the impression that you are standing perfectly straight. In fact, as you may have already found out, it can take a photograph to show you just how lopsided you are.

While years of incorrect sitting and standing can give a misleading feeling of 'rightness', and any change for the better is almost bound to feel 'wrong', persevere. With time, your brain will learn what it feels like to be truly balanced and will adapt its messages accordingly.

PRINCIPLES OF GOOD POSTURE

Learning the principles of good posture and putting them into practice is one of the best investments you can make. The principles themselves are not difficult. Vogue summed them up more than 60 years ago as 'an utter lack of rigidity, an appearance of having been dropped into one's clothes and remaining there by accident…' This delightfully carefree image conveys the feeling exactly. Good posture looks and is effortless. It makes for the least effort, or strain, because it enables you to perform any movement from the simplest to the most complicated with freedom and absolute economy of action. If the posture is right, only the relevant muscles and joints will be used to perform the movement, whether it is reaching out to turn out a light or walking along a tightrope.

Most people do not move economically. They over-react. They walk along a tightrope when they only need to turn out a light. The consequence is considerable strain on the body, both while the movement is being performed and after it has been completed. Residual tensions can remain in the muscle for days, if not months, at a time. Multiply such strains by a lifetime, and you will soon see how using the body incorrectly may restrict your ability to move freely and easily. Good posture, on the other hand, will do much to preserve your muscles and joints from the wear and tear of the advancing years.

While the principles of good posture are not difficult to grasp, putting them into practice will take a determined and committed effort. Start by identifying your weak points. Complete the tests and exercises in the Personal Profile and study the various guidelines listed over the page. Commit them to memory and, to begin with, maintain a state of fairly constant vigilance over the way you stand and sit and move. Only when the adjustments begin to feel right can you afford to let your vigilance relax.

A finely tuned sense of balance is essential for posture. Test yours by taking up the 'tree' position, above: one foot on the floor, the other resting as far up the inner thigh as possible, the arms extended upwards, the eyes open. You should feel comfortable enough to stay there for minutes rather than seconds. Now close your eyes. If you feel yourself beginning to topple over, your sense of balance needs attention. Practise this exercise daily until you can stand quite comfortably for at least a minute with your eyes closed. The ultimate goal? To be able to stand with the foot resting slightly lower down the leg (knee not thigh) and to change legs, transferring your weight to the opposite foot, without opening your eyes once.

Daily _posture improvers._
Counteract the forward pull of gravity and a sedentary lifestyle with shoulder rotations. Stand as shown, left, arms outstretched at shoulder level, hands making loose fists. Rotate shoulders back and down, away from the ears. Be careful not to let arms and hands drop too. Centering the pelvis correctly will help to take strain off the lower back and will also encourage exaggerated arches in the spine to lengthen out. Start by standing against a wall. If you can get your hand between the small of your back and the wall, your spine is too arched, as right. Bend your knees and then tilt your pelvis upwards, far right. Hold, release. Repeat several times. Then gradually straighten up the wall again. Notice how much flatter your back is. The gap should now be much too small for you to pass your hand through.

Your **HEAD** weighs up to 5 kg (12 lb). How you hold it influences the position of the vertebrae, not only at the neck, but also the whole way down the spine.

Place your hand along the middle of your back and tip your head first forwards towards your chest and then backwards as far as it will go. You will feel the vertebrae moving quite distinctly beneath your hand as the position of your head changes. Much smaller movements, such as holding your head slightly to one side, will also cause your spine to adjust its shape. To hold your head centrally balanced, imagine a string attached to the crown of your head gradually becoming taut and pulling it upwards, so that the back of your neck lengthens. At the same time, let your shoulders drop slightly, keep your eyes facing forwards and your chin at right-angles to your neck.

Holding the **NECK** in a set and rigid manner can lead to shortened and strained neck muscles, tension headaches and even migraine.

Free it by holding the head as directed and by feeling the sensation of lift as the vertebrae extend away from each other and the neck lengthens.

Aches and pains in the upper back are usually caused by holding the **SHOULDERS** incorrectly. Most of us tend to stand or to sit with one shoulder fractionally higher or further round than the other. Bring them level by standing with your weight evenly balanced on both feet and holding your head centrally so that the length between the ears and base of the collar bone is the same on both sides. Now rotate the shoulders, as above, to bring them comfortably back and down. If you do this correctly, your shoulder blades at the back and clavicles (collar bones) at the front will both lie quite flat.

Look upon your **ARMS** as an extension of the shoulders and upper back. Hold them loosely and easily by your sides, with the elbows turned slightly out away from the body in order to maintain the wideness in the chest and shoulder girdle, and the wrist and fingers loose and supple, not clenched.

Think in terms of making as much space between your **RIBS** and **HIPS** as possible. Keep your shoulders down and your back lengthened and extended, so that your respiratory and digestive systems have the room in which to work properly and your spine is extended right from its base at the coccyx to its tip at the back of the skull. To help get the sensation of lift, span your hands so that the middle finger is resting lightly on the hip bone and the thumb on the lowest rib. Adjust your posture as directed and see the distance growing between your thumb and finger as your body lengthens upwards from the back.

Your **SPINE** is one of the most susceptible areas of the body to the strains exerted by standing, sitting, moving, even lying down incorrectly. To meet the stresses of standing on two feet – a fairly recent event in our evolutionary history – the spine curves naturally in at the neck, to enable you to move your head freely, and at the small of your back, to relieve the pressure on your lower back. This receives the equivalent of a 45-kg (100-lb) jolt every time your foot touches the ground – considerably more when running or jumping. Poor posture may cause these curves to flatten or, more commonly, to become too pronounced. Keep your spine lengthened and supple and neither unnaturally straight nor unnaturally curved. Think in terms of 'growing' upwards so that each vertebra is extending away from the next.

When held correctly, your **PELVIS** supports your spine, takes the pressure off your lower back, keeps your buttocks firmly in the right place and enables your tummy to be held in naturally. When standing, your pelvis should be held forwards, facing the front.

Practise the wall exercise and the pelvic tilt, given here, to help you position your pelvis correctly.

When standing, walking or running, your **KNEES** should be slightly flexed to take the weight of your body and to act as shock absorbers, thus preventing jarring. If knees are held straight and rigid, the pelvis will be 'frozen', movement restricted and too much pressure exerted on the spine.

Your **FEET** take the weight of your body and provide its base for balance. The further apart they are, the more stable and balanced you will be. Stand with feet slightly apart, weight evenly balanced between them and supported mid-way between the ball and heel of your foot. Rock gently back and forth until you find this point.

EXERCISES TO BEWARE OF

Unless you are really strong and fit, and your posture is good, some exercises may place unacceptable strains on the body. Bicycling while balancing on your shoulders will encourage shoulders to round and exaggerate an arch in the upper back. Practising sit-ups with feet anchored, legs straight, encourages your lower spine to curve. Bend legs instead. Raising and lowering both legs from the floor is equally bad for the lower back. Knees are vulnerable joints. Protect them by doing deep knee bends with heels flat on the floor (see page 38). In addition, try to keep buttocks above standing position knee level and avoid full squats and 'Cossack' dancing – kicking out with the legs while crossing the arms in front. All these may stretch ligaments on either side of the knee, so weakening the joint.

USE AND MOVEMENT

Now that you know how you should hold your body, extend these principles into the way you use it. The most perfect standing position is unlikely to do much for you, if you slump or move awkwardly for the rest of the time. The main principle is to safeguard the health of your spine. Keep it lengthened and extended, straight but not stiff, and when bending down to pick something up, however light or heavy, always bend your knees, never your back.

Walking

Step forwards lightly on to the ball of your foot and land on the heel. Landing on the ball of the foot will exaggerate an arch in the lower back. High-heeled shoes pitch your body forward on to your toes and cause your hips to rotate inwards to compensate for the unnatural angle of the feet, so wear flat or low-heeled shoes for everyday use — a maximum of 5 cm (2 inches).

Sitting

Although sitting down is a position that most of us associate with great comfort, the strain on your back is actually greatest when sitting — about twice that when standing upright. Because prolonged periods of sitting, especially sitting in the wrong type of chair, can weaken the intricate network of muscles and ligaments that supports the spine, help yourself by choosing a chair that makes good posture easier, not more difficult, for you. 'Easy' chairs are not easy on the spine. Bucket-type chairs also cause your spine to curve and offer little or no support at the lower back, where you need it most. Go, instead, for chairs that are fairly straight-backed and that offer some support in the lower back. If your chair does not (car seats are common examples), place a folded towel or a small cushion in the small of your back so that your spine is supported.

When working or reading, try not to lean forwards over your work. Bring whatever you are doing towards you — the typewriter to the edge of your desk or the newspaper up to eye-level, for example — so that you do not have to bend your neck, drop your shoulders forward and curve your spine in order to be able to type or to read. When driving, make sure that your seat is close enough to the steering wheel so that you do not have to reach forwards to hold it.

Lying

The next time that you feel like relaxing do not collapse into the nearest chair. Instead, lie flat on your back on the floor, with your head supported by a book or a small cushion. This extends rather than bends the spine and reduces the strain exerted upon it to just about zero. Lying down is the best way of 'resting' your back and your body. Squatting and kneeling come next, sitting a very poor fourth.

Sleeping enables you to recover from the stresses and strains of the day, but an ill-designed mattress may rob you of the chance to do just that by placing additional stresses on your spine. While beds should be firm, they should not be hard-as-a-board firm as too much rigidity forces the body into an unnaturally straight line. Go for a bed that supports your spine and body well, however. A mattress that allows your body to sag, so that your buttocks are lower than the rest of you, is too soft. So are most waterbeds. Test a mattress by lying down on it — never buy it blind.

Bending

When you lean or bend over, whether to pick something off the floor, to wash your hair, or to make a bed, the bend should come either from your knees or from a natural rotation at the hips, so that the spine is still as straight as it would be when upright — it just changes its plane. Bending from the lower back is a major cause of backache and sore strained muscles.

Think laterally when doing or attempting to do anything that might affect the position of your spine. Kneel down when making the bed, bend your knees when lifting heavy weights, including young children, sit on a stool when washing your hair if the basin is too low, use a long-handled hoe when gardening, place heavier and more frequently used casserole dishes and pans in cupboards that will not entail bending or stooping to retrieve them. Standing or sitting, your work height should be such that you do not have to bend your lower back at all or your neck too much — small details, perhaps, but they may save you any amount of trouble, particularly back trouble, in later years.

When sitting, keep the spine lengthened and extended, the bottom well to the back of the chair and your weight evenly distributed on both buttocks. Do not cross your knees. It cuts down circulation to and from the legs, may aggravate, if not actually cause, varicose veins and will multiply the strains on your spine by throwing the body out of line. Instead, let your thighs lie parallel, and only cross your legs at the ankle, if at all.

useuseuse

exercise

'For the past fifteen years, I have made fitness a priority because I have experienced its very real rewards. I simply schedule it into my life as if my life depended on it, which in a way it does...'

Jane Fonda

Exercise tones the body, alerts the mind, increases resilience to physical and psychological stresses, firms muscles, loosens joints, banishes stiffness and general aches and pains, builds up the efficiency of heart and lungs, lowers blood/cholesterol, helps overcome insomnia, regulates appetite and generates a vigorous and vibrant sense of wellbeing. Of all the beauty routines you could adopt, exercise is undoubtedly the most worthwhile.

Energy generates energy. The more you move, run, stretch, jump and bend, the more vigorous and energetic you will feel. The next time lethargy descends, try overcoming apathy with activity. Take a brisk walk, jog up and down on the spot for a few minutes and see how much more alert and refreshed you feel. Now plan to increase the amount of activity you take during the day, first carrying out the general fitness test outlined in the Personal Profile to find out how active, or inactive, you are.

In addition, you should also aim to exercise fairly vigorously for at least 20 minutes three times a week. Exercise is one of the easiest things in life to find excuses not to do. Cold weather, alternative arrangements, indolence...all undermine the best of intentions. So make it as easy as possible for yourself. Choose a sport or activity you enjoy, and set out gently. Sudden enthusiasms and frenetic bursts of activity can lead to fatigue, exhaustion, sore aching muscles, strains, sprains, even fractures — all signs that you have pushed your body too far and have asked it to do something for which it was insufficiently prepared. Incorporate more than one exercise or activity into your fitness programme for maximum benefit. Start gently, build up gradually and progress more vigorously as you become fitter. The more unfit and the older you are, the more gradually you should go.

You should be especially careful if you are over 35; have not had a recent medical check-up; have not exercised for a long period of time; drink or smoke heavily; are more than 9 kg (20 lb) overweight; have a specific medical problem or a family history of heart disease. Check with your doctor first. However old you are and whatever the shape you are in, always observe certain cautions when you begin exercising. Never rush it, never pace yourself against someone who is younger or fitter than you are, never push yourself beyond your limits or force yourself into positions that feel painful and learn to listen to your body. Stop when you feel fatigued or breathless, or when your pulse rate is approaching its maximum safety figure (see page 18). Never attempt to 'run' off a sprain or a strain. If you do sustain an injury, rest instead and start more cautiously the next time round.

Lastly, try to make sure that all three basic essentials of exercise are incorporated into your programme. (A tailor-made exercise sequence that does this for you can be found on the following pages.) These three essentials are strength, suppleness and stamina. While other aspects, such as coordination, timing, balance, agility, judgement and skill, are also important, these are the three major benefits. Choose activities that are complementary in this respect. If you are a keen jogger or runner, practise yoga or go dancing once or twice a week. Running and jogging are long on stamina and short on suppleness. Yoga and dance, on the other hand, are two of the best suppleness exercises that there are.

STRENGTH

Your physical strength and athletic ability are largely determined by the strength of your muscles. Strong muscles are firm, give a sleek contour to the body and enable you to perform most types of movements with ease. The two exercises here are designed to test the relative strength of the upper and lower 'halves' of your body. Poor ratings indicate that you need to work at toning and firming the major muscle groups. This is achieved through exercise.

While the number of muscle fibres per muscle is determined genetically and cannot be increased or altered, exercise will enlarge the diameter of the individual muscle fibres and increase the blood supply within the muscle, thereby increasing its overall strength. One of the major advantages of a regular, well-integrated fitness programme is that, over a period of time, it will enable you to build up both muscular strength (the ability of your muscles to exert maximum force at a given moment) and muscular endurance (their ability to perform repeatedly without fatigue). Inactivity will cause muscles to diminish in size and to atrophy, or waste away. Diminished muscle fibres not only weaken the muscle, but also make it much more susceptible to injury by sudden and unfamiliar stresses. As the joints are supported and moved by the groups of muscles on either side, weak muscles will also tend to make for weak joints that are more susceptible to dislocation or injury to some or all of the supporting ligaments.

The strength of the large muscle groups is increased by working them, either through specific types of sports or activities or by using an exercise routine that combines certain movements to persuade the muscles to contract and then to extend. The second is the more reliable method, provided, of course, that the routine is sound, because it works systematically through each of the large muscle groups in turn. The most effective way of increasing the strength of the muscles is by long-term resistant exercise that makes muscles work harder by providing a counter force. Examples are swimming against the tide or using buoys to add 'drag', bicycling into the wind or incorporating the use of weights into your exercise programme.

To test lower body strength. Start by standing with your back to the wall. Now gradually bend your knees and bring your feet away from the wall until you are 'sitting' with your thighs parallel to the floor. How long can you stay there? Over 90 seconds (60 if over 50) is good; 60 to 90 seconds (40 and 60 if over 50) is fair; less than 60 seconds (40 if over 50) is poor.

To test upper body strength. Place a table against a wall so that it is quite steady. Now, do a series of modified press-ups, with hands shoulder width apart and back as straight as possible, trying not to arch or to hollow your spine. Bend both arms and bring your chest to the table, then straighten them. Do as many as you can without straining and then stop. How many did you do? More than 15 (10 if over 50) is good; between 10 and 15 (seven and 10 if over 50) is fair; less than 10 (seven if over 50) is poor. A poor score in this area indicates that you should work at increasing the strength of your chest, arm and shoulder muscles, often weak in women.

A sensible use of weights will not over-develop your muscles. Instead, it will firm and strengthen them, thereby protecting the joints. It will also greatly improve the general line and contour of your body, particularly those areas, such as thighs, buttocks and upper arms, that tend to be most resistant to weight-reducing diets. By working muscles not commonly used in everyday activities, these exercises can help you to 'sculpt' a better body shape. Dumb-bells and weights held in the hand will strengthen chest, arm, shoulder and upper back muscles — commonly weak in women. Strap-on weights, that can be attached to ankles as well as to wrists, will strengthen the muscles in the calf, thigh and abdomen as well as in the upper body. Both types are available from most sports shops and department stores or you can improvise with cans of food or bags of sugar from your store cupboard. If you are using weights, first make sure that you are relatively fit and able to carry out your basic exercise programme without any straining of the muscles or joints, or stiffness or soreness afterwards, then increase the amount of effort you put into your exercising by incorporating weights of between 1 and 3 kg (2 and 6 lb) each. You can exceed this amount if taking part in a carefully supervised weight training programme, such as the Nautilus system which was first developed about 10 years ago and is now widely available at gymnasiums and health centres throughout the USA and in London. The system uses a series of machines to work specific isolated muscle groups — arms, chest, back, thighs, etc — and is safer than using free weights because the amount of strain is very carefully controlled. Twice weekly workouts at 30 minutes a time will have an impressive toning and conditioning effect on the body when combined with stretching and aerobic exercises, but you must use it regularly — not more than every 48 hours (the muscles need time to recuperate) and not less than every 90 hours (the muscles soon slack off if underused).

To test for suppleness at shoulders. Stand or kneel, place your left arm along your back and take your right arm over your shoulder to meet it. If you can clasp your fingers together you have good rotation at the shoulder joint; if your fingers meet, fair; if they fail to touch, poor. (Try this test on both sides, as one shoulder is frequently stiffer than the other.)

To test for spinal mobility. Kneel down on all fours. Keeping hands in line with shoulders, drop your forehead down and bring your knee up to meet it, as shown. If you can touch your head with your knee without straining, you have good spinal mobility; if they almost meet, fair; if they are some way (10 cm/4 inches or more) apart, poor.

SUPPLENESS

Suppleness is both an inherited and an acquired characteristic and is determined by the relative ease with which you can move your joints through their full, or potentially full, range of movements — to reach, stretch, bend, twist and turn with ease and grace. On the whole, women tend to be more supple than men and we all grow gradually less supple as we get older.

Touching your toes is not a good indicator of suppleness because the ability to reach the floor with your fingers is determined as much by the length of your upper body relative to the length of your legs and by the length of your hamstring muscles, as it is by your ability to 'bend in half' from the hip. Try the four tests, given here and over the page, instead.

If the tests indicate that you are naturally supple, or loose-jointed, you will excel, when fit, in those sports, such as gymnastics and yoga, that demand a high degree of suppleness. If, on the other hand, the tests indicate that you are naturally tight-jointed, you will have to work hard to acquire flexible, mobile joints.

While suppleness is certainly desirable, both extremes can have their disadvantages. The greater range of movement of the loose-jointed carries a risk of dislocation or injury through moving the joints too far. If you are very supple, concentrate

strength of your muscles, it depends first on the strength (efficiency) of your heart and lungs. Muscles run on oxygen which arrives from the lungs via the heart — the more oxygen the muscles require, the harder the lungs and heart must work. When exercising really hard, muscles account for about 90 per cent of the body's total energy requirement. To meet this demand, the lungs must work harder to supply the oxygen the muscles need and the heart must beat faster to deliver it. Unaccustomed exertion can cause the unfit heart to double its rate. This may place unreasonable stresses upon it. Steady, regular exercise, meanwhile, will increase the capacity of the heart to pump blood through the system. Repeated studies have shown that, with regular fairly vigorous exercise, the heart muscle actually becomes stronger and may increase its output by as much as 20 per cent. By doing so, it will also lower the heart beat because, with each stroke, a greater volume of blood is being sent around the body. Athletes in training tend to have pulse rates that are as much as 20 beats <u>lower</u> than average.

There are several ways of building up stamina, while protecting your heart and lungs from the potential dangers of over-exertion. When you start running, jogging, swimming or cycling, intersperse periods of activity with periods of rest. Start by running for 100 metres, walking for the next 100, running again over the same distance and then walking home. Alternatively, if you are swimming, take breathers every third or fourth length rather than swimming 12 or 14 flat-out and feeling exhausted and nauseous at the end of them. As you get fitter and can manage more, prolong the distances you swim, run or jog and reduce the periods spent walking or resting.

A more scientific method of assessing your exercising capacity and keeping it within healthy limits has been developed by the Cardiac Research Unit at London's City Gym. This safe and practical method is called pulse rate control and is particularly recommended for men over the age of 35 (between 11 to 17 per cent of whom are judged to be at risk from sudden cardiac arrest without knowing it) and for women over the age of 45, particularly if they also drink or smoke heavily and are 6 kg (14 lb) or more overweight. Find instructions on using the method and a progress chart in the Personal Profile.

To test for mobility at knee and hip. Stand upright with feet apart. Keeping your back straight and your buttocks tucked well under, do a deep knee bend, keeping your heels on the floor, and return to the starting position. Do not strain the movement, just go as far as you feel is comfortable. Ability to do a deep bend with the knees well turned out to the side, to hold it for a few moments and then to return comfortably and easily to the upright position, indicates that you have good mobility at the knee and hip. Inability to bend more than a little way, with your knees tending to 'lock' after moving through an angle of 45 degrees or less, indicates that you have little rotation at the hip and knee joints – especially if you are aware of any creaking in the joints or find you cannot return easily and comfortably to the starting position. In between the two? Fair.
N.B. This test is quite demanding on the knee and should not be attempted if you have any history of knee trouble.

on building up the strength of the muscles that stabilize and support the joints, particularly the quadriceps at the front of the thigh, which protect the vulnerable knee joint. Find an excellent exercise for this on page 51. The restricted range of the tight-jointed tends to make for general stiffness and also renders the muscles more prone to strains and pulls. Concentrate on the simple lengthening and suppleness exercises, outlined in the following pages, to increase the mobility of the joints without in any way forcing them to move in an unfamiliar and potentially harmful direction. Do these regularly for at least a month before attempting any of the more demanding activities (i.e. those with high suppleness ratings, such as gymnastics or yoga).

A general loss of mobility that comes with age imposes certain, sometimes severe, limitations on the ability to move freely and easily. In order to keep joints moving freely and easily, everyone needs to build up and to maintain their suppleness, even those lucky enough to be born supple. To do this, each of the major body joints should be exercised through its complete range of movement at least three times a week and, preferably, once a day.

STAMINA

Stamina is staying power and it is the factor by which fitness is most commonly judged. Stamina enables you to go faster and further without becoming exhausted or breathless. See how good your stamina is by carrying out the test, opposite. If you did not achieve the highest rating, aim to improve it. Any type of 'aerobic', or oxygen-using, exercise will increase your stamina, if carried out for a sustained period of time over a number of weeks or months (see examples right).

While stamina depends, to a certain extent, on the

> **Ten examples of exercises and activities that will push your pulse rate up and so help to increase your stamina – rated here in order of effectiveness.**
>
> 1. Running two miles in maximum of 16 minutes.
> 2. Skipping for six minutes with 30-second breathers after each minute.
> 3. An energetic 30-minute game of squash or racquet ball.
> 4. Running up and down stairs for three minutes.
> 5. Cycling at a moderate to fast pace for 15 minutes.
> 6. Swimming for ten minutes continuously.
> 7. A vigorous game of tennis, badminton or any other team game, such as baseball.
> 8. Walking briskly up a steep hill for 10 minutes.
> 9. Jogging for a mile in a maximum of 12 minutes.
> 10. Brisk walking for two miles.

To test for stamina: see how long you can skip or jog on the spot (lifting your feet well off the ground) before becoming breathless. This test is demanding, so do not attempt it unless you are fairly fit and healthy, and do not become discouraged if, even then, your rating is poor: regular, fairly vigorous exercise will help to improve it.

Skipping 1½ minutes or more (1 minute or more if over 50) is good; between 1 to 1½ minutes (½ minute if over 50) is fair; less than a minute (less than ½ minute if over 50) is poor. Double these times if you chose to jog.

To test for suppleness at ankles: sit on chair, knees together and brush big toes as far off the floor as possible. Measure the distance from the top of your toe to the floor. Was it between 12.5 and 15 cm/5 and 6 inches (good); between 10 and 12.5 cm/4 and 5 inches (fair); less than 10 cm/4 inches (poor). If rating was poor, aim to improve it with the ankle exercise on page 51.

Strong mobile ankles help to keep feet in good shape, are important for most types of activity, crucial for athletic ones.

daily exercise programme

These exercises are divided into two sections: a daily programme which combines stretching and loosening exercises (blue leotard) with strengthening and firming ones (red leotard) and a sequence at the end designed to give you a really good general workout (yellow leotard). Between them, they should exercise every muscle and joint in the body.

● The secret of success with any exercise programme is to keep at it. The most effective exercises will do little to tone muscles and firm contours if abandoned after only a week or two. Set aside five or 10 minutes each day whenever you like but never after a heavy meal. Start by working systematically through the first section and, once you have mastered the programme, repeat it twice a day rather than adding further repetitions indefinitely.

● Start gently. The blue exercises are less demanding than the red, so concentrate on these to begin with if you are very unfit. When you get more proficient, many of the exercises can be made stronger by holding the positions. Once you become acquainted with the exercises, you can concentrate on particular weak points. If you find that you are stiff at the shoulders, or have little flexibility at the feet and ankle, put more work in there. If you are slimming, be particularly conscientious with exercises for abdomen, buttocks and thighs. Take as much as you need from the programme.

Wear whatever you like to exercise in, with two provisos: you should be comfortable and you should be able to move freely. Leotard, track suit, vest and pants, a loose baggy T-shirt over tights are all good. If your knees are weak, leg warmers can be very helpful.

● These exercises are designed for relatively fit, healthy people. If you are not, ask for your doctor's approval before starting. If you have a knee condition, avoid vigorous kicking exercises. If you have a chronic back condition, consult your doctor or specialist first and stick to the first exercise only in the back section and do all leg lifting exercises with a bent, not a straight, leg. If you are pregnant, the exercises on your front are not for you. Turn to pages 202-3 for specially designed postures and exercises.

● The exercises call on two basic principles. The first is posture. Check the way you are standing, sitting, or lying before each exercise. If you are not holding yourself properly, you may not be working the appropriate muscles and joints. It is particularly important that you master the pelvic tilt (see page 34). This is integral to many of the exercises as it helps to centre the pelvis and take the strain off the lower back. The second principle is breathing. Always breathe out as you exercise — as you kick out or curl up or lean back — and in as you rest the movement. You may find that this requires some concentration to begin with, but persevere and you will find that it soon becomes a spontaneous part of the routine.

● Finally, always finish exercising with 10 minutes of total relaxation, following the progressive relaxation technique outlined on page 176.

facefaceface

Tiny muscles, not bones, shape the expression of your **FACE**. You use them to frown, to smile, to raise your eyebrows, to flare your nostrils — to produce the range of expression that adds up to your unique way of responding to people and to situations. These muscles are important for another reason too: by providing the underlying support structure for the skin, they help to keep it firm and youthful. But no muscle remains firm without use, and you must therefore exercise your face muscles just as purposefully and as systematically as those elsewhere in the body.

These exercises will also help to remove any visible signs of tension. Anxiety always registers most tellingly on the face by freezing the expression and setting the jaw. So thaw out with these exercises. If you are anxious or tense, you will find it difficult to remain so while pulling faces at yourself. If you can actually laugh, so much the better. Laughter is invigorating, stimulating, liberating — a wonderful exercise for the face and body and one of the best ways of getting the tummy muscles into shape...

Exercise the muscles of your face by running through this routine. Start by crunching your face up into your nose, as though you have smelled something unpleasant (1). Then open your mouth and eyes as wide as you can (2) and stick your tongue out to release your throat muscles so that you are doing a silent 'scream' (3). This should be marvellously stimulating and relaxing. Proceed by pulling pursed lips to left (4) and right (5), and follow with a wide Cheshire-cat grin (6). Open your eyes wide and see if you can make the grin stretch from ear to ear. Hold, release and repeat, this time tucking in your chin and pulling your lower lip down as you do it. This will help firm the muscles at the front of your neck. Now run through the whole routine again.

necknecckneck

The **NECK** is remarkably delicate. It supports the weight of the head, acts as a pathway for blood vessels, central nervous system, digestive and respiratory systems, and transmits messages from the brain to all outlying parts of the body. It is also one of the most critical parts of the body when it comes to exercise, posture and relaxation.

External tensions produced by stress, anxiety or simply the habit of holding the head incorrectly (too far forward or back, too much to one side or the other) create internal tensions in the muscles that connect the neck to the shoulders, upper back and spine. Women seem to be particularly susceptible to tension and stiffness in the neck and shoulders. The purpose of the neck massage, below, and of the 'blue' stretching exercises is to persuade the tension to unlock. Commit these exercises to memory and run through them whenever you are aware of any tightness in the neck or shoulders or feel anxious and tense. You should find that it helps enormously. You can use the second exercise (2 and 3) as a barometer to see how tense you are. If you are extremely tense, the stretch you feel at the back of the neck will continue right down to the base of the spine. Either repeat the exercise gently until the tension eases or place an orange between your shoulder blades for an instant back massage (see page 176). A stretch that radiates from the neck down into the shoulder blade indicates tension in the diagonal trapezius muscle. Exercise 4 should help to release it.

Before you start these exercises, or graduate to the ones beyond them, check that you are sitting correctly. Use the picture here for reference, and bear these points in mind.

Sit squarely on the chair or stool, so your weight is evenly distributed on both buttocks (you should be able to feel the bones), your thighs apart and parallel with each other and your feet hip-width apart. Now lift your rib cage away from your hips to create as much length in front and behind as you can. But resist the temptation to pull your shoulders up too. Pull them down away from your ears and let your arms relax and hang downwards. Your shoulders should now be directly in line with your hip joints. Notice that, as you pull your shoulders down, the back of your neck lengthens freely. Hold your chin at about a right angle to your throat and enjoy the sense of lift flowing through you. Take a few good deep breaths. Now you are ready to start.

1 2 3

Above. Of the complex network of muscles at the neck, there are three critical ones: the narrow sternocleidomastoids at the side turn the head and tilt the chin upwards; the deep erector spinae muscles (hidden here) attach to the base of the skull and run all the way down the spine; and the trapezius muscle at the back – dark shaded areas, above right, are often tense.

Below. The neck is composed of seven vertebrae. These should follow the pattern of the first string of beads – each extending and lengthening away from the other. If the vertebrae are allowed to collapse, as in the second string, extra strain will be placed on the spine and supporting muscles.

Give yourself a neck massage. Start at shoulder blades and, keeping fingers together, stroke firmly upwards.

Continue kneading around the base of neck, paying special attention to tense areas.

Finish by clasping one hand over the other and pressing heels of hands firmly on to the neck on either side. Press and release as you move hands up and down the neck.

4

5

Start with stretching exercises to free tension and spend as long as you need on them. There is little point in working the rest of the body if the neck is tense and stiff. As you do the stretches, remember that your hands are there only to add weight and so to help with the exercise, not to pull the head down. If you feel the stretch is too strong, do the exercises without using the hands.

Stretch up to ceiling (1). Reach as high as you can, relax, and repeat. Now clasp hands on back of head (2) tuck chin in and lower it towards your chest (3). Keep going until you feel a stretch in the back of your neck. Hold and then release further into it. Check breathing is free, front of neck is soft, and jaws are unclenched. Come up slowly, breathing in. Anchor one hand on to back leg of chair or stool. Place other hand on head and let head drop diagonally forwards towards your knee (4). You should feel a stretch radiating from the top of your shoulder blade diagonally upwards to the base of the skull. Hold and release further into it when you feel you can take more stretch. Repeat on the other side. To complete the neck stretches, anchor one hand as before, place your other hand over the opposite ear and lower head to side, bringing chin in and shoulders down (5). You will feel a stretch along the side of the neck. Repeat to the other side. To complete this section, a neck strengthener and anti-double-chin exercise combined. Think back to front on this one; the jawline is kept trim by muscles at the back, not the front, of the neck. Clasp hands at back of head, press the head back and pull forwards with hands at same time (6). Place two thumbs just below the base of the skull so you can feel the neck muscles tighten. Hold for a moment, release and repeat.

6

Counteract the effects of gravity and improve your posture permanently with these exercises. Start by resting the hands flat on the lower ribs in front (1). Now pull the arms strongly together behind you. Pull back sharply several times. This is good for firming 'bra-strap' flab at the upper back. Now clasp hands behind back (2) and squeeze shoulder blades tightly together. Repeat several times. Progress to the stronger version (3). Make loose fists and holding both arms out at shoulder level, pull the shoulder blades together. Hold, and press arms back

1

2

3 4

several times, pressing the chest forwards slightly at the same time. Repeat until you begin to tire, remembering to keep arms up at shoulder level throughout. Rest for a few moments. Arms up at shoulder level again. Pull shoulder blades tightly together and hold them there as you press arms upwards strongly several times (4). Drop arms and circle shoulders backwards.
Lying on your back, use weights of no more than 0.5kg/1lb (or improvise, as here, with two cans of food) to strengthen upper arms (5) and (6). Pull arms upwards to the vertical position and lower again. Repeat several times slowly and then more quickly. Finally, compensate with a stretch in the opposite direction (7). Clasp hands in front, drop chin forwards, round your back, and pull your hands away from you. Repeat two or three times.

5

6

7

shoulder joint

biceps

triceps

elbow

Two different types of joint. The shoulder joint is a ball-and-socket joint that allows for great freedom as it rotates. The hip joint is also a ball-and-socket type but it is set much deeper in its socket and so tends to be more stable. The elbow joint, like the knee joint, is a hinge joint designed to work on one plane only.

The shoulder is moved principally by the deltoid and trapezius muscles which fan out across the shoulders and upper back and attach beneath the armpit. The elbow (and with it the lower arm and hand) is moved by the biceps and triceps muscles of the upper arm. The demands on these muscles, though frequent, are not very great – with the result that the muscle can lose its tone and become slack. But it is rewardingly responsive to exercise, particularly to exercise that incorporates the use of weights.

armsarmsarms

The **SHOULDERS** are the most mobile joints of the body. You only have to try the rotation exercise here (8 and 9) to see that you can move your shoulders through 360 degrees. This natural looseness at the shoulder has its disadvantages. It makes it much more prone to dislocation than either the knee or the hip because it has few ligaments to keep it firmly in place. Another major disadvantage is that it is possible to hold the shoulders in any number of ways that feel 'comfortable' and 'right' but that are, in reality, far from correct from the point of view of posture.

Look at yourself in a mirror, front on as well as side view. If you can see a dip between your clavicles (collar bones) and your neck or you can catch sight of your shoulder blades sticking out, all is not well. Both should lie flat. Round shoulders, which most of the population possesses, are aggravated by many factors from gravity to any occupation which encourages a slump forwards. These exercises are designed to reverse this tendency by encouraging the shoulders back and down.

UPPER ARMS are a problem area for many women. While no-one wants bulging muscles, the reverse — loose flesh caused by slack muscles on the underside of the arm — also leaves much to be desired. Happily, this is one area where exercise can count for a great deal. Carry out the upper arm strengthener exercise (10 and 11) at least twice a day and you will soon notice a difference.

The arms, like the face, are very expressive of tension, particularly the **HANDS** and the **FINGERS**. Tell-tale signs are shoulders lifted up towards the ears, arms held defensively into the body and clenched fisted hands. Next time you are anxious or upset, feel what happens to your body. Then unwind by releasing tension first in the hands (using exercise 12 and 13), then in arms, shoulders, neck, jaw. You will probably find that your mood improves as your muscles unlock. Although the hands and fingers are used constantly, they can become stiff. Counteract this by carrying out the stretching exercise daily, spacing your fingers wider apart as the joints become more flexible.

8
9
10
11
12
13

This is a good exercise for working shoulder, elbow and wrist joints simultaneously. Sit with elbows 'inside out' and palms facing the ceiling (8). Now turn the arms the right way round again, so that the palms are still facing the ceiling (9). Repeat several times. Continue with upper arm strengthener: make loose fists in front of you (10) and punch strongly back and upwards in firm movements, rotating the arms inwards so the backs of the hands face the front (11). Continue until tired and finish with a stretching exercise for the hands (12) and (13), making as much space between the fingers as possible.

45

frontfrontfront

There is a limit to how much exercise can do to help keep the **BREASTS** firm and well-toned, because the breast is not a muscle. As breast 'developing' exercises will not develop the breasts at all, but the pectoralis major muscle lying beneath and to the sides of them, you should avoid them if you do not want unsightly bulges at the armpit. Water therapy and massage treatments are similarly questionable 'aids' to beautiful breasts. Aim, instead, to keep the muscle toned, so providing a firm base of support for the breasts, and think in terms of preserving the shape of the ligaments known as the ligaments of Ashley Cooper, which provide the primary means of support for the breasts. Ligaments, unfortunately, do not have the elastic properties of muscle. Once they stretch, they do not spring back into shape; they remain stretched. The consequence? The breasts droop and sag. The culprit? Gravity. So, while braless is fine if the breasts are small enough and you do not move in ways that will jerk and stretch the ligaments (jogging is a major example of one that will), a good well-fitting bra should be worn at all other times.

You cannot separate the shape you are in at the front from the shape you are in at the back because each interacts with and affects the other. Think of your spine as the frame around which the rest of you is constructed and start adjusting your shape from there. Lower shoulders, lengthen spine, tuck buttocks under you and you should notice an immediate improvement at the front. Length at the spine opens the **CHEST** and makes space for the ribcage to work efficiently.

Achieve longer-term improvements through diet and exercise. Both are important. While exercising can firm the **WAIST** in a matter of weeks, it will take a good deal longer before you can expect to see similar results at the **HIPS**, where the underlying muscles are deeper.

It is important, too, to distinguish between fat at the waist and fat at the hips. Unlike the purely superfluous fold of fat at the waist, fat in the form of the natural curve at the hip is there for a good biological reason — to protect the reproductive organs. So firm up your abdomen (firming up your buttocks will do much to help, see next page), and lose weight there too if you like, but do not expect to lose it altogether.

2

To exercise muscles around the waist, sit on stool or chair, arms above head, fingers interlocked (2). Keeping shoulders down, bend first to the right (3), trying to bend further with small successive movements. Repeat to the left (4). Return to starting position (2), twist round to the side (5). Now lower right elbow towards right knee, imagining that you have a bar at your waist and have to lift your top half up and over it (6). You should feel the stretch along the left side of your back. Bend lower with small successive movements. Repeat to other side. Place hands on chest and twist from the waist so that you are looking as far around towards the back of the room as possible (7). Hold and continue in small successive movements.

Right. The breast, with the pectoralis major muscle underneath. This broad sheet of muscle should be exercised at three levels in order to keep it toned. The ligaments of Ashley Cooper, largely responsible for determining the lift and preserving the line of the breasts, attach to the fascia, or outer covering, of this muscle.

Sit with arms crossed, as shown, and, holding the biceps firmly, press strongly inwards several times (1). You should feel a tightness beneath the breasts. Repeat at eye and waist level in order to work every part of the muscle.

1

Above. You take six litres of air into your lungs a minute while at rest, up to 180 during vigorous exercise, so you need plenty of room in which the diaphragm can contract downwards and the lungs fill with air, when necessary. Normally, breathing should be fairly slow, even and relatively deep. To see if yours is, try this exercise: place one hand on your chest, the second on your navel. While the second should rise and fall to the rhythm of your breathing, the first should hardly move at all. If it does, you are breathing from the top of your chest – a sign of anxiety and tension...

8

9

To exercise abdominal (tummy) muscles start lying on back with hands on thighs (8). Flex feet and slide hands down towards knees as you bring your head up to look at your toes (9). Hold for a few moments and release. Repeat several times. Now sit up with legs bent and feet hip-width apart. Breathe out as you bring your chin towards chest, round your back and lower your body backwards, pulling forwards with the elbows at the same time (10). Hold it at the point where you feel your abdominal muscles tightening to prevent you falling backwards. Repeat several times. Take up starting position (11), breathe out and curl up bringing arms in front (12). Start by holding for two seconds and try to build to slow count of five. Repeat several times. As you get fitter, start with hands by your sides, then fold them in front, then finally, interlock fingers behind your head. (But do not attempt to curl up beyond the head and shoulders.) Repeat this exercise to either side (13) to work diagonal abdominal muscles, pulling well across the body with the top arm each time. Starting with your hands on your ribs, let your knees roll from side to side (14), so that the twist comes from the waist and the shoulders remain quite still. Lying flat on your back, bring one hip towards the ribs so that you feel a pinching at the waist where you are working the side abdominal muscles (15). Repeat to each side several times. Finish by lifting both legs up together (16) and feel a tightening under your hand where side abdominal muscles are contracting. Repeat slowly three times on each side.

horizontal vertical diagonal

The three major muscle groups that you are working with these exercises: the horizontal serratus anterior muscle, the diagonal external oblique and the vertical rectus abdominis. You need to work in each direction to firm your shape at the front and at the sides satisfactorily.

backbackbackback

BACKS need careful looking after. The spine, susceptible to the strain of simply standing upright, is soon weakened by poor posture and a sedentary, inactive lifestyle.

Exercises can help to keep your back strong and healthy by working the intricate network of muscles that support the spine, but these must be bolstered by good posture all the time. 'Corrective' exercises for a bad or damaged back should only be attempted under the strict supervision of an orthopaedic specialist and for this reason are not given here. If you do have a weak back or a previous history of back trouble, take these exercises very gradually. Start with a bent leg (4) and graduate to the more advanced exercises only when you feel that you have mastered the first ones. See page 35 for exercises that all but the fittest and the strongest should beware of if they want to safeguard their spines.

Of these exercises, those that involve lifting the head and shoulders will mainly work the muscles of the upper back, while those that involve lifting the legs will mainly work the lower back muscles and the gluteus muscles of the buttocks and backs of the thighs (see illustration on page 50). ALWAYS stretch out the muscles of the back after working them strongly, with the spine stretching exercise shown here (13).

Think of the **BUTTOCKS** as part of the back. Firm strong buttocks, integral to a healthy back and to good posture, are also extremely important in determining the general line of the body. Slack buttock muscles creeping round the side can add considerably to a bulge below the hips and at the sides of the thighs. While any exercise routine will help to firm up the buttocks (they are worked simply by lifting the legs), a specific buttock strengthener (such as 12) is of especial benefit. If your buttocks are slack — and they certainly are if you cannot see a definite 'dent' at the side just beneath the hip — do this exercise several times a day. The results will be rewarding. The buttock muscles, being broad and relatively shallow, are particularly responsive to exercise. Differences can often be seen in weeks, rather than months.

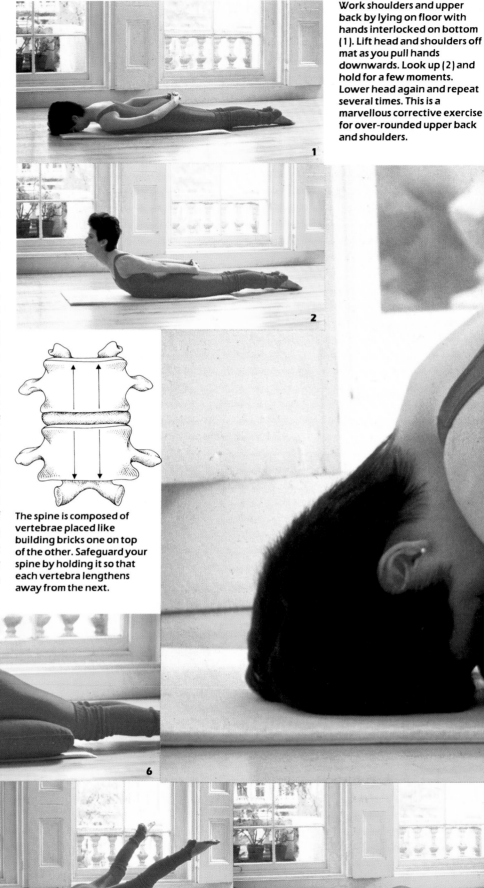

Work shoulders and upper back by lying on floor with hands interlocked on bottom (1). Lift head and shoulders off mat as you pull hands downwards. Look up (2) and hold for a few moments. Lower head again and repeat several times. This is a marvellous corrective exercise for over-rounded upper back and shoulders.

The spine is composed of vertebrae placed like building bricks one on top of the other. Safeguard your spine by holding it so that each vertebra lengthens away from the next.

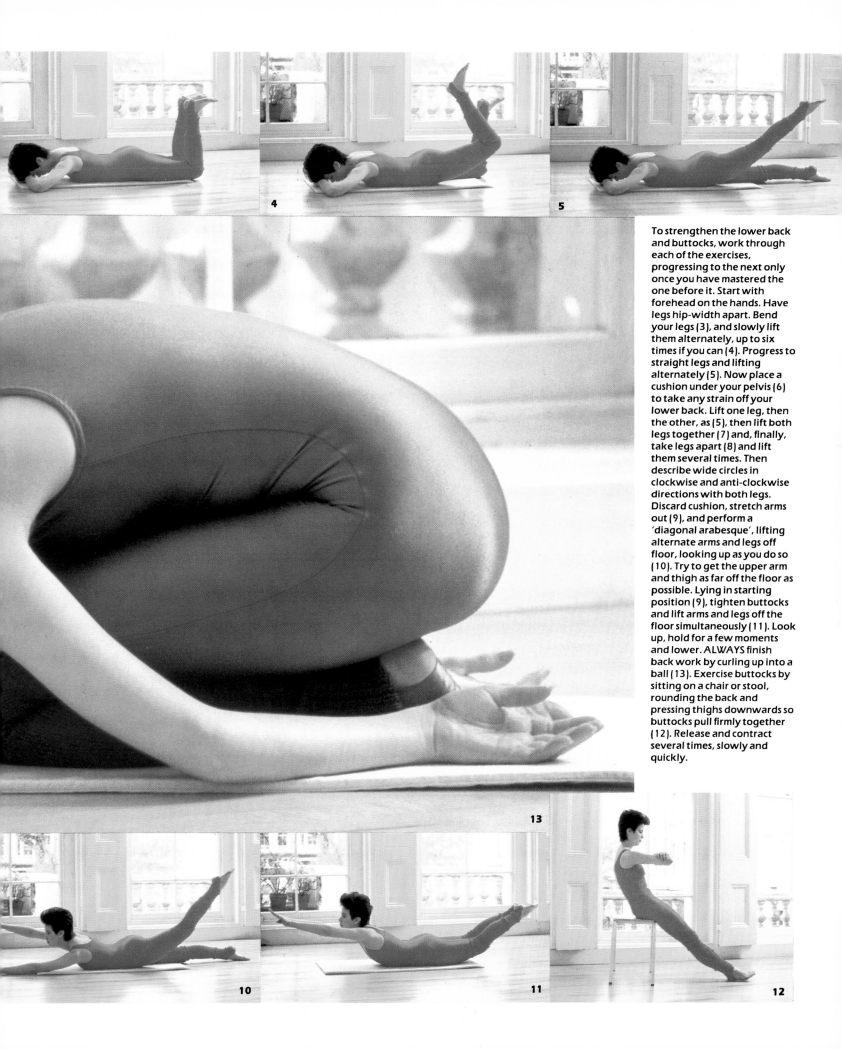

4

5

To strengthen the lower back and buttocks, work through each of the exercises, progressing to the next only once you have mastered the one before it. Start with forehead on the hands. Have legs hip-width apart. Bend your legs (3), and slowly lift them alternately, up to six times if you can (4). Progress to straight legs and lifting alternately (5). Now place a cushion under your pelvis (6) to take any strain off your lower back. Lift one leg, then the other, as (5), then lift both legs together (7) and, finally, take legs apart (8) and lift them several times. Then describe wide circles in clockwise and anti-clockwise directions with both legs. Discard cushion, stretch arms out (9), and perform a 'diagonal arabesque', lifting alternate arms and legs off floor, looking up as you do so (10). Try to get the upper arm and thigh as far off the floor as possible. Lying in starting position (9), tighten buttocks and lift arms and legs off the floor simultaneously (11). Look up, hold for a few moments and lower. ALWAYS finish back work by curling up into a ball (13). Exercise buttocks by sitting on a chair or stool, rounding the back and pressing thighs downwards so buttocks pull firmly together (12). Release and contract several times, slowly and quickly.

13

10

11

12

legslegslegs

Exercise, rather than diet, is responsible for improving the shape of the legs. Shedding extra weight may help to slim thighs by removing extra pounds, but it is unlikely to make a significant difference unless accompanied by exercise. Loose flesh, not fat, is the culprit and this is produced by insufficiently exercised muscles. Firm these up, and you could be amazed at the difference.

THIGHS can be slimmed down with a series of exercises that work all the major muscles of the upper leg. These comprise the group of hamstring muscles at the back of the thigh, the deeper underlying adductor (contracting) and abducter (extending) muscle of the inner and outer thigh and the large group of four muscles, known as the quadriceps, at the front (see below). This group is particularly important because it maintains strength and ensures stability at the **KNEE** — a vulnerable and unpredictable joint. Swimming is excellent for streamlining and toning the upper legs. Alternate a vigorous crawl kick with a backstroke one for best effect.

CALVES are common victims of high heels, poor posture and unwise exercising. Always loosen muscles at the back of the calves before and after any exercise that is at all demanding on legs or knees, such as jogging. Incorporate a few deep knee bends and/or stretching exercise 10 into your warming up routine.

Your feet are likely to carry you more than 70,000 miles during the course of your lifetime and so are worth looking after properly. This means keeping **ANKLE** joints mobile, **FEET** strong and supple. It means standing and moving properly too. Think of your feet as a tripod, with the weight of your body descending into the feet via the ankles and radiating out between the heels and the big and little toes. With the weight thus evenly distributed, the foot is freed from any incorrect pressures (provided, of course, that your footwear is good). If, however, the feet are at all weak, the ankle joints stiff or the shoes ill-fitting, you are asking for any number of problems from corns to backache, so beware.

The muscles at the front of the hip and thigh, far left, and on the back of the hip and thigh, left, which include the gluteus muscles of the buttock.

quadriceps

adductor

front

gluteus

hamstrings

back

Work outer thighs and hips by lying on side (1), with body and legs perfectly in line. Raise leg (2), keeping foot flexed and knee facing forwards. Do not aim for great height, as this will mean turning leg out from the hips, so defeating the object of the exercise. Lower leg to half-way position (3) and raise again slowly.

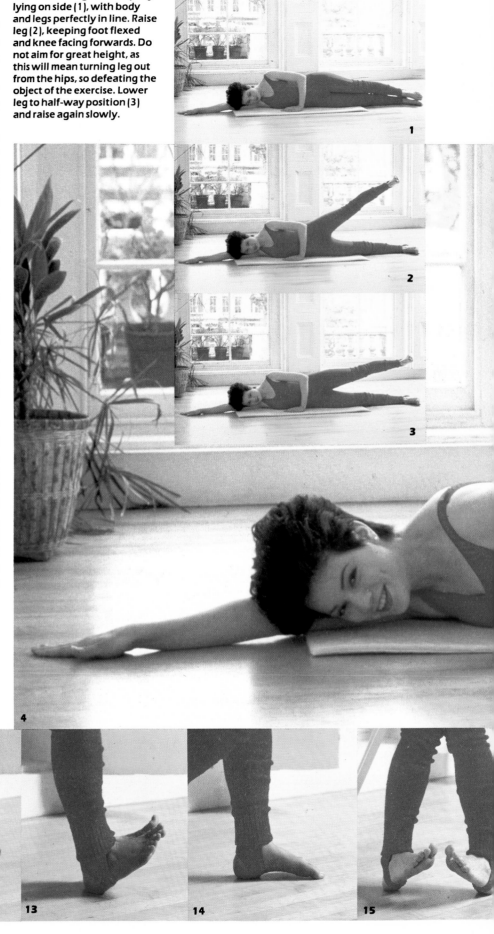

50

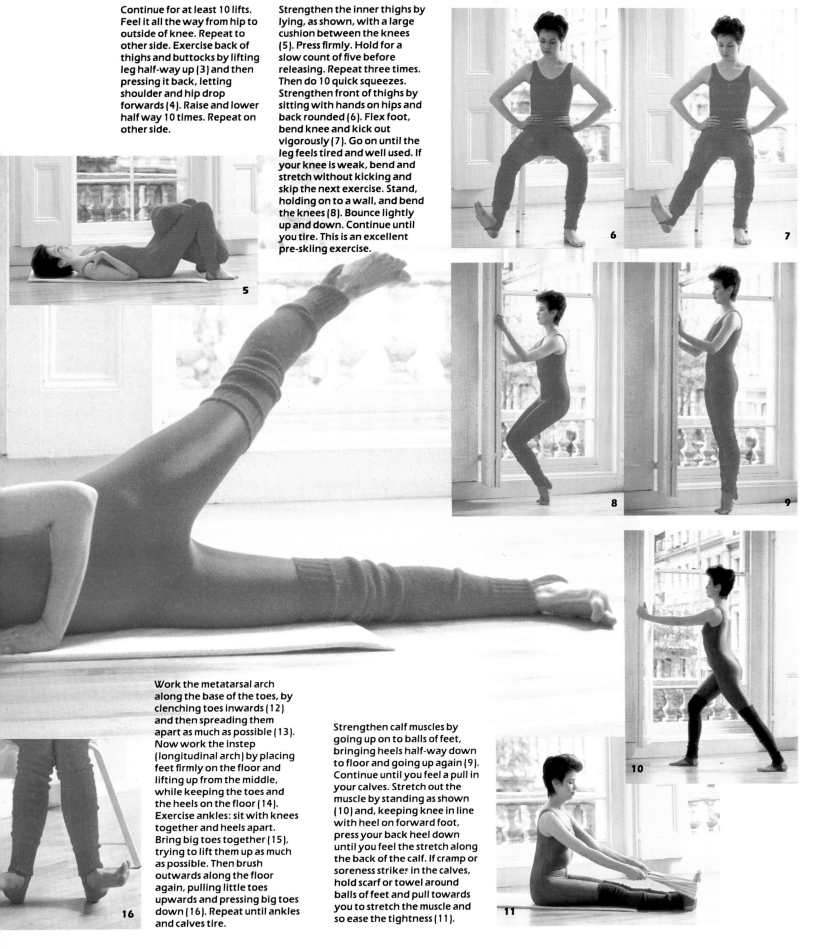

Continue for at least 10 lifts. Feel it all the way from hip to outside of knee. Repeat to other side. Exercise back of thighs and buttocks by lifting leg half-way up (3) and then pressing it back, letting shoulder and hip drop forwards (4). Raise and lower half way 10 times. Repeat on other side.

Strengthen the inner thighs by lying, as shown, with a large cushion between the knees (5). Press firmly. Hold for a slow count of five before releasing. Repeat three times. Then do 10 quick squeezes. Strengthen front of thighs by sitting with hands on hips and back rounded (6). Flex foot, bend knee and kick out vigorously (7). Go on until the leg feels tired and well used. If your knee is weak, bend and stretch without kicking and skip the next exercise. Stand, holding on to a wall, and bend the knees (8). Bounce lightly up and down. Continue until you tire. This is an excellent pre-skiing exercise.

Work the metatarsal arch along the base of the toes, by clenching toes inwards (12) and then spreading them apart as much as possible (13). Now work the instep (longitudinal arch) by placing feet firmly on the floor and lifting up from the middle, while keeping the toes and the heels on the floor (14). Exercise ankles: sit with knees together and heels apart. Bring big toes together (15), trying to lift them up as much as possible. Then brush outwards along the floor again, pulling little toes upwards and pressing big toes down (16). Repeat until ankles and calves tire.

Strengthen calf muscles by going up on to balls of feet, bringing heels half-way down to floor and going up again (9). Continue until you feel a pull in your calves. Stretch out the muscle by standing as shown (10) and, keeping knee in line with heel on forward foot, press your back heel down until you feel the stretch along the back of the calf. If cramp or soreness strikes in the calves, hold scarf or towel around balls of feet and pull towards you to stretch the muscle and so ease the tightness (11).

51

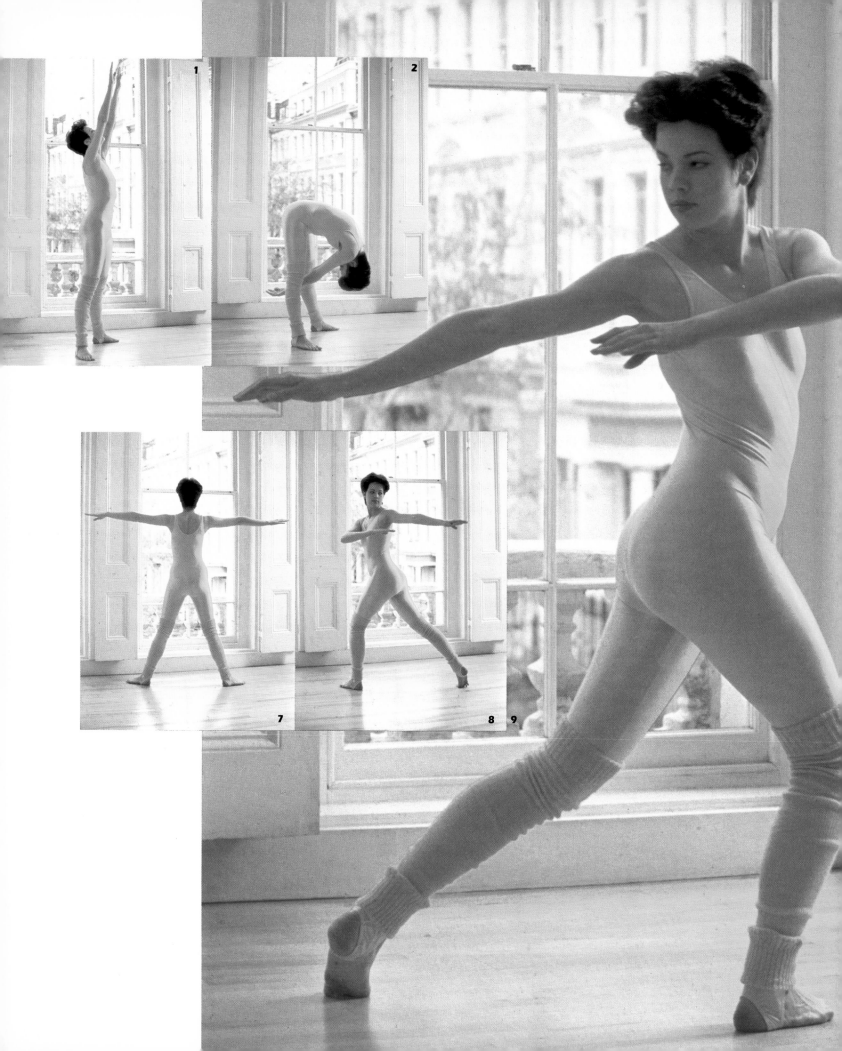

movemovemove

Start with a salute to the day: a really big stretch, arms straight, feet hip-width apart (1). Stretch one up further, then the other, several times. Next circle each arm backwards in wide circles to loosen shoulders, follow by circling both arms together and then bend forwards from hip and swish arms through legs (2). Bend your knees as you do this if you have a weak back. Repeat three or four times, before returning to starting position (3). Reach up to ceiling and bend to sides, keeping arms straight (4), so that you feel the stretch along your side, not in your back. Bend from side to side rhythmically several times. Now build a sequence, circling the body in one continuous movement. Bend (4), then twist into a diagonal forward stretch (5), continue down to brush past ankles (6), repeat diagonal stretch and side bend to other side and return to starting position stretching up. Make four circles each way, stretching as much as you can. Drop into 6 and swing loosely from side to side. Now try this marvellous body loosener. Start with arms extended out to sides (7) and swing around, bending knee as you go (8) and focusing on something on a wall behind you. This will help prevent you from getting dizzy. Repeat to other side (9) and continue twisting from side to side until you feel really warmed up.

● These general body conditioners will exercise all major muscle groups and joints and give heart and lungs a good workout too. But you should be relatively fit before starting. If you have not taken any exercise for a long time, spend two weeks practising each of the basic exercises illustrated on the previous pages every day before you graduate.

● The sequence should be fun to do. Work, first, at getting to know the movements and establishing a good rhythm. Then go, using whatever music you like — jazz, pop, classical, blues — to help you. Once you have a rhythm to your routine, you can start to improvise. Add a few deep knee bends, twists, turns, jumps, leaps or leg swings...keeping each new movement controlled and precise and letting it flow expressively into the next. While the sequence is flexible, it is important to keep to the basic framework. Always warm up into the jogging and wind down properly afterwards, finishing with the progressive relaxation routine outlined on page 176.

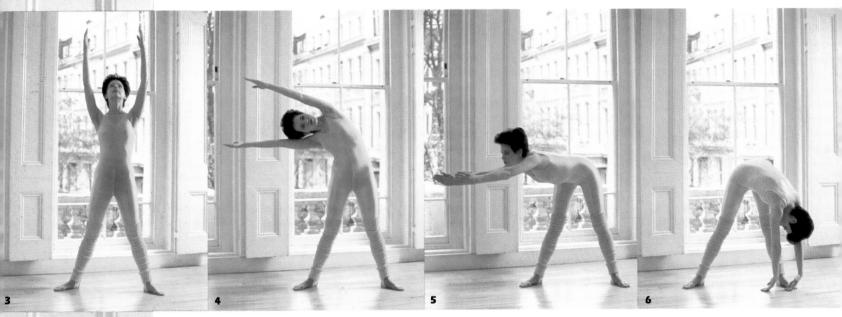

3 4 5 6

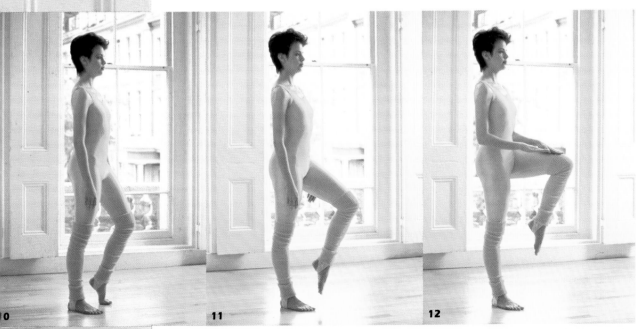

Now you are ready for the jogging. Before you start, do at least four deep knee bends, keeping your heels on the floor, to stretch out calf muscles. Begin simply by transferring your weight from foot to foot, lifting the heels only (10). Continue by lifting and stretching each foot (11). Then start to jump lightly from foot to foot, gradually lifting legs higher. Finish with the ultimate test: place arms out in front (12), and bring thighs up to touch as you spring from foot to foot – avoiding temptation to bring hands down to meet them. Always emphasize the upward spring. Continue until comfortably out of breath.

0 11 12

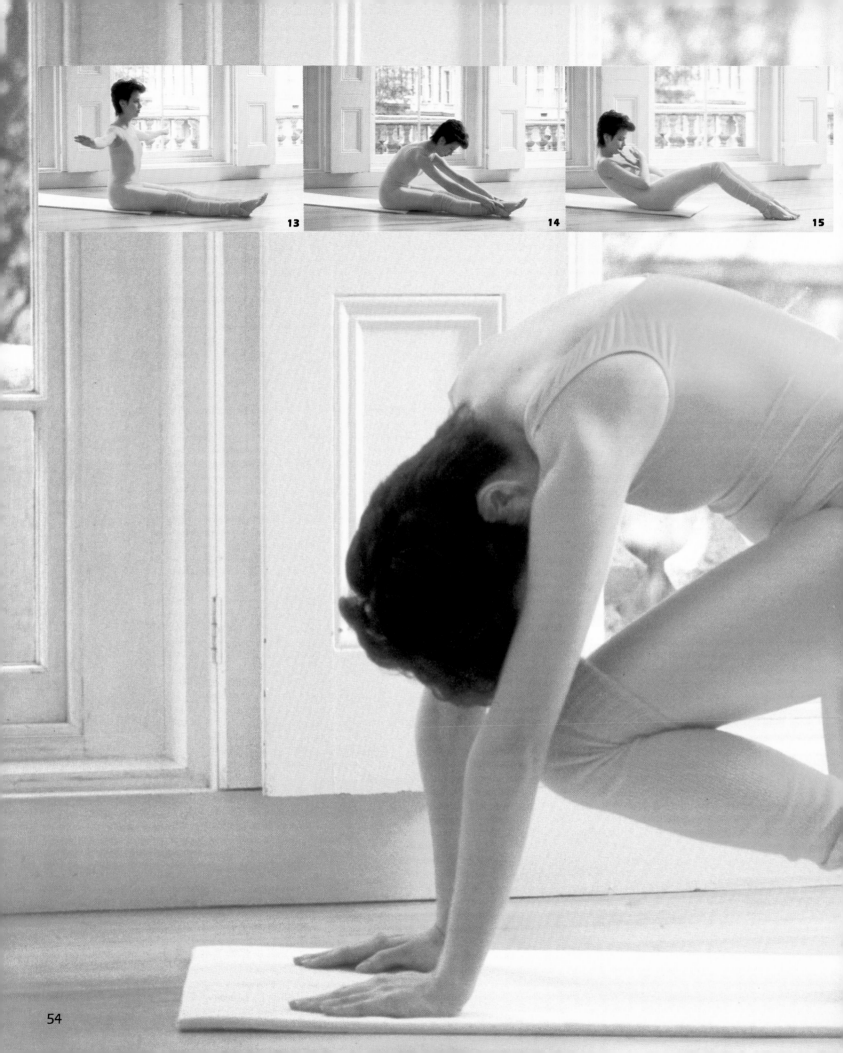

13

14

15

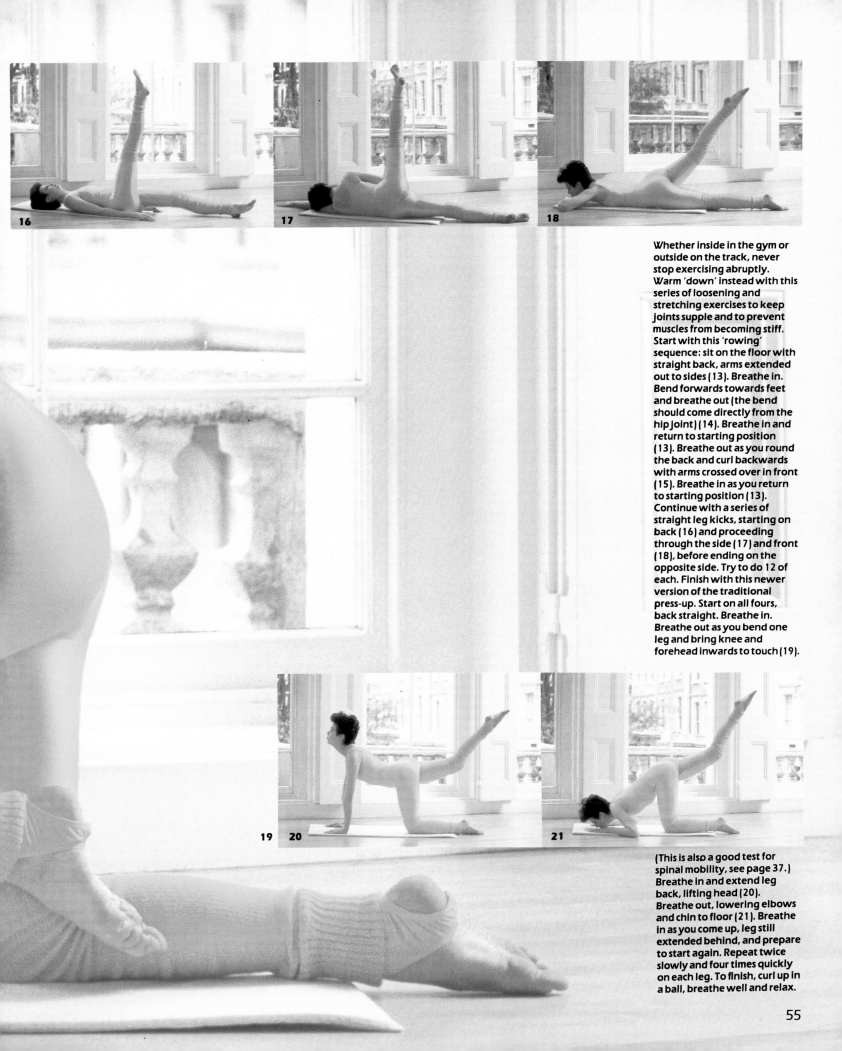

16 17 18

Whether inside in the gym or outside on the track, never stop exercising abruptly. Warm 'down' instead with this series of loosening and stretching exercises to keep joints supple and to prevent muscles from becoming stiff. Start with this 'rowing' sequence: sit on the floor with straight back, arms extended out to sides (13). Breathe in. Bend forwards towards feet and breathe out (the bend should come directly from the hip joint) (14). Breathe in and return to starting position (13). Breathe out as you round the back and curl backwards with arms crossed over in front (15). Breathe in as you return to starting position (13). Continue with a series of straight leg kicks, starting on back (16) and proceeding through the side (17) and front (18), before ending on the opposite side. Try to do 12 of each. Finish with this newer version of the traditional press-up. Start on all fours, back straight. Breathe in. Breathe out as you bend one leg and bring knee and forehead inwards to touch (19).

19 20 21

(This is also a good test for spinal mobility, see page 37.) Breathe in and extend leg back, lifting head (20). Breathe out, lowering elbows and chin to floor (21). Breathe in as you come up, leg still extended behind, and prepare to start again. Repeat twice slowly and four times quickly on each leg. To finish, curl up in a ball, breathe well and relax.

sportsportsport

SPORT OR ACTIVITY	SUPPLENESS	STRENGTH	STAMIN
WALKING (brisk) 300-350 calories an hour	*	*	**
JOGGING (steady) 360-420 calories an hour	*	**	***
RUNNING (moderate to fast) 500-600 calories an hour	**	***	****
CYCLING (brisk) 300-420 calories an hour	**	**	****
SKIPPING 150 calories for 15 minutes	*	**	***(*
TENNIS AND BADMINTON (energetic) 300-400 calories an hour	***	**	**
SQUASH AND RACQUETBALL up to 650 calories an hour	***	**	***(*
SWIMMING (fairly energetic) 540 calories an hour (800 crawl)	***	**	***
YOGA 180-300 calories an hour	****	**(*)	*
GYMNASTICS 380 calories an hour	***	***	**
SKATING (ice or roller skating) 500 calories an hour	**	**	**(*)
SKIING downhill (up to 600 calories an hour) cross-country (up to 1,200)	***	***(*)	**(**)
RIDING 200-400 calories an hour	*	**	**
FENCING 350 calories an hour	***	**	**
WATER SPORTS (water skiing, surfing, wind surfing) 400-700 calories an hour	*	**(**)	**(*)
WEIGHT & CIRCUIT TRAINING up to 800 calories an hour	***	****	**

Jogging: one of the easiest and most flexible of all the aerobic alternatives. To get into shape: start by walking briskly for five to eight minutes, intersperse with brief stretches of jogging, and gradually build up by shortening periods of walking, extending periods of running, until after three or four months you are running 20 or 25 minutes non-stop three times a week.

Details of common sports and activities are given here, together with relative exercise value ratings, and basic cautions. Approximate calorific 'burn-off' values are also given – but they are approximate. The amount of energy you burn off depends, first, on the effort you put into it, and, second, on your size to begin with (the larger you are, the more you burn).

OMMENTS	CAUTIONS
Walking has good toning effect on foot and calf muscles and is good gentle exercise for everyone. Aim to walk 5-6.5 km (3-4 miles) per day. Walking makes a valuable 'interval' pace when jogging or running – much better than stopping and starting again.	Remember to look where you're going.
Jogging will exercise heart and lungs and strengthen calves. It will do little to tone thighs or abdomen or to improve all-round mobility because it only exercises the hip, knee and ankle joints in a limited way, upper body not at all. To jog: stand up straight with arms hanging loosely by your sides, elbows bent, and push off from the ball of your foot and land on your heels. (You do not exercise your thigh muscles by running on the balls of your feet.) Build up as detailed, opposite.	Always warm up before jogging, warm down afterwards (see previous pages). If hip, knee or ankle joints are at all weak, use elasticated bandage for additional support, particularly if jogging on hard surfaces. Make sure that your shoes offer good support and are high-soled at the heel to protect the foot and absorb the shock (the heel takes five times the weight of the body each time it contacts the ground). Wear a bra to prevent breasts sagging. If you have heart, lung, back or joint problems consult your doctor before starting.
A wider running stride and swinging arms make for much more extensive and efficient movement of legs, arms and shoulders than jogging. Build up as jogging.	Ankle or knee joints unused to the demands of running may be sprained or injured, while sudden bursts of speed may result in sore, strained hamstrings (the muscles at the back of the thigh). Use a good pair of running shoes (see above) and elasticated bandages, too, if necessary. Always start slowly and cautiously. (See also jogging.)
Good, vigorous cycling over a period of 40 minutes or more will exercise heart and lungs, tone buttocks, front of thighs and calf muscles, and will increase flexibility at the knee and ankle. Start gradually if very unfit.	Go for conventional handlebars, not the curved racing ones which encourage a forward movement, and may put considerable strain on the lower back. Warm up first and stretch out calves afterwards (page 51) to prevent sore, stiff muscles.
Skipping can be a very useful part of any fitness programme, provided that it is built up gradually. Start by skipping in 30-second bursts, interspersed with short rest breaks of three to five minutes, and progress to skipping in one and a half minute bursts for 10 to 15 minutes.	Skipping is very demanding on the feet, ankle and knee joints and on the heart and lungs, so you should be reasonably fit and supple first. If you are tight-jointed or feel any jarring when you jump, use elasticated bandages for additional support.
An energetic game of tennis or badminton will exercise heart and lungs, promote flexibility in some, but not all, joints and strengthen shoulders, forearms (playing arm only), thighs and calves. Good players combine suppleness with strength for agility: the ability to turn and twist with speed. Skill, judgement, co-ordination and timing are also important.	The asymmetrical practice of serving and hitting the ball or shuttlecock with the same arm tends to make for uneven muscle tone and development. For best effect, combine with another more balanced sport, such as swimming. Sudden position changes may result in strains to muscles or twists and sprains to ankles, knees or elbows.
Squash and racquetball are more strenuous than tennis (hence higher stamina rating).	Both types exercise the heart and lungs quite vigorously, so make sure you are fairly fit first. Wear a protective visor: squash balls travel at speeds of up to 80 mph …
Water is the perfect exercise medium. Its buoyancy enables you to work muscle groups frequently missed out by other sports or activities; the resistance doubles the effectiveness of the exercise and the water supports your weight, so removing any risk of strain. Start slowly, resting every third or fourth length, building up until you are swimming 30 minutes without stopping. Different strokes have different exercise values; alternate them for best effect. The crawl is marvellous for improving the overall line of the body and the best for heart and lungs. Back butterfly exercises chest, thigh, arm and shoulder muscles. Backcrawl tightens abdominal muscles, slims inner thighs and upper arms. Sidestroke tones waist, legs and arms. Breaststroke is a great upper body strengthener (an area most women do not exercise enough).	Swimming is a marvellous exercise during pregnancy, but avoid breaststroke, as the wide leg action can put an additional strain on the sacro-iliac joints at the base of the spine. Try backcrawl and crawl instead.
Yoga is excellent for suppleness and, as you get better at it and able to hold the postures for longer, good for strengthening most of the large muscle groups. Start by using the postures on pages 178-9 and, if keen to pursue it further, seek instruction from a qualified teacher.	Build up general mobility first, particularly if generally stiff and tight-jointed. Remember that if you have to force your body into a position, you could be exerting unreasonable strains on it. In addition, observe all the more specific cautions on page 178.
Size and shape are important factors. On the whole, small, compact people tend to be better at gymnastics than longer, leaner types. This is probably because the centre of gravity is lower – giving additional stability and better balance.	Gymnastics are best suited to young and fit individuals who have the additional advantage of softer, more flexible bones should they fall or land awkwardly. Gymnastics are very physically demanding, so always increase your general level of fitness first.
Skill, balance and a degree of suppleness are very important – whether skating on four wheels or one thin blade. Also important: strength in the leg muscles and resilience.	Do not be too ambitious when starting out. When roller skating, protective clothing, including padding at the knees and elbows, will help to minimize the impact of falls.
Brackets apply to cross-country skiing – one of the most demanding forms of exercise.	Ankles, knees, and hip joints must be flexible for both forms of skiing and the leg and abdomen muscles strong. Get into shape well before you start – strong enough, ideally, to enable you to hold the wall sit (page 37) for three minutes or more.
First requirements are skill and a certain amount of courage. While ability counts for more than strength, riding is good for inner calf and thigh and will improve balance and posture.	Start by taking lessons and always wear a hard hat, however experienced or inexperienced you are.
Speed, agility and timing are important, not great strength. Fencing can be practised by anyone, provided that they are fairly flexible first. Fencing is very good for posture.	If tight-jointed, very unfit or stiff, increase your level of suppleness first. Proper protective clothing and qualified instruction are essential.
Water skiing strengthens leg muscles and increases flexibility at the knee; wind surfing strengthens upper body and is more generally demanding (hence the higher rating).	Instruction is essential for water skiing and wind surfing, helpful for surfing. You must be a competent swimmer before attempting any of these sports.
Weight training (not weight lifting) is one of the best ways of firming and toning areas that other types of exercise seem to leave untouched, such as upper arms and inner thighs. Provided that it is responsibly supervised, weight training will not over-develop muscles.	Weight training must be carried out under supervision, started gently and built up gradually to avoid placing unreasonable strains on any of the muscles or joints involved. You should also be relatively fit before starting (see also pages 36-7).

nutrition

'Tell me what you eat and I will tell you what you are.'　**Anthelme Brillat-Savarin**

Eating well means eating in a balanced, moderate and unanxious way. If this does not describe the way you normally eat, then your eating habits and, probably, your attitudes towards food require a certain amount of revision. (Check both of these by completing the nutrition tests in the Personal Profile before you start.)

The basics of good, healthy eating are simple, need not be expensive or unnecessarily time-consuming, and can be summed up as follows:

1. Make sure that you are getting good quality protein, especially if you are vegetarian.

2. Regulate and balance the amount of fat you eat.

3. Eat plenty of fresh fruit and vegetables (preferably raw).

4. Cut out most refined flour from your diet and replace it with wholegrains.

5. Make sure that you are eating enough fibre.

6. Cut out as much refined sugar from your diet as possible.

7. Eat less salt.

8. Drink plenty of water. Watch your intake of coffee, tea, cola drinks, refined soft drinks and alcohol.

9. Balance your food intake over the day and enjoy your food.

Ways in which you can achieve these objectives are outlined in the following pages. If your eating habits are way off these, be realistic, do not expect to be able to change them overnight. Give yourself three months in which to relinquish your bad habits and to adopt better ones — and to lose some weight if you need to. You will be reassured to find that it is possible to diet while learning the principles of good nutritious eating, so establishing a healthy framework that can be carried into your normal, non-dieting way of life. Once you have overhauled your eating habits, return to the nutritional profile and check your progress by seeing how you score.

FIRST PRINCIPLE – PROTEIN

The ideal proportions of any diet are 55 to 65 per cent carbohydrate, 25 to 35 per cent fat and 10 to 15 per cent protein. Although the percentage of protein is the smallest, it is one of the most crucial components of the diet, necessary to growth and to the repair and replacement of different body tissues. The need for protein is highest when the body is growing, such as during childhood, puberty or pregnancy, and lowest in adulthood. Adults do not require great quantities of protein. In fact, as little as 45 g/1 ½ oz of protein a day is now thought to be enough, provided that the quality is right.

Although protein is often equated with a large, rare steak, it is found abundantly in other foods. Some plants, such as the soya bean, actually have more protein, weight for weight, than roast beef. But quantity is not the major consideration. Of the 22 amino acids necessary to body function, there are eight which the body cannot make. These are found exclusively in protein-containing foods although, confusingly, not all protein-containing foods contain all eight amino acids. Eggs provide a nearly perfect amino acid balance, although relatively 'low' in protein. Fish and meat come next, then cheeses, milk, grains and legumes (soya beans and sprouts, mung beans, lima beans, peas, kidney beans, etc). Nuts and seeds provide relatively low quality protein. The best way of ensuring that you are getting all the protein you need? Eat a varied and balanced diet — and it need not necessarily be a carnivorous one.

Vegetarianism

Studies have shown that vegetarians tend to be healthier and slimmer, to have lower blood cholesterol levels, and to live longer than their meat-eating peers. Although one reason for this may be that vegetarians, as a group, are more conscientious about their health than the general population (few smoke, for example), it convincingly puts paid to the myth that a diet lacking in meat is a depleted one.

There are two different types of vegetarians. The first group are the ovo-lacto vegetarians, who eat no animal flesh but eat animal produce. For this group, diet is no problem, as long as it is nutritious. Alternative protein sources, found in milk, cheese and eggs, are abundant. Supplementation of iron, vitamin B 12 (only if very little milk is drunk) and vitamin D in winter, principally found in fish oils, may be necessary during pregnancy. The second group are the vegans, who eat no animal produce whatsoever. This diet will take more manoeuvring if it is not to be protein or mineral deficient. This is particularly crucial for children and pregnant women. All strict vegetarians should be aware of protein-rich vegetable sources and how best to balance them for healthy eating, combining grains (rice, wheat and corn) with legumes (peas, beans, etc), as these have a complementary amino acid make-up. Vegans should also be aware that they need foods high in iron (all dark green vegetables, watercress, cabbage, whole grains, cocoa) and calcium (sesame seeds, all green vegetables) and should take extra vitamin B12 (available in non-animal form) to guard against pernicious anaemia, extra vitamin D in the winter (during summer it is synthesized naturally by sunlight), and a zinc supplement if eating large amounts of soya.

SECOND PRINCIPLE – FAT

Fat is important in the diet. It provides one of the most concentrated sources of energy; it is essential for healthy teeth and bones and for brain function; it is a vital natural source of the fat-soluble vitamins, A, D and E, and, lastly, it makes food palatable and pleasant. In general, as the standard of cooking rises, so does the proportion of fat used.

While we all need some fat in the diet, we do not need the excessively high amounts that many people consume daily. These may affect blood cholesterol levels, constituting one predisposing factor to coronary heart disease, and will certainly cause you to put on weight — a sizeable health risk on its own. Fat leads to fat — carbohydrates, despite their reputation, are much less likely to.

Aim to reduce the total amount of fat in the diet from the average 40 to 45 per cent to about 30 per cent. In addition, replace some saturated fat with polyunsaturated fat. Such adjustments need not entail any radical changes in your

bread. Substitute polyunsaturated for saturated oils and lard when cooking or when making dressings.

● Take cream and top of the milk in moderation. If you are slimming, or have been advised to watch your intake of fats, avoid both and substitute skimmed for whole milk.

Which fats are which?

Saturated fatty acids are solid fats principally, though not exclusively, of animal origin. Milk, butter, meat and cheese are obvious examples. Because some plants and vegetables, notably coconut and cocoa, are high in saturated fat, an oil labelled simply 'vegetable oil' or a margarine containing 'edible oils' is not necessarily polyunsaturated and may, in fact, contain high amounts of saturated fat. Fats and oils that are normally unsaturated may become saturated when hardened through hydrogenation. These include hard margarines, lard, suet, etc. Saturated fatty acids have been shown to raise blood cholesterol levels.

Polyunsaturated fatty acids (PUFA) are found in some, but not all, vegetable oils. Rich sources are sunflower, safflower, corn (maize) and soya bean oils and some soft margarines. Chicken and fish oils are also rich sources and most nuts, except coconut, contain some. Interest in these fatty acids stems from the fact that they lower blood cholesterol levels.

Cholesterol is an essential precursor of cell metabolism and we all need it to function properly. Of all the cholesterol in the blood, only 25 per cent arrives via the diet. The rest is synthesized inside the liver, under the control of the stress-sensitive adrenal glands. Although cholesterol is not commonly found in foods — exceptions are egg yolks, offal, such as liver, kidney, brain and heart, and some types of shellfish — some foods, such as those containing saturated fats and sugar and alcohol in excessive quantities, can raise blood cholesterol levels. A number of other factors can also do this. These are obesity, smoking, excessive stress, physical inactivity, and the contraceptive pill.

These independent risk factors can add up to a sizeable one when combined, especially if you are male and middle-aged or female and have passed the menopause. In fact, it is becoming increasingly apparent that the much talked-about 'protective effect' conferred by the female sex hormones before the menopause is progressively whittled away by factors such as smoking. Heart disease and heart problems are not, as was once thought, an all-male preserve. As women's lifestyles become more highly pressured — and similar in many ways to those of men — these illnesses are showing a significant increase. So, whatever your sex, take steps now to eliminate risk factors within your control, such as smoking (now considered the major risk factor) overweight and inactivity. In addition, if you come within the age category given above, you should watch your intake of dietary cholesterol and saturated fat. Eat no more than one meat meal a day, restrict the number of eggs eaten to three a week, and substitute polyunsaturated margarine for butter and polyunsaturated oils for animal fats when cooking.

eating habits. Simply follow the guidelines given here. Do not become obsessive or fat 'phobic'. Saturated fats and cholesterol are not synonymous with heart attacks. Eggs, butter, milk and meat are all excellent sources of energy. In the wake of the great cholesterol controversy, it is worth remembering that the egg remains the best quality protein food there is.

● Eat less red meat and more poultry and fish. Choose lean meat and remove all visible fat before cooking. To find out which are the leaner and which the fattier types of meat and fish, turn to page 74. Grill rather than fry, bake or casserole rather than roast.

● Eat eggs in moderation, but do not feel that you have to exclude them from your diet. A sensible limit would probably be seven eggs a week. If you come within the 'at risk' category, or have been advised to watch your cholesterol intake, restrict yourself to three eggs a week.

● If you prefer the taste, by all means use butter on your

61

THIRD PRINCIPLE – FRUIT AND VEGETABLES

Fruit and vegetables tend to be high in carbohydrates (starch and natural sugar, or fructose), rich in vitamins and minerals and low in protein and fat. Together with grains and pulses (legumes), they should form the bulk of the diet and, to get maximum nutritional mileage, at least half should be raw. This will ensure that you are getting important vitamins and minerals —the elusive potassium, in particular —that tend to be destroyed or leached out during cooking. Fruit and vegetables should also be fresh: the closer they are to their natural state, the higher in vitamins and minerals and the more nutritious they will be. It is well worth looking around for shops that buy their produce fresh every day.

The way in which you prepare and cook your vegetables will also determine how nutritious they are. While overcooking is the greatest crime, there are other, less obvious ways in which goodness can be depleted. Follow these guidelines to get the best from your vegetables.

● Scrub rather than peel. Essential vitamins and minerals tend to be concentrated in the peel, rather than in the flesh, of the vegetable. The peel also provides more fibre and seals in flavour.

● Break vegetables into rough pieces or chop them into large slices. Dicing or shredding vegetables with a steel blade will deplete vitamin content.

● Only prepare as much as you need. Leave the rest whole (do not immerse in water) and keep in the refrigerator.

● Preferably, cook by boiling in a minimum of water in an ordinary saucepan or pressure cooker. This method is now thought preferable to steaming. Avoid roasting or frying.

● Add the vegetables to the water only once it is boiling and then cook as lightly and briefly as possible. Soft, soggy vegetables that do not need chewing are overcooked.

● Avoid adding baking soda to give 'colour' to green vegetables and do not use copper pans or utensils. Both dramatically reduce vitamin C levels.

● Do not throw away the cooking water, as some vitamins and minerals will always be leached out during boiling. Use it, instead, for making soups, sauces and gravies.

● Once the vegetable is ready, eat it immediately. Do not leave it for ages in a warming oven and try to avoid reheating.

FOURTH PRINCIPLE – GRAINS

A grain of corn in its natural state consists of three parts — the inner heart or germ, the starchy centre and the bran or outer husk. The first and the last of these are removed during the milling and refining processes, the germ because it contains a small amount of oil which shortens the shelf-life of the finished product, and the bran because it is coarse-textured and, therefore, considered undesirable. This is a pity because these are the two most nutritious parts of the grain, rich in B vitamins, essential trace minerals, protein and fibre.

If you want to benefit from the goodness in the original grain, you should buy wholegrain products — rice, bread, flour, pasta — and use them whenever you would use their refined equivalents (except when baking and making sauces, if you prefer a finer, lighter texture): At the very least,

you should incorporate two pieces of wholemeal bread into your diet each day. This is extremely nutritious in its stone-ground wholewheat form — a rich brown flour that contains every part of the grain. Combine these two slices with an imaginative filling (see suggestions on page 74), and you have a complete, satisfying meal that provides all the nutrition the body requires. Bread is more, not less, important when dieting as it provides essential carbohydrate and bulk and will help to guard against constipation, an occupational hazard to most dieters.

FIFTH PRINCIPLE – FIBRE

Fibre is the indigestible carbohydrate found on the outsides of foods — concentrated in the peels and rinds of fruits and vegetables and in the outer layers of grain. Although fibre contributes nothing in terms of nutrients to the diet, it is important because it controls and regulates the process of food absorption and enables the food to pass easily and smoothly through the gut, protecting against constipation, haemorrhoids (piles), appendicitis, diverticular disease and now, it is thought, certain types of cancer, obesity and coronary heart disease. Food that is high in fibre combines with water in the stomach and swells into a soft and spongy mass that can travel easily through the intestines, where it is gradually broken down and metabolized. Food that is lacking in fibre is much more rapidly broken down and has a difficult and constipated journey along the gut and out of the bowel. If this is the type of food you eat, you may be increasing your chances of succumbing to one or more of the diseases listed above and may well be suffering from constipation.

The list of foods, right, gives relative fibre contents. Although fresh fruit and vegetables provide relatively low sources of fibre when compared with pulses (legumes), nuts and dried fruit, recent research suggests that pectin, the type of fibre concentrated in the peel of some fruits, such as apples and plums, may be valuable because it appears to contain a cholesterol-lowering factor. Unprocessed bran is by far the highest natural source of dietary fibre.

If you do suffer from constipation, give the laxatives a rest. Try the fibre-rich muesli cereal given on page 71 and/or one tablespoon of unprocessed bran on your food, gradually increasing to two or three, if it does not have any effect.

SIXTH PRINCIPLE – SUGAR

On average, we eat 140 g (5 oz) of sugar a day, and some children and sweet-toothed adults eat three or four times as much. The consequences are overweight, tooth decay, maturity-onset (sugar-related) diabetes, kidney and even, perhaps, coronary heart disease. Resolve to cut out all or, at least most, refined sugar from your diet today, and you will be much slimmer and much healthier for it.

The metabolism of sugar in the body is regulated by the pancreas and the adrenal glands. The first lowers blood/sugar by releasing insulin which converts what sugar is needed into usable glucose for energy and stores the rest away in the form of glycogen (starch) in the liver. The second raises blood/sugar levels once they fall below a certain level by releasing hormones, principally cortisol, capable of un-

% Fibre in foods

Bread and flour	
Bread (white)	2.7
Bread (wholemeal)	8.5
Crispbread (rye)	11.7
Flour (plain white household)	3.4
Flour (100% wholemeal)	9.6
Oatmeal	7
Rice	2.4
Wheat bran	44
Cereal and pastries	
All Bran	26.7
Cornflakes	11
Doughnuts	0
Muesli	7.4
Pastry	2
Rich fruit cake	3.5
Vegetables	
Cabbage (raw)	3.4
(boiled)	2.8
Carrots	2.9
Celery	1.8
French beans	3.2
Haricot beans	7.4
Lettuce	1.5
Peas (frozen)	12
(fresh)	5.2
Potatoes (boiled)	1
(baked with skin)	2
Fruit and nuts	
Almonds	14.3
Apples	
(apple peel)	3.7
Apricots (raw)	2.1
(dried)	24
Brazil nuts	9
Dates	8.7
Desiccated coconut	24
Figs (raw)	2.5
(dried)	18.5
Lemon juice	0
Lemons, whole	5.2
Orange juice	0
Oranges	2
Peanuts	8.1
Prunes	16.1
Raisins	6.8

locking these sugar reserves and returning them to the bloodstream for energy. This self-regulating principle works well — provided that you do not habitually overload the system with sugar. Overloading can lead to overweight, to an exhausted (diabetic) pancreas or to a disoriented 'trigger happy' one. While there is some disagreement about how common this condition is (known as low glucose tolerance in the UK, hypoglycaemia in the USA), if you habitually crave sweet things and, while indulging the craving, are aware of mystifying mood swings and fluctuations of energy during the day, they may not be as mystifying as all that. Try cutting sugar out of your diet entirely for two weeks, eating little and often, substituting protein or fat for sugars and starches (cheese instead of biscuits, for example) and see how you feel.

Find alternative sugar sources in fruit and vegetables.

These contain both substantially less sugar and a different type, fructose and not sucrose, that is more slowly metabolized in the body and therefore provides a more sustained form of energy. Even this type of energy is ephemeral, when compared to the energy provided by starch (also contained in fruit and vegetables), protein and fats.

Wean yourself off sweetened foods by replacing all refined sugar with honey, raw cane sugar or blackstrap molasses (in ascending order of preference). Honey, although delicious, is nothing more than diluted sugar (25 per cent water, 75 per cent sugar and the merest trace of other nutrients) and has enjoyed a long, but quite undeserved, reputation as a 'health' food. Raw sugar and molasses are thought to be more nutritious, as they contain some vitamin B, together with other nutrients stripped out during the process of sugar refining.

63

SEVENTH PRINCIPLE – SALT

Most of us eat far too much salt — an average of between two and two and a half teaspoons a day, more than 20 times the body's needs. This quantity is exceeded only by the Japanese, who eat half as much again and have an unequalled record of hypertension (high blood pressure) and stroke to show for it. Both these conditions have now been strongly linked to an excessive amount of sodium in the diet.

Some sodium, probably as little as 1 g (0.04 oz) a day, is essential to the healthy functioning of the body because, together with another mineral, potassium, it regulates water balance. Too little salt and essential water is lost through sweat or in the urine and the body dehydrates.

Most of us, however, are much more likely to have too much salt in the body rather than too little. In addition to high blood pressure, high amounts of salt in the diet can lead to bloating and discomfort, particularly before a period, because it is so water-absorbent. A teaspoon of salt is said to be able to hold 70 times its weight in water.

In order to reduce salt consumption to a healthier 5 g (0.2 oz) a day, you will probably have to cut your intake by three-quarters. Here are some ways in which you can achieve this.

- <u>Avoid processed foods</u> —all hidden sources of salt—and avoid eating excessive amounts of seafood, smoked meat or fish and salted meats, such as bacon and corned beef.
- <u>Avoid processed and smoked cheeses,</u> which tend to be twice as high in salt as natural, hard, cheeses.
- <u>Use unsalted butter.</u>
- <u>Add a minimum of salt to the cooking water</u> when boiling vegetables and add it only in the last few minutes of cooking time.
- <u>Reduce the amount of salt you use when making soups,</u> stews, casseroles and other meat or vegetable dishes. Experiment with herbs and spices to add and enhance flavour.
- <u>Taste, then season.</u> If you habitually add salt to your food without tasting it first, you are certainly eating far too much. Taste it first, add a small amount of salt to the side of the plate and gradually wean yourself off it.
- <u>Never add salt to the food of young children.</u> It is an acquired taste not a natural preference. Adding salt to baby foods may actually be dangerous as a baby's kidneys are not strong enough to handle it.

EIGHTH PRINCIPLE – WATER AND DRINKS

Water is undoubtedly the healthiest way of quenching a thirst. It is also essential to the functioning of the body, because it maintains the fluid balance, both inside and outside the body cells. The 2 litres/3½ pints (USA 4½ pints) of water that is lost a day through perspiration and in the urine must be replaced. Drink at least eight glasses of water a day, straight from the tap or in its bottled mineral form.

Coffee and tea are fine in moderation, not in excess. This is because they contain caffeine, which acts as a stimulant by releasing the 'stress' hormone noradrenaline (norepinephrine) into the system. Although we tend to equate caffeine with coffee, a strong cup of tea contains the same amount of caffeine as a cup of coffee made from ground beans, and slightly more than a cup of instant coffee. Caffeine is also found in cola drinks. Too much tea, coffee or cola will make you nervous and jumpy, may interfere with the digestion and the absorption of vitamins and minerals, such as iron, can have a bad effect on the skin and may rob you of up to two hours sleep. Because caffeine is a drug, you can become 'addicted' to it. Withdrawal symptoms are irritability, agitation and headache. While this type of addiction is linked to relatively high coffee or tea intake (11 or 12 cups a day), smaller amounts may still have a significant effect. Restrict the number of cups you drink to three a day and drink them early in the day, so that they will not interfere with your sleep at night.

If you are a tea or coffee 'addict', try replacing tea with herbal infusions (tisanes) and coffee with the decaffeinated variety or one of the numerous coffee substitutes available from health food stores. Alternatively, try floating a wedge of lemon on a cup of hot, boiled water and drink it first thing in the morning. The freshness and slight acidity of the water may remove the desire for the muddier taste of tea and coffee.

Refined soft drinks, carbonated and still, contain large quantities of sugar and/or saccharin and high levels of phosphates. Too much phosphorus can interfere with the absorption of other minerals that the body needs for good health. Make your own soft drinks, instead, by blending fresh fruit with a little honey or liquid sweetener to taste, and topping with soda or mineral water. If you have a blender, these drinks can be made in minutes (see recipes on page 188).

Alcohol is pleasant and enhances the enjoyment of any meal. Taken in moderation, it will help to relax you and will give your digestion system the chance to work well and properly. Taken in excess, it will rob you of appetite and may seriously undermine your health . Women are particularly at risk to the physical ill effects of alcohol. Balance is the key. Find guidelines in the Lifestyle chapter.

NINTH PRINCIPLE – BALANCE

Most nutritionists recommend a large breakfast, an adequate lunch and a small dinner, so that protein and energy needs are met in the early part of the day and not concentrated in the last few hours when you are unlikely to be able to digest and absorb the food you eat before going to bed. There is more than a little wisdom in all this. Experiments have repeatedly shown that the body's ability to metabolize and digest protein and other nutrients deteriorates as the day wears on, that we make more efficient use of our food at breakfast time than we do at dinner.

The value of eating three 'good' meals a day, however, is not so clear cut. In most people, cues for eating derive from contractions, or 'hunger pangs', of the stomach muscle which are in turn prompted by lowered levels of sugar (glucose) in the blood. These hunger contractions occur at three-to-four-hourly intervals — though they can extend to six when fasting. This means that, if you sleep for eight hours, are up for 16 and act on your biological rather than your cultural food cues, you will probably eat four or five meals a day.

While some people manage to synchronize biological food cues happily with cultural ones, others do not. Such people will either suppress their natural hunger messages, probably over-eating at the next meal to 'compensate', or will indulge them guiltily on 'guilty' foods (sweet fattening snacks rather than nutritious 'mini' meals) because the indulgence is seen not as natural but as a weakness. An interesting British study looking at blood/sugar levels in both men and women after fasts of 24 hours or more has shown that women's blood/sugar levels tend to fall more rapidly after long periods of non-eating. If the same applies, albeit less dramatically, to day-to-day eating, it may do much to explain why women tend to feel hungry more frequently than men and why they are particularly prone to snacking between meals.

If you have never managed to adjust happily to a conventional three-meal-a-day framework, start by considering what your natural eating pattern is. Let your body 'free run' for a week or two, and allow it the space to adopt its own eating schedule. You should find that, with a bit of flexibility, you can adapt fairly easily to it. This need not be unnecessarily anti-social because you can always time your eating phases to coincide with at least one main meal a day.

Whether eating at conventional meal times or not, do try to balance your food intake over the day, so that you get your main source of nourishment and, particularly, protein before 2 pm, and taper off towards nightfall. You should also try to set aside at least 30 minutes for your meals when you can relax. Nervous energy and anxiety interfere both with appetite and with digestion and will affect your ability to get the most from your food.

Whatever you are eating, savour its taste and enjoy its flavour. Indulge your appetite for taste, smell and colour. Think of food as an adventure — experimenting with new ways of cooking and with unusual herbs and spices. Even familiar foods can be novel and exciting when cooked in a different and unfamiliar way. The recipes that follow should give a lead.

APPROXIMATE COMPONENTS OF WEEKLY DIET

eggs	between 3 and 7 times
liver	1-2 times
fish	3 times
meat	5 times
poultry	2-3 times
raw vegetables	7 times
cooked vegetables	12 times
fruit (raw and cooked)	18 times
cheese	4-5 times
yoghurt	almost daily

foodfoodfoodfoodfood

menusmenusmenus

	LUNCH	DINNER
Sunday	*Lunch with friends* * Aubergines (Eggplant) with Mozzarella * Braised Veal with Basil New Potatoes Mangetout (Snow Peas) * Prune Mousse	* Lentil Soup with Yoghurt * Watercress Omelette Tomato Salad Grilled Feta Cheese
Monday	* Cold Borsch (en Gelée) * Grilled Chicken Wings with Yoghurt or Garlic Sauce Green Salad Fresh Fruit Salad	* Spinach, Mushroom and Bacon Salad Gnocchi Baked Tomatoes Baked Apples with Cream/Yoghurt
Tuesday	* Vegetable Bouillon Grilled Liver and Onions Carrot Purée * Compote of Dried Fruit	* Caponata Grilled Mackerel Tomato Salad Pink Grapefruit and Kiwi Fruit
Wednesday	Leek Vinaigrette * Stuffed Peppers with Yoghurt or Garlic Sauce Fresh Fruit	*Dinner Party* * Seviche of Sole or Scallops Roast Beef with *Horseradish Sauce Purée Potatoes Steamed Marrow (Squash) * Floating Islands
Thursday	* Braised Fennel Cold Beef Salad Potato and Onion Cake *Cucumber with Yoghurt * Apple Snow	* Eggs with Watercress Sauce *Chicken with Herb Sauce (summer) or * Chicken Couscous (winter) Orange Salad and/or Sorbet
Friday	Chicken Noodle Soup or Chicken Couscous Soup Lentil Vinaigrette with Smoked Sausage, or Hard-boiled Eggs Cheese	* Fresh Tomato Soup *Steamed Prawns (Shrimp) with Vegetables or * Poached Rainbow Trout Yellow Sauce (2 versions) Melon with Limes
Saturday	* Salade Niçoise (summer) or *Chicken Liver Pilaff (winter) * Mango Fool	*Supper Party with Friends* Crudités with * Ricotta Sauce * Shabu-shabu Baked Apricots with Cream/Yoghurt

BREAKFASTS: three alternatives, to be varied.

1. ½ grapefruit
 1 slice wholemeal bread with butter and honey
 Tea
2. Yoghurt with a whole unpeeled apple grated into it
 2 oatcakes with butter and honey
 Tea
3. Homemade muesli (see recipes)
 1 crispbread with butter and honey
 Tea

ALTERNATIVE (PACKED) LUNCHES

Monday	Raw spinach and grilled bacon sandwich, on wholemeal bread Yoghurt, nuts and/or raisins
Tuesday	Chicken salad (chopped celery, carrot, apple, chicken and watercress in yoghurt dressing, with herbs) Brown bread and butter Fruit
Wednesday	Raw mushroom salad, or sandwich in wholemeal bread Water biscuits (crackers) with low-fat cream cheese and chopped herbs
Thursday	Cold roast beef sandwich, with horseradish sauce, in wholemeal or rye bread Cucumber and yoghurt salad Fruit
Friday	Hot chicken soup in flask Lentil vinaigrette with sliced smoked sausage or hard-boiled egg Yoghurt

*The Recipes

SUNDAY

Aubergines (Eggplant) with Mozzarella

Metric/Imperial/American
2 large aubergines (eggplant)
salt
1 Spanish onion
500 g/1 lb tomatoes
olive oil
freshly ground black pepper
sugar
125 g/¼ lb mozzarella, thinly sliced

Cut the aubergines (eggplant) in 1-cm (½-inch) slices, salt them and leave to drain in a colander. Cut the onion in half, then cut each half into 3-mm (¼-inch) slices. Divide the slices into rings. Peel the tomatoes, discard the seeds and juice and cut the flesh in strips like the onion.

Heat some olive oil in a broad, heavy frying pan and fry the aubergine (eggplant) slices until brown on both sides. Place the

slices on a flat dish and keep warm. Add more oil to the pan and cook the onion until soft, then add the tomatoes and cook the mixture a few minutes more. Season with salt, black pepper and a little sugar. Spoon the tomato and onion mixture over the aubergine (eggplant) slices and top with the sliced cheese. Bake in a moderate oven (180°C, 350°F or Gas Mark 4) for 30 minutes. *Serves 4.*

Right: Braised Veal with Basil

Braised Veal with Basil

Metric/Imperial/American
1.5 kg/3½ lb rolled shoulder of veal
40 g/1½ oz/3 tablespoons butter
1 large onion, thinly sliced
1 large carrot, thinly sliced
3 stalks celery, thinly sliced
150 ml/¼ pint/⅔ cup dry white wine
150 ml/¼ pint/⅔ cup chicken stock
sea salt and freshly ground black pepper
5-6 sprigs basil, when available, or
 watercress
2 tablespoons potato flour, or rice flour
75 ml/⅛ pint/⅓ cup single (light) cream

Brown the veal all over in the butter in a heavy casserole. Remove the veal and set aside. Put the sliced vegetables in the casserole and sweat them gently for 6 minutes, then lay the veal on top of them. Heat the wine and stock together and pour over the veal. Add sea salt and black pepper, and cover with foil and the lid. Simmer very gently, allowing 40 minutes per 500 g/1 lb, from the time the liquid starts to bubble. This can be done either on top of the stove, or in a moderate oven (160°C, 325°F or Gas Mark 3).

When done, remove the veal and stand, covered, for 5-10 minutes before carving, while you make the sauce. Strain the juices into a jug, reserving the vegetables. Make a bed of the vegetables on a shallow dish and keep warm. Remove the fat from the cooking juices, and pour half into another jug. Measure 150 ml/¼ pint/⅔ cup into a small bowl and cool, standing in a sink half full of cold water. Reheat the remainder with most of the basil (or watercress), reserving about 12 large leaves. When it simmers, cover and remove from the heat, leaving to infuse while you carve the veal. Cut the veal in medium thin slices and lay them over the bed of braised vegetables. Put the potato flour (or rice flour) in a bowl, and mix to a smooth paste with the cooled stock. Remove the branches of basil from the hot stock, and pour the thickened mixture into the same pan. Stir over gentle heat until it starts to bubble; cook very gently for 4 minutes, adding sea salt and black pepper to taste, also the cream. Pour enough of the sauce over the veal to almost cover it, and serve the rest separately in a sauceboat. Cut the reserved basil (or watercress) leaves in strips, using scissors, and scatter over the surface of the meat.

This can be served either hot or cold. If serving cold, do not carve the meat and assemble until all is cold, then serve at room temperature (do not chill). If the veal is to be served hot, accompany with new potatoes and mangetout (snow peas); if cold, with hot new potatoes and a green salad. *Serves 5.*

Prune Mousse

Metric/Imperial/American
250 g/½ lb prunes
cold tea, to cover
50 g/2 oz/¼ cup sugar
1 tablespoon lemon juice
3 egg whites, stiffly beaten

Soak the prunes overnight in the cold tea. Add the sugar and cook them slowly in the soaking liquid, until soft. Cut out the stones (pits) and put the flesh in a blender or food processor with enough juice to make a thick purée. Stir in the lemon juice and fold in the stiffly beaten egg whites. Pour into a buttered 900 ml/1½ pint/3¾ cup soufflé dish and bake for 25 minutes in a moderate oven (180°C, 350°F or Gas Mark 4). Serve at once. *Serves 4-5.*

Lentil Soup with Yoghurt

Metric/Imperial/American
125 g/¼ lb/½ cup brown lentils
125 g/¼ lb spinach
1 onion
1 clove garlic
2 tablespoons sunflower-seed oil
sea salt and freshly ground black pepper
300 ml/½ pint/1¼ cups yoghurt
juice of ½ lemon

Wash the lentils carefully and cover with cold water. Bring to the boil and cook gently until almost tender, about 45 minutes. Wash and slice the spinach. Add the spinach to the lentils and cook for another 15 minutes, or until both vegetables are tender.

Chop the onion and garlic and sauté in the oil. (Add the garlic about 5 minutes after the onion.) When golden, add with the oil to the rest of the soup. Put in a blender or food processor and process until smooth, then pour into a bowl and leave to cool. When cold, stir in the yoghurt. Add lemon juice to taste. Serve very cold. *Serves 6.*

Watercress Omelette

Metric/Imperial/American
1 bunch of watercress
50 g/2 oz/¼ cup butter
8 eggs
sea salt and freshly ground black pepper

Use only the tender sprigs of watercress, discarding the tougher ends. Wash and drain well, leaving them whole, then pat dry in a cloth. Divide in 2 equal parts.

Heat half the butter in an omelette pan and cook half the watercress until wilted, about 2 minutes. Pour on 4 lightly beaten eggs, seasoned with sea salt and black pepper, and cook gently until set. Do not attempt to fold, simply slide on to a hot dish. Repeat the process with the remaining ingredients. *Each omelette will serve 2.*

MONDAY

Spinach, Mushroom and Bacon Salad

Metric/Imperial/American
250 g/½ lb young (summer) spinach
175 g/6 oz/1½ cups mushrooms
125 g/¼ lb streaky bacon rashers
freshly ground black pepper
4-5 tablespoons sunflower-seed oil
1½ tablespoons white wine vinegar

Wash the spinach well, removing the stalks, and cut the leaves across in 1-cm (½-inch) strips. Pile in a salad bowl. Wipe the mushrooms, discard the stalks, and slice the caps. Lay over the spinach. Fry the bacon slowly until very crisp, drain well on soft paper, then crumble or chop in small bits. Scatter over the mushrooms. Add black pepper — salt will not be necessary — and dress with the mixed oil and vinegar. Serve immediately. *Serves 4.*

Spinach, Mushroom and Bacon Salad

Cold Borsch (en Gelée)

Metric/Imperial/American
1 kg/2 lb raw beetroot (beet)
sea salt
½ Spanish onion, thinly sliced
600 ml/1 pint/2½ cups good chicken stock
2-3 tablespoons lemon juice
25 g/1 oz powdered gelatine

Start 36 hours in advance. Scrub the beetroot and chop in a food processor, or by hand. Put it in a pressure cooker with roughly 900 ml/1½ pints/3¾ cups very lightly salted water. Bring to the boil and cook for 30 minutes under pressure. (Alternatively, cook for 1½ hours in an ordinary pan.) Strain the juice, throwing away the chopped beetroot. Measure the juice; you should have about 600-750 ml/1-1¼ pints/2½-3cups.

Put the sliced onion in the beetroot stock when it has cooled, then leave overnight in the refrigerator. Strain again, and mix with the chicken stock, reserving 150 ml/¼ pint/⅔ cup. Dissolve the gelatine in the reserved stock, then mix with the rest of the soup. Strain once more, then chill in the refrigerator until set. This makes a firm jelly, which should be roughly chopped with the edge of a palette knife and served piled up in soup cups or glass bowls.

This recipe makes enough for 6-8 people. It is not worth making in small quantities, and it keeps well for a day or two in the refrigerator. *Serves 6-8.*

Grilled Chicken Wings

Metric/Imperial/American
1 kg/2 lb chicken wings
4 tablespoons olive oil
juice of 1 lemon
1-2 cloves garlic
sea salt and freshly ground black pepper
yoghurt, to serve

1-2 hours before cooking, line the grill (broiler) pan with foil and rub it with oil. Lay the chicken wings on this and pour over them the olive oil and lemon juice. Crush the garlic and spread over the chicken; sprinkle with sea salt and black pepper. Turn over once or twice while marinating, then grill (broil) slowly, allowing about 8-10 minutes on each side. They should be very well browned, almost slightly charred, on the outside, but not over-cooked within. Serve with a bowl of plain yoghurt and a green salad. Alternatively, omit the garlic in the marinade and serve with a garlic sauce (see below). *Serves 4.*

Garlic Sauce

Metric/Imperial/American
300 ml/½ pint/1¼ cups yoghurt
2 cloves garlic
½ teaspoon sea salt
1 tablespoon chopped fresh mint, or
 ½ teaspoon dried mint (optional)

Beat the yoghurt until smooth. Stir in the crushed or pounded garlic and the sea salt. Add mint, if desired. Chill before serving. Serve with grilled chicken wings, or stuffed peppers. *Makes 300 ml/½ pint/1¼ cups.*

67

TUESDAY

Caponata

Metric/Imperial/American
500 g/1 lb aubergines (eggplant)
salt
1 small onion, chopped
about 150 ml/¼ pint/⅔ cup olive oil
3 stalks celery, chopped
250 g/½ lb/1 cup tomatoes, skinned and
 chopped
12 green olives, stoned and chopped
1 tablespoon capers, drained
freshly ground black pepper
½ tablespoon sugar
2 tablespoons white wine vinegar

Cut the unpeeled aubergines (eggplant) in cubes about 1-cm (½-inch) square. Put them in a colander and sprinkle with salt; weigh down lightly and leave to drain for ½ hour. Cook the onion gently in 2 tablespoons oil in a sauté pan. When it starts to colour, add the celery. A few minutes later add the tomatoes; cook slowly until thickened, adding the olives, capers, pepper, sugar and vinegar.

Heat the remaining oil in a broad pan. Dry the aubergines (eggplant) cubes and fry until soft and golden brown. Lift out with a slotted spoon and add to the other vegetables. Mix well, pour into a shallow dish and leave to cool. Serve at room temperature. *Serves 4 as a first course.*

Vegetable Bouillon

Metric/Imperial/American
1 large leek, quartered
2 large carrots, halved
2 stalks celery, quartered, with leaves
2 large tomatoes, halved
2 stalks parsley
a few stalks watercress
a few lettuce leaves
900 ml/1½ pints/3¾ cups water
1 teaspoon sea salt

Put all the ingredients in a pressure cooker and bring to the boil. Cook for 30 minutes under pressure. Strain, adjust seasoning as necessary, and serve either hot or chilled. Two tablespoons freshly cooked rice may be added, if desired. (If you do not have a pressure cooker, add 1.2 litres/2 pints/5 cups water to allow for evaporation, and cook for 1½ hours in an ordinary saucepan.) *Makes 900 ml/1½ pints/3¾ cups. Serves 4.*

Compote of Dried Fruit

Metric/Imperial/American
250 g/½ lb mixed dried fruit: apples, pears,
 apricots, peaches, prunes, figs
2 tablespoons raisins
½ teaspoon grated orange rind
½ teaspoon grated lemon rind
1 tablespoon sugar
juice of 1 orange
2 tablespoons coarsely chopped almonds
whipped cream and yoghurt, to serve
 (optional)

Soak the fruit for an hour or two if necessary. Cover with cold water, or the water in which it has been soaking, and cook quite quickly, until soft but still whole. The timing varies widely according to the quality of the fruit; it should only take about 15 minutes.

At the end of the cooking, add the raisins, the grated rind and the sugar. Leave to cool, then stir in the orange juice and the chopped nuts. If there is too much juice, lift out the fruit and nuts with a slotted spoon, leaving the juice in the pan. Boil up the juice until it is reduced to the right amount. Only add the orange juice after cooling. Serve warm, or after cooling, but do not chill.

For special occasions, serve with a bowl of whipped cream and yoghurt folded together, in equal parts. *Serves 4.*

Above right: Floating Islands
Below: Caponata

WEDNESDAY

Stuffed Peppers

Metric/Imperial/American
1 medium onion, chopped
3 tablespoons sunflower-seed oil
1 clove garlic, crushed
2 tablespoons pine kernels (nuts)
125 g/¼ lb/1 cup rice
600 ml/1 pint/2½ cups chicken stock
2 tablespoons raisins
salt and freshly ground black pepper
a pinch of mace or grated nutmeg
a pinch of cinnamon
2 tablespoons chopped parsley
4 peppers
25 g/1 oz/2 tablespoons butter
yoghurt or garlic sauce, to serve

To make the filling, cook the onion in oil in a frying pan until slightly coloured. Add the garlic and the pine kernels, and cook for another 2 or 3 minutes. Add the washed rice and stir around until coated with oil. Pour on 300 ml/½ pint/1¼ cups heated stock, and add the raisins, salt, pepper and spices and simmer until the rice is almost tender, about 15 minutes, stirring now and then. Cool.

To prepare the peppers, cut a thin slice off the top and remove the interior membrane and all the seeds with a small sharp knife. Rinse with water to remove any remaining seeds. Spoon in the stuffing when it has cooled, and stand the peppers upright in a deep dish with a lid. Heat the remaining stock with the butter and pour on. Cover with the lid or a double layer of foil and cook in a moderate oven (180°C, 350°F or Gas Mark 4) for 45 minutes. Serve hot or cold with a bowl of yoghurt or garlic sauce. *Serves 4.*

Seviche of Sole or Scallops

Metric/Imperial/American
2 medium sole, skinned and filleted, or
 8 large scallops
150 ml/¼ pint/⅔ cup fresh lime or lemon
 juice, or a mixture of both
1 tablespoon finely chopped shallot
1 tablespoon finely chopped parsley
1 tablespoon sunflower-seed oil

Cut the fillets of sole into diagonal strips about 1 cm (½ inch) wide. If using scallops, discard the orange tongues and cut the white part into 1-cm (½-inch) slices. Put the sole or scallops into a bowl and pour over the citrus fruit juice; there should be almost enough to cover them. Place in the refrigerator for anything from 12 to 24 hours, stirring occasionally.

Just before serving, drain off the juice and stir in the finely chopped shallot and parsley. Add a little oil, just enough to moisten them without leaving a pool in the bottom of the bowl, then divide the fish between 4 individual dishes. (Flat scallop shells are ideal; the curved ones are a little too big.) *Serves 4 as a first course.*

Horseradish Sauce

Metric/Imperial/American
4 tablespoons/¼ cup yoghurt
2 tablespoons sour cream
1 tablespoon freshly grated horseradish
2 teaspoons white wine vinegar
freshly ground black pepper

Mix the yoghurt and sour cream together, stir in the grated horseradish and vinegar, and add a little black pepper. Serve with hot or cold roast beef. *Serves 4.*
Note: for an extra low-fat version, use 6 tablespoons/⅓ cup yoghurt and omit the sour cream.

Floating Islands

Metric/Imperial/American
3 eggs, separated
4 tablespoons/¼ cup vanilla sugar
450 ml/¾ pint/2 cups milk

Beat 2 of the egg whites until stiff, and fold in half the sugar to make a meringue mixture. Have a large broad pan of water at simmering point. Drop in tablespoons of the meringue mixture, a few at a time, so that they do not touch each other. Poach gently, barely simmering, for about 3 minutes, then turn them over with a skimmer and poach for a further 2-3 minutes. Lift them out and drain on a cloth (paper will stick) while you poach the rest. When drained, lift off the cloth on to a plate and place in the refrigerator.

Beat the egg yolks with the remaining vanilla sugar. Heat the milk until almost boiling and pour on to the yolks. Place the bowl over a pan of boiling water and stir until slightly thickened, about 12 minutes. Cool quickly in a sink half full of water, stirring to prevent skin forming. Refrigerate for a few hours. To serve: pour the custard sauce into a shallow dish and lay the meringues on it. *Serves 4-5.*

THURSDAY

Braised Fennel

Metric/Imperial/American
3 heads fennel
25 g/1 oz/2 tablespoons butter
200 ml/⅓ pint/⅛ cup stock (chicken,
 game or vegetable)
1 tablespoon lemon juice
salt and freshly ground black pepper
extra 1 teaspoon butter
1 teaspoon flour

Trim the fennel, cutting off any discoloured leaves and scrubbing well under running water. Cut each root in half and lay them in one layer in a sauté pan. Cut the butter in small pieces and scatter over the fennel. Pour over the stock and add the lemon juice, salt and black pepper. Cover with the lid and cook very gently on top of the stove for 1½-2 hours, turning the fennel over from time to time, and adding more stock if necessary. When the fennel halves are soft (test by piercing them with a fine skewer) transfer them to a shallow dish and thicken the juice slightly by stirring in the butter and flour which you have mixed to a paste. Stir until smooth and pour over the fennel. *Serves 4-6.*

Cucumber with Yoghurt

Metric/Imperial/American
300 ml/½ pint/1¼ cups yoghurt
½ large cucumber
sea salt and freshly ground black pepper
a few drops of Tabasco

Beat the yoghurt until smooth.

Peel the cucumber and cut in small cubes. Stir into the yoghurt, adding sea salt and black pepper, and a dash of Tabasco. Serve with cold beef or barbecued or tandoori chicken. *Makes 450/¾ pint/2 cups.*

Apple Snow

Metric/Imperial/American
4 medium Bramleys (Greenings), peeled and cored
sugar
2 egg whites
whipped cream, to serve

Slice the apples and cook with a very little water and sugar to taste until soft. Push through the medium mesh of a vegetable mill. Cool, then fold in 2 stiffly beaten egg whites. Pile into glasses and serve with cream. *Serves 4.*

Eggs with Watercress Sauce

Metric/Imperial/American
2 bunches watercress
450 ml/¾ pint/2 cups chicken stock
2 tablespoons potato flour, or rice flour
sea salt and freshly ground black pepper
3 tablespoons single (light) cream
7 tablespoons yoghurt
6 hard-boiled eggs

Chop the watercress coarsely, stalks and all, and put in a saucepan with the chicken stock. Bring to the boil and simmer for 5 minutes, then cool slightly. Strain off 150 ml/¼ pint/⅔ cup of the stock, and put the rest of the mixture in a blender or food processor. Process until reduced to a purée, then return to the clean pan.

When the reserved stock has cooled, stir it gradually on to the potato flour (or rice flour) in a small bowl, beating with a small wooden spoon until a smooth paste is formed. Add this to the watercress purée in the pan, stirring until it is incorporated. Heat slowly until it simmers, stirring constantly, then cook very gently for 4 minutes. Add sea salt and black pepper to taste, and the thin cream. Remove from the heat and after a few moments, stir in the yoghurt.

Have the shelled eggs (hot) lying in a shallow dish, and pour the watercress sauce over and around them. Serve in shallow bowls. *Serves 4.*

Chicken with Herb Sauce

Metric/Imperial/American
1.5-1.75 kg/3½-4 lb chicken
8 thin leeks
3 long thin carrots
1 onion
4 stalks celery
1 bay leaf
sea salt
5 black peppercorns
2 tablespoons potato flour, or rice flour
4 tablespoons single (light) cream
4 branches chervil or dill

Put the chicken in a pressure cooker with the green ends of the leeks, 1 halved carrot, 1 halved onion and 1 stalk celery. Add the bay leaf, sea salt and black peppercorns, and enough hot water to cover the legs of the bird. Bring to the boil and cook under pressure for 20-25 minutes, depending on the size of the bird. (Alternatively cook in an ordinary pan for 1-1¼ hours.)

Lift out the chicken and boil up the contents of the pan for about 5 minutes, to reduce the quantity and strengthen the flavour. Cut the white parts of the leeks in long thin strips; cut the remaining 2 carrots and 3 stalks of celery likewise. Lay them in a steamer and cook over the boiling chicken stock for 3-4 minutes, until halfway between crisp and tender. Remove immediately and lay on a shallow serving dish; keep warm.

Carve the chicken in neat strips, free from all skin and bone, and lay crosswise over the vegetables. Strain the stock, and cool 150 ml/¼ pint/⅔ cup quickly by standing in a bowl of iced water. Pour this slowly on to the potato flour (or rice flour) in a small bowl, mixing to a paste with a wooden spoon. When smooth, pour it into 300 ml/½ pint/1¼ cups of the remaining stock, skimmed of fat, add the cream and heat slowly in a pan. Stir constantly while heating, and simmer for 4 minutes. Remove from the heat, and put in the branches of chervil or dill, after removing a heaped tablespoon of the best leaves. Cover and leave to infuse for 5 minutes. Meanwhile, chop the reserved leaves. Discard the branches of chervil or dill, and pour the sauce over and around the chicken. Scatter the chopped herb over all. Serve with steamed new potatoes and a green salad. *Serves 4-5.*

Chicken Couscous

Metric/Imperial/American
350 g/¾ lb couscous
1.5 kg/3½ lb chicken, jointed
6 small onions, peeled
4 leeks, thickly sliced
4 carrots, thickly sliced
2 stalks celery, thickly sliced
4 courgettes (zucchini) unpeeled and thickly sliced
6 tomatoes, peeled
1 packet (¼ teaspoon) saffron
sea salt and freshly ground black pepper
225 g/½ lb chick peas (garbanzos), pre-soaked and cooked (optional)

Put the couscous in a bowl and pour over it 450 ml/¾ pint/2 cups cold water. Leave for 10 minutes to absorb.

Put the chicken in a deep pan (or the bottom of a *coussoussière*) with the peeled onions left whole. Cover with 1.5 litres/2½ pints/6¼ cups hot water and bring slowly to the boil, skimming off any scum that rises. When boiling point is reached, and the surface is clear, add the leeks, carrots, and celery, all cut in thick slices. Tip the couscous into a colander or strainer lined with muslin (or the top of the *coussoussière*), and lay over the boiling stock. Cover with a lid and keep boiling steadily but gently for 30 minutes.

Lift off the couscous and add the courgettes (zucchini), also cut in thick slices. Stir the couscous, breaking up any lumps, and replace over the stock. Ten minutes later, add the whole peeled tomatoes to the bottom

Chicken with Herb Sauce

pot; after another 5 minutes, remove from the heat. Tip the couscous into a heated dish and break up any lumps with a fork. Lift off the fat from the surface of the stock, and stir in the saffron, and sea salt and pepper as needed. Lift out the pieces of chicken, discard the bony parts of the carcase, and lay the nice pieces over the couscous. Add the chick peas (if using) to the vegetables, reserving a few to scatter over the couscous. Reheat briefly, then tip into a large tureen and serve together with the couscous.

Serve in soup plates, with knife, fork and spoon. Any remains can be used to make a marvellous soup. *Serves 6.*

FRIDAY

Fresh Tomato Soup

Metric/Imperial/American
750 g/1 ½ lb ripe tomatoes
600 ml/1 pint chicken stock, free from all fat
sea salt and freshly ground black pepper
1 teaspoon sugar
1 tablespoon lemon juice, or to taste
2 tablespoons chopped basil, chervil, or dill (when available)

Skin the tomatoes and cut in quarters. Heat the chicken stock in a large pan and, when it is nearly boiling, drop in the tomatoes. Add sea salt, black pepper and sugar, bring back to the boil and simmer for 5 minutes only. Push through a medium mesh food mill (or wire strainer) to retain the seeds, then return to the pan to reheat. Add more salt and pepper if needed, plus a little lemon juice. Serve in cups, sprinkled with chopped basil, chervil, or dill. *Serves 4.*
Note: For a cold soup, serve chilled, with a lump of ice floating in each cup, and omit the herbs.

Below. Steamed Prawns (Shrimp) with Vegetables

Steamed Prawns (Shrimp) with Vegetables

Metric/Imperial/American
16 giant prawns (shrimp), or large scampi
3 long thin carrots, cut in long thin strips
3 straight courgettes (zucchini), cut in long thin strips
1 bunch large spring onions, cut in long thin strips
2 leeks, cut in long thin strips

Wash and drain the prawns (shrimp), or scampi, and chill them in the refrigerator until ready to cook. Keep all the vegetables separate. Lay them in a steamer, keeping them in clumps, and place over rapidly boiling water for 2 minutes only. Remove them from the heat, and transfer immediately to a hot flat serving dish, preferably round, arranging them like the spokes of a wheel. Keep warm while you cook the prawns (shrimp).
Lay the prawns (shrimp), unshelled, in the same steamer and cook over boiling water for 2 minutes if already cooked, 4 minutes if raw. Quickly remove the shells and heads, leaving the tails still attached to the bodies, and lay 4 prawns (shrimps) between each row of vegetables. Serve immediately, with a yellow sauce (see right). *Serves 4.*

Yellow Sauce I

Metric/Imperial/American
25 g/1 oz/2 tablespoons butter
1 tablespoon flour
150 ml/¼ pint/⅔ cup fish stock (use either liquid from steaming shellfish, or from poaching trout)
sea salt and freshly ground black pepper
150 ml/¼ pint/⅔ cup yoghurt

Melt the butter in a saucepan, stir in the flour, and cook for 1 minute. Reheat the stock and add to the pan; bring to the boil and simmer for 3 minutes. Cool slightly. If necessary, add salt and pepper to taste, then stir in the yoghurt, beating until smooth. Do not attempt to reheat after adding yoghurt or the sauce may curdle. Serve warm, with steamed prawns (shrimp) or poached trout. *Serves 4.*
Note: This is also good served cold, with cold shellfish, or fish pâtés. To serve cold, cool quickly by standing in a sink half full of icy cold water, stirring frequently to prevent a skin forming.

Yellow Sauce II (low-fat version)

Metric/Imperial/American
1 egg, separated
a pinch of sea salt
1 teaspoon Dijon mustard
150 ml/¼ pint/⅔ cup sunflower-seed oil
3 teaspoons white wine vinegar
2 tablespoons yoghurt

Put the egg yolk in a bowl and beat with a wooden spoon, adding the sea salt and mustard. Start adding the oil very gradually, literally drop by drop, beating constantly until an emulsion is formed. Then add it slightly more quickly; adding a teaspoon of vinegar if it gets too thick.
When all the oil is amalgamated, add the remaining vinegar, also slowly. Beat the egg white until stiff and fold 2 tablespoons of it into the sauce, together with the yoghurt. Serve with steamed prawns (shrimp), poached trout, or other fish dishes. *Serves 4.*

Poached Rainbow Trout

Metric/Imperial/American
4 smallish rainbow trout
court-bouillon:
1 medium onion, halved
1 carrot, halved
1 stalk celery
1 small bay leaf
6 black peppercorns
150 ml/¼ pint/⅔ cup dry white wine, or 2 tablespoons white wine vinegar
900 ml/1 ½ pints/3¾ cups water

To prepare the court-bouillon, put the vegetables, seasonings and liquids together in a saucepan and bring slowly to the boil. Simmer gently, covered, for 30 minutes, then strain and cool.
Pour the strained court-bouillon into a flameproof oval pan just large enough to hold the fish. When it is hot, but before it reaches boiling point, put in the trout. Reheat until the water starts to shake, then keep at that temperature, a very low simmer, for about 8 minutes, when the trout should be cooked. Lift them out carefully, lay them on a flat dish and serve with a yellow sauce (see above), or simply with lemon quarters. *Serves 4.*

SATURDAY

Salade Niçoise

Metric/Imperial/American
4-5 large lettuce leaves
3 tomatoes, cut in quarters
1 green pepper, cut in strips
½ Spanish onion, cut in half rings
175 g/6 oz string (green) beans, boiled and cooled
3 hard-boiled eggs, halved
500 g/1 lb canned tuna fish, drained
8 anchovy fillets (optional)
sea salt and freshly ground black pepper
¼ teaspoon Dijon mustard
6 tablespoons olive oil
4 large basil leaves, cut in strips

Line a large salad bowl with the lettuce leaves. Lay the quartered tomatoes and pepper strips in it, and cover with the semi-circular onion rings. Lay the whole string

(green) beans over this and surround with the halved eggs. Divide the tuna fish into chunks and arrange in the centre of the bowl. If using anchovies, cut them in half and scatter over the dish. Put the sea salt, black pepper and mustard in a small bowl and mix with the olive oil (I don't use any lemon juice or vinegar with this salad). Pour over the dish and mix well at the table, adding the basil. *Serves 5-6 as a first course, or 4 as a light main dish.*

Chicken Liver Pilaff

Metric/Imperial/American
1.75 litres/3¼ pints /8 cups water
sea salt and freshly ground black pepper
300 g/10 oz long-grain rice
1 Spanish onion, chopped (about 350 g/¾ lb)
2 tablespoons sunflower-seed oil
75 g/3 oz/6 tablespoons butter
25 g/1 oz pine kernels (nuts)
250 g/½ lb chicken livers, coarsely chopped

Bring the water to the boil, adding salt, then shake in the rice. Boil for 10 minutes, then drain and rinse. Brown the chopped onion in 2 tablespoons oil and 25 g/1 oz/2 tablespoons butter. When it has coloured, add the pine kernels and cook gently, stirring, until they are straw-coloured. Then add the chopped livers and cook for 1 minute, till fairly coloured but still pink inside. Add sea salt and black pepper and set aside.

Melt the remaining 50 g/2 oz/4 tablespoons butter and pour half of it into a heavy pot. Lay half the rice over the butter, and the chicken livers over the rice. Cover with the remaining rice, and pour the rest of the melted butter over all. Cover the pot with a folded cloth and the lid, and cook very gently for 45 minutes. Turn off the heat and stand for 5-10 minutes before serving. *Serves 4.*

Mango Fool

Metric/Imperial/American
1 large ripe mango
1 lime (about 2 tablespoons juice)
300 ml/½ pint/1¼ cups yoghurt

Skin the mango and cut the flesh off the stone (seed). Put the flesh in a blender or food processor with the lime juice and yoghurt. Process until smooth, then pour into 4 small glasses and chill for 3-4 hours. This is a rather startling colour, but full of vitamin C and very good. *Serves 4.*

Ricotta Sauce (for Crudités)

Metric/Imperial/American
125 g/¼ lb ricotta cheese
150 ml/¼ pint/⅔ cup yoghurt
juice of ½ lemon
2 tablespoons grated Parmesan
2 tablespoons chopped parsley

Mix the ricotta and the yoghurt until smooth. Add lemon juice to taste, about 1½ tablespoons, then stir in the grated Parmesan and the chopped parsley. Serve with crudités: strips of carrot and celery, slices of turnip, sprigs of cauliflower, etc. The raw vegetables should be well chilled after preparing. *Serves 6.*

Shabu-shabu

This is a Japanese dish, based on the Chinese Mongolian Hotpot, perfectly suited to a small party of close friends. Ideally, it should be made in a fire-pot in the centre of the table, but can be done very well on the stove. It is a very healthy dish, consisting of lightly poached meat and vegetables in a clear broth.

Metric/Imperial/American
stock:
2.5 litres/4½ pints/5½ pints water
1 leek, halved
1 carrot, quartered
1 stalk celery, quartered
3 stalks parsley
1 chicken stock (bouillon) cube
main ingredients:
2 leeks, cut in thin diagonal slices
1 large carrot, cut in very thin sticks, like long matchsticks
250 g/½ lb Chinese cabbage, cut across in 1-cm (½-inch) strips
1 bunch watercress, divided into sprigs
125 g/¼ lb bean sprouts (optional)
250 g/½ lb entrecôte (sirloin) steak, cut across the grain in thinnest possible slices (see below)
75 g/3 oz Japanese noodles, or vermicelli, freshly boiled and drained
sauces:
1) 4 tablespoons/¼ cup soy sauce
 4 tablespoons/¼ cup medium sweet vermouth, or dry sherry
 1 teaspoon sugar
2) 4 tablespoons/¼ cup tahini, or smooth peanut butter
 4 tablespoons/¼ cup sunflower-seed oil
 3 dashes Tabasco

Put all the ingredients for the stock into a deep pot and bring slowly to the boil, breaking up the stock (bouillon) cube. Simmer gently, half-covered, for 30 minutes, then discard the vegetables. Pour enough of the stock into a heavy round pot (failing a fire-pot) so that it is filled by not more than two-thirds. When ready to eat, bring to the boil, either on a table heater or on the stove. (Crudités are useful for eating in the meantime.)

Have the two sauces prepared beforehand by simply mixing the ingredients, then pouring some of each into tiny individual bowls — one of each for each guest. When ready to eat, put about half the sliced leeks, carrot and cabbage into the pot and simmer for about 3 minutes, then add half the watercress and the bean sprouts, if used. After another couple of minutes, start adding the slices of beef, dipping them up and down in the boiling stock just until they change colour all over, about 1 minute. (If cooked in the middle of the table, each guest can cook his own meat, using chopsticks.) Once the meat is ready, each guest lifts out the slices and dips them into one or other of the sauces for a second to cool, then pops them in his mouth. The broth must be skimmed regularly, and replenished as needed from the remainder which is keeping hot on the stove. When all the meat and extra vegetables are eaten, add the noodles or vermicelli to the broth; 2 minutes is long enough to reheat them. Serve in the same bowls, with some of the stock, flavoured with a little of sauce no 1 (the soy-based sauce). Finally, the remaining stock is ladled into the bowls and drunk as soup, again flavoured with sauce no 1, or simply with extra soy if the sauces are finished. *Serves 4.*

Note: the only difficult part of this dish is getting the meat cut thin enough. A useful tip is to half freeze it first, then cut it on a bacon slicer. Alternatively, keep a chunk of sirloin steak in the freezer, and thaw it for 30 minutes before slicing. Ready-sliced beef for shabu-shabu can be bought frozen from Japanese shops. This can then be kept until needed in the freezer.

FOR SLIMMERS

Yoghurt Salad Dressing

Metric/Imperial/American
150 ml/¼ pint/⅔ cup yoghurt
2 tablespoons sunflower-seed oil
½-1 tablespoon lemon juice
a dash of Tabasco (optional)

Mix the yoghurt and oil very thoroughly, then add lemon juice and Tabasco to taste. This is best done in a blender or food processor, as the oil and yoghurt tend to separate until properly emulsified. This makes a useful low-fat dressing for all types of salad. *Serves 4-5.*

FOR BREAKFAST

Muesli

This recipe is closely based on that of Dr. Bircher-Benner, the great Swiss dietician who invented muesli, the ideal grain dish to be eaten in conjunction with his regime, based largely on raw fruit and vegetables.

Metric/Imperial/American
1 tablespoon rolled oats, medium oatmeal, or oat flakes
3 tablespoons water
1 tablespoon lemon juice
1 tablespoon sweetened condensed milk
1 hard green apple, i.e. Granny Smith, unpeeled
1 tablespoon grated nuts, preferably hazelnuts or almonds

If using rolled oats or medium oatmeal, these must be soaked for 12 hours (or overnight) in 3 tablespoons water. If using oat flakes, simply mix them with the water when preparing. Mix the lemon juice and the condensed milk, and stir into the moistened oatmeal. Grate the apple and fold in lightly. Scatter the grated nuts over the top and serve immediately. *Serves 1.*

Below: Shabu-shabu

VITAMINS AND MINERALS

Vitamins are essential to nerve, muscle and brain function and are a vital part of the metabolic chain, whereby food taken in is broken down and used for energy. Vitamins are found in a wide range of foods and are provided in abundance by a good balanced diet.

Minerals, similarly, are essential to good health. These micronutrients are present in the soil, cannot be created by the body and must, therefore, come to us via the diet. As the land becomes more and more intensively farmed, ecologists are expressing concern at the rate at which the soil is becoming stripped of its minerals. In one British study, a sample group of lettuces grown on different types of soil showed dramatic differences in iron content — the richest at 516 parts per million and the poorest at only nine.

There is considerable disagreement among scientists about how much of a particular mineral or vitamin you need. The UK's recommended daily requirement for vitamin C (30 mg), for example, has been doubled by the USA and almost doubled again by the Soviet Union, who recognize that there is a large divide between getting enough of a vitamin or mineral to protect against the deficiency diseases and getting enough for good health. Early signs of depleted vitamin or mineral levels constitute the all-too-familiar signs of poor health — dandruff, rough dry, scaly skin, bleeding gums, weak decaying teeth, fatigue, irritability, bloodshot eyes, styes, brittle finger nails and a lowered resistance to viruses and other types of infection. If any of these apply to you, look first to your diet not to vitamin or to mineral supplements. You cannot transform a poor diet into a good one simply by sprinkling on a few vitamins or minerals.

'Raw' and 'fresh' are the watchwords of any mineral or vitamin-rich diet. Many vitamins and up to 80 per cent of the trace minerals are stripped out of foods during the refining process. The B and C vitamins, in particular, are extremely unstable and are easily destroyed by air, light, heat, water and storage. Just toasting a piece of wholemeal bread, for example, can take 30 per cent of the various B vitamins out of it, while an even greater proportion of vitamin C will be lost if vegetables are allowed to wilt and then over-cooked.

While a well-balanced diet, built around the mineral and vitamin rich food sources listed below, should always constitute your first line of defence against depleted vitamin or mineral levels, more specific supplementation may be necessary if you are a strict vegetarian, if you are pregnant or breastfeeding, if you suffer from premenstrual tension, if you are under considerable stress, or if you smoke heavily. If you do take a vitamin supplement, always keep within the limits specified on the label. Although huge 'mega' doses, sometimes hundreds of times the daily requirement, have been used experimentally in the treatment of diseases ranging from schizophrenia to rheumatoid arthritis, they should always be supervised by a doctor. Some vitamins, notably A and D, can be toxic when taken in excess and almost all can have unpleasant side-effects.

Vitamin and mineral-rich food sources

● 100 g (4 oz) of offal (liver, heart, kidney, brains) a week for iron. If you dislike these organ meats, make up your iron requirement with two good helpings of red meat, or one helping of seafood, and some dried fruit. In addition, eat a vitamin C-rich fruit or vegetable with your meal, which increases the uptake of iron from your food by at least four times, and avoid drinking tea while eating. Tannin reduces iron absorption to about zero.

Watching your iron and vitamin C intake is particularly important if you have very heavy periods or use an IUD, because the increased amount of blood lost over menstruation places you at an increased risk of iron-deficiency anaemia (see also page 215).

● 300 ml (½-pint) milk and two slices of wholemeal bread a day and three to four eggs a week will provide you with the complete range of B vitamins, necessary for metabolizing and making available the energy contained within food you eat. The B vitamins are also important mood vitamins. Deficiencies in vitamin B6 (pyridoxine) have been implicated in the premenstrual syndrome and in morning sickness, while deficiences in B12 (found exclusively in foods of animal origin) can lead to a form of anaemia, known as pernicious anaemia. Vegetarians are the obvious group at risk.

The need for the B vitamins rises under stress or when using high amounts of energy — whether nervous, mental or physical — and when drinking large amounts of alcohol or eating large amounts of sugar. Veterinary surgeons prescribe it for animals to improve the condition of their coats and it is also thought to be helpful for improving the condition of human hair. Bolster B vitamin levels with yeast extracts, wheatgerm, seafood and, if you like, six tablets of brewer's yeast daily — also a good source of most of the essential trace minerals.

● At least two helpings of fresh fruit and vegetables daily, one eaten with your main meal for vitamin C. Nearly all vegetables contain some of the vitamin, but blackcurrants, citrus fruits and green leafy vegetables are particularly good sources. Vitamin C is important for strengthening resistance to infection, for increasing the uptake of iron from your food, for maintaining the health of all body tissues and for neutralizing some of the damaging nitrates in meats and processed foods. It is particularly important if you smoke, because it helps to clear the lungs of traces of heavy metals such as cadmium which are present in the 'tar' of the smoke; if you are under considerable or prolonged stress (the adrenal glands use significant amounts of the vitamin in the manufacture of its stress hormones); or if you are taking drugs, such as aspirin, barbiturates or the tetracyclin group of antibiotics for a long period of time. You also need more vitamin C if you take the contraceptive pill, as the additional oestrogen seems to interfere with its absorption in certain cells.

● At least one dark green or deep yellow fruit or vegetable every second day for vitamin A (and C) and the minerals calcium and magnesium. These richly coloured vegetables contain beta carotene, a precursor of vitamin A which is necessary for healthy bones, a good clear skin, a keen sense of smell and good night-time vision. Vitamin A is now thought to have a value in protecting against certain forms of cancer. As too much can be toxic, these vegetable sources (carrots are particularly good) are preferable to supplements.

ABCDEFK

OVERWEIGHT

If you want to be fit and healthy, you must also be slim. While overweight predisposes you to almost any chronic complaint you can think of, obesity (that is, a weight 20 per cent or more above your desirable weight) triples your chances of succumbing to diseases such as stroke, coronary heart disease and diabetes. Remove the weight and you remove the risk.

It is as simple as that. Or is it? Diets have a conspicuously high failure rate. One New York study showed that, of 100 people embarking upon a calorie-controlled diet, only 12 will manage to lose substantial amounts of weight after a year and, of those 12, only two will have sustained that loss by the end of the following year. A dismal record. Yet there is no shortage of good advice, of well-balanced diets, of information on how to lose weight or, indeed, of people trying to lose it. At least half the women in the USA, for example, are thought to be anything from 1 to 12 kg (2 to 28 lb) overweight, and most of them will probably have lost (and put on) hundreds of pounds during the course of their dieting lives.

If your own dieting history is erratic, you may need to rethink your attitudes, before you revise your eating habits. Read the section on psychological eating problems on pages 76-7 before returning to this section.

Slimming

There is no reason why you should not follow any diet you wish as long as you take the following precautions.
- Check with your doctor before starting to make sure that he or she approves of the eating plan, considers that you do need to lose weight and confirms that you are healthy.
- Avoid diets, particularly long-term diets, which advocate a bizarre or highly restricted range of foods. The human instinct for variety is a healthy one because it helps to ensure that you get all the vitamins, minerals and essential nutrients you need. Balance is more, not less, important when you are slimming and eating considerably less than you normally would. The healthiest slimming regimen allows you to eat across the four main food groups: meat, fish and eggs; milk and milk products; wholegrains; fresh fruit and vegetables.
- Reserve a healthy scepticism when reading of the latest diet or wonder food. There is no truth in the suggestion that certain foods, such as hard-boiled eggs and apples, can be eaten with impunity because the energy it takes to eat them exceeds the energy (calories) they provide. Be wary, too, of claims such as that made in the famous Mayo ('Eat Fat and Grow Slim') diet which states that the acid contained in half a grapefruit, when taken before a meal, will 'dissolve' the fat in the food you eat. Untrue.
- Drink plenty of water, preferably eight or 10 glasses a day, and avoid diets suggesting that you should restrict your fluid intake. The body loses about 2 litres/3½ pints (USA 4½ pints) of water a day and it is essential that this fluid is replaced. As much of the water you need actually arrives via the food you eat — all foods, even the denser meats and cheeses, are at least 30 per cent water — the less you eat, the more you should drink.
- Avoid slimming 'aids' that may affect the normal function-

ing and metabolism of your body, unless prescribed by your doctor for clearly defined medical reasons. Such aids include the following.

Slimming pills all have side-effects (agitation, irritability, insomnia, diarrhoea, raised heart beat). Most also succeed in depressing you while depressing your appetite. Their use is now generally limited to the excessively obese at some physical risk because of their weight or to those suffering from a weight-linked condition, such as hypertension (high blood pressure), diabetes or arthritis.

Thyroid extracts are ineffective in low doses and dangerous in high ones unless you have an established thyroid deficiency which is something only your doctor, certainly no slimming clinic, can decide.

Diuretics for water retention should not be taken unless prescribed medically because, by stepping up the rate of urination, they place an extra load on the kidneys. If you are taking diuretics, you should make a particular point of eating foods high in the water-soluble vitamins B and C (see opposite) and potassium (orange juice and bananas are the richest sources) as you are likely to be losing considerably more of these vitamins and minerals than usual.

Hormone treatments or injections claiming to 'mobilize' or 'redistribute' stubborn deposits of fat. The most popular use a hormone known as hCG (human chorionic gonadotrophin). Although sometimes promoted as a 'cure' for cellulite, these injections are highly dubious, ineffective and expensive.

Laxatives for weight loss are ineffective and potentially self-defeating because, taken on a regular basis, they lead to a condition known as the laxative habit whereby the bowel and gut become lazy and unable to function properly without them. They are also potentially dangerous when taken in excessive amounts (see page 77).

Can dieting make you fat?

While over-eating is by far the greatest cause of overweight, there are indications that over-frequent, and certainly over-stringent, dieting may affect the body's capacity to readjust to a normal food intake once the diet is over.

Bodies do not understand dieting. They understand survival. When underfed for considerable periods of time, the body adapts to a state of famine, gets used to subsisting on less and reorganizes its internal energy priorities so that the system becomes more efficient and more economical. Animal experiments have shown that, with continued food deprivation, the basal (resting) metabolic rate may drop by as much as 20 or 30 per cent as the animal conserves more energy and, even when fed very minute quantities, shunts more food to fat for essential reserves in case things get even worse. The same is probably true for people — in which case, continual bouts of crash dieting, bad for the figure and bad for the health, may also turn out to be entirely self-defeating.

Losing weight

People lose weight at different rates, even when following identical diets in very similar circumstances. The general pattern, however, is almost always the same. The reason for high weight loss in the early stages of a diet is that the body is losing water, not fat. Low-carbohydrate diets lead to a rapid initial weight loss because carbohydrate is water absorbent and, as stores in the body are reduced, this 'bound up' water can be freed and excreted in the urine. Follow-ups, however, show that, in the long-term, the weight loss is no greater.

The weight loss to aim for when dieting is about 1 kg (2 lb) a week. This is about one per cent of your total body fat and is a loss that you should be able to sustain when following a diet that allows 1,000-1,200 calories a day.

If you find that you are not losing weight at this rate and you are keeping strictly to the amounts of food in the stipulated diet, take more exercise. Research suggests that exercise, far from making you hungrier, exerts a powerful stabilizing effect on the appetite.

Weighing yourself

Weigh yourself regularly, but not obsessively — once a week, first thing in the morning before you get dressed and after you have been to the lavatory. Enter your weight on the graph given in the Personal Profile, and always weigh yourself on the same set of scales. The most accurate have a beam and sliding counterweights that you balance yourself. Modern bathroom scales, which work by means of a spring, are fairly accurate but may give different readings when placed on a carpet and on a hard floor. You should check these scales for accuracy against another pair every six months.

Slimming diet

This is a balanced slimming diet, which provides about 1,200 calories a day, for a weight loss of about 1 kg (2 lb) a week.
Breakfast 120 ml (4 fl oz) freshly squeezed fruit juice (see list) OR half a grapefruit OR slice fresh pineapple OR wedge of melon.
1 egg, boiled or poached OR 20 g (¾ oz) unsweetened breakfast cereal OR 120 g (4 oz) porridge made with rolled oatmeal and water or milk from allowance.
1 piece of bread or toast with butter from allowance.
1 cup of coffee or tea (no sugar) with milk from allowance.
Mid-morning 1 cup of coffee or tea (no sugar) with milk from allowance.
Lunch (can be exchanged with Dinner if you prefer to eat the larger of the two in the middle of the day).
One cup vegetable bouillon (see recipe) OR consommé OR fresh vegetable soup from the vegetables on list (boil, season, blend and add yoghurt from allowance or fresh or dried herbs for flavour).
Wholemeal sandwich made from two medium slices of bread, butter or margarine from allowance and 60 g (2 oz) chicken, lean ham, beef, turkey, salmon or tuna OR 30 g (1 oz) hard cheese. Add lettuce, watercress, tomato, endive, etc as required.
Small salad made from any of the vegetables on the list with one tablespoon of the yoghurt salad dressing (see recipe). One piece of fruit.
Mid-afternoon 1 cup of coffee or tea (no sugar) with milk from allowance.
Dinner can be exchanged with Lunch.
120 ml (4 fl oz) any fresh vegetable juice from the vegetables on the list.
90 g (3 oz) chicken or lean meat OR 120 g (4 oz) steamed, baked or grilled fish OR one two-egg omelette with chopped herbs (dill, parsley, basil etc).
Salad OR any vegetable (steamed or boiled) from the list.
One small baked potato OR one boiled potato (unpeeled) OR one tablespoon boiled rice.
One piece of fruit.
1 cup of coffee or tea (no sugar) with milk from allowance.
Allowances: 300 ml (10 fl oz) skimmed milk.
15 g (½ oz) butter or margarine.
1 carton plain, low-fat yoghurt.
Three cups of coffee or tea (without sugar).
As much water as you like (no alcohol).
7 eggs a week maximum.

Vegetables and fruit

EAT apples, asparagus, aubergine (eggplant), broccoli, French, runner or string beans, Brussels sprouts, cabbage, carrots, celery, chicory, all citrus fruits, courgette (zucchini), black, red and white currants, gooseberries, leeks, lettuce, melon, mushrooms, onion, peaches, pears, peppers, pineapple, plums, radishes, spinach, swede (rutabaga), tomatoes, turnips and turnip tops, watercress.

AVOID avocado pears, bananas, beetroot, broad beans, haricot and lima beans, canned or frozen fruit or vegetables (unless preserved without sugar), dried fruits (dates, figs, apricots, raisins etc), grapes, greengages, lentils, nuts, parsnips, peas and sweetcorn.

Meat and fish

EAT lean beef, chicken, game birds (such as partridge, pheasant or grouse), hare, lamb, offal (liver, kidney, heart, brains), rabbit, turkey, veal, venison, most white fish (bass, bluefish, catfish, cod, flounder, halibut, rockfish) salmon, shellfish (clams, cockles, crab, lobster, mussels, oysters, prawns, scallops and shrimps), sole.

AVOID bacon, canned meats and stews, corned beef, duck, frankfurters, goose, luncheon meats, minced meat (unless 100 per cent lean beef), mutton, rich pâtés, pork, processed meats, salami, sausages, spare ribs. Fish canned in oil (such as tuna or salmon) unless well drained and washed or canned in their own juices, fish roes, herring, mackerel, sardines.

Fasting and cleansing diets

Fasting has been called 'the ultimate diet'. It entails eating nothing at all. Cleansing diets usually entail eating a limited range of fruits and/or vegetables. It is claimed that these 'clear' the system, release accumulated toxins, regenerate the metabolism and take off weight at a magically rapid rate. While both can have their advantages, they can also be very dangerous when followed unwisely for extended periods.

The best way to approach any short-term fast or cleansing diet is to think of it, not as a means of losing weight, although you will probably lose a little, but as a means of giving your body and digestive system a refreshing rest from the excesses piled on by unbalanced eating patterns and an unhealthy lifestyle. Set aside one day a week, when you drink only water (tap or mineral) in plentiful quantity and eat simple fruit or vegetable salads, such as the one given below. This can be marvellously regenerating. It will clear and concentrate the mind, will generate, rather than deplete, energy, and will leave you feeling refreshed and relaxed. But you must set aside a time when you are unlikely to be doing very much and avoid all stimulants, such as coffee, tea or cigarettes and alcohol, if it is to have any value. Remember, too, that this is a one-day wonder only.

Try blending the juice of 4 oranges, 4 lemons, with 2 ripe bananas and 6 apricots, a teaspoonful of raw sugar or honey and drink a glass six times daily with as much mineral water as you like (at least eight glasses). This combination provides a good range of vitamins (A, C and some B) and minerals and the bulk added by the apricots and banana should offset any hunger pangs. The addition of 2 egg yolks will turn this into a highly nutritious drink and one that can be taken whenever energy reserves are low or you are feeling ill and cannot face the thought of food.

FOOD ALLERGIES AND ELIMINATION DIETS

It is not without justification that food allergy has been called the fashionable disease of the decade. In some circles, food allergy is little more than a fad, providing an instant and easy 'answer' to a whole range of unexplained disorders, from general aches and pains to respiratory illness, skin conditions and even emotional problems. While many of these may have little to do with the diet, however, some almost certainly will. A growing and reliable body of medical research is indicating that allergies and sensitivities to certain foods are not only much more common than have previously been recognized but also constitute a widespread cause of chronic ill health, giving rise to symptoms, ranging from a mild headache or skin rash to a raging migraine (see also page 219), intense nausea, vomiting and dizziness. While the reaction may be clearly apparent, isolating the cause can be difficult. All allergy testing is a time-consuming and confusing business and one that should be carried out under medical supervision. One problem involved in tracking down an offending nutrient is that anyone can be allergic to almost anything. Another significant complication is that an allergy to a food can also seem like an addiction. That is, if the food is eaten, you will feel better for it initially and the symptoms will only assert themselves as 'withdrawal' takes place.

If you suspect that you may have an allergy or sensitivity to a food or group of foods, a certain amount of lateral thinking may enable you to isolate the problem before seeking medical help. Before you even think of embarking upon the allergy-testing campaign detailed over the page, eliminate all sugar, refined and processed foods and stimulants (tea, coffee and alcohol) from your diet — all of which have

been fairly conclusively linked with fluctuating mood swings, irritability, headache and a lumpy, blotchy complexion. Allergy-type reactions are often symptomatic of nothing more than an unbalanced diet or an unhealthy lifestyle. But do remember to replace the foods that you omit with plenty of raw fruit and vegetables, fresh meat and fish, milk and dairy products and wholegrains.

If your symptoms do not improve, start noting down everything you eat, together with your symptoms, if and when they occur. Code these on a sliding scale of zero to four — 0 being no symptoms, 1 mild, 2 moderate, 3 severe, 4 very severe. If you find that there is a connection between the familiar headache or hayfever-type symptoms and a certain food you are eating, try eliminating that food from the diet and see if your symptoms improve.

The next step is to eliminate the major food allergens, one by one, for at least a week. Then reintroduce them, eating them in normal but not excessive quantities. If you do have a sensitivity to a certain substance, such as the gluten in wheat flour, you will probably find that your symptoms appear fairly rapidly after a period of abstention, so making the job of detection easier. But you will need patience and perseverance. For groups that subdivide, you will have to test each type of fruit, fish or meat individually in the event of reacting positively to the group as a whole.

Major allergens
Grains containing gluten (found in wheat and wheat flour, not wheatstarch, also in barley, buckwheat, oats, rye — substitute soya, potato or rice flour, cornflour and sago)
Milk and milk products (including yoghurt but not cheese)
Eggs
Cheese
Fish
Meat
Fruit (especially bananas and the citrus group)
Alcohol (especially red wines and whisky)
Chocolate
Aspirin (use paracetamol/aminocetophen instead)
Refined and processed foods to which flavourings, preservatives and colourings have been added. This group includes the flavouring agent monosodium glutamate (found in particularly high concentrations in Chinese food) and the artificial colouring, tartrazine, found in a wide range of foods, from ice cream to orange juice.

EATING PROBLEMS
Stress-induced eating
People under stress display shortened oral cycles. That is, they eat more often, light cigarettes more often, drink more cups of tea or coffee and chew more gum. These cycles, which may shrink by about 20 per cent, are considered regressive because they mimic the shorter feeding cycles of small children.

While not everyone responds to pressure by eating more often, everyone does seem to respond by adjusting their eating patterns in some way — either up or down. In one experiment, the food intake of college students, led to believe they were taking part in a psychophysiology test,

was assessed first during their exams, when the pressure was considerable, and again three weeks later, when the pressure had subsided. On measuring the changing levels of small chocolate sweets in a bowl left on a side table during the tests, it was established that, while the students ate about the same amount when relaxed, one group ate significantly more (in fact double) over their exams, while the other ate significantly less (in fact half).

When questioned, many of the students were unaware of any change in their eating patterns. This suggests that stress-induced eating, unlike compulsive eating which may also be stress-induced (see below), is an unconscious activity — an accompaniment to and natural outlet for the pressure. For women, especially, it is a perfect outlet — socially acceptable in a way that drinking would not be and always available. It also makes an ideal 'displacement' activity because you can always find a pretext for eating, so excusing yourself from what you really should be doing.

Stress-induced eating is very common. Most women are thought to increase their food intake under pressure. To establish how stress-sensitive your appetite is, look back over recent crises. If you put on weight then or immediately afterwards, the key to your weight problem in the future might be simply to be aware of this potential pitfall and to seek a more appropriate outlet.

Compulsive eating
Compulsive eaters are compulsive dieters. They are not necessarily fat, but their weight fluctuates constantly. Unable to eat in moderation or for enjoyment, their lives revolve around food — either with eating it and hating it or with slimming and diets. Compulsive eating is so common that it probably explains why, for every successful dieter, there are at least 20 failures.

If this describes your eating habits, ask yourself what is causing you to eat so abnormally and why. Examine your notions of fatness and thinness. Ask yourself why all your previous attempts to lose weight have failed. Was there a pattern? Before you can break the vicious circle and, incidentally, successfully manage to lose weight, you must examine your attitudes — towards yourself, towards the food that you eat or do not eat, and towards the various pressures exerted upon you by society, employers, colleagues, friends, strangers, lovers, husbands, children and parents. In addition, some simple guidelines are given here. You may also find it helpful to join forces with a friend or to join a self-help group.

● Take two weeks out of your dieting life. Do not weigh yourself once. Instead, explore your hunger. Miss a meal or fast for a day and then re-examine your appetite. What do you feel like eating? Go through all the foods you can think of — not just the ones you happen to have in the cupboard — and then eat or buy the one that most appeals. Do not give a thought to how slimming or fattening it is. Think of how you feel as you eat it and whether or not it has relieved the hunger and satisfied the appetite. Go on in this way until you feel you are in touch with your hunger and can begin to trust your appetite.

● When the urge to eat descends on you, ask yourself what

else you are feeling. Is it anger, misery, boredom, pressure, professional, social or sexual frustration, rejection, anticipation, even excitement? Recognizing these underlying emotional clues, especially if they can be linked to a particular event, may help you to deal with them more appropriately the next time around. Food, at best, is a temporary anaesthetic.

● Be decisive about what you want to eat and give yourself time to enjoy it. Concentrate on the food in front of you — not the food you have just eaten or feel that you may be about to eat. If, after eating your meal, you still feel 'hungry' for more, try to let at least 20 minutes elapse before reaching for it. This is the time it takes for physiological sensations of satiation to convince the appetite it has had enough.

● Just as you should not rush your eating, so you should not rush your 'therapy'. Destructive eating habits can take some time to break. So do not be discouraged by setbacks. Try to learn from them, instead, by asking some of the questions given here and any others that seem appropriate to you. If you persevere, you may well find that your compulsive eating becomes a thing of the past and that you can lose weight without recourse to calorie or carbohydrate counting, willpower or weighing scales.

Bulimia nervosa

Although the compulsive starve/stuff routine can be confusing and deeply distressing, it is not fundamentally dangerous. It can become dangerous, however, if it is allowed to go one step further. Vomiting after bingeing or taking regular and excessively large amounts of laxatives, sometimes 20 times the dose stipulated on the label or more, describes an eating disorder known as *bulimia nervosa* (from the Latin, meaning 'appetite of an ox'). This condition is one of the most vicious of all vicious circles and one which women may be caught up in for years before seeking help. This is because it is often possible to maintain a normal, even slightly heavier than normal, body weight despite the illness.

The only way to avoid getting bulimia is not to start vomiting or becoming a regular laxative taker. If you have and you are in the early stages, stop at once. This habit has a terrifying tendency to snowball, however much you may think you are in control. If you find you cannot stop, you must seek medical help. Go and see your doctor. Bulimia is now a recognized illness and a treatable one. The sooner you realize that you have a problem and seek help for it, the greater the likelihood of a rapid and complete recovery.

Anorexia nervosa

Anorexia nervosa afflicts one to two per cent of all adolescent girls and is almost exclusively a female disease, affecting 99 women (usually in their teens and early twenties, but sometimes older) to every one man. Although anorexia is commonly known as the 'slimming or dieting disease', case histories reveal that relatively few anorectics begin by slimming their way down to an 'ideal' weight and then finding it impossible to stop. The psychology behind and the motives for the weight loss seem to be quite different from those of the dieter. Although both are deeply conscious of their own sexuality, the dieter seeks to express it by becoming slimmer

and so more desirable, while the anorectic seeks to repress it and, by starving, to return to the androgynous creature that she was before her breasts and hips began to develop. Anorexia is not so much a horror of being fat, but a phobia of being anywhere near a 'normal' body weight.

The topsy-turvy logic of the anorectic world is a deeply exclusive one, which cannot be shared or often even understood, by others. Family and friends remain on the outside, feeling guilty, frightened and helpless, as they watch the anorectic becoming more and more emaciated in front of their eyes. Strategies to get her to eat will almost always result in failure. The weight loss, meanwhile, will seem to follow an inexorable downward path of its own.

Anorexia must be treated medically, especially if the pattern of non-eating has continued for more than a year. People do not just become emaciated by the disease, they die of it. Research studies and clinical records are showing increasingly that success rates when treating anorexia depend very strongly both on the attitudes of the doctor or hospital and the follow-up they provide. Force feeding, together with the more punitive measures some hospitals take in order to get the anorectic to eat, such as withholding letters, visits from friends and family, newspapers, or television, are unlikely to be successful in the long term. Getting the anorectic to eat or, in advanced cases, to be fed, either by mouth or intravenously, is obviously important because her survival depends on it, but it must be bolstered by active and sympathetic counselling both while the weight is being regained and for some months afterwards.

skin, hair, teeth and nails

'...what with the creaming and splashing and putting on a mask and taking it off again and having her nails done and her feet... as well as having her teeth completely rearranged and the hair zipped off her arms and legs — I truly don't think I could be bothered.'

Nancy Mitford

Lady Montdore's time-consuming and elaborate beauty rituals may have achieved their ends ('the whole thing,' Fanny had to admit, 'was stunning') but the price was high — no less than total dedication. Today, the pursuit of beauty is infinitely less demanding. Skincare and haircare routines take minutes rather than hours, manicures and conditioning treatments for the nails can be easily carried out at home, and 'complete' rearranging of the teeth should not be necessary at all if you look after them properly in the first place. Today's beauty routines are compatible with the busiest lifestyle and the fullest schedule: there is no longer any excuse for not being bothered.

Simplicity, regularity and commonsense are the watchwords of any successful beauty routine. If you are conscientious about using a sunscreen, if you keep your skin and hair well conditioned, if you floss your teeth each time you brush them and see your dentist regularly, if you protect your hands from damaging influences, such as washing-up water, and file your nails properly, the pay-offs will be enormous. The input in terms of time and effort and expense, meanwhile, will be virtually negligible.

A healthy lifestyle, balanced diet and positive outlook are important too. Your skincare and haircare programmes may be faultless, but if your lifestyle is frenetic, your diet poor, your emotions turbulent or your health one or two degrees under, you cannot expect to get the best from your skin or your hair. So think inside out. Recognize that attention from the outside may be important but it is not the whole answer. Look upon it as an integral part of a much more general beauty plan, reading each of these sections in the light of the chapters that precede and follow them.

Before you even do this, you may find it helpful to assess the present condition of your skin, hair, teeth and nails, using the questionnaires in the Personal Profile to help you. These have also been designed to test your current beauty regimes and to help you to assess, as far as possible, how appropriate they are for you. If you decide they need changing, you will find guidelines and suggestions in the following pages.

skin

'No beauty can be a beauty today without a good skin.' *Vogue,* **1935**

The type of skin you have is determined by two unalterables — your genes and your sex — governed by your age and affected by the environment. It can also be enormously improved by the way you look after it. Skincare today means thinking 10, 20 and even 50 years ahead, protecting yourself against the harmful effects of sunlight, pollution and stress and having the wisdom to take the best from science and the natural world.

One of the most versatile and remarkable organs of the body, your skin provides a most accurate key to its inner state of health — not only on a physical level but on emotional and psychological levels too. Nervous reactions, such as blushing, can have immediate and visible effects on the skin or a more complicated and intricate action on a wide number of skin conditions. Psoriasis, eczema, rosacea and some types of acne, for example, all tend to flare up under anxiety and stress. It is now widely recognized that removing the root of that anxiety can have a more positive effect on the condition than any of the medications currently on the market, although no-one knows exactly why.

What is known is that skin is a complex, dynamic structure, continually renewing itself and constantly changing in response to many external and internal stimuli. It regulates body temperature by adjusting the rate of water elimination — you can sweat as much as 2 litres/4-5 pints during the course of a good hour's workout, hardly at all when you are less active or the weather is cool. It insulates the body from the cold by means of a primitive response that causes the fine hairs to stand on end — goose pimples. It frees the system from accumulated toxins and metabolic waste and can be one of the first and most immediate aids to diagnosis in the event of illness, such as diabetes, anaemia and diseases of the liver, kidneys and bile duct. Finally, it acts in a protective capacity, keeping your insides in, protecting the system from harmful substances and particles in the atmosphere and screening it from the damaging effects of ultraviolet and other types of radiation. This is why only a few substances — some poisons, such as arsenic and lead, and some medically prescribed ointments — are actually absorbed through the skin. It is a powerful barrier to many of the potentially damaging substances with which you daily come into contact.

STRUCTURE AND REGENERATION

The skin comprises several layers. These divide into the outer, waterproof epidermis and the inner, sensitive dermis. The epidermis contains the sweat and sebaceous pores and the pigmentation cells, or melanocytes. (Both black and white skins contain the same number.) The dermis is supported by a layer of fat and contains the hair follicles, sweat and sebaceous glands, nerve cells, blood vessels and the tough network of protein fibres, collagen and elastin, which determines the suppleness and elasticity of the skin and gives it its characteristic ability to contract.

Key matrix cells, lying between the epidermis and the dermis at what is called the basal level, initiate a process of cell division and multiplication. The vital DNA or genetic 'blueprint' contained within the nuclei of the cells ensures that each successive generation of skin cells is a perfect replica of the previous one. The new generation then migrates upwards, gradually flattening out and losing moisture so that, by the time the cells reach the outer surface of the skin to comprise the *stratum corneum*, or 'horny layer', they are dead, and act purely in a protective capacity to shield the younger, more vulnerable cells below. The whole journey normally takes about 28 days, but age, sunlight, systemic or skin disease can all retard or accelerate it. With psoriasis, for example, the cycle can take as little as three days. This abnormally fast turnover produces the characteristic pink scaly patches over the affected area. When you sunbathe, the epidermis thickens, sometimes by as much as four times, protecting the skin beneath by absorbing and effectively diffusing the damaging radiation.

The skin's remarkable repair mechanism rapidly heals any type of superficial damage, such as grazes, cuts and mild burns. Within 28 days or less, the damaged tissue will have flaked away to reveal a new layer of healthy skin beneath. Any injury to cells at the basal layer, however, through deep wounds, severe burns or excessive exposure to sunlight, can have a permanent effect on the skin tissue (scarring) if it damages the DNA in the cell nucleus. The damaged cell will then go on to produce an abnormal 'daughter' cell — and the deeper and more extensive the damage, the greater the abnormality. This is why repeated or prolonged exposure to the sun will produce a gradual, rather than an immediate deterioration in the quality of your skin.

GENETICS VERSUS THE ENVIRONMENT

Genes play as important a part in determining the texture and general look of your skin as they do in determining the height you will reach or the colour of your eyes. The number of your blood vessels, the relative concentration of your sebaceous glands, the size of your pores and the coarseness (diameter) and position of your hair within its follicles are all determined nine months before you arrive in the world and remain unalterable for the rest of your life. Nothing can change the overall genetic pattern which predisposes you to conditions as various as acne and vitiligo, and which determines your susceptibility to sunburn and the rate at which your skin will age, becoming thinner in texture and losing its

sweat gland sebaceous gland hair follicle

The skin comprises several layers. The uppermost layer of the epidermis (1) is known as the *stratum corneum*, or horny layer. It is composed entirely of dead skin cells and works to protect the young live cells beneath. These originate in the basal layer (2) and gradually travel upwards, losing moisture and flattening out as they go. Any damage to the skin at basal level may disrupt the genetic pattern of the cells and result in scarring. The dermis (3) contains sweat and sebaceous glands, is composed of tough connective tissue – elastin and collagen – and nourished by a network of tiny blood capillaries. A layer of subcutaneous fat beneath (4) gives the skin a springy, youthful texture.

bloom as the sebaceous glands become less active and the rate of cell division slows down.

However, the relative age or youth of your skin is also affected by a number of other factors that <u>are</u> within your control. You will never hold the ageing process entirely at bay, but a sensible skincare routine, started at an early age, may well retard it. 'Sensible' hinges not so much on choosing the right moisturizer or going for a monthly facial, though undoubtedly these can help, but on staying out of the sun, getting enough sleep, circumventing potentially stressful situations, cutting out or cutting down on the number of cigarettes you smoke and the amount of alcohol you consume and eating and exercising wisely. Anything, in short, that contributes to the health of your body will be reflected in the state of your skin.

SKIN DESTRUCTIVES
Sunlight

It has been estimated that, for every eight degrees you go south in America, there is a doubling of the skin cancer rate. So, if tanning as fast as possible without burning is your only consideration when choosing a sun cream, think again. You could be taking a short and sure route to a prematurely aged skin and significantly increasing the risk of getting two of the three types of skin cancer, developing a cataract or disrupting the body's immune system. Your strategy for maintaining a healthy skin and preserving its youthfulness should start with good sun protection and, preferably, a total sun block — at least on the face.

Sunlight damages the skin because, unless it is deflected by the upper layers of the epidermis, the ultraviolet radiation strikes at the nucleus of the basal cells, altering the DNA within them so that, instead of renewing themselves perfectly, the cells tend to divide defectively. A small change to the DNA will produce no visible signs of damage — we can all escape fairly lightly with a small amount of sun exposure. Intensive sunbathing repeated over the years, however, will cause the cells to divide more and more defectively and the damage to become more and more pronounced and, of course, visible. The effect is cumulative.

Any part of the ultraviolet spectrum carries the potential to damage the skin, although, up to now, the trend has been to single out the shorter wave, 'burning' UVB as the culprit and to exonerate the less energetic, 'tanning' UVA. UVB is therefore outlawed by most sunlamp manufacturers and is also the target for most of the sunscreens currently on the market. However, while sunburns are painful and suntans are not, both UVB and UVA can damage the skin and the only really effective sunscreens are those that protect you from both parts of the spectrum. Choose creams or lotions containing para-aminobenzoic acid (PABA), one of the B vitamins and a highly efficient UVB deflector, <u>and</u> benoxophenone, which screens out UVA as well as UVB.

While UVA is present in a fairly constant concentration from sunrise to sunset, UVB is partially absorbed by the atmosphere. This is why the overhead sun at midday is so hazardous: ultraviolet rays, travelling in a perpendicular line, have much less atmosphere to penetrate. So, if you want to tan safely, concentrate your sunbathing before 10 am or after

Skin type	Very strong sun		Less strong sun		Skin's natural protection
	Untanned	Tanned	Untanned	Tanned	
Ultra-sensitive (always burns, never tans)	12	8	8	6	5/10 minutes
Very sensitive (often burns, rarely tans)	8	6	6	4	10/20 minutes
Averagely sensitive (burns then tans)	6	4	4	3/2	20/30 minutes
Less sensitive (rarely burns, tans easily and deeply)	4	3/2	3/2	3/2	40 minutes

SUN PROTECTION FACTORS: which should you be using?

3 pm. If you do not have a watch with you, you can still assess your chances of burning by using your body as a sundial. Lie down on the sand and mark two lines where your head and feet reach. Stand at one of them so that your shadow slopes towards the other. If it falls short of the mark, there is a lot of UVB, the sun is burning and you should be especially careful.

The skin responds to sunlight in three ways. If the sunlight is very strong and the skin sensitive, it will burn. If the sun is milder or the skin more resilient, it will produce melanin, which 'spills' upwards into the epidermis to give a brown effect. As these cells gradually flake off, so will the tan — unless the stimulus is maintained, in which case the cells will continue to manufacture melanin and you will continue to look brown. Tanning confers only a moderate degree of protection against subsequent sun damage. A tanned body can stay out in the sun only twice as long as a white one before it begins to burn. What makes a sun-exposed skin more resilient to burning is the third factor — a natural thickening of the top layer of the skin cells which can multiply by as much as four times in depth. This layer absorbs the ultraviolet, translates it into heat and suffuses it into surrounding tissue before it hits the vulnerable cells deeper down. Nevertheless, brown bodies can still burn and none but the constitutionally dark skinned can afford to go out into the sun without first ensuring that they are well protected.

Up to two-thirds of UVB is scattered by the atmosphere before reaching sea level. This means that it reaches the skin via the sky rather than directly from the sun, which is why you can still burn when you are sitting under a parasol or are wearing a wide-brimmed hat. Ultraviolet light is also very strongly reflected by snow, sand, concrete surfaces and rippling water. If it hits the water head-on, it will penetrate up to a depth of about 1 metre (3 feet). Count swimming time as sunbathing time and remember that even waterproof or water-resistant sunscreens will eventually wash off. Reapply them frequently, especially along the backs of the legs, shoulders and neck, even if it means interrupting your swim. And do not forget tide marks around the bikini line.

Sunscreens and sun protection factors

The Sun Protection Factor (SPF) provides the only really reliable key to how much sun exposure you can take without risking a burn. The factors work from a base figure of one — the time a previously unexposed skin can lie in the sun without developing signs of redness — and are increased on a multiplication basis, according to the degree of protec-

Sunlight is important for the health of mind and body, potentially dangerous for the skin. Capitalize on the benefits and safeguard yourself against the dangers with a good broad spectrum, water-resistant sun cream for the body (see chart, above, to identify your skin type and the sun protection factor you should be using) and a total sunblock or high protection factor sunscreen (10 or above) for the face and neck.

When out sunbathing, assess your risk of burning by using your body as a sundial. Lie down on the sand or the ground and mark out two lines where your head and feet reach. Stand at one end so that your shadow slopes towards the other. If it falls short of the mark, the sun is especially burning and you should be extremely careful.

tion the cream or lotion provides. If you can normally stay out in the sun unprotected and without burning for 20 minutes, an SPF of three, for example, will enable you to increase that exposure time to one hour. Swimming, sweating and anything with which the skin comes into contact, such as towels and sand, all undermine the protective barrier. So apply the lotion frequently — every two hours at least and more often if you are swimming or perspiring a lot. Use the chart given on the previous page to identify your skin type and the protection factor you should be using.

Ideally you should use a total sunblock, or at the least a super-efficient sunscreen (SPF of 10 or more) on the face. The neck too. Often exposed and usually unprotected, it is hardly surprising that this is where the first real signs of ageing occur. So, start applications of your high-protection sunscreen at the collarbone, not the chin, and work upwards and reapply frequently.

If you do get too much sun, do not smother your body with creams and oils. These will only retain the heat and intensify the discomfort. Instead, soak in a tepid bath to which you have added 600 ml/1 pint of strong tea (tannin has remarkably soothing qualities). Stay there for 20 minutes, pat yourself dry and smooth on calamine ointment or a cream containing chamomile or allantoin — healing agents that help damaged skin recover. Alternatively, soak cotton wool in a milk and water mixture and use that as a soothing lotion.

Take severe burns to a doctor as soon as possible. An anti-inflammatory treatment, known as indomethacin (available only on prescription), can be effective if used within 48 hours of burning.

Sunlamps

As any ultraviolet has the potential to damage the skin, the current sunlamp boom may well bring a tide of skin cancers, dark liver spots and prematurely aged skin in its wake. No-one knows for sure as skin cancers can take up to 15 years to develop. So, while sunlamps give a good pre-holiday tan base or a healthy glow, you should not use them to maintain all-year-round brownness. This will damage the skin. Use them wisely and take the following factors into account:

● Do not go out sunbathing if you have had or intend to have sunlamp exposure that day. You are many times more likely to burn. Always use a high SPF when venturing into the real sun for the first time, however deep the tan. As the skin tans but does not thicken under UVA exposure, a sunlamp gives only minimal protection against burning in natural sunlight.

● Always shower before using a sunlamp. Cosmetics in general and perfumes in particular, present in deodorants as well as in scent, can produce excessive burning or tanning reactions and result in patchy pigmentation. Sun creams containing bergamot oil can have the same effect.

● If you are taking any form of medication, check with your doctor before using a sunlamp. Some drugs cause photosensitivity — that is, they increase the skin's sensitivity to sunlight and may produce a severe burning reaction.

● Do not use a sunlamp if you are one of the five per cent of the population with an intrinsic light-sensitive disorder which appears as a rash or as a series of raised lumps on the exposed area. This may last anything from a few hours to a few days after the exposure has ceased. This reaction or 'heat rash' is, of course, caused by direct sunlight too, but UVA will not reduce the problem.

● If you are pregnant or taking the contraceptive pill, there is a chance of developing chloasma (melasma) — dark pigmentation that usually appears above the upper lip, on the cheeks just below the eyes, on the forehead, on and around the nipples and under the armpits. This can suddenly appear for the first time after years of taking the pill or after previous trouble-free pregnancies. As the condition is aggravated and rendered more noticeable by exposure to sunlight, you should protect your skin from strong sunlight, including sunlamps, as much as possible.

● Always wear the special UVA goggles provided by the sunlamp manufacturer or buy your own. Although findings that ultraviolet causes cataracts in animals have not been substantiated in humans, it is known that pre-cataract conditions are more common in people who have had a lot of sun.

Smoking

Smoking seems to affect the skin in two ways. Firstly, the habitual inhalation will cause lines to develop around the mouth in much the same way as habitual squinting will cause lines to develop around the eyes. Secondly, carbon monoxide in cigarette smoke has a greater affinity for haemoglobin (the oxygen-carrying red pigment in the blood) than oxygen has itself, and displaces it, so substantially reducing the amount available to build up and replenish the skin tissue. Smoking 'suffocates' the skin.

An American study of crows' feet around the eyes of smokers, non-smokers and ex-smokers revealed some interesting results. It showed that smokers were much more likely to be wrinkled than non-smokers, even if they had abandoned the habit before the wrinkles first appeared. In addition, the degree of wrinkling could be surprisingly accurately linked to the number of cigarettes smoked per day. Finally, it was found that the most heavily wrinkled eyes belonged exclusively to smokers — a forceful aesthetic reason for giving up, even if the health risks seem remote.

Sleep and stress

With too little sleep the skin actually looks tired, becoming sallow, puffy, lifeless and grey. This is because while you are asleep your skin renews its texture. The hormones responsible for cell division and the renewal and replacement of skin tissue are at their most active during sleep, making this period of rest and regeneration as vital to the health of your skin as it is to the health of your mind and the rest of your body.

Most bodies adjust naturally to sleep deprivation by compensating over subsequent days, or even weeks, so do not become anxious if you feel that you are missing out on your sleep. Take a positive attitude, follow the guidelines on page 180 and you will probably find that your sleep returns (and your skin improves) as your anxiety diminishes.

skinskin

Confusingly, too much sleep can also affect the appearance of the skin. When you are lying down, body fluids tend to circulate less freely and to collect in the facial tissue, so that the skin often looks puffy on oversleeping. To avoid this, sleep with at least one pillow to keep the head slightly raised and resist the temptation to doze on for too long.

Living at fever pitch over a long period of time will almost certainly affect the appearance of your skin (you are unlikely to be sleeping well or eating properly for one thing), as will negative emotions, such as fear, grief, anger or excessive anxiety. But the mechanism that produces what often amounts to a dramatic loss of skin tone and suppleness is little understood.

Humidity

Ask any farmer, and he will tell you that it is not so much the drought that damages his crops, but the warm, drying wind that goes with it. The same is true for the skin. Dryness can be caused or accentuated by a low humidity atmosphere that literally lifts the moisture out of it. Central heating, ventilation and extractor fans all strip moisture from the atmosphere and bring your skin closer to its evaporation threshold (when the humidity is below 30 per cent). Central heating is the most drying of the three and can send humidity plunging as low as 20 per cent — a level on a par with that of the Sahara Desert.

Cut down moisture loss from your own skin by putting more moisture into the atmosphere. A number of steps can be taken to raise the humidity level, such as keeping house plants, putting a bowl of water on a table or work surface, or buying one of the more sophisticated humidifiers which can be attached to a radiator or simply placed in an unobtrusive corner of the room. You should also make a special point of putting a fine layer of oil on to your face to cut down the rate of evaporation when humidity is low.

SKIN TYPES

Skin types are confusing. Most of what we read encourages us to believe that the skin, like the hair, must either be oily OR dry OR normal. For most, however, some areas of the face will be dry while others are oily. Although it is difficult to be rigorously selective when caring for this type of 'combination' skin, a general guideline should be to use an astringent only where the face is oily and a moisturizer only where it is dry. A sunscreen, of course, should be used whenever the face is exposed to strong sunlight, whatever its skin condition.

Dry skin

Dry skin is dull, feels tight on washing — even with the mildest of soaps — flakes, scales and chaps easily. It is more likely to protest on coming into contact with harsh chemical substances and will tend to make wrinkles look more prominent, although it will not actually cause them. Most skins tend to get drier as they get older. The sebaceous glands become less active, produce less sebum and provide a less efficient barrier to prevent the loss of natural moisture into the atmosphere. As more moisture is lost from the skin when the weather is hot and humidity is low, dry skin should be especially well protected in summer. Use an oil-based sunscreen to protect the face and a good moisturizer to retain as much internal moisture as possible. A good moisturizer is also important in the winter when central heating can have much the same effect. Do not over-wash (one shower or bath a day is plenty), use a light exfoliant, such as washing grains, once a week, and always moisturize. As a general rule, the lower the humidity, the heavier (greasier) your moisturizer should be.

Oily skin

Oily skin feels relaxed and supple, but looks shiny and is much more prone to outbreaks of spots. This is because of a heightened production of sebum by the sebaceous glands. While we all need sebum on the surface of the skin in order to keep it lubricated and supple and to bind in moisture, too much sebum can cause a blockage in the duct, leading to inflammation and pimples. Children rarely have oily skins because their sebaceous glands remain small and dormant, only becoming enlarged at puberty when raised hormone levels provide a trigger for increased sebum production. Sebaceous glands are unevenly distributed, being more concentrated around the scalp, on the forehead, along the nose and on the chin, and scarcer on the cheeks and neck, and around the eyes. Consequently, most skins tend to be oily only in patches. Oily skin may or may not lead to acne, but it is important to distinguish between oil on the surface of the skin, which makes it look shiny, tends to break through make-up and gives the skin a slightly yellowish tinge, and oil trapped within the sebaceous duct. Oil on the surface is friend not foe. That is where it is meant to be — and any excess can be easily removed with careful and regular washing.

Normal skin

Normal skin is not at all normal. In fact, it is rarely seen on anyone other than very young children and a few adults — but you will know if you have got it. Normal skins are clear, soft and supple, uniformly textured and pigmented, neither too oily nor too dry and not over-sensitive to climate, cosmetics or your own internal environment. This type of skin may be an inherited blessing but it still needs careful looking after.

Sensitive skin

Sensitive skin is what we all have. However resilient it is (and it has to be), any skin will protest if it is assaulted by harsh sunlight or fierce chemicals. So remember that skin is delicate and treat it accordingly. Hypersensitive skins, on the other hand, are usually the preserve of the fair-skinned and the blonde- or red-haired. This is the sort of skin that never tans but only burns or freckles, that reacts to irritant substances by coming up in spots, rashes or blotches and that tends to belong to the allergy-prone, such as the hay fever or asthma sufferer. People with extra sensitive skins also tend to register their emotions more tellingly on the face. They flush and blush easily and pale visibly under stress, fear or nausea. They should be particularly careful of the products they use (find guidelines on pages 138-9).

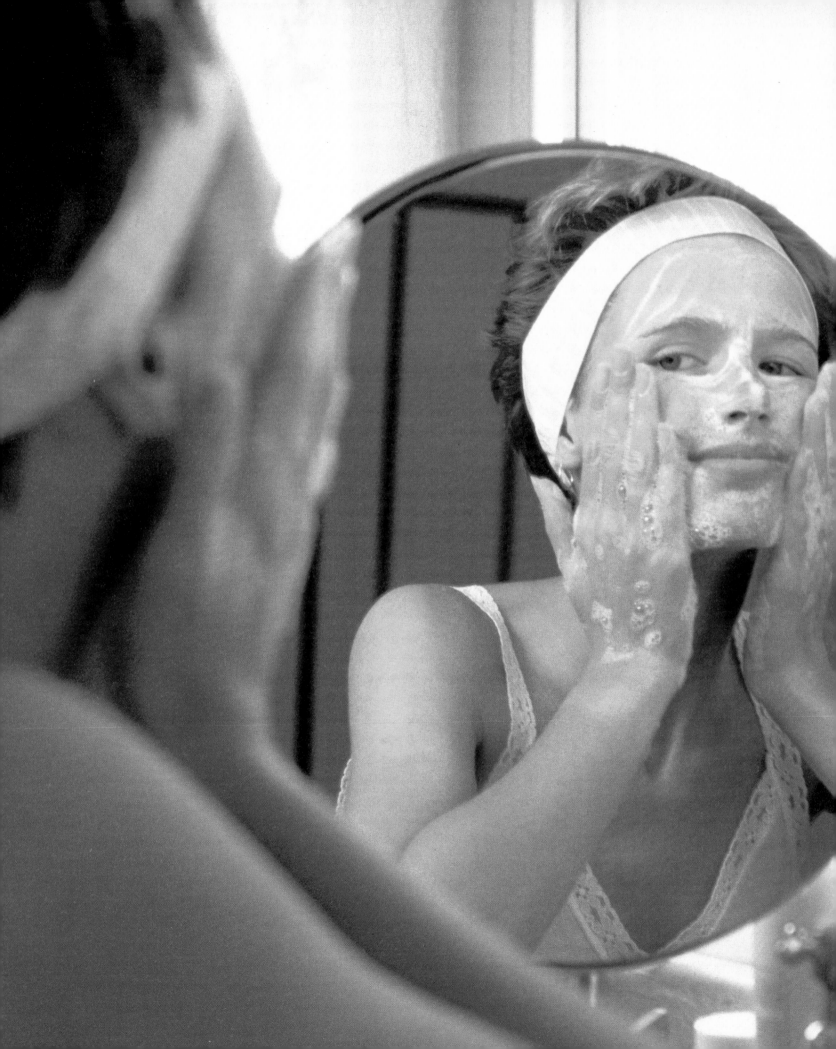

washwashwash

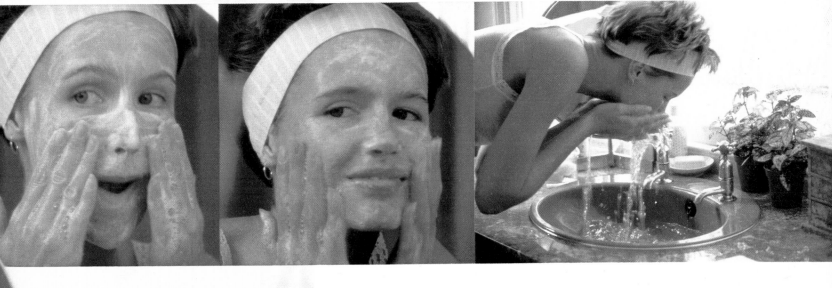

Wash the face with a mild unperfumed soap, lather briefly and rinse thoroughly. Because soap is an alkaline substance, washing will temporarily raise the pH of the skin, which is normally slightly acid at about 5.5. Most skins have an in-built ability to readjust the balance within 20 minutes of washing, though sensitive skins may take longer. You can speed up the process by using a citrus-based toning lotion or astringent afterwards.

If the skin feels dry and tight after washing, try using a superfatted soap which incorporates emollients such as lanolin or mineral oil into the soap base. Other causes of dryness: over-washing, incomplete rinsing, hard water (calcium and magnesium salts in the water combine with the soap to form a drying 'scum' on the skin) or sensitivity. Try a cream cleanser instead.

TAKING CARE OF YOUR SKIN

The first principle of any skincare routine is not to disturb the skin's normal function any more than you have to. Left to itself, the skin is a remarkable, self-cleansing and self-nourishing organ — and both nourishing and cleansing come from the inside. The purpose of washing or cleansing is to take off surface grime, excess sebum and accumulated dirt regularly and efficiently, but never abrasively. The skin is a finely tuned and delicate structure; over-enthusiastic cleansing procedures and very rich creams can upset it.

Because the skin is constantly changing in response to different stimuli, what is right one week may not always be appropriate the next. Pay attention to your skin. If it feels dry and taut, you may be treating it too harshly, using over-strong products or exposing it to unreasonable amounts of sun and wind. If it is shiny and oily with a tendency to break out, ask yourself whether you are removing every trace of greasy make-up removers, whether you would be better off washing it with soap and water or whether, perhaps, you are over-washing it.

If your skin develops lumps, bumps, pimples or scaly patches, start by simplifying your cleansing and make-up routines. Wash or cleanse the skin once a day only, using mild, unscented soaps and lotions. Skip commercial toners and astringents and splash your face instead with plain cold water or distilled water to which you have added a squeeze of lemon juice. If the condition persists or becomes worse, consult a dermatologist.

Washing, cleansing and removing make-up

There is nothing wrong with soap and water. In fact, most skins are washed most effectively this way, but it may be unsuitable if you have a dry or very sensitive skin or if you are trying to remove make-up.

When washing your face, always wash your hands first, otherwise you will merely be working additional dirt into the skin. Use an unperfumed soap — try a 'superfatted' or glycerine-based soap if you have a dry skin, a medicated one if you have an oily skin. Lather it first in your hands and then on your face, massaging gently for a few moments and then rinsing thoroughly, as any residue can have a drying effect. Splash with cold water and pat dry.

Wash only twice a day (once a day if the skin is sensitive), as it is possible to traumatize the skin by over-washing. This not only removes the excess, but also the essential, oil that renders the skin watertight, by preventing too much of its natural moisture evaporating into the air, and waterproof, by preventing absorption of grease, dirt and even toxins from the outside. If using soap and water leaves the skin feeling dry and tight, it could be that you are not rinsing thoroughly, that you live in a hard water area (try adding a pinch of borax to the water to soften it) or that your face is better suited to a cleansing lotion.

Most face foundations, blushers, powders and make-up bases are water-soluble and can usually be efficiently removed with soap and water. If particles of make-up still cling to the face or come away on the cotton wool you are using for toning, you should use a cleanser. If you have an oily skin, choose a cleanser that flows easily from the bottle, is well absorbed by cotton wool and leaves no shiny residue on the skin surface. While a drier skin will benefit from a slightly heavier cream, both types should avoid the heavier, grease-paint type of make-up remover. Theatrical make-up belongs to the theatre, so if you do need a heavy cream to get your make-up off at night, it is probably time to rethink your make-up techniques (see Cosmetics chapter).

Use gentle sweeping movements to remove dirt and grease and continue with successive pieces of cotton wool until the last comes away clean. Do not use ordinary cleanser on the eyes. Choose a specially formulated eye make-up remover — a thinner, water-based lotion, which is more sympathetic to the delicate eye tissue. Combine the use of an efficient cleanser with the gentlest possible removing technique. Pat it on to the eyelids and over the brow and leave for a few seconds. This will give the make-up a chance to dissolve into the lotion, so that it comes away easily with a minimum of rubbing. Finally, remove eye make-up and cleanser with a piece of cotton wool, dampened to prevent fibres getting caught in the lashes or irritating the eye.

To take off mascara, skim some eye make-up remover lightly over the lashes, place a flat piece of tissue or dampened cotton wool underneath the lower eyelashes and, taking a dampened cotton wool bud, roll it over the lashes on to the tissue or cotton wool beneath. Wearers of contact lenses should take their lenses out before removing their make-up, to avoid smudging grease or particles of make-up on to the lens.

Sensitive skin, some types of face make-up and all types of eye make-up require either a cream or liquid cleanser.
If the skin is young and/or has a natural tendency to oiliness, choose a light cleansing milk that flows easily from the bottle. If the skin is more mature and/or has a natural tendency to dryness, choose a slightly richer cream.
Start cleansing from the neck upwards, using as many pieces of cotton wool or tissue as you need. Use firm upward strokes and follow with a toner. (See following page for details on removing make-up.)

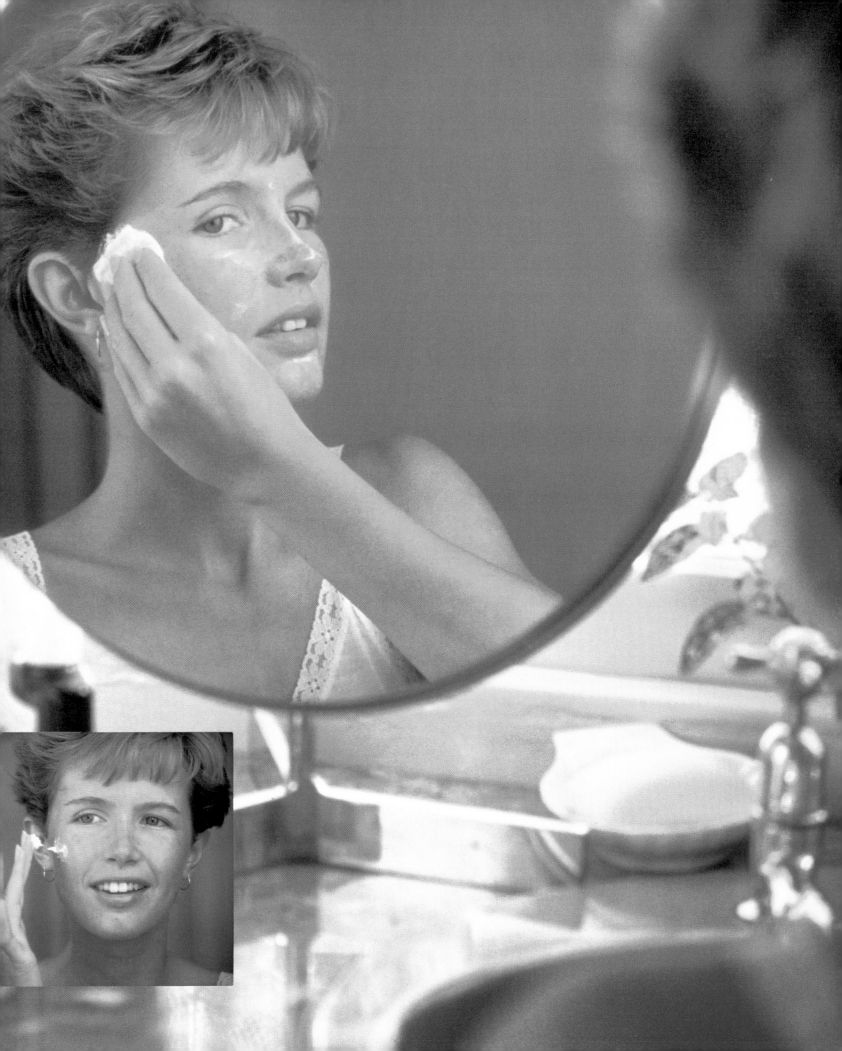

routineroutineroutine

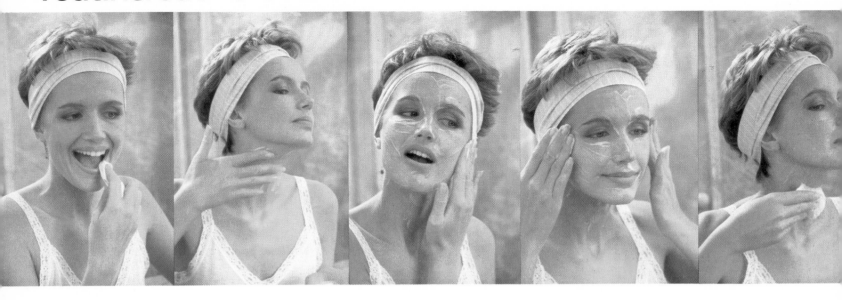

You should take as much care in removing your make-up as you do in putting it on. Particles of incompletely removed face make-up may block pores and contribute to skin problems while flaking mascara or eye make-up can irritate the eyes. Start by tying the hair well back from the face. If you wear contact lenses, remove these now.

Skim a light liquid make-up remover over face and lips, around the eyes and down the neck as far as you have taken the foundation.

Leave make-up and make-up remover on the face for a few moments, to help the make-up dissolve into the cleanser. This will enable you to remove your make-up with an absolute minimum of rubbing.

Take a folded tissue or a piece of cotton wool and wipe it over the face and neck in an upwards and outwards direction.

Toning

Skin toners have an evaporating and cooling action that causes muscles to contract and the pores to become temporarily (not permanently) smaller. Toning is pleasant and refreshing, can act as an additional cleanser on very oily or dirty skin and is valuable in removing any traces of grease the cleanser may have left behind.

Products are generally divided into fresheners, toners, clarifying lotions and astringents. Fresheners are the mildest and may contain lemon juice or citric acid to restore the acid balance of the skin after washing. Toners and clarifying lotions tend to be more abrasive, while astringents are the harshest of the lot. They contain a high proportion of alcohol, which has a drying effect on the skin, as it takes some of the skin's natural moisture with it on evaporation into the atmosphere. (Think how fast perfume — predominantly alcohol and water — evaporates when left in the open air.) Astringents may cause excessive dehydration and flaking on very dry or sensitive skins, so use them only on the oily areas of the face and on any oily patches across the chest and shoulder blades. You can make your own toner by mixing witch hazel, which has strong astringent properties, with gentler rosewater. Use equal quantities of rosewater and witch hazel for oily skins, two parts of rosewater to one of witch hazel for normal skins, and the same mixture diluted with distilled water if the skin is really dry. Bottle and keep in the refrigerator.

Straight witch hazel also makes an excellent 'emergency' treatment for spots and pimples. Apply it frequently to the area (at least four or five times a day) as soon as you feel a spot erupting. This will help to dry it out and, if applied early enough, may prevent it appearing at all.

Moisturizing

'Moisturizing' is a misleading concept. No moisturizer can or should put moisture into the skin. Everything works the other way round. 'Nourishing' is misleading too. Your food provides the nourishment, which is absorbed by the blood and carried to the skin cells along with essential protein, vitamins and trace minerals, all of which will have first been properly metabolized and minutely broken down by the action of enzymes, so that they can penetrate the cell walls. It is therefore improbable, if not impossible, for nutrition to reach the skin by any other means and, indeed, most cosmetics are only intended to act on the surface layers of the skin. So retain a degree of scepticism when you read the ingredients on product labels. Eggs, honey, assorted vitamins and minerals may all sound delicious but, if you really want to nourish your skin, do not plaster them on your face, eat them.

Moisturizers do have an important role to play in your beauty routine, but they must be used regularly and applied with care. They work by duplicating and strengthening the role of the body's own, naturally produced sebum and thus protect the skin against excessive moisture loss. Sebum emulsifies with sweat (99 per cent water) on the surface of skin, lubricating the upper layers of the epidermis by softening and plumping out the dry, dead skin cells, and produces a fine protective layer of oil to render the skin more water-

| Continue with successive pieces of cotton wool or tissue until the last comes away clean. | Eyes need special attention. The skin is very delicate here and the eyes are susceptible to irritation, even infection, if make-up or make-up remover come too close. Use a specially formulated, water-soluble lotion so that, should any make-up enter the eye, it can be easily flushed out by the tear fluid. | Apply make-up remover lightly to browbone and lids. Leave for a few moments, to give the make-up time to dissolve, and wipe off with a piece of dampened cotton wool to prevent stray particles or fibres getting caught on the lashes or irritating the eye. Use a cotton wool bud around the immediate margins of the eye. | When removing mascara, attend to lower and upper lashes, underneath as well as on top. Place a moistened tissue underneath the lower lashes, then smooth a small amount of the cleanser on to a cotton wool bud and roll it over top and lower lashes together. | Finally, wipe any traces of eye make-up or mascara away from the eyes, use a toner to remove any traces of greasiness left by the cleanser and follow with a light moisturizer. |

tight. Significantly, many moisturizers contain lanolin, which is derived from the natural oil (sebum) of the sheep. Like the oil on the skin's surface, moisturizers are water-and-oil emulsions. The richer day creams and most night creams have a greater oil-to-water ratio than the thinner, lighter ones, which are predominantly water based. If you have a very dry skin, you should use an oil-based emulsion, while younger combination skins will require only a lighter, water-based one. How can you tell the difference? Oil-based emulsions are thicker, cannot usually be poured and have to be scooped up with the fingers. They are not absorbed as well on to the superficial top layers of the skin and leave a fine, reflective sheen on it.

All moisturizers can be made to work more effectively by dampening the skin first, as the top, dead layer of skin will absorb a small amount of water. Body lotions are generally perfumed, and so should not be used on the face. But a good all-round moisturizer can be used everywhere, including on the forehead, neck and cheeks, gently around the eyes and anywhere else where the skin feels dry and tight.

Exfoliating

Cells that have been too long on the surface of the skin are greyish and dull in tone. They may flake and can clog the sebaceous pores, leading to superficial spots or blackheads and giving an uneven patchy look to the face and body. Cosmetic exfoliation helps to speed up the flaking and shedding process, by taking off the uppermost, dead layer of cells to expose the finer, more translucent tissue underneath.

it may also help preserve the youthful bloom of the skin. Some dermatologists now maintain that the reason why a man's skin tends to line less rapidly around the mouth and cheeks than a woman's is because the practice of shaving daily acts as a natural exfoliant.

The idea behind cosmetic exfoliation is controlled, not excessive, irritation and this can be accomplished in a number of ways. The ancient Egyptians used a recipe containing alabaster, honey and oatmeal and you can make up your own by combining roasted oatmeal with the zest of a citrus fruit and mixing to a paste with a little water. Alternatively, you can use one of the commercial brands. Other methods include a rough face glove or rotating facial 'scrubbing' brush, a peel-off mask or a chemical solution which usually contains a 'grease-stripping' solvent (salicylic acid, resorcinol or benzoyl peroxide) and is more likely to be marketed as a lotion for acne.

Whichever method you use, you should always exfoliate according to your skin's strength. The purpose is to leave the skin glowing, translucent and slightly pink, not red, inflamed and irritated. Exfoliants should be used with caution on dry and sensitive faces, but the tougher, body skin can well withstand a vigorous, twice-weekly sloughing session with an abrasive loofah to encourage the skin to flake off and to boost circulation through superficial skin vessels. Special attention areas: 'gooseflesh' on the upper arms, thighs and buttocks and rough scaly patches on the knees and elbows. Follow up with a body lotion to smooth new skin down and to leave it glowing and fresh.

1

2

3

4

5

6

A good facial massage will relax you and invigorate your skin by boosting the circulation and dilating the blood vessels, so helping to bring more oxygen to the skin surface.

Use a light moisturizer if the skin is oily, a richer night cream if the skin is dry, and smooth it on to the face and neck.

Start at the collarbone. Brush fingers up the neck and out under the chin (1), turning them out slightly so that each hand finishes just underneath its opposite ear. Use the backs of the fingers, too, if you like. Tap fingertips all around the mouth and chin. Give a deeper massage on the cheeks. Hold the fingers as though grasping an invisible ball and let the knuckles of the fingers play over the cheeks (2). Roll the skin gently between the first and second fingers and continue until the skin begins to tingle.

'Anchor' your thumbs under your chin (3) to ensure the lightest touch when massaging the eyes. Starting at inner corners, smooth fourth finger up over browbone, down below the eyes and into the corners again (4). Leave a fairly wide margin around the eye. Relieve any underlying tension by placing first and second fingers firmly on the temples, rotating them without letting them move across the skin and pressing down as you go (5).

Finish with a firm upward stroke along the bridge of the nose and forehead. Place thumbs on temples for stability and bring hands up alternately (6), concentrating the pressure on the outer edge of the first finger. Imagine all the creases and cares being smoothed out of the skin. Continue until you feel completely relaxed.

PROFESSIONAL TREATMENTS
Facial treatments

A good facial treatment has two main benefits. The first is that it leaves your skin tingling clean, fresh and glowing so that you look the better for it; the second is that it relaxes you and provides a psychological beauty boost, so that you feel the better for it. As almost anyone who has spent a week at a health farm or beauty spa will testify, being pampered is one of the best paths to feeling good in and about yourself.

There are many types of facial, ranging from the simpler mask, massage and herbal or oil treatments, which provide a more elaborate version of your own cleanse/tone/moisturize routine, to the speciality treatments, such as aromatherapy, which uses pure essential oils for specific therapeutic purposes, cathiodermie and ozone treatments, which use electrical currents to diffuse oxygen into the skin and lift impurities out, and 'freezing' facials, which use carbon dioxide because it evaporates on contact with the face and acts like a super-efficient astringent on oily and acne-prone skins. Faces react to facials in different ways. For some, the shock of such intensive attention seems to provoke a rash of spots and pimples. The face may actually look worse a few days after treatment — not necessarily a bad sign, according to some beauty therapists who maintain that it indicates that congested toxins and impurities in the skin have been freed and are coming to the surface. Other faces benefit more visibly and emerge after an hour or so in the beauty salon looking as though they have just spent two weeks in the country. The benefits, however, are temporary. Facials will not erase wrinkles or restore muscle tone, though they can do much for the tone and texture of the skin.

Laser therapy

A quite different and still relatively new type of facial treatment (widely available in Western Europe, less so in the USA) does claim to have long-lasting and far-reaching effects. This is the low-intensity helium/neon (class II) laser beam and it promises to soften and plump out lines and wrinkles, refine skin texture, tone up flagging facial muscles and generally take years off the age of the skin. The light, which penetrates the skin to a depth of only about one millimetre, is channelled through a fibre optic tube. The tip, which looks rather like the end of a ballpoint pen, is then traced along the lines and wrinkles of the face and applied to the acupuncture points to stimulate the muscle. While laser therapy is not, as has been claimed, a substitute for a face-lift, it does seem to have a 'youthifying' effect on some skins. But it is an expensive and time-consuming procedure — results usually only being perceived after 10 sessions or more and sometimes not even then, as not all faces respond to the therapy.

SKINCARE FOR EACH DECADE
What to do when

Your skin has its own chronological age which may or may not coincide with your real age. Determined first of all by the genes you inherit, it is also affected by your lifestyle, your state of health and, of course, how much sun-exposure you have had over the years. Too much sun combined with years of hard living, for example, can add 10 or 12 'years' on to the life of your skin. Common sense and a careful skincare routine, on the other hand, can subtract them. But it means starting early, preferably in childhood.

Childhood

Children may have a good, clear, glowing skin, but they are not often born with it. A surprisingly high percentage of babies show signs of jaundice at birth. Although the yellowish discoloration of the skin, which can extend to the whites of the eyes and the inside of the mouth, looks alarming, the condition usually resolves itself and should give no cause for real concern. The same applies to any small spots or pimples on the face, which result from the continued presence of the mother's hormones in the baby's blood. Infantile acne, which usually appears at three to four months and can last for up to two years, is more serious, as it may be an indication of some hormonal disturbance.

Childhood or infantile eczema can be an enormous problem. These itchy, scaly patches on the skin can develop into deep, sore cracks which will continually itch and irritate. Cut fingernails short to help prevent scratching, keep the skin free from strong soaps and detergents and avoid putting wool or any coarse, irritant materials next to the skin. Consult your doctor about long-term treatment.

This is also the time for infectious diseases, such as chicken pox and measles, so be on the lookout for any untoward changes in the skin, which might be an indication that the child has one of them. Otherwise, the skin should be washed twice daily and then left to itself. Start a strong anti-sun campaign as early as possible, because young bodies are much more susceptible to sunburn and to deep tissue damage than older, tougher ones.

Teens

With the exception of the first four months in the womb, puberty is the time of greatest development and growth. Even the eyeballs expand under the onslaught of new and rising hormone levels in the blood. These levels can hardly fail to have an effect on the skin. Acne, accompanied by oily, shiny skin and greasy hair, is a major teenage problem, which affects boys and girls alike (see also A-Z). Fortunately, much can be done to improve acne. So if it does not respond to the use of lotions and scrupulous cleansing, do not wait for miracles, go to your doctor, who may either treat you himself or refer you to a dermatologist. Most cases of acne can now be treated with the tetracycline groups of antibiotics. But do not expect immediate results, for it can take three months and sometimes much more before you see an improvement. It is also essential to observe scrupulous hygiene. If you have acne or a tendency towards oiliness, wash the skin twice daily, apply a medium-strength astringent (strong astringents may stimulate rather than inhibit oil production) and use moisturizer over the dry areas only. You should wash your hair frequently, too. Use a mild shampoo and choose a hairstyle that keeps the hair off the face, as oil secreted on to the scalp can cause acne all around the hairline.

This is the best time to establish your priorities. Spare a thought for sunburn and sun-damaged skin. Tan sensibly

and use a sunscreen. The action you take now to protect your face from the harmful effects of sunlight will pay huge dividends in 15 or 20 years' time.

Avoid crash dieting for the sake of your skin, if for no other reason. A subcutaneous layer of fat beneath the dermis gives the skin its springy texture and literally moulds the softer contours of the face. If this is undermined, the skin will sag, lose its suppleness and may look prematurely old, even at 18.

This is also the time <u>not</u> to take up smoking. After sunlight, smoking is one of the principle causes of early wrinkles and lifeless skin.

Twenties

This is a time for experimentation and change and an age at which you have to make many crucial decisions about how you want to live. Career … marriage … children? It is also a time when your hormone levels are still high and when your oil and sweat glands may be even more active than they were in your teens. Acne and oily skin may continue into your twenties or they may disappear as your hormone levels settle and your skin becomes less sensitive to them. Alternatively, acne may appear for the first time. Unlike teenage acne, which is inflammatory and red and extends over cheeks, chin and forehead, 'twenties acne' tends to take the form of small, scaly, red spots around the mouth and on the chin. Use conventional acne treatments and avoid the use of steroid creams, which may only aggravate the problem.

Now, and in subsequent years, hormones are immediately affected by pregnancy and by the contraceptive pill. Both can have a wide range of effects on the skin. While pregnancy is often a time of marvellous healthy skin and lustrous hair, it can also be a time when the skin and hair are quite unmanageable and the nails become very brittle and when, unless you are careful, varicose veins may appear for the first time (see page 221).

If you find you develop extensive, dry, scaly, flaking tissue on exposed areas and 'pressure points' of the body, such as the knees, elbows and scalp, you may have psoriasis, one of the most common and least understood of all the skin disorders. This completely harmless, but extremely distressing condition commonly appears for the first time between the ages of 15 and 30. (Find further details on page 220.)

Thirties

This is one of the most demanding phases of your life. You may be looking after a family and young children, managing a household, pursuing a career, or doing all three at once: responsibilities which may lead you to neglect your skin. Don't. What you do, or fail to do, now may seem insignificant but will certainly affect your skin's ability to weather the years later on. You may have already noticed some early signs of ageing. Fine lines around the corners of the eyes, caused by sun-exposure, squinting and the everyday movement of the muscles beneath the skin, are usually the first to appear, as the skin is thinner here, and sebaceous glands fewer, than anywhere else on the body. These are followed by 'smile' lines, running from the corners of the nose to the corners of the mouth, and 'frown' lines, running down the centre of the forehead. Dryness of the skin can accentuate wrinkles, although it will not actually cause them, so use a good moisturizer to keep the skin soft and supple and to encourage it to retain as much of its own moisture as possible. This will also seem to soften out any facial lines and wrinkles that you already have.

As the rate of cell division and replacement falls off by 50 per cent between the ages of 35 and 80, accompanied by an increasing tendency for the old cells on the surface of the skin to cling there for a bit longer, you should compensate for the slowdown by exfoliating regularly with a commercial lotion, washing 'grains' or abrasive brushes.

The oil glands also step down their production of sebum at this time. Where once your skin glistened because of the extra oil on your face, it may now be dry and dull. Be awake to this. The skin does change and your skincare routine should adapt likewise.

Forties

By now, your age will certainly be showing some effects on your skin, but how dramatically will depend on your own genetic make-up and on how much sun-exposure you have had. If your skin is showing the results of over-enthusiastic sunbathing in early life, remember that all damage caused by sunlight is cumulative and it is still not too late to protect it from further damage.

With the approaching menopause, the hormonally responsive sebaceous glands begin to shrink in size and to produce less oil, with the result that your skin may become dry and prone to flaking. Everything you put on to the skin

now, whether cleanser, sunscreen or make-up, should put something back. Use a clear glycerine or 'superfatted' soap or switch to a cream cleanser and cotton wool. Choose sunscreens that will also moisturize the skin and use a 'hydrating' foundation. Counteract the drying effects of the atmosphere by using a good moisturizer and installing a humidifier in centrally heated rooms.

Although your skin is likely to be much drier, most unfairly, you can still get acne or, more precisely, acne-like spots known as rosacea. Accompanied by mild inflammation and redness, this is most common in middle-age among those who flush or blush easily and who may have had a quite pimple-free adolescence. Indeed, there is now evidence that the condition is rarer among earlier sufferers of acne. Avoid hot drinks, spirits and curries — all of which tend to aggravate the condition — and use creams and lotions sparingly and with caution because your skin is probably dry. So restrict application only to the affected area and, if it does not clear up, see a dermatologist.

As the skin ages, the collagen and elastin fibres, which give it its elasticity and tone, become fused into an inflexible mish-mash called elastone. The skin becomes thinner too — more rapidly in women than in men, who start with thicker skins in the first place — as does the subcutaneous layer of fat, even though you may be putting on weight everywhere else. All this adds up to sagging, wrinkling, loss of skin tone and uneven pigmentation. In addition, the skin on the neck, jaw, and around the nose and mouth may feel and look several sizes too big. There is no known way of counteracting this effectively once it has happened bar cosmetic surgery, which, if carried out well, can have remarkable results and may last for up to 10 years. (Laser therapy — see previous page — is not a substitute for a face lift.) The years between 45 and 50 are now considered the optimum period for a 'first lift' by many cosmetic surgeons (find further details on page 167).

Fifties and beyond

There is no reason why, at 50 or over, your skin should not be soft and supple and your hair shining and healthy. Nevertheless, the menopause does take its toll on the condition of the skin and hair, as production of oestrogen, the 'good skin' hormone, gradually decreases. One of the beneficial side-effects of hormone replacement therapy (see page 213) is that the skin improves immeasurably in texture and tone and may acquire a bloom it has not had since you were 30.

But you cannot go on taking the tablets indefinitely and so, sooner or later, you will have to come to terms with increased dryness on the face and body. To counteract it, use a good, rich moisturizer like a second skin — applying it first thing in the morning and again if you are exposed to a drying atmosphere, particularly wind, sun and central heating. Use a rich night cream, the greasier the better.

Exfoliation is more important than ever, in order to ensure the skin texture remains smooth and glowing. Because the skin is drier and more delicate, use only the mildest of lotions and bypass the more abrasive techniques. Finally bathe, like Cleopatra, in a warm bath to which you have added a glass of milk — a natural water-in-oil emulsion — mixed with a capful of oil. Follow with a good after bath oil. If your skin feels dry and itchy (a condition known as 'winter itch'), bathe less often and , when you do, try adding oatmeal to the bath water and use more oil. You should find that the itching disappears if the skin is protected and moisturized well.

If you have had a lot of sun-exposure over the years, you may develop dark, hyperpigmented patches known as liver spots. A commercial bleaching agent or a chemical peel, strong enough to take off the top layer of skin may make them less visible (see page 168), but some permanent marking is inevitable. These spots are completely harmless, but you should be on the lookout for any more suspicious skin changes, such as sores that do not heal, a small, pearly patch on the skin and brown or black, mole-like growths. If you find any of these, go to your doctor.

After the age of about 35, everything that you put on to the skin – sunscreens, soaps, cleansers, make-up – should put something back. Use a light moisturizer beneath a hydrating (moisturizing) foundation during the day and a richer cream at night. Choose a thick oil-based emulsion that leaves a fine reflective sheen when smoothed on to the skin.

'Beauty draws us with a single hair...' Alexander Pope

Your hair should be your crowning glory. Not only is it the first thing that people notice about you (and that is something on which psychologists and hairdressers are in perfect accord) but it also offers you the most immediate prospect of change that you have. The way you wear your hair, its colour and condition all reflect a style, indicate an outlook and add up to a definitive statement about yourself. Change your cut and experiment with colour and you can spell out a whole new look.

Because there are few, if any, hard and fast rules about the way you should wear your hair and because fashions change, you will not find guidelines on cut below. This is a province for your hairdresser who will be able to match up a style compatible with your hair type, face shape and personality in a way that no book can do. Guidelines on colour are given, however, together with a chart for quick and easy reference so that you can check out each process against the present colour and condition of your hair and arrive at one that will work well for you. But first your hair and scalp must be in the best possible condition.

STRUCTURE AND GROWTH

Hair is made of a tough substance called keratin. It comprises the inner soft core (medulla), the central cortex, and the cuticle, an outer, transparent and protective layer. The cuticle is smoothed and flattened by natural secretions of sebum from the sebaceous glands situated at the upper end of the hair follicle. This fine layer of oil causes the cuticle to reflect light and gives healthy hair its characteristic lustre and shine. Under environmental or chemical influences, the position of the cells on the cuticle can be disrupted so that, instead of lying flat and smooth like tiles on a roof, they become raised and distorted, scattering the light and making the hair appear dull and lifeless. The hair also becomes dull if the cuticle is starved of sebum — a condition caused by inactive or clogged sebaceous glands or by dandruff, which soaks up the sebum as it arrives on the scalp and prevents it from travelling along the hair.

By the time the hair on your head emerges on the scalp it is completely dead. Living matrix cells, situated beneath the surface of the skin, divide every 12 hours and push the new cells towards the surface. Within a few millimetres of daylight, these are hardened and effectively 'fossilized' so that they emerge from the scalp impermeable, sealed and well able to withstand all normal environmental rigours, such as rain, moderate amounts of wind and sunlight and the action of milder shampoos and detergents. They are not always equipped to withstand the chemical onslaught of bleaching, perming, straightening or tinting, however.

We all lose hair at a rate of up to 150 strands a day, and we can all afford to lose hair at this rate, having between 100,000 and 150,000 strands on the head at any one time. Each of these observes a three- to five-year growth cycle. In some

exceptional cases, the cycle may take seven, but only one person in a million has such an abnormally regulated cycle and such tenacious follicles that fairy-tale, floor-length hair becomes a possibility.

The whole process of hair loss and replacement is a gradual and invisible one. It has been estimated that your hair needs to lose as much as 40 to 50 per cent of an area total before that area starts to look noticeably thinner. So if you find dramatic quantities of hair on your hairbrush or pillow, do not be alarmed; you will not go bald overnight. If the hair loss continues consult a trichologist or dermatologist and, in the meantime, reassure yourself that nearly all hair loss in women is completely reversible.

Hair grows at the rate of about 14 mm (½ inch) a month — one of the most prolific growth rates in the body. Any change in cell metabolism will affect the rate of growth, and fall, of the hair. Excessive hair fall, alopecia, can also be caused by stress, pulling, fluctuating hormone levels, ageing, anaemia and other metabolic disorders. While there is always a reason, isolating the cause can sometimes be difficult.

All hair gets finer as we grow older. After as few as three decades of constant renewal, the process of cell division can start to slow up. Some cells close down entirely. Others no longer have the muscle to push through the dense elastin fibres which form with age. Genetically induced hair loss is much more common among men than women, and it is always permanent. In the future, however, early hormonal control may prevent, or at least delay, its onset.

Temporary hair loss in women is commonly caused by hormonal fluctuation, such as while taking or coming off the contraceptive pill, during the menopause and, most commonly, after a pregnancy (see page 205). Patchy hair loss, *alopecia areata*, occurs when the hair falls out in small clumps, giving the head a moth-eaten appearance. It affects about one to two per cent of the population and should be treated by a trichologist or dermatologist. A condition most often seen among adolescent girls and thought to be a sign of sexual frustration, is caused by the sufferer actually pulling the hair out of the head herself. The family doctor, a psychiatrist or a sympathetic counsellor can often help with this psychological disorder. Patchy hair loss can also be caused by severe shock. If the shock is enormous, the loss may be permanent, but in most cases it will grow back.

Another type of hair loss, mechanical or 'traction' alopecia, is caused by over-rigorous brushing, any type of hair styling that pulls the hair back from the face and interferes with its natural direction of growth, and the action of chemicals used during processing (perming, straightening, etc), which undermine the strength of the hair. The answer to this type of hair loss is simple: leave it alone. The more naturally you style and treat your hair, the stronger and more resilient it will be and the less likely to fall out prematurely.

resting hair / growing hair

sebaceous gland / matrix cells

Hair grows from a cluster of matrix cells beneath the skin. These cells divide rapidly and push the new hair up towards the scalp. When the new hair emerges at the scalp it is effectively keratinized (dead). The sebaceous glands at the side of the hair follicle are largely responsible for the lustre of the hair: too much sebum will produce an oily hair condition; too little a dry one Each hair observes a growing phase (right), a resting phase of between two or three months (left) and a falling out phase. By the time the old hair is shed a new one will have already begun to form beneath it.

airhairhair

To check the condition of your scalp, make a parting down the centre of your head and scrape it gently with a wide-toothed comb (right). If there is any scaling, your scalp needs attention – but consult the checklist of possible culprits here, before you assume it is dandruff.

If dandruff seems to be the problem, try a gentle home-based treatment – using a mild antiseptic lotion, parting the hair and applying it as shown, below – before tackling the problem with one of the harsher acting anti-dandruff shampoos.

Diet

Most hair responds very positively to a balanced, healthy diet — improving in condition and lustre as the diet improves. Wholegrains, yeast extracts, organ meats (liver, kidney, etc) and eggs are particularly beneficial because they are high in the B vitamins. This important complex is thought to play a crucial part in the health and growth of the hair at matrix level. Veterinary surgeons, interestingly, frequently prescribe extra vitamin B if the condition of an animal's coat is poor. If your hair is dull and out of condition, try doing likewise. Having first considered your diet and revised it where necessary, take extra wheatgerm on soups, cereals, stews or salads or up to six tablets (one tablespoon) of brewer's yeast a day to see if the condition improves.

TAKING CARE OF YOUR HAIR
Treating your scalp

You cannot get the best from your hair if you do not have a healthy scalp. But do not automatically assume a scaling scalp means dandruff. A dry, flaking scalp could indicate any of the following: a generalized dry skin and hair condition, which should be treated with a light almond oil massage (see below); too much exposure to bright sunlight causing the scalp to burn and peel, just as with any other part of the body; and, commonly, a residue left in the hair after shampooing or using a hair spray or setting lotion. Before you switch to a dandruff shampoo, give your regular shampoo a chance to work for you, by rinsing it out thoroughly after washing. Leave hair sprays and setting lotions off your hair for a week or two.

If your scalp does not respond to these simple steps, then you probably do have dandruff (see page 216). Treat it with a weak cetrimide solution, made by gently heating half a teaspoon of the powder (available from most chemists) in 1.2 litres/2 pints (5 cups) of distilled water until it is completely dissolved. Part the hair at 2 cm (½ inch) intervals, apply to the scalp with swabs of cotton wool, and work systematically all around the head, starting at the forehead and working backwards. If cetrimide is not available, use a straightforward commercial antiseptic diluted with four parts distilled water to one part antiseptic.

If the condition continues unabated, switch to one of the stronger anti-dandruff shampoos. Choose one containing tar or zinc pyrithione, which is thought to have a slowing effect on the rate of cell turnover.

Massaging the scalp can have several benefits for the health of the hair. It will also relax you generally. To massage your scalp, use the pads of the fingers on both hands arched into a dome shape. Start at the hairline on the forehead and move gradually back and sideways with a firm, circular movement, rather as though you were kneading dough, taking care not to move the fingers more than a few centimetres across the scalp at any one time. Keep the scalp damp, by dipping your fingers into one of the following: plain tapwater for normal hair and scalp; cetrimide or diluted antiseptic solution (given above) for dandruffed and scaly scalps; the juice of half a lemon in a cupful of water for oily and mixed condition hair; warm almond oil (left on for an hour and washed out thoroughly) for dry scalp and hair.

Brushing and combing

100 brush strokes a day are not the best way to healthy, glossy hair. They create friction, disrupt the cuticle and may even scratch the scalp. If possible, comb it instead with a wide-toothed, 'sawcut' vulcanized rubber comb with specially moulded teeth. This is much kinder to both the hair and the scalp than the cheaper, mass-produced plastic variety with sharp and scratchy edges.

Brushing or combing wet hair is especially hazardous, so always use a conditioner to help the comb glide through.

Washing

Wet hair loses up to 20 per cent of its natural elasticity, making it an easy and vulnerable target to over-vigorous shampooing and drying. Most people do more damage to their hair through insensitive washing and drying than through using the 'wrong' shampoos. Shampoos, however, are popular scapegoats.

Choosing the right shampoo is largely a matter of trial and error, unless you are already using a prescription treatment specially made up for you by a trichologist. When choosing shampoo, do not be blinded by protein, promises or pH numbers. Go by what suits you. A good shampoo should clean quickly and effectively, should be easy to apply and to rinse out and should never irritate the scalp. Do not judge the effectiveness of any given shampoo by the lather it produces. Some manufacturers add foaming agents to their shampoos for purely commercial reasons.

KNOWING YOUR HAIR TYPE

CONDITION	CAUSES	WASHING: how often, with what?	DRYING	PROCESSING
OILY	Overactive sebaceous glands in the scalp produce excess sebum, which coats the hair, causing it to glisten with oiliness and to become limp and lank in appearance. Oily hair tends to be more common among fair-haired people, who often have finer hair (coarser-haired redheads almost always tend towards dryness). All hair tends to become greasier at puberty when the sebaceous glands become much more active due to hormonal changes. In some cases it can also become noticeably oilier at times of smaller hormonal fluctuation, such as the week before menstruation. Oily hair usually improves during the last six months of pregnancy when there is a surge in several hormones.	Keep scrupulously clean and wash daily with a mild shampoo. This will not step up sebaceous gland activity, but harsh acting shampoos will. By stripping essential, as well as excess, oil from the scalp, they create a shortfall which then stimulates the glands to redress the balance. Avoid 'dry' shampoos: the powder can clog the hair follicles on the scalp and aggravate the problem. Use a conditioner before shampooing (see guidelines on page 102) or add the juice of half a lemon or one tablespoon of vinegar to a jugful of water and use it as a final rinse. The acid will remove any greasy residue left by the shampoo and smooth down the cuticle, making it easier to comb out.	Use lower heat settings on blow dryers. Hot air currents can activate the sweat glands and step up sebum production.	As processing tends to dry out cellular moisture within the hair shaft, mild colouring (not bleaching) can improve the appearance of oily or limp hair.
DRY	Four to 13 per cent of healthy hair is water. Dry hair is usually symptomatic of dehydration (loss of water content at cellular level), often caused by a lack of sebum on the hair. Dry hair not only looks dull and lifeless, but is also much more susceptible to breakage and splitting due to its reduced elasticity. While a normal strand of hair will stretch to an additional 30 per cent of its overall length before breaking, a dry strand of hair may only stretch about half as far, if that. In other words, far less stress is required to break a dehydrated hair. For this reason, you should take steps to protect it from any chemical or mechanical means of stress, such as brushing, pulling or harsh styling. As exposure to strong sunlight exerts a natural and damaging bleaching effect on the hair, anyone with a dry hair condition should take especial care to protect it from the sun by wearing a scarf or wide-brimmed hat in hot weather.	Shampoo once only with a mild shampoo. If you massage the scalp thoroughly, the hair will be cleaned effectively. Use a good cream conditioner, rinse thoroughly and keep any brushing or combing to an absolute minimum when wet. Dry hair is often accompanied by a dry and flaking scalp, but avoid using one of the harsher acting dandruff shampoos until you have tried the antiseptic scalp treatment opposite. This has the advantage of treating only the affected area, while leaving the rest of the hair alone. If the hair is very dry, massage two tablespoons of warmed olive or almond oil well into the hair, wrap in a plastic bag to increase moisture absorption and leave for at least 30 minutes. Finally, remove all traces of oil by pouring a cupful of shampoo directly onto the head, massaging well and then rinsing.	Finger dry or leave to dry in the open air, if possible. Hair dryers should be used with care. Stop drying while hair is still slightly damp to ensure against over-drying which can aggravate any tendency to dryness you may already have.	Most dry hair is inflicted not inherited – and colouring, perming or straightening and bleaching (in ascending order of severity) are the principal culprits. As the chemicals used have to penetrate beyond the cuticle, some loss of natural moisture is inevitable. Anyone with really dry hair should, therefore, avoid processing and wait for the condition to improve. Instead go for highlights or one of the milder, temporary colours that do not disturb the hair beyond cuticle level. Semi-permanent rinses are a good example.
NORMAL	Healthy-looking, shining hair is the result of well-balanced, internal chemistry (good genetic profile and well-regulated hormone levels), common sense and careful management. Most people can end up with normal hair if they look after it wisely.	Wash your hair as often as you think it needs it – every day if necessary. Because your hair is normal, it does not mean that it is more resilient or less susceptible to damage. Keep it clean and shining, by using a shampoo and a conditioner that suits you, and interfere with its natural function as little as possible.	Follow all guidelines given on pages 101-2.	Methods of colouring and/or perming the hair are now so sophisticated that there is no reason why you should not be able to achieve the cosmetic effect you desire, as long as you proceed with caution (follow guidelines on pages 102-3).
MIXED CONDITION	Active sebaceous glands produce a glut of sebum that is absorbed at the base line on the scalp and prevented from travelling along the hair shaft, robbing it of essential lubrication and gloss. With mixed condition hair, the scalp and hair at the roots are oily, while the ends are dry, frizzy and prone to breakage and splitting.	Discriminate between cleansing the scalp and cleansing the ends of the hair. Each qualifies for separate attention. Start by giving your scalp an astringent treatment before shampooing (see page 102), follow with a mild shampoo, used once only, and finish with a conditioner applied only to the ends of the hair.	As dry hair, using the lowest setting when blow drying.	As dry hair.

Hair carries a negative electrical charge and, because dirt clings to these negative ions, to cleanse it efficiently you must reverse the charge. You can do this by using any of the alkaline detergents (shampoos) on the market. Baby shampoos do not come into this category. They carry no charge at all in order to avoid irritating the eyes, and do not, therefore, cleanse as efficiently as an ordinary shampoo. While kinder to the eyes, they are not necessarily gentler to the hair. There is little evidence either to suggest that 'pH-balanced' shampoos are preferable to ordinary shampoos for natural unprocessed hair — but they can be helpful for hair that is damaged or porous (this is particularly likely if it has been permed, tinted or straightened). As all but the most permanent hair dyes will fade slightly with each wash, anti-dandruff shampoos which are harsher acting should be avoided if you are anxious to preserve the colour.

washwashwashwash

- Wash your hair as often as you need to. It cannot be worn out through over-washing and a mild-acting shampoo will <u>not</u> stimulate the sebaceous glands to produce more sebum. If you have dry hair, shampoo once only.
- Wash your hair by leaning over a bath or basin, preferably using a shower attachment to ensure that the hair is well and evenly dampened and that it is rinsed in absolutely clean water. Do not wash your hair in the bath. Soaps, bath oils and general body dirt are not a good washing or rinsing medium for your hair.
- Dampen the hair well, then apply a small amount of shampoo evenly over the head by pouring it on to your hands, rubbing them together and smoothing them through the hair.
- The purpose of washing the hair is as much to clean the scalp as to clean the hair itself, so work the shampoo well down on to the scalp and massage it for a few minutes.
- If you have longish hair, do not pile it on top of your head. This is asking for snarls and tangles. Let it fall down into the water and run your fingers through from front to back instead.
- Always use a conditioner.
- Always rinse thoroughly and, when you think you have rinsed enough, rinse again. A soapy residue will dry out the scalp and may lead to scaling.

Wet hair loses up to 20 per cent of its elasticity and, with it, much of its natural resilience. So treat it as gently as possible after washing.

● Squeeze out excess water, wrap hair loosely in a clean towel, turban-fashion, and press firmly against the head. Do not rub vigorously.

● Once hair is no longer soaking wet, the best thing you can do is to leave it to dry naturally.

● When using a blow dryer, capitalize on the control, minimize on the damage: do not start drying until the hair is three-quarters dry; do not hold the dryer over one area of the head for too long; do not allow the scalp to become hot; use a brush <u>gently</u> to persuade the hair into the style you want; and, most important, do not continue to blow hot air on to hair that is already dry.

Conditioning

All shampoos are detergent-based, alkaline and work by swelling the hair shaft and lifting the cuticle. They also carry an electrical charge which will cause the individual strands to react to each other, producing static. You can reduce this natural electricity by using a conditioner after shampooing. Conditioners tend to be acid and carry a positive electrical charge which encourages the hair to lie smoothly and flat on the head, enabling you to comb it through easily while wet. It is for this ease of combing out that conditioners are especially valuable and no hair, however fine and oily, should go without. If you do have oily hair use a simple acid solution as a final rinse (see oily hair, on chart) or condition before you shampoo: dampen the hair thoroughly, towel dry, apply the conditioner and leave for about 60 seconds before combing out, rinsing thoroughly and shampooing.

All conditioners are designed to work within 30 to 60 seconds. (Warm oil treatments for dry hair or scalp are an exception.) Apply the conditioner exactly as you would a shampoo, rubbing it first between the palms and then on to the hair away from the scalp, so that the cuticle is encouraged to lie flat. If you have mixed condition hair, which is oily at the roots and on the scalp but dry at the ends, apply the conditioner only to the ends. Then rinse thoroughly.

Drying

Hair swells on getting wet. It also loses it elasticity and so is easily damaged by over-enthusiastic drying. The first rule is always to treat the hair as gently as possible, preferably leaving your hair to dry on its own and using your fingers to persuade it into the shape you want. Unless you are fairly adept at this, however, it is unrealistic to expect the control or the style that you would get from using a blow dryer.

Blow dryers are fine, as long as you use them with care. They should not be too powerful (1000 watts maximum) nor should they be held too close or for too long over any one area of the head. Use them on damp, not soaking wet, hair and go for a dryer that has two or more drying speeds — start with the hotter and turn it down once most of the moisture has evaporated.

Heated rollers and curling tongs can both be damaging because they concentrate heat on hair that is already dry. While traditional rollers (buy them as smooth and even-surfaced as possible) are preferable, they are not as quick and convenient to use. In the interests of convenience, spare a thought for your hair and use heated rollers, which are less damaging than tongs. Putting your hand on a pair of hot curling tongs will cause you to burn the skin, so imagine what can happen when you use them on your hair.

Processing

No chemical process is 100 per cent harmless to the hair, because it is precisely by disrupting its internal structure that the desired effect, whether colour or wave, is achieved. Nevertheless, the potential to damage will depend on three main factors. The first is the severity of the process involved. Bleaching a whole head of hair, for example, is much more damaging than adding a few highlights. The second is the general health and texture of the hair before processing. If it is already weakened and damaged, it will not 'hold' a perm or colour as well and will also tend to be less resilient to the chemicals used than healthier, stronger hair. The third is the hands that apply the chemical. Use your own with caution, and always seek the advice and guidance of a good hairdresser if you are contemplating changing the colour or wave of your hair for the first time, because he or she will be able to give you a reliable indication of how well your hair is likely to withstand the chemicals used. Never declare war on your own natural colour. Work with it instead. Everyone has five or six distinct colour tones, or natural highlights, already present in the hair. The most natural effects are achieved by adding to, never subtracting from, these, either by creating new ones (see 'Highlights' overleaf) or by going one or two shades lighter than your natural colour and so 'lifting' it. Darkening has the reverse effect because it kills the highlights already present in the hair and flattens the colour to give an unnatural 'matt' look.

Finally, remember that, whether it is permanent dye or permanent wave, effects are irreversible and mistakes expensive. You may have to wait many months for the colour or the wave to grow out.

Perming or straightening

These processes use a chemical called ammonium thioglycollate, or one of its derivatives, to prise open the sulphur bonds — resilient interlocking cross linkages like the rungs on a ladder — which give the hair its natural stability and strength. When the hair is processed the 'rungs' are broken and realigned into the desired formation with rollers (waving) or by stretching (straightening). Once the chemical has taken effect, its action will be curtailed by the application of a neutralizer which will enable most (not all) of the bonds to reform in their new position.

Do go to a good hairdresser if you want a perm. Home perms are hazardous, both because it is extremely difficult to get the effect you require, and because the chemicals within the solution can leave you quite bald if you let them. The compound literally dissolves the hair away if left on for too long.

If you want to perm and colour your hair, never try to do both at the same time. The chemicals used react against each other and will weaken the hair. Always perm first and allow at least two weeks to elapse, preferably longer, before tinting. Never perm your hair more often than once every three months and avoid perming entirely if your hair is already damaged or weakened. Allow any dandruff or scaling scalp condition to clear up before processing.

Straightening the hair tends to be more hazardous than perming as the chemical has to be applied closer to the scalp.

Bleaching

Bleaching, whether in a salon or at home is one of the most damaging things you can do to your hair, and the hit-and-miss practice of applying lemon juice in order to obtain 'natural' streaks in bright sunlight is no better.

Bleach uses a combination of ammonia, to act as a colour stripper, and peroxide, to act as a catalyst. This has a highly

abrasive action on the outer cuticle. Avoid it. If you want fine, light streaks, go to a good hair colorist and have the hair highlighted instead. The results will be much more effective, and the damage minimal, as the chemical (a lightener <u>not</u> a bleach) does not come into contact with the scalp and only a small amount of hair is being treated at one time.

Colouring

There are three main types of colour dye, of which the kindest and most temporary are the simple colour rinses, and the most dramatic and long-lasting are the permanent dyes and tints. These also offer the greatest control and versatility. The active ingredients are based on amine derivatives of which paraphenylenediamine is one of the more frequently used. These have had bad publicity in recent years, and controversy still surrounds the carcinogenic (cancer-producing) possibility of these compounds. While no conclusive evidence has yet been obtained, it is probably wise to forego colouring your hair during pregnancy, when chemicals can cross the placenta and reach the foetus. All hair dyes are now subjected to stringent tests and the amount of paraphenylenediamine has to be specified on the product label by law. As the percentage of active ingredient rises as the colour darkens (a blonde shade, for example, may contain only 0.002 per cent while a red or dark brown shade will have 15 to 20 times as much), a good general rule is always to go for a shade that is one or two shades lighter than your own. Not only is it safer from the chemical point of view, but it also looks much better.

It is always advisable to go to a good colorist for permanent tinting, but it can be expensive. If you do decide to do it at home, you must take the following precautions.

• <u>Test on a small area of skin before tinting the whole head of hair</u>, as it is possible, though unlikely, to develop a contact allergic reaction to the chemical. You should also do this if you are using a semi-permanent colour. Apply a small amount of the solution you want to use to an area on the inner forearm, cover it with a plaster, and leave for 24 hours. If there is any trace of irritation or inflammation, do not colour your hair. You should also do this if perming or straightening the hair for the first time or changing products.

• <u>You can also do a pre-colour test.</u> Take a few strands of hair, add the dye exactly in accordance with the maker's instructions and rinse it out after the specified time. This should give you some idea of the tone, but keep in mind that dyeing the hair en masse will intensify and darken the shade.

• <u>Always buy a well-known and reputable product.</u> Do not allow yourself to be unduly influenced by the picture on the front of the packet either. All colour photographs go through tone changes on printing and reproduction.

• <u>Never use permanent hair dyes for dying eyelashes, eyebrows or hair anywhere except on the head.</u> If you do want your eyelashes darker, go to a beauty salon and have them professionally done.

• <u>Always read the instructions at least twice,</u> however often you may have coloured your hair before. <u>Never trust them to memory.</u>

Black hair is usually coarse and often dry, but it can look marvellous when well-conditioned. Try a weekly oil treatment before shampooing. Use a warmed, pleasantly scented vegetable oil, such as almond, apricot or peach kernel. Massage it well on to the head (the ends and the scalp), cover with plastic and leave for 30 minutes. The oil will bond with the cuticle to give extra protection and gloss. To remove: add shampoo first, massage well into the hair, and then add water.

The three traditional ways of counteracting tight curls – straightening, tonging and cornrowing (tight plaiting/braiding along the scalp) – are all potentially damaging, because they stretch the hair leading to breakage and increased hair fall. Try sewing artificial plaits (braids) on to the head instead, or putting the hair up with brightly coloured combs. For more shine and a larger, looser curl, use a setting lotion after shampooing and finger dry to shape.

CHEMICAL DYES

DYE	ACTION	BEST EFFECTS ON	LASTS	TO USE	COMMENTS
Temporary rinses	Water-soluble dye in a mildly acidic base coats, but does not penetrate, the hair shaft to give a nuance, or hint, of colour.	Light, mousy or greying hair. Effects may be imperceptible on very dark shades.	Until next wash	After shampooing, as directed on packet	Do not over-apply or the hair will become dull.
Metallic 'crazy' colour sprays	Colour molecules in the spray settle on the hair to give frosting of colour.	Lighter shades	Visibly until brushed or washed off – though an invisible deposit of the metallic substance may still remain in the hair; see comments.	As directed, but do protect your eyes when spraying	Never tint your hair if you have used any metallic preparation on it without first asking your hairdresser to do a strand test. If metallic traces remain, they could react chemically with the hair.
Semi-permanent rinses	Complex chemical formulae containing a thioglycollate, or similar sulphur derivative, together with tiny colour molecules, penetrate the outer transparent cuticle and are absorbed to give a darker, richer glint to colour already present in the hair.	Light to medium brown hair; lightish grey or white hair to give darker 'cover'	Four to six shampoos	After shampooing, leave for between 20 and 40 minutes, depending on intensity of tone required, and rinse out	Semi-permanent colours will not add or change colour; they will intensify the colour already present in the hair, giving marvellous chestnut or auburn tones to dark hair, for example; not recommended for fair hair. Always patch test (see previous page) before using it.
Permanent tints (also called 'shampoo-in tints' and 'oxidation colours')	'Para' dyes largely based on paraphenylenediamine (see previous page), work with an oxidizing agent, such as hydrogen peroxide, to penetrate the inner cortex of the hair where they strip the pigmentation molecules out and replace them with the new colour.	Any colour	Permanently; regrowth tint on the roots necessary at four to six weekly intervals	Strictly as directed on the packet. Never on eyelashes, eyebrows or hair elsewhere on the body. Preferably not when pregnant, when it is best to avoid any kind of chemical.	The most versatile of all the colouring options and the one which offers the professional colorist the greatest degree of control. Do observe all the cautions listed on the previous page, together with a patch test for allergies, if doing it yourself, however.
Highlights/ lowlights	Hydrogen peroxide/ammonia or colour solutions are mixed to lighten selective strands of hair and so to multiply colour tones already present in hair for added movement and depth.	Dark mousy blondes – though they can look good on almost any type of hair, including brown, red and grey. If you have brown or red hair, the addition of subtle chestnut or marmalade tone can look sensational.	Permanently; roots will need retouching after three to four months. A soapy residue after shampooing may dim highlights. Keep them bright with a rinse of baking soda and warm water (1 teaspoon per 8 fl oz/1 cup); pour on, comb through and rinse.	The oldest method uses a poly-thene cap and crochet hook. Preferably: section off hair with clips and brush fine strands with the lightening solution (back of head first, around hairline and crown last, where the colour develops more quickly). Wrap strands in silver foil to make neat parcels. Watch timing carefully and rinse thoroughly.	This is the most natural of all the colouring effects – though inexpertly done, it can make the hair look striped. So it is well worthwhile going to a professional colorist to have highlights put in. Always have your hair cut first if you are contemplating having highlights, as the cut largely determines the pattern they take.
Bleaching	DON'T!				

colourscolourscolours

NATURAL (VEGETABLE) DYES

DYE	ACTION	BEST EFFECTS ON	LASTS	TO USE	COMMENTS
Henna	Natural reddish dye derived from the leaves of the Lawsonia plant stains the outer cuticle of the hair. Of the many different types of henna (their strength and effectiveness vary with country of origin), the best are the pure red and neutral (i.e. non-dye) hennas.	All shades of brown and black. On the whole, the darker the tone, the more effective the result. The effects that you will achieve with henna will depend very much on your natural colour. It's _not_ recommended for those with grey or fair hair as it can look very carroty. Neutral hennas can make fantastic conditioners and provide a beautiful sheen without producing a noticeable change in colour.	Permanently (henna is even more irremovable than a blue/black tint); roots will need retouching every six to eight weeks	Combine neutral henna with pure red Iranian henna, add hot water and stir to a paste (you can also add strong black coffee to add depth; hot red wine for chestnut tones on a light brown hair; a strong sage infusion for a warmer effect). Wearing rubber gloves, apply the paste first to the ends of the hair within an inch of the scalp and then to the roots where the colour develops much more quickly. Cover with plastic or foil and leave for about 35 minutes. Then check the colour by testing a strand of hair. DO NOT APPLY HEAT: this will affect the final colour. Shampoo and rinse out thoroughly.	Henna can either look marvellous or disastrous so, if you are doing it yourself, treat it with respect – going redder in stages until you get the effect you are after. Bear in mind that the theatrical red of too much henna is one of the most difficult colouring mistakes to correct. Never tint your hair if you have used a metallic (compound) henna as the chemical combination can cause the hair to disintegrate.
Rhubarb root	The strongest of all the herbal lighteners, this brightens and lifts colour on all types of hair and will give golden highlights to the hair even on first application.	Any colour from black (chestnut overtones) to light ash blonde (light gold overtones)	Permanently – once effects have been achieved	Boil 50g/2 oz rhubarb root in 1.2 litres/2 pints (5 cups) of water, cover, simmer for an hour, then cool and strain. Use as final rinse and run it through the hair again and again. To work most effectively, let your hair dry off naturally in the sun afterwards.	These pure herbal colours are all fun to use and entirely non-damaging to the hair. They do not, however, offer anything like the control that you can get with the chemical dyes and are also extremely time-consuming to use – taking many applications before an appreciable difference can be seen (rhubarb root is an exception). With patience and perseverance though, they can be quite effective. With the exception of the darkeners, they will all work most effectively if you let your hair dry off naturally in the sun after application. You can also combine the herbs: when marigold is added to the chamomile and quassia infusion, for example, it will produce a more intense effect; rhubarb root and chamomile are also effective together.
Chamomile	Very slight bleaching effect on blonde hair; combined with quassia chips (see right) and applied as a paste to hair, it will brighten darker hair; combined with red wine, it will give a warm glow to light/medium brown hair.	Naturally blonde hair	as above	Brew like tea, using 25 g/1 oz chamomile flower heads per 600 ml/1 pint (2½ cups) of boiling water; leave to infuse for 20 minutes and pour over the hair, as above. Alternatively boil 25 g/1 oz quassia chips in a little water for 30 minutes, pour over 25 g/1 oz ground chamomile and apply as a paste to the hair like henna (see above).	
Marigold	Rich honey tones to fair hair; soft yellow effect on white hair.	Blonde or white hair	as above	Make infusion, as above, using 75 g/3 oz crushed marigold flowers, and apply as final rinse.	
Sage; sage and tea/cloves; walnuts; dark tree barks, such as oak	All these combinations have a darkening effect – the sage combinations by dulling the hair, the walnuts and dark tree barks by staining it, provided that they are used in strong enough concentration.	Brown and, particularly, greying hair	Temporarily, unless applications are repeated frequently	Infuse 50-75 g/2-3 oz sage (preferably red) in plain water or in 600 ml/1 pint (2½ cups) of strong Indian tea or with a base of crushed cloves; infuse the ground bark and nuts in the same way. Apply as final rinses.	

While soft, downlike hair on legs, arms or face, as left, can be very attractive, a darker or heavier growth is not. The degree to which this occurs varies enormously. For some, a few coarse, dark hairs on the face, nipples, between the breasts or on the stomach present little more than an irritation that can be bleached or snipped away. For others, a thicker, more abundant growth can give rise to great embarrassment, considerable distress and may even require medical, rather than cosmetic, treatment

UNWANTED HAIR

With the exception of the lips, the palms of the hands and the soles of the feet, all of us, male and female, either have hair on the body or the ability to produce it in response to specific internal triggers. However, while women have as many hair follicles on their faces as men and an inherent capacity, therefore, for an equally abundant growth, most of these remain dormant throughout adult life. What hair we do have tends to be soft, downlike and invisible in all but the brightest of lights. It can become coarser and darker, however, under internal or external stimulation.

Many factors can be responsible for this. The first and most important one is undoubtedly hormonal and is caused primarily by a higher level of androgen (male hormone) circulating in the blood or by an increased sensitivity to existing hormone levels. One or both of these effects are

REMOVING UNWANTED HAIR

METHOD	DESCRIPTION	WHERE AND WHEN NOT TO USE
SHAVING	This is the most popular method of removing unwanted hair. It is quick, easy and efficient and does not cause the hair to grow back thicker or darker although the regrowth feels rougher because the hairs have been cut square. To shave: use soap and water, shaving cream, gel cleanser or anything that helps the razor glide over the skin. If you are using an electric razor the skin must be dry. Always shave in the direction of hair growth; down the legs from knee to ankle, for example. This will avoid getting an ingrown hair: tell-tale signs are a black dot or a thin line beneath the surface layer of the skin.	Shaving is the most temporary and least aesthetic of all hair removal options, as the hair grows back again within two to three days as a coarse stubble. Never shave hair on the face, around the nipples or the bikini line, where the angles are difficult to get right and there is a strong risk of cutting yourself.
TWEEZING/PLUCKING	This works best when there are only a few hairs to remove. Always pluck hair in a good light, with a magnifying mirror and in the direction of hair growth. Pluck hairs one at a time from the underneath of the eyebrow only. Clean skin and tweezers scrupulously before starting. If plucking is painful, place a warm damp towel or face flannel over the brows for a few moments to help open the pores.	Only pluck the eyebrows. Tweezing is the greatest stimulator of hair growth because it can activate a repair hormone which induces increased cell production within the hair follicle. It is impossible to tweeze a hair out by the root. The white bulb that you see at the end of the hair shaft is an indication of how strong and well nourished the hair is; it is not the root.
DEPILATORY CREAMS	These use an active chemical agent to dissolve the protein structure that gives the hair its strength and texture. The destructive action of the chemical is, therefore, limited by how far the cream can penetrate the skin tissue. Depilatory creams give a deeper removal than shaving and the regrowth will seem finer because the hair has been dissolved and not cut. But it is messy. When using a depilatory cream, always follow the maker's instructions and time yourself carefully. If you find that the cream does not work effectively within the time stated do not prolong it. Use another method instead.	You can use depilatories almost anywhere, except the eyebrows, where the tissue is too sensitive and the eyes too close, the breasts and the face, unless the label stipulates that it is safe for facial use. Always take especial care if removing hair around the bikini line. Wear bikini bottoms and use the margins as your guideline to prevent the cream getting too close to the vagina. Allergies or sensitive reactions to the chemical solvents in the cream are not unknown, so always do a patch test first, following the maker's instructions as though you were treating a larger area. If there is no reaction in 24 hours, you can then apply it where you wish. Repeat the patch test if changing brands.
WAXING (professionally)	Waxing is really 'mass tweezing' but, unlike tweezing, does not enable you to discriminate between the thicker and the finer hairs on the body or the face. Beauty salons use two methods of waxing: 1. HOT: the wax is heated, applied in patches, allowed to cool for a few seconds and stripped off the skin, taking the hairs with it. As hot wax dilates the hair follicle, the hair is almost always removed from its deepest possible point – just above the root. However, it also takes the uppermost layer of dead skin cells with it and can irritate a sensitive skin. 2. COLD: a fine film of sticky, honey-based, liquid wax is smoothed over the area to be treated and covered with a layer of gauze. The gauze is then stripped away taking the wax and the hairs with it. As cold wax is not as harsh on the top layer of skin, it is better for very sensitive skins. However, it is not as effective for removing very thick or coarse hair. You have to let your hair grow sufficiently long before waxing so that the wax has something to grip on to. Waxing breaks off the hair beneath the surface of the skin and is therefore more likely to lead to ingrown hair than any other depilatory method. Regrowth is slower than any of the other temporary methods and will seem finer.	Never wax painful, inflamed or sunburned skin. The method should not be used on the nipples or the delicate tissue of the face.

removeremoveremove

een at the menopause. Hormone replacement therapy (HRT) often works to counteract this tendency.

Stimulation of the hair follicle can also be drug-induced, although the offenders are so well known that doctors only prescribe them with the greatest of caution. It is much more often self-induced. Plucking can stimulate the follicle via a response from a repair hormone and thereby create a more vigorous growth. Consequently, stray hairs on the nipples, stomach or above the lip should never be tweezed. Bleach them, snip them with scissors or go to an electrolysist.

Electrolysis is the only widely available way of removing excess hair permanently although some salons in the USA are now experimenting with radio waves. If you suffer from thick, pronounced coarse hair growth on your face or body you should see your doctor. If he or she suspects that you may be suffering from a hormonal disorder, you will be referred to an endocrinologist (hormone specialist) for treatment. With the exception of electrolysis, all the methods detailed here have only the most temporary effect on hair growth and they all have their advantages and drawbacks. Hair grows like grass — while some is being removed, more lurks just beneath the surface — so you are always going to have some regrowth after two to three days whatever depilatory method you use. Although waxing or using a depilatory cream may give the impression of producing a finer, sparser regrowth, because the ends are tapered, not stubbly, they actually leave the growth cycle unchanged. Plucking can even accelerate it.

If, after consulting the chart, you are still in a quandary, seek the advice of a beauty therapist. Advice never costs anything and most beauticians will only be concerned in helping you to decide which method will work best for you.

METHOD	DESCRIPTION	WHERE AND WHEN **NOT** TO USE
WAXING (at home)	More hit-and-miss than going to a professional beautician but, with practice, you can become quite proficient. It is also available in hot and cold forms: 1. HOT waxes are much trickier to use but the technique, once mastered, will give better results. If you are using hot wax, do make sure that you buy a kit which includes an in-built thermostat control. Apply the wax with a spatula, according to the instructions, and wait for it to set like toffee. On no account let it become brittle. It should be both applied and removed against the direction of hair growth. When taking it off, hold the skin down at the end you are starting with and rip it off at a backwards angle close to the skin. Apply a soothing lotion. If you are using a hot wax treatment for the first time, you may find that it hardens and becomes brittle before you have realized it. If this happens, do not panic, simply apply another layer of wax over the top and pull them both off together. 2. COLD pre-waxed strips have the advantage of being much more manageable and considerably quicker. They are not as effective, however. In cold weather, place them on a radiator for a few minutes to soften.	As for professional waxing. Do not be over-ambitious with the areas you attempt to treat yourself. It is always advisable to seek the services of the professional if you want to remove hair under the arms or around the bikini line and it is a good idea to go at least once to a salon to get an idea of the processes involved.
BLEACHING	Bleaching is an excellent way of dealing with dark hair on the face (and on the legs if you are going out into the sun, because the chemical bleach lightens them before the natural bleaching effect of the sun takes over). Although bleaching can be professionally done, the home kits are so good that, providing instructions are carefully followed, the results are equally impressive. As hair grows back at different rates, the interval left between each bleaching varies. The effect on facial hair can often last up to four weeks before the darker regrowth becomes visible.	Always use a bleach that has been specially formulated for the face and avoid commercial hair bleaches which have a tendency to turn the hair yellow. All facial hair bleaches are extremely mild (10 vol peroxide) and cannot bleach the skin underneath. If left on for too long, however, they may cause redness and irritation. If you find that the hair does not respond effectively to the bleach solution within the time allowed, it is probably worth considering electrolysis.
ELECTROLYSIS (professionally)	Electrolysis is the only widely used way of removing hair permanently. It uses an electric current (shortwave diathermy) to generate a heat reaction within the hair follicle producing a cauterizing effect on the tiny blood capillaries that nourish the hair root. It takes a fraction of a second to kill the hair and only the most sensitive of skins will find it painful. It is uncomfortable, however, and most skins tend to react quickly to the current, becoming pink and producing raised lumps over the follicles. These should subside within an hour or so. A newer method uses tweezers to pass the current through the hair shaft. Although it is completely painless, it is not as effective as diathermy. Not all the hairs will be killed the first time but, while some do grow back, the hair will be finer and the shaft weaker and less resilient with each regrowth. With patience and perseverance, electrolysis will work better than any other method, but it does take a long time before any improvement becomes really apparent. It can take as long as 18 months to clear a lipline, for example. For this reason, electrolysis is not a practical method for removing large areas of unwanted hair, but it is extremely good for stray dark hairs on the face, breasts or stomach.	Never use electrolysis in the inner ear and nostrils – these hairs should be snipped with scissors or left to themselves – on the eyelashes, in moles or warts, on or around the nipple if pregnant or breastfeeding and anywhere where the skin is infected, inflamed or unevenly pigmented – if you have chloasma (melasma), for example (see page 215). Avoid electrolysis if you are a diabetic and your doctor advises against it, if you have an allergy to metals or an underlying hormonal disorder. Go to a reputable and properly qualified electrolysist. Incorrectly done, treatment can lead to local infection or, more commonly, to scarring caused by the needle rupturing the wall of the hair follicle. If the skin is registering any signs of damage, such as red marks above the follicle, a day or so after treatment, cancel your next appointment. You can do much to help the skin heal quickly by keeping the treated area scrupulously clean and leaving it free from creams, lotions and camouflaging make-up for at least a day or two. Never squeeze a spot on the treated area as there is a risk of scarring.
ELECTROLYSIS (home kits)	At the time of writing, the use of do-it-yourself electrolysis kits is strongly advised against. The current is usually too low to guarantee a good result and there is a high risk of scarring if the needle is inserted incorrectly.	Not at all.

teeth

'Such a pearly row of teeth, that Sovereignty would have pawned her jewels for them.'
Laurence Sterne

The tooth is composed of hard outer enamel, softer inner dentine and a sensitive pulp chamber right at the centre, which contains blood vessels and the nerve. The crown of the tooth (1) is the only visible part. The neck (2) extends down below the gum and the roots (3) anchor the tooth into the jawbone. Teeth have between one and four roots, depending on their position in the mouth.

After the age of 16, more teeth are lost through gum disease than decay. The insidious process is shown above. First, bacteria accumulate on the side of the tooth. If not removed in 24 hours, the bacteria harden and work their way down, forming a pocket beneath the gum which is inaccessible to the toothbrush. The bacteria then begin to attack the surrounding bone. If not checked in time, the tooth will become loose in the mouth.

We are not all born with the potential for perfect teeth, but heredity is a popular scapegoat for bad teeth and an unhealthy mouth. Conversely, good teeth and a healthy mouth can be acquired by almost anyone, provided that the battle against tooth decay and gum disease is started as early as possible, that the teeth are straightened or rearranged, if necessary, by a good orthodontist and that they are looked after with common sense and dedication. Teeth fall out or weaken for specific and preventable reasons. They do not fall out or weaken with age. In fact, it has been estimated that a healthy tooth will outlast its owner by some 200 years.

Human beings develop two sets of teeth during their lives. The first set of baby, or deciduous, teeth starts to form well before birth and erupts in the mouth during the first two years of life. The second set of 32 adult, or permanent, teeth starts to develop at birth. These lie buried in the jaw bone beneath the baby teeth until they are fully formed at about the age of six, when they begin to push through the gum and the baby teeth fall out. An orthodontic evaluation should always be carried out at about this age, so that the dentist can determine whether the adult teeth have enough room to come through and will not be knocked off-course by the baby teeth above them. If this looks likely, then the removal of one or more of the baby teeth may be all that is needed to ensure that the adult teeth come through correctly.

STRUCTURE

Each tooth comprises the crown, which is the part we can see, the neck and the root or roots. It is composed of the outer enamel, which is about 98.7 per cent mineral and the hardest substance in the body, the inner dentine, which is softer and more sensitive, and the pulp chamber right at the centre, containing blood vessels and the nerve which supplies sensation to the tooth. This chamber extends all the way down the root canal which anchors the tooth to the bone of the jaw. While the front teeth have only single roots, the molars right at the back of the mouth may have as many as four. The tooth is cushioned against the bone by an elastic membrane — soft sensitive tissue that acts as a shock absorber, gives additional support to the tooth and folds over to form the gum, creating a slight gap or crevice, before attaching on to the tooth.

The bite

The mouth is built like an extremely efficient food processor, with jaws that work both horizontally and vertically. When they come together, they cause the teeth to overlap, the upper jaw over the lower, rather like a closed pair of scissors. If they collide or miss each other entirely, then the bite will be

affected. An orthodontist (tooth-straightening specialist) will be able to correct this by means of removable or fixed appliances, which persuade the teeth to move into the required position. Sometimes, they are also used to restrain the growth of the upper jaw so that the lower one can catch up. The aim of orthodontic treatment is to get the bite right so that the relationship between the jaws and the teeth is harmonious, with the teeth coming together correctly and pressure evenly distributed throughout the mouth. Happily, appearance always improves as a result.

LOOKING AFTER YOUR TEETH

Care of the teeth starts with regular and thorough cleaning of the mouth and, equally important, regular dental check-ups. Fluoride, too, is an essential part of any early preventative campaign. Taken from birth, or even, as some dentists recommend, from before birth, it will strengthen the teeth as they form in the mouth, making the enamel harder and much less susceptible to the acid attack that initiates decay. Fluoride is invaluable taken up to the age of about eight or nine, after which most adult teeth are fully formed in the mouth and can no longer be strengthened from the inside. Start by telephoning the appropriate local authority to find out whether the water is either artificially or naturally fluoridated. If it is not, use a supplement in the form of drops or tablets. Your dentist will advise you when to start administering it and how much to give.

The acid responsible for producing decay is a by-product of the sucrose in refined carbohydrates and certain bacteria in the plaque growing on the teeth. Painless in the early stages, decay attacks the outer edges of the enamel before spreading into the soft, sensitive dentine beneath. As all sticky, sugary things are candidates for causing decay, they should be avoided as much as possible. You will feel much better for eliminating sugar from your diet too. If you must eat it, however, always brush your teeth well afterwards. By substituting the natural sugar (fructose) found in fruit and vegetables, for refined sugar (sucrose), you will be safeguarding the health of your teeth. For, although all sugar is potentially corrosive, the sugar found in apples and carrots will not cling to the teeth in the same way as the sugar in a doughnut.

Tenacious and transparent plaque film forms from substances in food and saliva. This contains up to 300 different organisms. Some of these are benign and protect the mouth from viral and fungal infections, such as thrush. Others are toxic, capable of eating into the gum tissue and initiating the slow, insidious process of gum disease. If you have managed to keep all your teeth by the age of 16, the chances are that any subsequent loss will be caused, not by decay, but by

teethteethteeth

infected gums. As plaque becomes damaging within 24 hours of formation, the teeth must be thoroughly and correctly brushed at least once, preferably twice, a day, so that the bacteria within it will not have a chance to infiltrate the gum tissue. Remember, it is not just the frequency that counts, it is how well you do it.

Protecting your gums

Gum disease is almost universal. Tell-tale signs are puffy, inflamed gums, which bleed on brushing, and soreness or irritation. Although the process can be halted and, to some extent, reversed, as long as the tooth is still in the mouth and has some bone around it, the measures necessary become increasingly more radical, time-consuming and expensive as the disease progresses. In its early stages, you can brush and floss your way out of it. However, if the bacteria are allowed to work their way down into the space between the tooth and the gum, a small pocket will form, inaccessible to the toothbrush, from which the bacteria will begin to attack and corrode the surrounding bone. At this stage, the disease can be treated by a minor surgical procedure, which involves cutting the gum away from the tooth and eliminating the pocket, so that the bacteria can be flushed out, the gums returned to health and good oral hygiene can be maintained. But, if the bacteria are allowed to remain in their pockets and continue to corrode the bone, the teeth will eventually become loose in the mouth and much more radical surgery will be needed to save them. Vigilance is all — both on the part of your dentist, who should make a gum evaluation an integral part of every visit, and on your own part, as professional attention will do little to safeguard your gums if you do not look after them properly in the meantime.

Orthodontics

Orthodontics is the science of straightening and rearranging the teeth. It is not cosmetic dentistry. If the teeth are out of line, if there are large gaps or overcrowding, or if the relation between the lower and upper jaws is unharmonious and

the teeth do not come together as they should, then all is unlikely to be well in the mouth.

Overcrowding is by far the most common problem seen by orthodontists. If the mouth is too crowded, the teeth are pushed out sideways, the line becomes irregular, the bite is affected and the mouth becomes much more susceptible to gum disease, because plaque builds up on the overlapping edges between the teeth. It is also, of course, a problem from a cosmetic point of view. Fortunately, both this and many other irregularities with the teeth can be put to rights at any age, providing that the sufferer is prepared to put up with a certain amount of temporary inconvenience and minor discomfort.

In the long term, fixed appliances, usually consisting of brackets directly attached to the teeth by means of a strong bonding agent, are preferable to the removable kind. They offer the orthodontist greater control and enable the roots of the teeth to be moved into their correct position in the jaw. Removable appliances tend to be only about 50 per cent effective, because they do not offer the same control, nor do they move the roots into place. As a general rule, no discrepancy between the teeth or the jaws should be overlooked. So, if you feel distressed for yourself or your child, ask to be referred to an orthodontist.

Seeing your dentist

Do not wait until you find a hole in your tooth or are struck down with toothache before seeing your dentist. You should have regular dental check-ups at six monthly intervals, unless your dentist specifies otherwise. These check-ups will enable your dentist to establish that there is no decay, that your gums are sound and healthy and that there is no untoward change in the mouth, such as the eruption of wisdom teeth, that might alter the position of your teeth and affect your bite.

You should also make a point of seeing a dental hygienist at least once a year, so that you can have any tartar, a hard calcium deposit in the plaque, removed (scaled) and your

To brush your teeth:
Start right at the back on the outer side of the lower jaw. Hold the brush at an angle of 45 degrees to the gum, so that it is lying lengthwise across the teeth and the bristles can nudge just under the fold of skin tissue where the gum meets the tooth. Now, gently flex the bristles back and forth in about 20 or 30 small vibratory movements, so that they, but not the brush, are travelling over the teeth, rather like running on the spot. Once you have cleaned this area, move on to the next and so on, all the way around the jaw. You will probably complete it in five to seven stages. Now repeat the procedure on the inner tooth surface of the lower jaw. Next scrub the top of the teeth, the biting surfaces, before turning your attention to the upper jaw. It is essential that you treat the upper and lower teeth independently. Finally, brush the tongue gently to remove any bacteria and food particles that may contribute to bad breath and rinse the mouth well.
Once you have finished, or think you have, use a plaque discloser. To begin with, continue to use the discloser every two to three days after brushing, as a useful check on yourself. Once all the plaque is off the teeth, stop brushing. Obsessive cleaning and scrubbing can be as bad for the teeth and gums as failing to clean them adequately in the first place.

mouth professionally cleaned. Many dental practices now have a hygienist on the premises. If yours does not, ask your dentist to refer you to one. A really good teaching programme on cleaning and caring for your teeth will also stand you in good stead.

Unfortunately, finding a good dentist is not always easy. There are good and bad dentists, just as there are good and bad doctors, teachers or lawyers. Use the following guidelines as a safeguard:

● Never go to a dentist who does not give a local anaesthetic. He may leave decay in the tooth in order to save his patient pain. The infection will then continue to spread and the tooth will decay beneath the filling.

● Never go to a dentist who makes a routine practice of giving a general anaesthetic or one who gives his own anaesthetic without another practitioner present. Although general anaesthesia has its advantages in some areas of dentistry, the health risks do not justify its use for simpler procedures.

● Never go to a dentist who does not look for obvious or incipient signs of gum disease, by gently probing the areas between the gum and the tooth to test for bleeding, redness, inflammation and loss of tissue around the tooth. After the age of 16, your teeth are much more likely to be threatened by gum disease than by decay.

● Do go to a dentist who uses X-rays as an integral part of any dental evaluation. X-rays enable the dentist to check on decay, particularly decay that may have crept in behind the fillings (these tend to shrink over the years and can thus provide pockets for bacteria). They will also help him to see if there is any infection around the nerve and roots of the tooth and to spot any loss of bone caused by advanced gum disease.

● Do go to a dentist who, in the event of finding anything wrong in your mouth, will take the time and the trouble to explain what is wrong, why it happened in the first place and how you can prevent something similar happening, elsewhere in the mouth, in the future.

● Do go to a dentist who finishes off the work carried out in your mouth with care. If you do have your teeth filled, or crown or bridge work carried out or dental veneers fitted, there should be no rough edges and you should be able to clean around the treated area without difficulty.

Brushing

Your toothbrush should have bristles which are flat along the top and multi-tufted (i.e. densely packed). Nylon is better than 'natural' bristle, because, unlike hog's hair, it can be made to a precise specification. The bristles should be soft enough to flex over the tooth surfaces, reach into the gum crevices and flow into the irregularities between the teeth. Many dental practices keep a wide stock of toothbrushes for their patients together with interspace brushes, which look like miniature toothbrushes with a single densely packed tuft. These can reach into the corners that ordinary toothbrushes cannot.

Replace your toothbrush as soon as the bristles start to splay out and are no longer parallel. Used intelligently, a toothbrush should last about three months. If you find your toothbrush is wearing out after just a few weeks or, even worse, a few days, you are scrubbing too hard and your brushing technique is almost certainly wrong. So revise it, following the guidelines given here.

Toothpaste will help you to clean your teeth more efficiently. Always use a fluoride toothpaste. With regular daily use, a certain amount of the mineral will become absorbed into the enamel and will strengthen the teeth against decay. Toothpastes contain detergent, to help clean the teeth and remove the greasy plaque, sorbitol and saccharin, to make it palatable, and tiny abrasives, to remove surface staining. Tooth powders and commercial 'whiteners' have larger abrasive particles and should be avoided, as they will grind into the enamel and may gradually erode it. Avoid liquid 'stain removers', too, as they contain acid, which will remove some of the enamel as it removes the stain. If your teeth are badly stained, go to see your dentist or dental hygienist and

No tooth brushing routine, however efficient, can clean more than three of the five sides of the tooth, so the use of dental floss is essential. To use the floss: wrap it around the tooth in a wide V-shape. Slide it down just a little way into the gum crevice and up again. Repeat this about a dozen times, less if you are using the floss daily, before changing the direction of the V so that you are flossing the surface of the neighbouring tooth. Repeat all the way around the mouth.

To test a toothbrush: run the bristles backwards and forwards over the back of your hand. They should feel comfortable, even soothing – not scratchy – and should flow evenly over the contours of your knuckles. If they don't, don't use it.

have them professionally cleaned and polished. Enamel is not completely impermeable. Substances that cause the teeth to discolour on the outside might stain them internally, if adequate steps are not taken to remove them.

Dentists can treat bad staining or discoloration by bleaching the teeth, using a hydrogen peroxide solution. Often, the effect is only temporary and may last for as little as one year. In any case, it can do little to improve the condition if the discoloration has infiltrated the enamel and stained the tooth from the inside. Your first line of defence should be to prevent the teeth becoming stained in the first place by careful, regular brushing.

The primary purpose of brushing is to remove plaque. To do this, you need to combine a good brushing method with persistence. To see how effective your current method is, clean your teeth as usual and then use a disclosing agent. This is available from any good chemist in liquid or tablet form. Swill it round your mouth, so that the colour coats your teeth and gums, and then rinse out, once only, in clear water. This will wash away any loose colour on the enamel, but will leave traces of colour where the spongy and porous plaque has absorbed it. If you have any patches of staining around the teeth and, particularly, around the margin of the tooth and gum, then you have not cleaned your teeth properly and you should revise your brushing technique. Aim to clean your teeth thoroughly at least once, preferably twice, a day, as plaque matures and produces its corrosive acids within 24 hours of formation. The whole routine (see previous page) should take about five minutes.

If, while you are brushing this way, your gums bleed and your mouth feels rather sore afterwards, then you have the early stages of gum disease (gingivitis). Although your first impulse may be to slack off on your brushing, you should do the opposite. The only 'cure' for gingivitis is good, regular brushing, so carry on regardless. Although the gums may bleed quite profusely for the first few days and the mouth may feel sore, the condition should have righted itself after about 10 days. If it has not, make an appointment to see your dental hygienist as you probably have a build-up of tartar on the tooth which is irritating the gum.

Flossing

Once you have taken off the visible plaque, you must remove the plaque lurking between the tooth surfaces. These areas are inaccessible to any toothbrush, however good your technique. It is here that flossing is important, but take care — used wrongly, it can do more harm than good. A notorious jail break-out in the USA was achieved purely through toothpaste and dental floss which the prisoners used to 'saw' through the bars. Your gums are infinitely more vulnerable, so be careful.

Dental floss comes in two varieties — waxed and unwaxed. Unwaxed is better for perfect teeth or teeth that have completely smooth fillings with no sharp, hanging edges to catch and break the thread. If you find that unwaxed thread catches on your teeth, either have your fillings smoothed down by a good dentist, or use the waxed floss, which has the necessary lubrication to glide over the rough surfaces.

Flossing does require a certain amount of dexterity, This

comes with practice, so persevere. Alternatively, go for one of the ingenious dental floss 'holders' now available which hold the floss tightly across two prongs, making the job much easier for you. If you are confused about the technique you should be using, consult your dentist or dental hygienist. If you find that you cannot slip the floss between the teeth, that you cannot move it up and down once it is there or that you cannot get it out again, you have overhanging filling edges and/or tartar and you should see your dentist. If you find using dental floss impossibly fiddly, at least use the wooden interspace cleaners (they look like pared-down toothpicks) to remove debris caught between your teeth.

Mouthwashes

Most mouthwashes tend to be cosmetic rather than therapeutic and have little real value, as they will only disguise a bad smelling mouth for a few minutes.

Fluoride mouthwashes can be valuable, however, both because they give some additional protection to the teeth and because they tend to desensitize the mouth, reducing soreness when brushing sensitive teeth and gums. In fact, if your teeth are very sensitive, you may well find that a fluoride mouthwash is more helpful than some of the specially formulated toothpaste brands now on the market.

Ulcers and abscesses

Mouth ulcers are caused by complex, hereditary factors and tend to flare up under stress. Although they will disappear with time, little can be done to accelerate the natural healing process, beyond keeping the mouth as healthy as possible and trying to avoid any unnecessary stress.

While ulcers generally affect the upper and lower gums, roof or insides of the mouth, an abscess is a swelling just below or on the margin of the gum and tooth caused by infection inside the tooth. It should be treated by a dentist.

Tooth cleaning kit (right): toothbrush and fluoride toothpaste; small mirror to help you check teeth and gums at the back of the mouth; a dental floss holder, here shaped rather like a tuning fork, to make flossing easier; dental floss, which comes in two varieties, waxed and unwaxed to remove plaque and food debris from inner surfaces of the teeth; a neat interdental brush to help clean larger spaces between the teeth; wooden interdental sticks to reach into awkward corners and to massage the gum (if gums are sensitive, soak the stick in warm water first to soften it); plaque disclosing tablets to test your brushing routine and to see if you are using each of the above as it was designed to be used...

COSMETIC AND RESTORATIVE DENTISTRY

'Cosmetic dentistry' is an unfortunate and misleading term. While crowns, bridges, veneers and all the paraphernalia of dental repair work can do much to improve the appearance of the teeth, nothing is more attractive than a perfectly healthy and uncluttered mouth, with no tell-tale flashes of gold, nickel or even porcelain. On the whole, the less you do to a tooth, with the exception of orthodontics and the removal of decay, the better and stronger it will be. For this reason, the principle behind any form of cosmetic intervention must be to achieve the desired result with the minimum possible trauma to the surrounding teeth and gum tissue.

Cosmetic dentistry is always expensive, but the results can be extremely good and many satisfied customers consider that these justify the expense. While it is essential that any dentistry is carried out by a good and competent dentist, it is especially important in the field of crown and bridge work, where mistakes are invariably expensive and often extremely difficult to put right.

TYPE	DESCRIPTION AND MATERIALS USED	ADVANTAGES	DRAWBACKS
CROWNS	An artificial 'cap' is cemented on to a tooth, already fined down to about half of its original diameter, so that the crown slips easily and unobtrusively over the top. Material used depends on the position of the tooth in the mouth. Porcelain is the most natural looking but does not have the strength to withstand constant pressure, and is therefore used only on the front teeth. Even then, dentists usually prefer to fuse it on to a gold or metal alloy substructure. Crowns are often made entirely of 9-carat gold at the back of the mouth, where strength counts most and appearance matters least. Some of the new metal alloys on the market can now be substituted for up to 40 per cent of the gold, saving modestly on cost while losing little in the way of strength. A greater percentage of alloy to gold, however, will make the crown weaker and more susceptible to damage or splitting: they may be slightly cheaper but it is a false economy and should be avoided.	Unless badly fitted and barring unforeseen accidents, crowns are permanent and tend to 'age' well, staining and discolouring at much the same rate as natural teeth. The cosmetic result is usually very good, especially if the surfaces have been carefully matched to the surrounding teeth.	The cement fills a space between the crown and the tooth and, if infection is allowed to creep in and dissolve it, a space is created for decay to seep in behind the crown. This can result in loss of bone, infected nerves, abscesses or gum disease. The success of any crown or crown and bridge work also depends considerably on the dedication of the patient. Scrupulous cleaning is absolutely vital as the cement used is less resilient to the acid and bacteria in plaque than ordinary tooth enamel. Problems can also arise if the crown is fitted too ambitiously and the join buried beneath the gum line. The edge, however finely graduated, can rub against the soft tissue and may lead to gum disease.
BRIDGES	These are used to attach one or more 'dummy' teeth to the surrounding teeth, using crowns on either side to anchor the new tooth into position. Bridges are usually made from gold or a gold and metal alloy and covered with porcelain to give a natural effect. A new type of bridge, known as a Rochette bridge, is cheaper than the conventional bridge, kinder to the anchor teeth (which do not require crowning) and, if fitted well, will last for up to 15 years. However, it can only be used for small spaces with adequate clearance.	A bridge is an excellent solution in the event of a missing front tooth, as the new dummy tooth stays firmly and permanently in place and cuts out the need for dentures.	Badly done, the bridge may be ill-fitting and the dummy tooth, if insensitively matched, may look unnatural and false. As conventional bridge work involves crowning the supporting teeth, drawbacks for crowns will also apply.
VENEERS	Veneers are pre-moulded covers, rather like artificial fingernails in appearance. They are bonded on to the tooth with a special adhesive, or are painted on to the tooth in layers and left to 'set' in the mouth.	Veneers are cheap, require very little preparation and are easy to fit. They can be used to disguise a badly stained or blackened tooth but are most useful on children who have a chipped or broken front tooth that needs attention only until the adult teeth are fully grown.	Because the plastics used are more absorbent than enamel or porcelain, they tend to stain and discolour easily. Tea, coffee or red wine and cigarette smoke will all accelerate the staining process. If badly fitted, veneers may irritate the gum and lead to infection.
IMPLANTS	Implants are metal stumps which are fixed into the jaw bone and then crowned. The idea, though not often the reality, is that, if large gaps between the teeth can be 'crowned' in this way, there will be no need for false teeth.	There are very few advantages. For some, but by no means all, people who are able to tolerate them, implants may be preferable to false teeth, in a cosmetic sense. They are rarely preferable in a medical sense, however (see Drawbacks).	Implants have a high failure rate and rarely last for more than five years before the body rejects the artificial material. As any implant may undermine the strength and health of the jaw bone, there is also a high risk of infection. Gum disease may start to develop around the artificial 'roots'.
PARTIAL FALSE TEETH	False teeth are not so much cosmetic as essential, if you are unfortunate enough to lose some or all of your teeth. They maintain the shape of the face and enable you to chew and eat your food. Partial false teeth are most commonly made out of plastic materials bonded on to metal alloys and fixed into the mouth by means of clasps and brackets in order to maintain stability.	Partial false teeth are cheaper than extensive crown and bridge work or elaborate attempts to save weakened, existing teeth. Because they sit on, rather than underneath, the gum line, they carry little risk of irritation or infection. In the event of infection, they can be easily removed and the affected area treated.	The obvious disadvantages are aesthetic, together with the necessity of taking them out at night and using special cleaning materials. A band or plate across the roof of the mouth to hold the teeth in place may also be off-putting, as you need time to adjust to it and speech may be slurred at first.
COMPLETE FALSE TEETH	A full set of dentures is generally made entirely of plastic and is retained in the mouth by close fitting to the gum.	There are few advantages, but false teeth are better than no teeth at all, both from an aesthetic and practical point of view.	As feeling in the teeth comes from ligaments holding the teeth into the jaw, it can be difficult to adapt to the lack of sensation in the mouth when biting or chewing.

nails

'The modern woman tucks her toes into a fur foot-warmer, draws up her little table and friend by friend indulges in what used to be gossip but is now just a French phrase or two well punctuated by a few meaningful silences. "Manicuring" the process is called...'

Vogue, 1927

Nails are useful. They protect your fingers, enable you to pick small things up, untie knots and shoe laces and pluck guitar strings. Over-long nails, though, will do few of these things without breaking or splitting, however strong they are. This is because most of the nail — the part you see — is made from layers of dead protein, held together by oil and moisture to keep it supple and resilient, and anchored to the nail bed beneath. The further the nail grows from its anchorage, the weaker and more susceptible to breakage it becomes. The first rule for healthy nails, then, is to keep them relatively short, with the tips shaped to a gentle curve, not to a point, in order to distribute any pressure as evenly as possible.

The nail grows out over the nail bed and is sealed to the skin by the cuticle. This protects it and the skin underneath by preventing bacteria and other substances working their way into the space between them. Never attempt to cut or clip away the cuticle. If you have a large fold of skin over the nail (hangnail), seek out the services of a professional manicurist. If you try to deal with it yourself, you may damage the new, living, nail at the lanula — the small, white half-moon at the base of the nail.

Fingernails grow at a rate of up to one millimetre (0.04 inches) a week, about twice as fast as toenails. On average, it takes about five months for a fingernail to grow out completely from base to tip, but it can take as little as three months or as long as eight months. Nails grow faster during pregnancy, during the spring and autumn and in youth, especially during the twenties and thirties.-Trauma, illness, infection and crash dieting can slow and, in some cases, temporarily arrest the growth of the nail. When growth returns, a line or furrow often forms at the lanula and grows out with the new nail. Other signs of ill-health reflected in the nail are heavy ridging, flaking, splitting, white bands, and a yellowish discoloration on the surface. Brittleness, in particular, is symptomatic of certain types of illness and specific mineral or vitamin deficiencies, such as anaemia. This condition is often diagnosed by looking at the nail (see page 215) and usually corrects itself once the proper iron levels have been restored in the body.

While a well-balanced diet is vital to the health of the nails, as it is to the rest of the body, there is little evidence that particular foods, such as calcium or gelatin, have a specifically beneficial effect. Zinc may be an exception. As a lack of this mineral has recently been linked to leukonychia (white spots or bands in the nail), you should ensure that you are getting enough zinc in your diet. Try taking brewer's yeast tablets or eating a helping of seafood once a fortnight — oysters are a particularly rich source. Do not expect the spots or bands to disappear overnight, though they should grow out with the nail. Other possible causes for white spots: straightforward

wear and tear (they are rarely seen on the toenails which are better protected) and over-vigorous manicuring.

Dry, brittle nails are more commonly caused by abuse than by any specific deficiency in the diet. Detergents, glues, film developers, paint strippers and many other chemicals will all dry out and weaken them. So, too, will excessive and repeated use of polishes, hardeners and removers, however carefully applied. Varnish removers contain acetone, a highly flammable and extremely powerful solvent capable of dissolving many materials — plastics and rubber included — in addition to nail varnish. It is also extremely drying for the nails, whether or not conditioning agents are added. So, keep varnishing to a minimum and protect your hands and nails from detergents and other chemical substances by wearing rubber gloves. Remember, too, that even the sturdiest and most resilient of nails will break if used to prise off lids. Use a mechanical lever, instead. It is stronger and, unlike your nails, specially designed for the job.

If you develop separated or ingrown nails, a fungus infection, or a stripy, uneven, discoloration on the nail surface, consult your doctor.

Artificial nails

Artificial nails were first developed in Hollywood in the 1930s using crude plastics which just about passed muster for photographic purposes. Today's false nails are much more sophisticated, the materials tougher and the methods used less likely to damage the nail underneath.

A single, artificial nail can be superimposed on to a chipped or broken one, using a strong adhesive and paring down the surfaces so that the join is virtually imperceptible. Alternatively, a complete set can be made, using a chemical formula painted on to the existing nail (pre-roughened with a file to hold the new surface) and shaped or 'sculpted' to the required length. Because the material has a clear base and a white tip, the new nail does not need disguising with varnish and can be left alone. It grows out with the ordinary nail, leaving a thin divide at the base after about 10 days, which then needs 'filling'. Although not recommended for normal nails, because the constant filing can weaken them, artificial nails can be a boon if you have resolved to give up biting your own.

Go to a reputable and competent manicurist. Do-it-yourself sets are not ideal, as the nails are pre-cast and tend to look unnatural, while the glue is often too weak to ensure reliable adhesion. Avoid techniques using machine filing, too, as these tend to take off the top layer of the nail, weakening it considerably. If you develop a reaction to the chemicals used, have the nails removed immediately, and, if the reaction does not improve, consult your doctor.

matrix cells
cuticle
live nail
dead nail

Nails start growing from matrix cells situated about 3-4 mm from the base of the nail. By the time they become visible they are often completely dead, though a patch of live nail can sometimes be seen at the white half moon (lanula). Any damage to the nail at this point may cause it to grow out unevenly.

MANICURE STEP BY STEP

Excessive or over-enthusiastic manicuring can injure the nail and damage the cuticle, particularly if sharp-ended, metal instruments are used. Signs of bad manicuring are ridges, dents or nicks along the nails and a pink inflamed cuticle. Consistent use of heavy lacquers, together with the chemical solvents needed to remove them, particularly acetone, will dry out the nail. So while your first impulse might be to disguise out-of-condition nails with a coating of colour, you would be wiser to leave them to themselves, giving regular manicures and warm olive oil treatments: soak the fingertips in a bowl of the oil for a few minutes each week and see the difference. Seek the advice of a good manicurist for any more specific problems. If your nails are in good condition and you want to use nail colour, use it with restraint and apply it carefully (see next page), but do try to give your nails an occasional rest. Fragile nails may benefit from a relatively new technique, known as 'wrapping', which uses strong tissue fibres to bolster the strength of the nail from the underside. It must be carried out by a competent manicurist.

If you can, file rather than cut, because cutting can weaken the nail and cause it to flake. File in one direction only, from sides to centre, using the softer (lighter) side of an emery board, not a metal file. Aim for a rounded tip: the shape at the tip should reflect the shape at the base of the nail to make a perfect oval, as left.

PEDICURE STEP BY STEP

You should take as much care of your feet as you do of your hands. For, although the sole of the foot is admirably and necessarily tough, it is more prone to viral, fungal and other infections than almost anywhere else on the body. Many of the more common foot afflictions are caused by ill-fitting, restrictive footwear, so choose your shoes carefully. Make sure that they have their widest point at the base of the toes, that your toes can move freely inside them and that the uppers are soft and flexible and will not cause undue friction when you walk. Above all, never believe that a new pair of shoes must be 'broken in'. This is an almost certain guarantee of future trouble. Get into the habit of alternating shoes and, more important, heel heights, to give your calf muscles plenty of exercise and your heels and soles a rest.

Start by soaking the feet in a warm footbath. Although many commercial products smell delicious, it is the temperature of the water that really counts – about 40°C (104°F). To make a traditional footbath: add a teacupful of Epsom salts or ordinary sea salt to every 4½ litres/1 gallon (10 US pints) hot water. Alternatively, use your favourite bubble bath and add two tablespoons of baking soda, to soften rough dry patches of skin if necessary.

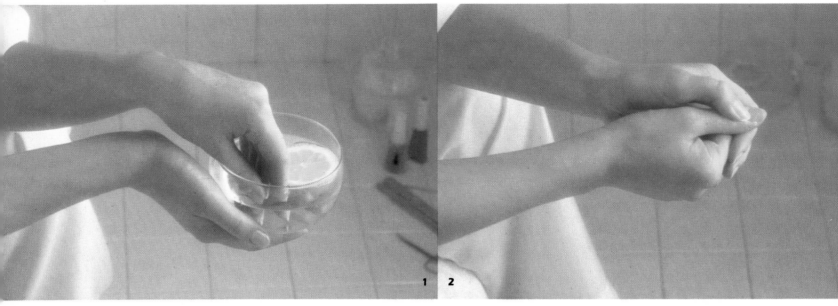

1. Soak the fingers briefly in a bowl of warm, soapy water, or water to which you have added a slice of lemon, to loosen dirt beneath the tips and to soften the cuticle. (If nails are very dry, soak them in warmed olive or almond oil instead.) Dry the fingers and scrape any loosened dirt from the underside of the nail with an orange stick. Do not poke or prod. If dirt has become embedded in the pink part of the nail, let it grow out.

2. Flick a little cuticle cream on to the base of each nail in turn. The cream should be thick and firm in consistency, like lard. Massage it well into the cuticle and surrounding nail using the ball of the thumb in a firm rotating movement. This will also help to stimulate the circulation, so promoting a healthy pink glow beneath the nail.

5. Once the feet are soaked, and the skin soft, take a pumice stone, rough skin remover or chiropody sponge. Remove any hard dead skin from the heels, sides and soles of the feet, but leave the toes well alone.

6. Dry your feet scrupulously, particularly between the toes where fungi and bacteria can breed easily. Once your feet are clean and soft, inspect them. Take any obvious incipient problems to a registered chiropodist. (See also Athlete's Foot, Corns and calluses, Enlarged toe joints in the A-Z.)

7. Cut the nails square along the top, following the shape of the toe and taking care not to cut them too short. Do not cut the corners of the nails back into the nail grooves as this may lead to an ingrowing nail (see page 218). Smooth sharp corners with the coarse (darker) side of an emery board.

3. File down the sharp end of an orange stick so that it is smooth and rounded and then gently slide it a little way under the cuticle at the base and sides of the nail, lifting the cuticle slightly as you do so. Be gentle: persuade don't push; never use an orange stick with a pointed end or a metal instrument; never clip the cuticle and avoid cuticle 'removers', as they may open up the space between the skin and the nail, inviting dirt, detergents, even nail enamel into the matrix.

4. Rub a generous amount of hand cream on to the hand, first pulling the finger joints upwards, then using the first and second fingers to pull the skin tissue down towards the knuckles, as though putting on a pair of gloves. Finish by massaging the palm. See below if applying varnish.

8. Repeat the cuticle cream/orange stick routine, massaging the cream well into the cuticle first. A rubber-ended implement, known as a 'hoofer', is particularly good for this.

9. Apply hand cream or petroleum jelly to the feet, rubbing in well and avoiding the spaces between the toes. (If the skin feels moist there, wipe with surgical spirit.) Knead and massage every inch of the sole, heel and top side of the foot.

10. When applying varnish, first ensure that any traces of the old colour are removed (to remove varnish around the cuticle, wrap cotton wool around an orange stick and dip in the remover). Begin with a clear base coat to prevent pigments being absorbed, follow with two coats of colour (three if frosted). Allow each coat to dry. Finish with a top-coat of clear polish to seal in colour and add gloss.

nailsnailsnail

the senses

'All our knowledge has its origins in our perceptions...' Leonardo da Vinci

To the ancient Greeks, sensitivity constituted the essential difference between plants and animals, and between animals and humans. It was not that any one specific sense was better developed in humans — just one glance at the animal kingdom will give examples of more acute vision (birds of prey), hearing (dogs and bats) or smell (insects). Rather, it was that, between them, they provided a range of information that the intelligent brain could sift through and use for the purposes of communicating, socializing, improvizing and inventing.

Every moment of our waking lives, millions of sense signals from the eyes, nose, mouth, ears and skin are sent to the brain — most of which are never perceived on a conscious level. All these signals are constantly being adjusted, analyzed, edited, eliminated, even completed by the brain. It is, for example, hard to find the blind spot in the eye not because it is not there but because the brain 'fills in' the missing part of the visual jigsaw. The world of perception is very different from and much more selective than the world of sensation.

In adulthood, the senses have a strict hierarchy, ruled first by the eyes and then by the ears — the 'distance' senses of sight and hearing — and only later by the skin, the mouth and the nose — the 'proximity' senses of touch, taste and smell. You can see how this sensual hierarchy organizes itself simply by closing your eyes... What happens? Your subjective, inner world becomes filled with sound — you can pick up the rhythm of your own breathing, and background noise, which you may not have been aware of before, seems amplified. You do not need absolute quiet to hear a pin drop when your eyes are shut. If you carry this experiment one stage further and place your hands over your ears, you will now find that sensation arrives predominantly from your sense of touch. You will suddenly become aware of the comparative softness or hardness of the chair on which you are sitting, of the texture of the clothes you are wearing and of sensations arriving from different parts of your body — your neck, your back, your shoulders, even your scalp. These are not new sensations — they are continually being communicated to the brain via the skin. The difference is that you have only just begun to perceive them.

We are all much more receptive to the messages arriving from our senses than we, perhaps, realize — although most of the time we make use of just a fraction of their full potential. Think of the virtuosity displayed by the piano tuner, who carries all the notes of the scale in his head and can detect and adjust the slightest variation in pitch, or the discernment of the master of wine, who has educated his senses of smell and taste to such a point of refinement that he can identify, not only the vintage of a certain wine, but the locality and even the vineyard that produced it.

sight

'Each day as I look, I wonder where my eyes were yesterday.' Bernard Berenson

Sight is the most highly developed of all the senses. The eye forms from two of the three layers of embryonic tissue — ectoderm and mesoderm — and communicates with the brain via the optic nerve, which is not a nerve in the sense of all the other nerves found in the body, but is actually an extension of the brain.

How do we see?

In construction and function, the eye works in much the same way as a simple, pinhole camera. Light from an object within your field of vision — about 200° — strikes the cornea, is partly focused and passes through the pupil which cuts down the beam, thus improving depth of field and perspective. A crystalline lens inside the eye performs the last five per cent of the fine focusing. A clear image is then thrown on to the back of the eye, or retina, as an inverted or upside-down picture of the original object, translated into electrical charges and relayed to the brain, which reverses and makes sense of the image it receives. The point at which the smaller nerve fibres converge to make up the optic nerve is known as the 'blind spot', but this does not interfere with the visual picture we receive because the brain fills in the missing part to provide perfectly focused, binocular vision in most people.

Perfectly focused, however, is only partially focused. Only the few central degrees of vision are, in fact, in focus at any one time. All the rest, about 90 per cent, is out of focus.

Having your sight tested

Taking care of your eyes, or those of your children, starts with an eye test during which each eye will be checked to ensure that it is focusing normally, quite independently of the other, and that the muscles controlling the movement of the eyes are working properly as a well-matched pair. Babies' eyes should always be checked for possible signs of squint. If the eyes are not working in unison, this should be corrected as soon as possible. Left to itself, a 'wandering' eye can eventually go 'blind' because the brain ignores conflicting images and only accepts the image from the good eye.

Eyesight should first be tested at nursery school age. Children do not need to be able to recognize the alphabet in order to have their sight tested. If all is well, sight does not need to be tested again for some years, unless symptoms lead you to suspect that the quality of your child's vision may be slipping.

If you manage to weather your teens and early twenties without wearing glasses, you should find that your vision remains stable until the age of about 40 or 45. Everyone, whether they suspect their vision to have deteriorated or not, should have an eye test at about the age of 45. This will check

for early signs of cataract or glaucoma (see pages 215 and 217) which, if not detected and controlled soon enough, may lead to impairment or even loss of sight. It is particularly important that you have your eyes checked if there is a history of either or both of these conditions in your family.

A second reason for having your eyes checked in your forties is that everyone gets more long-sighted with age. This is caused by a gradual deterioration of the crystalline lens inside the eye. To 'accommodate' for objects seen at close range, usually 1 metre (1 yard) or less, the lens has to bulge outwards, but with age, it becomes less elastic. Where a child can see an object sharply at a distance of only 8 cm (3 inches) from the eye, the adult of 45 may not be able to focus clearly on objects less than about 45 cm (18 inches) away. By the age of 60, the lens is usually completely inelastic and reading glasses will have to be worn.

Standard of sight is given as a ratio of an individual's ability to see what a hypothetically 'normal' eye can at a given distance — 6 metres in the UK, 20 feet in the USA. So, if you have to stand at 2 metres to see what the normal eye can see at 6, you are said to have 2/6 vision — the US equivalent would be 6/20. It is also possible to have better than average vision: 6/5 vision, for example, means that you can distinguish letters at 6 metres that the normal eye can only pick up at 5.

Avoiding eye 'strain'

Although you cannot actually 'strain' the eyes they can feel strained, particularly if concentrating for long periods of time. Concentration is wearing for the eyes because the muscles controlling them are held in a fixed position and do not allow the eyes to swivel as they would normally and because you literally forget to blink. The normal blink rate of every two to four seconds falls to every ten seconds or so when reading or driving. Hardly surprising, therefore, that after an hour's solid concentration, your eyes feel sore and tired. The best way to avoid eye strain is simply to remember to blink when driving, and to break up periods of reading or close studying about every half an hour, to give your eye muscles a chance to unlock and your tear film an opportunity to replenish itself. You should also avoid reading in insufficient light or under glaring strip lighting, both of which generate tension in the muscles.

If your eyes do feel strained and tired, try bathing them gently in a weak salt water solution. Dissolve one teaspoon of salt in 600 ml/1 pint (2½ cups) of cold, boiled water. You can also place cotton wool pads soaked in milk, or slices of fresh cucumber, over the eyelids to cool, soothe and rest the eyes and thereby to relax the eye muscles. Even better — go to sleep.

cornea optic nerve
lens retina

A vertical section through the eyeball showing the pupil, the small crystalline lens inside the eye, which is responsible for 'close up' focusing, and the optic nerve, which carries all information received by the eyes to the brain. The point at which the nerve fibres converge to form this nerve is the 'blind' spot.

Most problems with vision arise from difficulties in focusing. Long-sightedness (hypermetropia) and short-sightedness (myopia) are the most common of these and are usually caused by a slight defect in the proportions of the eyeball.

The long-sighted eyeball, above, is functionally too short, so that light arriving from a distant object converges behind the retina. A convex lens in front of the eye will shorten the focal point of the light.

The short-sighted eyeball is functionally too long, so that light arriving from a distant object converges in front of the retina. A concave lens in front of the eye will lengthen the focal point of the light.

TAKING CARE OF YOUR EYES

On the whole, the eyes protect themselves remarkably well. The eyelids close instinctively whenever dust particles, smoke or irritants in the atmosphere come into contact with them; the pupil contracts in bright light or glare, in order to reduce the amount of light coming through; the gentle windscreen-wiper action of blinking circulates the tears, bringing fresh oxygen to the surface of the eye and keeps the white of the eye clean and clear; the tiny lipid pores along the inner eyelid secrete the fine layer of oil that maintains the integrity of the tear film, by preventing over-fast evaporation. Heavy creams, eye liners, some mascaras and even make-up remover can all block these pores, if carelessly applied, and will cause irritation if allowed to come into contact with the eye itself. Caution is the watchword.

● If you habitually wake up with swollen, puffy eyes in the morning, bathe them gently with cool water or witch hazel and leave them alone. Any puffiness should subside within half an hour or so. Puffy eyes later in the day can be treated in much the same way or soothed by specially formulated eye pads.

● When moisturizing the face, never put cream on to the area directly around the eye. Concentrate instead on the skin to the side and beneath the eye and, even then, leave a fairly wide margin. You will find that the cream migrates naturally upwards.

● When putting eye creams or shadows on to the lid, always use the lightest possible touch. A sable brush or cotton wool bud is ideal for this. If possible, avoid using kohl or an inner lid liner (or at least make sure the point of the pencil is soft enough for the eye, see right), keeping outside the eyelashes when defining the shape of the eye, so that the tiny lipid pores on the lid are not interfered with.

● False eyelashes, if very long and thick, can upset the natural balance of the eyelid. If you do use them, be especially careful when sticking them on as the glues may cause irritation if carelessly applied.

● Lash-building mascaras are fine for the lashes but not for the eyelids, so apply them carefully. Keep well clear of the lid and do not put too much on: an overload may cause small pieces to flake off, causing redness and irritation if they fall into the eye.

● Although 'artificial tear' solutions for uncomfortable itchy eyes are quite safe, you should avoid commercial eye 'whiteners'. These contain a blue pigment to give 'washing-powder' whiteness and a substance which causes the blood capillaries in the white of the eye to contract and temporarily to disappear. As they will reappear, and probably more conspicuously than before, you are altogether better off without them.

● If you wear contact lenses, you should be especially careful when applying or removing make-up. Always put your lenses in before applying it (you will be able to see what you are doing for one thing), and take them out before removing it, in order to avoid smudging grease or dirt on to the lens. Contact lens wearers should also avoid all cosmetics that might shed particles into the eye or stick to the surface of the lens, such as powder eye shadows, heavily 'pearlized' products and filamented ('lash building') mascaras. Try

to use water-soluble eye make-up instead.

● If your eyes do become sensitive, infected, red or puffy, do leave your make-up off for a few days. It could be that you have developed a sensitivity to one of the products you are using (see pages 138-9).

Sunglasses

Eyes are naturally sun-sensitive. The pupil regulates the amount of light entering the eye by contracting in bright light and dilating when the light is dim — when, like the shutter in a camera, it needs a greater exposure to make sense of what it sees. This is why it takes a few moments to 'acclimatize' to shade after bright sunlight and why eyes, habitually protected by sunglasses, can feel lost without them. Because the eyes have their own in-built protective mechanism, you do not damage them simply by being in bright sunlight, but you can place additional stresses on them. We strain to see well in bright light, forcing the eyes open and squinting through the glare. Over a long period of time, squinting tires the eyes and can even hasten the appearance of premature lines and wrinkles. Most sunglasses are designed primarily to protect the eye from visible light, not from ultraviolet. They do this by using a variety of tints to cut down as much as 65 to 85 per cent of transmitted light from various, and often extremely specific, parts of the colour spectrum — blue, for example, is colour specific for yellow (its opposite number in the spectrum) and therefore recommended for a desert environment.

Although your choice of tint, like your choice of frames, depends very much on your own personal preference, some colours, particularly those at the centre of the spectrum, offer greater protection than those at either end. The wisest choices are brown, sage green (which probably gives best all-round protection) and neutral, smoky grey. All these reduce the intensity but do not affect the values of the colours. Avoid the rosier tinted reds, pinks and oranges.

Sunglasses are extremely important in high glare conditions such as skiing, where the light is intensified by reflection off the snow or ice, or driving, where the dazzle may blind you to oncoming traffic. But you should not wear them superfluously, when the light is not bright and you need all the visual information you can get. Never wear sunglasses when driving at night, in fog, rain or any other conditions that already restrict visibility.

Choosing sunglasses

If made from a poor quality material, sunglasses can hinder, rather than help, your vision, so always test both for general and for optical quality before you buy. Check first that the two lenses are matched for colour and tone, that there are no surface defects or scratches, that the frame has strong enough hinges to withstand normal use and that the side pieces are narrow enough not to obstruct vision any more than necessary. Then, put them on to see how they suit you and look carefully in a mirror. With the exception of gradient and photochromic lenses, which will not darken in sunless shops, you should not be able to see your eyes, without having to peer very closely into them. If you can see them, the lenses are too light to afford effective glare protection.

eyeseyeseyes

Sharp eye liner pencils will irritate skin around the eyes. Make sure that your pencil is soft enough by testing it between thumb and forefinger. This spot is closest in texture to the skin on your eyelids. If the pencil scratches or drags along the skin, do not use it.

To check for optical quality, hold sunglasses so that a patch of overhead lighting is reflected off the inside lens and move them slightly, so that the reflection moves across it. If the line waves or dips, the edges bulge anywhere but at the corners, where the glass is curved, or the colour seems streaky, the glasses will not give top optical quality. (Prescription sunglasses are intentionally distorted and cannot be tested in this way.)

SUNGLASSES

TYPE	DESCRIPTION	ADVANTAGES	DRAWBACKS
PLASTIC	Different types of plastic have different optical qualities. The degree of protection derives both from the depth and the type of the tint. The newer, gradient lenses give the cosmetic advantage of allowing your eyes to be seen, while screening out the more intense overhead light.	They are extremely light, often weighing less than 28 g (1 oz).	They are prone to scratching, so never place them lens side down. Poorer quality, cheaper plastics may cause distortion and interfere with vision. Always check optical quality before buying (see previous page). They give little protection against infrared. Gradient lenses are not suitable for reflected glare, such as when sailing or skiing.
GLASS	Glass lenses are individually ground and polished to the required surface finish and shape.	For optimum quality, glass lenses are preferable to plastic because they contain no distortion, unless they are prescription glasses (see previous page).	They tend to be fairly heavy.
POLARIZED	These lenses are made by sandwiching a sheet of polarized material between two pieces of plastic or glass.	Polarized materials have the unique property of cutting down reflected glare and will cut it out entirely, if reflected at a certain angle (53° on water for example). Extremely useful for high-glare conditions such as fishing, boating, skiing.	As laminated windscreen glass is already polarized, car windscreens can appear blotchy when driving.
PHOTOCHROMIC	Sun-sensitive or photochromic lenses darken in bright light and vice versa. The effect is caused by crystals in the glass which respond to ultraviolet. The brighter the light, the darker they go, cutting out about 80 per cent of all transmitted light in really high-glare conditions.	Ideal for most activities and light conditions, particularly if the light is ambient, as they give optimum protection when there is a lot of glare and optimum vision when it is less bright – the field of vision being assisted by the degree to which they lighten.	They can take several light/dark cycles before reaching peak performance. Photochromic sunglasses darken to 75 per cent in about 30 seconds in cold bright conditions, but take longer to adjust if the temperature is higher. As ultraviolet is deflected by a car windscreen, and as it takes time for the lenses to adjust from light to dark, photochromic lenses are less effective and potentially dangerous when driving (e.g. when entering a dark tunnel).
MIRRORED	A thin coating of a steel alloy over the lens cuts down light transmission by as much as 85 per cent by bouncing the light off the surface of the lens. Traditional sunglasses absorb it.	They protect against ultraviolet and infrared and are extremely good when there is a high degree of reflected light and/or overhead glare. They are especially good for sports activities, such as boating, bicycling, fishing and skiing.	They may restrict vision and affect perception when the light is only moderate.

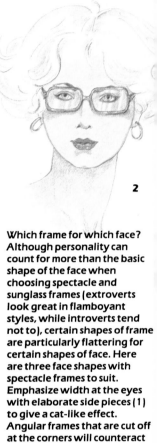

Which frame for which face? Although personality can count for more than the basic shape of the face when choosing spectacle and sunglass frames (extroverts look great in flamboyant styles, while introverts tend not to), certain shapes of frame are particularly flattering for certain shapes of face. Here are three face shapes with spectacle frames to suit. Emphasize width at the eyes with elaborate side pieces (1) to give a cat-like effect. Angular frames that are cut off at the corners will counteract fullness in the cheeks (2), while curving lines will plump out the face by 'breaking' the long vertical at the sides (3).

Contact lenses

The idea of wearing a convex lens on the eyeball to improve or correct vision was first mooted by Leonardo da Vinci in the fifteenth century, but it did not receive serious consideration for a further 400 years, when injuries to pilots in the First World War revealed that the acrylic material used in aircraft windscreens was inert, or chemically 'non-damaging', to the eye. After this came the first all-plastic contact lens which was worn over the entire eye surface. This cumbersome lens was gradually refined into a much smaller one that covered only part of the cornea. The first soft lens was produced in the 1950s. Since then, contact lenses have become so refined that today very few individuals are unable to wear them.

Contact lenses have many advantages over traditional glasses. Beyond their obvious cosmetic appeal, they tend to provide a more constant quality of vision than glasses do because they sit right on the eyeball and do not mist or fog up. They also eliminate the need for special prescription sunglasses. Some eye afflictions can only be optically remedied by the wearing of contact lenses.

It is essential to have contact lenses fitted well. To find a good contact lens specialist, go by local reputation or the recommendation of your doctor, never by the shop front. Once the prescription has been made up for you, your practitioner will show you how to put them in and take them out, how to look after them, what sort of cleaning agent to use and how long to wear them — in short, how to give your eyes the best chance to become quickly and easily accustomed to the presence of the lenses.

Always expect some initial discomfort. Although the edges of most lenses are so finely graduated that only the most sensitive eyes will be irritated, they are bound to

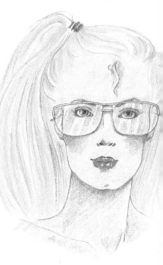

lenseslenseslenses

register a change of touch, rather in the same way as a finger with a new ring would do. This sensation should disappear within two or three weeks with hard lenses and within minutes with soft ones.

Once you have had the lenses fitted, your practitioner will arrange a future appointment to check how well your eyes are adapting to them and whether you are putting them in and taking them out correctly. Never exceed the wearing time specified. Some types of damage only become apparent hours, or even days, afterwards.

All contact lens wearers should go for regular check-ups. You may be unaware that the quality of your vision has deteriorated slightly, but your practitioner can check this and, if it has, will alter the prescription of the lenses.

CONTACT LENSES

TYPE	DESCRIPTION	ADVANTAGES	DRAWBACKS
HARD	The most traditional type of lens, made of polymethylmethacrylate. A hard lens is rather like having a miniature spectacle lens on your eye – with the advantage that it gives back the 15-20 per cent of range of vision that spectacle frames cut out.	Hard lenses give crisper, clearer vision than soft lenses, can be repolished if surfaces are scratched or damaged and day-to-day cleaning regimes are simple. With care, hard lenses will last for between 10 and 12 years, sometimes considerably longer.	Initially uncomfortable, hard lenses take between three weeks and a month to 'wear in'. They are unsuitable for occasional use and extremely sensitive eyes. Hard lenses distort the cornea very slightly, and so can cause vision to become blurred when lenses are taken out. The problem, known as spectacle blur, is not helped by glasses. Although the cornea will adjust back to normal in time, it can occasionally take some months. Dust can get underneath the edge of the lens and irritate the eye.
SOFT	Soft lenses look like drops of rainwater and contain 40 to 60 per cent fluid, depending upon the material used.	Soft lenses are much more comfortable initially than hard lenses. Most eyes adjust to them within four to five minutes. They are also suitable for occasional use, are less inclined to slip than hard lenses, and are preferable in dusty environments (see hard lenses).	Soft lenses react to external temperature and, in some cases, to altitude and lowered atmospheric pressure. Maintenance costs are high. They require special cleansing chemicals to remove accumulated calcium and protein, by-products of natural tear deposit, and wear out much more quickly than hard lenses. Eighteen months is a good span and, if you live in an urban environment or are a heavy smoker, you may need them replaced after as little as three or six months. Some individuals may develop a reaction to the chemicals in the cleansing solutions.
'GAS PERMEABLE' HARD LENSES	These combine the good qualities of both hard and soft lenses, while minimizing the drawbacks. They maintain the integrity of the cornea, by allowing it to absorb its oxygen from the atmosphere, rather than via the tear film.	They give crisper vision than soft lenses, will improve the quality of vision for those with astigmatism and do not lead to 'spectacle blur' when the lenses are taken out.	Gas permeable lenses are more like hard than soft lenses in structure and are therefore not as comfortable as soft.
EXTENDED WEAR	First developed in the UK about 10 years ago, these lenses can be worn for extended periods (usually between one and three months) without taking them out at night. After this time, the lenses should be professionally cleaned.	Excellent for the very young or the very old for whom the business of taking the lenses in and out every night presents obvious problems. (They are often fitted on babies, for example.) Extended wear lenses are also particularly good for post-cataract patients.	An accumulation of protein on the surface of a soft lens produces discomfort, but you may be unaware of any such build-up on extended wear lenses. It is essential therefore to observe follow-up visits. If you do not, it can lead to eye infection and may even affect your vision. Watch out for redness, reduction of vision or discomfort.
COLOURED LENS FILTERS 'COCKTAIL' LENSES	These lenses can be worn for medical reasons in the event of one or both eyes being damaged or for purely cosmetic reasons, to enhance or to change the colour of the eyes. They can be either hard or soft (the cosmetic type is usually soft) and can be made up to whatever prescription is required. As a general rule, the paler the eye the wider the choice of colours. People with grey, light blue or green eyes, for example, can choose any colour from violet or hazel to brown, while those with dark green eyes will have little choice other than brown. Very dark brown eyes can be made to look lighter with an orange filter.	They do not affect the quality of vision, are versatile, fun and useful for theatrical or cinematic special effects. They are also a marvellous boon for people whose eyes have been damaged, as the colour of the lens can be so carefully matched to the good eye that it is impossible to tell which is which.	As hard and soft lenses. If you are wearing coloured lenses for purely cosmetic reasons, remember that these are still lenses and the same care must therefore be taken when taking them in and out, putting on or removing eye make-up and generally looking after them.

hearing

'A lover's ear will hear the lowest sound...' William Shakespeare

The sense of hearing develops early, probably well before birth. The developing baby is surrounded by sound. In fact, the natural synchrony of the two heartbeats (the baby's is twice that of the mother's) is now thought to constitute our earliest appreciation of rhythm. Experiments, showing that babies can be soothed to sleep by recreating sounds left behind in the womb, have borne this out. New babies do not learn to recognize or to locate sound for some months. Like all information received by the senses, it must first be 'translated' and made sense of by the brain, before it becomes meaningful. Association is all, whether it is the rattle of a spoon against a cup, meaning food, or the soothing words of the mother, meaning closeness, security and pleasure. If a baby is not brought up in a world of sounds and, more specifically, words, he or she will fail to associate sound with meaning and may appear 'deafer' at the age of two or three than the child whose hearing is actually impaired.

How do we hear?

Sound originates as a movement or vibration of air, which then sets up smaller vibrations which get fainter and fainter as they move through the atmosphere. The function of the ear is to receive and transmit sound to the brain first by amplifying the pressure of the vibrations as they travel through the ear (see below right) and second by translating the vibrations into electrical nerve impulses, intelligible to the brain, which then decodes them. As with sight, we hear not with the ears, but with the brain.

Pitch and loudness

Frequency of sound, or pitch, is measured in Hertz. One Hertz is one cycle, or vibration, per second. Middle C on the piano, for example, is 256 Hertz, or cycles per second. We all respond to certain frequencies at a very subtle level, particularly at the lower end of the scale, because they set up and generate internal rhythms in the brain — hence the powerful effect of meditative mantras, chanting and rock music. The human ear starts to pick up low frequency notes at about 20 Hertz and goes on hearing successively higher notes to a level of about 20,000 Hertz, after which sounds become too high to be heard. Some animals, however, can still detect them. 'Silent' dog whistles, for example, are pitched at about 22,000 Hertz, and bats actually navigate by ultrasonics, emitting high-pitched squeaks and finding their way by means of the echoes bouncing off obstacles. The same principle is used for radar, depth sounders in submarines, burglar alarms and for medical scanning when X-rays are unsuitable, such as during pregnancy.

Intensity of sound, or loudness, is measured in decibels (dB). Nought decibels, or 0dB, indicates the threshold at which sound becomes perceptible to most people. Some people, with an extremely acute sense of hearing, will be able to perceive sound at minus 10 decibels, but this is rare. Hearing tests work by measuring the quietest perceived sound (decibels) for different frequencies (Hertz).

Hearing tests

One out of every 1,000 children is born with some degree of hearing impairment. If there is reason to suspect that the hearing might be damaged, a rudimentary test can be given at birth. All children should have a hearing test at seven months.

Hearing deteriorates appreciably with age. By the age of 80, one in two people will have a moderate to severe degree of hearing loss. This type of hearing loss is very similar in pattern to noise-induced hearing loss. In fact, one study carried out in the Sudan among a people who live in a world unassailed by urban and traffic noise and who show a much sharper sense of hearing in old age, suggests that the hearing deterioration we normally attribute to advancing age might, in part at least, be noise-induced. If you suspect that your hearing is not as sharp as it was, have a hearing test. The earlier any impairment is detected, the greater the chances of compensating successfully for it. Using a hearing aid takes practice and concentration, as it does not just amplify speech, but all foreground and background noise as well.

The ear is a highly intricate and complex organ containing, among other things, the vestibular mechanism of balance (see page 33) and dividing into three parts. The outer ear (1) receives sound at varying frequencies and intensities and transmits it, via vibration on the ear drum, to the middle ear (2). This sends it along progressively narrower corridors of bone (the hammer, anvil and stirrup), forcing up the pressure of the vibration and preparing it for detection in the cochlea. This snail-shaped organ in the inner ear (3) is filled with fluid and contains thousands of tiny, highly sensitive fibres, coded for pitch and loudness and capable of transforming vibrations into electrical nerve impulses that are intelligible to the brain.

Noise

Because noise is invisible and, often, intermittent, it is very difficult to assess — both in terms of what the population as a whole finds tolerable and of what constitutes a potentially damaging source of sound. Even so, it is now well recognized that exposure to excessive noise can cause irreversible loss of hearing — particularly of the lower pitched sounds. How loud is too loud? If you have to raise your voice to carry on a conversation with someone three to five feet away, the noise level is potentially damaging.

For most people, noise is most significant in terms of sleep disturbance. The relatively low decibel rumble of passing traffic not only extends the time it takes you to get off to sleep, even if you claim to be unaware of it, but may also rob you of your normal level of 'dreaming' sleep (see page 181). If you spend most of your day feeling tired, irritable and depressed, consider the possibility that your sleep is being disturbed by noise. Lack of sleep — and, it is now thought, lack of the right type of sleep — is both an important contributor to and result of excessive stress. A Dutch study revealed that all stress-related conditions, such as hypertension, headaches, ulcers and cardiovascular disease, were more common among those living near an airport and exposed to aircraft noise than among the rest of the population.

LOOKING AFTER YOUR EARS

The less you interfere with your ears, the healthier they will be. The ear is an efficient self-cleansing organ. The wax inside it picks up dirt and potential irritants as they enter the ear and prevents them from travelling further down. The warmth generated at body temperature melts the wax as it accumulates so that both it and the dirt can run out of the ear quite freely. The most you should do is to wipe the outer ear with the corner of a face cloth. Poking around with a finger or any type of instrument will tend to push the wax further down towards the eardrum where it is less accessible and more likely to harden and affect your hearing.

● If you suspect that an excessive accumulation of wax is affecting your hearing, go to see your doctor who will arrange to syringe your ears. This is done by directing a jet of water at the eardrum (not at the wax) so that the wax is pushed out from the inside. If you have any history of trouble with your eardrum, you should not have your ears syringed. Your doctor will use an alternative method.

● Earache is usually 'referred' pain and often accompanies dental problems. These should be your first grounds for suspicion when or if it strikes. If taking a painkiller every few hours does not help the problem, do not resort to home-spun remedies, go to see your doctor or dentist.

● Having your ears pierced is a perfectly safe procedure as long as it is carried out under sterile conditions. Stud sleepers are initially preferable to ring sleepers, as the dirt on your fingers may cling to the ring and infect the ear as you turn the ring round. Choose gold in preference to other metals, as this is the least likely to lead to infection. If your ears do flare up, consult your doctor.

● Keep your ears protected from the cold and use a good sunscreen while sunbathing. The cartilage at the top and back of the ear is particularly susceptible.

SOUNDS	LOUDNESS (DECIBELS)
Whispering	30-40
Conversation	60-70
Loudest recorded snore	69
Pneumatic drill	71-90
Inside small car	78
Crowded bar	79
Passing lorry	85-91
Pop music	87
Peaks of sound at rock concerts	105

touch

'Sight has to do with the understanding; hearing with reason; smell with memory. Touch is realistic and depends on contact; it has no ideal side...'

Arthur Schopenhauer

Our world evolves out of touch. Of all the senses, this is the first to develop and the last to desert us. At six weeks, the developing foetus apprehends sensation through the skin — long before the eyes or the ears have started to form. After birth, it is largely through contact with his mother's body, as she holds, cuddles, bathes, soothes and feeds him, that the child learns whether the world is to be feared or trusted. Touch gives a child his most fundamental ideas of the world: he is, for example, able to grasp an object long before he can focus on it and will acquire a better sense of roundness from holding and touching a ball than he will by looking at it.

Innumerable studies and experiments have shown that the child brought up and nurtured on a sense of touch and physical intimacy with his parents is more sociable, alert and curious, is better able to ward off pain and infection, has a healthier appetite, will sleep more soundly and will laugh and smile more often. We need to touch and to be touched to develop as normal, happy, healthy beings.

For most of us, ruled by our eyes and ears, the immediacy of the sensation of touch subsides as we grow older. Often, it is only reawakened in moments of doubt to make sense of what we see or hear and to verify the reality of a thing, such as a work of art in a museum or, more perversely, a 'wet paint' notice on a park bench. For people deprived of their senses of sight and hearing, however, touch becomes immensely important. Braille, an alphabetical and numerical 'reading' system, is perhaps the greatest celebration of the skin's ability to 'perceive'. Devised by a blind French boy of 17, it can be read by an accomplished reader at a speed equal to, if not greater than, a sighted person reading the text out loud.

How do we feel?

Touch keeps us informed of both our external and internal environments — we 'feel' aches and pains in our joints and muscles in much the same way as we feel and register changes of temperature in the outside world. There are over 50 sense receptors in a piece of skin the size of a small coin. Each of these is responsible for picking up and transmitting a separate impulse — warmth, cold, pressure or pain — to the brain.

The sense of touch is the most diffuse of all the senses and the threshold of sensation shifts, depending on the area being touched, the medium through which the sensation is being transmitted (bone, muscle or fat), the distribution of the various sense receptors, the individual's state of mind and even the time of day. We are also most sensitive to temperature and touch on the first encounter, becoming gradually less aware of the sensation as it continues.

Pain

Pain is the body's oldest warning system and its threshold, like those of warmth, cold and pressure, varies from person to person. The lower the threshold, the more sensitive to pain a person is. Sufferers of alagia, an extremely rare condition, are born without a sense of pain and can actually set fire to their limbs without being aware of it.

The pain threshold tends to be fractionally higher in men than in women and to increase with age, regardless of race or sex. Extroverts tend to be less sensitive to pain than introverts and we are all more sensitive to pain when anxious or upset, but considerably less so when the emotions or muscles are engaged. There is a strong, psychological component to pain — which is not to say that all pain is imaginary but that, on certain physical or mental cues, the brain releases its own morphia-like painkillers, called enkephalins and endorphins. These recently discovered hormones (10 years ago no-one knew they existed) are now thought to play an important role in childbirth. They may also explain why some of the ancient Chinese therapies, such as acupuncture, work.

The earliest and most instinctive way of dealing with pain is to 'rub' it away. Pressure, it seems, works whether it is in the most immediate or the 'long distance' sense. In acupuncture, one or more of the 657 *tsubos*, or energy points, of the body is stimulated in order to 'anaesthetize' or stimulate a quite different part of the body. The same can be done with finger pressure, instead of needles, and is known as *Shiatsu* or acupressure. Try pressing on the underside of the big toe or on the crown of the head to relieve headaches, or on either side of the ankle to relieve period pains.

MASSAGE

One of the most pleasurable and practical ways of reawakening, and communicating through, your sense of touch is massage. It is not difficult and, with practice, imagination and sensitivity, you can become quite accomplished, provided you remain within the 'safe', basic framework given on the following pages.

Before you start, it is essential to realize what massage can and cannot do for you. It will reduce aches and pains, relieve tension, promote a feeling of warmth and relaxation and have a demonstrable, though temporary, effect on the circulation. It will not 'break up' fat deposits or reshape the body and, although it is sometimes called passive exercise, it is not and should not be looked upon as a substitute for the real thing. Amateurs should start by using the four basic strokes on the following pages and extend and improvize their repertoires as they become more proficient.

Basic rules

● <u>Practice, not theory, makes perfect.</u> The more you practise massage, developing and improvizing these four basic strokes the more sensitive your hands and sense of touch will become.

● <u>Your hands should be supple and relaxed,</u> so that they can shape themselves into and around the contours of the body on which you are working. Use the hands to communicate, the body to apply pressure and firmness, and let the movement come from deep within the centre of the body, rather than just from your wrists or elbows. You will then give a deeper, more even massage and you will also find that your arms become much less tired.

Massage only with the palms of the hands, fingers and thumbs. Applying pressure with elbows, knuckles or fists should be left to the expert.

● <u>Establish a smooth working rhythm</u> before you begin to experiment with more ambitious strokes or changes in pressure. Breathing evenly will help you to achieve this. Breathe in as you move the hands over the body and out as you apply the pressure. Start with an uncomplicated, shallow stroke that allows you to establish a basic rhythm.

● <u>To give an effective and relaxing massage, you must first</u> <u>understand what tension is and how to locate it.</u> Muscle is composed of a series of fibres which shortens as it contracts and lengthens as it relaxes. If it is held in a contracted state over a long period of time it will give rise to residual tension, aches, pains, even muscular spasm. To feel muscular tension, run your thumb along the muscle. It should feel soft and spongy. If you can feel a hard lump or knot along the muscle, you have found tension. Persuade tension to undo itself, either by massaging the entire length of the muscle or, if it is too tight and painful, by working around the area. You should find that the muscle unlocks as you release all the surrounding tension. Do not expect to eliminate all the tensions that you find in the course of a single massage, however. Massage is a progressive therapy, not a one-off cure-all.

● <u>Massage should always be lighter over those parts of the</u> <u>body where the bone is near the surface.</u> Bony areas include the face, the breast bone, the lower rib cage (back and front), the spine (the hands move alongside not on top of it), the hands, knees, calves and feet.

● <u>The more relaxed the body you are working on, the greater</u> <u>the benefits of the massage.</u> Ask your subject to have a warm bath before starting. Heat, whether the dry heat of a sauna or

1. Light stroking (effleurage)
Start and end your massage with this stroke. It is a simple, long stroke of light to moderate pressure which can be used on arms, legs, abdomen, chest, back and shoulders. The hands should be relaxed and flexible and the fingers slightly apart, with the thumbs innermost. Proceed in a continuous gliding movement up or down the length of the area you are massaging. Massage in the direction of the heart, keeping the stroke very light to begin with and gradually increasing in depth as you progress.

2. Deeper circular stroking (petrissage)
This is a more difficult stroke. It takes time and perseverance to achieve the necessary co-ordination and manual dexterity, but it is worth persevering. To start with, keep the pressure fairly light and concentrate on using the two hands together in differing, circular directions. This is the difficult part: if the right hand is moving in a clockwise direction, the left hand should be working in an anti-clockwise one and vice versa. The hands should be about 10 cm (4 inches) apart, and the fingers soft and pliant. Add pressure by clasping one hand on top of the other and travelling clockwise up one side of the spine or body area and anti-clockwise up the other.

3. Kneading
Kneading is excellent for relieving tension on the muscular and fleshy areas of the body, such as the thighs, buttocks, upper arms, shoulders and base of the neck. It is relatively deep and, as with kneading bread dough, is performed with the pads of the fingers and thumbs. Do not knead the skin over the bony areas of the body.

4. Friction
This variation on kneading is performed only with the thumbs, which describe small circles. Friction is excellent for releasing areas of muscular spasm and can be used along the entire length of the spine, including the neck, the backs of the calves, the sides of the ankles, the heels and the lower inside arms.

the wet heat of bathwater, promotes relaxation by forcing the muscles into a state of relaxed submission.

Try, also, to ensure that there are as few outside distractions as possible, so that you can <u>both</u> concentrate on what the massage is aiming to achieve. Successful massage always asks and receives a measure of participation. Ask your subject to release his body into the surface he is lying on and to concentrate on the sensations generated through your hands. Always tell him to let you know when or if the massage becomes uncomfortable.

● <u>If the massage is to work, you must both be comfortable.</u> A bed is not ideal, as it is too soft to support the body correctly. Best of all is a table or bench at hip height, but a floor is fairly good, although more tiring for you — remember to stand up and stretch from time to time. When lying on the front, a pillow should be placed under the stomach in order to support the lower back, and a small cushion or folded towel placed underneath the forehead to support the head and neck. When lying on the back, a pillow should be placed under the knees.

● <u>Use a light oil to enable your hands to glide easily over the skin.</u> The essential or 'pure' oils are ideal for this, when diluted with a neutral oil, such as wheatgerm. Pour a small

amount into your hands, rub them together to warm the oil and spread it over the entire area of the body surface on which you will be working.

● <u>If you have never given a massage before, it is a good idea to concentrate on the back,</u> which presents an ideal, large, flat, even surface and often contains most of the residual muscular tensions — particularly on the upper back, around the neck and shoulders. As you get more proficient, extend and adapt the strokes to the outlying parts of the body, with their more awkward angles and differing distributions of flesh, fat, bone and muscle.

● <u>Do not massage anyone who is in ill health or suffering from infection, arthritis, rheumatism or any swelling in the joints.</u> Avoid areas with warts, moles and varicose veins, too. As a rule, if in doubt, do not give a full body massage. Give a foot massage instead. This is one massage that you can also give yourself. Start by oiling the foot well. Then, supporting the foot in one hand, grasp the toes in the other hand and bend them as far as possible towards and away from the ankle. Stroke, rub and knead every centimetre of the sole of the foot, using a circular movement around the ankle bone. Finally, 'wring' the foot out rather as you would a dishcloth. You should feel deliciously relaxed.

smell and taste

*'I have been here before,/But when or how I cannot tell:
I know the grass beyond the door,/The sweet keen smell . . .'*

Dante Gabriel Rossetti

Evolution has blunted some senses and sharpened others and there is every reason to suppose that our sense of smell is not what it once was. Animals live, communicate, struggle and perish in a world of smell which marks territory, asserts dominance, deters rivals, attracts mates and distinguishes species from species, male from female and friend from foe. By comparison, our sense of smell is obtuse indeed.

How do we smell?

The human mechanism for picking up and differentiating smells is, nevertheless, still remarkably delicate. Some 10 to 20 <u>million</u> olfactory receptor cells are situated in an area the size of a small coin in the roof of the nasal cavity just beneath the eye sockets. Not only can these cells detect as many as 4,000 separate and clearly identifiable odours, but they also only require the tiniest fraction of the essence to do this. The smell of garlic, for example, becomes perceptible at a concentration of less than one-millionth of a milligram in a litre of air and will also contribute very strongly to your appreciation of its taste.

Odours are created by moisture molecules evaporating into the air. All living and many inert things give off their separate, invisible and highly volatile essences — whether it is the balmy fragrance of roses or the acrid fumes of car exhaust — and, as long as the air temperature is just above freezing, will go on releasing them indefinitely. This is why leaving the stopper off a bottle of perfume or the petrol cap off a car will eventually cause perfume and petrol to evaporate entirely away.

Most smells have very distinct properties. We can say that they are spicy, fragrant, fruity, woody, aromatic, pungent or tarry, but our appreciation of them will be highly individual. Association, memory and even anticipation play an enormously important role in determining whether we respond positively or negatively to a certain smell. Smells, subconsciously catalogued away in the vast olfactory library of the brain, evoke strong associations of events, people or places, once they are reawakened. 'That unforgettable, unforgotten river smell' was Grantchester to the poet Rupert Brooke, but the same smell might have carried someone else back to somewhere quite different. Some psychiatrists are now exploiting these strong associative qualities by using the smell of vanillin in breast milk to unlock early painful associations or memories when treating patients with certain types of psychological disorder.

There is no doubt that scents and essences do exert a powerful psychological effect on the brain, influencing mood to calm and soothe, invigorate or even stupefy, if arriving in large enough doses. They also play an important role in human communication and sexuality, but just how

important no-one quite knows. It does seem likely that human smell is a part of the highly complex body chemistry that sends out its signals of like and dislike, attraction and repulsion, excitement and fear. The ingredients thought to be responsible, known as pheromones, have now been isolated in the laboratory.

Receptivity to smell depends on several factors, such as the time of day (sensitivity increases as the day wears on), the stage of the menstrual cycle (women become between 100 and 5,000 times <u>more</u> receptive to smell over ovulation), and the length of exposure. Whether it is the smell of cabbage water or the exotic scent you have dabbed on your wrist, the nose soon tires of it. This is what makes people so impervious to their own body 'odour'.

HUMAN SMELL

All body odour — both the subtle odour that attracts and the stale odour that repels — derives from sweat. Sweating is an integral and essential part of the body's internal temperature control mechanism. If exertion, fever or emotional tension cause the body temperature to rise above 37.4°C (99.3°F), over 3,000,000 tiny sweat glands come into play. Known as eccrine glands, they release a substance (99 per cent water and one per cent sodium chloride) which exerts a cooling effect as it evaporates into the atmosphere. It is completely odourless. Emotional arousal, such as fear, embarrassment or sexual anticipation, steps up sweat production in the armpit, groin, hands and feet and brings a second set of glands, known as the apocrine glands, into action. Both types of sweat, however, are colourless, odourless and totally inoffensive and it is only when they combine with bacteria living on the skin and body hair that odour is produced.

Controlling and counteracting odour

● <u>Stay clean.</u> A daily bath or shower is the best way of guarding against odour, as it washes off the organic substances present in apocrine sweat. There is no need to become obsessive about cleanliness. Not all bacteria are harmful and many serve to protect the body against infection. An over-enthusiastic use of anti-bacterial soap, together with more elaborate types of germ warfare, may contribute to rather than eliminate problems by washing away the essential bacteria that live on the skin and body hair and destroying the natural layer of fatty acids that acts as a barrier to invading germs.

● <u>Change your clothes frequently.</u> Sweat clings to clothing, preventing it from escaping into the atmosphere so that it becomes 'stale'. Some synthetic fibres are particularly absorbent and you will probably find that it helps to wear natural

*regio
olfactorio*

*nasal
bones*

**The nasal cavity and *regio olfactorio*, a small area just below the eye socket which contains thousands of smell receptors each responsible for identifying specific smells and transmitting them to the brain.
The nasal cavity communicates not only with the nostrils but also with the back of the mouth. The appreciation of flavour derives from the joint action of the separate senses of smell and taste. Only a very few foods, such as salt and sugar, are identified by taste alone.**

'One of the scourges that the woman of today has completely eliminated from her path is that of the trying outcome of perspiration in any form...' said *Vogue* in 1916. Had such a drastic measure been possible (which, thankfully, it was not), it would have had dire consequences for the body. Perspiration is a natural, healthy and important part of the body's temperature control mechanism. It is also essentially odourless. Perspiration is only trying when it is excessive or stale. Staying clean and bathing daily should guard against both of these. If not, the use of an anti-perspirant or deodorant certainly will.

fibres, such as cotton or silk, next to the skin. To remove sweat stains from clothing, rub on full-strength, liquid detergent and leave for about one hour before washing.

● <u>Use a deodorant or anti-perspirant regularly,</u> as protection builds up over a period of days, even with regular bathing, and tapers off if use is discontinued. Roll-ons tend to be more efficient than aerosols, and both are considerably more effective if applied to clean, cool, dry skin.

Deodorants contain perfume that masks odour by over-

powering it. They are made more effective by the addition of an anti-bacterial agent. Anti-perspirants contain metal salts, usually aluminium compounds, which restrict the secretion of sweat from the eccrine and apocrine glands by as much as 50 per cent. They will not actually stop you perspiring altogether, nor will they adversely affect the body's thermostat as there are more than enough sweat glands in the rest of the body to compensate. Although you cannot become 'immune' to a brand of roll-on or aerosol, it does take a

smellsmellsmell

certain amount of trial and error to find the best for you.

- If you are already using a strong anti-perspirant and you continue to sweat copiously, see a doctor or dermatologist, who will be able to make up a special prescription for you. The same can be done for sweaty palms and soles, if your regular anti-perspirant does not work.
- Avoid using the so-called 'feminine' deodorant sprays. The healthy vagina keeps itself clean and does not need deodorizing. Straightforward washing with soap and water should constitute your first line of defence and, should you smell something abnormal, do not disguise it with a deodorant — go to see your doctor.

It is a myth, too, that menstrual blood smells. Like any other type of blood, it only begins to smell when it decomposes and that can only happen when it comes into contact with the air. Use an ordinary unscented, cotton or natural fibre tampon while menstruating and change it regularly — at least every six hours and preferably more often.

- Cut down foot odour by washing socks and stockings frequently. Wear wool and cotton, rather than synthetics, and shoes that enable your feet to 'breathe', by allowing air to circulate freely around them.

A liberal application of surgical spirit or a foot spray can be helpful in counteracting odour when applied to clean dry skin. While foot sprays do not entirely prevent perspiration, they do contain alcohol, which exerts a cooling and drying effect, and an anti-bacterial agent which inhibits the action of the naturally occurring bacteria that mingle with the sweat to produce the odour. A second line of defence is to buy medicated insoles which combat odour through absorption or through the slow release of a deodorant.

- Eliminate bad breath at source — not necessarily the mouth. The most common sources of bad breath are the throat (particularly if you have a throat infection), the stomach (particularly if you have not eaten for some hours) and the lungs (particularly if you smoke or drink). Because bad breath emanates largely from the digestive and respiratory systems, and not from the mouth, the usefulness of mouthwashes is limited. They may give the impression of fresh-smelling breath but it is only a temporary one.

Overcome or guard against bad breath by having regular dental check-ups, stopping smoking, cutting down the amount of coffee you drink and eating frequently. If you are fasting or crash dieting, you will become aware of an unpleasant taste in the mouth. Crunching an apple or a carrot should make it disappear.

Garlic, one of the strongest known smells, which has an unpleasant way of lingering on the breath for hours, and sometimes even for days, has no really effective 'antidote'. Of the many old folk remedies, the only one that really appears to work is that of eating large amounts of parsley with the garlic. Alternatively, make sure that those you live with have eaten it too — so you are all oblivious of the smell.

- Use scent judiciously to enhance your own natural smell, not to kill it. Using a cloying, heavy scent or excessive amounts of a lighter one will actually make you smell worse than if you had left it off entirely. (See pages 162-4 for guidelines on wearing scent and for ways of ensuring that it works with, not against, your own body chemistry.)

TASTE

If you blindfold people and offer alternate glasses of red and white wine, both at room temperature, you will find that they have the greatest difficulty in distinguishing between them. An appreciation of the differences in flavour depends first on colour, second on temperature, third on smell or 'bouquet' and only fourth on the sensation of taste. The same thing can be repeated with a large number of foods. Even onion, which most of us think of as having a very distinctive flavour, will taste exactly like a strawberry if you are not allowed to see or smell it first. This is because all these foods have considerably more smell than taste and your preference for one over the other originates, not from the sensations they produce in the mouth, but from the sensations they produce in the nose.

Unlike the appreciation of colour, sound, touch or smell, the appreciation of flavour arrives from a combination of senses, particularly the sense of smell, which is why nothing impairs your taste like a heavy cold. Even when certain types of food have arrived in the mouth, your appreciation of them may have more to do with sense receptors other than the taste buds. Mustard, peppers and spices are irritants that trigger the pain and touch receptors in the mouth, while smooth and crisp foods are more likely to be distinguished by virtue of their textures, rather than their tastes.

How do we taste?

Taste buds do not have anything like the extensive repertoire of smell receptor cells. They are capable of distinguishing four qualities. These are sweet (sugar), salt, sour (acidic juices, such as lemon) and bitter (coffee). It is the balance between these qualities that determines exactly how a food will taste. Although no food can stimulate all four types of taste buds at once, most foods stimulate at least two, and often three, of them.

Your taste 'threshold' or ability to taste certain foods, depends on three factors. The first of these is how acute your other senses are. Smoking, contrary to popular opinion, does not affect the transmission of taste impulses, but probably does undermine the sense of smell. The second factor is age. The number of taste buds in the mouth decreases as you grow older and, with them, your sensitivity to the tastes of various foods. The third factor is the intensity and duration of the taste stimulus. Taste buds tire very quickly. It is not flavour that makes you reach for a second helping, but unsatisfied appetite.

The appetite, a still little understood control mechanism situated in the hypothalmus in the brain, is influenced by a number of factors of which conditioning is probably greatest, and taste probably least. Appetite may be stimulated by taste sensations but it seems to 'free run' after that. In fact, experiments have shown that there is a lag of about 20 minutes between the stomach feeling full and sending its messages of satiation to the brain and the appetite responding to them and switching off. Put this observation to practical use. A failsafe way of regulating what you eat is to concentrate on sensations of taste rather than appetite, and to stop when they do.

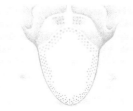

- bitter - salt
- sour - sweet

The taste buds are responsible for transmitting one of four basic taste 'sensations' to the brain. Sweet is detected at the tip of the tongue, sour and salt along the edges and bitter right at the back of the mouth, which is why some foods are said to have a bitter 'aftertaste'. There are no taste buds in the centre of the tongue.

cosmetics

'One cannot use enough lip rouge.' Tallulah Bankhead

Before paint was ever splashed on to canvas or cave wall, it was splashed on to faces and bodies, where it was used not only for symbolic purposes but also for purely decorative ones.

The ladies of ancient Rome used the pulverized paste of crocodile intestine and dung to remove freckles and promote 'fairness' to the complexion, red *fucus* derived from moss to colour the cheeks and lips, saffron and charcoal for the eyes and, more painfully, a soot-filled needle to make the eyebrows more luxuriant by puncturing small holes into the skin. 'She who is blushing with no real blood is blushing with the aid of art,' wrote Ovid in his *Ars Amatoria* and counselled his female readers to do likewise, adding, ''Tis no harm, too, to mark the eyes slightly with ashes or with saffron.' But it had to look <u>real:</u> 'Let not your lover discover the boxes exposed upon the table; art by its concealment only gives aid to beauty.' It would be hard to find a better prescription for the 1980s.

What had been a fashionable diversion for the ladies of imperial Rome, became a positive rage in Elizabethan England. The range of ingredients incorporated into the cosmetics of the day reads more like a modern-day list of poisons than something which could be bought over the counter from the local apothecary: lead oxide, antimony and mercury compounds were all used to contribute to the unearthly pallor which was the prized possession of every Elizabethan lady. Although some women were fatally poisoned by the cosmetics they wore, the fashion persisted right through to the Victorian era, when make-up was firmly relegated to the stage and lower castes of society. No self-respecting Victorian woman would have allowed her appearance to suggest that it owed anything, even remotely, to artifice.

When cosmetics made their cautious come-back at the end of the last century, they were marketed as medical rather than beauty aids. One cold cream was even described as being good for constipation. By the 1920s cosmetics were firmly back in favour, but this time with a different emphasis — that of giving, not of robbing, expressiveness. A Cupid's bow hinted at sensuality, a touch of colour at coyness, a dark shadow at decadence. Expressiveness was pre-packed, promises abounded and the aim was always to achieve <u>the</u> look. Nothing else qualified.

Only in the last 20 years or so have attitudes towards cosmetics finally relaxed. There are no longer any rules. Instead, there are suggestions that will enable you to create your look — a look that is as individual as the clothes you wear or the attitudes you adopt. And one which, like your clothes and your attitudes, will change with your mood. Experiment with your make-up, define and enhance your features, add and subtract colour as you like. Find guidelines to help you on the following pages.

GETTING THE BEST FROM YOUR COSMETICS

Used sensibly and with reasonable regularity, most cosmetics will last just as long as you want them to. If used carelessly or applied only infrequently, you run the risk of irritation and/or infection from bacteria which will eventually form in even the most stable of products. Homemade cosmetics have about the same shelf-life as foods, must always be kept in the refrigerator and should not be used after a week. The shelf-life of commercial products is much longer and far beyond most people's 'usage' time once opened. Products most susceptible to contamination by the air, house dust or dirty fingers are those using cream formulae, such as moisturizers, eye colours and lipsticks. Powder- and alcohol-based cosmetics, on the other hand, will last infinitely longer. But remember to balance medical and aesthetic considerations. When your product starts to separate or discolour, lose its fragrance, flake, cake or harden, it has probably outlived its usefulness and the time has come to replace it. Use the following guidelines to get the best from your cosmetics.

● Heat, light, air and moisture all have a damaging effect on cosmetics in general and perfumes in particular (see page 164). Keep them in a cool, dark place and try to ensure that all containers are absolutely air- and water-tight.

● All cosmetics are subject to oxidization (contamination from oxygen in the air), although those with anti-oxidant preservatives are less so. Cosmetics in open top jars are much more susceptible to contamination than those in tubes. Stoppers or tops should always be replaced after use to prevent air circulating inside and to discourage the introduction of bacteria from dirt and dust.

● Keep your cosmetics to yourself. One study of over 1,000 eye cosmetics showed that, although they were all absolutely free from germs on purchase, nearly half had developed some degree of bacterial activity when examined after six months. Most of them had been used on more than one set of eyes. False sensitivities to products may develop after using a cosmetic that has come into contact with other people's skin or fingers. If you do have a sensitive skin, avoid free-for-all make-up displays on cosmetic counters — that is asking for trouble.

● Clean fingers are the safest cosmetic applicators of all, particularly if you are using cream-based cosmetic products, as bacteria and germs can cling to the greasy residue left on sponges and brushes. If you do develop a sensitivity, it may not be on account of the cosmetic at all, but of the applicators or brushes you have been using, particularly if you have been using them for years.

Replace brushes every year or 18 months and cream eye shadow applicators and sponges every six months. Be particularly careful with mascara wands, or applicators, because these pick up germs very readily and can infect the eye if carelessly applied. Return the wand to the tube immediately after application and limit yourself to, say, two refills of mascara before throwing the whole thing away and buying afresh.

ALLERGIES AND SENSITIVITIES

When you consider that there are over 100,000 differently formulated cosmetics, using several thousand ingredients, it is surprising not that some people develop allergies or sensitivities to one or more of them, but that so few of us do. The processes by which cosmetics are made are so carefully controlled and the ingredients so scrupulously screened, that most of us can put anything we choose on to our skins with absolute confidence and in perfect safety. Even so, there is always a chance of reacting adversely to a product at some time in our lives and it may quite possibly be one which we have been using happily for months or even years. The odds of this happening were put as high as one in two in one study, as low as one in 12 in another. The reaction itself may either be a 'true', demonstrable allergy or — more commonly — a sensitivity which may be slight or severe, temporary or prolonged, may arrive for no clear reason at all and may even disappear on reusing the product that produced it.

Allergic reactions

True allergic reactions to cosmetics are very rare and probably afflict no more than one per cent of users. They are the result of a highly complex immunological response to a substance to which you have already been exposed (see page 214). They can often be successfully isolated and are extremely specific. A similar, but not identical, substance will often produce no effect whatsoever. With very few exceptions, once you have an allergy you will always have it. The only way of avoiding a reaction is to take appropriate evasive action, either by avoiding the type or types of cosmetics likely to contain the allergen or by going for a cosmetic range that you know excludes the offending ingredient.

Sensitivities

Sensitivities to cosmetics are much more common and often more puzzling than allergies, as they tend to be produced in response to a group of substances rather than to one particular component. You may, for example, develop a sensitivity to perfumes in general rather than to geranium in particular. Because of this, sensitivities tend to be much harder to isolate and you may, therefore, find it more useful to adopt the general strategy detailed below than to try to detect the precise culprit.

If you frequently have dry, red, itchy patches on your face, neck and body, you are likely to be what is known as generally sensitivity-prone. This category tends to include those who are pale-skinned, red- or fair-haired, suffer from asthma, hay fever or eczema, burn easily in moderate sunlight and have naturally dry skins. These are all indications that you should use the gentlest skincare and cleansing routines. Choose simple, unscented products and stick with the ones that seem to suit your skin. Read labels before buying products. These have to state any ingredients used from a 'short list' of potential sensitizers and are currently being phased into the UK under EEC regulations; they have been statutory in the USA for some years.

Finally, remember that it is not only possible to grow out of but into a sensitivity and that all skin tends to become more sensitive as it gets older.

Common allergens and sensitizers

Lanolin, vegetable and mineral oils. Lanolin is an oil taken from the sebum of the sheep and used in a wide range of cosmetics — baby oils, moisturizers, night creams, nail varnish removers and some soaps and shampoos. 'Superfatted' or 'moisturizing' are the words to watch out for. Look for creams containing petrolatum instead. An allergy to lanolin can produce a dramatic reaction — a dry, scaly rash, often accompanied by severe inflammation.

Vegetable oils and mineral oils (linseed oil, olive oil, sesame oil, cocoa butter, petrolatum, oleic acid and butyl stearate in particular) are less likely to cause an allergic reaction but have been implicated in intermittent break-outs of small pimples known as acne cosmetica.

Paraphenylenediamine. This ingredient, used in the formulation of permanent hair dyes, is now well recognized as a common sensitizer. Always ask for a patch test, if having your hair coloured and, if colouring your own hair, carry it out yourself (see page 103 for instructions). An allergy or sensitivity to this chemical can be extremely unpleasant and may not necessarily be restricted to the scalp and the hands, appearing as scaling on the face or inflammation around the eyes.

Parabens. This group of preservatives has extremely effective anti-bacterial properties and is used in most cosmetic and medical preparations. Because of their effectiveness, the concentration is so low that it is often well tolerated, but reactions are not unknown. Other allergenic preservatives: quaternium-15 and imidazolidinyl urea.

Formaldehyde. This anti-bacterial agent, used as a preservative in some cosmetics and in much higher concentration in nail 'hardeners', can produce sensitivity reactions on the skin and discoloration or separation on the nails.

Perfumes. These are the most common sensitizers in cosmetics and, even though they are incorporated into cosmetics at a fraction of the concentration used in pure perfumes, may produce irritant reactions. Almost all cosmetic products contain perfume unless labels specifically state otherwise.

Aluminium salts. These highly acidic salts are used in the formulation of all anti-perspirants. While allergic reactions are rare, sensitivities and irritations are common, particularly if the skin is already sore, sunburned or newly shaved.

Allergy and sensitivity check list

If you develop a rash or a patch of sore, scaly skin and suspect that it is product linked, check the following.

● Have you started using a new product or a new version of an old product lately? Check bath oils, body lotions, shampoos, soaps, nail varnishes, moisturizers, cleansers and deodorants, as well as make-up and products that may have been used on your skin or your hair in a beauty salon or by a hairdresser. Check new formulae of old favourites, too, as they may contain new chemical compounds.

If you have a naturally sensitive skin, use one new product at a time to see how your skin reacts to it and patch test it first. Put a coin-sized amount of the product on to the skin every day for a week and discard it if there is any untoward reaction. Remember, too, that reactions may occur after years of contact with the 'offending' substance.

● Is the rash confined to one specific area of the skin or is it more generalized? The response may not be caused by the cosmetics you are using. Allergies to metal, such as nickel, may manifest themselves on the face where rings, bracelets or long drop earrings have come into contact with the skin. A body rash may be caused by a detergent used for washing clothes or bed linen. Confusingly, too, sensitivities to products do not always appear on the area to which they have been applied. An allergy caused by nail varnish, for example, is rarely seen on the hands and appears more commonly on the cheeks or chin where they have rested on the fingers.

● Is the reaction worse at some times and better at others? Does it coincide with times when you wear a different or heavier make-up — the more you put on, the greater the chance of irritation — or a different type of perfume? Or does it become noticeable after washing your hair or painting your nails? If there does seem to be a link with a specific product, stop using it. If the picture is less clear, start a gradual process of elimination, leaving one product aside at a time, until you manage to identify the culprit.

● Is the reaction severe enough to require medical attention? While amateur detection is fine if the response is mild, any severe reaction, such as pronounced inflammation, should be taken to your doctor and, if necessary, referred to a dermatological clinic for diagnostic patch testing. This should determine the ingredient responsible and the products to avoid using in the future.

● Is your skin damaged, sunburned or excessively dry? If so, do not be surprised if it reacts unfavourably to products previously tolerated quite well. This sensitivity is temporary and there is no reason why you should not return to these products, once your skin has regained its natural resilience.

THE LANGUAGE ON THE LABEL
What it's really saying

Hypoallergenic. The 'hypo' in hypoallergenic means 'less' not 'non'. Everyone is sensitive to something and some people will even react to distilled water sprayed on to the face. If you do have a sensitive skin, however, a hypoallergenic range can be very helpful. Products are usually unscented, exclude known sensitizers, such as lanolin, and keep to formulae that are as simple as possible.

pH balanced is a popular selling line used to indicate the relative acidity or alkalinity of a product — relative, that is, to the acidity of your skin and hair (5.5 and 6.8 respectively). The acidity/alkalinity scale is measured in numbers from one to 14. Seven is neutral; numbers below this are acid and above it are alkaline. PH 'balanced' soaps and shampoos are of questionable value for normal skins and hair, which have an in-built ability to adjust their pHs back to normal within about 20 minutes of washing. The process can be speeded up by the use of a toner or hair conditioner, both of which are slightly acid in nature. While pH shampoos can be helpful for processed or damaged hair, because they avoid the swelling caused by the alkalinity of detergents, people with sensitive skins that feel dry and taut after washing should forget their pHs and use a cream cleanser instead.

Organic (as in organic soaps, shampoos, etc) is pseudo scientific for owing its origins to the garden and not the laboratory. As the real meaning of organic is 'belonging to or having the characteristics of a living thing', no product can be organic per se. That is the province of plants, animals and humans. The fact that all cosmetics contain organic derivatives in varying degrees and concentrations probably accounts for the confusion. Although organic (i.e. 'natural and good') is usually considered preferable to synthetic (i.e. 'man-made and bad'), synthetic substances can make valuable and extremely effective cosmetic ingredients.

Natural, anyway, is not always good. There are more known plant or plant-derivative allergens than chemical ones — chamomile is one example. In addition, the possibility of developing a sensitivity or untoward reaction is compounded if preservatives are left out of the preparation. Be wary, therefore, of homemade recipes for creams and cosmetics. They may sound delicious, but it is difficult to ensure that the utensils and containers you use are scrupulously clean and sterile. The lack of preservative makes home preparations an ideal breeding ground for bacteria. Herbal enthusiasm is fine and can make for marvellous looking and smelling products, as long as it is tempered with a little scientific resource. The products to go for are those combining natural ingredients with synthetic preservatives.

Bio (as in bio-energetic and bio-active) is derived from the Greek word, *bios*, meaning 'life'. Whatever its implied sense, the only thing that can be said about a product that is 'bio'-something is that it is designed to be used, and to have an effect, on living tissue. But what product isn't?

Medicated soaps, lotions, deodorants and shampoos are those which have a specific action on the skin or hair beyond their normal cleansing, toning or deodorizing properties. Additives like benzoyl peroxide or salicylic acid have grease-stripping properties and are added to some soaps and certain types of make-up for excessively oily, acne-prone skin. Zinc pyrithione and selenium sulphide are used in anti-dandruff shampoos, aluminium salts are added to anti-perspirant roll-ons and sprays, and bactericides, such as triclocarbon, to anti-bacterial 'deodorant' soaps. These additives tend to make the products harsher and increase the chances of sensitivity or allergic-type reactions. Use them sparingly on sensitive skin and very dry or damaged hair.

Soapless shampoos and cleansing products have not been saponified (made into soap by mixing natural animal or vegetable oils with an alkali, such as potassium). Instead they use a combination of lanolin, oils, colouring, perfume and protein. Soapless preparations are particularly good for washing the face or hair in hard water, as ordinary soap tends to combine with traces of magnesium and calcium salts in the water, leaving tiny deposits on the skin and hair which may contribute to dryness and can even produce a dandruff-like scaling on the scalp.

Superfatted soaps are made by leaving unsaponified fat in the soap during the processing or by adding lanolin, glycerine, beeswax or mineral oils to the soap base. They are particularly good for dry skins.

Emulsions are products containing ingredients that would normally separate rather than combine. Creams and body lotions are emulsions of oil and water mixed freely together during processing but sometimes liable to separate, particularly if they have been kept for some time. Stirring the cream or shaking the bottle should remedy this.

Unscented products have no perfume added during preparation. Unless a label states that the product is unscented, it will probably contain a scent or group of scents — whether it is an innocuously bland-looking foundation or a richly coloured eye-shadow. Scents are usually present in cosmetics at a concentration of around 0.5 per cent (pure perfume 'concentrate' may contain up to 20 per cent). Although the concentration used in cosmetics is relatively low, perfumes are common sensitizers and people whose skins are easily irritated would probably do well to seek out unscented products.

Preservatives are essential to any product not destined for immediate use because they prevent oils and creams from going rancid. Preservatives used may include anti-oxidants to preserve the product from contamination from the air; anti-bacterial compounds (such as phenols and formalin-releasers) to prevent or, at least, discourage the growth of bacteria and moulds; and stabilizers with anti-bacterial properties (parabens) which combine the qualities of the first two and tend to make the best preservatives. They are widely used in cosmetic formulae. Alcohol and alcohol compounds also work as stabilizers and inhibit, but do not entirely prevent, the growth of bacteria. Toners, astringents and perfumes, which are often predominantly alcohol, may not require the addition of further preservatives.

wordswordswords

measuringmeasuringmeasuring

'There is no excellent beauty which hath not some strangeness in the proportion' said Sir Francis Bacon 300 years ago, recognizing that interest and beauty in a face derive much more from how the features work together than on how symmetrically 'perfect' they are.

Beginning your self-analysis with a similar appreciation of harmony, make the most of your face by working with it — accentuate the good, minimize the not-so-good and rebalance the shape where necessary. Make-up can help you to do this, but first consider your features not in isolation but in relation to each other — length of face in terms of width, shape of nose in terms of shape of chin, line of eyebrow in terms of line of eye. Assess your face shape too. If, as is probable, your face is so familiar to you that you cannot pinpoint exactly what is good or not so good about it or what its general shape is, try some objective arithmetic.

Take off your make-up and pull your hair well away from your face. Taking a ruler and holding it absolutely straight, measure the length of your face from the top of the forehead to the tip of your chin (left). Be as precise as possible and measure in centimetres, not in inches. Continue by measuring the widest part of the face (usually along the top of the cheekbone, as right). The perfect oval-shaped face has a length that is one and half times the width. If the width is two-thirds or more of the length, the face is wide (usually round). If the length is more than one and three-quarters of the width, the face is long. Now measure your face across the jawbone. If it is significantly less than the width measurement and the chin is pointed, the face is heart shaped. If it is the same and the chin is blunt, the face is probably square.

Assess the width of the mouth by placing the ruler at the outside corner of the mouth so that it lies parallel with the bridge of your nose, as above right. Look straight ahead. The outside edge of the ruler should line up with the inner edge of the iris.

To see how well spaced your eyes are, measure them for length and then measure the distance between the eyes (below right). It should be one eye's length. If it is less than three-quarters of the length, the eyes are definitely close set; if more than one and a quarter times the length, they are wide spaced.

Test your profile by placing the ruler against your nose and chin (below left). Your lips should come well within it. If they touch the ruler, the chin is weak.

detailsdetailsdeta

Foreheads can be helped enormously by a flattering hairstyle which creates the right frame for the face. When did you last think of changing yours?

Eyebrows should be natural but not unruly. If they are too sparse, allow them to grow out. If too luxuriant, thin them, but always pluck from beneath the brow and never start further back than the inner corner of the eye.

Are your **eyes** round or oval or almond shaped, large or small? Do they droop at the corners? Are they set too close together or too wide apart? Make the most of their shape and size with careful shading.

Dark circles detract from eyes that would otherwise enchant. Camouflage them with a light concealer stick.

High cheekbones are an inherited blessing. If you have to suck in to see them, take heart: careful use of light and shadow can 'lift' them.

Noses that are broad at the bridge or the base can be narrowed by using a darker toned foundation. Noses that are crooked can be 'straightened'.

Skin should be smooth and even in tone and texture. While the right type and shade of foundation will help to refine a complexion, people with problematic skins should look to skincare first, make-up second.

Your **mouth** – is it well-defined and are your lips about the same length or is the top or bottom lip too thick or too thin? Look at the length of each lip too. Lip pencils, a firm hand and the use of two shades of lipstick will help rebalance your mouth.

A heavy **jawline**? The use of a darker foundation blended up over the weighty part will lighten it. The same tone blended at the edges of the jaw will soften a square face.

A **double chin** can be minimized by applying a darker toned shader along the length of the jaw, and blending beneath the chin.

Begin your make-up with a good, even base. If you are fortunate enough to possess one naturally, a plain or tinted gel moisturizer with a light dusting of blusher over the cheekbones is probably the best daytime look. If the skin is blotchy in colour, or uneven in texture, a foundation will help to even out skin colour, making the complexion appear smooth and refined.

If the skin is dry, moisturize first, allow your skin five or 10 minutes to 'settle' and then use a hydrating foundation. There should be no sign of greasiness, certainly no shine, when you start. If the skin is oily, use a good astringent first to remove any immediate oil on the skin and cover with a medicated or matt foundation. Transparent gels and tinted moisturizers can look marvellous on a good, healthy skin.

Aim for a foundation that is as close as possible to your natural skin tone. Try to avoid shades that have a lot of pink in them (not good for any colour type) and go instead for a colour base that complements your natural colouring. Always test a foundation on your face, not on the back of your hand. You only have to put your hand up to your face, to see the difference in colour between them. Be sure to continue the colour as far down your neck as will be showing.

Once you have applied the foundation, conceal or contour where necessary (see right). For the purposes of shading or contouring you will need a foundation two shades or so darker than your natural skin tone and — most important — a light hand. Blushers and shaders that are clumsily applied or incompletely blended can make the face look bruised or striped.

Special covering creams camouflage surface scars admirably — and they are equally effective for birth marks, broken veins and dark circles around the eyes. These dark circles are caused not so much by late nights and lack of sleep as by a natural thinness of the skin, making blood vessels more visible because they are closer to the surface. In addition, the brow and cheekbones cast their own shadows. While concealing creams can be useful for taking the colour out of a pimple, they will not conceal it entirely. A bump in the skin will always show in certain lights. As the head is always turning and the face moving, the light is bound to strike it unflatteringly from time to time. It is therefore worth giving more thought to prevention than to concealment. Spots will disappear more rapidly if not smothered with make-up.

The right light is crucial when making up. First rule: it should be as close as possible to the light you will be seen in. This means making up in daylight during daylight hours and under an electric light after dark. Second rule: whatever your light source, it should be shining directly on to your face. A cross-light that leaves half your face in shadow will not produce an even make-up. Recommended lighting arrangement: a mirror with bulbs, as left, is ideal because it casts a flat even light; alternatively, place one lamp to either side of your mirror so that they are on a level with your face.

For an even foundation blend outwards, following arrows.

basebasebase

The smoothest way to apply foundation: dot it on forehead, nose, cheeks and chin, keeping to the centre of face and away from hairline. Then, using a slightly damp sponge, or fingers, blend outwards following arrows on diagram, below. Smooth some gently on and around the eyelids and lips too. Take foundation as far down the neck as will be showing. Finally, check that foundation is evenly blended around jaw, just under nose, and around the hairline.

Conceal dark circles under eyes and any other darker patches on face with a concealer stick just a shade or two lighter than your natural skintone. Press in with clean fingers over the foundation.

To take the colour out of a pimple, use a small make-up brush, dab it on to a concealer that is the same shade as your natural skin tone and stroke the spot gently. This will help to cover all the contours of the spot.

Narrow a nose that is too broad at the bridge or base by drawing triangles of foundation about three shades deeper than your skin tone on either side of the wide area (1). Then blend into surrounding make-up. Intensify the effect by adding blusher.

Straighten a nose that is slightly crooked by applying a darker toned foundation along the crooked side (2), a lighter one on the other.

Lift a heavy jaw by applying a darker foundation in a long triangle just above the weighty part (3) and blending it into the lighter more natural shade on the face and neck.

Lift cheekbones with clever use of shadow and light. But do not forget to blend. The shader should look like a shadow cast quite naturally by the bone, not a diagonal stripe. Suck in your cheeks to find your cheekbones. Place a triangle of the darker foundation colour in this hollow – the widest part extending towards the ears (4). Blend and add highlight across the bone above (5).

1 2 3 4 5

blushblushblushblush

To find your starting point: look straight at yourself in a mirror and place blusher directly below each eyeball.

For evenings and an exotic look, apply iridescent blusher to temples, earlobes, chin and across the nose...

Blusher enlivens the face, adds colour and polish and, when whisked over eyelid and browbone, gives a natural no-make-up look for daytime. The art in using it lies in three things. The first is picking the right colour — go back to your basic skin and foundation colour and make sure your blusher tones well with it (see colour quiz, page 22). The second is knowing where to apply it (see above) and the third is knowing how much to use. It is much easier to add than to subtract colour. Start with just the lightest touch and build up until you get the depth you want. For evenings, intensify your make-up by moving one or two shades brighter with blusher and lip colours.

Of the three basic types of blusher, gels with their transparent effect are best applied over a moisturizer, or a light

Unless aiming for a dramatic effect, blushers and lip colours should complement each other. In fact, you can improvise very effectively by using your regular lip colour on your cheeks in place of blusher. As a general rule: the lighter the skin tone, the lighter the blusher.

Apply blusher along the cheekbones (opposite). Add iridescent highlights above the bone for shine, darker shading beneath for more emphasis. For daytime and a natural look, whisk blusher around the hairline at the forehead and temples, over the browbone, and centre it on the 'apples' of the cheeks to give a healthy glow. If the face is round, use shader, not blusher (pink has a plumping effect), and emphasize the diagonal slant of the cheekbones. If the face is long, apply blusher horizontally to give an impression of width. Set make-up with a fine covering of a translucent powder, as detailed below.

foundation, but with no powder; cream blushers should be blended over the cheekbones on top of foundation but under powder; powder blushers should be applied over the powder.

Loose face powder is the best way to set a make-up. Choose a fine translucent powder and apply it liberally on a young face, sparingly on an older one. If the skin is dry, the powder should be whisked on lightly with a powder puff or broad soft brush (paint brushes are ideal provided that they do not moult). Remove any excess with a brush. If the skin is oily, powder will help to counteract 'shine'. But it must be applied firmly. Take it across forehead, down centre panel of face and across the chin, pressing in well and releasing as you go.

Before making up eyes, check that foundation is smooth, dark rings are camouflaged and all powder has settled. Attend to the eyebrows. Check them first for length, thin if necessary and brush upwards for an instant wide-awake look. If brows are sparse, fill in with light feathery strokes, using an appropriately coloured eyebrow pencil.

Now take an eye pencil. Check first that it is soft enough (page 123), then line the lids, top and bottom, preferably outside the lashes, keeping hand steady and pencil at a flattish angle to the eye. Neutral, smoky colours – charcoal, browns and greys – are the most natural. Stop the line short of the inner corners of the eye to avoid a narrowing effect. If eyes are close set, keep to the outer halves of the lids only. Use the same pencil to emphasize the natural contour of the eye at the crease.

Next the shadow. Choose one that tones well with your eye pencil, smudge it over the upper lids, blending it down into the line and up into the crease. You can continue building with the colour here in order to intensify the effect. Continue colour out to the sides of the eyes.

For a more elaborate make-up, add highlighter to brow bone. Use clean fingers or applicator and blend outwards.

Finish with mascara. Apply in several thin coats to underneath as well as to top side of lashes. Then remove any excess with a brush, separating lashes as you do so.

Lift droopy eyes by drawing a thin line at the inner corner of upper lid and steadily widening it so that it covers the outer corner of the lid entirely.

Widen eyes set too close together: shade a dark triangle across the outer corners of the upper eyelid.

Minimize the space between the eyes if they are wide-set, by blending shadow across the inner halves of upper lid and up towards the browbone. Slant shadow on outer corners of lower lid.

Make small eyes appear larger. Line inside of lids with soft white pencil. Use a smoky grey or brown pencil underneath lower lashes. Finish with black mascara.

Elongate round eyes by lining insides of upper lids, outer half of lower ones. Apply shadow at corner, as shown.

Bring deep-set eyes forward, by lining outer halves of upper and lower lids with darkish pencil, widening line as you go. Then apply a lighter shadow over the pencil and smudge out.

lipslipslipslipslips

Lip pencils, lip brushes, lip colours and lip gloss will add the finishing touch to your make-up. Prime first with a good base. Smooth foundation on to lips – medicated foundations are particularly good as they dry the lips out and help lip colour to last. If lipstick tends to 'bleed', apply lip colour twice – once before and once after the powder.

Outline lips with a soft lip pencil just a tone or so darker than your chosen lipstick shade. Blot with a tissue to soften the line, recontouring the mouth if necessary. Lift a droopy expression by extending lower lip at corners and 'raising' slightly. Match the length of top and bottom lips by filling the area with a pencil.

Now fill in the mouth with your chosen lip shade. Use an applicator or lip brush to apply the colour. Finish with a transparent gloss.

To line lips, place fore and middle fingers at each corner of the mouth so that the lips are taut. You will find it much easier to draw a steady line.

To make your upper or lower lip less full, line just inside your natural lipline with a colour as close to your own natural colour as possible. Then fill in.

To make the whole mouth less prominent, use two lipstick shades. Fill in the centre section of both lips with the darker tone of your chosen lip colour. Apply the lighter one to either side and blend inwards with a clean lipbrush.

To add fullness to the upper or lower lip take a white pencil and draw a line just outside your natural lipline. Go over the line with lipstick and fill in.

152

The key to a successful daytime make-up: restraint. Concentrate on evening out skintone, add a touch of colour to the face and definition to the eyes and mouth for an effective and completely natural 'no make-up' look. Here, a light moisturizing foundation is smoothed over the skin and dark circles around the eyes are concealed. A soft pink blusher is brushed over the cheekbones and across the browbone and lightly whisked around the temples and the hairline for a healthy glow. Eyes are defined with a neutral brown below and a gentle cinnamon above, and smudged slightly with a cotton wool bud to soften the effect. The lashes are emphasized with brown mascara. A light natural pink lipcolour adds the finishing touch.

The key to a successful evening make-up: emphasis and shine. Build on blusher, lip and eye colours to intensify the effect, remembering that artificial light tends to flatten colour tones in the skin. Add glamour with iridescent highlights and gleaming lipcolour.
Here, exactly the same foundation and blusher shades are used as for daytime (see above). The difference: the blusher is intensified over the cheekbones and dabbed lightly on to the tip of the nose and the chin for a warm 'party' look; a light dusting of pearly translucent powder adds shine.
The eyes are defined in dark bronze, which is continued over the upper lid, into the crease and out to the corners of the eyes, above and below, to emphasize their natural shape. The lids are then lined with black and the browbone highlit with shining gold. The lips are outlined with a deep red lip pencil and filled in with lipcolour in a similar shade.

The 'mousy' colouring of the dark blonde lends itself beautifully to highlights in the hair and to almost any colour make-up. Make the most of this versatility.
Here is a warm look: honey-toned foundation gives a golden feel to the skin, while terracotta blush at cheeks and temples and a deep coral on the lips adds depth. Eyebrows are softened in brown and eyes are defined in deep green, shading out into bronze and gold across the browbone.

Alternative make-up: try a sultry look. Emphasize the eyes in dark grey, shade silver over the lid and crease, use a tawny red on the cheeks and lips. For an exotic 'special occasion' look, define eyes in black, add depth at the crease in charcoal, shade gold over lids, across browbone and above cheekbones and onto the tip of the chin. Try a rich red on the lips and brush lightly with gold for extra shine.

mousemouse

If you have fair hair and a fair skin, you must beware of looking over made-up. As a rule, keep make-up natural and soft and avoid harsh colours and contrasts. Here, a happy medium for evening. Eyes are emphasized with green to reflect the tone of the clothes, shaded in brown across the upper lid and blended up over the crease to a browbone highlit with creamy beige. The cheeks are blushed with apricot and the lips defined in a deeper shade.

<u>Alternative make-up:</u> keep the whole look soft and natural for daytime. Define eyes with brown or grey, shade with pink or silver. Add mascara to the lashes, a touch of rose pink blush to the cheeks and finish with a clear or rose pink lip gloss.

fairfairfair

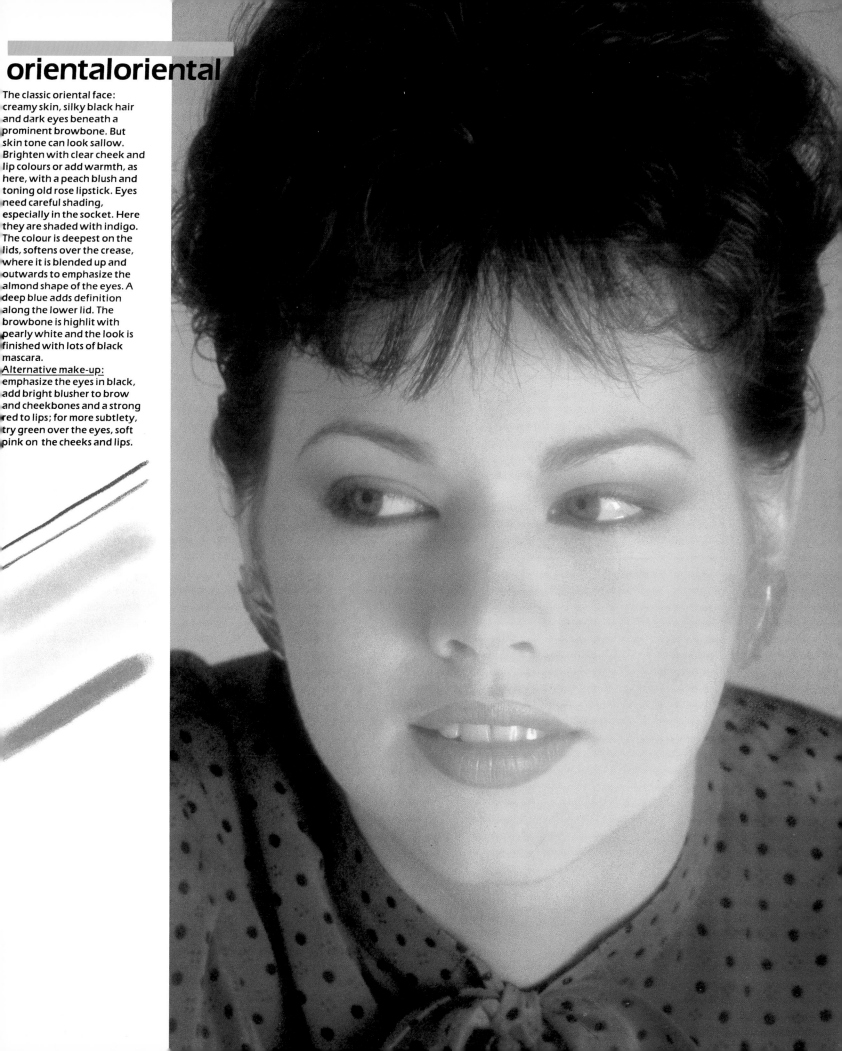

orientaloriental

The classic oriental face: creamy skin, silky black hair and dark eyes beneath a prominent browbone. But skin tone can look sallow. Brighten with clear cheek and lip colours or add warmth, as here, with a peach blush and toning old rose lipstick. Eyes need careful shading, especially in the socket. Here they are shaded with indigo. The colour is deepest on the lids, softens over the crease, where it is blended up and outwards to emphasize the almond shape of the eyes. A deep blue adds definition along the lower lid. The browbone is highlit with pearly white and the look is finished with lots of black mascara.
Alternative make-up: emphasize the eyes in black, add bright blusher to brow and cheekbones and a strong red to lips; for more subtlety, try green over the eyes, soft pink on the cheeks and lips.

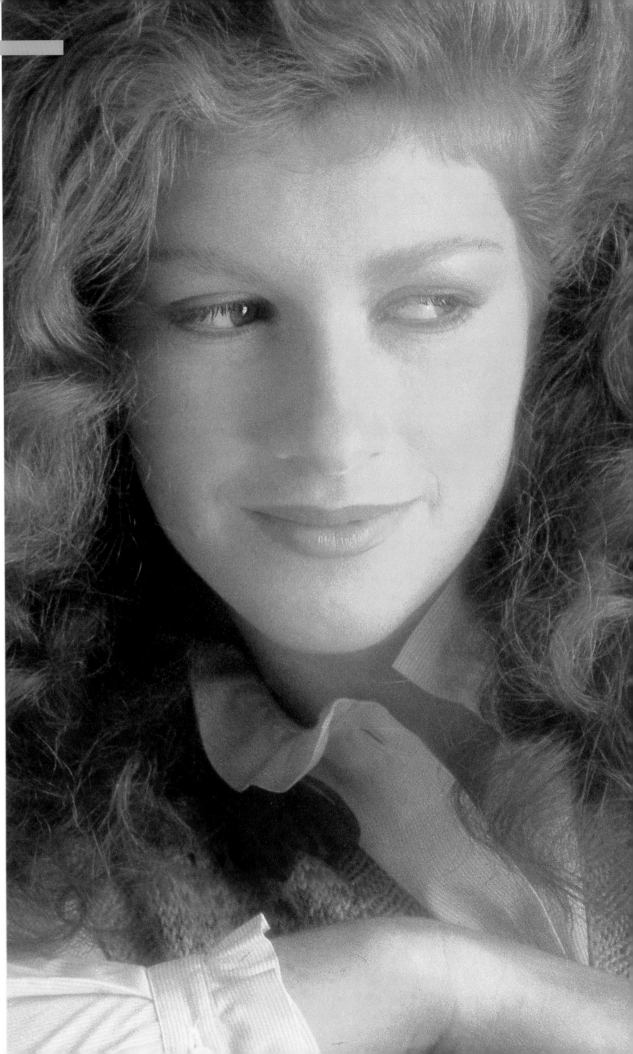

redredred

Redheads should make the most of their natural colouring, particularly if they have freckles. Use the lightest textured foundation or a simple tinted moisturizer for daytime to let them show through. Shape eyes with shades of brown, from bitter chocolate through bronze to pale apricot and gold. Add a touch of tawny blusher and paint the lips a dusty pink.

<u>Alternative make-up: for</u> evening, go for a creamier skin tone and translucent powder to cover. Experiment with deep violets to define the eye, soft mauve for shading and colour. Add an iridescent touch of lilac on the inner and outer corners of the eyes and reflect in a luminous highlight across the brow and above the cheek. Finish with deep pink cheeks and lips.

Black skins tend to have uneven skin tones. Correct with a tinted moisturizer or dark shade of foundation. If necessary, blend your own from two or more different shades until you get the appropriate depth of tone. The result should even out skin tone while giving a polished sheen to the face. Add highlight to intensify the effect, using transparent white or pink over the cheekbones and temples in place of blush.

A neutral daytime make-up is chosen here, with the coral accessories in mind. Eyelids are shaded brown with a hint of green, blended into pink across the brow and defined well with black mascara. Blush and lips are complementary tones of gleaming amber. Alternative make-up: shade eyes in strong peacock shades (bright pinks and blues), cheeks and lips a deep fuchsia or raspberry pink. Try dark burgundies and purples around the eyes for greater depth, silver and gold for an exotic evening look.

blackblack

As you get older and start to lose colour in the skin and hair, you should reappraise your make-up colours and techniques regularly – at least every five years – to check that they are still appropriate for you. As the face becomes drier and more lined, foundation may tend to sink into the skin and to accentuate lines around the eyes and mouth. Use the lightest 'hydrating' foundation on top of a good moisturizer and match the tone carefully with your skin. Choose subtle, positive colours for eyes and lips to counteract greyness.

Here, skin tone is smoothed with its matching foundation and the lightest dusting of powder on the centre of the face (not around the eyes where lines are all too easily emphasized). The soft peach tones of the shirt are reflected in the soft peach cheek colour and slightly richer lip shade. Eyes are shaded to their natural colour – grey/green – and emphasized with mascara, brown not black.

Alternative make-up: define the eyes in soft brown or grey and add colour to lift and enliven face. Try pinks and lilacs or mauves across the eyes, with peaches, corals and soft pinks on cheeks and lips.

greygrey

darkdark

This unusual combination – dark hair with pale skin and light eyes – positively invites contrasts. Use an ivory tinted foundation to match skin tone, a light blush on cheeks, and try soft brown shading for emphasis around the eyes blending into a rosy pink with a white highlight over the browbone. Add brilliance with poppy red lips.

<u>Alternative make-up:</u> emphasize the eyes with darker shading. Try charcoal for definition, soft pink for shading over and above the crease, a deeper tawnier shade in the socket. Add bright sugar pink to cheeks and lips or keep the mouth soft with a simple gloss.

scent
The invisible difference

'One is aware of a woman's perfume before one sees her and her perfume creates the first impression. If I do not know her, I can imagine her. If I do know her, it is a lovely reminder.'

Marcel Rochas, creator of *Femme* (1942) and
Madame Rochas (1960).

The word perfume literally means 'through smoke' and it was by walking through the smoke of a fire, on to which a fragrant pot-pourri of scented woods and spices had been thrown, that the earliest perfumes were worn. Later, incense was burned in temples and on altars and the fragrant wreath of smoke offered up as a gift to please or propitiate the gods. Indefinable and invisible like the deities themselves, the essences were not only inconceivably precious — only one of the Magi brought gold, the other two brought frankincense and myrrh, both aromatic gum resins from Arabia — but were thought to possess almost magical properties. They were used to cleanse and purify the spirit, lift the soul and soothe and heal the body.

Today the context may have changed, but much of the magic remains. Perfume speaks its own language. The language may be soft and subtle, fresh and surprising, mysterious and exotic, but the most important thing is that, because perfume develops and changes on your skin, it is a language that is entirely your own.

If you think of a perfume, any perfume, as a bunch of flowers, you will see that the hands holding them will determine whether they remain an indifferent assortment or are transformed into a beautiful bouquet. Just as it takes an artist to arrange a perfect bouquet, so it takes an artist to create a perfect perfume: one that will never overpower or cloy, that will make its own expressive statement as it changes and develops on your skin and that will last and last and, as it gradually fades, will leave the faintest trace of a fragrance that is still absolutely true to itself. These are the hallmarks of all great or 'classic' scents. Such scents are built, note by note, through all the stages of the evaporation scale (see right). At every stage of the process, different essences will be combined, one on top of the other, until the perfumier gets the combination he is after. Some of the essences used may not be natural at all, but synthetic. These are not inferior in any way. Rather, they are a means of allowing the great perfumier, or 'nose', to indulge his imagination and to create an entirely new smell that has all the freshness and sweetness of a midsummer bouquet but could never be found in one, however artfully arranged. This use of synthetics has enabled scientists to create a 'truer' rendering of fragrances that lose their purity of smell when the essence is extracted in the traditional way — hyacinth and lilac are examples of scents that smell delicious in the garden, but disappointing and almost unrecognizable when the pure perfume is extracted from them. Even more important, it has enabled perfumiers to make use of fixatives — the stronger, longer-lasting smells derived from animals, such as the musk deer and civet cat — without having to endanger the animal kingdom to find them.

All scents are built note by note, according to an evaporation scale, so that together they will create an amalgamated 'chord' and a tangible whole.

The top note is the most volatile part of the fragrance. It has the most immediate effect on the sense of smell, evaporates into the air in seconds, gives the first fleeting impression and remains for about 10 to 20 minutes, before gradually subsiding as the lower notes develop. Examples: bergamot, lemon, lavender, mint, *bois de rose*, coriander.

The middle note is the 'heart' of the perfume. This melts into and transforms the top note and carries the perfume for about 20 to 30 minutes, while the base note is developing. It usually takes 10 to 20 minutes to develop and lasts for two to three hours. Examples: *Rose de Bulgarie*, jasmine, neroli, orange flower, galbanum, verbena, thyme, lily-of-the-valley, rose absolute, lavender absolute, ylang-ylang, 'synthetic' aldehydes C8, C9, C11 and C12.

The base note determines the holding power of a fragrance and is the true characteristic from which the rest of the smell will be created. Initially strong and unpleasant smelling, base notes can take up to half an hour to develop their 'true' smell, when they will be quite beautiful. The base note lingers for six hours or more and, once all evaporation has taken place, a small residual part of it will remain for months or even years. This is known as the dry-out. Examples: patchouli, vetivert, oakmoss, orris, jasmine absolute, sandalwood, cedarwood, artificial musks, ambergris, civet and castoreum.

WEARING SCENT

There are no hard and fast rules about wearing scent. Every scent you buy becomes emphatically your own from the moment you spray it over you. Your 'body chemistry' is the main factor that will determine whether a fragrance works well for you. Once you have found one that does, however, bear the following in mind.

Where to wear it

'Perfumes smell sweetest,' wrote Apollonius of Herophila in a *Treatise on Perfumes* in about 420 BC, 'when the scent comes from the wrist.' Over 2000 years later, Coco Chanel advised that it should be worn wherever one intended to be kissed. They were both right. You can wear scent wherever you choose, but do remember the pulse points — those places where the blood vessels are nearer the surface of the skin and body temperature is therefore slightly warmer. Warmth encourages evaporation and allows the full bouquet of the perfume to develop.

Pulse points are around the hairline, the nape of the neck, behind the ears, under the breasts, in the crook of the arm and inside the wrists and knees and on either side of the ankles. Dab a small amount of the pure perfume *extrait* or a more liberal dash of *eau de toilette* on each of these and let the fragrance wrap itself around you. Avoid overdosing around the neck or in the cleavage because, as the scent rises, it will suffocate your sense of smell — a pity because scent should be worn as much for your own pleasure as for anybody else's.

You can also spray a *parfum* or *eau de toilette* on to your hair and inside the lining of your clothes. But do not spray directly on to fabrics — furs, silks and light materials in particular — as the dry-out, or residual oil, will stain them.

In summer, avoid spraying scent on to parts of the body exposed to bright sunlight. If the scent contains bergamot, a citrus note and a common ingredient in many fragrances, it may stain the skin, leaving a dark ring where scent and sunlight have mingled. In hot weather, apply scent to areas that will not be directly exposed to the sun, such as the palms of the hands, the soles of the feet, the insides of the heels, the hair and the armpit. (Be careful though — this will sting. A good idea is to dab a small amount of the fragrance on to a piece of cotton wool, wave it around for a few moments to let the spirit evaporate and then apply it.)

What to wear it with

Avoid mixing different fragrances. As any fragrance takes about six hours to 'clear', this includes scented soaps, bath oils and body lotions. If you want the fragrance to remain true to itself, use unscented soaps and lotions, baby oil and talcum powder or go for the range of bathroom accessories that matches your scent. If you do want to use a bath essence, go for a floral-based, not a herbal one. Deodorants can collide unhappily with fragrances. Use an unscented deodorant or anti-perspirant and, for sweet-smelling armpits, apply the fragrance there afterwards, as detailed above. Two more killers are strongly scented hair sprays (use an unscented one) and smoking — any fragrance will be smothered by clouds of smoke.

When to wear it

Wear it all day long, from the moment you get up to the moment you go to bed and there too, if you like. Pure perfume *(extrait)* lasts longer than *eau de parfum*, which, in turn, lasts longer than *eau de toilette* or Cologne. As a general rule, repeat the application of scent every four hours. This will give a fresh burst of the fragrance and keep it going throughout the day. As body heat and sweat intensify a fragrance and speed up the rate at which it 'lifts' or evaporates into the air, you will need a lighter fragrance and more of it in hot weather. If you are going somewhere special, bear the temperature rule in mind. Allow the scent 20 minutes to develop in warm weather and up to an hour when the weather is cooler or you happen to be feeling cold.

To avoid a collision of perfumes during the day, take one of three options.

1. Start in the morning with a light *eau de Cologne* or *eau de toilette* and repeat the application every few hours. At lunchtime and in the early evening, dab on a few drops of the more concentrated *extrait* of the same perfume to intensify the effect. Thus, you will build on your fragrance as the day develops.

2. Break up the day with a bath or shower — either using unscented products, so that you present a totally blank canvas for the new fragrance, or its matching accessories — and a complete change of clothes. Any daytime fragrance, even the lightest *eau de toilette*, will 'dry-out' and cling to your clothes for some hours or even days. Then spray or dab liberally with the new scent.

3. Most people find that the different fragrances produced by one House will mix fairly happily and harmoniously. This is because they are characterized by a single signature, from which all the separate scents are then built. If you find two scents that you like and they are both made by the same perfumier, start off the day with the lighter, fresher one and switch to the deeper, woodier one for the evening.

CHOOSING AND BUYING SCENT

All scents are expensive and mistakes can be expensive too. You should choose a scent with the same, or even a little more, care and thought that you put into buying clothes. While the first impression you receive when trying on new clothes is likely to be an enduring one, the same is not true of scent, which takes at least 20 minutes to develop on the skin and to give off its true smell. A quick over-the-counter spray on and a sniff will tell you nothing about the complete perfume. Bear the following in mind when trying, or buying, a new fragrance.

• Apply a small, concentrated spot of the scent. Smell it, leave it and smell it again after half an hour, when the heart of the fragrance is developing. This will give you a real idea of its character and how well it develops on, and is likely to suit, you. Then decide.

• If you can, take a small sample of the pure perfume *extrait* away with you (most companies now make samples expressly for this purpose), live with it for a day or two, ask your friends what they think and see how you like it. Because

perfumes develop at different rates according to their concentrations, it is quite possible that you will change your mind about a smell once you have worn it for a while. If this is not possible, go for the smaller-sized, less expensive *eau de toilette* and use it over a period of days or weeks before buying the perfume proper.

● <u>When trying scent, keep your field of experimentation down to four scents or less.</u> Spread each testing area as far away as possible from the others — a dab at each wrist and in the crook of each arm, for example — to avoid creating a 'stew' that will tell you little or nothing about the individual character of each scent. It is also a good idea to make a note of which perfume you put where. Once you have had them on for some time, you may forget which is which.

● <u>Try to avoid smelling new perfumes on smelling strips or to be influenced by the way a perfume smells on somebody else.</u> This is not the way they are going to smell on you.

KEEPING SCENT

All perfumes are delicate and will deteriorate on exposure to air, heat, moisture and sunlight. Store scents in a cool, dark, dry place and always make sure that you replace the stopper firmly after use.

When a perfume 'goes off', it breaks down into its constituent parts and therefore changes in character. The volatile top note is the first to be lost. You will know that this has happened when the perfume darkens in colour. Once you have opened a bottle of a pure *extrait* you should use it frequently. Because it has a higher proportion of oil to alcohol and water, it is more susceptible to contamination than the more dilute *parfums* and *eaux de toilette*.

Never decant scent into a plastic container, because the plastic will react chemically with it and may alter its character quite considerably. Decant it, instead, into a glass bottle, preferably made of opaque or frosted glass which will protect it from the damaging effects of bright sunlight.

To refill a scent spray or decant a perfume: rinse the container in warm soapy water, fill with half alcohol, half water and allow to stand overnight. Rinse it thoroughly with fresh water and fill.

TYPE	COMPRISES	LASTS
EXTRAIT or **PARFUM**	15-20 per cent perfume; 80-85 per cent spirit.	Two to six hours, depending on your body chemistry. The *extrait* is the truest expression of the perfume. Sometimes, part of the spirit (alcohol) content is replaced by an oil, in order to increase the 'staying power' by slowing down the rate of evaporation.
PARFUM DE TOILETTE	12-15 per cent perfume; mostly spirit; some water.	Two to five hours. This was developed in the USA to provide a stronger and longer lasting alternative to the *eau de toilette*.
EAU DE TOILETTE	5-12 per cent perfume; more water than spirit.	Two to four hours. The higher water content and greater degree of dilution make for faster evaporation. Dab or spray on lavishly.
EAU DE COLOGNE	2-6 per cent perfume; predominantly water; some spirit.	One to two hours. *Eaux de Cologne*, which developed out of the original *Kölnischwasser*, are created to give only the lightest veil of fragrance. They are refreshing, delicate and marvellously revitalizing.

cosmetic surgery

The art of the possible

'For five days I lie in secret
Tapped like a cask, the years draining into my pillow
Even my best friend thinks I'm in the country...'

Sylvia Plath

Greek myth tells the story of Pygmalion, a sculptor on the island of Cyprus, who one day made a statue of a woman so breathtakingly beautiful that he promptly fell passionately in love with it. In vain he embraced it until the goddess Aphrodite, seeing his distress, brought the statue to life. It moved, perfection became reality and Pygmalion and his creation, Galatea, were united at last.

Cosmetic surgeons sometimes tell this story to illustrate what they call a 'Pygmalion complex': the desire to create perfection, not out of marble, but out of human flesh. In reality, however, their aims and their art are very different. Cosmetic surgery is, above all, the art of the possible — not for those in pursuit of perfection, but for those in a realistic search of a better profile, more youthful facial contours, fewer wrinkles or larger or smaller breasts. It has a great deal to do with reality — the reality of what you have or have not got and of what can be done to improve it.

Derived from the Greek word *plastikos*, meaning 'capable of being moulded', plastic surgery embraces a range of reconstructive surgical techniques that were originally developed to help repair the injuries of soldiers wounded in the First World War. These were subsequently expanded to include a series of operations, both for corrective purposes — 'mending' hare lips and cleft palates and lessening the damage inflicted by severe burns, accidental injuries and birthmarks — and for purely cosmetic ones.

It is the cosmetic side of plastic surgery that has become a minefield of medical ethics. Its image is not improved by the handful of surgeons prepared to carry out almost any operation a patient requests, regardless of the possible outcome, as long as the fee is high enough. If you are considering cosmetic surgery, you must ask your doctor or a reliable medical source to refer you to a qualified and competent surgeon.

Although some types of cosmetic surgery sound deceptively simple, it is important to recognize that any surgery, elective or otherwise, involves an operation under anaesthetic, a number of stitches, a certain amount of scarring, a period of convalescence and a risk, however slight, of post-operative bleeding, infection or swelling. With these factors in mind, it is possible to divide the various types of cosmetic surgery available into four categories.

1. Operations carried out on an out-patient basis under local anaesthetic; results are usually good, discomfort minimal and complications rare.
Examples: pinning back the ears (otoplasty) and straightforward eyelid surgery (blepheroplasty).

2. Operations carried out under general or local anaesthetic, with a short stay of three days or less in hospital; discomfort small, results usually good, scarring concealed and complications rare.
Examples: nose surgery (rhinoplasty), most face-lifts.

3. Operations carried out under general anaesthetic, with a stay of up to a week in hospital; period of general discomfort and/or restricted mobility, some visible scarring, together with some risk of complication; results usually justify the risk where the need is indicated.
Examples: all cosmetic breast surgery, abdominal lipectomy (removal of excess fat and folds of skin around abdomen).

4. Operations carried out as above (3), but with considerable discomfort and/or a tendency to disappointing results; scarring tends to be visible and may be extensive.
Examples: breast reconstruction after radical mastectomy; 'recontouring' buttocks, upper arms and thighs.

DECIDING ON COSMETIC SURGERY

Before you embark on cosmetic surgery, and certainly before you seek the advice or assistance of a cosmetic surgeon, ask yourself the following questions.

● What is wrong with my appearance? Look at yourself really objectively in the mirror and try to be as specific as possible about what you feel needs changing. While cosmetic surgery can improve features on the face and body, it cannot change an attitude, reverse a body image or necessarily alter the way you fundamentally feel about yourself and the way you look.

● Who/what am I having the operation for? Again, while a cosmetic operation may be able to redefine a profile, lift a sagging chin or add to your bust measurement, it does not claim to be able to repair a marriage, salvage a broken relationship, reattract an errant lover or secure a job promotion. So be honest with yourself and examine your motives for having the operation. Have it for yourself or not at all.

● What do I expect from surgery? Are you being realistic? If you are 40, nothing is going to make you look 20 again or, if you are habitually shy and retiring, no amount of adding or subtracting is suddenly going to make you the life and soul of the party. The happiest results of cosmetic surgery tend to owe more to the basic outlook of the patient — a mix of realism and optimism is probably ideal — than to the technical skills of the surgeon, although these are obviously important too.

● Can I afford it? Even minor cosmetic surgery is very expensive. In Britain, under some circumstances, an operation may be carried out under the National Health Service or one of the private medical insurance schemes (the latter also applies to the USA). Examples are rhinoplasty, where the shape and structure of the nose interferes with breathing; breast reduction, if the size of the breasts is great enough to cause physical inconvenience, backache or psychological embarrassment; blepheroplasty, if drooping eyelids interfere with vision; and, occasionally, abdominal lipectomy, if muscles have ruptured following a pregnancy. Cosmetic surgery for major disfigurements as a result of injury or accident is, of course, almost always available on the NHS.

• Do my family and friends know that I am contemplating cosmetic surgery? If so, what do they think about it? If I do decide to proceed, who am I going to tell? To some people, cosmetic surgery is an intensely private affair; to others, it is no more secret than going to the dentist and having a tooth out. Most people tend to fall somewhere between the two extremes, seeking advice and/or support from a close friend or member of the family and telling others afterwards, only when the subject arises. Problems can occur if someone close to you is either over-enthusiastic in encouraging you to have the operation or adamantly set against it. In these circumstances, it is difficult to remain uninfluenced by what they think. But, as a general rule, try not to be persuaded either into or out of surgery by someone else.

Whether or not people will be able to detect that you have had cosmetic surgery, depends largely on the type of operation you have. Most of the popular types of cosmetic surgery, if well done, are not easily detectable and this is particularly true of facial surgery. A good face-lift, nose 'job' or pinning back of the ears can make the face look younger or more harmonious but most people will be conscious only of an indefinable improvement in appearance and will not be able to say exactly what has changed. Additional ways of fending off curiosity are to explain the change by growing your hair or adopting a new hairstyle, by saying that you have been away on holiday or that you have lost weight.

Other types of surgery tend to vary widely in detectability and it is usually the degree and extent of the scarring that is the deciding factor. The more bizarre fringes of cosmetic surgery or 'body contouring' — the operations for buttock, thigh and upper arm reduction — tend to be less satisfactory and to leave quite considerable visible scarring. They are no substitute for losing weight through dieting and exercise and results tend to be disappointing. For this reason, details of such operations are not given below.

The first step

During the initial consultation with a cosmetic surgeon, do not be afraid to ask about anything that may be troubling you. In particular, ask your surgeon:

• For his or her assessment of what is required. And be prepared to listen to it. The aim of all cosmetic surgery is to restore harmony and proportion to the face or body and the surgeon is more likely to know how to achieve this than you are. While you should never let yourself be bulldozed into accepting a nose or a breast size that you do not want, you should think twice, for example, about having a snub nose in place of your Roman one, if the surgeon advises against it. It might end up looking totally out of place.

Be wary of a surgeon who is prepared to do exactly what you ask, without first taking a full medical history, giving you a thorough examination and asking your reasons for seeking surgery. This is not prying — it is the professional concern of a highly qualified specialist, only prepared to carry out the operation if he or she genuinely believes that the result will be a happy one.

• What degree of improvement you can reasonably expect. A good cosmetic surgeon will outline all the possible com-plications and roughly assess the chances of any of these happening to you, together with the likely degree of scarring and the time the wound will probably take to heal. For your part, remember that, while you are entitled to honest and straightforward answers to your questions, you cannot expect the surgeon to be clairvoyant. No-one knows for certain how well scars will heal. All people heal differently and even different parts of the same body do not heal at the same rate. Incisions made in the area between the neck and the nipples, for example, do not tend to heal as well as those made elsewhere on the body. This is one reason why dermatologists are often reluctant to remove moles on or in between the breasts if they are situated above the nipple line, and why all cosmetic breast surgeons attempt, wherever possible, to undermine the flesh from the lower quadrant of the breast.

• Where the incision(s) will be made. Any incision leaves a scar and the most successful types of surgery are therefore those where the incision is either totally concealed or rendered inconspicuous. With rhinoplasty, or the nose operation, the bone, cartilage and tissue are undermined from within and there is no external scarring whatsoever. With some other operations, the scar is hidden by a crease or fold in the skin or by a head of hair. Men should be wary about brow lifts that 'bury' the incision mark in the hairline. If the hairline subsequently recedes, the scarring may well become visible.

If the scar is going to be subject to tension (that is, it will not run along a natural fold in the skin), there is about a 10 per cent risk of developing what is known as hypertrophic scarring — an angry, red, raised scar, which can take many years to fade out in the manner of normal scars and may occasionally never fade at all.

• What stitching technique will be used. An incision closed by the traditional 'cross stitching' method will leave a coarser, more noticeable scar line than one closed with stitches buried beneath the skin.

• What the likely degree of postoperative discomfort will be, how long you should set aside for your recuperation and in what ways your lifestyle may be restricted or affected. Any operation involves a certain amount of shock to the system and you will certainly be cheating yourself if you expect to get away absolutely painlessly. So do make sure that you know as closely as possible what you are letting yourself in for.

• What you should do, or avoid doing, in order to make the healing as swift as possible. This will usually include avoiding all sunbathing for at least six weeks (after which, cautious sunbathing may help to 'weather' the scars by giving them a more natural colour), controlling your smoking and drinking as both can increase post-operative bruising and so slow recovery, avoiding rapid weight gains or losses and not attempting or expecting too much during the first few weeks. Bruising and swelling can take some weeks to fade and results are usually seen at their best six months or so after surgery. Finally, keep to all the instructions given to you by your surgeon.

cosmetic surgery

THE OPERATIONS

Face-lift (rhytidectomy)

'Face-lift' is a single, very general term covering a number of different surgical procedures and techniques. Many cosmetic surgeons now have an impressive and flexible repertoire, which can be adapted to each new patient in the light of what needs doing.

For surgical purposes, the face divides roughly into three parts: the upper third being forehead and eyebrows; the middle third being the skin tissue around the eyes and on the cheeks; the lower third being the mouth, jawline and neck. Although the middle section is the one most commonly chosen for the partial or 'mini' lift, the other two can both be lifted independently, if required. Blepheroplasty (eyelid surgery) may sometimes be indicated at the same time, especially if there is excessive wrinkling, puffiness or bagging of the skin tissue on and around the eyelids. Dermabrasion and chemical face peeling procedures should never be carried out at the same time as a face-lift, though they may be carried out three months or more afterwards where the need is indicated.

The idea of a face-lift is not to remove all the lines from the face. Rather it is to eradicate the lines of wear and tear that suggest age, exhaustion or ill health, while leaving — though softening — the natural expression lines. The art lies in creating just enough tension for the 'lift' to hold its new contour, while avoiding the mask-like expressionlessness that can be one of the greatest give-aways of this type of surgery.

As a general rule, the incisions made by the surgeon run parallel to the scalp margins, but about 2 or 3 centimetres (¾ or 1 inch) further back, so that any scarring will be buried in the hairline and thus invisible to the eye. During the face-lift, excess skin and fat are undermined (cut free) and the underlying muscles and supporting tissue pulled backwards and upwards at right-angles to the incision. The operation takes about two hours. Stitches around the eyes are removed after two or three days, around the ears after about a week and on the scalp after 12 days to a fortnight.

As facial skin reacts dramatically to any kind of trauma, all face-lifts are accompanied by a certain amount of bruising, swelling and temporary feelings of numbness and tightness, particularly around the ears, over the eyelids and on the neck. These will usually soon subside, but it will take about six months before the results are seen at their best. The effects last between five and 10 years or more, depending on such factors as hereditary ageing patterns, general lifestyle and freedom from illness, stress and rapid weight fluctuation.

Finally, be wary of surgeons offering an apparently easier method or claiming to be able to tighten slack muscles and remove excess skin tissue in a matter of minutes. This type of treatment can leave a legacy of stretched and sagging skin tissue after only a few months.

Eyelid surgery (blepheroplasty)

Blepheroplasty is carried out both for medical and cosmetic reasons. The puffing and bagging of the upper or lower eyelids that interfere with vision is an inherited trait known as

Brow lift
The incision is made across the top of the hairline on the forehead. The skin is undermined back and up to smooth out 'worry' lines and wrinkles running across the brow. There is no visible scarring in women; scarring may become visible in men if the hairline recedes.

Jawline and neck
The incision runs behind the ears and down just behind the hairline away from the chin. Sagging skin, excess tissue and slack muscles are undermined and tightened to give a firmer, cleaner jawline and to iron out some, but not all, of the wrinkles around the mouth and on the neck.

Mid-face: the mini or 'mannequin' lift
The incision runs inside the hairline at the sides of the eyes and down in front of the ears, where it is hidden by a natural fold in the skin. As the incision does not extend behind the ear, it will do little to affect skin tissue around the jawline and neck and will have minimal effect on lines and wrinkles above the lip or around the eyes. However, it will tighten sagging muscles and drooping skin around the middle and upper face. It is most successfully performed on a patient who has just started to show the first real signs of ageing and does not yet require the full lift. It can last as long as the full lift, after which time it can be repeated or, if indicated, a full lift given in its place. This operation may be slightly complicated by a small amount of residual scarring.

blepherochalasis and is considered a medical problem. The bagging and wrinkling that appears with age is considered a cosmetic problem. In both cases, surgery tends to be straightforward and healing rapid — the stitches being removed after only two to three days. It may involve a short stay in hospital or, if the case is uncomplicated, be carried out under local anaesthetic on an out-patient basis. Scarring is usually imperceptible but a certain amount of bruising and swelling makes the wearing of dark glasses advisable for about a fortnight. As the scars are still very delicate during this time, you should not wear eye make-up for at least two weeks and may feel some tightness over the eyelids for up to six weeks after the operation.

Eyelid surgery
The incision for the upper lid follows the upper eyelid fold and extends out to the outer corner of the eye, where it is buried by the smile lines. Sagging skin on and above the lid and to the side of the eye is cut away and brought down so that the remaining skin tissue is smooth and unlined. The incision for the lower lid is made just beneath the eyelashes. Excess skin and subcutaneous fat are undermined and drawn upwards, before being stitched. An incision should never be made above the eyebrow, as this leaves a visible scar.

Nose surgery (rhinoplasty)

One of the most popular and most successful types of cosmetic surgery, rhinoplasty can do much to restore a sense of harmony and proportion to the face, while leaving none of the tell-tale signs of surgery. The first recorded case of reconstructive surgery on the nose was that carried out by the Hindu surgeon, Susrata, in 6,000 BC. But only in the last 30 years have advanced techniques enabled surgeons to straighten, shorten and reshape the nose from the inside, by undermining and remodelling bone and cartilage. The nose can also be lengthened by the introduction of plastic or bone implants, which are grafted on to the existing bone.

The nose may be altered for medical reasons, such as chronic sinusitis or difficulties with breathing, or for cosmetic reasons. It should not be done until growth has finished at around the age of 15 in girls and 16 in boys. The operation is performed under general or local anaesthetic ('twilight sleep') and usually involves a short stay in hospital. A plaster is worn for up to two weeks after the operation. Although any bruising and swelling should soon subside, breathing may take several weeks to return to normal. The full result is seen after a period of about six months and will, of course, be permanent. Possible complications are nose bleeds, excessive bruising or infection.

Chin implant
The incision is either made across the lower gum inside the mouth or underneath the chin. A high-grade plastic implant is then inserted to bring the chin forward.

Ear surgery
The incision is made just behind the ear. Cartilage and excess skin are removed and the skin restitched.

Chin implant

A chin implant may either be performed on its own for a recessive chin that throws the profile out of balance, or in conjunction with rhinoplasty to restore the relationship between nose and chin. It may be carried out under general anaesthetic but an operation under local anaesthetic on an out-patient basis is more usual. A tight chin bandage is worn for about 10 days and the diet restricted to soft foods only in order to keep the jaw and chin as immobile as possible.

Possible complications are rejection, infection or slippage of the implant, but these happen in less than three per cent of cases and can usually be rectified.

Ear surgery (otoplasty)

Otoplasty involves 'pinning back' over-prominent ears by removing the bands of cartilage behind them which are forcing them to jut out. Most otoplasty is carried out on an out-patient basis under local anaesthetic. A dressing, wound round the head like a wide hairband, must be worn for a week.

Any postoperative discomfort can usually be successfully relieved by painkillers. Stitches remain in for seven days and results are usually excellent.

Dermabrasion (surgical skin planing)

Dermabrasion is a surgical procedure carried out on the face during which the top layers of the skin are removed right down to the deeper dermal layer. It can be effective for some types of facial scarring, particularly pitted acne scars, and for improving the texture of an ageing skin. The operation is carried out under general anaesthetic and involves a two- to three-day stay in hospital. Afterwards, the face is protected by a fine, colourless dressing that gradually peels off as the new skin heals. To begin with, the new young skin will be pink and very tender to the touch. You must not wear make-up for at least three weeks and all sunbathing is outlawed for the first three months, as exposure to ultraviolet can result in patches of permanently altered skin pigmentation. There is a similar risk if you are taking the contraceptive pill. Anyone undergoing dermabrasion should therefore use an alternative method of contraception for at least one month before and two months after surgery.

Although results are often effective, dermabrasion will not remove deeper facial scars and there is a possibility of developing crusts or small white spots while the skin is healing. Allow at least three weeks to convalesce before resuming normal activity.

N.B. Although dermabrasion sounds less drastic than having a face-lift, it is still a surgical procedure and, if not carried out competently, can leave the skin very damaged, even scarred. So make absolutely sure that you go to a reputable doctor.

Chemical face peeling

Chemical skin peeling is less drastic than dermabrasion and can be performed without anaesthetic or hospitalization. While it will not remove small scars, it can improve and refine the texture of the skin and soften fine facial wrinkles. If you have had a face-lift let at least three months elapse before having a chemical peel.

Chemical paste is applied to the skin or to areas of the skin, such as the upper lip, producing a burning sensation, rather like having had too much sun. A dressing is then applied for 48 hours. This is followed by a powder and antibiotic ointment to soften the dry crust of skin which will have formed. This crust gradually peels away to reveal the new, pink skin underneath. As with dermabrasion, it is probably best to keep out of circulation for about three weeks, while the skin is healing and fading to its normal colour. Avoid strong sunlight for six months and do not use any make-up on the area until the healing process is complete.

Breast reduction

Reducing the size of over-large or pendulous breasts is a major procedure that involves an operation under general anaesthetic, a three- to four-day stay in hospital, bed convalescence at home for at least seven days, taking life gently for three weeks and avoiding any strenuous activity for six.

Scarring from breast reduction is more extensive than from breast augmentation, but it will usually fade out quite well after a year or so. However, it will continue to be visible at close range or under bright light. As the scars are not buried in natural folds of skin tissue and are therefore subject to tension, there is an increased risk of unsightly, hypertrophic, scarring in about 10 per cent of patients. Other complications include permanent loss of sensitivity in the nipple (temporary loss is quite normal and usually lasts for no more than three months) and/or the ability to breastfeed, if the operation is not correctly carried out. Future pregnancies can also result in a loss of shape and firmness to the breast and, in some cases, surgical revision might be necessary to rectify this. But, for most people, the dividends of being relieved of such a physical and psychological burden outweigh any of the possible disadvantages.

Breast reduction
Incisions are made around the nipple, down to the base of the breast and across the fold beneath, leaving a scar like an inverted 'T', or to the side, as shown. The path taken will depend on the size and shape of the breasts. Breast volume is reduced by removing fat and surplus skin, while leaving blood and nerve supply to the nipple intact, in order to preserve sensitivity and ability to breastfeed.

Breast augmentation

One of the most popular of all cosmetic surgery procedures, breast augmentation is achieved by the insertion of either an inert, soft, silicon gel implant or an 'inflatable' implant, which is filled with saline after insertion into the breast. The operation usually involves a two-day stay in hospital and a general anaesthetic, though in some US practices it is now being carried out on an out-patient basis under local anaesthetic. The stitches and dressing are removed one week to 10 days after the operation and, until then, patients may be aware of some soreness. Life should be taken very carefully for three weeks and violent exercise avoided for at least six.

Results are often extremely good. The breast feels supple, moves naturally and there is no loss of sensitivity in the breast or nipple. The operation will not interfere with ability to breastfeed, nor will it increase the risk of developing breast cancer or interfere with its detection. There is, however, one significant complication: in about 25 per cent of cases (a very general figure which is higher in some practices, lower in others) the implant can harden, causing the breast to become unnaturally firm and immobile. Practices with low 'hardening' rates tend to place the implant at a deeper level, actually behind the pectoral muscle, and encourage their patients to massage their breasts daily for at least six months after the operation. This persuades the implant to flatten out and counteracts the formation of hard scar tissue around it. In the event of hardening, about 50 per cent of cases can be dealt with through manual compression of the breast by the surgeon. For the rest, surgical revision may be necessary and, in a few cases, the implant may have to be removed entirely. A newer type of implant, known as the double lumen, consists of an outer membrane around an inner core of silicon gel. This counteracts the risk of hardening significantly because antibiotics and corticosteroids can be injected into the space between the layers, thus inhibiting the formation of scar tissue. It will not, however, eliminate the risk altogether.

Breast augmentation

A 4-5 cm (1½-2 inch) incision is either made under the fold of the breast, or in the hair-bearing skin of the armpit, where the scar is effectively rendered invisible, though the operation itself is more difficult as the surgeon is inserting the implant 'blind'. Although incisions are sometimes made around the outer circumference of the nipple, this is not recommended because it may interfere with sensitivity. The implant is inserted into the breast, just behind the existing breast tissue and the nipple. It may occasionally be inserted behind the pectoral muscle.

Lifting ptiotic (drooping) breasts

Breasts that have sagged due to pregnancy, fluctuations in body weight or as a consequence of the natural process of ageing can be elevated by an operation which involves moving the nipples upwards, while still attached to the underlying breast tissue, and cutting away the excess folds of skin. Although this type of surgery will improve or 'rejuvenate' the natural contours of the breasts, it will not fill out breasts which have shrunk in size. In this case, the operation can be carried out with breast augmentation.

The surgical procedure and after-care are as for breast reduction (see opposite). The incisions also follow the same lines. Possible complications are a risk of developing red, inflamed hypertrophic scars (as for breast reduction) and of the breasts sagging anew after a subsequent pregnancy. For this reason, it is advisable to wait until you have had all the children you anticipate before undergoing surgery.

Breast reconstruction after mastectomy

Reconstructive surgery for women who have had part or all of a breast removed, following the detection of a cancer, is still in its early days and the results of the operation depend very largely on the kind of mastectomy that has been carried out. The best results are achieved when a simple subcutaneous mastectomy has removed underlying breast tissue, but has left the surface skin, together with the nipple and the areola, intact. In this case the procedure for reconstruction largely follows the principles of straightforward breast enlargement or augmentation. In the event of more radical mastectomy, where the entire breast has been removed, often along with the lymph glands and much of the chest muscle as well, it is much more difficult to achieve an effective and lifelike result. The breast literally has to be rebuilt, nipple included, and this usually involves a series of operations and skin grafts.

Abdominal lipectomy

Abdominal lipectomy is a major operation, in which excess tissue and folds of skin, left by pregnancy or large fluctuations in body weight, are removed, the muscles and subcutaneous tissue undermined and a new navel constructed. This radical procedure involves a three- to four-day stay in hospital, a week's convalescence in bed and at least four weeks of gentle recuperation. Anyone considering undergoing this type of surgery should first get down to their optimum weight and stay there. Both dramatic weight increase and subsequent pregnancies can reverse the results of the surgery, causing the skin tissue to slacken again. Scarring tends to take about two years to fade.

Possible complications include developing hypertrophic and inflamed scars (about 10 per cent), infection (rare) and swelling or numbness of the skin. This is fairly common and can last for up to six months.

Fat aspiration ('body sculpture')

Although this cosmetic procedure is not strictly surgical, it must be carried out by a competent surgeon under a general anaesthetic. It involves first injecting a non-toxic enzyme into an area of the body (commonly buttocks, abdomen or thighs) to liquefy the fat-forming cells and then introducing a narrow tube and literally sucking the fat out. Although up to 2 kg (4½ lb) may be removed, this is not a means of weight reduction but a means of eliminating stubborn areas of fat. The art lies in removing just enough to iron out the lump or bump, while leaving enough to preserve the natural contours of the body and to match up thigh with thigh or buttock with buttock. Inexpert or over-ambitious aspiration may result in uneven contours, even dents or ridges, where too much fat has been removed. The procedure involves a two-day stay in hospital. Immediate after-effects are bruising, puffiness and oedema (water retention) but these are temporary. After-care includes wearing a dressing for 10 days and having regular massages to help stimulate the blood circulation and to break down fat nodules. The scar is no wider than a fingernail. One possible complication: ridging of the area if the skin is not sufficiently elastic to readjust to the new shape. This is more likely in patients over 40.

Abdominal lipectomy
A horizontal incision is made right across the lower abdomen, just above the pubic hair. Excess skin, fat and muscle are then undermined all the way up the rib cage and pulled down so that the correct level of tension in the skin can be re-established. A new navel is made in the correct place and the skin drawn together and stitched. Up to 6.8 kg (15 lb) of surplus skin tissue and fat may be removed during the course of the operation.

cosmetic surgery

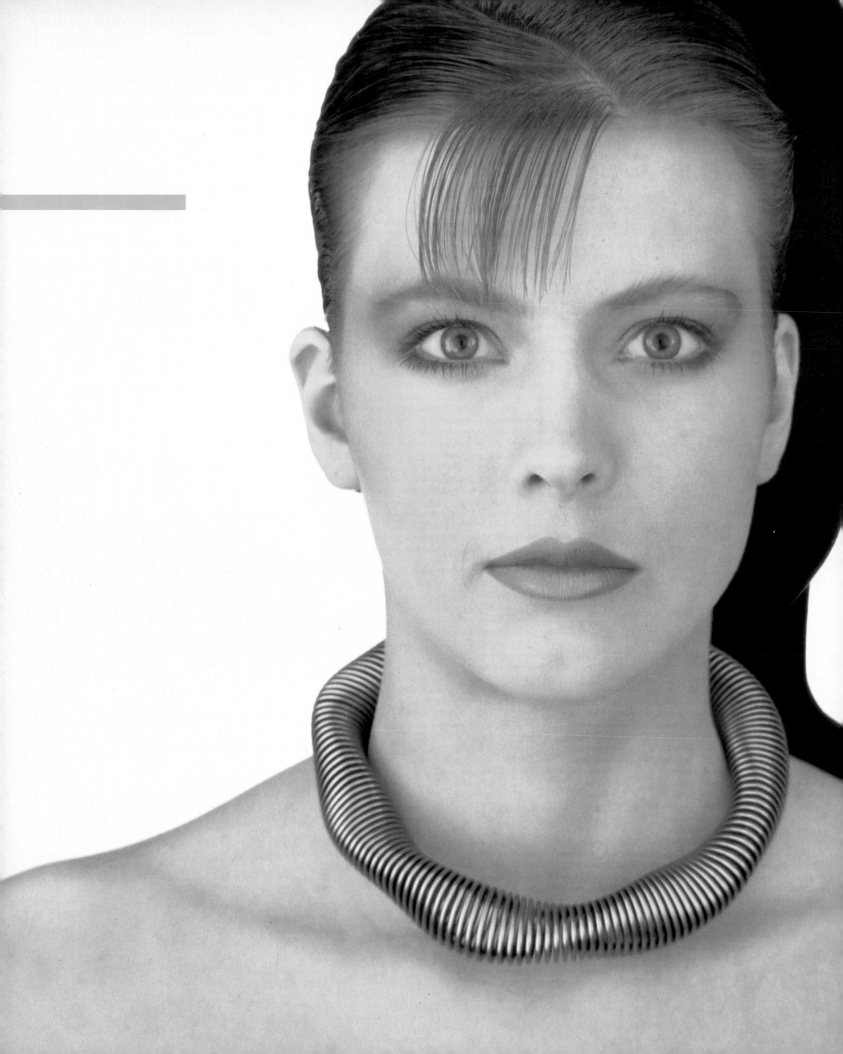

lifestyle

'What is freedom? Freedom is the right to choose and the right to create for yourself alternatives of choice.'
Archibald MacLeish

Your lifestyle has as much to do with beauty as any of the more specific routines you may adopt. You can fast on orange juice for two days out of every seven, exercise frenetically from dawn to dusk, apply your make-up with scrupulous care but, if you do not know how to relax and how to enjoy the 'highs' and manage the 'lows' of life, you will never look or feel your best.

Beauty is wellbeing. It is feeling fulfilled in whatever sphere of life you have chosen, feeling confident about your relationship with the world and its relationship with you, being able to distinguish between the things that matter to you and the things that do not, pursuing the things that you can change and accepting the things that you cannot. It is feeling <u>positively</u> well. Such wellbeing may be reflected in the mirror, but it goes much deeper. It means sleeping well, eating properly, recognizing when you are tense, learning to relax, making some time for yourself in your day, accepting challenges but not expecting to achieve the impossible, taking control of your life and not relying on false stimuli or sedatives such as cigarettes, alcohol, sleeping pills, tranquillizers or other drugs to prop you up. A long list perhaps, but it is the small changes in lifestyle, not the major upheavals, that make the difference. Such changes are within your own control.

Guidelines to help you consider certain aspects of your lifestyle and, if necessary, to revise them can be found in the following pages, but they are only guidelines. First you must ask yourself what you want out of life, what you think is important and where your priorities lie. Take a long critical look, take your Stress Test on page 23 and, if appropriate, complete the smoking and drinking questionnaires in the Personal Profile, then read this chapter and put it into the context of your own life.

Flexibility is important. If you have become entrenched in a certain way of living or manner of doing things, it is all the more important that you should aim to get a new perspective on your lifestyle. Examine your day-to-day habits and question your reasons for doing things, especially things that you do automatically. Examine the way in which you schedule your day and ask yourself how productive it is. Be objective.

Inevitably, things will happen throughout your life that will disturb your equilibrium — most temporarily, sometimes more permanently. But if you can organize your priorities around the things that matter to you and, recognizing what you want to achieve, have the courage and confidence to pursue your aims, you will be able to regain your balance and come out on top.

stress

'We boil at different degrees...' Ralph Waldo Emerson

A writer once likened life to sliding down a razor blade. If you could smooth down the edges, he said, much of the pleasure would disappear with the pain. Stress provides these edges and they can be very productive, giving you the drive to create, to strive and to achieve. It is too much stress that can lead to tension and ill health. Balance is the key.

MANAGING STRESS

● Distinguish between positive and negative stresses and establish your own optimum stress level. A confrontation at work, a tight deadline, the prospect of an evening out among strangers ... There is no single definition of what makes one situation stressful and another not. The situation, while important, is not the major determining factor. The person is. Very similar situations can generate very different degrees of strain. Whether such a strain turns out to be positive or negative will depend principally on what Professor Hans Selye, a leading expert on stress and stress-related ill health, has called the 'optimum stress level'. This level varies from person to person according to personality and methods of handling stress.

Experience is the best yardstick. The stress that will work for you is the one that will take you up to, but not beyond, your limits. At this point, you will be performing most efficiently, will feel most stimulated and will be at your happiest and most self-confident. This is your optimum stress level. If you let stress rise much above this level, you will feel tense, agitated and unable to think or act clearly. If you let it fall much below this level, you will feel bored, unfulfilled and drained of energy and enthusiasm. Being under-challenged, that is, living below your optimum stress level, can be just as stressful as being over-challenged and living above it. In 1981, a British survey revealed illness rates among the unemployed to be significantly higher than among the working population. Elsewhere, too, lower recorded cases of ill health have been noted among women going out to work and running a home than among women doing just one, or neither, of these things.

If you are constantly living below your optimum stress level, fend off boredom with variety and challenge. Seek out new goals and think, perhaps, of changing your job or revising certain aspects of your lifestyle so that you regain your interest and enthusiasm. If you are constantly living above your optimum stress level, modify your goals, take time off to give yourself a breathing space. Immerse yourself in something quite removed from all the pressures and demands exerted upon you at work or at home. Walk, jog, paint, take classes in drama or china restoration, learn a new language, start developing your own photographs. Seek an outlet that is enjoyable and creative — not competitive —

and put the pressures of life aside for a while.

If you have type 'A' personality traits (see test on page 24), are highly competitive and ambitious and tend to thrive under pressure, you should make a particularly determined effort to do this. Studies in the USA, by physicians Dr Ray Rosenman and Dr Meyer Friedman, have shown a consistent and significant link between these personality traits and incidences of stress-related ill health — from tension headaches all the way through to coronary heart disease and complete physical and nervous breakdown. In addition, analyses of the data obtained from a long-term study on health patterns in general and the effects of excessive stress in particular, have recently revealed that women may actually be more stress-sensitive than men. The type 'A' woman is now thought to be four times more prone to stress-related ill health than her more easy-going type 'B' counterpart, while the type 'A' man, the traditional victim, appears only twice as prone.

● Defuse the negative effects of stress by taking more exercise and practising relaxation techniques. The stress response is a highly physical one. It gears the body and the mind to react to a state of physical, not mental, emergency. This is unfailingly appropriate in cases of immediate physical stress, such as finding a bus coming straight towards you when you start to cross the street. (It gives you the energy and the impetus to jump out of the way.) It is less appropriate in cases of longer-lasting psychological stress, such as being caught in a traffic jam for 20 minutes or mentally replaying the previous night's argument and preparing for the next.

Any type of stress alerts the body for action (see following page). If none follows, relatively large amounts of the stress hormones, together with their more dangerous by-products (such as free fatty acids which can raise cholesterol levels) are left circulating in the bloodstream with no chance of being burned off. In such cases, it is up to you to restore the balance. Remember the old adage, 'when in danger, when in doubt, shout and scream and run about', and whenever you feel anxious, aggressive, hostile or tense, let off steam by taking more exercise. This is much more productive than politely suppressing your feelings or losing your temper. It has another advantage too: by taking more exercise, you will be keeping physically fit and experiments have repeatedly shown that a healthy resilient body makes for a healthy resilient mind.

A second way of defusing stress is to practise the relaxation, meditation and breathing techniques outlined on pages 176-8 and so 'switch off' the stress signal in the brain. Anything that calms a restless agitated mind will also quieten a restless agitated nervous system. Relaxation and meditation, essential recreation for mind and body, are two

of the best ways of persuading the sympathetic 'fright, fight and flight' stress response to switch off and the parasympathetic 'rest and digest' response to switch on. With a bit of practice and mental agility, the techniques involved can be learned by anyone.

● Avoid adding unnecessarily to your stress burden. Cigarette smoking, caffeine (found in tea, coffee and cola drinks), cold conditions, competitive behaviour and car driving all have one thing in common. They act on the brain to release the hormone noradrenaline (norepinephrine in the USA) into the system. This hormone (see following page) has wide-ranging physiological and psychological effects. It releases fat for fuel, puts the body into overdrive and makes the brain buzz. It is also highly addictive. Noradrenaline 'addicts' are stress seekers. The 'highs' they seek — and find — are generated by a rush of nervous energy. It is usually only when this energy exhausts itself, that the real ill effects become apparent.

● Control the amount of change in your life. We all thrive on change and variety. But too much change disorientates and distracts and may multiply the negative effects of other, not necessarily related, stresses that you encounter — particularly if the changes threaten to disrupt or substantially to alter your present way of life. Study the list of life change units on page 23 of the Personal Profile, add up your score, be aware of the major changes that may contribute to a high stress count and, as far as possible, take the big events in your life singly — not all at once.

Remember, too, that changes, good and bad, sought and unsought, will be less easily accommodated if your present lifestyle is rigid and inflexible with an outlook and attitudes to match. Flexibility is crucial. Learn it by practising it. Brush aside the cobwebs of habit from time to time by getting up at a different hour, taking a different route to work, reading a paper you would not normally read, seeking new interests, going away on holiday at a different time of year and to a different place.

● Preserve a sense of proportion in the running of your day-to-day life. If every minor setback that you encounter becomes a major crisis, you are making yourself needlessly anxious. So save your energy, and your anxiety, for real crises and emergencies and introduce a healthy sense of distance into your life. Achieve the necessary objectivity by bearing in mind Boswell's sage advice to Johnson: 'Sir, consider how insignificant this will appear in a twelvemonth hence.' Or imagine yourself recounting the event to a friend and, if you can, laughing over it. Most of the minor disasters of life have a distinctly funny side and you often do not have to search far to find the humour. Laughter is marvellous therapy and, like tears, a reliever of stress in its own right. Both erupt on the moment and act as valuable distractions by interrupting the serious, often self-defeating, process of thinking and worrying. Mark Twain, himself a great humorist, gives a memorable insight into the positive effects of laughter in *The Adventures of Tom Sawyer:* 'The old man laughed loud and joyously, shook up the details of his anatomy from head to foot and ended by saying such a laugh was money in a man's pocket because it cut down the doctor's bills like anything...'

WHAT HAPPENS DURING STRESS?

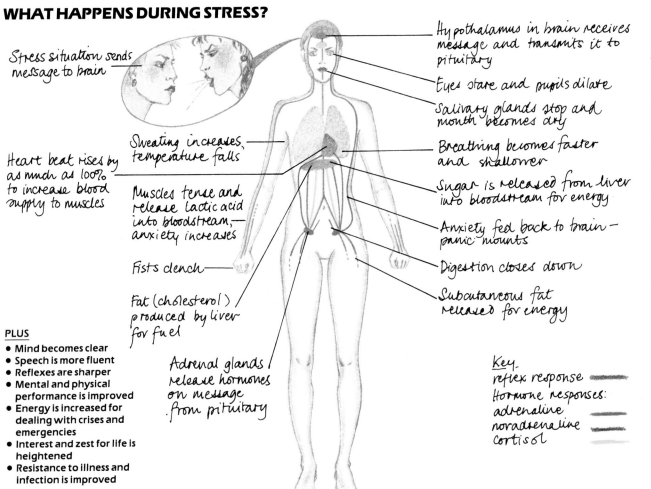

Stress situation sends message to brain

Hypothalamus in brain receives message and transmits it to pituitary

Eyes stare and pupils dilate

Salivary glands stop and mouth becomes dry

Sweating increases, temperature falls

Breathing becomes faster and shallower

Heart beat rises by as much as 100% to increase blood supply to muscles

Muscles tense and release lactic acid into bloodstream, anxiety increases

Sugar is released from liver into bloodstream for energy

Anxiety fed back to brain – panic mounts

Digestion closes down

Fists clench

Subcutaneous fat released for energy

Fat (cholesterol) produced by liver for fuel

Adrenal glands release hormones on message from pituitary

Key.
reflex response
Hormone responses:
adrenaline
noradrenaline
cortisol

PLUS
- Mind becomes clear
- Speech is more fluent
- Reflexes are sharper
- Mental and physical performance is improved
- Energy is increased for dealing with crises and emergencies
- Interest and zest for life is heightened
- Resistance to illness and infection is improved

MINUS
- Mind becomes flustered
- Body is tense and unresponsive
- Speech is confused with liability to stammer and to become tongue-tied
- Mental and physical performance is impaired
- Energy is depleted for dealing with crises and emergencies
- Interest and enthusiasm are low
- Resistance to infection – colds, 'flu, other viruses, possibly even cancer – is lowered

Specific symptoms
- Tension headaches
- Tense, sore muscles – backache, cramp
- Digestive problems – indigestion, frequent attacks of diarrhoea, gastric ulcers
- Physical fatigue and nervous exhaustion
- Insomnia
- Irritability
- Palpitations, panic attacks, raised blood pressure, increased susceptibility to stroke or coronary heart disease

● <u>Control your time, do not let it control you</u>. Time is like money — it goes. The answer, as with money, is to spend it wisely not frivolously. You will then find that you always have something in reserve for the occasions when you really require it.

Spending your time wisely does not mean being ruled by the clock or having to fill every available moment of the day, but being decisive about the way you wish to spend it. If you want to work, to relax, to eat, to watch television or to go away on holiday, make a conscious decision to do so and then follow that decision wholeheartedly. Try not to 'end up' doing something that you do not feel positive about, simply because you are so overwhelmed by the mass of other things to be done that you cannot actually get round to doing any of them. Nothing is more tiring, or more stressful, than not doing the things you intend to do.

● <u>Be single-minded and acquire the art of concentration</u>. A certain amount of pressure can be beneficial. It channels thought and focuses the mind. But too much pressure and too many conflicting demands on your time will lead to panic, confusion and an inability to think or to act clearly. So be selective, decide what you are going to worry about and forget about the rest. No-one, however competent, can do more than one thing at a time. Focus the mind on the one thing that needs doing and needs doing first — and do it. This requires concentration and, for most of us easily distracted by the smaller details of life, concentration requires practice. 'As every divided kingdom falls,' Leonardo da Vinci

observed, 'so every mind divided between many studies confounds and saps itself…'

● <u>Establish an order of priorities each day by writing down everything that you intend to do</u>. This includes everything that you would like to do as well as everything you feel you ought to do. Arrange them in order of importance. If you feel it helps, put approximate times beside each one to indicate when you think you are going to be able to do them. Then do them — but singly and in the order in which they appear on your list. If something has been preying on your mind for days, or even weeks, promote it to the top of the list and get it done before turning your attention and energies elsewhere.

At the end of the day, run through your list and see what you have managed to achieve and what still remains to be done. By noting down how much you manage — or fail — to do, you will become more realistic about what you can expect to achieve. This will then enable you to undertake only those tasks or commitments that you know you have a reasonable chance of completing comfortably.

As you become more practised, you will find that you can only expect to control a part of your day — perhaps no more than an hour if you have a family and children or a particularly demanding job. This is fine, as long as you make that hour your own, protect it and make use of it. Making space for yourself during the day and taking time off from everyone else's demands on your time is an investment, not an indulgence, and one of the best possible ways of keeping the amount of stress in your life within reasonable limits.

On reception of the stress signal, a primitive survival response comes into action. It is known as the 'fright, fight and flight' syndrome and it equips the body to meet the challenge just as though it were going to war. Three key hormones – adrenaline (epinephrine), noradrenaline (norepinephrine) and cortisol – pour into the bloodstream and produce the wide range of biochemical and physiological changes shown above. This stress response is part of an age-old defence mechanism better suited to the stone-age lifestyle of our ancestors than to the space-age one of today. For us, the 'frights, fights and flights' of life tend to be psychological rather than physical, prolonged rather than immediate. This can result in a state of continual arousal or emergency. The consequences: prolonged physical and mental tensions which may place an unacceptable strain on the body.

ANXIETY AND DEPRESSION

Many of us are anxious about something much of the time. Often we may not even know what we are anxious about. A universal experience, anxiety has been described as 'not a fear of illness, pain or death, but a fear of fear…' Such apparently 'free-floating' anxieties often turn out to have the most concrete of causes. In such cases, simply being able to identify the cause may be enough to help the anxiety to subside. Most spectres become infinitely less frightening once they become familiar.

In moderation, anxiety can be a very productive form of stress. It can act as a stimulant — providing the drive to do well under pressure and the acumen to size up a potential threat and to take the appropriate action. But if the threat appears disproportionately large, the anxiety may become excessive and the action inappropriate. In extreme cases, such anxiety may lead to panic 'attacks' or, more specifically, to phobias — inordinate fears of apparently innocuous things, such as cats, thunderstorms or the necessity of leaving the safety of the home environment for the insecurity of the world outside. Such fears can often be alleviated through counselling, sometimes combined with the prescription of certain drugs. Anyone suffering from panic attacks or phobias should not hesitate to seek help.

Anxiety usually emerges in response to a future situation or possibility, depression as a consequence of a past event. They are, however, similar in one essential: just as nobody goes through life without experiencing some degree of anxiety, so nobody goes through life without experiencing some degree of depression. Depression ranges from mild transitory feelings of unhappiness to the much rarer severe depressions which require emergency treatment.

Depression has been dubbed the 'common cold of psychiatry'. It is not a good comparison. Colds are rarely serious, while depression frequently is and must always be taken seriously, whether or not there is a clear underlying cause.

Depressions can be divided into five main groups. The first and most common type is known as 'reactive' depression, because it has a cause and is partially, if not totally, understandable in the light of past events. Most reactive depressions can be traced back to a loss or separation of some kind — loss of self-esteem, of a job, of a close friend, of a long-standing relationship, even of an ideal. The second type is endogenous depression, also known as 'the misery syndrome' because, in this case, there is usually no clear cause for the depression — it is just there. If it is profound, it may linger for months, or even years, before it subsides. It can sometimes, but not always, be successfully treated with anti-depressants. A third type of depression may be said to be caused by hormonal disturbances. Although the influence of hormones on mood is extremely difficult to assess, it is likely that changing levels at critical times of life or, for some women, stages of the month — during or after a pregnancy, over the menopause, before a period — do have a profound effect. While it can be difficult to separate hormonal causes from other factors that may be causing or contributing to the depression, carefully prescribed hormone and vitamin therapy can sometimes have very positive results. Depression can also occur as a 'side-effect' of certain drugs, such as those sometimes prescribed for rheumatoid arthritis, hypertension, or even slimming. Occasionally, severe depressions may be symptomatic of an underlying disorder, such as true manic depression or schizophrenia.

Tranquillizers and anti-depressants

Women use a much wider range of psychotropic ('mood-changing') drugs than men do. A New York survey revealed that women account for 72 per cent of all minor tranquillizer prescriptions, 80 per cent of all amphetamines (principally diet pills), 70 per cent of all anti-depressants and, probably, an equivalent proportion of sleeping tablets. British surveys have produced similar figures. Almost inverse proportions for figures quoted on alcohol abuse (about twice as many men as women) suggest that men tend to use alcohol to sedate themselves from the stresses and strains of life, while women tend to use these drugs.

When carefully prescribed, tranquillizers, anti-depressants and sleeping pills have their advantages in the treatment of some, but not all, types of anxiety or depression. They have their disadvantages too. As these become more apparent, it is being increasingly recognized that these drugs must be prescribed, not in isolation, but in combination with the enlightened support and active therapy of doctor, family and friends. Taken in this way, they can give the depressive time to come to terms with the underlying cause of the depression while alleviating those symptoms that interfere with his or her ability to do so.

Anti-depressants are less frequently prescribed than tranquillizers, because of their limited effectiveness on all but the chronic types of depression. These drugs have a curious action on the brain and central nervous system. While they may make someone who is chronically depressed feel more 'cheerful', they will not produce a 'high' in someone who is not. They will merely make her feel drowsy and ill. Even patients considered suitable candidates for anti-depressants may suffer side-effects, such as blurred vision, drowsiness, lowered concentration, tremors and sleeplessness. In fact, some patients stop taking the drug soon after prescription because they find the depression preferable to the side-effects.

Tranquillizers tend to be more generally effective than anti-depressants and are, therefore, prescribed much more widely. In fact, one of them, Valium, is the most widely prescribed drug in the world. When prescribed for about three to six months, tranquillizers may help in relieving some, but not all, cases of reactive depression. But they should work quickly and effectively. If they do not, an alternative course of action should be considered. Tranquillizers, unlike anti-depressants, can produce a dependency when taken over long periods of time. Withdrawal symptoms are heightened anxiety, raised sensory thresholds — lights appear brighter, sounds louder and tastes metallic — trembling, dizziness, nausea, headache and impaired memory or concentration. If tranquillizers have been taken for a relatively long period of time, they should never be stopped abruptly. A gradual reduction of the dose is essential if side-effects are to be minimized or avoided entirely.

RELAXATION

The secret of relaxation, whether snatching a few minutes out of a busy working day or floating off before going to sleep at night, is not to try too hard. Relaxation, like sleep, is a passive exercise, not an active one, and a human necessity, not an achievement. But the most natural things in the world can be some of the most elusive. The difficult art of doing less and less becomes twice as hard in a world that places ever-increasing importance on <u>doing</u> rather than <u>being</u>, and on <u>making</u> rather than <u>letting</u> things happen. If, like many people, you find it difficult to relax, the yoga and breathing exercises on the following pages, together with one of the following relaxation and mind 'switching off' techniques, may help.

Progressive relaxation

This is a tried and tested technique which involves a mental and physical journey through the body, from the toes up to the head, in which you tense and then relax each part in turn. It works on the sensible basis that you have to be able to identify and recognize a tense, contracted muscle before you can recognize — and acquire — a relaxed, extended one. Do you know what a relaxed muscle feels like? Clench your fist hard and hold the pressure until you become aware of a dull, taut feeling running from your hand, through your wrist and up towards your elbow. Now release it and feel the sensation subside. That is relaxation.

To relax 'progressively' lie down on your back on the floor, with your legs falling comfortably away from each other, your arms away from your sides, your palms facing the ceiling and your head straight. Now you are ready to start. (You may find it helpful to have a friend read the passage through to you so that you can concentrate on the exercise.)

Stretch out your legs, pointing the toes down towards the floor as far as they will go. Hold the stretch for a few moments, then stretch again and release. Feel the tension gradually ebb away. Concentrate on the sensations you receive. This procedure can be applied all the way up the body. Pull your buttocks close together, hold them there and release. Pull your abdomen and pelvis down into the floor, press, hold, press again then release. Clench your fists, feel the tension running along your lower arms, hold and release. Pull your shoulders up towards your ears, hold them there, and release. Press your head into the floor and release. Clench your jaw, clamp your teeth together, press your tongue hard against the roof of your mouth and feel the tension radiating outwards towards your ears. Release, let your mouth drop open and your tongue lie flat. Swallow and feel your throat soften as the tension subsides. Close your eyes tightly together and release. Close them again. Turn your eyes up to 'look' at your eyebrows, down to your toes, to the left and to the right. Lift your eyebrows up as far as possible and, as you release them, feel your forehead open and widen as the muscles relax. Imagine all the lines of worry being smoothed away. Take a deep breath, hold it for a few moments and then let go in a long, drawn-out sigh. Finally, check every part of your body for signs of tension — feet, hands, shoulders and mouth in particular. Then let your mind relax. Think cool, white thoughts and drift.

Autosuggestion and autogenics

These techniques work on the principle that you can talk your body into a state of relaxation. At its simplest, this is achieved by the slow and rhythmic repetition of a two-syllable word, like re-lax or hea-vy. Allow your breathing to follow its own rhythm (the second syllable should fall on the out-breath) and you will find that you can soothe your mind while simultaneously encouraging your body to unwind.

A much more sophisticated version, known as autogenics ('generated from within'), was developed by a German neurologist Dr Johanne Schultz in the 1930s. This involves persuading different parts of the body to generate their own specific sensations — starting with heaviness and warmth in the limbs and progressing to calmness and regularity of the heartbeat, awareness of a natural breathing rhythm, warmth in the abdomen and, lastly, coolness over the forehead. The complete technique takes time, practice and the guidance of a trained teacher. A simpler, abbreviated technique is therefore given below.

Start by thinking yourself heavy. Turn all your attention to your right arm. Say 'my right arm is heavy', repeating the phrase to yourself until you feel your arm becoming increasingly heavy and more immoveable. Repeat the exercise with your left arm and, once you can generate sensations of heaviness quite easily, extend the exercise to your legs ('my right leg is heavy', etc). If you find that you can achieve a good state of relaxation, progress to thinking yourself warm. But do not rush it. Try to acquire what Schultz termed an attitude of 'passive concentration'. Listen without judging, observe your body without thinking 'good' or 'bad' and concentrate simply on producing the appropriate sensation.

Biofeedback

This is an excellent and practical aid to relaxation, if you have access to a machine. It works like a lie-detector, using tiny electrodes on the skin to measure resistance or temperature

Neck, shoulders and upper back are commonly tense. Release the tension by giving yourself a massage. Place an orange between you and a wall or door and roll it around, by bending and straightening the knees. Concentrate on tense and painful areas – between the shoulder blades, along the spine, up across the shoulders and the neck ... (This is not an exercise for smart walls and precious wallpapers, as the orange may stain them.)

and to relay the 'message' as a series of lights on a screen or as audible bleeps. The more tense you are, the greater your skin resistance (or the lower your temperature) and the more numerous the flashes and the bleeps. The idea is to try to widen the intervals between them by using whichever relaxation method you find effective. Because the machine gives constant information (feedback) on how well you are doing, it is usually only a matter of minutes before you find that you can exert some control over the frequency of the flashes or bleeps. Biofeedback is valuable both because it shows you that you can relax, and you are not alone if you are convinced that you cannot, and because it encourages you to adapt your methods to the machine and so helps you to select the technique that suits you best.

Massage

Massage is an excellent aid to relaxation. The most profitable areas of the body to concentrate on: the neck (left), the foot and the stomach. Many of the nerve endings of the body lie in the sole of the foot and, when stimulated or soothed through massage, can generate a strong sense of wellbeing throughout the body. Take a ball and roll it under your foot, varying the pressure as you go. Imagine that it is coated with ink and that you must cover every centimetre of the sole with it.

A good stomach massage is extremely calming. This one centres around the ancient Chinese acupuncture point known as the *Hara*, or 'Sea of Energy', and is situated three fingers' width below the navel. Lie on your back with your knees bent so that your abdominal muscles are fully relaxed. Massage the stomach with the palm and fingers. Move in a clockwise direction. Breathe out and apply more pressure as you stroke down and across the *Hara*, breathe in and release the pressure as you move up and over the navel.

Mind control

This refreshingly down-to-earth means of quietening the mind simply involves starting at the number 100 and counting backwards to zero. Breathe out as you mouth each number and let the numbers follow the rhythm of your own breathing. If other thoughts intervene do not chase them away. Watch them passing across your mind and disappearing out of view, rather like a train travelling through a landscape. Then return to your counting, picking up where you left off. As you get more practised, you should find that sequences are longer, interruptions fewer and that you can achieve the same degree of mental relaxation counting from 25 as you did from 100.

Meditation

Meditation can be an extremely effective way of controlling restless, fragmented thinking, overcoming anxiety, releasing tension and refreshing the mind.

You do not need a guru, or even a particular philosophy, in order to meditate, although some guidance may be helpful initially. You do need 15 to 20 minutes when you know you will not be disturbed. You must also be comfortable — or you may find yourself meditating on your own discomfort.

Sit with legs crossed and hands folded in your lap so that your body makes a circuit around which your energy can flow. Close your eyes. Quieten your mind by allowing it to dwell on an object. Let the object be all-absorbing. Visualize a symbol, focus on a rhythm of breathing (see following page) or repeat a single word or phrase. Some sanskrit words and phrases known as mantras, while meaningless to Western minds, have a remarkable resonance. Try the ancient Siddha Yoga mantra *Om Namah Shivaya* or simply repeat the word 'One'. As you do so, retreat a step and watch your mind at work. Become a passive observer. Meditate.

Yoga

Yoga postures (*asanas*) and breathing exercises (*pranayama*) are a practical and effective way of counteracting stress and tension. The straightforward steps here can be practised by anyone. Although some of the positions may appear awkward or difficult, they are not contortions and should be practised with gentle and precise movements — not with great athleticism. The postures are designed to refresh the body after an inactive day, increasing muscle tone and bringing oxygen to every cell in the body. Although they may appear to be static, you will soon discover that the spine and limbs will continue to stretch as the muscles relax. The postures can be held for some seconds, even minutes.

The yogic practice of deep breathing takes time to acquire and is best taught by a qualified teacher. Beginners should concentrate on establishing a steady rhythmic breathing. Draw the breath in from the pelvis so that the abdomen is pulled back towards the spine and the chest expands as the lungs fill. The exhalation should be smooth and the air gradually released, not consciously pushed, from the lungs. Practise the breathing separately at the end of the session and you will find that, as the breath is deepened and controlled, the nerves are soothed and the brain refreshed.

Basic rules

1. Practise in a well-ventilated room.
2. Progress slowly and methodically, studying each picture, together with the instructions, before attempting the poses.
3. Practise on an empty stomach.
4. Practise the postures regularly, preferably every day. Enjoy it. Do not force the postures. Go as far as feels comfortable.
5. If in doubt about your health, consult your doctor first. Do not use these postures as a curative. While yoga can do much to improve the many minor ailments that result from poor posture and wrongly used muscles, some of the claims made for it have been greatly exaggerated.

Breathing

Breathing techniques provide some of the most rapid routes to relaxation. Here are two of the simplest.

The first is an emergency technique which works first by distracting, second by soothing, the mind. Use it whenever you feel anxious or agitated. Standing if possible by an open window, breathe in through your nose, steadily and deeply, over a slow count of 12. Hold for 12. Then open your mouth and produce an audible 'haaah' as you release the air from your lungs. This invaluable instant calmer should not be repeated more than two or three times as the depth of breathing may make you dizzy.

The second breathing technique is much gentler and can be practised indefinitely. It is Chinese in origin and is known as the 'Breathing of Selflessness'. It makes a useful adjunct to any of the relaxation techniques described earlier and entails breathing through your nose throughout. Breathe in to a count of four and out to a count of 12. Keep the rhythm so smooth and so gentle that a feather would not stir if it were held in front of your nose. Continue counting until the breathing falls easily and automatically into the rhythm you have established and a deep state of relaxation is reached.

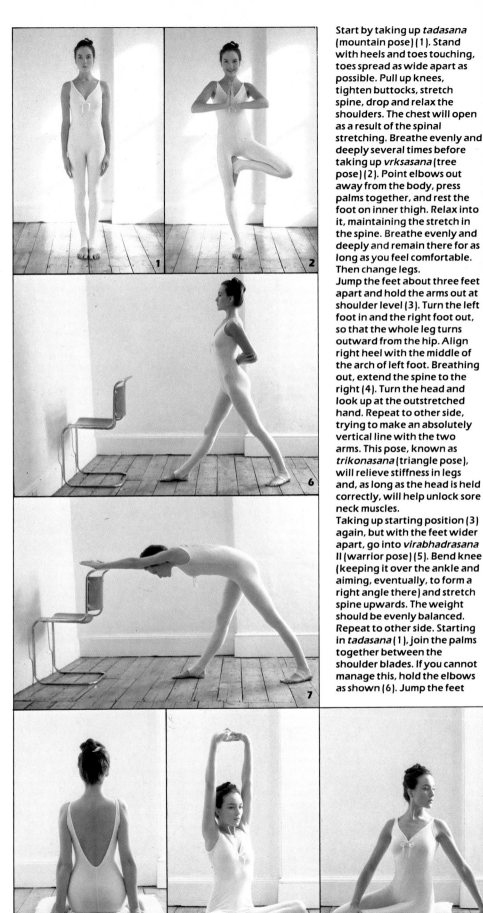

Start by taking up *tadasana* (mountain pose) (1). Stand with heels and toes touching, toes spread as wide apart as possible. Pull up knees, tighten buttocks, stretch spine, drop and relax the shoulders. The chest will open as a result of the spinal stretching. Breathe evenly and deeply several times before taking up *vrksasana* (tree pose) (2). Point elbows out away from the body, press palms together, and rest the foot on inner thigh. Relax into it, maintaining the stretch in the spine. Breathe evenly and deeply and remain there for as long as you feel comfortable. Then change legs.
Jump the feet about three feet apart and hold the arms out at shoulder level (3). Turn the left foot in and the right foot out, so that the whole leg turns outward from the hip. Align right heel with the middle of the arch of left foot. Breathing out, extend the spine to the right (4). Turn the head and look up at the outstretched hand. Repeat to other side, trying to make an absolutely vertical line with the two arms. This pose, known as *trikonasana* (triangle pose), will relieve stiffness in legs and, as long as the head is held correctly, will help unlock sore neck muscles.
Taking up starting position (3) again, but with the feet wider apart, go into *virabhadrasana* II (warrior pose) (5). Bend knee (keeping it over the ankle and aiming, eventually, to form a right angle there) and stretch spine upwards. The weight should be evenly balanced. Repeat to other side. Starting in *tadasana* (1), join the palms together between the shoulder blades. If you cannot manage this, hold the elbows as shown (6). Jump the feet

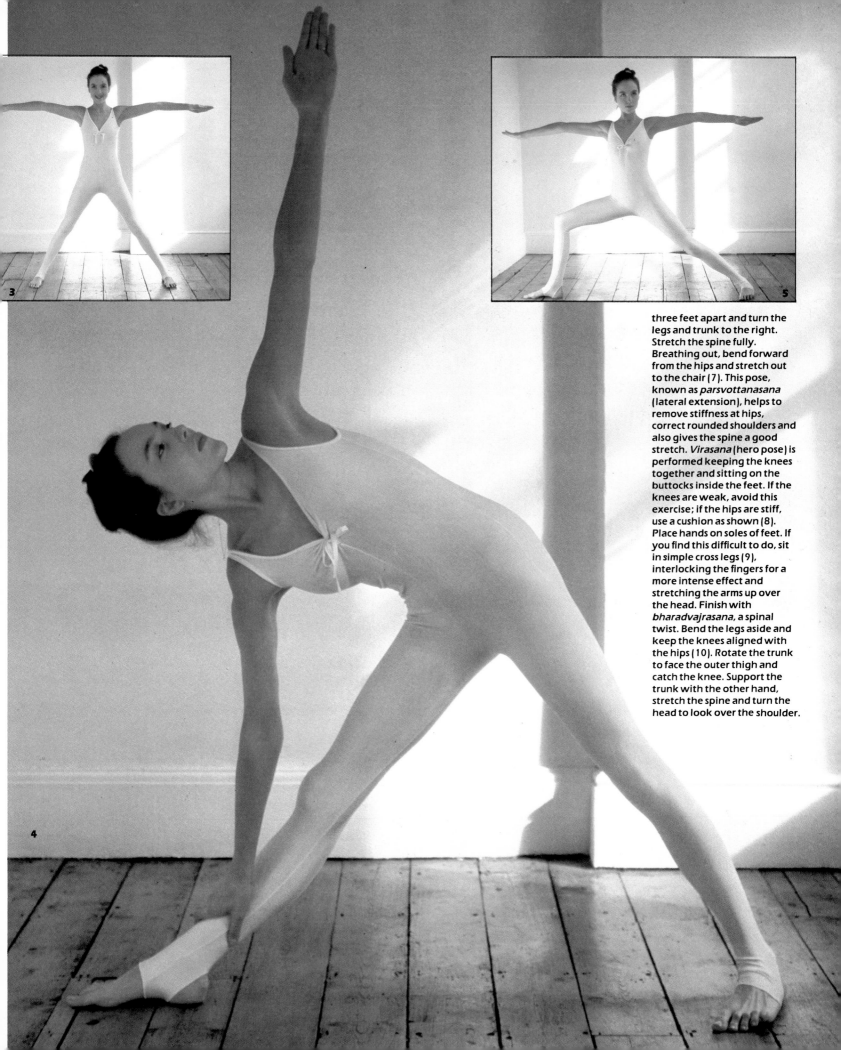

three feet apart and turn the legs and trunk to the right. Stretch the spine fully. Breathing out, bend forward from the hips and stretch out to the chair (7). This pose, known as *parsvottanasana* (lateral extension), helps to remove stiffness at hips, correct rounded shoulders and also gives the spine a good stretch. *Virasana* (hero pose) is performed keeping the knees together and sitting on the buttocks inside the feet. If the knees are weak, avoid this exercise; if the hips are stiff, use a cushion as shown (8). Place hands on soles of feet. If you find this difficult to do, sit in simple cross legs (9), interlocking the fingers for a more intense effect and stretching the arms up over the head. Finish with *bharadvajrasana*, a spinal twist. Bend the legs aside and keep the knees aligned with the hips (10). Rotate the trunk to face the outer thigh and catch the knee. Support the trunk with the other hand, stretch the spine and turn the head to look over the shoulder.

sleep

'How do people go to sleep? I'm afraid I've lost the knack...' Dorothy Parker

'Don't go to bed,' advised Mark Twain, insomniac and humorist, 'because so many people die there.' But the truth is that, if you did not, you would soon find yourself yearning for cool sheets and a soft pillow. Sleep is essential to all living things, which have their own cycles of waking and sleeping, activity and rest, stop and go. It is the balance between them that generates energy and interest. During sleep, the body gathers its resources, regenerates its energies, rebalances its metabolism and orders its psyche. Just how much it refreshes the brain and the body becomes apparent as soon as you are deprived of it. Lack of sleep quickly diminishes the quality of life when awake.

Fortunately, this does not happen very often. Sleep is so natural and vital that the body tends to take just as much, or as little, as it needs — 14 hours or more as a baby, six hours or less as an octogenarian. But it is not just age that determines your sleep requirements. The amount of sleep needed varies considerably from person to person and with the state of the mind and emotions. The 'eight-hour rule' stands corrected: experiments in sleep laboratories have consistently shown that some people need as few as five hours sleep before waking refreshed and alert, while others may need as many as 11. Body and brain seem to restore themselves at different rates in different individuals.

If you are worried that you are not getting enough sleep, consider first that you may, in fact, be getting all the sleep that you need and that you are only suffering from unreal expectations. Use your diary to record how much sleep you got, or <u>thought</u> you got, over a two-week period and how you felt the following day. If you habitually wake up feeling unrefreshed and carry on feeling excessively tired throughout the day, then you may not be getting your full quota.

You should bear in mind, too, that if you are going through a particularly demanding phase in your life and are getting very little sleep, you do not have to 'make it all up'. Studies on students kept up for three nights in a row at the University of Florida, USA, showed that they only needed three to four hours extra sleep to make up for the 24 that they actually lost.

GETTING TO SLEEP

Sleep cannot be forced. It is easy and effortless and seeks you out. It does not come with 'trying', still less with anxiety. As worrying about not getting off to sleep is almost certain to keep you awake, relax using any of the methods detailed on the previous pages and let sleep surprise you. It almost certainly will.

Even so, there will be times in most people's lives when sleep is elusive. You may take hours to go off to sleep and then find that your time asleep is disrupted by periods of wakefulness. Or you may wake up at dawn, overcome with

tiredness, and yet find it impossible to drop off again. You may get up in the morning and somehow struggle irritably through the day, only to go to bed at night to find that exactly the same thing occurs. Sleeplessness has become a pattern. While it is a pattern that usually resolves itself spontaneously, prolonged periods of insomnia can lead to considerable strain and should be discussed with a doctor, in order to rule out any medical cause.

If you are suffering from sleeplessness, do not automatically reach out for the sleeping tablets. These should be a last, not a first, resort and should be prescribed only for a short period of time in order to help you ride through a particularly difficult period. Despite their evident drawbacks, however, sleeping pills (hypnotics) are still widely prescribed. In fact, it has been estimated that every tenth night's sleep in the UK is hypnotically induced. While the newer generation of sleeping tablets may be safer than the previous ones (the barbiturates and the highly addictive Mandrax), they still work in large general areas of the brain, often depressing the central nervous system in amounts above that simply required to produce sleep. They may linger in the system long enough to give feelings of 'hangover' on awakening together with impaired concentration and alertness the following day. In addition, these sleeping tablets, which are almost identical in chemical composition to tranquillizers, can lead to dependency. With long-term use, it becomes increasingly difficult to get to sleep without them — so treat them with respect.

Countdown to sleep

● <u>Go to sleep when you are tired, not when it is time for bed.</u> If you feel wide awake, stay up. Capitalize on having a little extra time. Write letters, read a book or take a short walk. Fresh air and gentle exercise are two of the best sleep inducers, particularly if taken an hour or so before going to bed.

● <u>Get up earlier.</u> One of the most effective ways of counteracting difficulties in getting off to sleep at night is to get up an hour earlier in the morning. It takes a certain amount of discipline, but persevere and you will soon find that you start feeling sleepy at bedtime — if not before.

● <u>Avoid over-loading the stomach just before going to bed.</u> Meals are best eaten early in the evening and proteins, despite their unearned reputation for causing bad dreams, make much better bedtime foods than carbohydrates. Cheese, milk and yogurt are all good, late night foods. Milk is especially suitable because it contains high levels of an amino acid (tryptophan) that seems to play a significant part in mobilizing the sleep-inducing chemicals in the brain.

● <u>Make sure that your system is not running on overdrive by the time you go to bed.</u> Question your intake of all stimu-

Stage IV: the deepest stage of sleep. The body temperature is at its lowest and breathing at its slowest and most even. It is difficult to arouse the sleeper out of this stage and dreams are very rarely recalled. This is the period of sleep walking and night terrors – the most terrifying dreams of all. Brain waves follow the delta pattern – very large, slow and jagged. Because restoration of body and brain is thought to be at its most intense during stage IV sleep, it is traditionally considered to be the most valuable. Onset usually occurs within the first hour of sleeping and may not be repeated for the rest of the night. Insomniacs and people who take sleeping pills will miss out on this stage entirely.

REM (Rapid Eye Movement): the busiest period of sleep. Brain waves resemble the waking alpha pattern and the more adventurous type of dreaming occurs. These dreams are often vividly recalled on awakening. Blood pressure, pulse rate and breathing become faster and irregular. The need for REM sleep varies greatly with age. Children, especially babies born prematurely, need most. There have been speculations that the foetus spends all its sleeping time in REM. People taking sleeping pills have little or no REM sleep and on ceasing to take them, go into what is known as 'REM rebound' – compensating by having more on subsequent nights until the shortfall has been made up.

Sleep threshold

Stage I

Stage II

Stage III

Stage IV

REM

lants, including alcohol, sugar, salt, coffee, tea and cola drinks. The caffeine present in the last three speeds up the metabolism and its 'buzz' may last for up to seven hours. If you go to bed at midnight, coffee or tea drunk at six o'clock in the evening could well be keeping you awake. While caffeine tends to interfere with sleep in the early part of the night, large amounts of alcohol, though sleep inducing, will cause you to wake early. Because the alcohol is still in the process of being metabolized, it can react upon the digestive and nervous systems, causing restlessness and gastritis — not to mention hangover.

● Take a warm bath before going to bed. Use an aromatic essence to soothe and relax you. Some of the pure, essential oils, such as chamomile, melissa and orange blossom, are deliciously relaxing. As you soak, try going through a simplified progressive relaxation procedure, or simply lie there and enjoy it, letting your mind drift. Do not drift off altogether, though.

● Make yourself a sleep pillow. Place a pot-pourri of herbs — dried hops, lime blossom, rosemary, lavender, jasmine and chamomile — in a flat linen 'envelope' and tuck it inside your ordinary pillow. Hops and lime blossom, in particular, have very strong sleep-inducing properties.

● Check that you are comfortable in bed. This may sound obvious, but it is crucial. There are no hard and fast rules about what makes one bed and bedroom preferable to another — it is your own comfort that counts. If you find you tend to sleep better in other beds, your mattress may be too soft or too hard, or your bedroom too cold or too hot. The ideal temperature is thought to be 15.5-18°C(60-64°F). Consider these points and, if necessary, change them.

● Is your sleep disturbed by background noise? Some people find sound, whether the indistinct rumble of traffic or the louder ticking of an alarm clock, conducive to sleep. Others find it infuriating. In addition, there is the possibility that your sleep is being disturbed by noises of which you are unaware. If you do find it difficult to get off to sleep, keep waking up during the night, or feel excessively tired the following day, embark on an anti-sound strategy. Move to another bedroom away from street noise, have double-glazing fitted to bedroom windows, or buy a pair of earplugs.

● If sleep still eludes you, try building up the amount of carbon dioxide in your body. It is easy to fall asleep in a crowded room when the windows are tightly shut, because the amount of oxygen available is gradually being displaced by carbon dioxide. Carbon dioxide acts as a natural tranquillizer (in excess as a poison too, of course), numbs the brain, slows the body responses and produces a range of 'symptoms' identical to Stage I sleep. This breathing technique will temporarily raise your carbon dioxide levels, without dangerously depriving you of oxygen. Take three deep breaths and, at the end of the third, hold on to the outward breath for a count of six, so that the lungs are completely emptied of air. Repeat this twice. Then do it once again but, this time, having exhaled as deeply as possible, breathe 'minimally', not gulping for air but breathing from the top of your chest in short, shallow breaths. This will increase the amount of carbon dioxide in your system and can be repeated every 10 minutes or so — if you are still awake.

drugs and dependencies

'The chains of habit are too weak to be felt until they are too strong to be broken...'
Samuel Johnson

None of us likes to feel that our lives are bound in and circumscribed by habit. Yet we order our days within its comfortabie, reassuring framework: From the moment we wake in the morning, we run through a habitual pattern of doing things — getting up at a certain hour, dressing in a certain order, having a certain type of food for breakfast, reading a certain daily newspaper, taking a certain route to work . . . All these are habits. Try changing a few of them to see how odd and 'wrong' they feel.

While it would be ridiculous to suggest that such habits are harmful, a second set of habits does require more careful attention. These are the dependencies. They can be physical, emotional or psychological — sometimes all three at once. A psychological or emotional dependency can be defined as an overriding need for something or someone without the involvement of a drug. The dependency of an infant upon its mother is an obvious example. This early and natural dependency may later be exchanged for others in adulthood that are not only inappropriate but are also, often, potentially harmful. You can become dependent on almost anything — gambling, people, eating, television, noise, slimming pills, sleeping tablets...These are not simply habits, but props used to bolster up confidence, to give a sense of security, to add excitement or to provide a refuge from the pressures, miseries and frustrations of life.

Of all the dependencies, the most dangerous are the drugs, because theirs is a physical as well as a psychological dependency and one which may end up by destroying your health, if not by actually killing you. In medical terms, drug use is said to constitute a dependency when two factors are present. The first is a tolerance to the drug at doses that non-users would find unacceptable or unpleasant and the second is physical signs of withdrawal if the drug is denied. The obvious drawback: many drug users are not aware either of their tolerance to the substance or of their possible susceptibility to withdrawal symptoms while continuing to take it. It is, therefore, crucial to recognize and to break the chains of these drug habits before they become too strong to be broken or, at least, to be broken easily.

It is extremely difficult to quantify the effects of many drugs. Some, like LSD and other hallucinogens, may not lead to addiction but may still cause irreparable mental or physical damage. Others, like marijuana, cause no apparent physical damage but the 'high' they produce can lead to a strong psychological and social dependency. In addition, marijuana produces distortions of time and space that could be potentially dangerous when driving. Although some drugs have their uses, it is important to recognize what these are, together with their limitations, and to examine your own reasons for using them.

SMOKING

'Most people who drink alcohol or take sleeping pills are able to do so in moderation or on special occasions and can tolerate periods without them, but the most stable and well-adjusted person will, if he or she smokes at all, almost inevitably become dependent on the habit…' The British Royal College of Physicians

Smoking is not only one of the most habit-forming activities there is; it is also one of the most dangerous habits on which to become dependent. The main dangers are cancer of the lung, mouth, throat, oesophagus, pancreas and urinary tract; stroke and coronary heart disease (the risk of sudden and fatal heart attack is up to five times greater if you smoke); chronic bronchitis (95 per cent of sufferers are smokers), emphysema and pneumonia. These health risks should not seem remote. If predictions are right, the lung cancer rate for women will have exceeded that for breast cancer by the end of the decade in both Britain and the USA. No woman is complacent about getting breast cancer, yet millions invite lung cancer every time they light a cigarette.

There is another aspect to consider if you smoke: other people. Smoking during pregnancy presents a known and established hazard to the foetus (see page 200). Less well known are the perils of 'sidestream' smoke. This is emitted into the air from a smouldering cigarette and sometimes contains carcinogens (cancer-producing substances) in higher concentrations than those inhaled directly by a smoker. Two important studies, one in Japan and one in Greece, have shown that the risk of lung cancer among non-smoking women is higher if they are married to smokers. Such findings are likely to make 'passive' smoking the health issue of the decade.

If you smoke at all, answer the questionnaire on page 25 of the Personal Profile. Consider your reasons for continuing to smoke and the reasons why you should stop and write them down in two columns. If the second outweighs the former, make a really determined effort to stop. In addition, consider the following.

Stopping smoking: guidelines to giving up

● Is a low-tar cigarette really better for you? Yes, if you take notice of the advertisements with their emphasis on 'wising down' or 'adopting a low profile'. Not significantly, if you listen to the scientists, whose research results show almost unanimously that, if you change your brand of cigarettes from a high to a lower tar variety, you will also tend to change your manner of smoking. In other words, you will compensate for the loss of nicotine, either by inhaling each cigarette more deeply and more often or simply by smoking more of them. The difference, then, is probably smaller than it has been made out to be, unless you smoke high tar unfiltered cigarettes. In this case, a lower tar count and a filter will certainly work in your better interests. If a cigarette is to work in your best interests, however, you must leave it in the packet.

● Will cutting down the number of cigarettes you smoke each day or week help you to give up? Perhaps, but only if you have tremendous reserves of self-discipline, in which case giving up right away should present no problem. In most cases 'cutting down' is simply a euphemism for not giving up entirely and is unlikely to work, because the rules you set yourself are too flexible: if people know you are cutting down, they will not exclaim when they see you with a cigarette in your hand, but they will if they know you have made a resolution to give up. Many 20-a-day smokers, reluctant to give up completely, talk of embarking on a 'cutting-down' strategy until they reach a point where they are smoking one or two cigarettes a day. This rarely, if ever, happens. The truth is that occasional smokers account for less than two out of every 100 smokers and do not have a history of heavy smoking.

If you do want to 'wean yourself' off nicotine, stop smoking and chew nicotine gum instead. This is available on prescription in the UK and, at the time of writing, under trial in the USA prior to sales there (nicotine lozenges are currently available across the counter without a prescription). Although the taste of the gum is initially unpleasant, it is worth persevering because it satisfies your cravings for the drug, while minimizing the effects of withdrawal, and thus enables you to break the smoking habit. In the UK, trials for the year 1980-1981 showed the gum to have a success rate of nearly 50 per cent after 12 months. This is an impressive figure when compared with the five per cent who manage to give up on their own for an equivalent period of time. Other therapies that can help you to negotiate some, but not all, of the early hurdles include acupuncture, hypnotherapy and aversion therapy (smoking yourself sick). All of these can work well, provided that the desire to stop and to stop permanently is there in the first place. No technique is yet available to help the smoker who does not want to stop — nor is there ever likely to be.

● Is there such a thing as a 'right' time for giving up? Yes, it must be when you wholeheartedly want to stop. Anything less than complete commitment is likely to come to grief. No-one ever claimed that giving up was easy. It can be extremely difficult and the longer you have been smoking and the more ingrained the habit has become, the more difficult you are likely to find it. Good times for giving up are, first and foremost, the moment you really decide you want to, without delaying until tomorrow morning, next week or the New Year; after an illness or a cold, when the desire to smoke has temporarily disappeared; when embarking on a relationship with someone who does not smoke and dislikes the fact that you do; on holiday when you are temporarily removed from most of the everyday cues that fuel your desire for a cigarette; before you become pregnant.

● Once you have made the decision to give up, how can you keep to it? Reinforce your resolution by making it as public as possible. Make sure that everyone you know is aware that you have given up and ask them to support your non-smoking. Every time you resist the urge to smoke, count it as a victory and remember that each victory becomes progressively easier to achieve. Be aware, too, of all the positive aspects of giving up — how much better you are feeling, how much money you are saving, how much healthier you will be in 10 or 20 years' time and how much younger your skin will look.

● Will giving up smoking cause you to put on weight?

habitshabits

Possibly in the short term, not significantly in the long term.

Three factors are thought to be responsible for a gain in weight after giving up smoking. The first is that you start to feel hungry: your palate wakes up, your sense of smell becomes more alert and your appetite more suggestible. In addition, the hand-to-mouth habit dies hard. Eating in general and snacking in particular are the closest substitutes for lighting and smoking a cigarette. Fight against this by being on your guard. Find something else to occupy your mind and your hands. The third factor may be physiological. Some studies have shown that smoking raises the metabolic rate by reducing the rate of oxygen consumption. After giving up, the metabolic rate drops so that, even if the amount of food eaten remains constant, you absorb more of it because you metabolize it more slowly.

Some weight is commonly put on over the first three months of non-smoking. In the USA, the largest single study on the long-term effects on weight of giving up smoking among women (a 42-year trial) revealed that the immediate weight gain varied from smoker to smoker and correlated closely with the amount smoked — the heaviest smokers gaining up to 13.5 kg (30 lb) while the lightest ones gained less than 2 kg (4½ lb). Encouragingly, this survey, in common with others in Britain and Europe, revealed the greater part of the weight gain to be temporary. Over a lifetime of non-smoking, it levelled out to just 1.8 kg (4 lb). The heaviest smokers must have subsequently lost considerable amounts of weight.

If you are one of the millions of women who use cigarette smoking quite consciously as a means of suppressing your appetite and so controlling your weight, review your priorities. The prospect of gaining a few pounds should not seem more terrible than the prospect of succumbing to one of the diseases listed earlier. So take a long-term view. Be aware of the pitfall of 'substitute eating' but do not be too censorious with yourself — enjoy the new appreciation of flavour you are experiencing instead. If you are a heavy smoker, you may find nicotine gum (or lozenges in USA) helpful. This not only helps you to break your habit in stages but also seems to have a positive effect on weight. The four studies on the subject have all shown that gum chewers gain up to 50 per cent less weight than average over the first six months of non-smoking.

● Are there any ways of minimizing the dangers of smoking, if you are not yet confident about your ability to give up? Yes, with reservations, since the only safe cigarette is the one that you do not smoke. There are ways, however, of making one cigarette less unsafe than the next. Take fewer puffs, try not to inhale, put your cigarette out earlier and never relight it. Never smoke a cigarette right down to the filter. All the toxic substances in the tar are at their most concentrated in the last third.

Try to cut down the number of cigarettes you smoke. If you are a 'packet-a-day' person, buy them in packets of 10 not 20. Start smoking later in the day. Analyze your desire for each cigarette you take out of a packet, and cut out those you would have smoked 'automatically' and without enjoyment. As you find yourself smoking less and less, ask yourself whether you would not be better off giving up altogether.

DRINKING

'The first draught serveth for health, the second for pleasure, the third for shame and the fourth for madness…' Anarchasis

Alcohol is a relatively simple chemical substance easily produced in decaying vegetable matter. It is found naturally in the body as a by-product of the breakdown of food in the gut. It is a powerful sedative and reinforcer of mood and has been used throughout the ages for its deliciously intoxicating effect.

Alcohol has a curious two-fold effect on the brain and central nervous system. First it stimulates — releasing inhibitions and generating mild feelings of elation and wellbeing. Then it depresses — slowing responses, causing speech to be slurred, coordination to be lost and sexual desire to evaporate. In moderate amounts, alcohol will send you to sleep. In massive quantities, it can lead to coma and even to death.

Drinking is enjoyable and relaxing, promotes a sense of wellbeing and can contribute hugely to the enjoyment of any meal. In excessive quantities, however, it is both poisonous and highly addictive and can leave a massive trail of destruction in its wake — broken marriages and homes, financial crises, psychological and physical breakdown and innumerable symptoms of ill health. Because alcoholism is 20 times more prevalent than all other forms of drug addiction put together and because we are all at risk, we must choose what role we are going to let alcohol play in our lives — how much we are going to drink, in what manner and towards what end.

If you have not already done so, check your responses to alcohol and your reasons for drinking in the questionnaire in the Personal Profile. Start counting the amount you drink rather as you would the number of calories you eat or cigarettes you smoke. For the purpose of counting, alcoholic drinks can be divided into units. One unit is a centilitre of alcohol, contained in 284 millilitres (half a pint) of beer or its equivalent. Hence, 1 unit of alcohol = 284 ml (½ pint) beer = 1 glass wine or champagne = 1 sherry glass fortified wine (sherry, port, vermouth, etc) = a standard single measure whisky, gin, vodka or brandy. The size of the glass or measure is obviously important. Some wine goblets can hold twice as much as the smaller, standard glass and allowances must, therefore, be made for this.

Drinking habits

Light drinking (occasional or weekend drinking; no more than two or three units a day). Drinking for enjoyment on special occasions or restricting the amount you drink to two or three glasses of wine (or their equivalent) a day will enhance mood and reduce tension. This type of drinking can be positively beneficial, particularly if the alcohol is taken with a meal, because it relaxes you and gives your digestion a chance to work properly.

You should be especially careful when driving though. As few as two units of alcohol will impair your judgement to some extent.

Moderate drinking (frequent drinking; between four and seven units a day). Although medical experts are reluctant to draw up hard and fast rules about how much anyone should drink (tolerance varies from individual to individual as does susceptibility to physical dependency and/or damage), four units is generally agreed to be the amount of alcohol people can consume daily without putting their health at risk. Even so, if your intake is habitually closer to five than, say, three, certain chemical changes in the blood will be detectable and the burden on the liver will be increased. Women are particularly at risk of liver disease. A woman who regularly drinks seven or more units of alcohol, particularly if it is on a daily basis, has a significantly higher chance of developing hepatitis or cirrhosis than a man.

At five units, your blood/alcohol level will almost certainly have risen to a level that will make you unfit to drive in the legal sense in Britain and in many states in the USA.

Heavy drinking (daily or 'binge' drinking; eight or more units a day). Drinking in this quantity may lead to the formation of a strong habit. Even if there is no physical dependence on alcohol, there is likely to be a strong psychological one.

Heavy drinking increases your susceptibility to a number of hazards — physical, emotional, social and professional. These include aggressive or withdrawn behaviour, tearfulness and loss of confidence, poor work performance, absenteeism, loss of interest, loss of memory, anaemia, digestive upsets, frequent bouts of colds or 'flu, ulcers of the stomach and digestive tract, heart disease, pneumonia and the diseases of the liver mentioned above. Heavy drinkers should make a positive and determined effort to reduce their consumption to that of the moderate or light drinker (preferably the light one). If they find this difficult or impossible, they should seek medical help.

At 10 units, your blood/alcohol level is almost twice the British legal limit and your judgement is substantially impaired. The likelihood of your having a car accident is 25 times greater than if you had drunk nothing at all.

Excessive drinking is not so much a question of the amount as the manner of drinking. Excessive drinkers may drink furtively or in secret, will create excuses and seek outlets for their drinking, and will continue to drink, and to become drunk, even when they know they should not. Excessive drinkers need to drink. For them, alcohol is one of the most important, if not the most important, aspects of their lives.

If you drink excessively, and continue to do so, some degree of ill health is inevitable and physical dependence is likely. Do not wait for double vision, with or without hallucination, loss of sensation in the hands and feet, trembling of the hands (*delirium tremens*) or nightmares before you do something. Cut your drink consumption right down. If you find it impossible, seek help right away.

Drinking codes
- Stop when your drinking exceeds the safe unit count.
- If you can, eat when you drink, so that the alcohol is absorbed more slowly into your bloodstream. If you will not be eating, have something to eat or a glass of milk first.
- Avoid unfamiliar drinks and avoid mixing your drinks.

When you drink, alcohol passes through the stomach into the intestine where it is rapidly absorbed into the bloodstream. The rate of absorption is determined by the strength of the drink (diluting slows it down), the amount of food eaten (drinking on an empty stomach more than doubles it) and your body weight (the lighter you are, the more rapid it is).

Once in the bloodstream, alcohol is oxidized (broken down) at a rate of about one centilitre an hour – the equivalent contained in a glass of wine or a single measure of spirits. Oxidization renders alcohol harmless by releasing toxins which are, in turn, potentially damaging to the liver cells. Excessive drinking can lead to liver diseases such as hepatitis and cirrhosis. Women are particularly susceptible.

Water... satisfying, refreshing, 100 per cent natural and absolutely calorie free. Acquire a taste for it – become a water expert. Run through the ranges of bottled mineral waters from the great spas or volcanic regions of Europe or the USA. True connoisseurs can identify waters by their taste, just as wine experts can identify wines by their bouquet...

● <u>Drink slowly and sip rather than gulp.</u> Slake your thirst with water or soft drinks, not with alcohol. Do not keep your drink in your hand, put it down on a nearby table. You will then be drinking when you really want to and not just because it is 'there'.

● <u>Do not drink spirits neat</u> — dilute them. Still 'mixers' are preferable to carbonated ones, as the effervescence can speed up the rate of absorption into the blood. Both red and white table wines can be diluted with water and lose surprisingly little of their taste and colour. Top up white wine with soda water and ice and you have a deliciously cool summertime drink.

● <u>Beware the continually topped-up glass,</u> because you will certainly be drinking more than you think you are. If you are doing the topping up, do not fill glasses before they are empty. Never rush to fill a glass if someone is drinking too fast.

● <u>Develop a positive attitude towards non-drinking, both in yourself and in others,</u> particularly those who have determined not to drink. Never press people to drink more than they want and do not allow yourself to be pressed either. Always provide soft drinks and/or mineral water when entertaining. Recipes for non-alcoholic cocktails are given over the page.

● <u>If you go to a party and you are not drinking alcohol, get a soft drink in your hand as soon as possible.</u> If you are holding a glass, no-one will worry about what is in it. They are much more likely to be concerned about what they are drinking than about what you are not drinking.

IS SOMEONE CLOSE TO YOU DRINKING TOO MUCH OR TAKING DRUGS?

If you think that someone close to you is drinking too much or is taking drugs or is obsessively concerned with not eating (*anorexia nervosa*, see also page 77), you have two options. You can stay silent or speak out. If you elect to do and say nothing, you must recognize that the situation will probably not improve. It will merely drift on. If, on the other hand, you elect to confront the person with your feelings, bear in mind that confrontation does not have to be hostile, antagonistic or tearful. Well-managed, it can be diplomatic, tactful and caring. But before you do anything, examine your own feelings and fears. Ask yourself whether your suspicions are reasonable and how far you are prepared to offer your support. It is also a good idea to get as much information on the subject as you can so that you know what you are dealing with.

Choose your time carefully. Do not bring the subject up after a difficult scene or an argument and never confront an alcoholic when drunk, or a drug user when 'high'. Try, if you can, to lead the discussion round after you have been laughing together or sharing a confidence.

Even when the mood is right, you must expect a brush-off. Whoever you are talking to and whatever the problem, he or she is likely to feel caught out or cornered and to see your concern, however well meant, as an intrusion. But, behind the defensiveness and the denial, they are likely to be feeling unhappy and isolated, racked with fear and guilt and to be suffering a complete lack of self-esteem. So tread very carefully and do not make accusations. Show your concern and offer your support instead: 'I know you have been taking drugs/eating nothing/drinking too much, and that upsets me. Why don't you see the doctor and talk it over? I'm prepared to go with you.' If you are met again by denial, try to think of things that have happened as a result of the problem and mention them — the absences from work, the loss of enthusiasm for old interests, the loss of a licence because of drunken driving, the consistent complaints of feeling unwell. Ask why they have happened and point out that not only do you want to know but that you are confused and want to understand: 'I love you, I'm concerned for you. Please help me to know what is wrong so that I can understand.'

Do not expect miracles the first time you try this approach. Take it carefully and in stages. The first step is to show your concern, your support and your willingness to talk openly and reasonably. The second is to encourage them to talk and to try, if possible, to get them to admit that they are alcohol/drug dependent or, more simply, that they are unhappy or have been feeling unwell. The third is to give them the confidence that they can get better and to persuade them to seek help. This is important: most help and referral agencies do not accept appointments made on someone else's behalf, rightly recognizing that recovery starts from personal motivation and cannot be achieved by 'proxy'. Finally, do not lose sight of hope. There is cause for optimism, particularly in the early stages of a dependency. No drink or drug problem is untreatable and people who have once been totally dependent frequently recover.

non-alcoholic cocktails

Whole Lemonade

Metric/Imperial/American
3 lemons
3-4 tablespoons clear honey or liquid
 sweetener to taste
900 ml/1½ pints/3¾ cups cold water
slices of lemon or lime, to decorate

Cut each of the lemons into eight pieces, removing the pips but leaving the peel. Place in a blender or food processor with the honey (or sweetener) and half the water. Blend thoroughly, then add the rest of the water. Strain and serve, decorating each glass with a slice of lemon or lime. *Serves 4.*

Sunrise

Metric/Imperial/American
4 oranges
2 lemons
300 ml/½ pint/1¼ cups soda water
150 ml/¼ pint/⅔ cup Grenadine
crushed ice

Squeeze the oranges and lemons and pour into a jug (pitcher). Add soda water (for special occasion imbibing, you can substitute champagne) and stir in the Grenadine. Place crushed ice in tall glasses and add the cocktail. *Serves 4.*

From left: Whole Lemonade; Banana and Hazelnut Flip; Redcurrant, Orange and Almond Drink; Sunrise; Avocado and Cucumber Cup; Peach, Apple and Ginger Fizz; Caribbean Cocktail; Clam and Tomato Cocktail; Chestnut Flip.

Iced Mint Tea

Metric/Imperial/American
600 ml/1 pint/2½ cups water
3 sprigs of mint
1 tablespoon honey (optional)
2 teaspoons China tea (or 2 teabags)
mint leaves and lemon slices, to decorate

Place the water in a pan, add the mint and the honey, if using, and bring to the boil. Then pour on to the tea and leave to cool. Pour the infusion into a jug (pitcher) and place in the refrigerator until ice cold. To serve: strain the mixture and serve in tumblers decorated with fresh mint leaves and lemon slices. The colder the cocktail the better it tastes, so make well in advance. *Serves 4.*

Clam and Tomato Cocktail

Metric/Imperial/American
2 medium carrots, scrubbed and chopped
4 sticks celery, scrubbed and chopped
600 ml/1 pint/2½ cups tomato juice
300 ml/½ pint/1¼ cups clam juice
good dash of tabasco
2 tablespoons Worcestershire sauce
squeeze of lemon juice
celery salt
generous grinding of black pepper
olives, to garnish

Combine all the ingredients in a blender or food processor, then chill in the refrigerator or add ice, if preferred. Serve in tumblers garnished with an olive on a cocktail stick (toothpick) balanced across the top. *Serves 4.*
Note: Clam juice is available from good delicatessens and most large supermarkets and makes an interesting combination with the tomato. This cocktail makes a particularly good pre-lunch apéritif. But, if you do not like the taste, or have difficulty finding the clam juice, you can leave it out and still have a delicious tomato and vegetable drink.

Peach, Apple and Ginger Fizz

Metric/Imperial/American
2 medium peaches, peeled, stoned
 (seeded) and chopped
1½ eating apples, peeled, cored and
 chopped (or 120 ml/4 fl oz/½ cup apple
 juice if a thinner consistency is required)
½ tablespoon chopped stem ginger
600 ml/1 pint/2½ cups chilled ginger ale
crushed ice
apple slices, to decorate

Place the peaches, apples and ginger in blender or food processor with 2 tab spoons of the ginger ale and ble thoroughly. With the machine still runnin add the rest of the ginger ale. Pour in tumblers over crushed ice and decora each glass with a slice of apple. Drink wh still frothy. *Serves 4.*

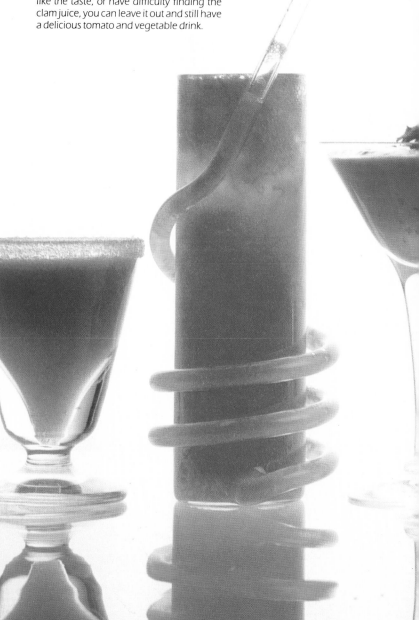

Redcurrant, Orange and Almond Drink

Metric/Imperial/American
300 ml/½ pint/1¼ cups redcurrant 'nectar'
6 tablespoons frozen orange concentrate
juice of ½ lemon
300 ml/½ pint/1¼ cups dry ginger
small teaspoon almond essence (extract)
salt or sugar

Combine all the ingredients in a jug (pitcher) or cocktail shaker and pour into cocktail glasses, having dipped the rims first in water and then in salt or sugar so that they have a fine white dusting around the top. *Serves 4.* *Note:* Redcurrant nectar is available from delicatessens and most supermarkets. Alternatively, use redcurrant concentrate diluted and sweetened to taste.

Banana and Hazelnut Flip

Metric/Imperial/American
2 eggs, separated
2 teaspoons honey
600 ml/1 pint/2½ cups milk
2 ripe bananas
40 g/1½ oz/⅓ cup chopped hazelnuts (optional)

Whisk the egg yolks until frothy. Add the honey and, when blended, gradually incorporate the milk. Allow to stand and to chill in the refrigerator for an hour, then blend the mixture with the bananas and the hazelnuts, if using. Whisk the egg whites until stiff and fold into the banana mixture. Pour into chilled tumblers. *Serves 4.*

Chestnut Flip

Ingredients and method as above. Simply substitute 325 g/11 oz can chestnut purée (unsweetened) for the bananas and hazelnuts, pour into cocktail glasses and decorate with grated nutmeg. *Serves 4.*

Avocado and Cucumber Cup

Metric/Imperial/American
2 small avocados, peeled, stoned (seeded) and chopped
juice of 1 lemon
1 teaspoon horseradish
¼ cucumber, chopped
sprig of parsley
3 teaspoons mayonnaise
generous grinding of black pepper
pinch of sea salt
2 ice cubes
250-350 ml/8-12 fl oz/1-1½ cups chicken stock, chilled
cucumber slices and parsley sprigs, to garnish

Combine all the ingredients in a blender or food processor, ice cubes included, and adding chicken stock gradually until the cocktail is the consistency you require. Adjust seasoning, if necessary, pour into chilled tumblers and garnish with cucumber and/or parsley. *Serves 4.*

Caribbean Cocktail

Metric/Imperial/American
1 thick (1 cm/½ inch) slice ripe pineapple or scooped flesh of 2 mangoes
2 ripe bananas
juice of 3 oranges
8 ice cubes
2 tablespoons crème de coconut (optional)
good squeeze of lime juice
crushed ice

Combine all the ingredients, except the crushed ice, in a blender or food processor. Pour into tall glasses over crushed ice. *Serves 4.*

Passionfruit Cooler

Metric/Imperial/American
3 passionfruit or 200 ml/⅓ pint/⅞ cup passionfruit 'nectar'
600 ml/1 pint/2½ cups soda water
good dash of angostura bitters
ice cubes

If using passionfruit, cut them in half and scoop out the flesh. Combine the flesh (or 'nectar') with soda water and a dash of angostura. Mix thoroughly. Serve 'on the rocks' in tall glasses. *Serves 4.*

biological body clock

'I know the melody now — it is the rhythm that escapes me ...' Confucius, 600 BC

We are aware of time and yet oblivious to it. We are aware of a gradual change in the seasons, of the ceaseless alternation of night and day, of light and dark. We are aware usually to the hour, often to the minute, what o'clock it is. Yet we are strangely unaware of a corresponding rhythmicity within ourselves. We become oblivious to the ebbs and flows of our own inner rhythms, we even tend to live at odds with them.

Bodies observe a set of very precise temporal laws of their own. Vitality, fatigue, mood, irritability, hunger, blood/sugar levels, body temperature, the rate of urination, sensory awareness...all rise and fall according to their own separate cycles over the course of a 24-hour day.

The pages that follow concentrate on this inside story. Understanding and observing how your body works can help to put you back in touch with your natural rhythms. As you get more attuned to them, you will find that you can predict some changes in advance, and, by so doing, protect those times when you are lacking in energy or feeling lower than usual. You will also be able to exploit those stronger moments when your energy and vitality are high. A chart to help you in your introspection can be found on page 27.

Being in tune with your inner rhythms has another advantage: it enables you to distinguish between naturally occurring changes and other unfamiliar changes that may signal anything from early pregnancy to a benign breast cyst. This is self-help because you can then go on to seek professional help and advice at the earliest possible stage.

PUBERTY AND ADOLESCENCE

'There is nothing so wonderful as youth,' enthused *Vogue* in 1938. 'Youth can do anything; it can even apply its paints in round patches wherever it pleases...' In fact, if youth were to do any such thing, it might soon find that its paints were aggravating a far from wonderful tendency to oiliness and spots.

In addition to acting on specific 'target' sites, such as breasts and ovaries, the hormones produced at puberty affect the functioning of a wide range of glands and organs. The eyeball expands slightly in size, the apocrine glands start to function for the first time and the sebaceous glands, previously small and dormant, enlarge as they increase their output. The results are possible long-sightedness, a tendency to perspire more and in a different way, as the neutral smell of childhood changes into the individual one of adulthood, and increased oiliness of body, face and hair. Although acne is a major teenage problem, few teenagers (probably less than two per cent) seek medical help. While severe acne may need treatment with drugs, the milder type can be treated by washing with a medicated soap and using a grease solvent lotion afterwards. Many excellent lotions and creams are now available across the counter. Those containing retinoic acid or benzoyl peroxide are particularly good.

If you have an oily skin, bypass elaborate cover-up strategies. These will only contribute to the problem by clogging the fine pores of the skin with particles of incompletely removed make-up. If you need camouflage, be area specific. Use a special concealer stick applied to the pimple with a fine brush (see page 147). The best contain an astringent or antiseptic to help dry spots out. For more cover, use a matt, medicated foundation and 'set' with powder to prevent breakthrough shine. Attend particularly to the T-zone of the face, where the sebaceous glands are more numerous and oil more abundant. Apply powder across the forehead, central panel of the face and chin, pressing firmly down as you go.

Changes in weight and shape

Of all the changes at puberty, the most noticeable is a change in shape. Breasts develop, contours become softer and rounder as the distribution of fat shifts from waist to hips and the pelvic bones widen. These changes are always preceded and accompanied by a gain in weight. About 5.5 kg (12 lb) is gained in the year before puberty starts and the same amount again in the following two years. This is an integral part of puberty and may be a major trigger mechanism for it. One theory, known as the 'critical' theory of body weight, actually maintains that weight is not only a crucial determinant of the timing of puberty, but also that nearly all girls start puberty at the same weight of 48 kg (106 lb). While surveys have tended to discredit this theory, a more plausible offshoot — namely, that each girl must achieve her own trigger weight — is now widely accepted. Even so, there are two important provisos — the ratio of fat to muscle and bone must be high enough and the psychology must be ripe.

Psychology is probably the greatest determining factor. The mind governs the endocrine system to a considerable extent. It can override all physical cues, working via the higher centres of the brain to inhibit biological responses and delay time signals. This is true at puberty and throughout adult life, when it can postpone periods, suppress fertility and produce physical symptoms, such as stomach ulcers and skin rashes. Its effect should never be underestimated.

The weight factor, too, can continue to be important after puberty. One of the first clinical signs of *anorexia nervosa*, the 'slimmer's disease', is amenorrhoea, or failure to menstruate. Smaller weight losses can also have the same effect, particularly if the weight is lost very quickly. The theory is that by crash dieting, the dieter 'crashes' through the barrier separating childhood from adulthood and so becomes, biologically speaking, a child again. According to some doctors, 'reproductive' anorexia is very common among girls in their teens and early twenties. Any diet that inhibits or disrupts menstruation over more than one cycle is too meagre and should be increased until the hormones controlling menstruation are switched on again and a regular cycle re-established.

Adolescence is a time of psychological as well as physical change. A rapidly changing body brings with it a rapidly changing body image. It is usually not long before the second temporarily overtakes the first. In one experiment at a London teaching hospital, a group of adolescent girls was asked to estimate the size of their waists and thighs. Nine out of 10 judged them to be larger by up to 70 per cent than they really were. While the shape of a stranger standing nearby was judged quite accurately, the shape of a best friend was, interestingly, over-perceived to much the same degree as the subject over-perceived herself. Other independent studies have shown that adolescents commonly see themselves as larger than they really are and that real size and perceived size only finally tend to mesh in the late teens or early twenties.

THE MENSTRUAL CYCLE

While a man's hormonal profile might be visualized as a straight line that starts at birth, is underlined at puberty and then stretches indefinitely onwards, a woman's is characterized by a series of even, regular loops that begin at puberty, run in approximately 28-day cycles, revolve around one key event — ovulation — affect every single cell in her body and can have considerable repercussions on the way she feels and looks.

The word 'menstrual' derives from the Latin *menstruus*, meaning monthly, but, in fact, few cycles run the classical 28-day course. Some may run for as many as 35 days, others for as few as 21. All are normal. There are wide variations, too, in the length of time the period lasts and the amount of blood lost. Some last for just a day or two (they are especially likely to be brief if you are taking the combined contraceptive pill) while others may persist for up to 14 days — actually half the cycle. This condition can be aggravated by the IUD (coil) and, if bleeding is excessively heavy, may even lead to anaemia (see A-Z).

The average woman can expect to menstruate for 30 to 35 years of her life and, in that time, to menstruate between 300 and 500 times for between two and five days at a time. In almost all periods, 90 per cent or more of the menstrual

blood will be lost in the first three days. Although periods may be infrequent and/or irregular in early adolescence while the body is switching to a new hormonal gear, a regular pattern of intervals between each bleeding should soon establish itself. The cyclical nature of the menstrual cycle is caused by fluctuations in the hormones controlling it (see below).

The premenstrual phase

It has been estimated that nine out of 10 women have some clue that a period is on its way. Common signs are poor concentration, a dragging feeling or ache in the abdomen, weight gain, loss of libido and sore, tender breasts. These, together with tension, irritability, tearfulness, bloating and headache, constitute the major symptoms collectively known as the premenstrual syndrome (PMS). These symptoms are suffered in moderate to severe form by about 10 per cent of women.

Ever since the term 'premenstrual tension' was coined in 1931, more and more symptoms, both vague and specific, have been attributed to the fluctuating hormone levels over the three to 10 days before the onset of menstruation. The withdrawal of the ovarian hormone progesterone (see below) is most commonly thought to be the aggravating cause. Before 1931, the tendency was to blame menstruation rather than the few days preceding it. The 1892 *Dictionary of Psychological Medicine*, for example, lists the following 'side-effects' of menstruation: 'Kleptomania, pyromania, dipsomania, suicidal mania, erotomania, nymphomania, delusions, acute mania, delirious insanity, impulsive insanity, morbid jealousy, lying, calumny, illusions, hallucinations and melancholia...'. Apart from melancholia, PMS is unlikely to be the cause of any of these.

Less dramatic but, nonetheless, disruptive physical and psychological symptoms may indicate PMS, if they appear regularly each month over the premenstrual phase. If you think that you suffer from PMS, chart your symptoms, using the symbols suggested on page 27, on the day or days they occur in a special diary. But bear in mind that your symptoms may have no connection with the cycle at all. Research has shown that women encouraged to believe that they are entering the premenstrual phase tend to ascribe unconnected problems to the syndrome. If you do spot a definite cyclical connection, see your doctor and take the diary with you. PMS can be effectively treated both through hormone and vitamin therapy and with diuretics, if bloating is a problem. Find further details in the A-Z. Self-help can also do much to relieve tension. Keep as physically fit as possible throughout the month and protect the few 'bad' days before your period by keeping them as free as possible. Arrange exacting appointments, interviews and tasks for other days when you are likely to be feeling stronger.

Other effects of the premenstrual period may include an increased tendency to oiliness of the skin and hair due to extra hormonal stimulation of the sebaceous glands. If you suffer from spasmodic outbreaks of acne, it may be worth charting the appearance and disappearance of these spots. If there is a cyclical link, try adapting your beauty routines about halfway through the cycle. Use a medicated soap

and/or a fairly strong astringent from about the tenth day after your last period finished and see if you notice an improvement.

The premenstrual phase is not a 'bad' time of the month for all women. One study, analyzing the standard of work in a girls' boarding school and correlating the results with the stages of the cycle, revealed that, while 27 per cent of the girls showed a drop in standard over the premenstrual period, over 50 per cent showed no appreciable change and 17 per cent actually showed an improvement. Such apparent contradictions indicate that different women respond differently to the monthly ebb and flow of key hormones, such as oestrogen and progesterone. The hormone levels do not appear to differ greatly from woman to woman. The threshold of sensitivity is probably the determining factor. This is borne out in clinical practice, where analyses of the blood of patients with very severe PMS often do not reveal anything demonstrably 'different' or 'wrong' with the hormones themselves. Nevertheless, their symptoms will

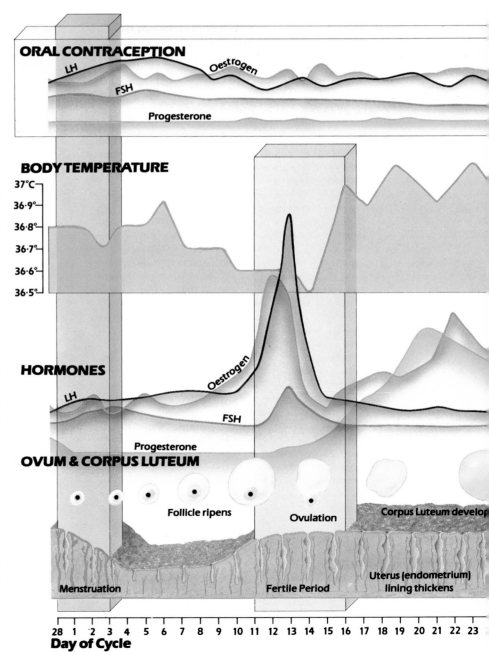

ORAL CONTRACEPTION
LH
Oestrogen
FSH
Progesterone

BODY TEMPERATURE
37°C
36·9°
36·8°
36·7°
36·6°
36·5°

HORMONES
LH
Oestrogen
FSH
Progesterone

OVUM & CORPUS LUTEUM
Follicle ripens
Ovulation
Corpus Luteum develop
Menstruation
Fertile Period
Uterus (endometrium) lining thickens

28 1 2 3 4 5 6 7 8 9 10 11 12 13 14 15 16 17 18 19 20 21 22 23
Day of Cycle

often improve when these apparently normal hormone levels are adjusted through carefully prescribed therapy.

A mild 'down' at the end of the cycle is not uncommon. Probably as many as 75 per cent of women feel that they are not functioning at their best over this time. But such low points are usually balanced by 'ups' elsewhere in the cycle, often over ovulation. Pinpoint this time for yourself, using the chart in the Personal Profile to help you, and capitalize on it.

Changes at ovulation

As well as its very variable effects on mood, performance and appearance, the menstrual cycle produces two other changes, which can be observed around the time of ovulation at mid-cycle. The first is a change in the appearance and consistency of the cervical mucus, which thins out and becomes stretchier and more elastic as ovulation approaches; the second is a slight dip in resting (basal) body temperature at ovulation, followed by a rise of about half a degree until the end of the cycle and the onset of menstrua-

tion. Although the dip in temperature may be so small as to be imperceptible, a temperature that does not rise or that remains absolutely stable throughout the cycle almost certainly indicates that the cycle was anovular.

Occasional anovular cycles are not unusual among normally fertile women. In fact, they tend to become more frequent after the age of about 25, when the ovaries and reproduction system have passed their peak of efficiency. A succession of anovular cycles, however, will indicate one of four things: that you are pregnant or taking the contraceptive pill (both inhibit ovulation by maintaining hormones at a constant level), that you have been through the menopause or that you have an ovulatory disorder.

These two changes offer a natural method of birth control, which can be up to 97 per cent reliable when taught by skilled medical personnel to motivated couples. Equally important, couples who are having difficulty conceiving can time their lovemaking to coincide with ovulation and so maximize the chance of pregnancy occurring.

Nearly every month between the years of puberty and the menopause, the body prepares for a possible pregnancy. The major exceptions: when pregnant already or when taking oral contraception (see left), which flattens out hormonal levels to produce an arhythmic, anovular cycle.

Follicular phase. A number of follicles in the ovaries develop and ripen under the influence of the follicle stimulating hormone (FSH), released by the pituitary gland in the brain. As the cycle progresses, and usually by the eighth day, most of these follicles die or cease to develop. One, occasionally two, continue to develop and the immature egg within to ripen. Throughout this time, oestrogen is being produced by the ovaries. Once it reaches a critical level, it stimulates another pituitary hormone, luteinizing hormone (LH). This triggers the release of the egg.

Ovulation usually occurs between the fifteenth and thirteenth day before the next period begins. The body temperature dips slightly and then rises by about 0.5°C (0.9°F) and cramp-like pains, known as *mittelschmerz* (literally 'middle pain'), may be felt in the lower back and abdomen.

Luteal phase. The egg is transported down the Fallopian tube towards the uterus. Fertilization can take place at any point within the next 24 hours (it is also viable up to three days before ovulation as sperm can survive for up to 72 hours). Progesterone, responsible for preparing the lining of the womb (endometrium) for the implantation of the fertilized egg is produced by the ruptured follicle (corpus luteum). It surges with oestrogen about eight days after ovulation. If fertilization occurs, they continue to rise and effectively to maintain the pregnancy. If fertilization does not occur, they subside and the endometrium disintegrates and is shed.

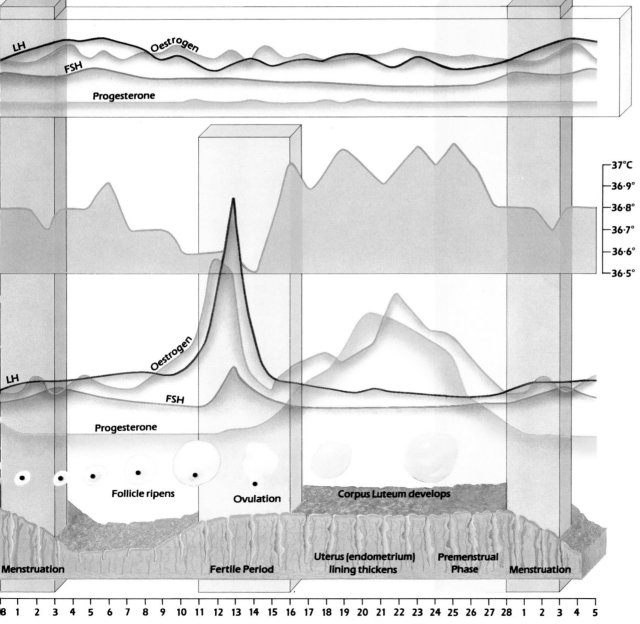

37°C
36·9°
36·8°
36·7°
36·6°
36·5°

LH
Oestrogen
FSH
Progesterone

Menstruation
Follicle ripens
Ovulation
Corpus Luteum develops
Fertile Period
Uterus (endometrium) lining thickens
Premenstrual Phase
Menstruation

8 1 2 3 4 5 6 7 8 9 10 11 12 13 14 15 16 17 18 19 20 21 22 23 24 25 26 27 28 1 2 3 4 5

sexuality

'i like my body when it is with your body. It is so quite new a thing. Muscles better and nerves more...'
e.e. cummings

Sexuality is enormously complex and individual. Much more than just an outward aspect presented to the world or an inward one preserved for your private life, it is an intrinsic part of your personality, reflected in the way you respond to other people and the way you feel about yourself. There is no such thing as 'good' or 'bad' in sex. Good sex is what is good for you — and for your partner.

Sexuality fluctuates according to mood, season, circumstance, even to the time of the day or month. Although sexuality is more than 'just sex', sex is its ultimate expression. Early sexual encounters are often fraught with anxiety, but ironically, the two principal anxieties, appearance and performance, have little to do with sexuality. Novelty, on the other hand, does. It is a powerful aphrodisiac and a powerful awakener of a usually hidden, more vulnerable self. Most people, men and women, remove their defences with their clothes.

Where anxiety can make you vulnerable or tense, relaxed, happy sex can make you feel and look marvellous. That vibrant and visible aura of wellbeing may have much to do with the fact that sex is the best 'de-stresser' of all, combining vigorous physical exercise with straightforward mental release. As feeling takes over from thought and instinct from conscious decision, tensions, frustrations and anxieties are dispelled. This can happen as much during the lingering pleasure of foreplay as in the final rush of feeling at orgasm.

Sexuality is individual. There is no one prescription for 'successful' loving. All things to all people, sex can be casual or committed, abandoned or inhibited, gentle or intense, pleasurable or painful, exciting, disappointing, all eventful, even boring. Times when sex tends to be not so good include when you are insecure about what one of you is feeling, when you are tired, preoccupied or anxious about how reliable your contraceptive method is and at some more specific phases of life, such as after birth, when the pelvic floor muscles are stretched and need tightening (see contracting exercises on page 205) and at the menopause, when falling levels of oestrogen produce a thinning of skin tissue and dryness in the vagina that may make penetration difficult. Hormone replacement therapy (see page 213) can often help to counteract this problem.

Sex can and should be a happy, relaxed and enjoyable experience whether you 'come' separately, simultaneously or not at all. In fact, for most people the emotional intimacy and the sharing aspects of sex are held to be just as fulfilling as orgasm alone, if not more so. Even so, failure to reach orgasm blights many otherwise happy relationships and is the most common reason for women seeking help from sex therapists. Anxiety not only tends to forestall the event itself but also interferes with the considerable pleasure that might have been derived without it.

In addition, old attitudes die hard. The comprehensive surveys carried out in the USA strongly suggest that, for all the new liberation, many women are still reluctant to assert themselves sexually or to indicate what they want in bed. If there is an absence of communication and encouragement, sex usually proceeds at the pace determined by the male. In such cases, it is hardly surprising that orgasm is elusive: men can be aroused and ready for intercourse in seconds, while women usually take much longer to become aroused and will take an estimated 10 to 20 minutes of intromission (penetration) before they reach the point of orgasm.

The time factor is the most critical difference between the sexes. In fact, it is now widely held that, in almost every other respect, there is less dissimilarity between the sexes than there is individual variation among members of the same sex. Sexual preferences, it seems, have more to do with personality than they do with gender. Physiologically, men and women share the same erogenous zones and, with the exception of ejaculation, go through identical stages of arousal and orgasm. There also seems to be a definite correlation between length of arousal and intensity of orgasm, particularly if the orgasm is delayed with repeated stimulation up to points of near climax, followed by a drift back to that state of limbo-like suspension that sexologists call the 'plateau' phase. Such a leisurely preamble not only makes for a more rewarding and intense orgasm for both sexes but is, for many women, the only way to achieve one.

Many women find that they first climax on their own, when they can explore their own responses to touch without the pressure of having to perform for, worry about or hurry for someone else. Masturbation can be helpful, because it enables you to concentrate on what you like, to discover what pleases you and to show your partner — either silently through touch or through words and sounds.

Communication is very important. Your mutual pleasure is, after all, your mutual responsibility and intuition is only a small part of lovemaking. If you find that you cannot express what you like or dislike, or what you are feeling or not feeling, you should begin to examine your relationship in more depth.

The relationship is critically important. A stale relationship, which has exchanged love for habit, will diminish pleasure in sex (even if, as sometimes happens, it is the only pleasure which remains), as will most casual encounters. The pleasure that is derived from complete physical and emotional intimacy, on the other hand, can be one of the richest and most rewarding areas of human experience.

Choosing a contraceptive method is not always easy. All the methods currently available have their drawbacks as well as their advantages.
This chart should enable you to weigh up the drawbacks against the advantages and to choose a reliable method that will work for you. Factors to consider: your age, your relationship, your degree of motivation, your medical history, your personal attitudes and religious beliefs. The chart does not include details of the following:
1. The use of spermicidal creams, foams and pessaries on their own.
2. The 'rhythm' or 'calendar' method, which calculates 'safe' and 'unsafe' times for intercourse on the risky assumption that ovulation always happens in the middle of the menstrual cycle ('natural' contraception, see chart, is quite different).
3. *Coitus interruptus* (withdrawal), which is both frustrating and unreliable because some sperm are almost always released in the seminal fluid prior to ejaculation.
No family planning clinic would endorse any of these methods and, for this reason, they are not given here.

CONTRACEPTION: the alternatives

METHOD	DESCRIPTION	DRAWBACKS	COMMENTS
Combined oestrogen/progesterone contraceptive pill (Effectiveness with conscientious use: 99.7%)	Method used by about 70 per cent of women at some time in their lives, and, at present, by 50 million women throughout the world. There are at least 20 different types. The smallest dose oestrogens are 'triphasic', that is, tailored to specific stages of the cycle. Usual dose of 35 mcg oestrogen may be increased to 50 mcg in the event of breakthrough bleeding. The pill works by altering hormonal behaviour, so that there is no 'true' menstrual cycle and the body is 'fooled' into thinking itself pregnant. It has four specific actions: 1. It prevents ovulation. 2. It reduces the 'motility' (muscular movement) of the Fallopian tube so that, if ovulation were to occur, the egg could not pass from the ovary to the uterus. 3. It prevents the thinning of the cervical mucus so that it remains sperm-resistant. 4. It inhibits the build-up of the lining of the uterus.	In susceptible women, oestrogen may cause excessive blood clotting, which can lead to thrombosis, stroke or heart attack. Risk is now only thought to be appreciable in women over 35, especially if combined with other risk factors – smoking, overweight, high blood pressure. Liver tumours, gall bladder disease and cervical ulcers have also been implicated with the combined pill, as is an increased susceptibility to thrush and, rarely, difficulties in conception on ceasing to take it (about two per cent). Mild to moderate side-effects may include headache, depression, weight gain, nausea, chloasma (melasma), and raised blood pressure. You are unsuitable for the combined pill if: 1. Two or more of the risk factors described above apply to you. 2. You have had a thrombosis. 3. You have a hormone-dependent cancer. 4. You have a serious liver disease. 5. You suspect you may be pregnant. 6. You are breastfeeding. 7. You are about to undergo surgery. All surgery carries increased risk of thrombosis.	The most reliable and convenient of all contraceptive methods bar sterilization. However, bouts of diarrhoea or sickness may mean that the hormones are not in the bloodstream long enough to guarantee contraceptive effect. Consult a doctor, and, if in any doubt, use additional means of contraception for 14 days. The same applies if more than 36 hours elapse between taking pills. Future possibilities: 1. The use of surgical implants for continuous, slow release of oestrogen and other hormones to give protective and reversible cover for up to five years. 2. The development of a vaginal 'ring', which would have a similar action (already available in progestogen-only form). 3. Immunization against pregnancy, using a protein or hormone produced during pregnancy, to guarantee reversible immunity for up to five years. 4. Nasal contraceptive sprays to inhibit the release of hormones initiating ovulation. 5. A male pill has already been developed in China but has significant drawbacks and toxic side effects.
Progesterone only contraceptive pill, also known as POP or the 'mini' pill (Effectiveness with conscientious use: 98%)	This pill is taken daily throughout the cycle, even when menstruating, and must be taken at the same time each day. It has three actions: 1. To prevent thinning of cervical mucus so that it does not become sperm receptive. 2. To render the lining of the uterus inhospitable to the egg, should fertilization occur. 3. To prevent ovulation in about 40 per cent of cycles.	Not as effective as the combined pill. Higher incidence of breakthrough bleeding and irregular menstrual cycles. May provoke migraine in susceptible women. You must be conscientious about taking it, and if more than three hours have elapsed since your last pill was due, you must take additional contraceptive precautions.	The main advantage is the considerable lowering (some even maintain elimination) of the risk of blood clotting and subsequent thrombosis in high-risk women. It is, therefore, an extremely useful alternative to the combined pill in women over 35, especially if other risk factors are already present (see above). POP is also sometimes prescribed for women experiencing side-effects on the combined pill.
Progesterone injections (Effectiveness with conscientious use: 98%)	Single dose progesterone gives contraceptive protection for three months. It works in the same way as the progesterone-only pill (see above).	Outlawed as a means of long-term contraception (more than three months) in the UK and the USA, after it was found to cause breast tumours in beagles, but still widely used in the rest of the world. Also linked with primary (temporary) infertility after long term use.	Useful means of contraception for the highly forgetful and for partners of men who have had vasectomies, as the operation takes three months to become effective (see opposite).
Inter uterine device (IUD) or 'coil' (Effectiveness with conscientious use: 98.3%)	Copper-and-plastic or plastic-only devices, fitted into the uterus with a loose thread so that you can check it is still in place. Any foreign body in the uterus seems to inhibit conception. Copper devices release minute traces of the metal into the system and have simultaneous effects on the sperm, the cervical mucus and the lining of the uterus. They are more effective than the plastic-only devices.	The presence and pressure of the IUD in the uterus can cause pain and heavy, prolonged periods together with an increased risk of anaemia, due to excessive loss of iron in the blood. Occasional expulsion. If a pregnancy does occur, there is an increased risk of miscarriage (25 per cent) and of ectopic pregnancy (five per cent). The IUD is not suitable if you have an acute pelvic infection or undiagnosed vaginal bleeding. It may be inadvisable if you have a history of pelvic infection.	More suitable for older women and/or women who have had a pregnancy, both because they are less likely to have menstrual difficulties and because they are less susceptible to pelvic infection. For maximum contraceptive effectiveness, the copper devices should be replaced every two years. Provided there are no complications, the plastic ones may be left in indefinitely. IUDs are also sometimes fitted as a means of post-coital contraception (see opposite).

cautioncautioncaution

METHOD	DESCRIPTION	DRAWBACKS	COMMENTS
Diaphragm or 'cap' (Effectiveness with conscientious use: 98%)	Vulcanized rubber membrane with flexible rim fits over the cervix to block access of sperm to uterus. It should be used in conjunction with spermicidal creams or pessaries and left in place for six hours after intercourse. An increasingly popular method of contraception, partly because of the degree of control it offers a woman over her own body and partly because of the side-effects and bad publicity connected with the pill.	Requires a certain amount of premeditation before intercourse and a lot of motivation. Some women also find the creams and pessaries messy and unpleasant and this may inhibit their sex lives. Not an ideal method if you are a forgetful, easy-going, risk-taking type of person or if you are very sexually active. 　May aggravate recurrent cystitis.	The size of diaphragm depends largely on the amount of intra-pelvic fat, so always have it refitted after losing or gaining more than 4.5 kg (10 lb) in weight or after a pregnancy. Fill it with water or hold it up to the light regularly to check for holes or defects in the rubber. 　<u>Imminent advances</u>: a sponge diaphragm, pre-treated with a spermicidal agent, and a 'made-to-measure' extended wear cervical cap with a one-way valve to allow for the downward flow of menstruation while preventing the upward one of sperm.
Condom (Effectiveness with conscientious use: 97%)	Vulcanized rubber sheath that slips over the penis. Still the most common method of contraception. According to one survey it is used by 25 per cent of all married couples in the UK.	Loss of sensitivity during intercourse for the male. 　High risk of pregnancy, if used irresponsibly or if the sheath slips off or breaks during intercourse.	Invented by men for men, not as a precaution against pregnancy but as a protection against venereal disease. The sheath still confers a higher degree of protection against this than any other method.
'Natural' contraception (Effectiveness with conscientious use: 85%)	A highly scientific method (not the riskier rhythm or 'calendar' method or *coitus interruptus*). It works by: 1. Assessing the consistency of the cervical mucus, which thins out just before ovulation. 2. Taking and charting your basal (resting) temperature over the menstrual cycle.	A complicated and time-consuming method, at least initially, that requires a high degree of motivation. Until you become more practised, sex is often accompanied by anxiety that you have failed to identify signs of ovulation correctly. Anyone interested in the method should receive specialized instruction at a 'natural' family planning clinic. 　Other disadvantages: 1. The temperature method cannot predict ovulation in advance. 2. The period of abstinence over the unsafe time may place strains on the relationship.	As new and more accurate ways of identifying the fertile period are developed, this method is likely to become increasingly popular. It is particularly suitable if personal, health or religious reasons make other types of contraception unacceptable. 　One advance is the 'intelligent' thermometer which records body temperature and assesses chances of ovulation. Future possibilities include: 1. Home urine or saliva sampling kit to assess fluctuating hormone ratios. 2. A 'bionic' bra to register dip in temperature at ovulation.
Sterilization (Effectiveness: approaching 100%)	The ultimate answer to fertility control. 　Male sterilization (vasectomy) involves minor surgery to cut or tie the *vas deferens*. Fertile sperm may be left circulating for up to three months so contraceptives must be used for some time after. Female sterilization uses one of two methods. 1. Diathermy or excision to destroy all or part of the Fallopian tubes. 2. Blockage of the tubes, either by tying or by means of clips or rings.	Any of the risks of normal surgery applies here, plus an increased risk of pelvic infection.	Advances in microsurgical techniques for female sterilization mean less damage to body tissue in order to ensure complete sterilization. The failure rate (just a fraction of a per cent) is also substantially lessened. 　When in doubt – DON'T. The numbers of both men and women seeking reversal of sterilization are increasing. 　NEVER combine abortion with sterilization. These two momentous and possibly traumatic decisions should always be made independently.
Post-coital or 'morning after' contraception (Effectiveness: to be assessed)	Methods of counteracting the possibility of pregnancy, once intercourse has taken place, include taking relatively high doses of oestrogen within 36 and preferably 12 hours of intercourse and having an IUD fitted. Both methods work in an interceptive capacity to prevent implantation of the fertilized egg in the uterus.	Both methods are still relatively new and therefore not widely available. 　Oestrogens may produce nausea. 　Some gynaecologists would not recommend fitting an IUD as the chances of infection may be too risky under certain circumstances. Chance of IUD producing an ectopic pregnancy in the event of fertilization has yet to be assessed.	The timing, dosage and right type of oestrogen are essential, so seek the assistance of a doctor or family planning clinic. 　The IUD works within 60 hours of intercourse and therefore makes a better 'late' choice than the course of oestrogens. It can also be left in place, offering long-term method of birth control once the crisis is over, in which case drawbacks will apply as above.

pregnancy

**'Irrefutable, beautifully smug...the women/ Settle in their belling dresses.
Over each weighty stomach a face/ Floats calm as a moon or a cloud...
They listen for the millennium,/ The knock of the small, new heart.'**

Sylvia Plath

PREPARING FOR PREGNANCY

The healthier and fitter you are before you conceive, the better your chances of having an uncomplicated pregnancy and a healthy baby. If you are sleeping well, taking regular exercise and eating in a balanced way, you will be more able to meet the considerable demands of the growing foetus. Many doctors believe that the present system of antenatal care, which usually begins in the twelfth week of pregnancy, starts much too late. By this time all the critical stages of development are well under way. The foetal heart, for example, has started to beat by the eighth week. The mother-to-be, meanwhile, may not even know she is pregnant.

● To ensure that your baby has the best possible start in life, become as fit as you can before you attempt to conceive. Allow yourself a minimum of three months. Take at least 20 minutes exercise every day and revise your diet, if necessary. Make sure that you are getting plenty of fresh food and include 600ml/1 pint (2½ cups) of milk, three slices of wholemeal bread and plenty of fresh vegetables a day. Balance your intake of protein and fats against carbohydrates. Recent studies on morning sickness and diet prior to conception suggest that a high protein diet may predispose towards sickness in pregnancy, while a well-balanced diet with adequate carbohydrate may protect.

● Make sure that you are at a healthy weight. Being underweight is probably a greater hazard to your own health and to that of your baby than being slightly overweight. If you are very overweight, however, the pregnancy may be complicated by a tendency to higher blood pressure, fatigue and even diabetes. Pregnancy is not a time for strict dieting. Erratic and compulsive eating patterns are also unwise, so straighten yours out well in advance.

● Avoid taking any unnecessary drugs both before and after conception, when you might find some of the 'alternative' homeopathic remedies for minor disorders worth exploring. Although you should avoid all unprescribed drugs during the first 56 days of pregnancy, there is no need to become drug phobic. If you are unwell, consult your doctor and let him or her know that you are pregnant. If untreated, some illnesses present a much greater health risk than the properly prescribed medication.

Unnecessary drugs also include smoking and drinking large quantities of alcohol, coffee or tea and excessive use of common drugs, such as aspirin and even laxatives. 'Hard' drugs, such as cocaine and LSD, are very dangerous and their harmful effects on the developing foetus are well-established. 'Soft' drugs are also inadvisable. Marijuana, for example, is now thought to depress the activity of the sperm, so possibly reducing the chances of conceiving easily.

● Of all the common 'environmental' hazards, cigarette smoking is undoubtedly the most dangerous. Smoking reduces the blood supply to the placenta, so interfering with the nutrition of the baby, passes on toxic chemicals contained in the tobacco smoke and reduces the amount of oxygen available. This may produce an acute rise in the baby's heart rate. Rises of as much as 30 per cent have been recorded during cigarette smoking and are considered a definite sign of foetal distress. The consequences of smoking during pregnancy include lower birthweights, higher rates of miscarriage, stillbirth and foetal death, lowered resistance to infection, particularly respiratory infection, during the first years of life, and even retarded physical growth and mental development. The rate of foetal death alone rises by 35 per cent in women who smoke 20 or more cigarettes a day. If you do smoke, make a concerted effort to give up before you plan to become pregnant. If you find this impossible, cut down to five cigarettes a day or less.

● While heavy drinking during pregnancy is almost certain to affect the foetus, there is now thought to be a link between moderate drinking and minor defects, particularly those affecting heart, face and limbs. Either abstain entirely or limit your drinking to an absolute maximum of two drinks a day. Restrict your intake of caffeine similarly. Make three or four cups of tea or coffee a day your upper limit.

Much of the evidence of the effects of taking these and some other drugs is circumstantial, but it is significant that many women develop an aversion to tea, coffee, alcohol and cigarette smoke well before they discover that they are pregnant. Such aversions are probably regulated by powerful biological factors working to protect the foetus from potentially harmful influences and are well worth heeding.

● Two diseases, rubella (German measles) and venereal disease, can affect your developing baby. Ask your doctor for a blood test to check whether you are immune to the rubella virus well before you plan to conceive. If you are not, you can be immunized against it, but you must continue with contraception for three months afterwards, as you will still be susceptible to the virus. Sexually transmitted diseases, such as gonorrhoea and syphilis, may also affect your baby. If you or your partner have or suspect an infection, go to your doctor or to a clinic for a check-up. If one of you is infected it is essential that you are both treated and that you continue to use contraception until you receive confirmation that the infection has completely cleared.

Finally, in cases where one or both potential parents has a family history of genetic disorder, pre-pregnancy genetic counselling clinics and chromosome screening facilities are available, so that some assessment can be made of the chances of having a healthy baby.

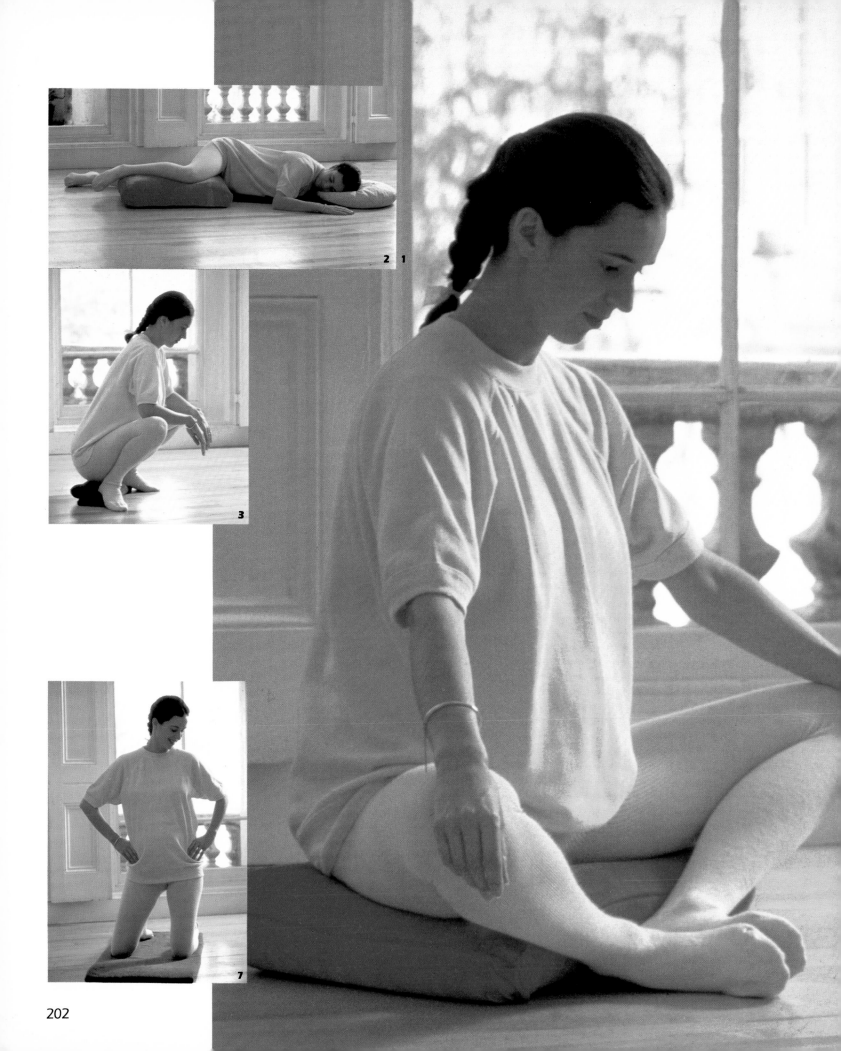

2 1

3

7

posturespostures

Keeping fit is important during pregnancy, when a good regular exercise programme combined with a gentle sport, such as swimming, can do much to help prepare you for the birth by keeping muscles strong and joints flexible. Posture is critically important, too, and can make all the difference between nine months of joyful burgeoning and nine months of aches and pains that seem to increase in direct proportion with your size.

The exercises given here are not intended to comprise a 'keep fit' routine. They are simple postures designed to help ease specific problems, such as lower back pain or cramp, together with some of the more general aches and pains

that you may become aware of as your pregnancy progresses. You may also find these postures helpful for the early stages of labour.

Modified versions of some of these postures, the squatting position in particular, are sometimes used for the delivery of the baby during natural childbirth. Whichever way you decide to have your baby, however, the most important thing is to feel comfortable and relaxed. Recent research strongly suggests that fear and anxiety can block the production of key hormones, such as oxytocin, that help labour to progress, and can also inhibit the production of endorphins (see page 128), the body's own natural painkillers.

4 **5** **6**

Sitting, though apparently comfortable, can be a major contributor to backache. Take the strain off your back by sitting cross-legged, tailor fashion (1).

Sleeping can also be a problem in later pregnancy. Lie on your side, keeping the knee raised on a pillow (2). This will give the abdomen more space, take the pressure off the uterus and enable the blood to circulate more freely round the pelvis.

Squatting is one of the most comfortable and restful positions, once you get used to it. Practise from your early pregnancy, supporting your heels and bottom with a folded towel if you need to (3). An adaptation of this, in which the mother is supported beneath her upper arms and elbows, is the most widely practised of all the upright postures during childbirth, because it greatly increases pressure in the pelvic area with the least possible muscular effort. The body's weight is taken by the knees and the ankles and by the person supporting. (These aspects are reversed if the mother lies on her back, as in

the conventional manner, with the uterus tipped backwards against the pull of gravity.)

Cramp in the legs is a common problem in later pregnancy when congestion in the pelvis prevents the blood circulating freely in the legs. Counteract it by holding a towel or scarf around the balls of the feet and pulling the toes upwards to stretch out the muscles at the back of the calf (4).

To overcome tension and stiffness and to help relieve backache, take up starting position (5) and arch the back (6). Then straighten it, but do not allow it to hollow. Repeat several times.

Rocking and circling movements of the pelvis, commonly seen preceding birth among primitive peoples, have been shown to help the baby down the difficult passage from the uterus into the birth canal. Even if you are not planning to incorporate rocking and circling movements in your birth programme, you will find them useful for restoring blood circulation and easing any

dragging pains in the abdomen and lower back. The pelvis can be rotated through 360°, using the belly-dancing movement (7), or rocked gently from side to side (8). Start on hands and knees and look round to either side, bringing each hip towards you as you turn to look at it.

8

PREGNANCY NOTES
First to third month

Although your antenatal care programme should ideally start from well before conception, some women find it hard to revise their lifestyles until they are pregnant. If you have not done so already, give up smoking, drink only in strict moderation, avoid all unprescribed drugs and rebalance your diet along the guidelines already given, as much for your own sake as for the baby's. During pregnancy, a priority system operates to ensure that the foetus has all the nutrients it needs, even if it means depriving the mother. If your diet is unbalanced or too meagre, you will almost certainly be undernourishing yourself, even if the baby has all the nutrition he needs.

Your doctor may advise you to take mineral and vitamin supplements. In addition to folic acid, now thought to play a vital part in protecting against spina bifida and other birth defects, other vitamins and minerals, such as vitamin D and iron, may also be prescribed. Iron may be necessary, but your doctor must determine this. The mineral is no longer routinely given in early pregnancy because too much can interfere with the absorption of other essential minerals, such as zinc. Vegans and vegetarians may well require additional vitamin and mineral supplements.

Enrol at a local antenatal class, make sure that you feel happy and relaxed with your doctor or obstetrician (you have a year's close contact ahead and it is essential that you should be able to ask any question without feelings of unease or embarrassment) and arrange to see your dentist. Important at any time, good dental care is essential now, when you are more susceptible to gingivitis and other gum infections.

During the first 12 weeks your need for rest is greatest, you are most likely to be feeling nauseous (see below) and you are most likely to miscarry. Miscarriages put an early end to one in 10 pregnancies, are most common in the tenth and eleventh weeks and are usually caused by abnormalities in the foetus. While very distressing, first time miscarriages are very unlikely to affect the outcome of subsequent pregnancies. Even women who miscarry twice or more have an 80 per cent chance of delivering a healthy, full-term baby the next time.

Nausea, with or without actual sickness, affects 70 per cent of all pregnant women. Although it is often called 'morning sickness', less that 10 per cent find that their symptoms are restricted to the early part of the day. It occurs most often on an empty stomach and is usually most severe at around the ninth to tenth week of pregnancy, when the hormone human chorionic gonadotrophin (HCG), now thought to be a contributing factor, is at its peak. Try overcoming nausea with small, bland meals at frequent intervals, a piece of dry toast, a cracker or biscuit on wakening, and 'sharp' fruit drinks such as grapefruit and lemon. If sickness persists or is severe, consult your doctor.

Pregnancy is traditionally a time of clear skin and shining hair, but the first three months can be quite the reverse. A sudden surge in hormones can produce a rush of activity in the sebaceous glands and increased oiliness on the face and hair is fairly common. Counteract oiliness on the face with a good astringent, acne with creams not drugs and oiliness on the hair by washing it frequently with a mild shampoo.

If your nipples are inverted, special nipple shields, which fit into the bra and evert the nipples, can make breastfeeding possible. It takes some time for these to work, so buy them in early pregnancy and wear them daily.

Fourth to sixth month

This is usually a time of great physical and emotional wellbeing. Any early tiredness, nausea and depression should have subsided and you will probably be feeling on top of the world. The foetus is now growing fast. In the fourth month alone, it will double in size. You, too, will be growing fast over the course of the pregnancy, you will probably gain about 11 kg (25 lb) in weight, sometimes more. This essential weight goes into nourishing the baby, building up the placenta and the amniotic fluid, enlarging the breast tissue, increasing the blood supply and creating reserves of fat and protein for late pregnancy and the post-natal period.

As you get larger, adapt your beauty routines. Your hair and skin should be looking marvellous now, so capitalize on this by wearing new hairstyles, rethinking your make-up and dressing up necklines with jewellery and other accessories. Calling attention to your top half will draw it away from your stomach.

As your weight increases, so does the strain on your abdomen. The increased blood flow to the pelvis and congestion caused by the enlarged uterus may lead to haemorrhoids (piles) and varicose veins. Protect against them by practising the rocking and circling exercise on the previous page and by following the guidelines on page 221.

As your skin stretches, tiny tears or stretch marks may occur beneath the surface. They happen in the deeper layer of the dermis, so massage creams and oils will not prevent them, though foods high in zinc and vitamin C (seafood and fresh fruit and vegetables) might. Find further details in the A-Z. If your skin feels dry, use a good, oil-based lotion to keep it supple. Get accustomed to handling your body and breasts in preparation for birth and breastfeeding. At about five months, you will notice a discharge coming from the nipples, which may cause them to become sore and cracked. Bathe them daily to remove the discharge and apply a lanolin-based cream to keep them soft and supple and to prepare them for breastfeeding. As the breasts enlarge, keep them well supported with a comfortable, well-fitting bra, to prevent any stretching of the supporting ligaments.

Between 16 and 20 weeks, you will become aware of the baby moving (quickening) inside you. At 20 weeks, the foetal heartbeat becomes audible and, by the end of this period, the foetus is 30cm (12 inches) long, weighs just over 225g (8oz), has well-formed lungs, identifiable fingerprints, an expressive face, will respond to touch and may suck its thumb.

Seventh to ninth month

By the seventh or eighth month, you may be carrying 6kg (14lb) or more of extra weight and, by the ninth month, your blood volume will be one and half times that of your

non-pregnant state. All this may lead you to feel very tired and breathless, to lose your balance and to feel dizzy. Take things slowly, ask for help getting into or out of the bath, get plenty of rest, continue with your exercises and practise your breathing techniques, so that you remain relaxed and calm. Try to avoid even moderate drinking. Recent studies have shown that mothers who drink alcohol during the last three months of pregnancy tend to give birth to restless babies who sleep less and cry more.

The final three months are a time of growth, consolidation and perfection of detail. The foetal respiratory and digestive systems become fully developed, the eyes open and the foetus becomes more acrobatic. Vigorous punches and kicks will be felt clearly and a limb, foot or elbow can often be identified. This is also the time when essential immunities to infections are passed on to your baby through the antibodies in your bloodstream.

AFTER THE BIRTH
Getting back into shape

As with pregnancy, getting back into shape after the birth will take nine months. If you are young, extremely fit, naturally lithe and slender with a supple, elastic skin tone, you might just manage it in six. But you should not rush your post-natal programme, nor should you expect too much of yourself at this extremely demanding and challenging time.

Start gentle exercises a few days after the birth with some of the stretching and limbering routines in the Shape chapter (blue leotard), graduating to the stronger exercises as you get fitter. You do not need a special set of post-natal exercises — with one exception. This concerns the internal muscles of your pelvic 'floor'. These stretch with the birth and, if allowed to remain stretched, can seriously reduce sexual enjoyment and may lead to leaking on coughing, laughing or energetic exercise, if not to actual incontinence. The pelvic floor muscles should be strong enough for you to leap vigorously up and down, while opening and closing your legs and coughing with each stride, with no leaking at all. To exercise these muscles, think of yourself 'gripping' during intercourse or stopping an imaginary flow of urine, squeeze, hold for a few moments and let down gently. Repeat this exercise whenever possible. It will pay enormous dividends.

Changes in shape and breastfeeding

All the weight gained during pregnancy does not instantly fall off after the birth. People lose weight at different rates. Many women do not return to their normal weights until they stop breastfeeding.

All breasts change shape after pregnancy, tending to lose some of their roundness at the top. This is caused by the weight-gain and change in shape during pregnancy and has nothing to do with whether you choose to breastfeed. Breastfeeding will not make your breasts droop or sag any more than they would have done naturally, as long as you wear a well-fitting nursing bra.

When breastfeeding you need plenty of carbohydrate in order to manufacture the milk, so do not let any cravings you thought you had left behind depress you. While you should

not be censorious with yourself over your eating patterns, you should remain as conscientious about your general health as you were when pregnant. Consult your doctor about vitamin supplements, do not smoke, do not take any unprescribed drugs and drink only in moderation as harmful substances can be passed on in the breast milk.

Hair care

While your hormone levels are readapting to your non-pregnant state, you may notice that your skin and hair lose condition. This is aggravated by fatigue, so try to get as much rest as you can and, if possible, some help with the baby.

During pregnancy, the hair growth phase is extended by a surge of several hormones. An increased rate of hair fall is both natural and extremely common around 12 weeks after the birth, when you start to shed the hair that would normally have fallen out during the previous nine months. It may continue to fall out for two months or more, but it will grow back. You can do much to help it regain its stability and strength by looking after your general health and by taking wheatgerm or brewer's yeast — both natural sources of the B vitamins which are important to the condition of the hair.

The first few weeks with a new baby: this uniquely rewarding and challenging time can also be extremely exhausting. Preserve your energies by taking life slowly and giving yourself a full nine months to get back into shape after the birth.

INFERTILITY

When you consider the intricate process by which a fertilized egg, no more than 0.13 mm (0.005 inch) in diameter, and considerably smaller than the size of a full-stop on this page, grows and develops into a new human being, it is surprising not that some of us have difficulties in conceiving and bearing a child, but that it ever happens at all. Even so, for one in every 10 couples, regular unprotected sex for over a year will not result in conception. While nothing is more agonizing to a couple attempting to conceive than the dawning anxiety that one of them may be infertile, the fear of a childless future is often unfounded. The treatment of infertility is one of the most optimistic areas in medicine and is now coming to the rescue of six out of every 10 couples referred to infertility clinics for further investigation.

If you have been trying to conceive for two or more years or you are older and the pressure of time is upon you, make an appointment with your doctor. In a surprisingly high number of cases, a preliminary interview with both of you will be enough to bring on conception. It may be that a return to normal, non-anxious lovemaking works the magic. But the connection between consultation and conception, about 20 per cent, is too high to be coincidental. During the interview, your doctor may suggest that you try some simple, self-help methods to increase your chances of conception.

If these methods fail or the necessary premeditation for carrying them out is placing strains on the relationship, further investigation should be embarked upon right away. It is important that both partners should be tested for possible infertility. First, the incidence divides fairly equally between men and women at 40 and 50 per cent respectively (in 10 per cent of cases, no clear reason for infertility is found). Second, tests for male infertility (sperm count and clinical examination) are considerably simpler and less extensive.

Ovulatory disorders

Ovulatory disorders are the most common cause of female infertility and, therefore, tend to be investigated first. Such disorders may be the result of inadequate hormonal stimulation or, less often, an imbalance caused by raised prolactin levels (this can be treated by a course of tablets). Or they may simply reflect a temporary difficulty in conceiving. This is particularly possible in the late twenties or thirties, as frequency of ovulation declines past the age of 25. A blood test or endometrial biopsy (scraping taken from the lining of the uterus) taken in the second half of the cycle will establish whether or not ovulation has occurred by testing for levels of the ovarian hormone, progesterone. This is the key hormone because it is secreted by the ruptured follicle once ovulation has taken place (see page 194).

In the event of ovarian malfunction, the ovaries can often be stimulated with a weak anti-oestrogen, chlomiphene citrate. This raises the level of naturally occurring ovarian stimulating hormones in the pituitary gland to induce ovulation in about 80 per cent of women. There is a six per cent risk of multiple birth, almost always twins and very occasionally triplets. If this fails, the stronger gonadotrophin hormones (LH and FSH) may be prescribed. As these act directly on the ovaries, excessive stimulation gives a higher (20 per cent)

chance of multiple pregnancy. Although usually twins, these drugs are responsible for the dramatic incidences of quintuplets and sextuplets and careful assessment of the level of stimulation required is therefore essential.

Damaged Fallopian tubes

The second most common cause of female infertility, damaged Fallopian tubes, unfortunately, cannot usually be as easily or as successfully treated as ovulatory disorders. The Fallopian tubes are most commonly damaged by venereal infection, but other factors can be an ectopic pregnancy, in which part or all of the Fallopian tube is removed with the growing embryo, any type of pelvic surgery and even a ruptured appendix. Sometimes, microsurgical techniques are used in order to free blocked or scarred tissue that might be interfering with the passage of the egg from the ovaries to the uterus. This, however, sounds much simpler than it is. The Fallopian tubes are so delicate that surgery can sometimes aggravate, rather than mend, the damage.

In the future, correction of this type of infertility probably lies with the newly-developed methods of 'in vitro' (test tube) fertilization. The egg is taken from the ovary, either during natural or stimulated ovulation, fertilized by the sperm outside the body and then re-implanted in the uterus. But it is still a young science and several difficulties must be overcome before it becomes more widely available.

hopehopehope

health care

'Nothing in life is to be feared. It is only to be understood...' Marie Curie

Self-help methods can increase the possibility of conception by enabling you to time your lovemaking to coincide as closely as possible with ovulation. Most women ovulate on or around the fourteenth day before the beginning of their next menstrual period. Charting the length of three or more cycles should give an average. Observable signs of ovulation include a thinning of the cervical mucus one or two days beforehand, a slight (not always apparent) dip in basal body temperature as ovulation happens, followed by a rise of about 0.5°C which is then sustained for the rest of the cycle. Use a clearly marked clinical thermometer to take your temperature every morning as soon as you wake up. A rise in temperature indicates that you have ovulated, provided that you feel well and are not succumbing to an illness or infection, and should make love within the next 24, or preferably the next 12, hours.

Knowing how your body works will stand you in good stead. Being aware of what can occur, being awake to the danger signs and having a baseline knowledge of what is and is not normal for you, means you are substantially reducing the risks, not of illness or infection occurring, but of allowing it to develop to a stage when it may, indeed, be ominous. This is your first line of defence and your most important one. It means taking the responsibility for your own good health, looking upon your body intelligently, not being frightened to find out about it and having the common sense to consult your doctor, should you find — or feel you might have found — anything potentially abnormal.

BREASTS

How women feel about their breasts largely determines how they feel about themselves as women. Because of this, breast cancer and with it the thought of losing a breast, generates more fear among women than almost any other single disease. This fear keeps the average British or American woman at home for five or six months before she consults her doctor about a lump she has found in her breast.

Not every lump, however, has to be a cancer. In fact, very few are. Even so, breast cancer is the most common form of cancer among women and afflicts one in every 17 women at some time in their lives. For this reason, it is essential to be especially vigilant — and vigilance begins at home.

Although there is a tendency to talk of breast cancer as a single disease, there are many different types. Some are very slow-growing and may not spread beyond the breast for 10 to 15 years. Others spread much more rapidly. The 'doubling' time for breast tumours (in other words, the time it takes one abnormal cell to become two and two to become four) can be as little as two months or as much as nine years. Whatever the type of cancer, the chances of successful treatment increase dramatically with early detection.

Early detection depends, first and foremost, on regular, monthly self-examinations (see page 210). The more practised you get at examining and feeling your breasts and the better acquainted you are with the natural differences and irregularities between them, the greater your chance of spotting a significant change at the earliest possible opportunity. Early detection depends, secondly, on medical screening procedures. There are two basic methods for screening the breasts, clinical examination and mammography. With advances in technology it is possible that a third — ultrasound — may provide a major breakthrough.

While it is undesirable that any screening method should carry a risk, however slight, of aggravating the condition it is supposed to be protecting against, mammography (soft tissue X-ray) is undoubtedly the earliest way of reliably detecting a breast lump before it has become large enough to be felt, by either doctor or patient. A breast lump usually only becomes 'palpable' (able to be felt) at about 2 cm (¾ inch) in size. The mammogram can detect a lump at ½ cm (⅕ inch), sometimes less, and will pick up between a quarter and a third of all breast cancers before they become large enough to be felt. As long as minimal dose radiation is used, the risks carried by the screening process are virtually negligible when set against the considerable advantages of early detection. The findings of a recent US study on the comparative risk-to-benefit ratio of mammography are illuminating. Clinical records and various established factors enabled scientists to compute that if one million women were to be screened annually for 10 years, radiation-induced breast cancers would be induced in seven — in the meantime, 138,000 early cancers would have been detected.

Breast cancer: the risk factors

Although isolating specific risk factors is difficult with any disease, the following are now regarded as being the major ones for breast cancer and the ones at the top of the list are considered to carry the highest risk. They do not suggest that you are likely to get breast cancer, accounting as they do for at least half the female population. But they do suggest that you should be especially vigilant.

● If you have already had cancer in one breast or have any other type of hormone-dependent cancer, such as cancer of the cervix, uterus or ovaries.

● If you have a close relative who has had breast cancer, particularly if the cancer occurred at an early age (35 or younger) and was bilateral (in both breasts).

● If you have never been pregnant or, particularly, if you had your first full-term pregnancy over the age of 35. While childbearing in your teens and early-to-mid twenties seems to have a definite protective effect, breastfeeding does not appear to have a significant one.

● If you are over 35. Breast cancer is extremely rare in women below this age group, when a lump in the breast is most likely to be a benign tumour or cyst (see A-Z).

● If your periods started early (at 12 or younger) and finished late (at 50 or over).

● If you have had benign breast disease. Some breast lumps, though 'benign', occasionally show signs of abnormal, pre-cancerous growth.

● If you have undergone prolonged hormone replacement therapy, after hysterectomy or over the menopause, you may be at a slightly increased risk. The progesterone component of both the combined hormone replacement therapy and the combined contraceptive pill seems to confer a protective effect against benign breast disease.

CERVICAL AND PELVIC SCREENING

Cancer of the cervix, or neck of the uterus, accounts for five per cent of all cancer deaths in women and a quarter of all such deaths in women under the age of 50. It shouldn't do. The most common type of cervical cancer, cancer *in situ*, can be detected before it actually becomes a cancer by carrying out a simple smear ('Pap') test. This involves scraping cells from the surface of the cervix with a wooden or plastic spatula and sending them to a laboratory for culture. Detected at this early stage, abnormal pre-cancerous cells can be eradicated by using cold, heat or, more recently, laser treatment. The advantages of the laser are that it works at the speed of light, can be focused with breathtaking accuracy, requires no anaesthetic and involves a simple 10-minute out-patient procedure. As the disease progresses, however, so the methods of treating it become increasingly more radical. Early detection, then, is vital and it is to every woman's advantage to seek smear tests at regular intervals (see calendar, below). For, although they do not constitute an absolute guarantee against developing the cancer, they will considerably reduce your chances of doing so. Of all the British women who died of cervical cancer between 1973 and 1978, nine out of 10 had never had a smear test.

Cancer of the cervix has several clearly established risk factors. By far the largest is sexual intercourse. As sexual activity moves you immediately from a no-risk to a high-risk

HEALTH CALENDAR: the whys and whens of screening

Screening is controversial. Some doctors consider it very helpful, potentially life-saving and too little practised, while others consider it a potential disservice because it may either engender unnecessary alarm or a false sense of security, even complacency, by encouraging people to hand the responsibility for their health over to their doctors. Your family history and your lifestyle – your diet, your smoking and drinking habits, and how much exercise you take – may be more important in determining good health than are regular check-ups, but infections and diseases can strike the healthiest individual. Happily, some of these can now be caught early enough to increase the prospects of successful treatment quite considerably. This more than justifies screening for them. The thinking on health checks has changed over the last decade or so. No longer is the annual 'physical' the preventative prescription. Most important is to have specific tests for 'high-risk' parts – breasts, cervix, heart– as age, sex and family history indicate. Use this chart to see at a glance which health checks you should be having when.

WHAT?	WHEN?	WHY?
Complete physical check-up	Healthy people who carry no special risk, such as a family history of heart disease, do not necessarily need an annual check-up. A more realistic schedule would be every two years from the age of 35 to the age of 50; once every year after that.	To establish that you are fit and in good health with no obvious or incipient signs of illness, that your lifestyle is healthy and that you have no risk factors, such as high blood pressure, that can be precursors of ill health.
Breast self-examination	Every month just after your period has finished; on the first day of each calendar month, if you have been through the menopause.	To check for any changes in the breasts (see following page) that should be referred to your doctor for further investigation. Of the 100,000 new breast cancers per year in the USA, 90 per cent are detected by women themselves.
Mammography (minimal dose radiation) and/or clinical breast examination	Mammography once at the age of 35; a single view can be done annually thereafter. If you fall into one of the 'higher' risk categories, detailed on the previous page, your doctor may suggest that you have mammograms taken earlier and/or more frequently. If a female relative (mother or sister) has had breast cancer, you should start mammography screening at an age earlier than that at which the relative's cancer was detected. Clinical examinations should be carried out annually.	To give the doctor a 'baseline' reading of the normal architecture of the breast, if it is the first mammogram, against which subsequent X-rays can be referred to detect any changes; to pick up the 'high risk' breast – certain tissue patterns being linked with a higher incidence of cancer; to provide reassurance that all is well in the breast; to clarify the nature of a lump that has been found (i.e. whether it is cystic and benign or potentially cancerous) and thus occasionally avoid the need for surgical investigation (biopsy). A clinical examination entails having the breasts checked manually by medically trained personnel. This can be especially helpful for women who feel apprehensive about examining their breasts or who would like instruction on how to examine them.
Cervical smear (Papanicolaou ['Pap'] test)	Soon after the time of first intercourse and again one year later; thereafter at three-yearly intervals up to age 35 and at five-yearly intervals up to age 60. If all results have been negative, testing can be discontinued. You should have an annual smear test if you have had the herpes virus.	To detect the presence of abnormal cells on the cervix which may be pre-malignant (i.e. indicative of future cancer) and which, once found, can almost always be completely eradicated. The first smear should be followed by another one year later, to guard against the possibility of a 'false negative' result. As it takes an average of 10 years for localized (*in situ*) cancer of the cervix to spread, a three-yearly check-up thereafter should give time to detect any changes.
Blood pressure reading	Every three years up to age 35 and annually thereafter; annually, whatever your age, if you smoke, are very overweight or have diabetes; when you are pregnant; whenever your prescription for the contraceptive pill is renewed. If you already have diagnosed high blood pressure and are taking pills for it, you should have your blood pressure checked each time the prescription is renewed as the same dose of pills may not be required.	To check for high blood pressure (hypertension) which can be completely symptomless. It is important that you get your blood pressure checked regularly over the age of 35 (pressure tends to rise with age) because it is a recognized risk factor in heart disease (pumping against the high pressure places additional demands on the heart). A good average pressure is considered to be 120/80. Slightly lower than average pressure is hardly ever a problem – in fact it can be a health plus. High blood pressure during pregnancy may indicate that the pregnancy and birth will need careful monitoring. It is important to have blood pressure checked both when starting oral contraception and when renewing prescriptions, because it can rise while taking it and might make a change in birth control necessary.

screenscreenscreen

category, a smear test should always be carried out at the age when sexual intercourse is first begun, particularly if still in your teens. A young cervix is many times more susceptible to the cancer than an older one. If you have had the herpes virus (see page 216), a smear test should be carried out annually, as this is now thought to increase the risk of developing abnormal cells on the cervix.

When you have your smear test, you should also have a bi-manual pelvic examination to check for cysts, fibroids (benign growths) and early signs of pelvic inflammatory disease, though this is not always identifiable by examination. Pelvic inflammatory disease is caused by an infection that either originates or migrates beyond the cervix. The cervix protects both the uterus and the more susceptible Fallopian tubes beyond it. Any situation in which the cervix has recently been opened, such as after having had an IUD fitted, after a birth, abortion or miscarriage or after having a D and C (dilatation and curettage), can increase the risk of developing a pelvic infection. Early symptoms of pelvic inflammatory disease are tenderness, pain during intercourse, irregular or very heavy periods, bleeding abnormally between periods (a small amount of 'breakthrough' bleeding is quite common at mid-cycle; a heavier flow is not), or any bleeding six months or so after the menopause. These symptoms may or may not be accompanied by a discharge, but you should always be medically investigated.

WHAT?	WHEN?	WHY?
Chest X-ray	Chest X-rays are usually no longer included in the routine series of health checks and are not generally recommended.	Chest X-rays are now not even recommended for heavy smokers because they cannot pick up a cancer early enough to reduce mortality rates, though they can be useful for picking up infections, such as asymptomatic TB.
Lung function test	Not at all, unless you get breathless walking up two or three flights of stairs, in which case tests may be indicated.	To see how much air you can shift through your lungs by blowing into a breathalyzer-type bag, known as a spirometer; a poor result may indicate emphysema or bronchitis.
Electrocardiogram (ECG) and blood/cholesterol reading	At age 35 in men; 40 for women. As recommended – usually annually for men and less often for women, for whom the sex hormones before the menopause seem to confer an inbuilt resistance to coronary heart disease. Your blood/cholesterol levels should be screened more frequently if you have passed the menopause, smoke heavily, take the contraceptive pill or are substantially overweight, as these factors counteract the protective effect.	The ECG is considered of limited value for healthy people, but nevertheless important for getting a baseline pattern against which any subsequent deviations can be spotted. Because the ECG measures the heart's electrical activity, certain abnormalities, such as flutters, will show up. As men are especially at risk of heart disease, an ECG should be taken at regular intervals after age 35. Of potentially greater value, however, is the blood/cholesterol test. Raised blood/cholesterol levels are a recognized risk factor in coronary heart disease. By enabling preventative action to be taken (the diet adjusted, for example), a blood/cholesterol test could prove life-saving.
Dental check-up and/or visit to dental hygienist	Your teeth and gums should be checked every six months and at the beginning of pregnancy, unless your dentist specifies otherwise. You should see a dental hygienist to have your teeth scaled and professionally cleaned and polished once a year (more often if living in a hard water area).	To check for early signs of tooth decay and/or gum disease. The visit to the hygienist is important because tartar (an accumulation of plaque) calcifies and hardens on the tooth and can initiate gum disease by irritating the gum. Once calcified, tartar cannot be removed by brushing. Tartar tends to build up faster in hard water areas due to deposits of mineral salts in the water and may need removing at six-monthly rather than yearly intervals.
Sight testing	At nursery school age (four or five); thereafter as indicated by ophthalmologist or if and when problems present themselves. Most people will require a sight test at between the age of 40 and 50 when focusing at close range starts to diminish due to natural deterioration of crystalline lens inside the eye. This sight test can be combined with an investigation for early signs of cataract. Diabetics should have regular check-ups for the eyes.	To check for long- or short-sightedness; to fit reading glasses to counteract the natural tendency to long-sightedness that increases with age; to look for early signs of cataract on the eye.
Glaucoma testing for eyes	Between the ages of 40 and 50; earlier if there is a family history of glaucoma.	To check for evidence of glaucoma, a sight disorder caused by a build-up of pressure in the eye. Glaucoma leads to 'tunnel vision' through a gradual loss of peripheral vision. It is important that the eyes are checked even if the sight seems perfectly all right, because glaucoma can be absolutely painless and symptom-free in its early stages.

BREAST SELF-EXAMINATION

Examine your breasts once a month just after your period has finished. Breasts undergo glandular changes through the menstrual cycle and many people find that their breasts are naturally lumpy and tender just before menstruation. If you have been through the menopause, you should examine your breasts on the first day of each calendar month.

Most breasts are naturally asymmetrical — the shape may be uneven, the nipples may point in different directions or one breast may be significantly higher or lower or larger or smaller than the other. Study your breasts to see whether any of these apply. The key to successful, unanxious breast examination is change, so you must be aware of what is normal for you.

What to watch out for

● <u>A lump in the breast.</u> Only a very small proportion, probably less than 10 per cent, of all lumps are cancerous, but it is impossible to tell by feeling whether a lump is innocent or not. Only a doctor can decide whether or not this is the case. In order to do so, it may be necessary to remove the lump surgically (biopsy) and to subject it to various tests. This does not necessarily indicate anything ominous. Between 60 and 80 per cent of all lumps examined in this way turn out to be harmless. Even so, you should always see your doctor if you find, or suspect that you have found, a lump in your breast.

● <u>Any moles that have changed in size, shape or colour.</u>

● <u>Dimpling or puckering of the skin, an unusual prominence in the blood veins on either breast, or a retraction (drawing in) of the skin tissue.</u> Any of these may indicate the presence of a lump pressing on the ligaments inside the breast, thus affecting its contour and appearance. Again, only a doctor can decide whether or not this is the case.

● <u>Inverted nipples.</u> Some women have naturally inverted nipples or, more rarely, one nipple may always have been inverted while the other one is not. If your nipples have always been this way, you have no cause for concern. Any situation, however, in which the nipple has recently become inverted requires further investigation.

● <u>A discharge coming from one or both nipples.</u> Check for this by looking inside your bra before carrying out your monthly breast self-examination. Although a discharge is not uncommon when taking or (particularly) when coming off the contraceptive pill, just prior to menstruation, or after breastfeeding, when a small secretion may persist for some months, it should never be ignored, particularly if it is persistent, coming from one nipple only or is bloodstained. This may indicate the presence of a small wart, which, if left untreated, may lead to cancer. So consult your doctor and, in the meantime, do not squeeze or interfere with the nipples in any way. Consult your doctor, too, if you have an ulcer or sore on the nipple that does not heal.

● <u>Enlarged or inflamed lymph glands.</u> The lymph glands surrounding the breast lie on the outer sides and run up towards the armpit. They are essential for regulating the body's fluid balance and for fighting off infection. Although they may enlarge quite naturally if you have an infection or before menstruation, you should see a doctor if the inflammation has not subsided after three weeks.

checkcheckcheck

2

3

1

- Start with a visual inspection (1). Stand in front of a large mirror with a good light placed to the side, not overhead. Now look at your breasts. If this is the first time you have carried out a breast examination, take the opportunity to note exactly how they look.
- To help check the differences between the two breasts, place the hands on top of the head (2) and turn slowly to the left and the right. The crossways angle of the lighting should help you to spot any irregularities or dimpling in the skin surface.
- Place your hands on your hips and press firmly down and inwards (3). This should tighten the pectoral muscle and, thus, help you to spot any dimpling. Then, keeping your hands where they are, lean forwards from the hips, so that the breasts fall straight downwards, and inspect them head-on. Look particularly for any tautness in the skin tissue, any change in the way the nipple is pointing, and for a nipple that becomes inverted on leaning over but everts itself naturally as you stand up again.
- Lie down on a firm surface and place a folded towel or pillow beneath the shoulder of the side you examine first (4). This is especially important if your breasts are large, as the breast will then sit evenly on the chest wall. Feel each breast in turn with the opposite hand and, to begin with, keep your arm by your side. Feel with the flat surface of your middle three fingers, keeping them straight, but not

tense, and the wrist flexible. The amount of pressure you exert should be firm enough for the skin surface to move with your fingers (they should not just glide over it) but not so firm that the natural texture becomes hard and lumpy if you press too hard. Press the breast tissue gently but firmly towards the chest wall, starting just above the nipple and tracing concentric circles radiating outwards in a spiral the whole way round the breast. Be particularly on the look-out for any fixed, hard lump that will not move away easily when you press the breast tissue between your fingers. Make sure that you feel every part of the breast, beneath as well as above.
- Finally place your arm above your head so that the outer side of the breast is stretched and accessible (5). Repeat the examination, as above, and pay particular attention to the upper part, or tail, of the breast which extends up into the armpit.

ageing

'It's not catastrophes, murders, deaths, diseases, that age and kill us; it's the way people look and laugh and run up the steps of omnibuses...'
Virginia Woolf

THEORIES AND THERAPIES

Ageing is an unalterable, unavoidable, inevitable fact. The degenerative process starts in the brain, spreads throughout the body, infiltrating every cell and producing all the familiar physical and mental signs of age — hair greys, skin wrinkles, eyes lose their focusing ability and other senses become feeble, joints become creaky, memory falters.

From the beginning of time, man has sought to explain this dismal process. Modern theories, often no less colourful or bizarre than those postulated by the ancients, range from a 'death' hormone, released by the brain at the time of adolescence with the awesome power of slowly starving body cells of oxygen, to an insidious invasion of bacteria in congested faecal matter in the gut — a sort of toxic constipation. Another theory, maintaining that ageing is equivalent to rusting to death and is caused by an accumulation of oxidants in the blood, made vitamin E, well-known for its anti-oxidant effect on the blood, a youth tonic overnight.

What we do know is that ageing is principally, though not wholly, a matter of wear and tear. The straightforward business of living is registered at cellular level, where it affects the process of division and renewal. The damage is cumulative. Small defects, imperceptible at first, become increasingly noticeable as the years pass by.

Genetic evidence that body cells have a finite capacity for reproduction supports this theory. Instead of dividing indefinitely, cells can only divide a fixed number of times. RNA therapy uses injections containing nucleic acids in order (theoretically) to prolong the life expectancy of these cells. But its value, if any, is far from clear. The same applies to other types of cellular or glandular extract and the numerous multi-vitamin packages currently on the market. Science may one day provide us with a means of significantly prolonging youth, but it is unlikely to happen in our lifetime.

The secret of eternal youth may elude us, but we still 'make do' with anti-wrinkle creams, cosmetic surgery, hair dyes, vitamins, youth tonics and elixirs. In our 'Keep Young' culture, we age fearfully not gracefully, associating age with inevitable physical decay and mental slowdown. We ignore the example set by great artists, actresses, designers, writers and politicians, such as Monet, Mattisse, Celia Johnson, Chanel and Churchill, whose vigour and creativity carried well into their seventies and eighties has shown abundantly that this need not be the case. Ageing is an attitude. Helena Rubinstein, convinced that you are, literally, as young as you feel, maintained that the secret was to stay committed, involved and right in the mainstream of life. 'Work,' she wrote in her nineties, 'has indeed been my beauty treatment. I believe in hard work. It keeps the wrinkles out of the mind and the spirit....'

Beauty points for 40 plus — skin, hair, make-up, health

Taking responsibility for your own health is your first priority if you want to preserve your looks from the advancing years. Start with regular exercise, concentrating particularly on the loosening and stretching exercises (blue leotard) in the Shape chapter in order to keep joints mobile. Continue with plenty of fresh air and sleep, a balanced diet, a conscientious skincare regime and regular health checks.

● <u>Rethink your skincare programme and make-up techniques every five years from about the age of 40.</u>

A skin that has become drier and looks flaky in patches needs a mild exfoliant once a week and a richer (greasier) moisturizer at night. The throat and neck tend to age particularly rapidly, so always start moisturizing from the collar bone up and take a preventative line with the neck strengthener exercise on page 42. Increased facial hair, due to declining levels of oestrogen, is an age-related problem. Treat it temporarily by bleaching or permanently by electrolysis.

● <u>Cosmetics can subtract years from the look of the face but, unless applied very carefully, they are more likely to add them.</u> Layers of foundation and face powder can be very ageing because they tend to settle into the creases of the skin, bringing out every line. So use a lighter hand when making up. Apply a thin layer of moisturizing foundation with a slightly damp sponge and cover with a translucent dusting of powder. Keep to the barest minimum around the eyes, where wrinkles are all too easily emphasized. Once past the age of 60 and provided that your skin tone and texture are generally good, use foundation only on the cheeks if red veins are a problem; powder not at all.

Bearing in mind that complexion tones change as you grow older, make sure that foundation, blusher, eye and lip shades are still appropriate. Choose a foundation that is as close to your natural colour as possible and keep blusher, lip, nail and eye colours neutral and soft. Outlaw black mascaras and eyeliners, frosted colour shadows and bright dramatic colours. All of these tend to be more ageing than effective.

● <u>Although you lose colour most perceptibly in your hair, you also lose it in your skin.</u> This mutual mellowing of complexion and hair colour is due to a gradual loss of the pigment in the cells of the hair and the skin. Striving to recapture your old 'natural' colour when your hair starts to go grey can produce an unhappy, jarring contrast between skin and hair tones. Capitalize, instead, on the new tones and have the lightest strands brightened a shade or two for a head of soft, natural highlights. If your own natural colour is very dark, lighten the base a shade or two for a softer effect. You can go on in this way until you are as much as 80 per cent grey. After this, you may want to consider tinting your hair.

THE MENOPAUSE

For many women, the menopause signifies the dividing line between youth and age. This feeling is reinforced by the many myths surrounding the menopause — feeling terrible, hating sex, becoming old, tired, wrinkled and depressed. These are not physical symptoms produced by hormonal changes, but psychological symptoms produced by society's attitude towards middle-aged women.

Medically, this phase of life is known as the climacteric; the menopause refers only to the last menstrual period. For most women, this occurs between the ages of 48 and 53. After this, the ovaries cease to produce a monthly egg and the levels of the hormones, oestrogen and progesterone, gradually fall. About three-quarters of women experience some symptoms while this is happening. These include a tightness and loss of lubrication in the vagina, which can make sex uncomfortable, and hot flushes (flashes in the USA). These are sudden sensations of heat, which usually originate in the chest and spread rapidly upwards, raising surface body temperature by as much as 4°C (7°F). Other effects may include thinning hair, increased facial hair, dry, flaky skin and an increased tendency to loss of bone mass and to a disease known as osteoparosis, in which the bones become thin and brittle and more prone to fractures. All women once through the menopause should take fish liver oil capsules (vitamins A and D) together with extra calcium to help keep bones strong and healthy. This is particularly important during the winter, when there is little sunlight (a major source of vitamin D).

In as many as 70 per cent of women, the tangible symptoms of the climacteric are not severe. If you do feel discomforted by hot flushes or by dryness in the vagina, consult your doctor. Responsibly prescribed hormone replacement therapy (HRT) is an effective way of treating menopausal symptoms. Natural oestrogens are taken with synthetic progesterone (progestogen) to produce a monthly bleed. HRT is most often prescribed for between 24 and 36 months, although in some cases it might be taken for longer. It should always be stopped gradually as abrupt withdrawal can exacerbate the symptoms.

The uterine cancer 'scare' of the mid-1970s has now been largely overcome by the inclusion of progesterone. In addition, the oestrogen component of HRT is now thought to confer a protective effect against coronary heart disease, a greater cause of death among women after the age of 55 than cancer of the uterus. Research figures published by the American Heart Foundation in March 1982 showed that of a sample of 2269 women between the ages of 40 and 69, the death rate for women not taking the oestrogen was nearly one per cent a year compared with three-tenths of one per cent for the oestrogen users. The current thinking is that the risks of HRT are more than justified by the positive advantages where the need is indicated. One of the most positive advantages is the fact that women on the therapy conserve their bone mass, do not lose height and do not develop osteoparosis. Research increasingly suggests that, by helping to keep women agile and active into their 70s and 80s, HRT may be our closest step yet to stalling the ageing process.

213

a-z of common disorders

'None of us are perfect. I myself am peculiarly susceptible to draughts...'
Oscar Wilde

This alphabetical guide is intended to give you a basic understanding of the way in which your body functions and, occasionally, malfunctions. It is also designed to help you to relieve some of the more common aches and pains by giving simple and practical notes on self help. It is not, however, intended to replace your doctor. No amount of medical 'knowledge' gleaned from reading books can replace the deep understanding that a qualified doctor gains from years of training and experience. So use this guide for interest and for reference and, if in any doubt, consult your doctor.

Acne

In the normal course of events, sebum, made in the sebaceous glands deep down in the skin, travels up the hair follicle to emerge through a fine pore on the surface. There, it emulsifies with sweat to fulfil its vital double role of lubricating and protecting the skin. However, if the sebum hardens and becomes trapped just beneath the surface of the skin, or if the dead epidermal cells stick together and clog the opening of the pore, a small pimple or blackhead will appear. If the blockage occurs deeper down, inflammation and primary bacterial infection combine to produce a much larger and angrier spot. Both are acne.

The more severe inflammatory types of acne are thought to be caused by the male hormone, androgen, circulating in the bloodstream and causing the sebaceous glands to secrete grease. Nothing is demonstrably 'wrong' in a hormonal sense: some people are simply more sensitive to the hormone than others. This sensitivity will depend on familial inheritance and skin type.

Although diet has no direct causal link with acne, an imbalanced diet can certainly aggravate it. So, too, can stress, over-zealous self 'treatment' and squeezing. The first rule is to leave your skin alone. (If you are an habitual picker or squeezer, cut the fingernails short and watch your skin improve.) Wash your skin twice daily with an antiseptic or medicated soap, use topical creams and lotions sparingly and remember that there is absolutely no virtue in fanaticism. Dirt and oil on top of the skin have nothing to do with any but the smallest of pimples—it is the oil trapped beneath that is to blame.

If you have persistent or severe acne, or are distressed about the condition, see your doctor. Acne can be treated — often extremely effectively — with a course of antibiotics, prescribed over a period of months or even years. It works by counteracting the effects of the problem, not by 'curing' it. It may be as many as three months before a noticeable improvement in the condition of the skin can be seen.

Topical acne treatments range from mild antiseptic lotions (astringents) to stronger, more abrasive chemical solutions that 'strip' off the dead layer of skin cells to unblock the pore and free the sebum. Lotions containing benzoyl peroxide, salicylic acid or retinoic acid (vitamin A) are probably the most effective. However, while they can be valuable in treating superficial non-inflammatory acne, they will not help more severe types and may even aggravate them. In addition, if these lotions are used too often or applied over-enthusiastically, they may produce redness, dryness and excessive irritation. 13-Cis Retinoic acid (at present only available in the USA), taken orally as a course of tablets, works by cutting down sebaceous activity and can be very effective. Its disadvantage, however, is that it tends to dry up the skin. Common side-effects are chapped lips and general flaking and dryness.

In the future, medical treatment of the more severe types of acne may involve regulating the hormone levels responsible for producing the condition, either by prescribing an anti-androgen, usually cyproterone acetate, or additional oestrogen, depending on the patient. While effective in combating and protecting against acne, the drug is at present being combined with an oestrogen for a contraceptive effect. Risk factors on ovulation and pregnancy have still to be assessed.

Allergy

An allergy is an exaggerated reaction to a substance, or group of substances, that is usually tolerated perfectly well. The substance itself may be inhaled (grass pollen, house dust), eaten (eggs, wheat, penicillin) or absorbed on contact with the skin (lanolin, detergents, perfume, metals). The list of these allergens, or allergy-producing substances, is virtually endless. Anyone can be allergic to almost anything.

Confusingly, too, allergies are the result of a number of paradoxes. The first is that you only develop an allergy to a substance <u>after</u> you have been exposed to it. Allergies to insect bites, for example, are much more common after the age of 30 as it takes at least one sting and usually more before a susceptible person becomes allergic to the venom. The second paradox is that allergies are produced by the antibodies that would normally serve to protect the body from disease by recognizing invading germs and viruses as potentially harmful and alerting the body's auto-immune (disease-fighting) mechanism. An allergic reaction occurs when these antibodies identify a completely harmless substance as being potentially harmful and dangerous. This prompts the release of chemicals, such as histamine, that are normally sealed away in the cells of certain body tissues — skin, gut, mucous membranes of the nose, conjunctiva of the eyes and respiratory system. The result is the familiar allergic reaction: running nose, sore streaming eyes, wheezing and asthma, hives (a nettle-like rash on the skin), eczema and itching and swelling. Sometimes the allergic reaction may be so severe as to cause breathing difficulties or even anaphylactic shock during which blood pressure drops suddenly and breathing, heart beat and circulation may weaken and even fail.

If you have a reaction to a substance, known or unknown, and you suspect it may be an allergy, you should see your doctor who may then refer you to an allergy clinic for diagnostic patch testing. This entails placing minute amounts of the substance in question or a number of common allergens on the skin, usually the forearm, and waiting for a local reaction, such as a series of raised bumps, to appear at the site of contact. In most cases (some food allergies are an exception, see pages 75-6), this will enable doctors to determine the cause of the allergy. Treatment will then largely consist in avoiding the offending substance and in treating the reaction symptomatically when or if it recurs. The most notable of all the drugs used for this purpose is antihistamine, which can be applied as cream, inhaled as a spray or taken in tablet form. Although anti-histamines have a reputation for making you drowsy, there are many different types of the drug and, by changing your prescription, it is usually quite possible to find one that works well for you. There is also a new drug which works like an antihistamine but has none of its potential side-effects. One word of warning: if treating yourself for allergy, do not over-medicate. This is especially important if you are using the nasal spray as it can have a rebound effect and serve to exacerbate rather than mitigate your symptoms.

One particularly common type of allergy is hay fever, or 'allergic rhinitis', a condition suffered by 15 million people in the USA and 3 million people in Britain. Hay fever is not caused by hay at all but by the pollens of various trees, grasses and moulds. Although there is no clear pattern to the allergy it tends to appear first between the ages of 12 and 20 — but it can begin after the age of 30 or later. You can also grow out of it, the condition vanishing as mysteriously as it first appeared. Most hay fever is caused by the pollen of common grasses which flower from mid-May to mid-July, reaching their peak in June. As there is a considerable amount of cross-reactivity between the various grasses, hay fever sufferers are likely to show an allergic response to all or most of them. If symptoms start much earlier or later the reaction may be due to a tree pollen (mid-January to April or May) or mould (August to October). Preventative treatments are particularly important in the case of hay fever, as grass pollen, being airborne, permeates the atmosphere — in cities as well as in the country, indoors as well as outside. Various forms of preventative treatment, if taken at the onset of an attack, can block the reaction at source (eyes, nose, throat) but, once it sets in, can take several days to relieve it. There are preparations for the eyes and lungs and a steroid spray to offset sneezing and running noses.

You can also be vaccinated against hay fever. This involves a simple course of injections in which the dose of pollen vaccine is successively stepped up, usually in three stages but sometimes more. This has made it possible to relieve symptoms and desensitize sufferers to a point where the symptoms are either greatly relieved (60 per cent) or, in a small number, cease entirely. Injections should begin in February or March so that desensitization has been completed by the time the first grass pollen is in the air. These do have a cumulative effect and it is therefore quite possible to find, after two or three years of treatment, that your hay fever is indeed a thing of the past.

Amenorrhoea
(absence of menstruation)

Between the ages of 15 and 45, the most common cause of amenorrhoea is pregnancy. Pregnancy should always be suspected if a period has been missed for more than a fortnight and sexual intercourse has taken place at any point over the preceding cycle, regardless of whether or not contraceptives were used. Stress, anxiety, changes or disruptions in your day-to-day life (such as going on holiday), crash dieting and coming off the contraceptive pill are other common inhibitors of ovulation and may well disrupt your cycle. If you are in your 40s or early 50s, absent or irregular periods may indicate that you are approaching, or have passed through, the menopause (see

page 213). If you are over the age of 16 and have never had a period or have not had a period for three months or more, you should see your doctor. Tests may be necessary in order to determine the cause.

Anaemia

Iron-deficiency (dietary) anaemia is by far the most common type and women are much more susceptible to the condition than men. In fact, in one recent study, 10 per cent of all women between the ages of 15 and 44 were said to be on the threshold of this condition, due to excessive blood (and iron) loss during menstruation. A loss of iron in the blood produces a whole range of non-specific symptoms — tiredness, breathlessness, giddiness, pallor, weakness in the limbs and, often, an overwhelming lethargy — because it depletes the amount of haemoglobin, the oxygen-carrying pigment in red blood corpuscles. Haemoglobin is responsible for nourishing and regenerating every cell in the body and for producing the characteristic 'redness' of the blood. Many cases of anaemia present two important diagnostic clues. These are nails that are 'spoon'-shaped and curl up or downwards and a lack of colour either beneath the nail or in the normally richly supplied conjunctival tissue inside the lower eyelid. Although iron-deficiency anaemia is often caused by menstrual blood loss (one of the drawbacks of the IUD is a heightened risk of anaemia in some women due to an excessively heavy menstrual flow), but it may also be caused by other types of external or internal bleeding, such as a silent and slow-bleeding peptic ulcer.

If you suspect you have anaemia, or are feeling excessively tired, you should see your doctor. You should not dose yourself with iron supplements because, if you do have the condition, commercial iron-bolstered multivitamin pills will not contain enough iron to rectify the balance. If you do not have the condition, too much iron can be as bad for you as too little as it interferes with the absorption of other essential minerals, principally zinc. For this reason, iron supplements are no longer automatically given as a routine part of ante-natal practice during pregnancy. If you want to safeguard yourself against iron-deficiency anaemia, incorporate a dark green leafy vegetable, such as broccoli, into your diet together with a helping of liver, kidney or heart each week. Eating a vitamin-C rich fruit or vegetable with your meals will also help as this vitamin has been shown to aid iron absorption in the body (see page 72).

A second, rarer, type of anaemia is known as pernicious anaemia and is caused by a deficiency of vitamin B12 or, more commonly, an inability to absorb it from the diet. As B12 is found only in foods of animal origin (meat, fish, milk, etc), strict vegetarians, or vegans, should always take additional B12. Supplements are now available in synthetic vegetable form. An inability to absorb the vitamin is hereditary and seems to occur most often in middle-age, particularly among those who are blue-eyed and white or fair-haired. Once diagnosed, the condition can be remedied by giving regular doses of the vitamin through injection directly into the bloodstream.

Athlete's foot

This infection is by no means exclusive to athletes and is caused by a fungus. Although most commonly seen on the feet, the same infection can also occur in the groin, mouth or armpits — any corner of the body that makes a moist, dark and attractive breeding ground for bacteria. The most common site of athlete's foot is in between the toes. You can protect against it by washing and drying the feet and toes thoroughly, although not rubbing harshly. If you get the infection, treat it with strong salt footbaths, apply surgical spirit twice daily to dry out the skin and one of the many anti-fungal powders available. Do not use ordinary powders as these will tend to clog. If the infection is very painful and the skin cracked and sore, anti-fungal antibiotics can be prescribed to make healing more rapid.

Back trouble

'Back trouble' is a blanket term that covers everything from the smallest twinge along the spinal column or crick in the neck to the more serious disorders of the spine and central nervous system. Four out of five people will have at least one severe attack at some time in their lives. Many will be fortunate enough to recover in a few days or weeks, but a growing number — and some experts now maintain that it is 10 per cent of the population — live in chronic pain from which they can find little or no relief.

By far the most common cause of back trouble is lumbago. This is a chronic, nagging pain in the lower back. It can be triggered off by any number of things from the single event, such as standing awkwardly over a low basin when washing your hair, to the undramatic accumulation of years of bad standing, together with all the stresses and strains of everyday living. It can also strike during pregnancy, after the birth of a child, before a period and during the menopause. Following the guidelines on posture and on safeguarding the health of your back and spine given in the Shape chapter should help to prevent the onset of back trouble and to relieve the pain if you do get it. (See pages 202-3 for positions that will help to relieve backache during pregnancy.)

If you have persistent backache or a sharp pain in your spine or neck, you should always see your doctor. Because there are so many different causes of backache, you should never do 'corrective' exercises unless these are individually tailored for you by your doctor or specialist. (See page 35 for a list of exercises you should beware of).

If your back suddenly 'gives way', stop what you are doing immediately, call a friend and lie down on your back or your side (never your front). Bend your knees and ask your friend to apply cold compresses to the injured or painful area, by wrapping a plastic bag filled with ice-cubes in a towel. Call your doctor.

Boils

Boils, or abscesses, are infected hair follicles and they can appear anywhere on the body. Adolescents are particularly prone to them. Treat boils with an antiseptic lotion, preferably povidone iodine or magnesium sulphate, and leave them well alone. Avoid squeezing them or using the old-fashioned and now outdated method of applying hot compresses, as both of these may spread the infection. If you have recurrent boils, you should consult your doctor as, just occasionally, they may be symptomatic of diabetes.

Bruising (haematoma)

Bruising is caused by a blow to the body breaking the blood capillaries beneath the skin. While nothing can hasten the disappearance of a bruise once it has appeared, prompt action immediately after receiving the blow may prevent it appearing in the first place. Apply ice packs (fill a plastic bag with ice-cubes and then wrap in a towel) or cold compresses for about an hour to lower the skin temperature and thus reduce the activity of the skin cells.

Bunions

See Enlarged toe joints.

Burns and scalds

Burns are caused by direct contact with heat, such as a naked flame or an electrical current, and scalds by the products of heat, such as steam. They are classified in order of severity. First degree burns are the least severe and you can usually treat them yourself. Third-degree burns are very severe indeed and require immediate first-aid and admission to hospital.

Fast action is essential if somebody's clothes or hair are on fire. Grab a blanket, a towel, a thick woollen jacket or an overcoat and wrap it around the body to smother the flames. Then cover with a blanket to keep the body warm (body temperature tends to drop very rapidly) and telephone immediately for an ambulance.

Minor burns or scalds should be treated by running cold water over the injured area for at least 10 minutes and then applying ice packs (put ice in a plastic bag and then wrap in a towel, never apply directly to the skin) for up to an hour. This lowers the temperature and thus the activity of the skin cells and minimizes the damage, while acting as a natural 'anaesthetic'.

Never apply butter to burns. Use a dry dressing instead and then leave to the air. Blisters should be left to themselves and will usually break spontaneously. If they do not, consult a doctor. Do not attempt to lance them yourself.

Cataracts

Cataracts are caused by a gradual clouding of the crystalline (fine focusing) lens inside the eye. As the lens becomes more opaque, so the vision becomes more blurred. Because the condition is caused by a defect inside the eye, it will not be improved or helped by the wearing of glasses. Although some babies are born with cataracts, the condition is particularly linked with advancing age. In fact, it is now thought that, by the age of 70, 90 per cent of people may have some degree of it. Everyone should have their eyes checked for early signs of cataract soon after the age of 40. Cataracts can also occasionally be caused by injury or trauma to the eye, by certain drugs, by excessive radiation or sun exposure and by diabetes. The condition can be treated surgically by removing the damaged lens and increasing the focusing power of the eye by placing the appropriate lens in, on or in front of the eye.

Cellulite

Does it exist or doesn't it? Depending on whom you talk to, cellulite is either a non-existent condition invented by the French or it is 'fat gone wrong', an exclusively female and virtually universal condition caused by sluggish circulation, congested blood vessels, accumulated toxic and metabolic waste and mineral and vitamin imbalances. The truth is probably half way between the two. Whether you call it cellulite or call it fat, there is absolutely no doubt that women do have a different type and different distribution of fat to men. For where, in men, fat is packaged in small compact compartments that are fairly evenly distributed beneath the skin, in women the cellular arrangement is not only much looser but has a marked tendency to accumulate on bottoms and thighs. This type of fat is uneven and dimpled in appearance (the French, expressively, call it peau d'orange) and can feel uneven and grainy when rolled beneath the fingers. While there is no doubt that factors hormonal and genetic are to blame for this, together with (probably) too little exercise and too much to eat, what is dubious, is the number of treatments and therapies — from wearing inflatable boots to undergoing courses of dandelion injections — that claim to be able to 'break up' or to 'mobilize' fatty deposits, 'disperse' toxic waste, 'stimulate' a sluggish circulation and so 'recontour' the body. None of these has been shown to work really effectively on a clinical basis and results, while expensive, are often disappointing.

Chloasma (melasma)

This is a blotchy darkening of the pigmentation in the skin that usually appears on the cheeks just below the eyes, above the lip, on the forehead, in the armpits, on the nipples and around the genital area. It occurs in as many as one-third of all women on the pill and is not uncommon in the last three months of pregnancy. While it will fade in time, chloasma is aggravated and rendered more noticeable by exposure to bright sunlight. Keep out of the sun as much as possible, avoid sun lamps and use an efficient sun block. You can sometimes counteract the darkening by bleaching the skin, but results are not always good and may even leave the skin looking blotchier than before.

Colds

Colds are caused by a number of different viruses and produce a range of symptoms, including sneezing, coughing, streaming eyes, a congested or running nose, sore throat and headache. A raised temperature is rare.

If you seem to have a persistent cold or suffer intermittently all through the winter months, your resistance is low and so, too, probably is your general health. Keeping fit, strong and well-nourished and avoiding sudden drops or rises in temperature (do not overheat rooms) should constitute your first line of defence. You can, if you like, also take additional vitamin C in the form of tablets, although opinion as to whether or not this is an effective safeguard is very divided. Nobel laureate Linus Pauling recommends 'mega-doses' of up to two grams of the vitamin a day (equivalent to 200 oranges) to keep the cold virus at bay, together with a further

500 mg every four hours, if you feel that you are about to or have succumbed in order to reduce the severity of the symptoms.

More traditional methods of treating colds involve relieving the symptoms. Most doctors now recommend that you do this by treating each of the symptoms independently. Take an antitussive cough medicine for a dry, hacking cough; an expectorant for a 'productive' one; lozenges containing phenol or benzocaine or gargle (½ teaspoon salt or two drops tabasco in 225 ml/8 fl oz/1 cup of warm water) for a sore throat, or suck ice which works like a surface anaesthetic by numbing the throat; a decongestant for a blocked nose, (but do not use for more than three days as it has a rebound effect); an anti-histamine preparation if your nose is runny, which works in the early stages of a cold much as it does in the early stages of hay fever (see Allergies). You should also drink plenty of fluids to replace those you are losing.

Cold sores
These can appear anywhere on the body and are transmitted on contact by a virus known as herpes, from the Greek herpein, meaning to creep. They may have nothing to do with colds at all. The sexually transmitted type of cold sore, for example, is caused by a quite different strain of the virus to the one that produces the characteristic sores around the mouth and may accompany a cold. These cold sores are painful and extremely difficult to cure completely, for although they tend to be self-limiting— that is, they usually disappear quite spontaneously after only a few days— the recurrence rate is high. Although the sores disappear, the virus retreats to a nerve cluster at the base of the spine and remains there until the next attack when it returns to its usual eruption site. Symptoms can often be relieved by keeping the area clean and dry— bathing with a salt/water bath solution.

Because the sexually transmitted herpes virus has now been implicated as a possible trigger for cervical cancer, anyone who has had the virus should have annual smear ('Pap') tests to check for the presence of abnormal, pre-cancerous cells on the cervix. If abnormal cells are detected on a smear, they can usually be easily eliminated in the early stages (see pages 208-9). (See also Sexually transmitted diseases.)

Conjunctivitis ('pink eye')
Conjunctivitis simply means inflammation of the conjunctiva — the thin, transparent membrane that covers the white of the eye. This condition can be caused by allergy, infection or irritation. The eyes feel sore and gritty, may water profusely, particularly if the cause is allergic, and will look red and bloodshot where the blood capillaries that bring oxygen to the surface of the eye have dilated to help fight the infection. Conjunctivitis is usually best treated by leaving the eyes well alone. If it is infective, however, it will need treating with antibiotic eye drops. In the case of allergy such as hay fever, special drops may also be prescribed to reduce the inflammation.

Constipation
A considerable amount of constipation exists only in the mind. One of the most signifi-

cant side-effects of the great fibre revival of the last 10 years is an obsession with 'regularity'. But you do not have to open your bowels once a day — or even every other day — in order to be functioning normally and healthily, as long as when you do open them, you do so at regular intervals and without straining or discomfort. Straining may lead to haemorrhoids and is almost certainly an indication of constipation. So too are hard, 'bullet'-type stools. If you do find you are constipated, look first to your diet.

Although laxative tablets or medicines can be effective in the short-term, they are self-defeating in the long term because they encourage the bowel and gut to become lazy. Eat a tablespoon of bran on your cereal or in soups or stews once a day instead, increasing to a quarter of a cup if necessary, and give your body at least a month to adjust to the new working regimen before you conclude it is not working and return to the laxatives or the doctor (preferably the doctor). If you have constipation that alternates with diarrhoea, or notice blood or black streaks in your stools, see your doctor.

Corns and calluses
Corns are caused by an over-growth of the top layers of the skin on the foot in response to pressure or friction, and can be considerably uncomfortable, even painful. Do not attempt to treat corns yourself beyond applying a dressing or unmedicated corn plaster to relieve the pressure. Paring away at the layers of accumulated skin may lead to septic infection and will most certainly increase the soreness. Medicated corn plasters should be avoided too, particularly if you have poor circulation or are diabetic. Seek the help of a chiropodist, who will be able to treat it and to advise on ways of avoiding a recurrence.

Calluses are more general patches of hard, rough skin that build up on areas of the body, usually the foot. Guard against getting them by looking after your feet well, by wearing comfortable shoes, by combating dryness with a daily application of moisturizer and by using a pumice stone to rub away dry spots with a little soap and warm water.

Cuts
If you have a cut that is very deep or unclean, check whether you have had a recent tetanus booster. If in doubt, ask your doctor to give you one, particularly if you are on holiday abroad or living in a hot climate. In all cases, clean the wound thoroughly under cold running water, then clean your hands thoroughly and, using ordinary soap and water or a mild diluted antiseptic solution, wash the wound, sweeping cotton wool away from it so that you are not rubbing dirt into it. Remove all visible dirt and cover with a clean dressing. Once the bleeding has stopped, the wound should be left to the air as much as possible. If it is deep enough to require bandaging, or if it does not dry up within a day or so, or if you notice pus forming and leaking from the wound, you should see your doctor. The wound may be infected. If this is the case, it can be cleared with an antibiotic preparation.

Profuse bleeding should be treated as a medical emergency. This is almost always

arterial in nature and should be treated by holding your hand over the bleeding part, either by applying pressure directly over the wound (put on a tight bandage and press very firmly) or by holding the two sides of the wound together. If this fails to stop the flow, and the injury is on a limb, apply a tourniquet, using anything that can be wound around the injured part, such as a handkerchief, a belt, or a scarf. Place the tourniquet between the injury and the heart and hold it as hard as is required to stop the bleeding. Do not keep the tourniquet on for longer than fifteen minutes and always take the injury to a doctor or hospital as soon as possible. These are first-aid measures only and medical advice must be sought as soon as possible.

Cystitis
Cystitis is a urinary infection and is caused by bacteria, known as E. coli, and also occasionally by other germs, travelling from the anus and bowel up to the urethra and into the bladder, where they cause the lining of the bladder to become inflamed and infect the urine. Cystitis is extremely common and afflicts 60 per cent of all women (often repeatedly) at some time in their lives. It can also be very painful. Symptoms are a constant and weary desire to pass water, pain and a burning sensation when doing so together with an inability to pass more than a few drops at a time, a dragging ache in the lower abdomen and a dark or 'strong' looking urine which may be streaked with blood from the inflammation.

If you suspect you have cystitis, you should always see your doctor. Most, but by no means all, types of cystitis can be cleared up with a quick (five-day) course of antibiotics. In the meantime, there are several self-help measures you can take to help relieve the pain. On the first signs of infection, drink two glasses of cold water. Fill two hot water bottles and settle down with one between your legs (warming the skin in this way reduces the burning sensation when urinating) and the other behind your back. Then drink the following: 300 ml/½ pint (1¼ cups) liquid, such as water-based squashes, every 20 minutes for at least three hours; a cup of black coffee or tea hourly (this encourages urination); a teaspoon of bicarbonate of soda mixed with a little water hourly (bicarbonate of soda is an alkali and, by making the urine less acid, takes the sting out of it). This should help to flush out the infection. Every time you urinate, wash yourself gently from front to back with plain warm water and dab yourself dry.

If you suffer from recurrent cystitis, take the following steps to reduce the likelihood of your getting a further attack:
Drink plenty (about 2 litres/3½ pints/4½ pints) of water or a bland fluid, such as milk or weak tea, every day to keep the bladder clear of germs.
Keep your vagina and urethra extra clean — wash with plain warm water, using a separate flannel, and always work from front to back to avoid transferring germs from the anus to the urethra. Avoid bath oils, talcum powders, vaginal deodorants and antiseptics and wash carefully with plain warm water before intercourse and again afterwards. It may also help if you pass water fairly soon after intercourse in order to flush

out any germs which may have entered the urethra.

Cysts
Cysts are fluid-filled capsules that can appear on any part of the body. They may be as tiny as a grain of sand or as large as a squash ball and are usually benign. In fact, sebaceous or skin cysts, which are the more common type, are always benign and are only removed for cosmetic reasons. Other types of cyst, however, may be more ominous and for this reason always require medical attention. Breast cysts often give rise to great concern, even panic, when first discovered, but they are rarely ominous and can often be both easily diagnosed and treated by a simple out-patient procedure. A common type of cyst that women get is an ovarian cyst. This is usually caused by one of the ovaries failing to release an egg at ovulation and the follicle that encloses it continuing to grow. It may also be caused by endometriosis (see opposite) or simply by a combination of factors, both hormonal and general. Many ovarian cysts disappear spontaneously. If they do not, they may grow, giving rise to feelings of fullness or distention across the lower abdomen and/or pain during intercourse. They may then require medical treatment, usually hormonal in nature. Surgery is not the preferred method of treatment. In some hospitals in the USA, vitamin E has been used with apparently impressive results. (See also Lump in the breast)

Dandruff
Dandruff is a common scalp disorder and it affects nearly everyone, often repeatedly, at some time in their lives. Like all other skin tissue, the outer layer of dead cells on the scalp is constantly being shed and replaced by younger cells beneath it. Dandruff occurs either when this outer layer accumulates on the scalp and fails to shed itself normally or when the process of cell division is stepped up in the basal layer of the epidermis.

If you have dandruff, treat it with the weak cetrimide solution given on page 98 before switching to one of the harsher acting dandruff shampoos. If the condition then continues unabated, buy a shampoo containing tar or zinc pyrithione, which is thought to have a slowing effect on the rate of cell turnover beneath the skin. Dandruff that is patchy or that comes away in large scaly pieces creating scabbing or bleeding is not necessarily dandruff. Some skin disorders, such as psoriasis, eczema and ringworm, can masquerade as dandruff — affecting the scalp, while often leaving the rest of the head and body quite clear. So be awake to the possibility that your dandruff may not be dandruff at all and, if in doubt, consult a trichologist or dermatologist.

Diarrhoea
Diarrhoea can be symptomatic of almost anything, from jittery nerves to food poisoning, and can be a particular hazard when travelling abroad where standards of hygiene and sanitation may be poor. While nervous diarrhoea subsides with the nerves and does not require treatment, diarrhoea produced by digestive or systemic upset can be treated with an anti-bacterial agent if severe. One of the most effective medicines

col-gon

for treating diarrhoea is kaolin and morphine, or straightforward kaolin, which is widely available throughout the world and in many countries can be purchased across the counter without a prescription. Take it as directed and, if the recommended dose produces no improvement in 24 hours, consult your doctor. You should also consult your doctor if you notice any significant change in your bowel habit and, particularly, if you have bouts of diarrhoea that alternate with constipation.

Dysmenorrhoea (painful periods)

Two out of every three women suffer from period pains (cramps) at some stage of their lives. Produced by strong contractions of the muscles surrounding the uterus, these pains are thought to be produced by local hormones, known as prostaglandins. In some sufferers, levels of this hormone can actually climb to eight times the normal level.

Unlike PMS, dysmenorrhoea is much more common among younger women up to the age of 25. Dysmenorrhoea usually disappears spontaneously after the birth of a baby and is often helped by the contraceptive pill, when hormone levels are 'balanced' out. Bad pains in later life should always be investigated medically.

Mild to moderate period pains rarely last more than about two hours and can often be helped by simple exercises — the pelvic rotation ('belly dancing') on page 202 is particularly good — which persuade tense muscles to stretch and relax. Other self-help methods include taking a 'shot' (1 oz) of brandy or whisky as a relaxant; taking a pain-killer, such as soluble aspirin, which is also a mild prostaglandin inhibitor, every four hours; drinking catnip or mint teas; sitting propped up with one hot water bottle against your back and another between your thighs; or pressing the small hollows by your ankles on either side of the Achilles tendon with your thumbs (an ancient Chinese remedy). Severe cases of dysmenorrhoea can be treated by the prescription of anti-spasmodic agents, such as mefenamic acid, which have an inhibiting effect on the action of the prostaglandins, to relieve the pain in over 80 per cent of cases.

Earache

Earache usually arises either as a result of a local ear infection or as 'referred' pain from an infection elsewhere, such as in a tooth. As all ear infections require medical investigation and usually a course of antibiotics to clear them, you should consult your doctor if the pain persists for more than 24 hours. In the meantime, treat it with a painkiller and leave the ear well alone.

Eczema (dermatitis)

Eczema is a general term used by dermatologists to describe a non-specific or specific (i.e. allergy-related) skin reaction that itches. The word itself derives from the Greek, *ekzeeim*, meaning to boil or bubble over, and this is particularly expressive of the red scaling patches and watery blisters characteristic of the condition known as infantile eczema — so called because it particularly affects children and usually disappears at around the age of eight. This type of eczema is particularly wretched. Because the condition itches unbearably, the child scratches and so sets up a vicious itch-scratch-weep-crust cycle. The sores themselves are not infectious and can be helped to heal by preventing the child from scratching (cut nails short and avoid putting irritant materials next to the skin), and using a steroid cream, such as hydrocortisone, to reduce the irritation and soothe the damaged skin. Zinc lotions and creams are also effective — particularly if the latter also contains coal tar which can help to relieve the itching. Cold compresses of linen or lint moistened with a watery solution of aluminium acetate (available over the counter from your chemist) may also help. Avoid over-frequent bathing and the use of soaps and detergents which can aggravate the condition by drying out the skin. Special diets have been shown to help in a few cases — particularly diets from which all cow's milk products have been eliminated and goat's milk substituted.

In adults, eczema can occasionally be an expression of an allergy (see page 214), usually but not always a 'contact' allergy to a substance such as nickel, or rubber. Treat the eczema topically as above and ask your doctor to refer you to a dermatologist for patch testing, which may determine the culprit.

Endometriosis

This gynaecological disorder is caused by patches of the uterine lining attaching themselves outside the uterus — such as on the Fallopian tubes or the ovaries — and, confusingly, continuing to behave as though they were still inside the uterus, i.e. bleeding during menstruation. The most common symptoms of the condition are bad period pains and/or pain during intercourse. If undetected, these patches may obstruct the Fallopian tubes or the ovaries and may then cause infertility.

The most effective way of controlling the condition is to stop menstruating. This can be achieved either through hormonal control or by becoming pregnant. Sometimes the pregnancy in itself turns out to be 'treatment' enough, leaving the sufferer symptom free after it. If you do have diagnosed endometriosis, and if pregnancy is not a viable option now, it is certainly worthwhile considering having children sooner rather than later in the light of possible future infertility.

Enlarged toe joints (bunions)

These almost always occur on the big toe and tend to be an inherited condition. Although they are not necessarily caused by ill-fitting footwear (some people who spend their time walking barefoot have them), they are certainly aggravated by it — particularly if the toes are too cramped.

As the enlarged joint becomes increasingly inflamed and the pressure within it rises, the traditional 'bunion' shape will begin to appear — the big toe being forced in towards the others, as the joint juts outwards to the side. If you have enlarged toe joints, or a familial tendency to them, keep your weight within limits, apply paddings and dressings to relieve the pressure, wear comfortable footwear and take the weight off your feet whenever possible. Prevention is always better than cure: choose shoes that have their widest part at the base of the toes and that allow the toes to move freely inside them. Although bunions can sometimes be rectified surgically, it is very much a last resort and results are often disappointing.

Eyes (chemicals, eyelashes, foreign bodies in)

If a chemical comes into contact with the eye, wash it out under cold running water by holding your head beneath a tap or shower head, letting the water flow gently and opening your eyes underwater several times. Continue for a minute or so. Keep your head tilted to one side to prevent the chemical from being washed into the other eye and be gentle; never direct the water straight at the cornea.

If an eyelash or particle comes into contact with the eye and the instinctive blinking and watering reaction fails to clear it, do not rub the eye. Hold the eyelids apart and gently coax the offending particle or lash out of the eye with the corner of a tissue or clean handkerchief. If you cannot see anything in the eye, it is probably lodged beneath one of the lids. Try holding the upper lid over the lower for a few moments to dislodge it. If this does not work, pull gently upwards on the upper lashes and bend the lid upwards. Someone else should then be able to spot it and to retrieve it.

N.B. If a particle scratches the cornea, the eye will feel as if it is still there for some time after it has been removed and may require antibiotic drops to help it heal.

If a piece of glass or metal comes into contact with the eye, see your doctor immediately.

Fainting

Fainting can be induced by emotion, shock, illness, tiredness, staying for too long in a sauna or very hot bath, not having eaten for a long time, early pregnancy and even by prolonged periods of standing. Warning signs are usually sensations of dizziness or cold and pallor in the face as the blood drains away. As loss of consciousness is caused by a reduction of blood supplied to the brain, the best possible thing you can do if you feel you may be about to faint is to sit or crouch down with your head between your knees. The action of gravity should be enough to restore blood supply to the brain.

If someone has already passed out, lie her on her side (never sit or prop her up in a chair) with her legs raised above the level of her head. Loosen tight clothing around the neck and the waist and, when she comes round, give her sips of cold iced water and — most important — time to recover fully.

Food poisoning

Food poisoning is caused by toxic bacteria breeding in food and infecting the intestines. Symptoms, which can be extremely unpleasant, include intense vomiting and diarrhoea, together with severe stomach pains. These can take anywhere between one and 48 hours to develop. Common sources of the bacteria are reheated meat, shellfish, rice, frozen foods that have not been properly thawed and canned fish and meat that have been contaminated during packaging.

If you have food poisoning, avoid all solid foods. It is essential, however, that you replace the fluids you are losing, so try to drink plenty of clear liquid, such as water, tea without milk, juices or consommé, even if you can only manage a mouthful or so at a time. If your stomach does not settle within 24 hours, ring your doctor and give details of everything eaten in the 48 hours before developing the symptoms.

Foot problems

See Athlete's foot, Corns and calluses, Enlarged toe joints.

Gastritis

Gastritis is a pain — often persistent — in the upper abdomen and it is caused by excessive acidity in the stomach, leading to inflammation of the stomach lining. The condition itself is usually a sign of self-abuse, and is aggravated by highly spiced foods, alcohol, very rich or acidic substances and erratic eating habits. It may occasionally be caused by metabolic disease or infection. Counteract the acidity in your stomach by drinking plenty of milk (this is preferable to stronger alkalis, such as bicarbonate of soda) and by looking after your general health more diligently. If the pain persists, consult your doctor.

Gingivitis (gum disease)

This is such a common condition that there is a greater likelihood of your having it than not. Sore or bleeding gums are the main sign and a clear indication that your tooth brushing routine needs revising (see pages 110-12).

Glaucoma

Glaucoma is an eye affliction caused by a disturbance of the fluid balance within the eyeball and a consequent increase of pressure inside the eye. If allowed to persist, glaucoma may damage vision by pressing against the optic nerve. One of the main symptoms of glaucoma is 'tunnel vision' — in other words, an increasingly restricted field of vision, even though you can still focus perfectly well. Other warning signs and symptoms, which may or may not be present, are headaches and seeing auras or 'haloes' around bright objects. Because glaucoma is an age-associated defect — it is rarely seen in people under 35 — and because it can be absolutely symptomless in the early stages (by the time it is diagnosed medically, the process has often gone so far that the sufferer can be classified as 'blind' for health insurance purposes), you should have an eye test at about the age of 45 to check that you have not got it. This is particularly important if there is a history of it in your family. Once detected, glaucoma can never be 'cured' but it can be controlled in one of three ways: medically, through prescription of certain drugs, surgically, in order to release pressure inside the eye, or through the use of prescription eye drops which use a drug called pilocarpine to constrict the pupil, so making the wearing of glasses unnecessary.

Gonorrhoea

This is extremely common and highly infectious and now second only to measles in the British league of infectious diseases (first in America, where about 20,000 people catch it each week).

Gonorrhoea is transmitted only on intimate contact by the *gonococcus bacterium* which has a rapid two- to three-day incubation period. Symptoms in men are fairly dramatic at the onset with a thick discharge and a burning sensation when urinating. They are much less dramatic in women in whom there may sometimes be a thin, yellowish discharge. Usually, however, there are no symptoms at all. Although the condition can be treated very effectively in most cases with a single dose of penicillin, follow-up is essential, both because some strains of the disease are becoming resistant to this antibiotic and because gonorrhoea, if left untreated, may lead to salpingitis (inflammation of the Fallopian tubes) which can in turn lead to infertility.

Although most clinics now aim for an immediate 95 per cent cure rate, there is increasing concern over the number of penicillin-resistant strains of the disease. In 1978, for example, out of a total of 60,000 cases in the UK, 35 were totally resistant to penicillin. In 1979, this number had risen to 100 and, in subsequent years, has continued to rise, although the total number of reported cases has actually fallen a little. In 1981, 444 cases of total resistance were reported. These figures make follow-up more important than ever. (See also Sexually transmitted diseases.)

Haemorrhoids (piles)
Haemorrhoids are dilated veins in the anus, the opening to the bowels, that may become inflamed and painful. They are caused by anything that increases blood volume in the abdomen, such as constipation or straining when opening the bowels, overweight and pregnancy. You do not get haemorrhoids from sitting on radiators. Symptoms of haemorrhoids are itching, bleeding, soreness and, often, intense pain on coughing, laughing or going to the lavatory. The best way of protecting against haemorrhoids is to make sure that you are getting enough fibre in your diet (see page 62). This can also be an effective way of treating them in the early stages, when suppositories and hot baths tend only to offer temporary relief. More advanced cases, however, may require the application of elasticated bands to cut off circulation, injections (as for Varicose veins) or surgery.

Halitosis (bad breath)
This can be caused by any number of factors, most of which do not originate in the mouth. As eliminating the problem involves eliminating it at source, mouthwashes are not on the whole a satisfactory solution or safeguard against the condition (see also page 135).

Hangovers
Hangovers have probably been around for almost as long as alcohol. In the first century AD, Pliny advised sufferers to take an elaborate morning-after concoction of owl's eggs doused in red wine and so became the first recorded advocate of the now proverbial 'hair of the dog' theory. This theory may have some substance because it helps to offset some — but by no means all — of the unpleasant effects of 'withdrawal', namely the raging headache, general malaise, gastritis caused by raised

acidity in the stomach and general feelings of sickness and nausea.

As the main effects of hangover are caused by dehydration, you can help to guard against them by interspersing alcoholic drinks with water, milk or fruit juice and by drinking copious amounts of water before you go to bed. Early morning hangovers are usually accompanied by a mild form of gastritis (see page 217). Taking a mild alkali, such as a glass of milk, may help. If you want to take a painkiller for the headache, however, take paracetamol (acetaminophen in USA) in preference to aspirin, which can irritate the stomach and thus make the condition worse.

Hay fever
See Allergy.

Headache
Headaches can be caused by any number of things. These include tension, frustration, fatigue, infection, sensitivity to certain foods, colds in the head, infected sinuses, alcohol, changes in altitude, injuries or blows to the head and fluctuating hormone levels. This list is virtually endless.

About 70 per cent of all headaches are thought to be tension headaches. These are caused by a prolonged, often uneven, contraction in the muscles at the base of the neck and shoulder blades and are aggravated by poor posture and psychological stresses, such as frustration, fear or even excitement. Tension headaches commonly feel like a tight band across the head, are worse in the evening than the morning and are twice as common among women as men. As any type of headache — and this one in particular — is associated with muscle spasm around the head and neck, relieve the tension by relieving the contraction in the neck muscles. Try any of the exercises shown on pages 42-3; lie down so that the head is supported and rotate the neck gently to relieve stiffness; massage sore strained muscles by clasping one hand over the other and pressing in firmly with the heels of the hands from the base of the neck up to the skull; ask a friend to 'free' your neck: you lie on your back with your head supported by a pillow while she gently stretches it out away from the shoulders and turns it to left and right; try the Chinese acupressure point, known as *tsuan schu*, and press firmly inwards with the thumbs on the inner corner of the eye just beneath the eyebrow for the duration of a complete outbreath. If none of these works, take two soluble aspirin or paracetamol (acetaminophen in USA) and wait for the pain to subside. If this type of headache is a frequent occurrence, you should take steps to identify and, where possible, to remove or relieve the root of the problem.

The second most common type of headache is known as a cluster headache and is linked with three major factors. The first is sex. Men are eight times more likely to be sufferers than women. The second is age. It usually first appears between the ages of about 30 and 45. The third is lifestyle. Heavy drinkers and/or smokers seem to be particularly prone.

Cluster headaches can be excruciatingly painful, are often considered to be a form of migraine but can be distinguished from the

normal type of migraine because they tend to be self-limiting. They last in bouts from two to 17 weeks and during that time they tend to arrive with alarm-clock regularity, sometimes as often as six times a day. Like migraine, cluster headaches tend to be unilateral (on one side of the head only). The sensation of pain is first felt around the eyes, travelling downwards to affect nostrils, jaw and mouth. Treatment usually consists in the careful prescription of drugs which will inhibit the dilation of the blood vessels. It is now also generally recognized that sufferers can help themselves enormously by avoiding alcohol. (See also Migraine.)

Herpes
See Cold sores.

Hypertension
(high blood pressure)
When you have your blood pressure checked — which should be whenever your contraceptive pill prescription is renewed, if you are under the age of 35, and once a year if you are over the age of 35 — two readings will be taken. The first figure is called the systolic pressure, and represents the pressure of the blood in the arteries as the heart pumps it through. The second figure is called the diastolic, or resting, pressure and represents the pressure of the blood in the arteries between heart beats. Although 120/80 is considered classically 'normal', there are wide variations all considered to be within normal limits. However, once your blood pressure, and particularly your diastolic pressure, rises beyond a certain point, (insurance companies usually put it at 150/90), it is considered high and you are said to 'have' hypertension.

Hypertension is not a disease but it requires medical management because it is a recognized predisposing factor towards diseases such as stroke, deep vein thrombosis or coronary heart disease, which can have serious, even fatal, consequences. Although, in some cases, blood pressure can be lowered by practising relaxation and breathing techniques, it can usually only be effectively controlled through the prescription of certain drugs. If your doctor prescribes tablets for high blood pressure, it is essential that you take them <u>even if you are feeling perfectly well</u>, that you report any side-effects as the prescription may need adjusting, and that you return for regular check-ups.

An excessively high salt intake is now thought to be a major contributory factor to hypertension.

Ingrowing nails
These occur only on the feet, never on the hands, and are caused by the edge of the nail growing into the skin which then folds back over it. Ingrowing nails can be caused by a number of things, principally a blow or injury to the toe and bad cutting (see pages 116-17 for guidelines) or, more simply, an hereditary predisposition. Ingrown nails can be extremely painful and usually require minor surgery in order to remove part, sometimes even all, of the nail. If you have a tendency to ingrowing toenails or have a toenail that is digging into the flesh on either side, roll up small pipes of cotton wool and wedge them gently between the nail and

the flesh to prevent irritation and inflammation.

Irregular menstrual bleeding
Spotting or 'breakthrough' bleeding during the middle of the cycle often occurs quite normally, especially in women on the pill. As long as this is not heavy or prolonged, you have no cause for concern. If, however, your bleeding is very irregular, or is excessively heavy or if you have been through the menopause, you should consult your doctor. In these cases, bleeding may indicate a gynaecological disorder, such as endometriosis or the presence of a polyps (harmless growths) in the uterus, and should always be investigated.

Jet lag
Jet lag occurs because the internal clocks that help control your body temperature, blood/sugar levels, hunger and sleeping patterns are out of synchronization with the outside world — usually four or more hours in front or behind it. Normally, when moving from place to place, these clocks have time to adjust gradually to a new schedule, but air travel has changed all this. Such travellers are liable to become confused, disorientated, hungry when no-one else is, sleepy when the rest of the world seems wide-awake and vice versa. The mere fact of travelling so far so fast is enough to induce any or all of these symptoms (particularly, and still inexplicably, when travelling east) but they will certainly be aggravated by drinking alcohol 'in flight' and, it now seems, eating and drinking in ways that appear to inhibit your ability to adjust easily to a new time scale. From these findings, an American physician, Charles Ehret, has devised this diet to help minimize the effects of jet lag.

Three days before take-off: three full meals (high-protein breakfast and lunch, high-carbohydrate supper). Tea or coffee only in the afternoon.

Two days before take-off: three light low-carbohydrate meals. Tea or coffee only in the afternoon.

Day before take-off: as for three days before.

Day of flight (travelling east): fast or eat very little before flying. Once on the plane, drink lots of tea and coffee, omit alcohol and evening meal, try to sleep, and eat a high-protein breakfast (if necessary take your own).

Day of flight (travelling west): fast on the plane, drink lots of strong coffee or tea in the morning, but none in the afternoon. Omit the lunchtime or evening meal.

On arrival: whatever the time, eat a hearty meal in accordance with local mealtimes, stay active and go to bed reasonably early.

Keloids
Keloids are scars that develop over wounds and that grow much larger than the original wound. Also known as hypertrophic scarring (see page 166), keloids are 10 to 20 times more common on black skins than they are on white ones and commonly appear after surgery, particularly if the scar is subject to tension. Caesarian delivery is one example, ear piercing another. The area between the neck and the nipple is particularly prone to this type of scar formation. Although keloids can be removed surgically, there is always the danger that renewed surgery will simply

hae-pho

aggravate the problem, thus resulting in an even larger 'scar'. Most doctors prefer to leave keloids alone, although steroid injections can sometimes help to bring them down.

Lice

Lice on the hair are extremely contagious and are common among schoolchildren. These can easily be treated by washing the hair with a specially formulated shampoo, available over the counter at chemists and drugstores. Lice on the genitals (crabs) are similar, but not identical, to the ones which affect the head. These can only survive in short hair, commonly pubic hair, but may migrate to other hairy parts of the body, such as the armpits or the legs or chest in men. Symptoms of lice are, first, visual (the insects can be clearly seen, although not the eggs) and, second, itching. They can be treated by applying a lotion to remove both insects and eggs — something that shaving the pubic hair will not do.

Lumbago

See Back trouble.

Lump in the breast

Finding a lump in the breast is a traumatic event for any woman. Often unnecessarily so: of all lumps in the breast, only a small proportion (probably less than 10 per cent) are cancerous. But, even so, you must consult your doctor if you find a lump, or suspect you have found one, for the following reasons.

● It is impossible to tell merely by feeling whether a lump is cancerous or not.
● Any lump in the breast requires further investigation (biopsy or X-ray, see page 207) if its cause cannot be determined by clinical examinations.
● Most lumps should be removed surgically to guard against the possiblity, however remote, of their turning malignant or cancerous at a later date. In most cases, the surgery required to remove lumps is restricted only to that area of the breast and leaves the smallest of scars, especially if surgery is carried out below the level of the nipple.

Painful, lumpy breasts among women under the age of 30 are most commonly caused by naturally fluctuating hormone levels just prior to menstruation, causing the breasts to become extremely sore, tender and granular in texture. The condition can often be successfully treated by adjusting and regulating the hormone levels. Because there are no specific lumps — just a general feeling of lumpiness — there is no need for surgery. Other common types of breast lump are benign tumours, or fibroadenomas (these are most common between the ages of 25 and 35, may feel like hard round marbles beneath the skin and should be removed surgically), and benign fluid-filled cysts (most common in early adulthood). These may appear and disappear for no clear reason at all or may require medical treatment. Cysts may sometimes feel so hard as to seem quite solid. They can sometimes be diagnosed and treated at the same time by aspirating the lump with a needle and drawing off the fluid inside it.

You can help yourself by being aware of any changes in the shape, size and texture of your breasts that do not normally occur over the stages of the menstrual cycle, and by reporting anything that seems abnormal or potentially abnormal to your doctor (see Breast self-examination, pages 210-11, and Cysts on page 216).

Migraine

Migraines are very common. The latest figures suggest that as many as four women out of every 10 will suffer a headache at some time in their lives which may be classified as migrainous. Classically, the condition starts with disturbances of vision caused by a constriction of the blood vessels supplying oxygen to the eye. These may include seeing bright lights, zig-zag lines, auras or 'haloes' around bright objects, or vision may be blurred or even double. Less commonly, tingling or sensations of numbness may be experienced in the hands and feet. This stage usually lasts for about 20 minutes.

The headache, unbearably oppressive in nature, often starts on one side of the head (the word itself derives from the Greek, via the French, meaning 'half a head') and, in up to 90 per cent of cases, is also accompanied by feelings of nausea, if not by actually vomiting.

Migraine seems to run in families (about 50 per cent of sufferers can trace an hereditary factor), usually arrives before the age of 40 and afflicts three times as many women as men. While the cause is not yet established — the most likely theory is that it is caused by a blood disorder causing the vessels to spasm and dilate — attacks have been fairly conclusively linked to a number of factors. Principal among these are stress (anxiety and tension are common precursors of migraine attacks) menstruation and foods containing nitrite, glutamate and other yet unidentified chemicals. Recent studies suggest that migraine sufferers may be unable to metabolize proteins present in certain foods. Higher levels of these proteins still circulating in the bloodstream are then thought to act as a stimulus or trigger for the attack. In one study on 500 migraine sufferers, the following foods were most consistently implicated:

Chocolate	75%
Cheese and dairy products	48%
Citrus fruits	30%
Alcoholic drinks	25%
Fatty fried foods and vegetables	18%
Tea or coffee	14%
Meat, especially pork	14%
Seafood	10%

Other contributing factors may include a change in routine, physical or mental fatigue, too little or too much sleep, travel, a change in climate or temperature, high winds, bright glaring sunlight, noise, sleeping tablets, oral contraceptives, hunger, head injury, high blood pressure, toothache and other pains in the head or neck.

Because migraine is triggered by so many different things and because each sufferer will have particular sensitivities to some, but not all, of these trigger factors, the best preventative course lies in working out which ones you are sensitive to and taking steps to avoid them. Keep a diary for a period of at least three months and record your attacks of migraine together with any associated factors, such as the stage of the menstrual cycle, foods eaten, meals missed and particular stresses. You can also help yourself by recognizing the warning signals that precede an attack and taking appropriate action. Along with, or in place of, visual disturbances, you may experience dizziness, numbness, nausea, increased sensitivity to noise or light, unusual energy or hunger, yawning, trembling, changes in mood and outlook, unusual pallor or an increase in frequency of passing water. When these occur, do not soldier on. Use any of the relaxation methods detailed on pages 176-7, lie down in a darkened room and try to sleep. If you feel very sick, anti-emetic drugs, which your doctor can prescribe for you, may help. Take soluble aspirin or paracetamol (acetaminophen in USA) for the pain and, if attacks are severe, consult your doctor. Stronger analgesics may then be given or, occasionally, drugs to reduce the dilation of the blood vessels and thus to prevent, or at least minimize, the headache. But some of these, such as ergotamine, do have side-effects — over-frequent doses leading to incessant headaches, for example — and are therefore rarely prescribed.

Nail separation

Nail separation is caused by a fungal infection working its way from the tip of the nail to the lanula at the base, thus causing it to lift from its anchorage on the nail bed. A white spot at the tip of the nail is an early sign of separation. It can be extremely painful and, although it can be treated in a variety of ways, it always requires evaluation first by a doctor or dermatologist in order to establish which type of fungus is responsible.

Nail inflammation (paronychia)

This condition, also known as 'housewives' hands', is caused by a fungus and produces painful inflammation around the folds of skin that surround the nail. Treatment usually consists in the prescription of an anti-fungal ointment. You can do much to help prevent the condition by protecting your hands with rubber gloves when immersing them in warm, soapy water.

Non-specific infection (non-specific urethritis or NSU in men)

This is one of the most common of all sexually transmitted diseases. In about 50 per cent of cases, a tiny microgerm, chlamydia, has been detected.

In men, symptoms of the disease resemble a milder version of gonorrhoea (see page 217). In women, there are often no symptoms whatsoever, though sometimes there may be a thin yellow discharge and a burning sensation when passing water.

In women, there is a danger that chlamydia may migrate to the Fallopian tubes and cause an infection which may lead to permanent damage (sterility). In men, chlamydia may occasionally produce pain and inflammation and may also be a contributing factor to lowered fertility. If present in the birth canal, there is a risk of eye infection to babies together with an increased risk of pneumonia and failure to thrive.

NSI is treated with a seven- to 14-day course of tetracycline (antibiotic). This carries a cure rate of only 80 to 85 per cent. Although the other 15 to 20 per cent will often respond to a different antibiotic, the recurrence rate for both types of treatment is high. (See also Sexually transmitted diseases.)

Nosebleeds

Nosebleeds can be caused by any number of factors, from changes in blood circulation during pregnancy to a blow on the nose. Some nosebleeds start spontaneously for no clear reason and most stop just as abruptly.

What to do: lean forwards and let your nose drip for a few minutes. If the bleeding does not stop, gently pinch the nostrils together for about 10 minutes, so that you are breathing through your mouth. Release slowly. If your nose is still bleeding, repeat the procedure by pressing the sides of the nose together with an ice pack (put ice cubes in a plastic bag and wrap in a small towel). If bleeding persists, consult your doctor. If bleeding stops, help prevent a recurrence by not blowing your nose for several hours afterwards.

N.B. If you suffer from recurrent nosebleeds, you should see your doctor, as this can be symptomatic of high blood pressure.

Painful periods

See Dysmenorrhoea.

Phobias

You can be phobic to almost anything — cats, dogs, spiders, snakes, heights, thunder and lightning, eating in public, illness, death, germs, dirt, fire — anything which engenders such terrifying fears that you will go to any lengths to avoid it. Of all the phobias, the most common is agoraphobia (fear of going outside the home or 'safe' environment) and it afflicts many times more women than men.

Many phobics combine their own private and specific fear with the more general one of admitting to it or seeking help. This is a major hurdle and usually an unnecessary one. Phobias can be treated, often extremely successfully. So if you do have a phobia, help yourself by seeing your doctor or by contacting one of the excellent voluntary associations. Sometimes just 'sharing' your fear with someone who is prepared to offer help and support may make it seem less terrifying and will certainly lessen the terrible feeling of isolation.

Treatment for phobias tends to be managed either by psychiatric (behavioural) means or by medical ones. Most phobias are thought to be the result of an early conditioning experience — a comparatively trivial stimulus, such as a dog or a thunderstorm, becoming associated falsely with a panic reaction. Psychiatrists can often help patients to 'unlearn' this association by exposing them to the fear stimulus. Sometimes this is done in gradual stages, at others much more quickly. This last approach is known as 'flooding' and can have remarkable results. Because anxiety and depression can be so intense while undergoing treatment, and because some phobias and some types of patient may not respond positively to such psychotherapy, anti-anxiety or anti-depressant agents may also be prescribed.

Some types of anti-depressant have been effectively used in the management and treatment of agoraphobia.

Piles
See Haemorrhoids.

'Pink eye'
See Conjunctivitis.

Premenstrual syndrome
PMS, also known as PMT, is a blanket expression for a number of symptoms regularly experienced by some women in the days before their periods start. These symptoms may include breast tenderness and bloating (rings and shoes, for example, that are worn quite comfortably over the rest of the cycle may become tight and painful), headache, lethargy, irritability and depression. For some women, symptoms are mild and transitory and can be satisfactorily relieved by a certain amount of foresight and simple self-help. For others (about one in ten), symptoms may last for up to 14 days — actually half the cycle — or may be so severe that they seriously disrupt both their own lives and those of the people living close to them.

Although the premenstrual syndrome was first identified as long ago as 1931, the precise cause has yet to be established. It is known to be hormonally based, however, and through this finding several treatments have now emerged. The first, particularly helpful for bloating, breast tenderness and depression or tension, is to take 45 mg of vitamin B6 (pyridoxine) twice daily after meals three days before you anticipate the start of your symptoms. Increase this to 75 mg twice daily if there is no improvement but do not exceed 100 mg, as too much of the vitamin may lead to increased acidity in the stomach. A second method, particularly helpful for depression, irritability, abdominal distention and bloating, is to top up levels of progesterone using a synthetic compound which is taken over the second half of the cycle. This must be prescribed by your doctor. A diuretic, spirolactone, may also help to counteract bloating. Meanwhile you can help yourself by keeping a chart of your symptoms (see page 27), together with details of your period (heavy, light, prolonged, brief, etc) and any symptoms experienced elsewhere over the cycle. If you are suffering from PMS the cyclical nature of your symptoms will soon become apparent and should convince your doctor if he or she happens to be sceptical. You can also help yourself by getting plenty of rest, by not attempting or undertaking too much over this time, by practising relaxation, taking gentle exercise and by eating less salt (now thought to be a contributing factor).

Physical symptoms of PMS: swelling and bloating, breast discomfort (tenderness, lumpiness, pain), weight gain, headache, migraine, backache, cramps, skin disorders.

Psychological symptoms of PMS: depression, irritability, lethargy, lack of co-ordination, clumsiness, tearfulness, erratic and illogical behaviour, lack of confidence, lowered sex drive.

Psoriasis
At least two people in every 100 have psoriasis, but although it is one of the most common skin disorders, there is still much to be learnt about it. The condition itself consists of raised red patches covered with fine silvery scales. It rarely itches, is not infectious or contagious, and commonly first appears between the ages of 15 and 30. It is usually confined to the legs, knees, elbows, scalp, lower part of the back and the shoulders and it disappears and reappears with sickening regularity. The patches themselves are produced by an abnormal thickening of the top layer of the skin, which is, in turn, produced by an excessively rapid cell turnover rate in the basal layer. In severe cases, it may take the skin cells just four days to get to the surface of the skin instead of the usual 28. Nobody knows why. What is known is that there is a strong family tendency (if both parents have it, there may be about a one-in-three chance of getting it), that it is aggravated by a number of factors, such as stress, alcohol, injury, throat infection and certain drugs, and that there is no permanent cure. Although psoriasis can be effectively treated, it will always reappear. Until recently, treatment has consisted of creams and lotions, principally tar ointments and dithranol. These are both fairly effective but extremely messy to apply. A comparatively new treatment, known as PUVA therapy, has had encouraging results and seems to produce a preventative as well as a curative effect. This capitalizes on the fact that psoriasis usually responds very positively to moderate sunbathing, particularly if there is a lot of UVA in the atmosphere. This therapy combines the controlled use of ultraviolet with psoralens. These sensitize the skin to sunlight, when taken by mouth or painted on to the skin before exposure. PUVA must be administered with caution and under supervision, as it is now fairly well established that excessive ultraviolet exposure can lead to skin cancer. For this reason, it is rarely prescribed for patients under the age of 40. The depressing fact that there is still no simple and effective long-term treatment for psoriasis, together with a general lack of understanding about the condition, can make sufferers feel isolated and depressed. In Britain, the Psoriasis Association is an important source of information and reassurance. Three equivalent self-help organizations also operate in the USA. Ask your doctor or a dermatological department of a hospital for details.

Scabies
This fairly common condition is caused by a tiny mite. It is spread both by sexual contact and by contact within the family. Symptoms are a general skin rash, characterized by linear burrows in the skin between the fingers and toes, red spots elsewhere on the body and itching, especially when warm and in bed at night. Scabies can be treated with creams and lotions. It is essential to get it cleared as the spots are liable to further infection.

Sexually transmitted diseases
If you have sexual intercourse, you are at risk from sexually transmitted disease and the greater your number of partners, the greater your degree of risk. It is important, therefore, that you should be on the lookout for any signs that may indicate that you have contracted one, or sometimes more, of them. As symptoms of sexually transmitted disease in women are often undramatic and easily missed, you should also be aware of how each of these diseases and infections will affect your partner, so that in the event of his getting one or more of the symptoms listed here, you can both go to your nearest clinic for a check-up. Never be embarrassed about seeking medical attention for conditions that you may have contracted sexually. If undiagnosed, some of them can become widespread, may lead to more generalized infection and may also affect your chances of bearing children.

Symptoms of sexually transmitted disease include painful sores on or around the vagina, a discharge that may be yellow, white or brownish in colour and may be foul-smelling, and sensations of itchiness or discomfort when passing water. Sometimes, however, few or none of these symptoms may be present.

Once you are at the clinic, an investigation will be carried out. This may be uncomfortable but not painful. Smears will also be taken and sent to a laboratory for culture. Sometimes you may get an immediate diagnosis. It is absolutely vital that you return to the clinic both to receive your test results and for the follow-up checks that your doctor specifies in order to ensure that all lingering traces of the infection have disappeared.

Protect yourself against infection by observing scrupulous hygiene (see Cystitis), by asking your partner to wear a condom if you know, or believe he might have, a sexually transmitted disease or if you have recently had a baby, abortion, miscarriage, D and C or IUD fitted (all of these increase the possibility of infection for a few weeks afterwards). Have regular check-ups — at about six monthly intervals — if you are sexually active with more than one partner, particularly if you are in your teens or early twenties, as both factors increase your susceptibility to infection. Finally, wear cotton, in preference to nylon, underwear. It is more absorbent and reduces the risk of irritation in the event of your getting an infection. (See also Cold sores, Gonorrhoea, Non-specific infection, Syphilis, Thrush, Trichomoniasis.)

Stretch marks (striae)
These appear after pregnancy or as a result of large and repeated fluctuations in body weight, and are permanent, although they will fade slightly with time.

Stretch marks are caused by the skin stretching as the weight increases. Once a certain degree of strain is reached (the threshold for which varies from individual to individual and is almost certainly genetically determined), the skin breaks beneath the surface leaving transparent, long white scars on hips, thighs, breasts or abdomen. You can guard against getting these long tears in the connective tissue by keeping your weight as stable as possible and trying not to let it fluctuate within a range of more than, say, 3 kg (7 lb). You obviously cannot and should not watch your weight in this way during pregnancy when most doctors consider a gain of anything between 9 kg (20 lb) and 12.5 kg (28 lb) to be healthy. While keeping the skin supple and well moisturized probably helps to minimize the damage, it will not prevent stretch marks occurring. This is because the break happens much deeper down in the dermal layer of the skin. Vitamin E supplements and creams have also been shown to have little, or no, effect as a preventative measure — despite the many claims to the contrary. A more credible theory is that people who develop stretch marks during their teens (when most skins stretch easily to accommodate the changes occurring at puberty) or during pregnancy have lower levels of zinc than women who go through several pregnancies with no sign of a stretch mark anywhere. As zinc, along with the vitamins C and B6, is involved in the production of the collagen and elastin that give the skin its elasticity and strength, there may well be a case for eating zinc-rich foods (namely all seafoods, especially oysters and herrings) at least once a week during pregnancy.

Styes
Styes are caused by an infection in the hair follicle at the root of an eyelash. The infected area becomes sore and red, making blinking extremely painful. Later, a spot will form and the eyelid may itch. Rubbing the eyes must be avoided, however, because this will only increase the irritation and may spread the infection. Do not try to treat a stye yourself beyond bathing it gently, using cotton wool moistened in warm water or a weak solution of boric acid. There is no truth in the old 'gold' remedy, so if you do get a stye, consult your doctor instead, who will treat it with an antiseptic ointment. Very occasionally a stye may be 'blind'. That is, it develops in a gland beneath the skin and becomes blocked. This will need separate treatment, sometimes even surgery, to clear it.

Sunburn
Prevention is always better than cure and, now that there is a science to suntanning, there is little excuse for burning. So heed the warnings, take note of the SPF factors and tan safely. If you ignore all this or still manage to burn, see page 84 for notes on first aid and, if the burn is severe, take it to a doctor as soon as possible.

Syphilis
This causes 100 deaths a year in the UK. Because of the severe complications of this disease (skin ulcers, heart disease, paralysis, blindness, insanity, death), early diagnosis is absolutely essential.

Seen most commonly among homosexual or bisexual men, syphilis is transmitted sexually by a tiny germ, *treponema pallidum*, which has an initial incubation period of up to three months. If this early stage of the disease goes undetected, however, the disease then enters a dormant or latent stage for between five and 50 years.

Early signs of syphilis are painless and transient spots or ulcers on the genitals. While these are always visible in men, they may go completely unnoticed in women. Even if this is not the case, there is an additional risk that concern will evaporate once the sores have disappeared. At the next stage, a generalized rash appears all over the body (this is also temporary) and may be accompanied by headaches, fever and general body ache. Once these symptoms have passed and the disease has entered the latent stage, syphilis can only be diagnosed in a blood test but it can still be transferred

sexually. Because of this and because babies born to mothers with syphilis may be born dead or diseased, antenatal clinics should always give blood tests to check for the disease.

In the early stage, syphilis can be completely cleared with a 10- to 14-day course of penicillin with follow-up to ensure there are no lingering traces of infection. (See also Sexually transmitted diseases.)

Thread veins

Thread veins — also called broken, spider and red veins — are dilated blood vessels in the skin. These can be caused by anything from pregnancy to injuries or blows to the skin and are also hereditary. Those ruddy faces and rosy cheeks that run in families are often the consequence of a maze of such 'veins' on the cheeks. Thread veins are also a natural 'side-effect' of the ageing process, when the thinning of the collagen makes for a lack of support so causing them to become more pronounced. Thread veins can be treated using the same method as for varicose veins (see right) in miniature. A sclerosing agent is given by injection and, on meeting the tiny blood leakages, causes them to constrict and to reform as bruised blood. They then fade away as any bruise would do. While this method can be effective, particularly on the coarser veins, it is expensive and time-consuming and it may take as long as a year of treatment before any real improvement can be discerned. A much more hopeful method is to use a laser beam which works painlessly, effectively and at the speed of light to cauterize the vessels. However, this treatment is still very expensive and not likely to become generally available for several years.

Thrush (vaginitis)

Thrush, monilia, and candidiasis all describe the same problem and it is one now thought to afflict as many as nine out of 10 women at some time in their lives. The infection itself is caused by a germ known as *candida albicans*. This yeast, which lives quite normally in the mouth, vagina and anus, can become more rampant when taking antibiotics or steroid drugs, if you are diabetic or have a thyroid disorder, if you are pregnant or take a contraceptive pill or for no clear reason at all. Other predisposing factors include wearing nylon underwear (choose cotton or silk), incorrect or lack of hygiene (always wipe front to back) and sexual intercourse when the germ is most commonly transmitted or transferred.

Symptoms of thrush are intense recurrent vaginal itching (never scratch as this will only intensify the discomfort), a thick white discharge, irritation and redness around the vulva and a burning sensation when passing water. These symptoms are not always present.

Once diagnosed, thrush can be treated in a variety of ways — with local pessaries and creams, with tablets or, more recently, with special tampons impregnated with an anti-candida agent. If you are using pessaries or creams to treat the infection, you must complete the course prescribed, even if the symptoms seem to have cleared completely. If there are any traces of the infection, the likelihood of a recurrence is high.

Thrush is one condition where household remedies can be extremely effective. These are certainly worth trying if, for any reason, you cannot see your doctor. They include douching with two tablespoons of white vinegar or lemon juice in 600 ml/1 pint (2½ cups) water, to increase the acidity of the vagina and suppress the activity of the yeast, and applying live natural yoghurt to the vagina with a blunt-ended injector tube or with your fingers. This contains a bacterium (*lactobacillus*), which is also found naturally in the vagina and is known to have an inhibiting effect on the candida bacteria. Always see your doctor as soon as you can.

Toothache

Toothache <u>always</u> occurs for a reason, so never sit it out and wait for the pain to subside. Make an appointment to see your dentist and, in the meantime, take an analgesic or painkiller and apply oil of cloves to the tooth and gum which has a numbing, anaesthetic effect.

Toxic shock syndrome

Toxic shock syndrome (TSS) is not a common disorder. In fact, it is more of a 'freak' phenomenon. In the whole of the USA for example, no more than 50 cases are reported a year. Alarm set in, however, following a sequence of events in 1978 in which the syndrome, which can be fatal, became linked with menstruation and, in particular, with the use of tampons. One particular high-absorbency tampon found to be recurring in case histories has been withdrawn from the market. Since then a considerable amount of research carried out indicates that toxic shock is not tampon-linked. But, as long as any doubt exists, it would be wise to follow the safeguards suggested by US doctors: change tampons frequently, use sanitary towels for night-time and avoid tampons with abrasive plastic applicators that may damage the skin on insertion.

Trichomoniasis

This condition is a common cause of abnormal discharge in women (men tend only to be carriers) and is transmitted sexually by a tiny one-celled organism, *trichomoniasis vaginalis*, which has an incubation period of less than a month.

Symptoms of trichomoniasis ('trich') can be extremely unpleasant — inflammation of the vagina together with a thick, yellowish discharge and itchiness and discomfort when passing water. Sometimes, however, there may be no symptoms at all. The main complication of the disease is that mothers may infect daughters at birth.

Fortunately, once diagnosed, trichomoniasis is easily and rapidly cured with a single dose or short tablet course of Flagyl. (See also Sexually transmitted diseases.)

Vaginal discharge

Changes in the consistency of the naturally-occurring mucus on the cervix and in the vagina over the stages of the menstrual cycle are a healthy indication of ovulation (see page 195), except when on the contraceptive pill, or pregnant when the stability of the hormones throughout the cycle results in an absence of ovulation and a minimal or non-existent 'discharge'. An abnormal discharge persists throughout the cycle, is thick, white, yellow or brown in colour, may smell unpleasant and be accompanied by itching and irritation or discomfort when passing water. If you have any of these symptoms, you may have an infection, so consult your doctor. (See also Sexually transmitted diseases, Thrush and Trichomoniasis.)

Varicose veins

Varicose veins are hard, knotty, distended veins that appear just beneath the surface of the skin and are almost always confined to the legs. They are caused by a weakness in the valve that controls the blood flow from the deep veins to the smaller, superficial ones. Once the volume of blood rises past a certain point, the smaller veins dilate and buckle under the increase in pressure.

Varicose veins are an inherited condition and can run unerringly in families for generations. This familial tendency can be allayed by taking the following common-sense measures to reduce pressure on the veins. Remember, too, that anything that increases the stress on the legs or that affects the volume of blood circulating around the lower half of the body can aggravate or even trigger the appearance of these veins.

● <u>Avoid anything that restricts blood flow round the legs,</u> such as tight clothes or boots or sitting with your legs crossed.

● <u>Take some exercise daily,</u> such as brisk walking, swimming or cycling, to stimulate the circulation.

● <u>When sitting down, support your legs.</u> Once horizontal, the pressure on the veins is negligible. Get into the habit of doing small foot exercises to keep the blood moving — wriggle toes, rotate ankles.

● <u>Avoid extremes of temperature,</u> such as excessively hot baths.

● <u>If pregnant or standing for long periods of time, wear support tights.</u> These offer greatest compression at the ankle, working like a tube of toothpaste, by directing the blood flow upwards.

● <u>Get enough fibre in your diet</u> (see page 62 for sources). A constipated digestion concentrates blood in the abdominal area of the body and increases the pressure on all surrounding veins.

Varicose veins can be treated in one of two ways. The older, more traditional and much more drastic method consists of 'stripping' and tying the vein. If the veins are not concentrated at the top of the thighs and provided that there are no contra-indications, such as a deep vein thrombosis or other obstruction of the blood vessels, they can be treated by injecting a sclerosing agent into the vein which causes it to contract and, eventually, to shrink away completely. The veins are treated one or two at a time. Aftercare consists in bandaging the treated leg for about a week and exercising gently to keep the blood circulating freely.

Vitiligo

Vitiligo is a condition in which the skin gradually loses its pigment. Almost always progressive in nature, the condition first appears at any age and on any part of the body. The white patches are usually symmetrical (i.e. on both hands or both feet) and are particularly susceptible to sunburn, as the skin no longer has any melanin to protect it. Less of a problem for fair-skinned people, who can usually camouflage the condition with cleverly applied make-up, vitiligo can be extremely traumatic for darker-skinned people because the contrast in colour is so much more apparent. PUVA therapy (see Psoriasis) can sometimes help to repigment the skin but this has the disadvantage of making the normal, surrounding skin darker too. If the white patches are very widespread, it may be worth bleaching the darker patches of skin but this can have disappointing results as it is extremely difficult to match up margins perfectly.

Warts

Warts are caused by the *papova* virus and can appear anywhere on the body, including the genitals. They have an almost indefinite incubation period, are slightly contagious and can be transmitted by intimate contact. Most warts are self-limiting. That is, if left untreated, they will eventually go. It usually takes between three months and 15 years for the body to develop its own anti-bodies, or immunity, to the virus — after which time the wart simply disappears. Most disappear after about two years: just about the time when disillusioned sufferers are turning to alternative remedies, such as hypnosis or charms! More conventional means of hastening the disappearance of a wart include cutting it out, freezing it (cryotherapy), passing an electrical current through it (diathermy) or applying strong organic acids to dissolve the infected tissue. All of these methods involve some degree of pain or discomfort and most leave a scar. For this reason, it is now thought preferable to leave warts to heal in their own time unless they are causing pain or discomfort. Plantar warts or verrucae on the sole of the foot are one example. Whatever you do, do not stab away at warts in the hope of 'removing the roots'. You may spread the infection.

Water retention (oedema)

In some circles, water retention is no more than a fashionable euphemism for over-weight (see also Cellulite). In medical circles, however, water retention is a much rarer and, often, more serious disorder. It may, for example, be symptomatic of underlying metabolic, cardiac or kidney problems requiring immediate medical treatment in order to maintain a healthy fluid balance. If everything is running smoothly, however, the body does all this for itself — automatically and unerringly adjusting its fluid balance to accommodate for changes in activity, temperature, diet, even the time of day.

Problems, however, may sometimes set in four days or so before menstruation when falling levels of progesterone (see page 194) are thought to cause the body to retain more water than usual, producing the characteristic 1-2 Kg (2-5 lb) weight gain and, occasionally, puffiness, bloating and discomfort. This is known as 'cyclical' oedema and is a recognized clinical feature of the premenstrual syndrome. If this causes distress or discomfort, it can usually be relieved with vitamin or hormonal therapy or with a diuretic, such as spirolactone.

Hormones and diuretics should always be taken under medical supervision. Never dose yourself with diuretics if trying to lose weight as they may place an unacceptable load on the kidneys.

Index

A

abdomen:
 exercise, 46, 47
 surgery, 165, 169
abscesses, 215
 in gums, 112
acidity, skin, 140
acne, 80, 93, 94, 192, 194, 204, 214
activity, see exercise
adolescence, 191
 skin in, 93-4
ageing, 82, 93-5, 212-13
alagia, 128
alcohol, see drinking
Alexander principle, 16, 33
alkalinity, skin, 140
allergy, 214
 check list, 139
 and cosmetics, 138-9
 and food, 75-6
alopecia, 96-8
aluminium salts, 139
amenorrhoea, 192, 214-15
anaemia, 114, 215
ankles, supple, 39, 50
anorexia nervosa, 77, 187, 192
anti-depressants, 175
anti-histamines, 214, 216
anti-perspirants, 134-5, 163
anxiety, 175
 exercises and, 40, 42
 signs of, 40, 80
 see also stress
appearance, assessing, 14, 165
appetite, 135
 assessing, 19
 see also eating
arms, exercises, 45
aromatherapy, 93
astringent lotions, 90
athlete's foot, 215
autogenics, 176
autosuggestion, 176

B

babies, skin, 93
back:
 exercise, 48-9
 massage, 130-1
 pain, 215
 strain, 35, 48
badminton, 56-7
balance in diet, 19, 58, 64-5, 73
balance, improving, 33
baths, 95, 182
beauty:
 factors affecting, 171
 routines, 20-1, 79
beds, choice of, 35, 182
bending, 35
biofeedback, 176-7
biorhythms, 27
birth, 205
birth control, 192, 198-9
 natural, 195, 199
bleaching:
 hair, 102-3, 212
 teeth, 112
bleeding, see nosebleeds;
 menstruation
blepheroplasty, 165, 167
blindness, 128
blisters, 215
blood pressure, checking, 208, 218
 see also hypertension
blow driers, 102
blushers, 22
 applying, 148-9
body:
 clock, 27, 191, 218
 holding, 34-5
 image, 14, 165, 192
 mechanisms, 207
 type, 30
 use, 35
body contouring, 165, 166
boils, 215

boredom and stress, 24, 172
bras, 46
breakfasts, 66, 71, 74
breastfeeding, 205
breasts:
 examination, 207, 208, 210-11
 exercise, 46
 lumps, 207, 208, 216, 219
 in pregnancy, 204, 205
 surgery, 165, 168-9
breath, bad, 135, 218
breathing:
 in exercising, 40
 techniques, 172, 178
brow lift, 167
bruising, 215
bulimia nervosa, 77
bunions, 217
burns, 215
 from sun, 82, 84
buttocks, exercise, 48-9

C

caffeine, 64, 173, 180, 200
calves, exercise, 50-1
calluses, 216
camouflage, make-up, 146-7, 150, 192, 213
cancer, 207, 208-9
candidiasis, 221
carbohydrate in diet, 60, 62, 73-4
carbon dioxide, and sleep, 182
cascarilla, hair dye, 105
cataract, eye, 120, 215
cathiodermie, 93
cellulite, 32, 215
cervical cancer, 208-9
chairs, choice of, 35
chamomile, hair dye, 105
charts, keeping, 14-15, 27
cheekbones, 144-5, 147-9
chemical face peeling, 168
chest:
 exercise, 46
 X-rays, 209
children:
 skin, 93
 and touch, 128
chin:
 implant, 168
 make-up, 144-5
chloasma, 84, 198, 215
cholesterol, 61, 62, 209
cigarettes, see smoking
circadian rhythms, 27, 191
clarifying lotions, 90
cleansing skin, 85, 87-9, 132, 214
clock, body, 27, 191, 218
cluster headaches, 218
cocktails, non-alcoholic, 188-9
coffee, 64, 75, 76, 200
coil, see IUD
colds, 215-16
cold sores, 216
colouring:
 hair, 103-5, 213
 natural, 22, 213
compulsive eating, 76-7, 200
concentration, 174
conception, 200
 problems, 206
condom, 199, 200
conjunctivitis, 216
constipation, 62, 216
contact lenses, 88, 123, 124-5
contours, body, 31
contraception, 192, 198-9
cooking methods, 62
corns, 216
cosmetics, 136-53
 and allergies, 138-9
 applying, 146-52
 care of, 138
 ingredients, 140
 see also make-up
cosmetic surgery, 95, 165-9
crab lice, 216
crash dieting, 94, 135
cues, time, 191, 192

curling tongs, 102
cuts, 216
cycles, bodily, 27, 76, 191, 192
cycling, 37, 38, 56-7
cystitis, 216
cysts, 207, 216

D

dance, 36
dandruff, 98, 216
danger signs, 207
dehydration and alcohol, 218
dental routines, 21, 209
dentistry, 110-11, 209
 cosmetic, 113
deodorants, 134-5, 163
dependence, in stress, 24, 175, 180, 183
depilatories, using, 106, 107
depression, 175
 post-natal, 205
dermabrasion, 168
dermatitis, 217
diabetes, 62, 63, 73, 80, 107, 209
diaphragm (cap), 199, 200
diarrhoea, 216-17
diet:
 allergies and, 75-6
 balanced, 19, 58, 64-5, 73
 cleansing, 74-5
 menus, 66, 74
 and migraine, 219
 nutritious, 19, 58-77
 in pregnancy, 204
 questionnaire, 19
 and sleep, 180
 slimming, 74
dieting, 73-5
 and compulsive eating, 76-7
 'crash', 82, 94, 135
 graphs in, 14-15
 recipes, 71, 74, 75
dinners, 66, 74
discharge, vaginal, 221
diuretics, 221
dizziness, 33
dreaming, 127, 180-1
drinking, 24, 175, 186-9
 assessing, 26, 186-7
 hangovers, 218
 moderate, 64, 186
 non-alcoholic cocktails, 188-9
 and pregnancy, 200, 205
 and sleep, 180-2
 water, 58, 64, 187, 218
drinks, recipes
 avocado and cucumber cup, 189
 banana and hazelnut flip, 189
 Caribbean cocktail, 189
 chestnut flip, 189
 clam and tomato cocktail, 188
 lemonade, 188
 mint tea, iced, 188
 passionfruit cooler, 189
 peach, apple and ginger fizz, 188
 redcurrant, orange and almond drink, 189
 sunrise, 188
drugs:
 dependence, 175, 180, 183
 and pregnancy, 200
dry hair, 99
drying hair, 99, 102
dry skin, 85, 90, 94, 95, 139, 146, 149, 212
dyes, hair, 102, 103-5
dysmenorrhoea, 217

E

earache, 217
ears, 126-7
 cleaning, 127
 piercing, 127
 surgery, 165, 166, 168
eating:
 habits, 19, 58, 64-5, 200
 psychological problems, 76-7, 200
 and sleep, 180
ectomorphs, 30

eczema, 80, 93, 214, 217
elastone, 95
electrocardiogram, 209
electrolysis, 107, 212
elimination diets, 75-6
emulsions, 140
endometriosis, 217
endomorphs, 30
energy:
 food sources, 63
 increasing, 36
 rhythms, 27
exercise, 17-18, 36-57
 ante natal, 202-3, 204
 arms, 45
 back, 48-9
 breasts, 46
 charts, 17, 18
 dangers, 35, 48
 facial, 40-1
 finishing, 53, 55
 general, 53-7
 legs, 50-1
 neck, 42-3, 218
 post natal, 196, 205
 regular, 40, 212
 safe, 18, 36, 38, 40, 57
 shoulders, 44-5
 and stress, 172
 yoga, 36, 37, 38, 56-7, 178-9
exfoliating, skin, 91, 95
eyebrows, dyeing, 103
 plucking, 106
 shape, 144-5, 150
eyelashes:
 dyeing, 103
 false, 123
eyelids, surgery, 165, 167
eyes, 120-5
 assessing, 144-5
 chemicals, 217
 cleansing, 88, 123
 colouring, 22, 123, 150-1
 contact lenses, 88, 123, 124-5
 defects, 120, 122
 foreign bodies in, 217
 make-up, 22, 123, 150-1
 spectacles, 123-5
 strain, 120
 styes, 220
 testing, 120, 209

F

face:
 assessing, 22, 142-5
 cleansing, 85, 87-9, 132, 214
 exercises, 40-1
 hair, removal, 106-7, 212
 professional treatments, 91-3
 routines, 20, 79, 87, 88-91
 see also make-up; skin
face-lifts, 95, 165, 166, 167
facials, professional, 91-3
fainting, 217
Fallopian tubes, 206, 217, 218
fasting, 74-5, 135
fat, body, 30, 32, 37, 46, 215
 aspiration, 169
 estimated, 32
fat in diet, 58, 60-1
features, individual, 22
feet:
 care, 50, 115-17
 infections, 215
 massage, 131, 177
 odour, 135
fencing, 56-7
fertility, 206, 218, 219
fibre in diet, 58, 62, 216, 218, 221
fifties and over, skin, 95
fingers, tense, 45
first-aid, 215, 216
fitness:
 assessing, 17-18
 habits, 17, 36
 importance, 29, 36
 increasing, 18
flavour, 135

flossing, dental, 112
fluid retention, 221
fluoride, 108, 111
food, see diet
food poisoning, 217
forehead, 144-5, 167
formaldehyde, 139
forties, skin, 94-5, 212
foundation, make-up:
 applying, 146-7
 choosing, 22
 removing, 88
freezing facials, 93
fresheners, skin, 90
front, exercises, 46-7
fruit in diet, 58, 62, 74, 75

G

garlic, and breath, 135
gastritis, 217
genes, and skin, 80-2, 93
genetic disorder, 204
German measles, 200
gingivitis, 112, 217
glaucoma, 120, 209, 217
gonorrhoea, 204, 217-18
grains, in diet, 58, 62
gums, care of, 21, 110, 111, 112, 217
gymnastics, 37, 38, 56-7

H

habit, 20, 171, 173, 183
haematoma, 215
haemorrhoids, 204, 216, 218
hair, 21, 96-107
 bleaching, 102-3, 107
 brushing and combing, 98
 colouring, 103-5, 213
 conditioners, 102, 140
 drying, 99, 102
 growth, 96
 loss, 96-8
 perming, 102
 in pregnancy, 204, 205
 processing, 99, 102-5
 removal, 106-7, 212
 routines, 21
 structure, 96
 style, 96
 type, 21, 99
 unwanted, 106-7, 212
 washing, 93, 98-102
halitosis, 135, 218
hands:
 care, 219
 manicure, 21, 115
 tense, 45
hangovers, 218
hara, 177
hayfever, 214, 216
headache, 218
health, consciousness, 26, 207, 208-9
hearing, 126-7
heart:
 checking, 209
 disease, 60, 61, 62, 73
 and exercise, 38
henna, hair dye, 105
herpes virus, 200, 209, 216
highlights, hair, 102-3, 104-5
hips, exercise, 50-1
hop pillows, 182
hormone replacement therapy, 207
hormones, effect, 93, 94, 95, 96, 106-7, 175, 192, 196, 206, 214, 217
 stress, 172, 173
humidity, and skin, 85
hypertension, 18, 64, 208, 218
hyperventilating, 178
hypoallergenic products, 140
hypoglycaemia, 63

I

image, bodily, 14, 165, 192
infertility, 206, 218, 219
insomnia, 180-2

iron, in diet, 215
IUD, 192, 199, 209

J

jawline, 144-5, 147, 167
jet lag, 191, 218
jogging, 36, 38, 46, 53, 56-7
joints, 44
 massage, 131
 supple, 37-8, 212

K

keloids, 218

L

labels, information on, 138, 140
lanolin, 139
laser therapy, 93, 95, 208
laughter, 40, 173
legs:
 exercises, 50-1
 hair, removal, 106-7
lice, 219
lifestyle, 170-89
 and shape, 29
 and stress, 23-4
lifting, correct, 35
ligaments, 46
lip colour, 22, 152
lipectomy, abdominal, 165, 169
lips, 144-5, 152-3
liver spots, 95
LSD, habit, 183
lumbago, 215
lumps, breast, 207, 208-9, 216, 219
lunches, 66, 74
lungs, 209
lying, correct way, 35
lymph glands, 210

M

make-up:
 and ageing, 212-13
 assessing, 144-5
 camouflage, 146-7, 150, 192, 213
 colour, 22, 213
 eyes, 22, 123, 150-1
 individual, 22
 lips, 144-5, 152-3
 procedures, 144-52
 removing, 88, 123
mammography, 207
manicure, routines, 21, 115-17
marigold, hair dye, 105
marijuana, 183
mascara, 123
 removing, 88
massage, 128-31
 basic rules, 130-1
 facial, 93
 neck, 42, 176, 177, 218
 as relaxation, 177
 scalp, 98, 100
 strokes, 130-1
mastectomy, 165, 169
masturbation, 196
measurements, body, 14-15, 31
medicated products, 140
meditation, 172, 177
melasma, 84, 198, 215
menopause, 95, 107, 196, 207, 213, 215
menstruation, 135, 215, 220, 221
 absence of, 214-15
 cycles, 27, 191, 192-5, 196, 207, 218
 excessive, 215
 irregular, 209, 218
 painful, 217
menus, 66, 74
mesomorphs, 30
migraine, 219
migraine and stress, 24, 172
milk bath, 95
mind control, 177
minerals, in diet, 72, 114
mixed condition hair, 99, 102

mobility:
 assessing, 38, 55
 exercise, 55
moisturizing skin, 85, 90-1, 123, 146, 212
monilia, 221
morning sickness, 204
mouth:
 cleaning, 108, 112, 135
 shape, 144-5, 152-3
movement:
 general exercises, 40-55
 principles of, 35
muscles:
 abdominal, 47
 chest, 46
 damage, 38
 facial, 40
 legs, 50
 neck, 42
 relaxation, 176
 shoulders, 44
 strength, 36-7
music, and exercise, 53

N

nails, 114-17
 artificial, 114
 and health, 114
 inflammation, 219
 ingrowing, 218
 routines, 21
 separation, 219
natural ingredients, 105, 140
nausea, 204
neck:
 exercises, 42-3, 218
 massage, 42, 176, 177, 218
nicotine gum, 184
nipples, care of, 204, 205, 210
noise, 127, 182
non-specific infection, 219
noradrenaline (norepinephrine), 173, 174
normal hair, 99
normal skin, 85
nosebleeds, 219
noses:
 make-up, 144-5, 147
 surgery, 165, 166, 167
nutrition, 19, 58-77, 204

O

oatmeal in bath, 95
obesity, 62, 73; see also weight
odour, 132-5
oedema, 221
oily hair, 99, 194, 204
oily skin, 85, 93, 94, 146, 149, 192, 194, 204
oral cycles, 76
organic ingredients, 140
orgasm, 196
orthodontics, 110
otoplasty, 168
ovaries, 206, 216, 217
ovulation, 27, 195, 206, 207
ozone treatments, 93

P

pain, 128, 217
 periods, 217
'pap' test, see smears
parabens, 139
paraphenylenediamine, 139
pedicure, 115-17
peeling, chemical, 168
pelvic examination, 209
perception, 119
perfume, see scent
periods, monthly, see menstruation
perms, hair, 102
pernicious anaemia, 215
personality and stress, 24, 172
perspiration, see sweat
pH balance, 98, 140
phobias, 175, 219
photographs of posture, 16

piles, see haemorrhoids
pillow, sleep, 182
pimples, camouflage, 147
plaque, dental, 108-10, 111, 112
plastic surgery, 95, 165-9
plucking hair, 106-7
poise, 33
posture:
 assessing, 16-17
 in exercising, 40, 53
 improving, 33-5, 44
 principles of, 33
powder, face, 149
pregnancy, 94, 200-5, 215
premenstrual syndrome, 27, 194-5, 220
preservatives, in cosmetics, 140
pressure, and stress, 23, 24, 174
priorities, establishing, 174
profile, personal, 13-27
 beauty routines, 20-2
 drinking, 26, 171
 fitness, 17-18, 29, 31, 36, 38
 health, 26-7
 measurements, 31
 nutrition, 19, 58
 shape, 14-17
 smoking, 25, 171
 stress, 23-4, 173
 use of, 13, 184
props, and stress, 24, 171, 183
protein in diet, 58, 60
psoriasis, 220
psychology and stress, 23-4
puberty, 192
 and skin, 93
pubic lice, 219
pulse rate, 18, 36, 38

R

racquetball, 56-7
rashes, 139, 214
recipes, 66-71
 apple snow, 69
 aubergines (eggplant) with mozzarella, 66
 borsch, cold, 67
 caponata, 67
 chicken couscous, 69
 chicken with herb sauce, 69
 chicken liver pilaff, 71
 chicken wings, grilled, 67
 crudités, 71
 cucumber with yoghurt, 69
 eggs with watercress sauce, 69
 fennel, braised, 68-9
 floating islands, 68
 fruit compote, dried, 68
 garlic sauce, 67
 horseradish sauce, 68
 lentil soup with yoghurt, 67
 mango fool, 71
 muesli, 71
 peppers, stuffed, 68
 prawns (shrimp), steamed with vegetables, 70
 prune mousse, 67
 rainbow trout, poached, 70
 ricotta sauce, 71
 salade niçoise, 70-1
 scallops, seviche of, 68
 shabu-shabu, 71
 sole, seviche of, 68
 spinach, mushroom and bacon salad, 67
 tomato soup, fresh, 70
 trout, poached rainbow, 70
 veal, braised, with basil, 67
 vegetable bouillon, 68
 watercress omelette, 67
 yellow sauce, I and II, 70
 yoghurt salad dressing, 71
relaxation, 176-9
 and beauty, 171
 after exercise, 40, 53
 progressive, 176
 techniques, 176-9
rhinoplasty, 165
rhubarb root, hair dye, 105
rhythms, biological, 27, 191

rhytidectomy, 167
riding, 56-7
rollers, heated, 102
rosacea, 80, 95
routines, 20, 79, 183
rubella, 200
running, 56-7

S

sage, hair dye, 105
salt in diet, 58, 64, 180
scabies, 220
scalds, 215
scales, choosing, 31, 74
scalp:
 massage, 98, 100
 problems, 98, 216
 routines, 21, 98
scars, 218
scent, 135, 162-4
 choosing, 163-4
 in cosmetics, 140
 production, 162-3
 sensitivity to, 138, 139
 storing, 164
 wearing, 163
screening, health, 207, 208-9
selflessness, breathing of, 178
senses, the, 119-35
sensitive skin, 85, 90, 123, 138-9, 140
sensitivity, threshold, 194
sexual intercourse, and cancer, 209
sexuality, 196
sexual relationships, 196
sexually transmitted disease, 200, 216, 217-18, 219, 220, 221
shampoo, choosing, 98-102, 140
shape:
 assessing, 14-17, 29
 changeable, 29, 30-3
 development, 192
 importance, 29
 unchangeable, 29, 30
 see also posture
shaving hair, 106
shoes, correct, 35, 50, 115
shoulders:
 exercise, 44-5
 massage, 176
sight, 120-5, 209, 219
silicon implants, 169
sitting, correct, 33, 35
skating, 56-7
skiing, 56-7
skin, 80-95, 144-5
 ageing, 93-5, 212-13
 allergic reactions, 138-9, 214
 cancer, 82, 84
 chemical peeling, 168
 childhood, 93
 cleansing, 85, 87-9, 132, 214
 colouring, 22, 213
 conditions, 80, 93-5, 144-5, 192, 214, 219, 220
 destructives, 82-5
 drying, 85, 90
 exfoliating, 91, 95
 function, 80
 genetics and, 80-2, 93
 and humidity, 85
 moisturizing, 90-1, 123, 146, 212
 nervous reactions, 80
 professional treatments, 91-3
 regeneration, 80
 routines, 20, 79, 87, 88-91, 93
 and sleep, 84-5
 and smoking, 84, 94
 stretch marks, 204-5, 220
 structure, 80
 surgical planing, 168
 in teens, 93-4
 toning, 90
 type, 20, 80, 85
skipping, 38, 39, 56-7
sleep, 180-2
 amount needed, 180
 and beauty, 171
 and noise, 127, 182

 and skin, 84-5
 stages, 180-1
 and stress, 84-5, 127
sleeping pills, 175, 180
slimming, see dieting
smear tests, 208, 209, 216
smell, 132-5
smoking, 24, 184-5
 assessing, 25, 184
 giving up, 25, 184-5
 and health, 61, 184
 and pregnancy, 200
 and skin, 84, 94
 and stress, 173
 and weight, 25, 185
soapless preparations, 140
soaps, ingredients, 140
sodium lauryl sulphate, 139
somatotype, 30
sound, 126-7
spectacles, 123-5
spine:
 curving, 35
 exercise, 48-9, 55
sports, 56-7
spots, camouflage, 147; see also acne
squash, game, 56-7
stamina, 17, 18, 36, 38-9
sterilization, 199
stomach:
 exercise, 47
 massage, 177
strength, 17, 18, 36-7
stress, 172-5
 assessing, 23-4
 and eating, 76-7
 managing, 172-4
 and migraine, 219
 optimum level, 172
 and relaxation, 172, 176-9
 and sexuality, 196
 and the skin, 80, 84-5
 and sleep, 84-5, 127
stretch marks, 204, 220
styes, 220
sugar in diet, 58, 62-3, 75, 108, 180
 and teeth, 108
sun, protection from, 82-4, 94, 220
sunlamps, 84
sunburn, 84
 avoiding, 82, 94, 220
sunglasses, 123, 124
superfatted soaps, 140
superfluous hair, removing, 106-7, 212
suppleness, 17, 18, 36, 37-8, 39
surgery, cosmetic, 95, 165-9
sweat, 64, 132-5
swimming, 37, 56-7
symptoms, interpretation, 191, 207
syphilis, 200, 220

T

tampons, 221
tanning, skin, 82-4
taste, 135
tea, 64, 75, 76, 200
 as hair dye, 105
teenagers, 93-4, 191
teeth, 108-13
 abscesses, 112
 bite, 108
 bleaching, 112
 brushing, 110, 111-12
 cosmetic dentistry, 113
 false, 113
 flossing, 112
 and gums, 110, 111, 112
 orthodontics, 110
 routines, 21, 108-10, 209
 structure, 108
temperature, rhythms, 191, 195
tennis, 56-7
tension:
 headaches, 218
 and massage, 130
 and neck, 42-3
 visible, 40, 45
test tube babies, 206

223

Acknowledgments

thighs, exercise, 48, 50
thirties, skin, 94
thread veins, 221
thrush, 221
time:
 controlling, 174
 rhythms, 27, 191
tinting hair, 102, 103-5
toe joints, enlarged, 217
toenails, 218
toning, skin, 90, 140
toothache, 221
toothbrushes, 111
toothpaste, 111
touch, 128-31
toxic shock syndrome, 221
tranquillizers, 175
trichomoniasis, 221
tummy:
 exercise, 40
 massage, 177
tunnel vision, 209, 217
tweezing hair, 106
twenties, skin in, 94

U

ulcers, mouth, 112
urethritis, non-specific, 219

V

vaginal discharge, 221
varicose veins, 204, 221
variety, and stress, 23, 172, 173
vegetables:
 cooking methods, 62
 in diet, 60, 62, 74
vegetarians, 19, 58, 60
veins:
 thread, 221
 varicose, 204, 221
venereal disease, 200, 206
vision, see sight
vitamins, 62, 72, 215
vitiligo, 221
vomiting and stress, 77

W

waist, exercise, 46
walking, 56-7
 correct, 35
walnuts, hair dye, 105
warts, 221
water:
 in diet, 58, 64, 73, 187
 retention, 221
water sports, 56-7
waxing hair, 106-7
weight:
 graphs, 14, 15, 31
 ideal, 30, 31, 200
 losing, 14-15, 71, 73-5, 166
 in pregnancy, 204, 205
 at puberty, 192
 and smoking, 25, 185
weights, use of, 37, 56-7
whole grains, in diet, 58, 62
winter itch, 95

X

X-rays, 209

Y

Yoga, 36, 37, 38, 56-7, 178-9

ILLUSTRATION

Special photography by: Robert Golden: 62-5, 76-7, 162-3, 164, 188-9; Sandra Lousada: 1-5, 12-18, 20 (centre and right), 21, 22, 26-59, 74-5, 78-81, 86-103, 106-117, 121, 129, 134-7, 142-161, 176-181, 190-212; Tim Simmons: 23-5, 118-19, 126-7, 133, 170-3, 182-5; Charlie Stebbings: endpapers, 19, 60-1, 66-73, 104-5, 187.

Other photography

Werner Forman Archives: 6 (above left); The National Gallery, London: 6 (above right); The Bridgeman Art Library: 6 (below left); The Ashmolean Museum, Oxford: 6 (below right); The Metropolitan Museum of Art, gift of Consuelo Vanderbilt Balsan, 1946: 7 (above); The Trustees of the Tate Gallery, London: 7 (below); Beaton: Paula Gellibrand and Greta Garbo 8; Aquarius, London: Marilyn Monroe 8; Rutledge: Henrietta Tiarks 8; Bailey: Penelope Tree and Jean Shrimpton 8-9; Toscani: Margaux Hemingway 9; O'Lochlainin: Katharine Hepburn 9; Albert Watson: 20 (left), 83; Alan Randall: 139, 141.

Make-up for special photography by:

Christine at Image
Teresa Fairminer at Image
Maggie Hunt at Models One/Elite
Carol Hemming
Ariane

Hair for special photography by:

Ivy at Schumi
Vicky at Molton Brown
Barbara at Molton Brown
Meryl at Molton Brown
Robert Lobetta

Photographic styling by:

Alison Pollard

The publishers would like to thank the following companies for kindly lending accessories for photography:

Butler and Wilson (jewellery) 154-161, 193; A Bigger Splash (taps and basin) 109; Casa Catalan (tables, plants and pots) 28, 181, 210-11; Conran (bowls) 115, 116-17, (tray) 210-11; Courtenay (shirt) 58, (camisole) 95; Damart (vests) 20, 109, 110-11; The Dance Centre 1, 40-55, 56; Debenhams (blouse) 160; Designers Guild (cushions) 176-7, (lamp, china, rugs) 210-11; Detail (earrings) 103, (necklace) 170; Edina and Lena (pullovers) 158, 161; Fenn, Wright and Manson (suede top and shirt) 156, 159; Freeds (leotards) 33, 34, 35, 40-55; Gamba 40-55, (exercise suit) 178; Graham and Green (blinds, paper and chair) 28; Great Expectations (dress) 201; Harrods (bowls, etc) 21, (loofah) 94, (towels) 101, (bowls) 115, (towels and manicure equipment) 20, (towels) 116-17, 134; James Drew (shirt) 154-5; Jasper Conran (shirt) 190-1; Jones (earrings) 136, (necklace) 190-1; Kenzo (blouse) front cover and 3, (dress) 193; Laura Ashley (wallpapers) 28, 210-11; Liberty (shawls) 154-5, 156; Lunn Antiques (sheets) 26, (bed linen, cushions) 28, (camisoles) 98-101, (linen) 181, 197, (quilt) 201, (bed linen, cushions) 210-11; Miss O (shirt) 157; Mitsukiku (kimonos) 20, 98-101; Next (jumpers) 75, 103; Nina Campbell (glass) 109; Osborne and Little (wallpapers) 20, 109-11, 115, 116-117; N Peal (knitwear) 190-1; Paul Smith (shawl) 161; Pineapple Dance Centre 40-55; Philip Kingsley 78-9, 100-1; Piero de Monzi (shirt) 158; Sulka (pyjamas) 26, 210-11; Telephone Box 28, 181, 201, 210-11; Molton Brown endpapers.

Page 160: Mrs Desmond Preston; hair by Barbara; make-up by Teresa Fairminer.

Pages 190-1: Olive Allan and Christine Davies; hair by Vicky; make-up by Christine.

Page 193: Polly Richards; hair and make-up by Carol Hemming.

Pages 202-3, 205: Juliet Hughes-Hallet; hair by Ivy; make-up by Christine.

Pages 212-13: Mrs Ronald Hutton; hair by Simon Southall of Headlines; make-up by Christine.

Artwork by: Arka Graphics: 194-5; Russell Barnett: 42-50, 122; Lynne Riding: 112, 115, 124, 146, 174; Maire Smith: 80, 96, 108, 114, 120, 126-35; Martin Welch: 14, 16, 42 (bottom left), 82, 111, 123, 147-69.

TEXT

Page 10: John Berger quotation from *Ways of Seeing,* published by the British Broadcasting Corporation and by Penguin Books Limited. © Penguin Books Limited, 1972.

Page 11: Virginia Woolf quotation from 'The New Dress', one of a collection of short stories from *A Haunted House.* This passage reproduced with the permission of The Author's Literary Estate and The Hogarth Press.

Pages 14 and 31: Weight graph devised from weight/height tables produced by the British United Provident Association (BUPA) and reproduced with their permission.

Page 19: Compulsive eating/dieting questionnaire adapted from Internal and External Components of Emotionality in Restrained and Unrestrained Eaters devised by J Polivy, CP Herman and S Warsh in the *Journal of Abnormal Psychology,* 1978, 87, page 497.

Page 23: List of Life Change Units reproduced with the permission of the British Safety Council.

Page 32: Body fat graph devised from figures produced by JVGA Durnin and J Womersley and cited in an article, 'Body fat assessed from total body density and its estimation from skinfold thickness: measurements in 481 men and women aged 16 to 72 years' in the *British Journal of Nutrition,* 1974, 32, pages 77-99.

Page 35: Exercises to beware of based on recommendation by the American Medical Association's Department of Health and Education.

Page 36: Jane Fonda quotation from *Jane Fonda's Workout Book* published by Allen Lane. © The Workout Inc, 1981. This passage reproduced with the permission of Penguin Books Limited.

Page 62: Fibre values for listed foods taken from McCance & Widdowson's *The Composition of Foods* by AA Paul and DAT Southgate, published by Her Majesty's Stationary Office (London, 1978) and reproduced with the permission of The Controller Her Majesty's Stationary Office.

Page 82: Sun protection factor chart compiled from figures produced by Piz Buin Protective Tanning.

Pages 142-3: Face measurements based on material from Mademoiselle Magazine, USA.

Pages 210-11: Breast self-examination series based on method recommended by the Women's National Cancer Control Campaign (UK).

PDO 83-1195